The Art of the Print

The Art

Fritz Eichenberg

of the Print

MASTERPIECES · HISTORY · TECHNIQUES

Harry N. Abrams, Inc., Publishers, New York

Editor's Note: The term "Masonite" is used in numerous places in this book as a synonym for hardboard, fiberboard or synthetic wood. MASONITE is a registered trademark of the Masonite Corporation and may be used only in connection with materials actually manufactured by them. The editors regret any misunderstandings that may arise from the innaccurate use of the term.

Designer, Ulrich Rüchti
Editor, Theresa C. Brakeley

Library of Congress Cataloging in Publication Data
Eichenberg, Fritz, 1901–
 The art of the print: masterpieces, history, techniques.
 1. Prints—History. 2. Prints—Technique. I. Title.
NE400.E32 769'.9 74–18024
ISBN 0–8109–0103–X

Library of Congress Catalogue Card Number: 74–18024
Published by Harry N. Abrams, Incorporated, New York, 1976
Printed and bound in Japan
Second printing

Contents

Preface

Anyone who has watched gallery crowds will have noticed that viewers of prints invariably step up close to savor the details, the textures, the quality of ink and paper, and the skill and dexterity of the printmaker.

The intimacy between the printmaker and his medium demands a similar rapport on the part of the viewer. The artist is closely engaged with his material, plate, block, or stone. Bent over the press, alone or with his printer, he experiences the excitement of producing his first proof or an edition of finished prints.

The print has proven to be the most democratic medium in the history of art. Its versatility seems inexhaustible. Depending on its purpose, it may cover any aspect of human life—social, political, technological, spiritual, aesthetic. It can be a source of enlightenment, pleasure, and information. It finds easy access into people's minds and homes, into collections large or small, public or private. It crosses language barriers and political borders, can influence public opinion for better or for worse, and on a fragile piece of paper may carry messages of far-reaching importance and cultural impact. It is altogether a charismatic force—black magic performed either by anonymous hands or by famed artists.

The print has never been a respecter of persons. It enters the homes of the poor and the rich, the ruler and the ruled.

Prints have changed the course of history. They have worked for peace or for war, for God or for the Devil. Tyrants and political bosses have feared their power. Prints have pleaded the cause of the Reformation against the popes, of the republic against the monarchy. They have championed student rebellions and peasant uprisings. They have fought slavery and corruption as they now fight war and pollution. The history of man's aspirations can be revealed by leafing through a great print collection.

It may be society's grudging recognition of an artist's power to transform a scrap of paper into a gilt-edged security when a print by Munch or Picasso is traded on the international art exchange at astronomical figures, seemingly out of all proportion in terms of material value and physical size.

The print has undergone many mutations. From a rather humble beginning as a religious keepsake, a political broadside, or a penny leaflet, it has soared to the sublime heights of Rembrandt's "Hundred Guilder Print" or Dürer's *Melencolia*. A new technology has often temporarily relegated the print to limbo, but time and again it has been resurrected, rehabilitated, and endowed with new significance. It has now become a sound investment in a bullish art market.

Perhaps it is idle speculation to predict the future of printmaking, since the print is shedding its old skin and rapidly changing into a "multiple"—often indistinguishable from reproductions printed on a power press, arbitrarily limited, and signed by the originator. Will it keep its intrinsic value as a work of art, as well as its high market value? Only time will tell.

Our media of communication have assumed increasing importance. Society has sought new means and materials to give concrete expression to its intellectual and spiritual aspirations. Paper and, subsequently, printing were invented when men

thirsted for wider dissemination of knowledge. Out of the precious manuscript developed the popular block book's solid text page cut in wood, which in turn gave way to movable type, facilitating larger and larger editions. The hand press then had to yield to the power press, producing gigantic editions to satisfy the increasing literacy brought about by greater prosperity and more leisure time.

As the woodcut replaced illuminations on the printed page, decoration of medieval armor and liturgical artifacts led to the development of engraving skills and ultimately to the creation of the great prints of the masters.

There are no available statistics on the popularity of individual print media, but, in scrutinizing countless print exhibitions in the United States and abroad during the past few decades, one may come up with some interesting observations.

The serigraph, which used to be the lowest medium on the graphic totem pole, has risen with a vengeance, largely because of the technical convenience it offers to avant-garde artists. From the artist's instructions, amplified by sketches and work drawings, it can be executed by commercial serigraphers. The serigraph has also been successfully mated with photography and, as an auxiliary medium, with lithography and intaglio prints. It can be applied to any surface and any shape, a most desirable quality in our age of multiples tending more and more toward three-dimensional forms.

The intaglio print has held a top position for many years and is still the front runner. There is a rather precious aura around etching, harking back to the glory of Rembrandt. An etching is usually printed on fine handmade paper on which the bevel of the plate leaves an interesting impression implying "authenticity." Even the rankest amateur collector seems to know that an etching is printed from a "genuine" copper plate.

Now, of course, the intaglio print can be produced by a multitude of processes. Instead of a beveled copper or zinc plate, the artist may use glue and gesso on Masonite or cardboard, or a collage plate made up of metal pieces or found objects, printed on an etching press. The range of this medium, its flexibility and variety of textures, is almost unlimited.

Lithography has been newly rediscovered and rates perhaps third place in the popularity contest. Forgotten are the days when an artist patiently produced a subtle range of shades with deliberate strokes of a grease crayon or the stipple of pen and tusche. Lithography has become the favorite medium of the painter, who freely uses washes as if he were working on canvas or paper, dropping turpentine into a pool of tusche and trusting his good luck and the printer to hold the texture in large editions.

More often than not the artist relies on the constant presence of an experienced printer to tell him what materials he can safely use and how—and entrusts the etching, rolling up, and printing to professional hands.

In our days of affluence the relief print, the German Expressionist's favorite medium, has become a poor relation, fourth and last on our popularity poll. Perhaps it is regarded as a rather primitive medium that cannot possibly compete with its dazzling confreres in tricks and textures. Wood is an honest, home-grown medium with a natural surface and grain which submit to the knife, gouge, or graver willingly, directly, and without pretense. Its sophistication usually lies in the subject matter and the message—suspect in these days of surface effects. But the relief print—be it woodcut, linocut, or engraving—will survive; it has developed stamina in its long and

honorable history of ups and downs.

The rest of our informal survey must consist of a plethora of new media, which arrive on the scene with a certain dash and bravura, displaying slashed and molded surfaces, cast or vacuum-formed, combined with photo images, peekaboo windows, optical illusions, or hidden lights and sounds, often winning praise from the critics one year and being discarded the next, like a skirt length or a hair style.

The print's prestige and market value have never been higher. The number of print exhibitions, national and international annuals and biennials, or busy workshops and print departments in schools and universities is steadily increasing. Laymen have turned into knowledgeable collectors; private industry, labor unions, and government agencies have taken an active interest in prints for reasons of cultural prestige. Newspapers and magazines are giving serious attention to the long-neglected print media. Painters and sculptors are beginning to realize the artistic as well as the economic potentials of printmaking. An era of technological development and experimentation offers exciting new tools, materials, and methods to the adventurous printmaker.

With the growing popularity of the print, the number of books on the graphic arts is increasing rapidly. There are scholarly books on important periods in the history of the print; there are monographs on specific masters and *catalogues raisonnés*, to be used as reference material. There is a host of how-to-do books with detailed technical information aimed at the budding printmaker and art student. Perhaps the ultimate book on printmaking has yet to be written.

This book is an attempt to combine some of the qualities of the categories mentioned above. It is addressed to the working artist, to art students, and to teachers, but it is intended also to be of help to the collector, the curator, the dealer, and the general public interested in prints. It is totally concerned with the print as a fine-arts medium, an extension of an artist's creative expression, linked to the greatness of the past and committed to the challenge of the present. Pride in the great tradition seems as essential as continuous exploration of the almost unlimited possibilities of the future in the field of graphics. Since each book necessarily reflects the bias of its author, I confess at the start that this volume is based on one artist's personal views, experiences, preferences, and antipathies, acquired during a lifetime of exposure to the print—living with it, creating it, enjoying it, writing and talking about it. Without pretending to be a scholar or an art historian, I have tried to trace the graphic arts from their dim beginnings, from the first engraved or chiseled line, through the ages, leading up for better or for worse to the most daring "multiples" of our technological era. I have tried to collect material that may be pertinent, exciting, and informative even to the jaded taste of a connoisseur who has seen "everything."

Whenever possible, I have steered away from showing the most famous master prints, which have lost some of their flavor and excitement through overexposure in countless books, catalogues, and articles. They can easily be studied in art reference libraries or, preferably, in their original state in most of the major print collections. Whenever feasible, I have selected prints which show an artist's work in progress, his fight with ideas and materials on his way to final perfection, or compared an artist's early struggles with the achievements of his later years.

Whenever I could quote an artist's reflections on his own work, I have done so, in preference to a commentary, however learned, by an art critic or historian. Not

even the best reproduction can reveal the excitement of the real thing, the original print; nor can words convey the atmosphere of an artist's or printer's workshop. I urge readers to go after firsthand experiences and to consult the source and reference material provided.

With the help of my many friends among artists and curators I have tried to make this book visually exciting by uncovering fresh material—a difficult task in our age of overexposure of well-known works of art through the mass media.

No book of this nature can be definitive and all-inclusive; it must have an open end. History is being written at this moment; the scene is ever shifting; new art forms are evolving in rapid succession. But the artist's quest for perfection and new insights, we hope, will never end.

Fritz Eichenberg
Peace Dale, R.I., 1975

Acknowledgments

This book has a personal history apart from the history set forth in its contents. It was started in 1965 and slowly grew in size and scope, accompanied by the customary vicissitudes attending an author who is also a working artist, teacher, editor, and at times chairman, committee member, or organizer of this and that.

Without the help and advice of countless friends among artists, curators, and printers the book could never have been finished; I owe them all a debt of gratitude. The list is long, and it can't be complete. My first thanks, however, must go to Gail Malmgreen, who, as editorial assistant, bore the brunt of the labor of organizing and researching the material with unfailing patience, intelligence, and dependability. To Theresa C. Brakeley fell the enormous task of checking the complete manuscript for accuracy, clarity, style, and structure, requiring experience, patience, and intelligence—qualities with which she is eminently endowed. The formidable job of coordinating the massive accumulation of illustrations with the text to create a cohesive and well-designed whole fell to Ulrich Rüchti. I am grateful to him for solving this difficult problem so handsomely and with such care.

My gratitude is due also to the many cooperative curators and keepers of print collections here and abroad whose advice and active help in providing unusual and interesting illustrations were invaluable. It will be difficult to give priority to anyone for special effort and graciousness in helping a nonhistorian, but I will plunge in and start with Mr. Lessing J. Rosenwald and Curator Fred Cain at the Alverthorpe Gallery and to Catherine Shephard and H. Diane Russell of the Rosenwald Collection, National Gallery of Art, Washington, D.C. Special thanks are also due to Kneeland McNulty, Curator of Prints, Philadelphia Museum of Art; to Dr. Heinrich Schwarz, former Director, Davidson Art Center, Wesleyan University; to Eleanor Sayre, Clifford Ackley, Sue Reed, and others on the staff of the Boston Museum of Fine Arts Print Collection; to Sinclair Hitchings, Keeper of Prints, Paul Swenson, and staff of the Boston Public Library; to Alan Fern, Curator of Prints, the Library of Congress; to Elizabeth Roth, Curator of Prints, the New York Public Library; to Riva Castleman and Donna Stein at The Museum of Modern Art in New York; to Alan Shestak, Curator, and his staff at the Yale University Art Gallery; to Ruth Magurn, Curator of Prints, the Fogg Art Museum, Harvard University; to Eleanor Garvey at the Houghton Library, Harvard University; to Janet Byrne of the Print Department of the Metropolitan Museum of Art, New York; to Joseph E. Young of the Los Angeles County Museum; to Elizabeth M. Harris, Curator of Prints, The Smithsonian Institution, and to Jacob Kainen, former Curator, Washington, D.C.; to Alice Mundt, Curator of Prints, Worcester Art Museum; to Gordon Washburn, Director of the Asia House Gallery, New York; and to the New Britain Museum of American Art, New Britain, Conn.

Among the members of foreign institutions I am indebted to Jean Adhémar, Cabinet des Estampes, Bibliothèque Nationale, Paris; Pål Hougen, Print Department of the Edvard Munch Museum in Oslo; Yura Roussakov and Larissa Douckelskaya of the Print Department of the Hermitage State Museum, Leningrad; the Staatliche Graphische Sammlung in Munich; the Albertina in Vienna; and the British Museum in London.

Among the galleries, Sylvan Cole and his staff at the Associated American Artists Gallery, New York, have been especially helpful; so have William H. Schab and the staff of his gallery in New York.

Some of the prints shown here have been created specifically to help make this book attractive and technically informative. Naoko Matsubara's strong woodcuts were designed for the book; and many of my artist friends have contributed color separations, work proofs, and special articles to enrich the technical sections. Knowing how difficult my requests often were to fulfill, I must be grateful for the time and effort expended on my behalf.

Vasilios Toulis of the Pratt Institute must head the list of contributors for compiling the section dealing with intaglio techniques; he also shared with me his extensive workshop and teaching experience in other media. Ann and Avon Neal, the outstanding practitioners of rubbing in the fine arts, have described that medium in words and pictures. Glen Alps writes about his discovery, the collagraph. Armin Landeck, Norma Morgan, and Leonard Lehrer, engravers, explain their methods. Clare Romano, John Ross, Warrington Colescott, Terry Haass, and George Nama have set forth fascinating, often experimental, examples of color intaglio printing. Bernard Childs, Sergio Gonzales Tornero, and Omar Rayo describe their unique processes. Other innovators who have contributed are Arthur Deshaies, who developed Lucite and plaster engraving; Boris Margo, inventor of the cellocut; Ed Casarella, originator of the papercut; William Kent with his slate relief cuts; Edward Stasack with Masonite intaglios; and Mario Avati, the master of the mezzotint. Michael Ponce de León describes his own metal collage prints and discusses the work of Rolf Nesch.

Special thanks are due to Gabor Peterdi and Misch Kohn for their extensive discussions of the various techniques for which they are famous.

I am greatly indebted to my friend Erich Moench, formerly of the Academy of Fine Arts in Stuttgart, for his article and series of experimental prints reflecting his work in lithography; to Christian Kruck, Städel Art Institute, Frankfurt, for the description of his "stone painting" lithographs; to Maltby Sykes for his article on multimetal lithography; to Paul Wunderlich for contributing a rare print; to Reginald Neal for his notes on photolithography; to the late Federico Castellon, who described his work at Atelier Desjobert, Paris; and to Tadeusz Lapinski for creating a special series of proofs for this book.

The color woodcut in its various stages is expertly presented by Antonio Frasconi and Ansei Uchima; Carol Summers outlines his characteristic wood-block printing method; H.A.P. Grieshaber and Felix Hoffmann talk about their color woodcuts; Jozef Gielniak demonstrates his intricate linoleum engraving; and the late grand old master, Frans Masereel, wrote about his woodcut technique.

Steve Poleskie and Robert Burkert develop their special silkscreen techniques in progressive proofs; James Lanier explains various photographic techniques in contemporary printmaking; and Douglass Howell writes about paper for printmakers. My sincere thanks to all of them.

Gratitude is also due to Adrian Wilson for sharing with me his rare layouts for Schedel's *World Chronicle* and to E. Irving Blomstrann for his excellent photographs, his patience, and his advice.

I want also to honor my hardworking colleagues in printshops, ateliers, and

studios all over the world, who make the prints that make this book: to Mourlot, Lacourière-Frélaut, Desjobert, S. W. Hayter, and a host of others, perhaps less famous, all over Europe; to the workshops in our own country and the people who started them—Bob Blackburn, Tatyana Grosman, Irwin Hollander, Kenneth Tyler, June Wayne, and many others following in their footsteps.

Finally I must express my gratitude to Pratt Institute, which, in 1956, allowed me to start the Pratt Graphics Center (then the Pratt Contemporaries) in Manhattan, now under the able direction of Andrew Stasik, and which also supported my dream of publishing *Artist's Proof,* a periodical totally devoted to the contemporary print and still thriving as this book goes to press. Both ventures have given me an insight into the world of the print—its never-ending excitement and its bracing discipline—from which I have profited and which I hope I have been able to pass on.

I
ANTECEDENTS OF THE PRINT

CHAPTER 1

IN THE BEGINNING WAS THE IMAGE

PREHISTORIC PERIOD

Opposite: *Naoko Matsubara. Cave Artists. Wood cut*

The theologian and the poet might agree that "In the beginning was the word," but the artist would state categorically: "In the beginning was the image"; and it would be difficult to refute him.

The First Image Makers

We cannot put a laurel wreath on the skull of the first artist who worked his magic on the walls of the dark caves of Altamira or Lascaux. He must remain anonymous, but we can assume with reasonable confidence that some Paleolithic hunter, reading the footprints and animal tracks in the primeval plains and forests, must have been struck by the storytelling power of these simple images. By measuring them for their shape, length, and depth, the hunter could put together a "picture" of the species, gauge the age, size, weight, and direction of his quarry, and track it down.

Perhaps this prehistoric man for the first time used his "imagination." An image began to form in his mind, and with it the dim desire to re-create the likeness of the animal; to capture its essence, its spirit; and thereby to gain possession of its flesh, skin, and bones, so essential for early man's survival. Thus the earliest prehistoric artists created their powerful images—supernatural in their majestic presence, suggestive of speed and bulk, and not at all primitive in execution or conception.

Emerging from the long winter of the Ice Age, the Early Stone Age artist depicted only what he knew—the animal world that so closely affected his own life, both sustaining and menacing it. There are indications that these animal images were used for a kind of magical target practice, in which the portrayed object of the hunt was pierced with spears and arrows, in a manner reminiscent of more recent primitive practices such as the construction of nail fetishes and so-called "voodoo dolls."

PLATE 1 The foundations of the print were really laid in prehistory, with the first incised line, the first scratch on a rock wall, the first impression made with the point of a sharpened flint on a soft stone or a piece of bone or horn. Such was the work of the earliest engravers, our "Neolithographers," our first graphic artists and writers on stone. We are prevented from crediting them with the invention of printing only by their lack of motivation—the absence of large communities eager for communication through multiple images—and the nonexistence of printing materials to facilitate the supplying of such demands.

Neolithic man, settling down to an economy based on planting and pasturing, began to look toward the sky, the sun, the moon, and the stars. The forces of nature became objects of deep concern, with an awareness of their power over man's destiny and welfare. The cycle of the seasons not only began to signal the auspicious times for hunting, sowing, and harvesting but also became the basis for the first recordings of time, the beginning of the calendar.

Imagery changed accordingly from realism to a more sophisticated form of abstract or geometric stylization, revealing the inner sense of an outer form. This marked the beginnings of a picture language, born out of man's desire to record and communicate by means of visual symbols. Turning his gaze toward the heavens, he became aware for the first time of the vast geometry traced out in light above him. His eyes followed the patterns of the stars and constellations, and his groping thoughts endowed them with form and symbolic meaning. The conformations he found in those unreachable figures in space became identified with the familiar creatures of the earth and the homely utensils of his own invention. Thus it came to be believed

that a man was born under the benign or evil configuration of signs in the sky, linked with a totem animal which ruled his life and that of his tribe or his progeny. To this day millions of the inhabitants of this world pin their fate, consciously or not, on the course of the stars, the signs of the zodiac, or the totem animal whose spirit they acknowledge.

Approaching the beginning of recorded time the anonymous artist emerged as a minor priest or magician, creating a caste of his own, heading a workshop in which he passed on his skill and knowledge to carefully selected apprentices. Evolving from a nomadic life of hunting and gathering into communal living, the prehistoric image maker devoted himself to the decoration and embellishment of the implements of daily life and to the creation of idols for the worshipers of kings or tribal chiefs, living or dead. Also, as man increasingly valued his function as progenitor and founder of a powerful race, artists were called upon to furnish him with the symbols for fertility rites and phallic worship.

Prehistoric Art Cultures

The collective name for the prehistoric artists would be *Homo sapiens,* the genus and species designation for mankind, who alone among the races of living creatures set out upon the pursuit of art roughly 30,000 years ago. The greatness of their work has been largely revealed to us only during the past hundred years, more or less through accidental discoveries. If we study a map of the Paleolithic world, with an estimated population of half a million, we can see "art centers" scattered over a vast area, each region with a distinct iconography. Obviously independent of one another, the artists expressed themselves in related, though often dissimilar, terms, depending largely on climatic and geographical influences.

We find significant examples of their work across the prehistoric millennia in Spain, France, England, Scandinavia, Germany, Italy, Austria, the Soviet Union, and in scattered sites all over Africa, Australia, and Asia. The names that now evoke our admiration and reverence are those of areas where our artistic ancestors practiced their skills and left behind them unequaled portrayals of their long-vanished world.

PLATES 2–4

One region, now known as France, formed a most important prehistoric art nucleus. It had a countryside liberally dotted with caves. Then, as now, the artist needed a "studio" in which to work his magic, and these caves not only offered protection but also presented the surfaces on which to create his first images. Lascaux, where spectacular cave paintings were discovered only in 1940, Niaux, Pech-Merle, and Trois Frères head the honor roll for France, followed in fame by Altamira in Spain, Parpallo in Sicily, and many other locations which gave distinction to their otherwise forgotten regions. Peaceful provincial places such as Aurignac, Moustier, and La Madeleine have lent their names as generic terms for Paleolithic cultures which created memorable art there thousands of years ago.

The artists labored under most difficult working conditions. The caves were dark and often almost inaccessible; the work had to be performed on vast walls and high ceilings with improvised primitive equipment.

Most of the art may be called "graphic"—drawn or engraved lines filled in with crude colors. Some of it was portable—whittled, carved, or engraved pieces of clay, stone, bone, ivory, or antler. The materials were furnished by nature but developed through man's growing ingenuity.

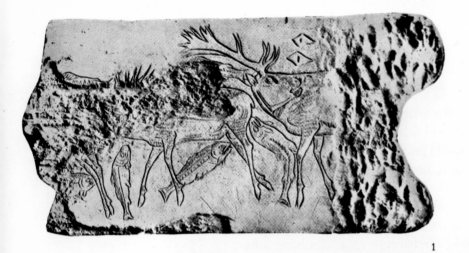

1

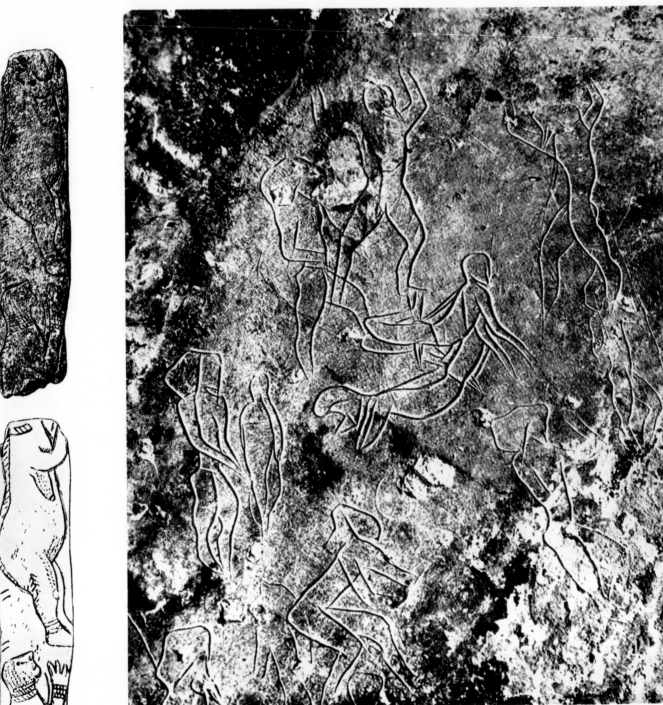

2

3

Black was easily produced with burned wood (charcoal) and soot. Red was obtained from iron oxide, yellow from ocher; white was chalk ground into powder. Blood, milk, or fat was used as a binding medium. Tufts of hair, bristle, feathers, or thin twigs served as brushes, if fingers alone could not do the work. Earth colors were often worked into sticklike crayons or pastels, and liquid colors were sprayed on by mouth. Charcoal may have been the earliest material used for sketching, exactly as it is today.

Just as artists in our time receive fresh impetus from the discovery of new media,

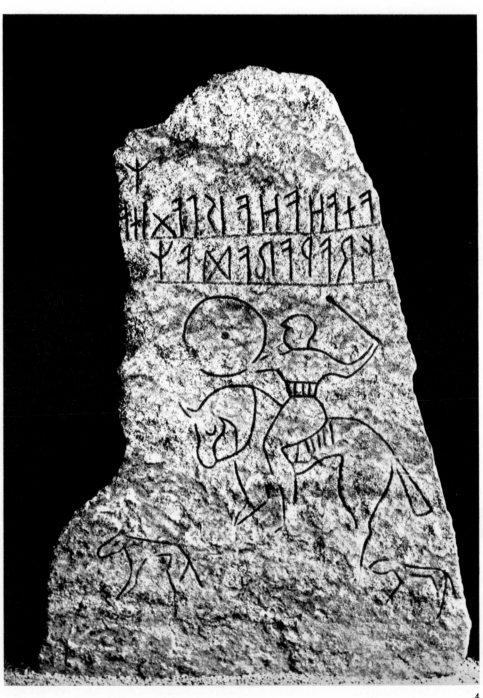

1 *Deer and salmon, from Lorthet, Hautes-Pyrénées, France. Upper Magdalenian period. Engraving on antler, width 9 5/8". Musée des Antiquités Nationales, Saint-Germain-en-Laye, France*

2 *Human figures, from Isturitz, Basses-Pyrénées, France. Magdalenian period. Engraving on bone (drawing by J. Bouyssonie), length 4 1/8". Morigny Collection, Saint-Périer, France*

3 *Human figures, in the Cave of Addaura on Monte Pellegrino, Sicily. Late Paleolithic period. Engraving on rock, height of figures c. 6–10"*

4 *Swedish gravestone with runic inscription. 4th century. (From Foldes-Papp, Vom Felsbild zum Alphabet, Stuttgart, 1966)*

4

Hohokam culture. Reptilian image, from Arizona. A.D. 1000–1200. First known etching on seashell with cactus juice (artist's wood-cut rendering). Arizona State Museum, Tucson

so the artisan of the Stone Age must have made tremendous strides forward when the knowledge of metalworking put new materials into his hands. He had already a-chieved a great technical breakthrough when he became a toolmaker in stone and set himself on the road to mastering nature. First came the weapons in stone: the arrowhead, the spearhead, the hand ax. The artist's tools were by-products; cutting and engraving implements and burins made of flint enabled him to chip, chisel, and incise on relatively soft stone surfaces, as well as on bone, antler, and ivory. With the conquest of metals the artist could fashion tools with which he could engrave and shape gold, silver, copper, bronze, and iron, as well as precious and semiprecious stones. Man, the artisan, made a great leap forward. Unfortunately, that advance also made him a more efficient killer. Even so, it defies our imagination how the early master craftsmen and artists at the dawn of the Iron Age could have achieved their intricate techniques of casting, chasing, engraving, cutting, and polishing with the primitive tools at their command.

To trace the graven image back to its earliest sources we must investigate art forms and symbols common to many primitive cultures. Tattoo designs on the body, designating tribe, totem, or rank, were an important, though ephemeral, part of this graphic heritage. Some of the motifs have appeared repeatedly, such as the evocative print or silhouette of the human hand, stenciled or offset on the living rock by prehistoric or primitive tribesmen for purposes as yet unknown to us. The hand and the significance of its gestures have carried specific messages through many civilizations. One may recall the many hand positions called mudras in Far Eastern religious art; the gestures of blessing, protection, and baptism in Christian iconography; the hand-sign language of the Amerinds, the V for Victory sign of World War II, the peace sign of our own days—all of which have been used in graphic terms; the typographical pointer of the hand with extended forefinger, calling attention to a particular item; the black hand of the Sicilian Mafia, threatening death or vendetta; the clenched fist on posters and insignia of present-day militant groups.

The human hand and similar graphic signs transmitted to us across the ages may often be enigmatic, but they give ample evidence of an emerging picture language which led to the art of printmaking as we know it today.

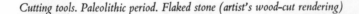

Cutting tools. Paleolithic period. Flaked stone (artist's wood-cut rendering)

CHAPTER 2
ANCIENT CULTURES

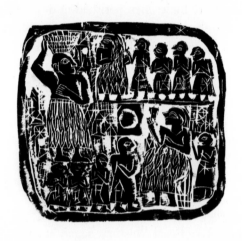

Little is known of the vast lapse of time between the relatively sparse art of the caves and the wealth of symbols and imagery that man devised in the service of developing civilizations at the dawn of history. With steadily increasing demands upon his skill, the artisan's mastery of tools and materials progressed, so that by the beginning of recorded time he was in possession of the potential elements for printmaking. Yet, for some reason he did not become fully aware of the importance of that great medium of communication for centuries to come.

This chapter will touch upon the interrelationship of the various ancient cultures, spread out over vast and thinly populated areas of this planet—how they impinged upon and fertilized one another, how they flourished and prospered and died, often disappearing almost overnight through natural or man-made catastrophes. Empires were built; men perished in devastating wars, burned or bled on sacrificial altars, vanished into tombs. Palaces crumbled; temples were devoured by creeping jungles; graves were defiled and stripped by robbers over the centuries. Yet what survived these millennia of building and destroying are the creative works of the artist's hands, works that emerged not too long ago from the bowels of the earth, tenderly excavated, cleaned, and polished by a new breed of men, the archaeologists.

By hit and miss we begin to decipher and piece together the mosaic of men's most noble and enduring efforts, created in the remote past in the far corners of the world by the skillful hands and imaginative minds of great anonymous artists and artisans.

Mesopotamia

It has been said that "history began at Sumer," that small kingdom of the lower Tigris-Euphrates Valley which gave us, during its more than two thousand years of existence, beginning in the fourth millennium B.C., many of the ideas, institutions, and inventions on which our civilization is based. The Sumerians perfected a system of writing on clay. They knew how to make multiples by casting in copper and bronze. They knew how to solder and rivet, to engrave and carve in stone. They made the first map of a city, engineered irrigation, used the wheel for chariots and for pottery making, compiled a law code, founded schools, trained teachers, doctors, *PLATE 6* musicians, and poets. Their epic of the hero Gilgamesh, a series of poems preserved on clay tablets and deciphered only recently, is a literary masterpiece. They left behind tens of thousands of tablets minutely describing their social, cultural, political, and economic life.

Sumer was united with other scattered realms by the Babylonians, who were *PLATE 5* conquered in turn by the Assyrians; these and later overlords absorbed their predecessors' inventions and skills, which then spread rapidly through Asia Minor and westward to the Aegean.

The Mesopotamians came very close to the invention of printing. Their magnificent seals, carved cylinders of lapis lazuli, alabaster, steatite, limestone, and other materials, were run off into wet clay on jars and tablets, leaving the imprint of ownership, rank, and authority. Rolled over ink and printed on papyrus, vellum, or textile they would have approximated the principle of printing on the offset or rotary press as we know it today.

One must admire the consummate skill, the erudition, the sure sense of design possessed by these early seal cutters. They carved the symbols of life and death, of

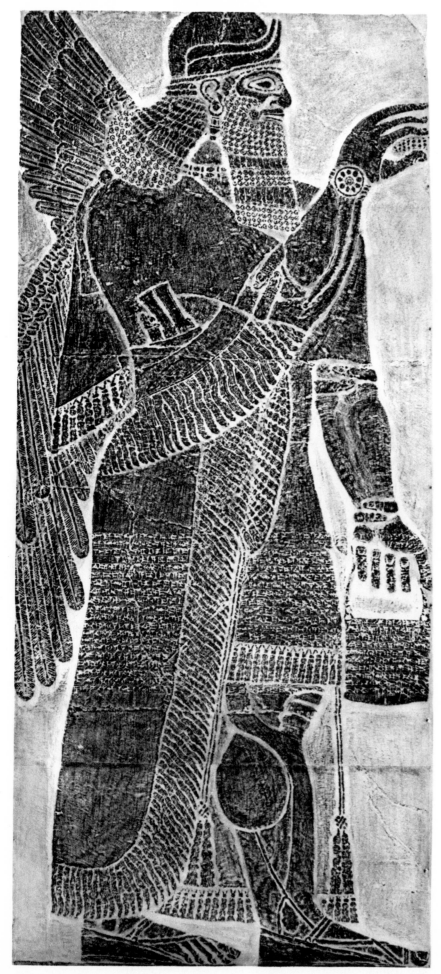

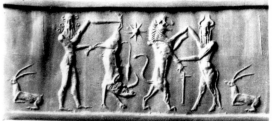

6

5 *Avon Neal and Ann Parker. Ink rubbing from Assyrian bas-relief from the Palace of Ashur, 883–859 B.C. 42 1/2 × 92".
Courtesy the artists. (Carving, Fleming Museum, University of Vermont, Burlington)*

6 *Gilgamesh subduing beasts, impression of Akkadian cylinder seal, from Tell Asmar, Iraq. Reign of Sargon, 3d millennium B.C. University of Chicago, Oriental Institute*

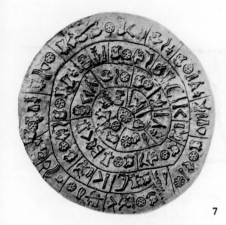

7

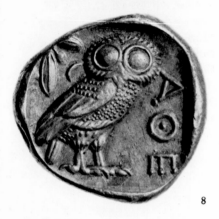

8

7 *Disk of Phaistos, from Crete. c. 1700*
B.C. Stamped clay, diameter c. 6 1/4".
Archaeological Museum, Heraklion, Crete

8 *Greek coin (tetradrachma), from Attica.*
c. 460 B.C. Silver. Museum of Fine Arts,
Boston

PLATE 7

good and evil, of the changing fortunes and seasons into these magnificent miniature relief compositions 2 or 3 inches high which could make duplicate impressions easily and perfectly. In the light of our new definitions of the "print" we must accept these ancient clay imprints as genuine "multiples," perhaps artistically more significant than the rather banal synthetic multiples of our day.

Egypt

In ancient Egypt seals were used for similar purposes, and an ingenious picture-writing system was developed, aided by the availability of a light and flexible writing surface, papyrus. Here a highly formalized art was fostered by the priestly hierarchies, conscious of the magic power of the image. Workshops, almost on an academic level, were set up at temples and palaces, where young artisans studied anatomy from plaster casts, or copied drawings, following strict canons for the presentation of the human body.

Although amazing skill and imagination went into the creation of outstanding examples of architecture, painting, sculpture, jewelry, and weaving, of elaborate scrolls and manuscripts such as The Book of the Dead, the invention of printing remained far in the future. There is evidence of hand stamps used for textile printing in the Coptic period, but that was about the fifth century A.D.

Phoenicia and Crete

By the late second millennium B.C. the seafaring Phoenicians had devised a true "alphabet," a handy system of notation that greatly facilitated trade. What powerful graphic symbols alpha, the head of an ox, and beta, the house, have proved to be! The alphabet has served as a means of communication practically unchanged, with only slight shifts of position, to our day.

In Minoan Crete and mainland Greece, artisans of the Bronze Age developed the art of metal casting, chasing, and engraving. The meteoric civilization of Crete shed sparkling treasures over its realm in the short space of about three hundred years, sinking suddenly into darkness and coming to light again more than three thousand years later through the excavations of Sir Arthur Evans and others. Minoan culture has, no doubt, influenced and intrigued many contemporary artists—Picasso included. Yet the script known as "Linear A" has resisted full translation, and the disk of Phaistos has so far refused to yield the secret of its symbols. The disk, a unique keystone of Aegean culture, had its pictographs stamped into the clay with a primitive version of movable type. (There are also examples of texts printed from stamps from the Assyrian period in Mesopotamia.)

A growing awareness of the power of the spoken word led to the effort to record for posterity the laws, legends, myths, ballads, and epics which had been transmitted orally from generation to generation. To give the sound concrete form, graphic symbols had to be invented. At first these consisted only of simplified pictures of objects—pictographs. Then followed the ideograph, a combination of evocative symbols which could express such abstract ideas as love, truth, spirit. Finally the letter, the most specific written identification for the sounds of speech, was evolved.

Numbers, so important for recording commercial transactions and principles of science, also required graphic symbols. The widespread forms that developed were the Arabic and Roman numerals essentially as we use them today.

Greece and Rome

From the Phoenician to the Greek alphabet was a short step. The instruments of writing included the reed pen and papyrus, the wedge and clay, the chisel and stone, the stylus and wax tablet, the quill and parchment—whatever was indigenous and handy. The way of writing was a matter of convenience—from right to left (unrolling the scroll with the left hand, writing with the right) or top to bottom—depending upon how the scroll was held. Perhaps it was logical for an agrarian society like that of Greece in the sixth century B.C. to write in the direction of a peasant plowing his field: first line right to left, then turning the corner, left to right for the second line, and so on to the bottom of the page. Unless we are left-handed, we write from left to right for convenience, to see each letter as it emerges from the pen.

One wonders why the idea of casting type elements did not occur to the highly cultured and articulate Greeks, whose literature has come down to us inscribed on Egyptian papyrus, stone, or metal. As early as the seventh century B.C. they were familiar with the principle of minting; that is, the use of the matrix and the patrix, or the female intaglio and the male relief forms, creating between them a sparkling new multiple, the coin. The history of coins has great significance for our survey. *PLATE 8* A form of coinage was used for commercial tender as early as 750 B.C. in Asia Minor, but not until the rise of Greece was the coin considered more than a valuable lump of metal. Here it became not only legal currency in gold, silver, electrum, or copper but also a token of a state's prestige, enhanced by a regard for its beauty, style, and craftsmanship.

That there was widespread interest in recorded literature in Roman times is clear from the writings of Cicero. One of his friends, Titus Pomponius Atticus, acted as his publisher and bookseller. Copies, sometimes thousands, or as many as the traffic would bear, were made by slaves. Scrolls were kept in cedar boxes to protect them from insect damage, and codices were placed in cedar chests, the forerunners of our bookshelves.

Private libraries were status symbols, but there were also thirty public libraries in Rome alone. Cicero's friend Tyrannio owned 30,000 volumes, but that collection was small compared with the library of Pergamon, with 200,000, or Alexandria, with 700,000. The last was partially destroyed by the Romans, burned by fanatic Christians in A.D. 391, built up anew, and pillaged again by Arab invaders.

In late Roman times stencils were used to expedite authorized signatures by high officials. Emperor Theodoric the Great, in the sixth century, is said to have had his name perforated in gold foil for stenciling on documents; this tradition is highly believable, because few of the rulers of the period were able to write themselves.

A brief glossary of terms commonly used in the graphic arts reveals the debt we owe to Greece and Rome—and not only for the writers, philosophers, architects, and sculptors they gave the world. From the Greek we have: *graphein*—to draw, paint, write, incise; *kalligraphia*—beautiful writing; *sērikos*—silk, plus *graphein* (our serigraph); *technē*—technique, skill, art; *chroma*—color; *scholē*—school, lecture; *kolla*—glue (our collage, collograph); *papyros*—papyrus (our paper); *typos*—blow, impression, model (our type); *lithos*—stone (our lithograph).

Add to these the Latin (or Latin derivatives) we use quite often in art (from *ars*): *color, materia, forma, figura, structus, focus, ratio, oleum, acidus, perspectiva, aquatinta,*

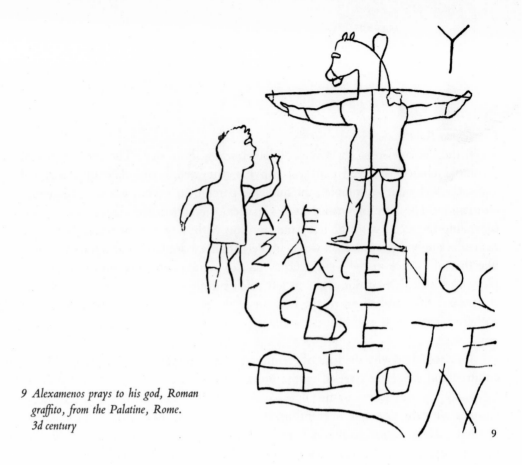

9 *Alexamenos prays to his god, Roman graffito, from the Palatine, Rome. 3d century*

mezzotinta, chiaroscuro, impasto, impressio, incunabula, codex, vellum—in addition to *pinxit, fecit, sculpsit, delineavit,* and *composuit* (all indicating the work done by the artist or craftsman whose name is signed); and you have a basic art vocabulary reaching back to antiquity.

Though the Romans gave us the superb classic lettering of Trajan's Column, still used as an ideal prototype by our type designers, the chiseled letter, a matrix in all its precise beauty, waited in vain for the genius who could have used it as a mold for the first Roman type.

PLATE 9

Graffiti were the medium for those who wanted to make their opinions known on the marketplace. Beneath the ashes of Pompeii many examples were discovered—some bawdy, some political—revealing a people's way of letting off steam. Newspapers did not exist, but Romans passing through the Forum could read tablets with the latest accounts of trials and executions, battles, Senate speeches, and events at the imperial palace or in high society. This was the Roman "Journal of Urban Events," the *Diurna Urbis Acta,* started by Julius Caesar in 59 B.C., a public bulletin board akin to the wall newspapers of modern Peking.

From Rome also came an early form of stenography (*notae*). The poet Ennius (second century B.C.) is credited with the invention of a thousand stenographic symbols. Cicero's freedman Tullius Tiro perfected a complete system of shorthand, used in recording public speeches. The methods of writing were to scratch with a pointed bone or metal stylus on wood, wax, or clay or to write with a reed or goose-feather pen on papyrus or wood.

The Etruscans

In Italy the Tyrrhenians, later called Etruscans, had founded by the ninth century B.C. a League of Twelve Cities, influential far beyond its size. Like the Sumerians in Asia, the Etruscans were only recently identified as the founders of a distinct culture.

They developed highly civilized concepts of religion, ethics, and social organization, which are reflected in their art.

The archaic virility, the spare but potent forms of their sculpture, have inspired such modern artists as Picasso and Giacometti. That they were skilled engravers is shown by their decorated mirrors and metal containers, often displaying stylistic links with Greece. Etruria flourished for seven hundred years before Rome swallowed it up and almost obliterated any trace of Etruscan achievements. If we compare Greek painting on ceramics and engraving on metal with their Etruscan equivalents, we find a close spiritual kinship between the two cultures.

The Far East

Far to the East, in the Indus Valley, there are manifestations of an important culture which flourished between approximately 2500 and 1500 B.C. The diggings undertaken by British archaeologists at Mohenjo-Daro and Harappa have yielded relief impressions of beautifully modeled animals and figures, delicately cut into steatite, surrounded by symbols not yet deciphered. They are so strikingly reminiscent of Babylonian seals of the same period that trade connections between the two cultures are assumed to have existed.

PLATE 10

Indus Valley culture. Seal with common water-buffalo motif. 2500–1500 B.C. Steatite (artist's wood-cut rendering)

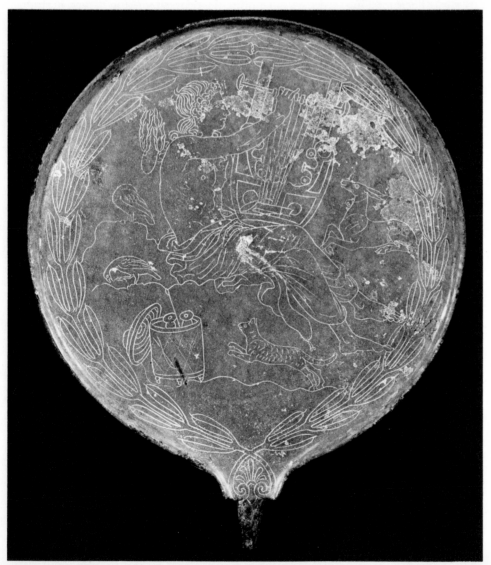

Priest practicing divination by liver, Etruscan mirror. c. 4th century B.C. Engraving on bronze (artist's wood-cut rendering)

10 Orpheus playing his lyre, Etruscan mirror. c. 4th century B.C. Engraving on bronze. Museum of Fine Arts, Boston (Francis Bartlett Fund)

10

The ancient Chinese believed strongly in the indivisibility of natural and spiritual phenomena. They saw divinity in every living thing and offered gifts and prayers to the deities of nature, to thank them for favors received or to appease their anger and ward off disasters.

In calligraphy the Chinese expressed the unity of aesthetic and spiritual values. When and where this system of writing originated has not been established. The oldest known Chinese characters are scratched on oracle bones and tortoise shells, of the Shang period, used to foretell the future. They date from about 1200–1100 B.C. It is likely, however, that these characters originated at least a thousand years before. Bronze vessels bearing engraved inscriptions have been traced to the Chou Dynasty (first millennium B.C.). By the Han period (206 B.C.–A.D. 220) Chinese calligraphy had attained the form which has been kept almost unchanged to the present.

The purpose of the early ideograms was not merely to communicate ideas from man to man but also to appeal directly to the deities. Calligraphic characters were contemplated for their deeper meaning and became an expression of harmony among Heaven, man, and nature.

The Chou Dynasty perfected and perpetuated the Shang tradition of incising and engraving on weapons, vessels, bells, and statuettes. The late Chou era was privileged to see the birth of two great philosophers, Confucius (c. 551 B.C.) and Lao-tsu (c. 604 B.C.). Their teachings were spread among the people by being carved in stone or written on bamboo strips like many other great Chinese classics—the Book of Odes, the Book of History, the Book of Rites, and the Book of Changes.

The Americas

There are fascinating similarities between the art forms of Southeast Asia and South America. The conjectures are many, the conclusions shaky; but that there are racial ties between the Incas, Mayans, Aztecs, and Toltecs, and Asian peoples seems evident. A Mayan stele from Guatemala resembles, in style and technique, the statuary of Angkor Wat in Cambodia.

The many drawings and rubbings which have been made of Pre-Columbian bas-reliefs show their remarkable graphic power. The great empires of pre-Conquest Latin America have left us a few of their codices, records of their achievements drawn on bark paper or skin. The Codex Vaticanus especially reminds us of the Egyptian Book of the Dead, recounting as it does the journey of the soul after death. Most of the records, alas, were destroyed by zealous Spanish iconoclasts, who cherished the gold but despised the pagan treasures on paper.

The Toltecs (A.D. 900–1000) are credited with the first metal smelting, writing, and weaving in their part of the world; but the Incas developed the art of casting, forging, welding, chasing, and engraving to the highest perfection. Completely authoritarian, they forced the establishment of enclaves for artisans according to their craft, very much like those of the Egyptians; thus skills were passed on from generation to generation. Toltec craftsmen could engrave complex designs on a pinhead. Their weavers could weave 300 threads into an intricate 1-inch pattern.

It is most likely that whatever printing they did was confined to the surface of ceramics, to fabrics, and perhaps to human skin, as some surviving carved cylinders (*sellos*) seem to indicate.

Mayan stele. Pre-Columbian period. Carved stone (artist's wood-cut rendering)

II
THE RELIEF
PRINT

CHAPTER 3
EARLY CHINESE PRINTS

Opposite: *Enlarged detail of plate 147*

In the year A.D. 105, according to some sources, a momentous event took place in China—the invention of paper. At last there was a material ready to receive the imprint of an inked surface.

It is certain that even before the invention of paper the Chinese had applied ink of different colors to their carved seals, using them on silk and other fabrics, on wood and bamboo strips. The word *yin*, Chinese for "seal," stands also for any impression on any surface, from clay to paper. Before A.D. 55 seals were often printed in white on red, creating the illusion of an intaglio impression, or in red on white, in the relief manner. A type of seal was used for printing currency from bronze plates during the rule of Kublai Khan (c. 1287).

However, the stimulus for printing on a large scale came, undoubtedly, from the great demand for rubbings from stone inscriptions of famous writings. The annals of the late Han Dynasty (206 B.C.–A.D. 221) record the fact that the engraved stone tablets of the Six Classics, displayed at the gates of the Imperial Academy, attracted people from far and wide, eager to obtain rubbings. So many came that their carts

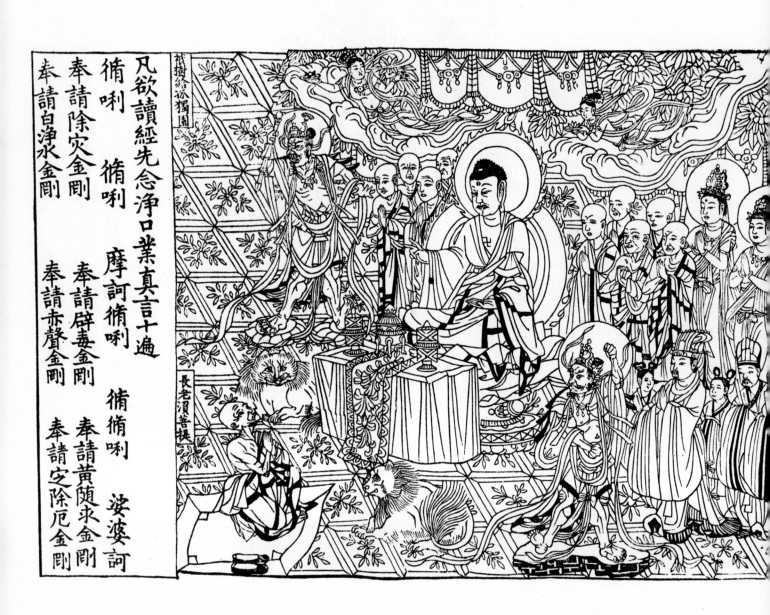

created a serious traffic problem in the streets. China, with her tremendous thirst for knowledge and her veneration of scholars, became the home of the largest printing and publishing ventures in the world, long before Gutenberg's time.

The first cutting of images and characters into wood blocks took place during the T'ang Dynasty (A.D. 618–906), whose early emperors, by and large, were enlightened patrons of the arts and literature who tolerated a variety of religious doctrines—Buddhist, Christian, Taoist, and Confucian. Books on magic, religious tracts, and a gazette, the *Kai-Yuan*, were published under that dynasty.

According to T. F. Carter, the earliest known authentic block print dates from A.D. 770 and came from Japan. The T'ang Emperor T'ai-tsung (627–49) started a library of some 54,000 scrolls of writings at his capital. Prime Minister Fêng Tao (882–954) of the Empire of Shu is usually mentioned as the first active promoter of the art of printing in central China. He initiated and supervised the printing from wood blocks of the Nine Confucian Classics. Outstanding scholars from the National Academy were selected, and the project, totaling some 130 volumes, was completed in twenty-one years, despite wars and invasions.

It was in the Buddhist cave colony of Tun-huang in Chinese Turkistan (founded in A.D. 366) that the greatest printed treasures were discovered. Found by Sir Aurel Stein in 1907 were thousands of well-preserved scrolls, among them the 17-foot-long *Diamond Sutra*, dated A.D. 868. The earliest known dated block book, it was dedicated "for universal free distribution by Wang Chieh to perpetuate the memory of his parents."

Among the Tun-huang scrolls we also see for the first time an example of the transformation of the scroll into book form, a little sutra consisting of eight pages printed on one side and put together like a modern accordion folder, complete with the name of the printer and the date (A.D. 949).

PLATES 11, 12

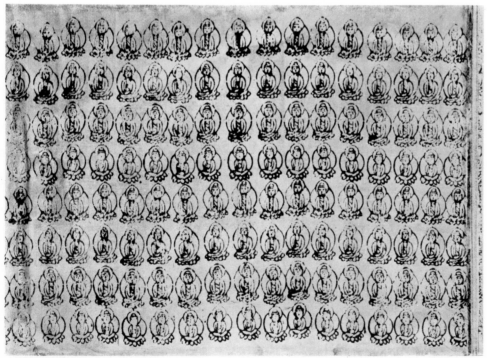

11 *Frontispiece from the* Diamond Sutra, *recut by Jung Pao Chai, Peking. c. 1960. Woodcut, 14 × 11 1/2". Courtesy Jan Tschichold and Schwitter, Ltd.*

12 *Seated Buddha, from the Caves of the Thousand Buddhas, Tun-huang, China. 8th century. Woodcut, 9 1/4 × 13". New York Public Library, Astor, Lenox and Tilden Foundations (Spencer Collection)*

12

These creations, of course, did not spring fully formed from the head of genius but were rather the product of long and patient experimentation to evolve a more practical way of presenting reading matter. No doubt many of the earlier incunabula were lost or remain buried in some dark cave or crumbling pagoda.

Most of the block printing was performed for devotional purposes. Countless thousands of images of Buddha were found, printed in various ways on paper, often huge rolls of them, such as the one 17 feet long and covered with 480 impressions of the same image, which is preserved in the British Museum. Images were evidently stamped by hand on the paper until it was discovered that it was easier to turn the inked block right side up and rub the back of the paper. Much of the earliest printing was probably destroyed in the great wave of intolerance that swept China in A.D. 845, when 4,600 Buddhist temples were reduced to rubble and mountains of sacred scrolls put to the torch.

Early Chinese printers made black ink of burned wood or lacquer mixed with glue and formed into a paste or brick, soluble in water. Cinnabar red was the most popular second color and is still used extensively on seals and calendars. The wood, usually pear or jujube, was squared into blocks, planed, and sized with rice-flour paste. The image drawn on paper was pasted face down to the wet surface and cut by the formcutter.

After the Mongol invasion we find, in addition to the religious classics, early editions of books on medicine, botany, agriculture, poetry, and literature, some with alluring titles such as *Beautiful Women Who from Dynasty to Dynasty Overturned Empires*. The most monumental publishing venture in ancient history was a Buddhist canon called *Tripitaka*, consisting of 5,048 volumes, with 130,000 wood blocks cut for an equal number of pages. It was published during the years 972–83 in Ch'êng-tu. The literate Chinese also pioneered with the first printed newspaper, in the early tenth century; it was produced from wood blocks on parchment and publicly displayed.

Copperplate engraving was first introduced in the period of the Five Dynasties (A.D. 909–960), but it seems to have died out, perhaps as a result of difficulties in printing large editions.

The printing of money may have started in China well before the year 1000. In 1024 the government officially monopolized the printing of money from iron, bronze, and copper plates on silk or paper. An official seal, printed in vermilion, made the currency authentic. Forgery was punished by death. The paper used was probably made of mulberry bark and was similar to that which artists still use for printing woodcuts, except that it was unbleached and slate-colored.

COLORPLATE 1

Among the less refined subjects for folk and popular prints were the "House Gods" or "Door Guardians," crudely cut and often hand-colored, perhaps going back to the beginning of the Ming Dynasty (1368–1644) or even earlier. Through them the common people could easily acquire a pantheon of protectors against all kinds of earthly woes. Other such prints showed the "Ancestors of the Last Three Generations" and were used to celebrate the New Year. They were destined, alas, to be burned during the festivities. We also find woodcuts illustrating folk tales—some colored by stencil, others printed in several colors. Some of them, as large as 2 by 4 feet, were printed from several blocks and then pasted together. The popularity of the drama and opera under the Yuan Dynasty (1260–1368) probably initiated the vogue

for theatrical prints, often rather crude and garishly colored.

One of the most far-reaching developments in large-scale printing was the meeting of movable type and paper. Pi Shêng, between 1041 and 1049, cut characters into clay, fired the individual pieces, and then mounted them with soluble glue on an iron plate, very much like the chase of a letter press. The glue could be melted and the type used again in different arrangements.

Later, tin was used for casting letters in a clay mold, but this type proved not very durable in the printing of large editions. The Uigur Turks engraved letters in wood, a formidable task when one thinks in terms of 30,000 characters, neatly sawed into separate pieces of even size. Paul Pelliot found specimens in the caves of Tun-huang and dated them about 1300.

Movable type was first developed in Korea in 1241 under Emperor Yi Kyo-bo. Steady progress was made in cutting and casting until, in 1403, the first government type foundry was established, an event of far-reaching importance. Vast numbers of books could now be published, fifty years before Gutenberg. The only innovation Gutenberg must be credited with is the perfection of the matrix, or mold, which originated in its germinal form in Korea.

Chinese books with color plates were published in 1606 beginning with a work

13 Hsu Chên-chün. Two pages from Yü hsia chi (Record of the Jeweled Casket, a work on divination), Soochow, China. 1433. Woodcut. New York Public Library, Astor, Lenox and Tilden Foundations (Spencer Collection)

14

14 *Bamboo, from* The Mustard Seed Garden Manual, *17th century. Color woodcut. New York Public Library, Astor, Lenox and Tilden Foundations (Spencer Collection)*

15 *Su Shih (Su Tung-p'o). God of Fortune. Late 11th century. Rubbing from stone, 20 7/8 × 14 1/8". Collection University of Rhode Island, Kingston*

16 *Portrait of Confucius. Ch'ing Dynasty. Rubbing from stone. Philadelphia Museum of Art*

17 *Illustration from Ch'in-ting Shu-ching t'u-shuo (Imperial edition of the* Canon of History, *ed. Shu Ching), Peking, 1905. Woodcut. New York Public Library, Astor, Lenox and Tilden Foundations (Prints Division)*

15

PLATE 14

on ink cakes, printed in six colors. Two famous album-manuals followed, the *Ten Bamboo Hall Painting Book* (sixteen volumes, dated 1633), a collection of exercises in drawing birds, fruits, and flowers, and the seventeenth-century *Mustard Seed Garden Manual*, also addressed to artists in need of instruction and inspiration. They are

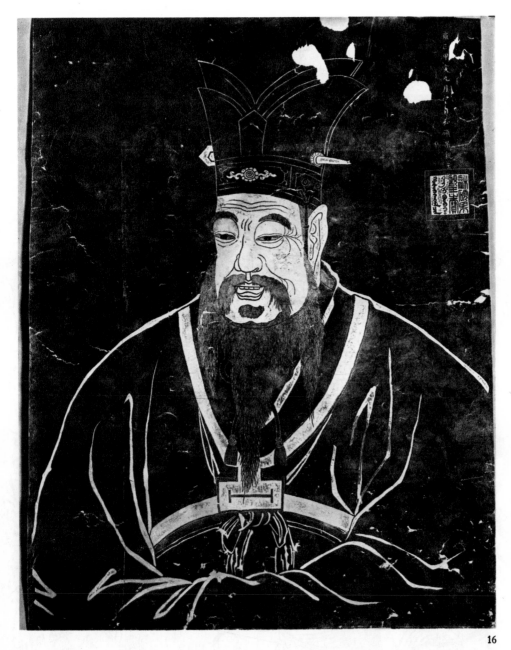

16

17

landmarks of beauty and skill in the history of the printed book. Up to twelve colors, often gradated by wiping the block, were produced at a single printing and ten more created by superimposition. Some of the prints dispensed entirely with key blocks, giving the impression of delicate pastels or watercolors. Scholars surmise that a combination of wood blocks, metal plates, engraved stones, and hand coloring was used to produce some of these prints.

Few of the early single prints have survived, since they were cheap and considered expendable. Many must have come from the printing centers of Nanking and Soochow during the seventeenth and eighteenth centuries, filling the great demand for popular broadsides.

It seems, however, that the fine print in China gradually lost its strength and attraction. But it certainly inspired and helped initiate in neighboring Japan the flowering of the popular style of print known as Ukiyo-e.

PLATES 13, 15–18

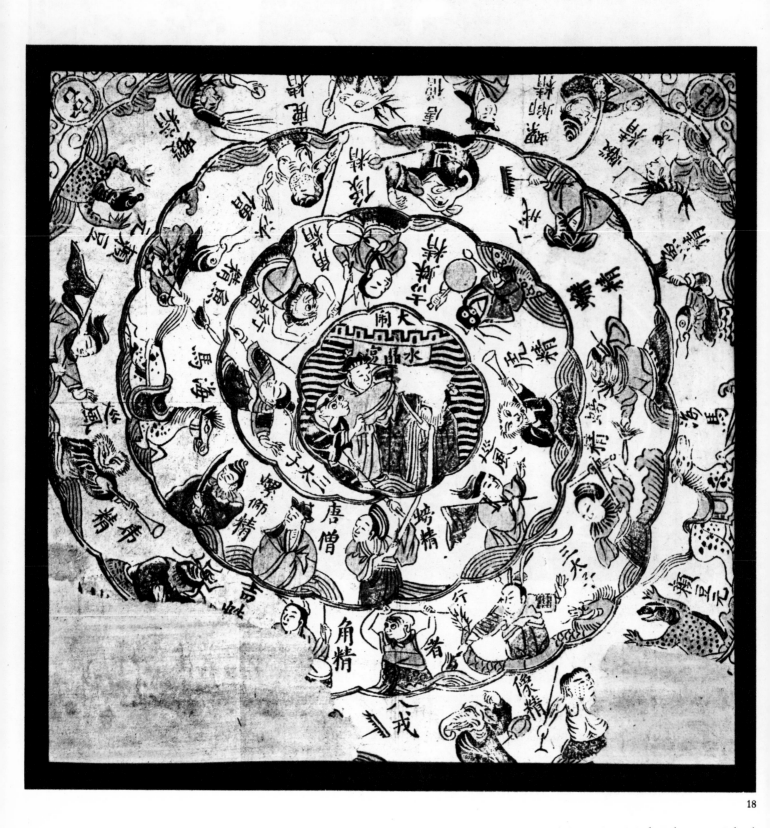

18 Scenes in a Spiral. *14th century. Colored woodcut. Philadelphia Museum of Art*

CHAPTER 4

JAPANESE PRINTS

For centuries Japanese prints flowered unknown to the Western world. According to T. F. Carter, "For a century and a half before the making of the first block-printed charms, Japan had been undergoing a process of complete transformation under the influence of China. Chinese literature began to enter Japan as early as 540 A.D. . . . A steady succession of Buddhist missionaries from China poured into Japan, and a steady succession of Japanese students went to China for study and on their return brought about sweeping changes in the customs of their native land, bringing Japan gradually abreast of what was then the world's most cultured country" (from *The Invention of Printing in China* . . ., 2d ed., New York, 1955, p. 46).

Nara, the capital from A.D. 710 to 784, set the tone and pace for emulating, not to say imitating, Chinese customs, art, and architecture. The first university was established at Nara in 735.

It was the Empress Shōtoku, residing in Nara from 748 to 769, who in her zeal to establish Buddhism in her country ordered the first mass printing in history, one million Buddhist sutras, carved in wood and printed on paper, to be placed in a million tiny wooden pagodas and distributed among various temples. The work was finished about the year 770 and the Empress's name firmly established not only as a great devotee of Buddha but also as the first patron of the art of block printing on a large scale.

PLATES 20, 21

Seals, of course, had been carved before in precious and semiprecious stones, even in wood, and were used by court officials, priests, and potentates. At Nara we can still admire block prints on silk and other fabrics, as well as on leather armor, made prior to the printing of the charms.

PLATE 22

Most of the earlier books were printed in scroll form. To quote F. A. Turk: "Texts, with or without illustrations, were engraved on small blocks of pear or plum wood . . . soaked in water before engraving commenced, and then the text, which had been written out by hand, was pasted down on to the wood and engraved to a depth of perhaps 3 to 5 millimeters. After the blocks had been inked with the use of two brushes . . . the paper to be printed was placed face down on the printing surface and pressed with a coil pad. According to the late Dyer Ball, some 16,000 copies could be taken before the blocks began to wear badly . . ." (from *The Prints of Japan*, 2d ed., London, 1966, p. 22).

COLORPLATE 2

The *History of the Nembutsu Buddhists (Yūzū Nembutsu Engi)*, written in 1125, shows the complexity of book production even at that early stage. It consisted of two scrolls, altogether 96 1/2 feet long, requiring many individual wood blocks of an average size of 3 1/2 feet. The cutting of text and pictures (presumably not the printing) began in 1389 and was finished in 1414, an indication of the emphasis on care and quality spent on important literary and religious works.

There is evidence of early engraving on copper (*bōshimei*) used for epitaphs in the tombs of the sixth and seventh centuries. The earliest dated pictorial wood-block print (740) is printed on leather, used for parts of a samurai's armor. "Souvenir" prints became popular at this time, very much in the manner of popular prints of patron saints sold at monasteries or country fairs in Europe of the Middle Ages. They

PLATE 23

showed images of deities, priests, and sometimes Buddha's footprint, and were no doubt a source of income to temples and shrines where they were sold to the faithful for a few pennies.

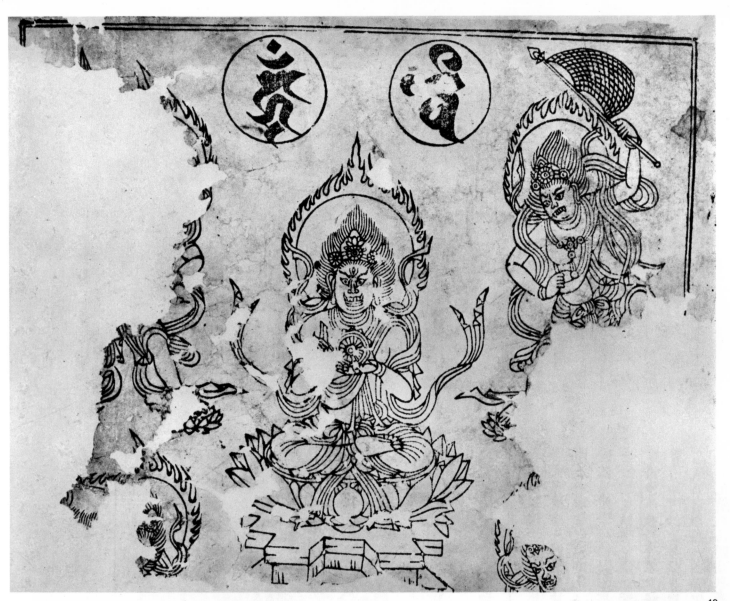

19

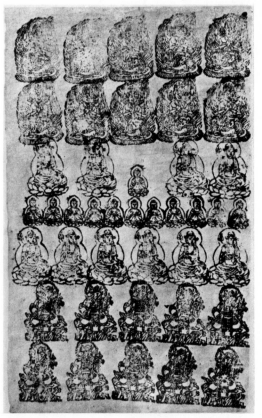

20

19 Images of the Five Guardian Deities, *from the album* Kodai Bukkyo Hanga Shu (Collection of Early Buddhist Prints). *13th century. Woodcut. New York Public Library, Astor, Lenox and Tilden Foundations (Prints Division)*

20 *Impressions from stamps of the late Heian period (794–1185). Hōryū-ji, Nara*

21 Above: *Block for stamping a circular design. Kamakura period (1185–1333). Wood, diameter 13 3/8". Hōryū-ji, Nara.* Below: *Pongee stamped with lion design. Kamakura period. Tokyo National Museum*

21

Early printing in Japan showed the growing excitement over the technical possibilities and aesthetic qualities of a new medium. Printers and artists experimented with different materials, different inks and papers. In the fan-shaped leaves of the *Hokke-kyō*, or *Lotus Sutra* (at the Shitennō-ji, Osaka), the paper is sprinkled with mica, gold, or silver dust, with a woodcut overprint.

COLORPLATE 3

Since poets and high society were interested in giving some durable and aesthetic form to their poems and letters, printed stationery decorated with wood-block designs (*shikishi*) became quite popular with the well-to-do.

According to Mosaku Ishida (*Japanese Buddhist Prints*), various unusual methods were used to bring variety to the printer's task; among them were: *kirasuri,* printing or stamping with powdered mica instead of ink; *gofunzuri,* printing with white opaque ink on mica-coated paper; *karazuri,* or gauffrage, printing from uninked wood blocks to create a relief effect, still popular today; *yaki-e,* designs supposedly

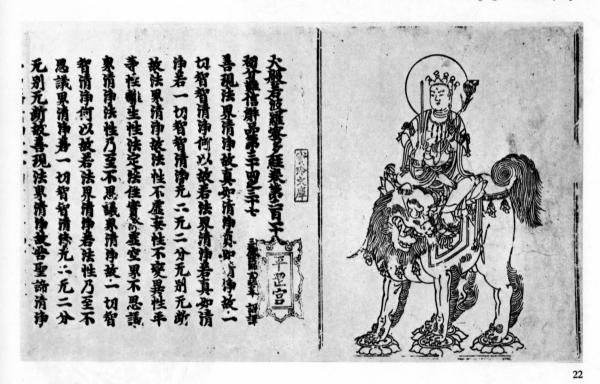

22

22 Bodhisattva, *frontispiece of the* Sutra of Dai Hannya, *scroll published by Eison, Saidai-ji, Nara, 1279. Woodcut. New York Public Library, Astor, Lenox and Tilden Foundations (Spencer Collection)*

burned into paper with heated metal plates, creating a pleasant light brown (which may also have been produced by using a chemical ink that turned brown after heating); *rōsen,* rubbing the back of the paper with a wax ball; *fuki-e,* a process by which ink was sprayed through stencils.

In the late Heian period (897–1185) we see some daring first collages, made by pasting together different colored papers as a background for the calligraphy of a collection of the works of thirty-six poets.

COLORPLATE 4

There is a soft deerskin breastplate of the early Kamakura period (1185–1333) which is covered with designs perhaps partly printed and partly stenciled. In that same period theatrical posters were printed from wood blocks. A book on military matters, with the odd title *A Collection of Beautiful Women (Bijin-gusa),* was begun in 1256 but not published until two hundred years later.

PLATE 19

For centuries Buddhist themes were prominent, and monasteries served as

printshops. In time, however, subject matter became more secular, and private publishers and printers, aware of commercial profits, began to take over.

The first Portuguese and Spanish traders and missionaries went to Japan in 1548, and with them Christianity and other alien influences were introduced. Western ideas gained some adherents, until an edict of 1637 banned the further promulgation of foreign religion. Yet the introduction of the Western technique of copper engraving must have influenced a number of Japanese artists, most of whose work was destroyed in the anti-Christian reaction. Perhaps the new style shows a little in the *History of the Priest Kūkai (Kōbō-Daishi gyōjo zue)*, a series of finely incised wood blocks printed on ten scrolls.

Another more significant influence made itself felt after the conquest of nearby Korea. Among the loot carried off by the victorious Japanese army were whole libraries of Korean books and the first fonts of movable printing type. With them went Korean artists and craftsmen, enabling Japan to set up its first printing plants and private presses, which issued their first books printed from movable type beginning in 1592.

Ukiyo-e

Much, perhaps too much, has been said, surmised, and written about Ukiyo-e. To most Japanese artists of today it is a period of days gone by—better forgotten for those who care to express themselves in a contemporary idiom. Ukiyo-e shackled them to an old tradition, to the "floating world" of actors and courtesans and the genteel ways of the middle class of past centuries. On the other hand, there are collectors who cherish the esoteric, stylized, unproblematic charm of these prints, which mirror a world of law and order, of knightly masculinity and feminine submissive grace that excites the Western mind. And there are scholars, would-be scholars, and collectors-turned-scholars who delight in classifying the hundreds of thousands of Ukiyo-e prints which stretch over an easily surveyed period of roughly three hundred years, confined to a very small territory.

As a sideline, the Ukiyo-e masters, with few exceptions, produced a large oeuvre of prints, not usually shown except under the counter, devoted to the glory and practice of sex in every form, shape, or position. This, no doubt, attracted many bona fide and also many spurious collectors of Ukiyo-e, but it also gives prints of this period a curiously schizophrenic quality. Where does art end and pornography take over? This question must bother many Ukiyo-e fanciers, even in our days of "sexual liberation."

The first Ukiyo-e prints to reach western Europe in the 1880s, more or less by accident, made a tremendous impact on a group of Parisian artists—perhaps the same impact that Western art is now making on Japanese artists. Mary Cassatt, Toulouse-Lautrec, and Bonnard would not deny it; nor would Bakst, Klimt, Schiele, Beardsley, and certain other luminaries of the Art Nouveau period.

To find the sources from which Ukiyo-e derived its strength we must go back to the decline of Buddhism, and perhaps of religious interest in general, and to the rise of the merchant class in the late sixteenth century.

Edo (now Tokyo) had replaced Kyoto as the capital of Japan at the beginning of the seventeenth century, bringing about profound changes in the art culture.

23 The Footprint of the Buddha, *from the album* Kodai Bukkyo Hanga Shu (Collection of Early Buddhist Prints). *13th century. Woodcut. New York Public Library, Astor, Lenox and Tilden Foundations (Prints Division)*

The prosperous seaports had produced a new class of merchants, traders, and shipbuilders who flocked to the new capital, infiltrated the court and the aristocracy, and established a vogue for the more mundane leisure activities. Artists, having lost the patronage of the Kyoto court and of its temples and monasteries, turned elsewhere for inspiration and livelihood. The Ukiyo-e school, which arose in the seventeenth century, although it drew upon all phases of traditional Japanese art, was formed out of an artisan class known as *machi-eshi* (literally, "town painters"), a miscellaneous group who worked, mostly anonymously, as painters, designers of wood blocks, and practitioners of the decorative arts in the service of the *chōnin*, or merchants.

Private presses, perhaps modeled after the first press set up by the Jesuits at Asakusa in the 1590s, sprang up in the outskirts of Edo. Most prominent among these first publishers were Honami Kōetsu (1558–1637), a man of many accomplishments— calligrapher, painter, and potter—and Suminokura Soan, one of his rich pupils who founded a press at Saga. It published the renowned *Ise Monogatari* (*Tales of Ise*) in 1608, two volumes with forty-nine woodcuts in two editions, one de luxe and one for the less affluent, printed from almost identical blocks. Books poured from the Sagabon Press in profusion (some even using movable type)—poems, ballads, dramas, guidebooks, epics of history, and translations of useful foreign books on medical or other subjects. Most of the illustrations were in black and white, in the tradition of the early *sumizuri-e* (pictures printed in black), but after 1625 color was added by hand.

The subject matter of the prints shifted to reflect the taste of the city dwellers, the wealthy merchants, and the roving military men. Ukiyo-e and a new literature, Ukiyo-zōshi, were devoted to the fleeting pleasures of life, spelling the decline and fall of the earlier court era.

Disaster ended this idyll in 1657, when fire destroyed three-quarters of the city and killed a hundred thousand people. Twenty-three years later an even greater fire, followed by a typhoon, again laid low the reconstructed city. The fragility of life, so dreadfully demonstrated, did not lead people back to religion but rather into the devil-may-care attitude of our own day.

Perhaps these catastrophes spawned the Ōtsu-e pictures (from the village of Ōtsu), folk broadsides of street scenes, patron saints, courtesans, or demons, intended as inexpensive souvenirs to be hung on a screen at home or perhaps created to make up for the treasures wiped out by the fire.

Ukiyo-e prints worked on a somewhat higher level, were aesthetically more refined, and yet deeply reflected popular taste and sentiment. Freed from the humble task of cheaply reproducing paintings, they attained a position of independence and popularity which lasted for three centuries, challenging the honored position of the painted scroll.

PLATES 24, 25

The subject matter mirrored "this transient world"—a geisha combing her hair, a bird asleep on a branch, the faces of well-known actors and popular wrestlers, a view of Fuji. These colorful images could be bought for a small coin and pinned up on a wooden pillar or hung in a shop window to attract customers. The Ukiyo-e artist did not have much more social standing than the people he depicted; he belonged to the low caste of actors, artisans, and little people. But the woodcut attracted great masters as a medium well suited to chronicling the contemporary scene and as a way of making a living. A collaborative team of artist, woodcutter, and printer ensured efficient performance, making inexpensive mass production possible.

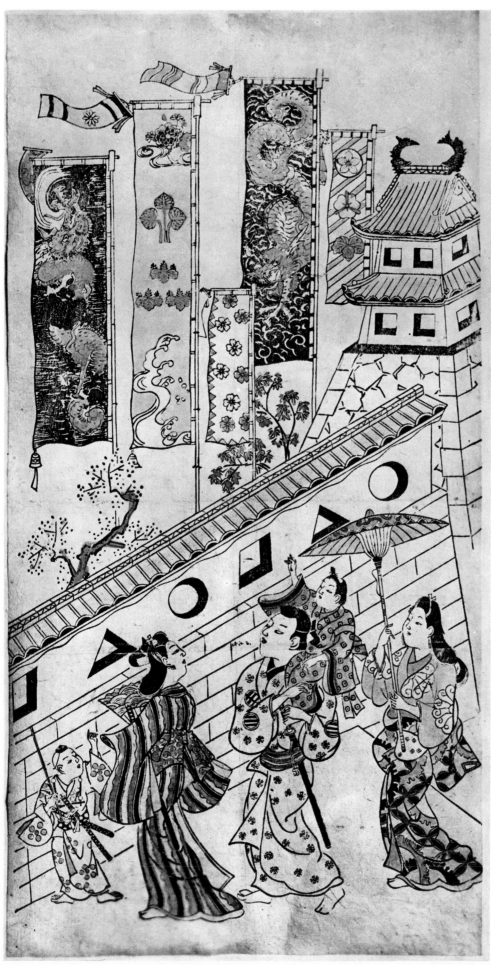

24 Sugimura Jihei (attributed). Tango Setsu
(Boys' Festival). *Late 17th century.
Colored woodcut, 23 1/8 × 11 3/4".
Worcester Art Museum (John Chandler
Bancroft Collection)*

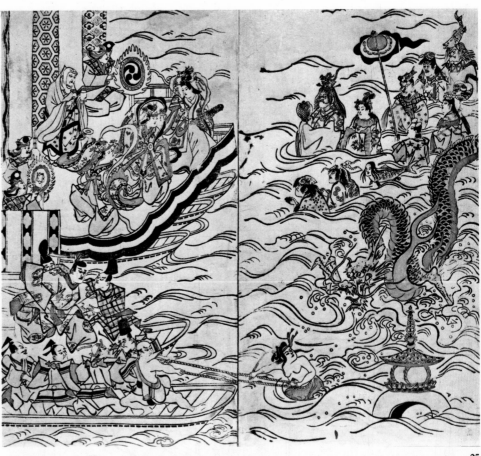

25

PLATE 27

PLATE 26

Hishikawa Moronobu (c. 1615/25–c. 1694), who lived at the beginning of the Tokugawa Shogunate, a regime noted for its interest in the arts, is generally credited with having popularized the Ukiyo-e woodcut. He ushered in a period of the highest standards for the illustrated book, which had slowly evolved from the scroll. Now it was folded in accordion fashion and sewn together at one side, with the pages turned from right to left.

Both Moronobu and the greatest master of the succeeding generation, Nishikawa Sukenobu (1671–1751), presented to the public glimpses of the passing scene in countless book illustrations. Wood blocks were being cut with increasing skill by a new generation of craftsmen. The swirling calligraphic strokes of the artist's brush were caught on the wing and cut into the wood with astonishing faithfulness. Gone was the stiff, archaic style previously used for ceremonial court scenes or worshipful sutras.

A dynasty of Ukiyo-e artists began with Torii Kiyonobu I (1664–1729). Like Toulouse-Lautrec, who was to discover his Japanese "ancestors" some centuries later, Kiyonobu became attracted to the world of the theater. He designed a profusion of portraits of entertainers; did posters, programs, and signboards; and lived in the easy atmosphere of the stage and teahouse.

Okumura Masanobu (c. 1686–1764), a most versatile and talented artist, bookseller, and publisher, was an innovator of daring. He designed enormous "pillar prints" (*hashira-e*), so called from their long, columnar shape. These prints were often used for announcements of secular and religious festivals. His prints also glorified the charms of the Japanese woman. Masanobu was probably responsible for promoting a form of color print called *urushi-e*, made by mixing gold dust and lacquer into the watercolor pigment. During his lifetime the color woodcut printed from separate blocks, at first only in red or green and black, came into being. It soon

replaced the hand-colored prints and blossomed eventually into dazzling color schemes, often requiring as many as eleven blocks.

Suzuki Harunobu (1725–1770) used the new medium to the full in paying homage to the ethereal beauty of young women. Many of his compositions were unorthodox, showing several figures in fully developed interior settings. He is credited with the first use of the *nishiki-e*, or "brocade print," the fully polychrome print. Technically he lightened the impact of the print by using delicate half tones and blind stamping, adding startling relief patterns. The gauffrage technique was later used with even greater effectiveness by Utamaro and Sharaku.

PLATE 28

The eighteenth century in Japan fostered numerous great artists who worked with equal facility as designers of prints and illustrators of books. Tani Bunchō and Katsukawa Shunshō, Torii Kiyomitsu and Torii Kiyonaga, all active in the same century, brought Ukiyo-e to its highest flowering, no doubt creating an expanding market for these colorful and inexpensive enhancements of daily life.

COLORPLATE 5

PLATE 29

Largely based on the traditional Japanese admiration of all things beautiful in nature—a flowering branch, a fragile woman, a misty landscape—or on the histrionics of the actor or the heroics of the samurai, these prints proved to be a major influence on Western culture. Perhaps the story is apocryphal that they made their way into Europe by the back door, as wrappings for imported cups, plates, and other knickknacks. Yet the output of such masters as Hokusai, Utamaro, and Harunobu was so enormous as to lend credence to the story.

28 *Suzuki Harunobu.* Geisha Masquerading as Daruma Crossing the Sea from China to Japan. *18th century. Color woodcut. Philadelphia Museum of Art*

29 *Torii Kiyonaga.* Kintaro Making Four Demons Draw Lots. *c. 1785. Color woodcut. Museum of Fine Arts, Boston (William S. and John T. Spaulding Collection)*

30 *Tōshūsai Sharaku.* Daizo the Substitute. *c. 1794. Woodcut. Brooklyn Museum, New York (Ella C. Woodward Fund)*

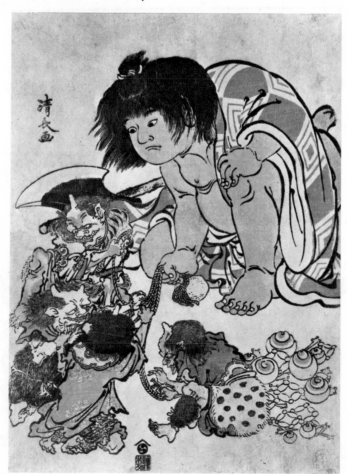

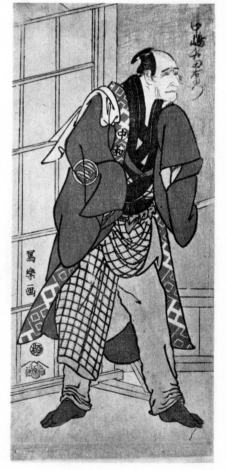

29

30

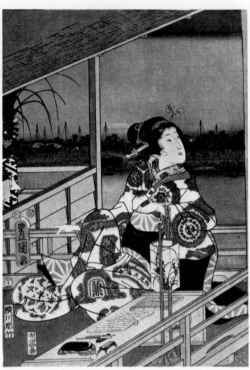

31 *Kawanabe Kyosai.* Crow on a Branch.
19th century. Color woodcut. Brooklyn
Museum, New York

32 *Andō Hiroshige and Utagawa Kunisada.*
View in Moonlight, with a Lady on
a Balcony. 19th century. Color woodcut.
Brooklyn Museum, New York

33 *Kitagawa Utamaro.* Leaf from the album
Uta-makura. *1788. Color woodcut.*
Victoria and Albert Museum, London
(Salting Bequest)

31

32

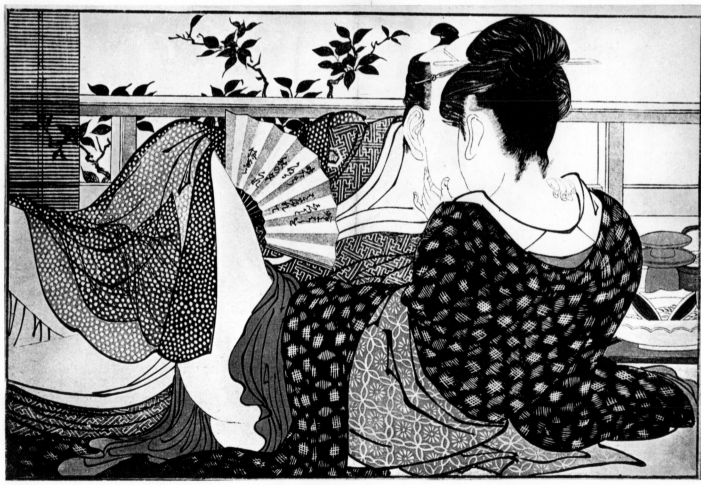

33

Tōshūsai Sharaku (1749–1803), reputedly gifted as a Noh actor and dancer, designed about one hundred forty magnificent actor portraits, almost all within less than one year (c. 1794).

PLATE 30

The incomparable Kitagawa Utamaro (1753–1806) created over a thousand prints in his short lifetime. Like Daumier thirty years later, he was imprisoned for *lèse majesté* in 1805. His life and health ruined, he died shortly after serving his term. The intimacy with which he observed women in their privacy—meditating, receiving a lover, tending a child—is unsurpassed and still deeply moving. But Utamaro was equally masterful as an observer of nature, of the life of a flower, the ebb and flow of the sea. His use of mica, gold, and silver dust gives some of his prints a jewel-like quality. The patterns and textures embossed into the design lend the work a third dimension. There is no ostentation to his technical bravura; nothing is overstated, and every detail remains a delight to the patient and discriminating eye.

COLORPLATE 6

PLATE 33

Katsushika Hokusai (1760–1849) is perhaps the Japanese artist best known and most easily understood in the West. There is no mystique about his perceptive graphic observations. His *Manga*, thirteen sketchbooks, show an encyclopedic knowledge of everything that grows, walks, flies, crawls, and swims. In addition he encompassed all the foibles of humanity, all the humble objects of everyday life, as well as the majesty of waterfalls, the mistiness of islands, and the moods of holy Mount Fuji. His prints are superbly and strongly colored in the new style that was to become popular in the nineteenth century. He was studying, learning, and working as he approached ninety, "the old man mad about painting."

PLATE 34

COLORPLATE 7

Kawanabe Kyosai (1831–1889) worked mainly in a humorous and popular vein in the manner of his master, Hokusai, in the declining years of Ukiyo-e. He was a prolific and skillful draftsman, dedicated to art—and the consumption of sake.

PLATE 31

Andō Hiroshige (1797–1858), the last of the great Ukiyo-e masters, less interested in the human condition, turned his talent to the loveliness and grandeur of the

COLORPLATE 8

34 *Katsushika Hokusai.* Morning Glories in Flowers and Buds. *First half of 19th century. Color woodcut. Brooklyn Museum, New York*

34

35 *Nagasaki school.* Interior View of a
German Warship. *19th century.*
Woodcut. Brooklyn Museum, New York

PLATE 32

Japanese landscape. As Utamaro had studied women, Hiroshige, roaming endlessly
over the countryside, recorded what he saw in his famous series of lakes and water-
falls, of views of Fuji, and the *Fifty-three Stages of the Tōkaidō Road.* With him ended
the heyday of the Ukiyo-e print. His death coincided with the arrival of Commodore
Perry's black ships and foreign trade. The deluge of Western technology and culture
smothered the lyrical, highly refined art form in which "this floating world" had
found its expression.

Nagasaki-e, Woodcuts of Westerners

COLORPLATE 9
PLATE 35

The Nagasaki color woodcuts occupy a unique place in Japanese printmaking. With
few exceptions they were devoted to the portrayal of that strange species, the for-
eigner. Nagasaki, a picturesque port, was visited by ships mostly from Holland and
Portugal, disgorging strange crews of oddly dressed, long-nosed people as early as

1602 and providing interesting subject matter for garishly colored souvenir prints. One of the first, dated 1644, shows forty-two types of foreigners; it established a pattern and a market for more to come. No matter how hard the artists (mostly anonymous) tried, no matter how long the noses or how European the costumes, the faces always seem to retain their Japanese character. Even a buxom Dutch blonde was made to look like a geisha in disguise. The artists naturally felt more at home portraying Chinese residents, who played an important part in the cultural life of Nagasaki.

In the beginning most of the prints were hand-colored; later they were printed from multicolored blocks on cheap paper and sold for a few yen. Their existence and increasing value were discovered only recently, largely through the publication in 1939 of N. H. N. Mody's book based on his own collection, which was later destroyed by fire.

36

37

36 *Ito Jakuchū. Flowering Plant and Butterfly. 18th century. White-on-black woodcut, 10 1/4 × 6 1/2". Worcester Art Museum*

37 *Katsushika Hokusai. Illustration from Quick Lessons in Simplified Drawing, Part II, 1812. Woodcut. Museum of Fine Arts, Boston (gift of William Sturgis Bigelow)*

Ukiyo-e Technique

Although color printing was known in Japan through seventeenth-century Chinese prints, Japanese artists long preferred color to be applied by stencil or by hand. Moronobu issued series of black-and-white prints with instructions for coloring, intended perhaps for print lovers with a bent for "doing it themselves."

With the increasing popularity of the Ukiyo-e print, color was added block by block, until it reached its apex in the *nishiki-e* ("brocade print"), with its dazzling display of color. By that time publishers in Edo, Kyoto, and Osaka had a firm hold on the lucrative market, commissioning artists, woodcutters, and printers and orchestrating their divided labors into a harmonious whole. If a text accompanied the picture, the services of highly regarded calligraphers were also required. The publisher paid the bills, distributed the prints, and probably reaped most of the profits.

The publisher, often a man of considerable learning, frequently gave the initial idea to the artist, who drew his design with a brush and ink on thin paper (*mino* or *gampi*). The wood was usually well-seasoned wild mountain cherry, cut lengthwise and carefully planed, to which the drawing was pasted face down. Somewhat softer wood, such as katsura (Judas tree), ho, jujube, or maple, might be used for the less detailed color parts of the print. The paper could be rubbed and peeled off, leaving the drawing on the block, or left on to dry. Then the cutter went into action, following the transferred lines or cutting through the transparent paper with his knife.

The tools used were simple: a straight-edged knife, some chisels, and a mallet to clear away the larger areas. Most important was the ability to keep the knife sharp on the whetstone.

PLATE 36

The main pigment used in the beginning was, of course, black (*sumi*), made of lampblack or soot from pine needles mixed with glue and diluted with water. Lacquer was sometimes added to obtain a glossy finish. Popular colors added later were *beni* (crimson, saffron red), *tan* (vermilion, cinnabar red), *ai* (indigo), *gunjō* (ultramarine), *zumi* (brown-yellow), and several others made chiefly from vegetable and mineral matter. The more lavish prints were printed with highly exotic colors, obtained from powdered mica, clamshells, brass, copper, or silver.

PLATE 37

The pigment was applied to the block with horsehair brushes, gradation being achieved by diluting the color with water. The moistened paper was quickly applied

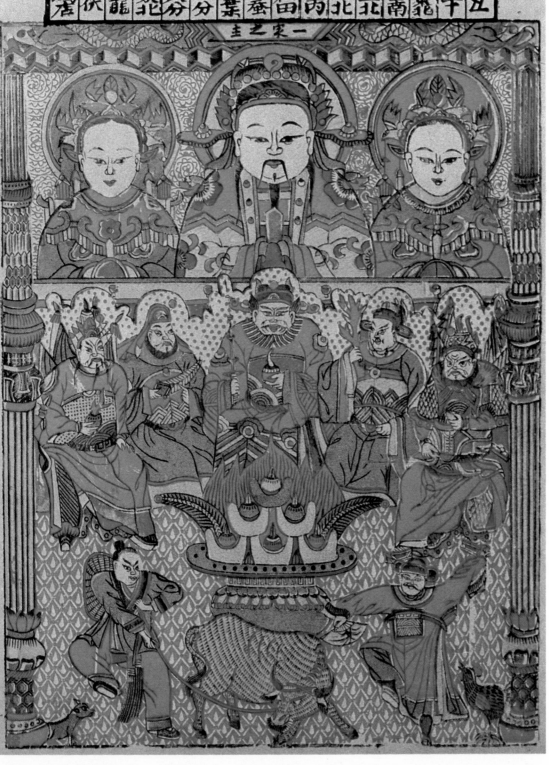

1 Door guardians, Chinese folk print. Color woodcut, 20 × 11". Collection the author

妙法蓮華經卷第七

說是妙音菩薩品時　無生法忍

3

4

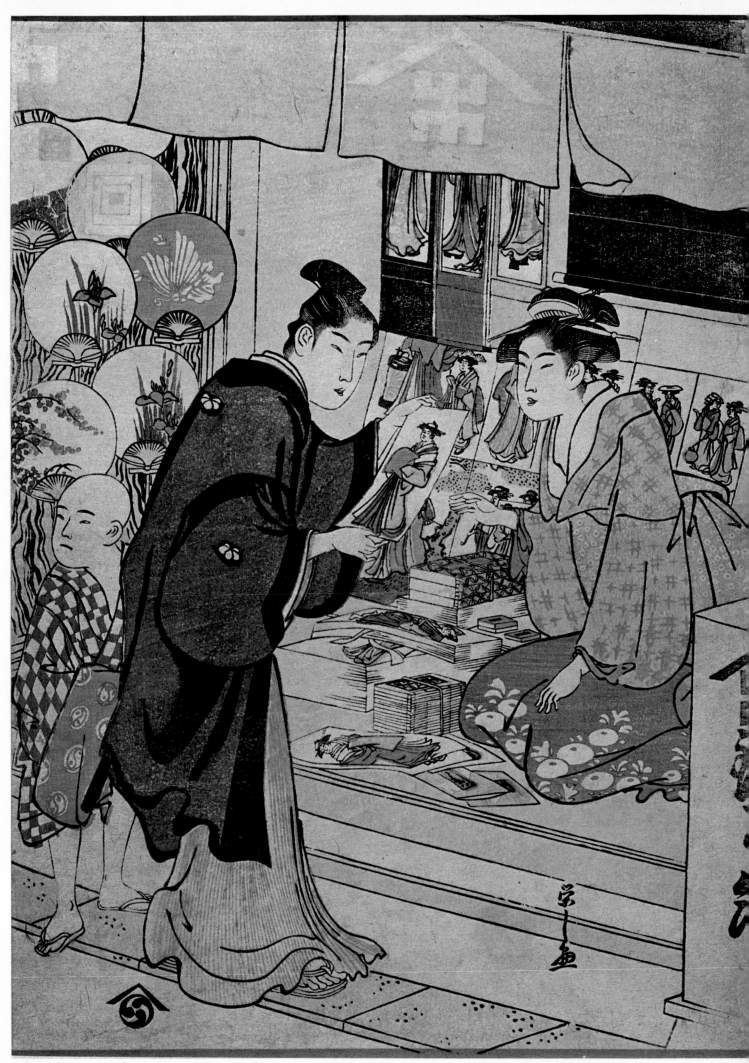

5

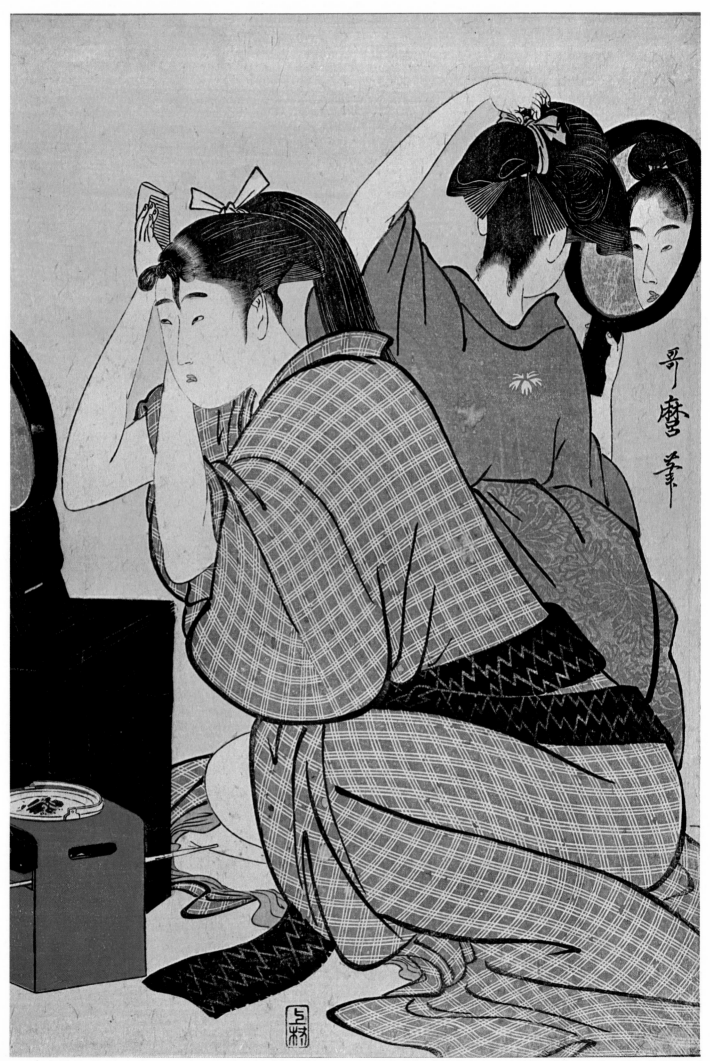

哥麿筆

7 *Katsushika Hokusai (1760–1849).* The Poet Ariwara Narihira. *Color woodcut in nishiki-e ("brocade") style, 18 1/2 × 8 3/4".* Museum of Fine Arts, Boston (Nellie P. Carter Collection)

8 *Andō Hiroshige.* Fireworks at Ryōgoku, *No. 98 in the series* The Hundred Views of Edo. *1858. Color woodcut, 15 × 10".* Brooklyn Museum, New York

OVERLEAF:

9 *Nagasaki school.* Picture of a Hollander, *from N. H. N. Mody,* A Collection of Nagasaki Colour Prints and Paintings, *Rutland, Vt., 1969. Colored woodcut, 17 1/8 × 12 5/8".*

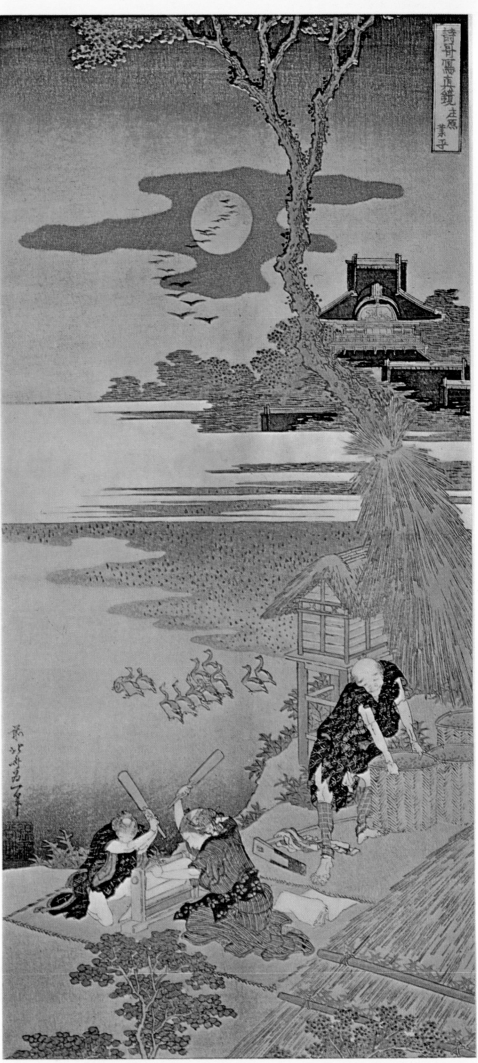

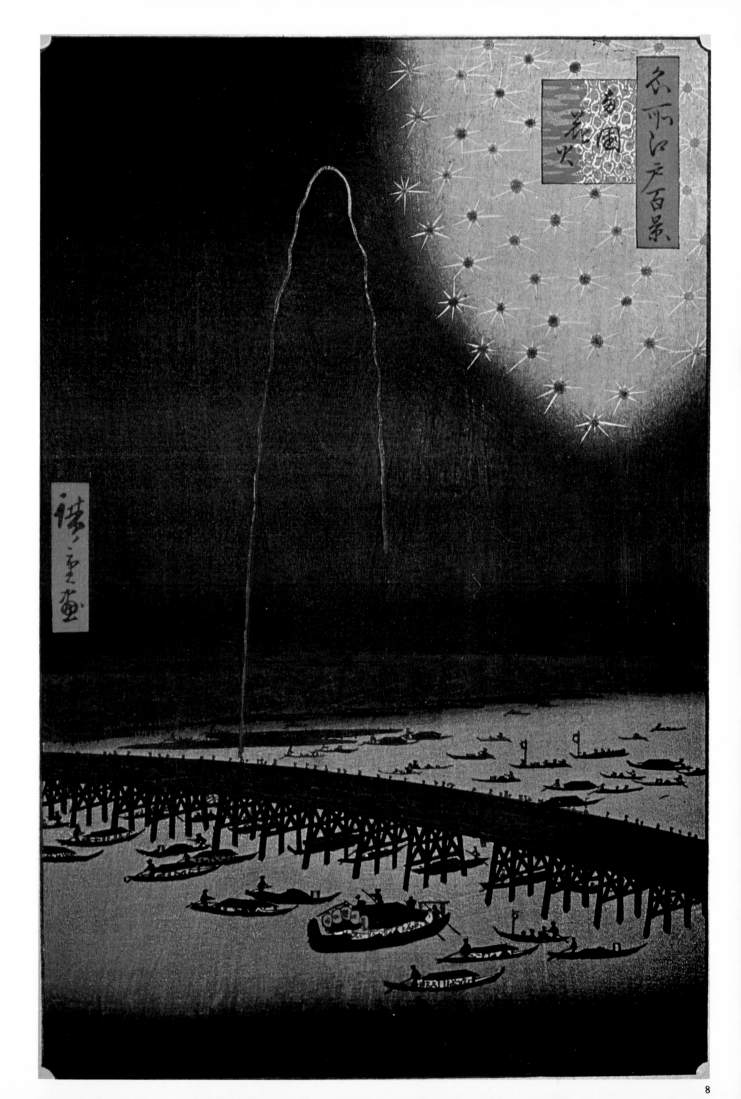

8

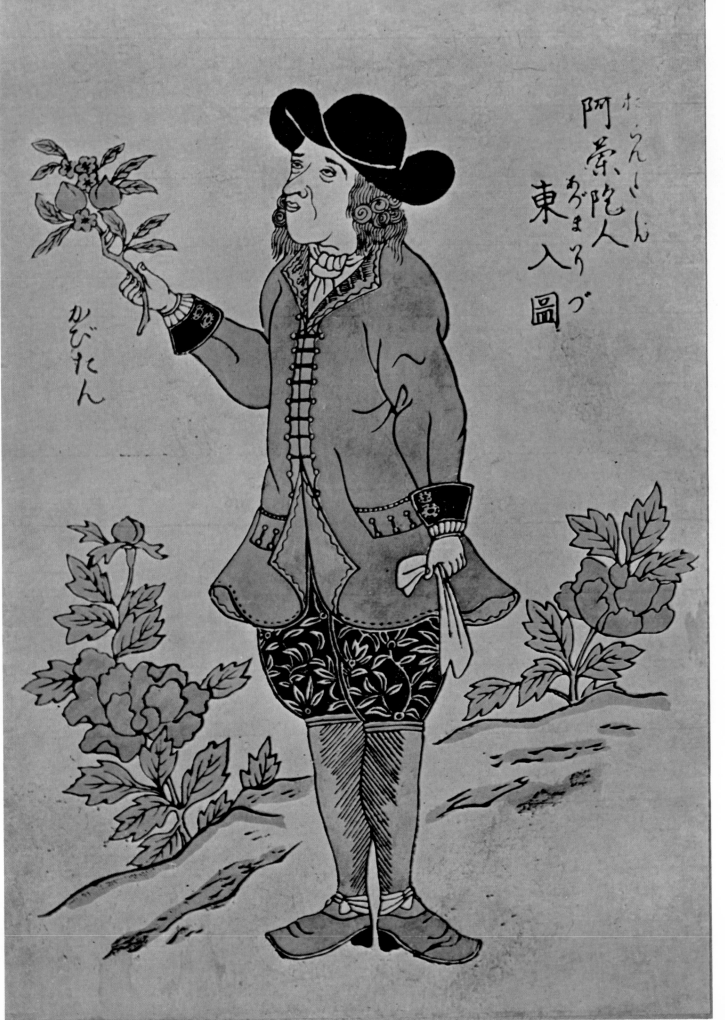

かびたん

阿蘭人
阿蘭陀人
あづまり入
東入圖

9

and rubbed with a baren before the water had a chance to evaporate. *Hōsho* paper, made from the bark of the mulberry tree and properly sized to suit different purposes, held a place of honor and was used extensively, then as now.

In the absence of presses, printing was mainly in the hands of well-trained artisan families, working according to a modified conveyer-belt system, following a master print and directions given by the artist. Register was achieved by leaving a raised corner (*kagi,* or key) on the lower right-hand side of the block and a short straight ridge (*hitsuke,* or drawing guideline) along the lower margin, into which each sheet was carefully fitted before printing.

The size of the edition depended on the popularity of the print and probably varied between one hundred and two hundred, at which point the block might have been worn down a little, though it is claimed that if well treated a *yamazakura* (hardwood block) could stand several thousand impressions.

The baren has been the Japanese artist's printing press since the fourteenth century and was probably imported from China. It is a deceptively simple-looking device; the making of it is a laborious, tradition-honored, time-consuming process. A well-made baren is not only difficult to obtain but also extremely expensive. The basic disk, about 5 1/2 inches in diameter, is made of thirty to forty layers of special paper, 1/8 inch thick, glued together by a method which may take several months. It is then covered with silk and lacquered. The padding consists of a 12-foot-long braid of tightly coiled fibers of white bamboo. This fits into the disk, which is covered with a dried bamboo sheath and loop-handled. The baren fits a human hand comfortably.

PLATE 38

38 *Totoya Hokkei.* Tortoises Swimming Among Marine Plants. *First half of 19th century. Color woodcut. Brooklyn Museum, New York*

39

PLATE 39

39 Japanese Crossing the Yoryoku-ko.
Early 20th century. Woodcut. Brooklyn
Museum, New York (gift of Mr. and Mrs.
Tessim Zorach)

In rubbing it over the back of the paper, one can apply and subtly regulate the desired pressure.

It is amazing how little has changed in this well-organized workshop procedure over the centuries. Although Japanese artists have adopted most of the tricks and trends of Western printmaking, some twentieth-century masters such as Munakata and Uchima combine their contemporary styles with traditional Oriental work methods and with the ingrained skills of the Ukiyo-e masters.

Gyotaku

Gyotaku, translated as "fish print," is a variation of the rubbing technique (see Chapter 8) frequently used in Japan. Although the technique was originally developed for taking impressions of fish, it can also be applied to obtain prints from any forms, natural or man-made, which have sufficiently deep relief.

In the indirect method a thin paper is affixed to the body of the fish (or other suitable object), and ink is dabbed on the outer surface of the paper until the convex parts of the body's surface have been reproduced.

In the direct method the object to be reproduced is brushed with pigment, the paper affixed to it, and the outer surface of the paper gently rubbed until the inner surface has acquired the impression of the object. Unlike other forms of rubbing, the direct method produces a reversed, or mirror, image of the original object.

A third type of Gyotaku is an extension of the direct method, but the final image is not reversed. Pigment is smeared on the object's surface, and a sheet of nylon or polyethylene is placed upon this inked surface. This sheet, having received the impression, is removed and pressed onto a sheet of paper, which, in turn, receives the offset impression of the original object.

CHAPTER 5

THE WOOD-BLOCK PRINT IN THE WESTERN WORLD

HISTORY

PLATES 40, 41

In the Western world the evolution of the relief print had its parallels with that in the Orient. The motivating force behind the early "publishers" was, no doubt, the propagation of a faith, be it Buddhist or Christian; and the wholesale distribution of religious images among the ordinary people helped to solicit their interest and support for a shrine, church, or temple.

The woodcut deserves perhaps the most honored place in the history of the print, since it is the most ancient, the most direct, and, by virtue of its great simplicity, easily the most democratic medium of graphic multiplication and artistic expression. The wood-block print is the descendant of the earliest graven images. The process of cutting into a piece of bone, engraving a seal design into a soft stone, or carving a relief into a temple wall, practiced thousands of years ago, required essentially the same skill necessary for the cutting of a wood block.

Designs cut in wood and printed on textiles in the Near East as early as the sixth century could be considered the legitimate forerunners of the woodcut. With the availability of paper in the West in the late Middle Ages, the massive production of printed images became possible there also. Thus the woodcut began to enter the lives of the simple people. The print could tell its story to those who could neither read nor write but might quickly grasp the meaning of a picture.

40

41

40 *Anonymous Italian.* Mater Dolorosa. *c. 1500. Original wood block. Museum of Fine Arts, Boston*

41 *Anonymous German.* St. Alto. *c. 1500. Colored woodcut. National Gallery of Art, Washington, D.C. (Rosenwald Collection)*

42 *Anonymous German.* The Hand as the Mirror of Salvation. *1446. Colored woodcut. National Gallery of Art, Washington, D.C. (Rosenwald Collection)*

43 *Anonymous Indian.* The Hand of Buddha. *Silk. Collection the author*

Early European Woodcuts

The early European woodcuts, often crudely colored, are, in their naive expression of faith, strangely similar to early Buddhist prints. The eloquence of the image could play on people's superstitions, implant fear of death and devil, or entertain with picture stories of miracles, disasters, and unnatural phenomena. In the popular form of playing cards, prints led gamblers down the primrose path.

PLATES 42, 43

PLATES 44–46
COLORPLATE 10

As Europe emerged from the Middle Ages, as the austere and pious Gothic reached its apex, and as a prosperous middle class began to yearn for a more abundant life on earth, rather than in the hereafter, the woodcut turned to more secular subjects and lost some of its severity. The stark black line gave way to a more sophisticated play of patterns. Saints began to look more three-dimensional and less ascetic. Herbals and calendars made their appearance, along with stories of love and passion. Fables and legends, romances of chivalry, heroic deeds of history, and world chronicles were published in sumptuous editions, and the first satirical prints, forerunners of the political cartoon, became popular with the masses. War, pestilence, and the fragility of life were reflected in the artists' favorite theme, the Dance of Death.

PLATES 47, 48

Since the burgher now had time and money for books, there was a growing market for literature in the vernacular. The fifteenth century gave birth to a profusion

42

43

of talents devoted to the making of books, many of which were illustrated with woodcuts by the finest artists of the time, assisted by gifted formcutters and skilled printers.

Soon the anonymous masters and the Monogrammists (so called because of the initials and other devices incorporated in their prints) became known by the character of their work and their favorite subject matter. Most of the earliest prints were single sheets (*Einblattdrucke*), which survived because they were pasted inside book covers, cabinet doors, traveling chests, trunks, or wardrobes, from which they were liberated by eager collectors centuries later. Most of them had been designed to serve the purpose of warding off disease and death, fire, or robbery, by showing images of popular patron saints. For added appeal almost all of them were hand-colored, in imitation of illuminations and paintings.

COLORPLATE 11

The early work consisted mostly of the great incunabula, the block books, of which about thirty-four different titles have survived. It can be assumed that with the establishment of craft guilds in towns and cities during the middle of the fifteenth century most wood blocks were cut by professional formcutters, recruited from the ranks of skilled craftsmen such as cabinetmakers and jewelers.

PLATE 49

The outstanding block books seem to have come from the Netherlands, among them the *Apocalypse St. Johannis*, the *Biblia Pauperum*, the *Ars Moriendi*, and the *Canticum Canticorum*, all published in Haarlem or Utrecht during the first half of the fifteenth century. These popular themes—tracts for the faithful, Bibles for the poor— appeared in many editions, translations, and sometimes imitations in Germany and the rest of Europe. It was the transition from the manuscript to the printed book that closed many a monastic scriptorium.

PLATE 50

Some of the incunabula were clearly intended to imitate the illuminated manuscript, with woodcuts often printed separately in light brown to resemble quill drawings, the text being printed in black or written calligraphically.

The Printing Revolution

The genius of Johann Gutenberg of Mainz changed all that. He revolutionized the printing of books not so much through the invention of movable type, which had been invented and used in Korea and China centuries before, as through the use of a steel matrix which served as a mold for any number of letters cast in durable lead alloy. The forty-two-line Bible (or Mazarin Bible), produced in three years of unremitting hard labor, is proof of Gutenberg's engineering skill, perseverance, craftsmanship, and sense of beauty. It was also, incidentally, the very first printing of the Bible with movable type and, as such, an event of epoch-making importance. Although he was cheated of the fruit of his labor, it gained him immortality. His invention marked the end of the block book and the exit of the scribe.

44

44 Anonymous German. St. Onuphrius. c. 1450, after a model of c. 1410. Colored woodcut. National Gallery of Art, Washington, D.C. (Rosenwald Collection)

PLATE 52

Pioneers are often made to suffer. Gutenberg went into bankruptcy; his shop and equipment were taken over by his "sponsor," Johann Fust, and his son-in-law, Peter Schöffer. Still, with their ill-gotten gains they produced the beautiful Mainz Psalter of 1457. In 1486 they printed and published one of the finest early travel books, Breydenbach's *Travels in the Holy Land*, magnificently illustrated by Erhard Reuwich, a perceptive artist who had accompanied the author, an ecclesiastic, on his trip.

Perhaps these impressive land- and cityscapes inspired a series of other grand views—one of Augsburg (Weiditz, 1521), another of Cologne (Anton Woensam,

45

45 Anonymous German. The Death of the
Virgin. *1465–70. Colored woodcut.
National Gallery of Art, Washington,
D.C. (Rosenwald Collection)*

46

47

48

46 Anonymous French, from Paris. Christ Appearing to Mary Magdalene. *c. 1500. Colored
woodcut. National Gallery of Art, Washington, D.C. (Rosenwald Collection)*

47 Anonymous German, from Ulm. Allegory on the Meeting of Pope Paul II and Emperor
Frederick III. *c. 1470. Colored woodcut (after the accompanying engraving). National
Gallery of Art, Washington, D.C. (Rosenwald Collection)*

48 Anonymous Italian, from Venice. Allegory on the Meeting of Pope Paul II and Emperor
Frederick III. *c. 1469. Engraving. National Gallery of Art, Washington, D.C.
(Rosenwald Collection)*

PLATE 53

PLATE 56

PLATE 51

PLATE 54

1531)—but probably the most grandiose was the panorama of Venice by Jacopo de' Barbari, 9 feet long and made up of six separate blocks.

Print shops sprang up all over Europe; presses were made; type was cast; artists, formcutters, and printers were engaged; reams of handmade paper were ordered. Among the many *officinas* a few are worth mentioning for having produced memorable books. In Cologne, an important trade and cultural center, Heinrich Quentell started a print shop about 1475 and produced more than two hundred titles in a quarter of a century, mostly liturgical and theological works, often illustrated with woodcuts. He is credited with printing the famous Cologne Bible (c. 1479) in Low German, with powerful woodcuts which are said to have influenced Koberger and perhaps Dürer in his early days.

Ulm and Augsburg became great printing and publishing centers. In Ulm Jacob Zainer and Leinhart Holle—famous for their splendid Boccaccio *De Claris Mulieribus*, published in 1473; for the Aesop of 1476; and for the great *Bidpai, das Buch der Weisheit der alten Weisen* (1483), an adaptation of Indian fables with 126 powerful woodcuts—eventually went bankrupt and had to leave the city. Brother Günther Zainer did slightly better in Augsburg, although he got into disputes with the formcutters' guild. He issued the first illustrated book from Augsburg, and perhaps the first illustrated Bible, the *Biblia Sacra Germanica* (c. 1475), "in the vulgar

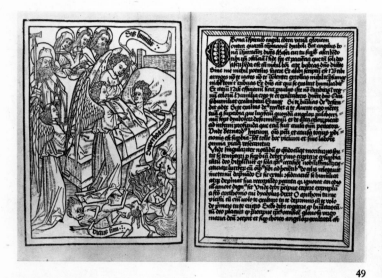

49

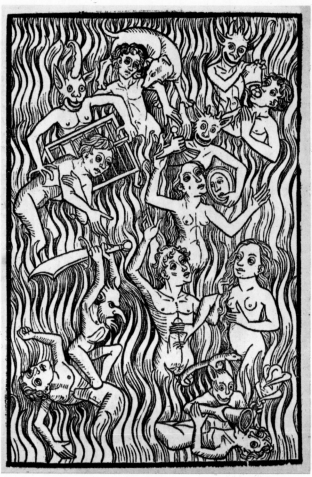

50

49 Anonymous German. Bona Inspiracŏ Angeli contra Vanagloriam, *from the block book* Ars Moriendi. *15th century. National Gallery of Art, Washington, D.C. (Rosenwald Collection)*

50 Anonymous German. "Von dem fegfeuer mit etlichen exempeln," *from* Seelenwurzgarten, *printed by Conrad Dinckmut, Ulm, 1483. Woodcut, c. 7 1/2 × 5". Davidson Art Center, Wesleyan University, Middletown, Conn.*

51

52

53

51 *Anonymous German. Illustration from* Das Buch der Weisheit der alten Weisen, *German version of Bidpai's Indian fables, Ulm, 1483. Woodcut, c. 7 3/8 × 6"*

52 *Erhard Reuwich.* Syrians, *from Bernard von Breydenbach,* Sanctae Peregrinationes *(Travels in the Holy Land), Mainz, 1486. Woodcut. Museum of Fine Arts, Boston (Marie Antoinette Evans Fund)*

53 *Jacopo de' Barbari.* View of Venice, *second part. 1500. Woodcut, 26 1/2 × 35 3/4". National Gallery of Art, Washington, D.C. (Rosenwald Collection)*

tongue." At the end of the century there were twenty printing plants flourishing there, which published and printed hundreds of books with thousands of woodcuts.

In Nuremberg Anton Koberger, publisher of 227 titles between 1471 and 1500, including Jacobus de Voragine's *Passional (Lives of the Saints)* in 1488 and the *Schatzbehalter (Treasure Chest)* in 1491, employed over a hundred artisans on twenty-four presses and was responsible for perhaps the greatest publishing venture of his time, Hartmann Schedel's *Weltchronik* (or *Nuremberg World Chronicle*) in 1493. Over eighteen hundred illustrations were provided by skillful repeated use of 645 woodcuts of cities, events, crowned heads, saints, and popes, cut by a team of artists headed

PLATE 55

PLATES 57, 58

54 **55**

56

54 Anonymous German. King David with
the Harp, *from the* Biblia Sacra
Germanica, *Nuremberg, 1483. Colored
woodcut. Metropolitan Museum of Art, New
York (Harris Brisbane Dick Fund, 1931)*

55 Anonymous German. St. Luke Painting
the Virgin, *detail, from Jacobus de
Voragine,* Passional *(Lives of the Saints),
Nuremberg, 1488. Woodcut. Museum
of Fine Arts, Boston*

56 Anonymous German. Illustration of the
Apocalypse, *from the Cologne Bible,
printed c. 1479. Woodcut, 4 3/4 × 7 1/2".
Metropolitan Museum of Art, New York*

by Michael Wolgemut, and assisted by his pupil Albrecht Dürer and his stepson,
Wilhelm Pleydenwurff. It was an enterprise unique in its magnitude and daring,
often imitated but never equaled in quality.

The nucleus of a French publishing center was started rather belatedly about
1473 in the great commercial city of Lyons by expatriate Flemish or German printers,
such as Guillaume Le Roy (Wilhelm Koenig), who published the first illustrated
books in France. The real impetus, however, was given by an Englishman, Geoffroy
Tory (1480–1533), who had established his reputation as a fine artist, book designer,
publisher, and bookseller with outstanding editions of Petrarch, Herodotus, Dante,
Boccaccio, and other remarkable books. Moving to Paris, Tory was responsible for
the *Praxis Criminis Persequendi* (*Criminal Law Practice,* 1541), a brilliant achievement,
inspiring the creation of many other fine books in a distinctly Gallic Renaissance
style.

In Italy the first press was set up about 1462, in an obscure little place at the
Benedictine Monastery at Subiaco outside Rome, by two itinerant German printers,
Conrad Sweynheym and Arnold Pannartz from Mainz. There the first book issued
in Italy, a Cicero, dated about 1464, was published, and the Roman alphabet was used
in the distinguished *Opera* by Lucius Lactantius.

The two printers moved to Rome two years later, but the real center of publish-
ing was established in Venice. There another German printer, Johann of Speyer,
known in Italy as Johann (or Giovanni) de Spira, was granted by the Signoria the
exclusive privilege of printing and publishing books. He started with Cicero, Pliny,
and Augustine in a "modern" Roman type, later copied by Nicolas Jenson and still
popular in our day. This first edition of Pliny's *Natural History*, with its bestiary of
freaks and abnormalities, was responsible for future flights of fantasy in many il-
lustrated books of the period.

Jenson set up shop in Venice after Johann's death in 1470, but it was Aldus
Manutius who succeeded in establishing the first publishing "conglomerate" in 1490.
It centered around the finest scholars of his age, assisted by a staff of the most ex-
perienced printers, producing books of surpassing beauty. His *Hypnerotomachia Poli-
phili*, a monk's romantic tale of passion, is still considered the ultimate in perfection of
printing, illustration, and typographic design. Aldus's Bembo type is still used
extensively in contemporary composing rooms.

Venice was also the place of publication of a remarkable medical book, the work
of Johannes de Ketham, a German doctor who lived there. It was printed under the

PLATE 59

57

58

59

57 *Michael Wolgemut. Design for the
 Nuremberg World Chronicle, 1493,
 Exemplar Folium xlvii, recto. Drawing,
 13 1/2 × 8 7/8". From Adrian Wilson,
 The Nuremberg Chronicle Designs,
 San Francisco, 1969*

58 *Printed Folium xlvii, recto, from the
 Nuremberg World Chronicle, 1493.
 Woodcut, printed area 13 1/2 × 8 7/8",
 page size 18 × 13". From Adrian
 Wilson, The Nuremberg Chronicle
 Designs, San Francisco, 1969*

59 *Illustration from Johannes de Ketham,
 Fascicolo di Medicina, Venice, c. 1494.
 Woodcut. New York Public Library,
 Astor, Lenox and Tilden Foundations
 (Spencer Collection)*

Italian title *Fascicolo di Medicina* in about 1494 by Joannes and Gregorius de Gregoriis,
after the Latin publication of 1491 (*Fasciculus Medicinae*).

The world, with growing literacy, had become hungry for news. The letter that
Columbus addressed in 1493 to the Royal Treasurer of Spain, reporting the discovery
of the New World, was translated and printed in every language of Europe. Count-
less were the broadsides, pamphlets, and gazettes printed sporadically from the
sixteenth century onward. We know that artist-craftsmen, mainly woodcutters, were
essential to most of these publications in an age when the level of literacy was still low
and the novelty of a printed illustration drew many customers.

Dürer and His Followers

The artists remained largely anonymous until, as celebrated artists became intrigued
with the possibilities of the illustrated book, a few great names appeared.

Albrecht Dürer casts a long shadow. Born in Nuremberg in 1471, he was early
exposed to the unprecedented developments in publishing and printing that were
generated by the first presses of southern Germany. No better start could be imagined
than to work on the monumental *Nuremberg World Chronicle* under the watchful eyes
of Michael Wolgemut.

Although the experts have never fully agreed, it is most likely that, after leaving
his native town, Dürer illustrated the *Ritter von Turn* (1493), a mirror of virtue for a
knight's daughters, and an unfinished edition of the plays of Terence; and created a
notable series of satirical woodcuts for Sebastian Brant's *Narrenschiff (Ship of Fools)*,
perhaps during his stay in Basel between 1491 and 1494. After his marriage at the age
of twenty-three and a first trip to Italy, he settled down to a respectable master's life
in Nuremberg. A dramatic change is evident in his first independent work, the
Apocalypse series of 1498, fifteen large prints with German and Latin texts, which

PLATE 60

established Dürer as a mature and thoughtful artist at the age of twenty-seven. This major work also made known at once his dramatic style and his famous monogram, to which he remained faithful to the end.

In all likelihood Dürer also functioned, with suitable assistance, as his own printer and publisher. With his *signum* he tried to protect his often-imitated works in a time that had no copyright.

PLATE 61

At that time he also started *Die Grosse Passion (The Great Passion)*, twelve large woodcuts in the powerful style of the *Apocalypse;* they were published in book form in 1511. He poured into his work his own deep faith and compassion without neglecting the minutiae of incidental detail, which rarely disturbs the grand sweep of his masterful compositions.

PLATE 62

Simultaneously he produced *Die Kleine Passion (The Small Passion)*, thirty-seven small woodcuts with Latin text, and the twenty prints of the *Marienleben (Life of the Virgin Mary)*, both published in book form in 1511. His productivity was staggering.

COLORPLATE 12

Many paintings, drawings, and single prints were created while he was working on these large series. Also, in 1497 he had already begun his first copper engravings, which will be discussed in another chapter.

It is still hotly debated whether or not Dürer did some of his own block cutting. He might have done the *Apocalypse* before the guild of formcutters had become

60

60 *Albrecht Dürer. Illustration from Sebastian Brant,* Narrenschiff, *Basel, 1491–94. Woodcut, 6 5/8 × 4 1/2″*

61 *Albrecht Dürer.* Ecce Homo (Christ Presented to the People), *in the* Great Passion *series, begun c. 1497–98, publishe 1511. Woodcut, 15 3/8 × 11″. Museum of Fine Arts, Boston (Harvey D. Parker Collection)*

62 *Albrecht Dürer.* The Martyrdom of the Ten Thousand. *c. 1497–98. Woodcut, 15 1/4 × 11″. Museum of Fine Arts, Boston (Stephen Bullard Memorial Fund)*

61

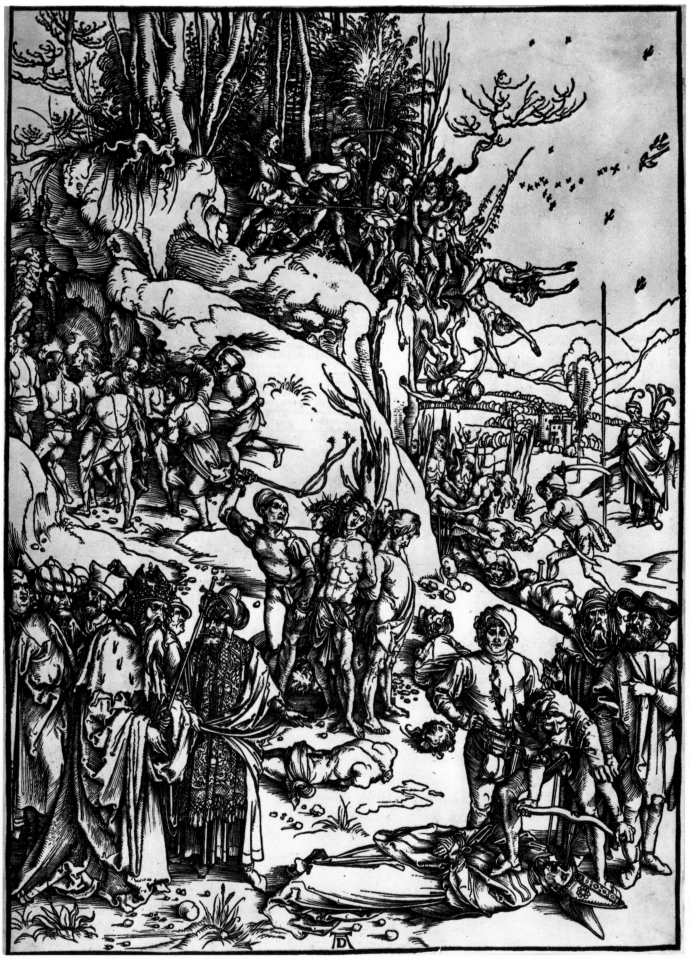

63

64

63 Albrecht Dürer. Celestial Map: The Northern Hemisphere. *1515. Woodcut, 17 7/8 × 17". National Gallery of Art, Washington, D.C. (Rosenwald Collection)*

64 Albrecht Dürer. Illustration from his Underweisung der Messung (Handbook for Draughtsmen). *1525. Woodcut. Museum of Fine Arts, Boston*

65 Hans Springinklee. Maximilian Presented by His Patron Saints to the Almighty. *Published 1526. Woodcut. Museum of Fine Arts, Boston*

PLATE 63

PLATE 64

officially entrenched in 1498, and before increasingly large commissions and projects made professional help necessary. In 1515 royal recognition came, when Emperor Maximilian I commissioned him to plan *Die Ehrenpforte (The Triumphal Arch)* and the *Triumphal Procession*, commemorating imperial achievements in the shape of a gigantic "collage" of prints, consisting of nearly two hundred separate wood blocks, composed in an arch 11 1/2 feet high.

This was a task so large and so complicated that only a well-organized team of artists and woodcutters could have achieved it; the group consisted most likely of Burgkmair, Beck, Schäuffelein, perhaps Altdorfer, and a few others, in collaboration with the Emperor's historians and architects. Ironically, the Emperor died in 1519, before the work was printed in its final form, and before he could take a last glance at Dürer's splendid gold-and-color woodcut portraying Maximilian's Hapsburg visage.

Dürer's restless mind drove him to more scholarly pursuits. Obsessed with the idea of passing his knowledge on to future generations, he published in 1525 *Underweisung der Messung*, practical geometry and instruction in perspective, both human and architectural; in 1527 *Etliche Underricht zur Befestigung der Stadt, Schloss und Flecken*, a manual on fortification. Four volumes on *Menschlicher Proportion (Human Proportion)* followed and were published a year after his death, in 1528.

65

These books show Dürer as a great typographic designer. The woodcuts are crystal clear, supplementing and enlightening the text, a fitting monument to a concerned artist and humanist.

It is almost inevitable that fellow artists were drawn into his orbit—mostly, of course, those who had personal contact with him as friends, students, or assistants. Some remained obscure in the master's shadow; some reached their own heights of

PLATE 65

PLATES 66, 67

achievement and fame. Hans Dürer, his brother, Wolf Traut, Erhard Schön, Hans Springinklee, all of Nuremberg, worked closely with Dürer on his many projects without gaining prominence on their own. Hans Schäuffelein (1480–1515), a prolific and skillful storyteller, followed Dürer in style and subject matter and collaborated with him on Maximilian's commissions. Hans Baldung Grien (1484/85–1545), after working with Dürer in his younger years, created his own "magic realism," as shown in his frenzied horses, mesmerized people, and wild chiaroscuro witches.

The second generation of Dürer's followers included the "Kleinmeister," a trio of able artists who preferred to work in a small format—Georg Pencz, Barthel Beham, and Hans Sebald Beham, later caught and punished after the abortive peasant rebellion in 1525.

The Reformation

PLATES 68–77

These were restless and disturbing times. Martin Luther had nailed his challenge to the Pope on the church door at Wittenberg and had been excommunicated. The peasants had taken up arms against intolerable oppression, and most of the artists around Dürer had been drawn into the battle.

Lucas Cranach (1472–1553) lived under the protection of the Elector of Saxony and sided with Luther, of whom he did several memorable portraits. Cranach's earthiness and sensuality set him apart from Dürer—his grandiose *Tournament* of 1509 is a swirl of clashing lances, plumes, and armor, beautifully choreographed. His woodcuts have a masculine vigor of their own. He advanced the art of chiaroscuro, heightened by gold and silver (*St. George,* 1507), and used tint blocks in several shades as well as specially tinted papers, often achieving the effect of gouache or watercolors.

PLATES 70, 72

Hans Holbein the Younger (1497–1543) also was deeply involved in the Reformation and actively engaged in Luther's pamphleteering against Rome. At the age of eighteen he went to Basel, where he worked closely with Froben, the printer and friend of Erasmus, for whose *Praise of Folly* Holbein created delightful marginal drawings. His small but powerful woodcuts for the Bible and for the celebrated *Dance of Death* were completed before he went to London as Henry VIII's court painter. Part of the success of Holbein's woodcuts may have been due to the phenomenal skill of his formcutter, Hans Lützelburger, but of course every woodcut artist of that period was dependent on the skill of his often anonymous xylographer.

PLATES 73, 74

Jost Amman (1539–1591) is known mainly for his 114 small woodcuts for the *Stände Buch (Book of Trades)*, published in 1569, a veritable encyclopedia of the social strata of his time, from Pope to beggar, with scathing doggerels written by the poet-cobbler Hans Sachs, of *Meistersinger* fame.

PLATE 71

Amman's fellow countryman Tobias Stimmer (1539–1584) also turned to the small format in his woodcuts for the Bible, published in 1576. They show the first influence of the Baroque, and it is said that Rubens studied and copied them in his youth.

Hans Burgkmair (1473–1531) stood somehow outside the political battles in which his fellow artists were embroiled. He was early drawn into the service of Emperor Maximilian, with a large commission to glorify the House of Hapsburg in a genealogy consisting of ninety-one woodcuts, which he began in 1509 and finished three years later. This was followed by the *Theurdank,* a poetic account of the Emperor's courtship, to which Burgkmair contributed fifteen designs. It was published

66 *Hans Baldung Grien.* Conversion of St. Paul. *c. 1510. Woodcut. Graphische Sammlung Albertina, Vienna*

67 *Hans Baldung Grien.* Adam and Eve. *1511. Chiaroscuro woodcut. National Gallery of Art, Washington, D.C. (Rosenwald Collection)*

68 *Anonymous German.* Caricature of Pope Alexander VI. *c. 1500. Woodcut, 8 1/16 × 5″*

69 *Anonymous German.* Caricature of Martin Luther. *c. 1500. Woodcut, 7 7/8 × 4 7/8″*

70 *Lucas Cranach the Elder.* Boy on Horseback. *c. 1500.*
 Woodcut, 7 1/8 × 12 7/8". National Gallery of Art,
 Washington, D.C. (Rosenwald Collection)

71 *Jost Amman.* Childbirth, *from* Rueff Hebammenbuch,
 1580. Woodcut. Philadelphia Museum of Art
 (Ars Medica Collection)

72 *Lucas Cranach the Elder.* Holy Family and Kindred.
 c. 1509. Woodcut, 8 7/8 × 12 7/8". Metropolitan
 Museum of Art, New York (Rogers Fund, 1921)

70

71

72

in Nuremberg in 1517 and is perhaps one of the most beautiful books, in artistry, design, and printing, of its period. The *Weisskunig*, a eulogy of the Emperor's life, with 238 woodcuts, followed but was never published in his lifetime. Though he shared this gigantic task with Schäuffelein, Beck, and Springinklee, Burgkmair's 118 blocks stand out by virtue of their mastery of detail and composition and imaginative handling of narrative, truly a great achievement, which was not published in its entirety before 1775. Burgkmair also contributed significantly to the Emperor's *Triumphal Procession*, mentioned earlier.

PLATE 75

The great mystery man of the century was the so-called "Petrarch Master," closely related to Burgkmair in style and conception but perhaps more fascinating in his "surrealist" symbolism, proficient draftsmanship, and deep knowledge of human nature. Lately identified by some historians as Hans Weiditz, he is best known for his *Trostspiegel (De remediis utriusque fortunae, A Book of Consolation in Good Luck and Misfortune)*, based on a Latin text by Petrarch, published in 1532 in Augsburg.

PLATE 77

Decline in the Woodcut Medium

As Dürer's contemporary, Albrecht Altdorfer (1480–1538) seems to have carved out a niche all for himself. A well-to-do and well-respected citizen of Regensburg, he is identified, together with Wolf Huber and Georg Lemberger, with the Danube school, related to the more playful spirit of the Latin south. It is evident that these artists had begun to think in terms of engraving. Perhaps the woodcut in all its glory had reached the limits of its refinement, and the time had come for the emergence of engraving as a new medium, expressing more adequately the growing sophistication of the sixteenth century.

PLATE 78
COLORPLATE 13
COLORPLATE 14

A younger compatriot influenced by Altdorfer was Heinrich Lautensack (1522–1568) of the Nuremberg school, who published a treatise on perspective in 1553. His

73

74

73 *Hans Holbein the Younger. Erasmus, detail. c. 1540. Woodcut. Brooklyn Museum, New York*

74 *Hans Holbein the Younger. Illustration for Psalm 53, from* Icones historiarum Veteris Testamenti, *published 1538. Designed before 1531. Woodcut, 2 3/8 × 3 1/2"*

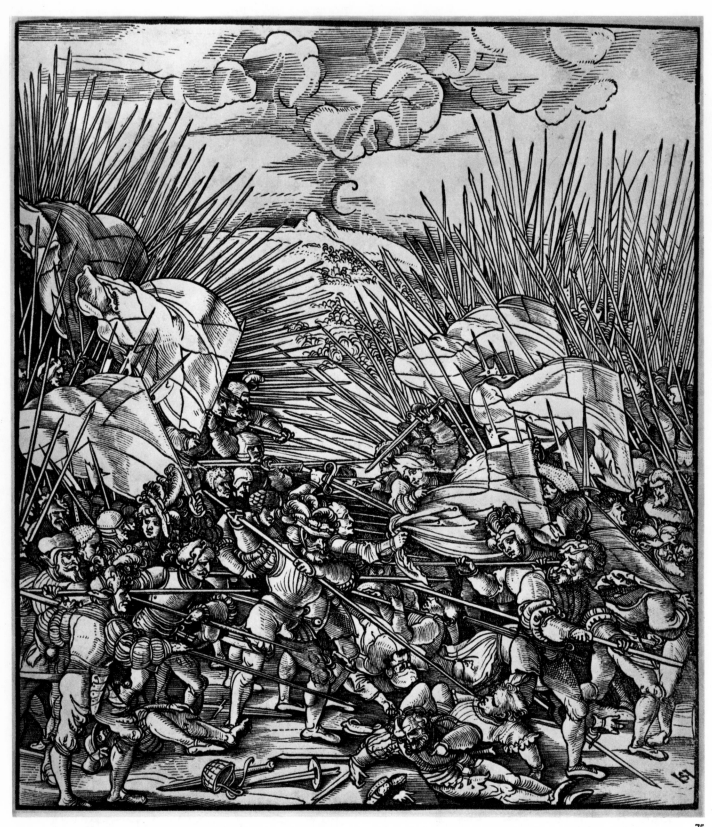

75

75 *Hans Schäuffelein.* Battle of Cividale, *from the* Weisskunig *series. Designed c. 1515, published 1775. Woodcut. National Gallery of Art, Washington, D.C.*

76 *Johann Wechtlin.* Allegory with an Owl. *Early 16th century. Woodcut. Fogg Art Museum, Harvard University, Cambridge, Mass.*

77 *Hans Weiditz. Illustration from Petrarch,* De remediis utriusque fortunae (On Good and Bad Fortune), *Augsburg, 1532. Woodcut*

78 *Albrecht Altdorfer.* Massacre of the Innocents. *1511. Woodcut. Museum of Fine Arts, Boston (gift of W. G. Russell Allen)*

79 *Heinrich Lautensack.* How to Draw Horses, *from* Perspectiva, *Frankfurt, 1564. Woodcut. Museum of Fine Arts, Boston*

80 *Katsushika Hokusai. Illustration from* Quick Lessons in Simplified Drawing, *Part I, 1812. Woodcut. Museum of Fine Arts, Boston (gift of William Sturgis Bigelow)*

76

77

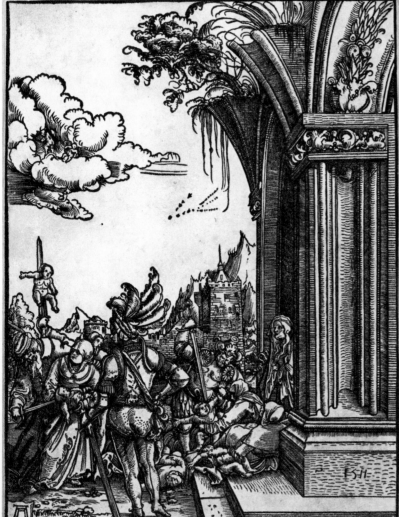

78

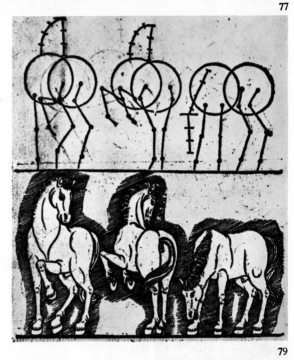

79

80

PLATES 79, 80

PLATE 81

PLATES 82–84

81 *Urs Graf. Satyr Family. 1520.*
White-line woodcut. Staatliche Graphische
Sammlung, Munich

82 *The Marriage of Mopsus and Nisa,*
after Bruegel, engraved by P. van der
Heyden, published by H. Cock, 1570.
Engraving. Metropolitan Museum of Art,
New York (Harris Brisbane Dick Fund,
1926)

efforts to pass on his knowledge and skills in printmaking to future generations of artists find an interesting parallel in those of Hokusai, despite the separation of two centuries, ten thousand miles, and totally different cultures. Lautensack also took up etching, a comparatively new method of printmaking (discussed in Part III, *Intaglio*).

In Switzerland Urs Graf (c. 1485–c. 1528) stands out as perhaps the last of that rugged generation of fighters for a cause, his insignia crossed by a dagger. Trained as a goldsmith, restless of spirit, he threw himself into the adventurous life of a *Landsknecht* mercenary without giving up his art. Unique and dramatic are his conceptions of the rough-and-tumble soldiers of fortune and their whores, with death as their constant companion. His swirling white lines, cut boldly into the dark wood block, seem to be forerunners of the white-line wood engraving of Thomas Bewick.

Niklaus Manuel Deutsch of Bern (1484–1530) belongs to the same generation, embroiled in the battles of the Reformation. Significantly he too, like Graf, added a dagger to his signature and showed the life of the *Landsknecht* in all its patched and tattered glory.

In the Netherlands Lucas van Leyden (1494–1533) stands out as a giant of his time. A friend of Dürer, with whom he exchanged prints, he is better known for his metal engravings, in which he showed uncanny proficiency at the age of fifteen (if his birth date is correct). A woodcut of *St. Martin* is dated 1508—a young master indeed! Much of his work is concerned with Biblical themes, often focused on the eternal *femme fatale*, from Eve to Salome.

Alas, of Pieter Bruegel the Elder (1525–1569) only one great woodcut is known, *The Masquerade of Orson and Valentine*, though there are other traces of his connection with the medium. It seems that after 1520 interest in the woodcut dwindled. Yet there were several of his Dutch contemporaries devoted to the wood block: Jakob Cornelisz van Amsterdam, Jan Gossaert (called Mabuse), and Jan Swart van Groeningen, all active in the 1520s and strong in the Dürer tradition, both in technique and in

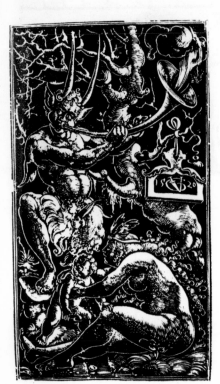

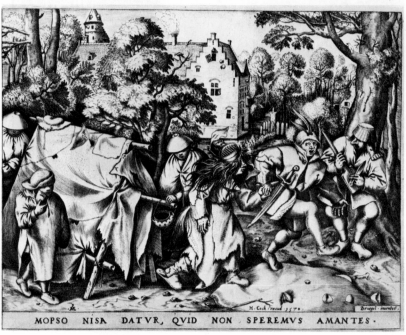

MOPSO NISA DATVR, QVID NON SPEREMVS AMANTES·

81

83

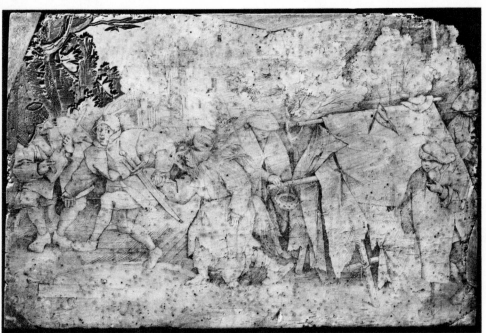

83 *Pieter Bruegel the Elder*. The Masquerade
of Orson and Valentine. *1566.*
Woodcut. Museum of Fine Arts, Boston

84 *Pieter Bruegel the Elder*. The Marriage of
Mopsus and Nisa ("The Dirty
Bride"). *Original wood block (cutting
unfinished). Metropolitan Museum of
Art, New York (Harris Brisbane Dick Fund,
1932)*

85 *Melchior Lorch.* Portrait of Ibraham I. *Mid–16th century. Engraving. Staatliche Graphische Sammlung, Munich*

86 *Titian (cut by Domenico delle Greche).* Pharaoh's Army Submerged in the Red Sea. *1549. Woodcut, 5 × 7".* *Brooklyn Museum, New York*

87 *Workshop of Titian (cut by Jan Stefan van Kalkar).* *Illustration of nerves, from Vesalius,* De humani corporis fabrica, *1543. Woodcut*

86

87

PLATE 85

PLATE 86

subject matter. The Dane Melchior Lorch (1527–c. 1583), a restless man and an adventurer, is known mainly for his remarkable series of 128 woodcuts on his travels to Turkey. His work shows his artistic independence and the keen perception of a roving reporter.

In Italy the woodcut assumed an air of classic elegance befitting the temper and spirit of the Renaissance. But, like a giant "spectacular," Titian's *Pharaoh's Army Submerged in the Red Sea* dwarfs the work of his contemporaries. More a mural than a print, it consists of twelve large blocks cut by Domenico delle Greche, dated 1549, and perhaps drawn on the wood by the master himself. It shows in an overwhelmingly dramatic sweep Moses consigning Pharaoh's army to its watery grave, with a medieval city in the background. In the foreground a little dog unmistakably shows his contempt for the Egyptians. There is perhaps no other print of any period which can compare in power, size, and scope with Titian's.

CVM PRIVILEGIIS.

88

88 *Rubens (cut by Christoffel Jegher).*
 Temptation of Christ. *Before 1640.*
 Woodcut. Smithsonian Institution,
 Washington, D.C.

89 *Ugo da Carpi (after Raphael).* David
 and Goliath. *Early 16th century.*
 Chiaroscuro woodcut, c. 10 1/2 × 15 1/4".
 Smithsonian Institution, Washington,
 D.C.

Jacopo de' Barbari's brilliant view of Venice (1500), mentioned before, may show some of Titian's influence. It was also in Venice that Jan Stefan van Calcar studied with Titian. Here, too, originated the astonishing medical masterpiece, *De humani corporis fabrica* by Andreas Vesalius (published in Basel, 1543), which offers a few interesting questions for the art historian: Were these plates designed by Titian—or by Calcar—after Vesalius's drawings? Or had Domenico Campagnola, also working in Titian's studio, a hand in it?

PLATE 87

Ugo da Carpi (c. 1480–c. 1520), who is credited with cutting Titian's *St. Jerome* and perhaps other wood blocks, had also succeeded in proclaiming himself the inventor of chiaroscuro in a petition to the Venetian Senate in 1516. This claim ignored previous similar color prints by Cranach and Burgkmair, prepared after their own designs. Ugo da Carpi, however, was chiefly interested in copying the work of popular masters. A tint block with the high lights cut out gave the black key block a new three-dimensionality by very simple means. Ugo da Carpi changed the character of chiaroscuro by adding more color and giving it the appearance of a multi-colored woodcut.

PLATE 89

Burgkmair had worked in this medium previously with his formcutter, Jost de Negker, using gold and silver inks in his equestrian portrait of Maximilian (1508) and in the later *St. George*. He also experimented successfully with several tint blocks, leaving out the black key plate and playing with loosely defined color areas.

Hendrik Goltzius (1558–1617), known especially for his masterful metal engravings, also experimented with chiaroscuro, using two or three additional wood blocks.

Peter Paul Rubens (1577–1640), much in demand and concerned with giving his work wide distribution, was fortunate in having the services of Christoffel Jegher, who translated his paintings and murals successfully into woodcuts, in black and white or chiaroscuro. These powerful prints, such as *The Garden of Love* and *The Rest on the Flight to Egypt*, cut with baroque exuberance in the manner of engravings, obviously under Rubens's supervision, were signed both by the artist and by his cutter. *Hercules* proved to be so popular that the famous establishment of Plantin in Antwerp is said to have printed 2,000 copies of it.

PLATE 88

The record of the declining woodcut may be closed on a hopeful note. Rembrandt, who, in his single-minded passion for the metal plate, ignored the woodcut, fostered at least one brilliant disciple who made up for the master's indifference. Jan Lievens of Leyden (1607–1674) showed a particular affinity for the medium. He left nine prints altogether, among which the *Cardinal* achieved lasting fame. One can assume that here the artist became totally involved in the work, drawing on the block and cutting directly into it with a freshness and vigor that were soon lost, to be revived again only two centuries later.

Woodcuts as Reproductions

PLATES 90–105

In the meantime the woodcut was to become a reproductive medium, a servant to the masters. The skill of the woodcutter even made it possible to reproduce drawings done with a quill, as in the case of Luca Cambiaso (1527–1585), faithfully imitating the quill strokes in the manner of facsimile reproductions.

PLATE 90

In England John Baptist Jackson (1701–1754) developed chiaroscuro into a multicolor reproductive medium, often using more than ten separate blocks and ink-

PLATE 91

less impressions to approximate the subtle shades of paintings, drawings, and water-colors. He even interpreted murals and sculpture in chiaroscuro. His favorite subjects were the Venetian masters—Veronese, Tintoretto, Titian, and others—but he also tackled Rubens and Rembrandt, not always with felicitous results. His career ended unhappily in London, where he worked on the production of wallpaper.

At this point the survey of the relief print must be enlarged to include the much-abused engraving on end-grain wood. Its vogue started with the Frenchman Jean-Michel Papillon (1698–1776), who claimed credit for its invention. For some time it remained a "poor cousin" of other printing techniques, reserved mostly for deco-rative purposes—vignettes, wallpapers, announcements, advertisements, and so on. As a medium it could hardly compete with the easy elegance of metal engraving.

Later, wood engraving was brought to a state of technical excellence by Thomas Bewick (1753–1828) of Newcastle-upon-Tyne in England. Bewick's most famous works were *A General History of Quadrupeds* (1790) and a two-volume set of *British Land Birds* (1797) and *British Water Birds* (1804), both published in many editions and widely imitated on the Continent and in America.

PLATES 94, 95

COLORPLATES 15–17

PLATES 92, 93

As for the woodcut of this period, chapbooks and broadsides, often gaily colored, became inexpensive folk art. *"Imagerie populaire"* concerned itself with provincial topics of interest, such as historical and political events, religious subjects, illustrations of fact and fiction, and awkwardly funny cartoons. Some of these prints were produced at the Rue St. Jacques in Paris, at Letourmy's shop in Orléans, and by dealers who peddled their wares much in the manner of the Flemish publishers of the fifteenth and sixteenth centuries, or of Currier & Ives in nineteenth-century America.

A modest new start was made at the beginning of the nineteenth century, when a small group of romantically inclined artists felt again attracted by the simplicity and directness of the wood block.

We have a small self-portrait by the great German Romantic Caspar David Friedrich (1774–1840), which he may have cut himself. Most of his other wood blocks

92

93

94

95

90 Luca Cambiaso. *Venus Mourning the Death of Adonis. c. 1560. Woodcut, 10 1/4 × 12". Davidson Art Center, Wesleyan University, Middletown, Conn.*

91 John Baptist Jackson. *The Murder of the Innocents. 1745. Chiaroscuro woodcut, c. 21 × 16". Yale University Art Gallery, New Haven, Conn. (Frederick Benjamin Kaye Memorial Collection)*

92 Anonymous French. *Illustration from Histoire de Robinson Crusoe, published by Martin-Delahaye, Lille, c. 1819. Woodcut. Museum of Fine Arts, Boston*

93 Anonymous American. *Certificate of birth and baptism, printed by William Gunckel, Germantown, Ohio, c. 1830–40. Example inscribed 1836. Woodcut. Brooklyn Museum, New York*

94 Thomas Bewick. *Wild Bull, from* A General History of Quadrupeds, *1790. Wood engraving*

95 Thomas Bewick. *Kingfisher, from* British Water Birds, *1804. Wood engraving*

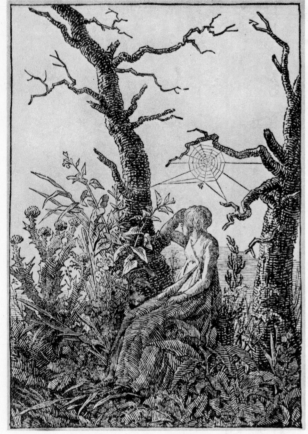

96

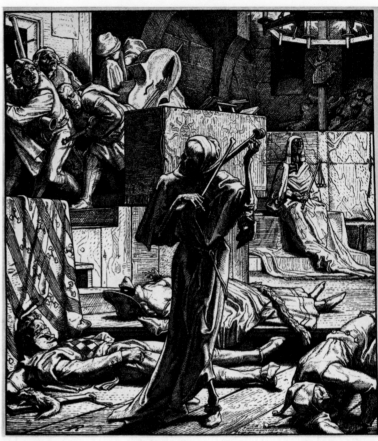

97

THENOT.

COLINET and THENOT.

98

96 *Caspar David Friedrich (cut by Christian Friedrich).*
Melancholie. Before 1840. Woodcut, c. 6 3/4 × 4 3/4".
Metropolitan Museum of Art, New York (Harris Brisbane
Dick Fund, 1927)

97 *Alfred Rethel (cut by Steinbrecher). Death the Destroyer.*
1848. Wood engraving. Philadelphia Museum of Art
(Ars Medica Collection)

98 *William Blake. Illustrations from R. J. Thornton's edition of*
Vergil's Pastorals, London, 1821. Wood engraving.
Museum of Fine Arts, Boston

99 *Adolph von Menzel (1815–1905). Prussian Soldiers in the*
Seven Years' War. Wood engraving, 7 1/2 × 5".
Collection the author

100 *Illustration from G. Doré and B. Jerrold, London, 1872.*
Wood engraving after Gustave Doré. New York Public Library,
Astor, Lenox and Tilden Foundations (Prints Division)

99

100

were probably done by his brother Christian. In their fragility they have a moving *PLATE 96*
poetic quality.

Alfred Rethel (1816–1859), reared in the same period of unrest and revolution, is
best known for his *Totentanz*, a Dance of Death series based on the March rebellion of
1848 in Berlin. Drawn by Rethel for the wood block in the tradition of Dürer, they *PLATE 97*
show a people cajoled, consoled, and mocked by Death. Cut by well-trained profes-
sionals, these prints might be considered the strongest and most influential of that
period and were more than just reproductions.

William Blake (1757–1827), the visionary poet, painter, and engraver, left us
seven small wood engravings for Vergil's *Pastorals*, published in 1821. They are
exquisite and unconventional and make us wish that Blake had tried his hand more *PLATE 98*
often in this medium.

Edward Calvert (1799–1883), Blake's contemporary, was inspired by the Vergil
illustrations and shortly after Blake's death created a series of *Spiritual Designs*, six of
them engraved or cut on wood. Among them were the now-famous *Ploughman*,
The Cyder Feast, and the *Chamber Idyll*. Calvert spoke of wood engraving as "that
most beautiful of all representative arts."

It may be inappropriate in a work devoted to the *art* of the print to dwell too
long on the technical bravura of reproductive wood engraving. Yet it is almost un-
believable that human eyes and hands could have created those engraved repro-
ductions of Grandville's "surrealist" satires, of Adolph von Menzel's pen-and-wash *PLATES 99–102*
drawings, of Schnorr von Carolsfeld's and Gustave Doré's Bible illustrations. Dau-

101

mier's and Manet's drawings were sometimes skillfully adapted for wood engravings and presented as bona fide prints. Corinth and Slevogt in Germany found their conscientious engravers in Bangemann and Hoberg, as Rouault engaged Aubert to translate his drawings into wood engravings for the monumental *Réincarnations du Père Ubu.*

PLATES 103–104

The list of artists who figure mistakenly as printmakers in many art history books is a long one, studded with such illustrious names as Dante Gabriel Rossetti, Sir John Tenniel, and John Everett Millais, who, like our own Winslow Homer, probably never touched a graver. Technical brilliance of engraving cannot conceal the bare fact that the artist had little to do with his print's production, except perhaps to make suggestions while looking over the engraver's shoulder or to scribble notes on the margins of drawings or trial proofs. We know that Menzel was the terror of his engravers. In a few cases the artist apparently drew his design directly on the wood with brush, pen, or pencil, but the spontaneity of cutting and improvising on the block usually got lost in the shuffle.

PLATES 107–152

The Modern Period

It was Paul Gauguin (1848–1903) who helped to make the wood block respectable again through his powerful images of pagan innocence, created during his voluntary

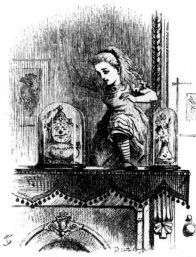

103

102

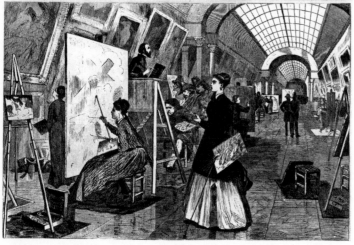

104

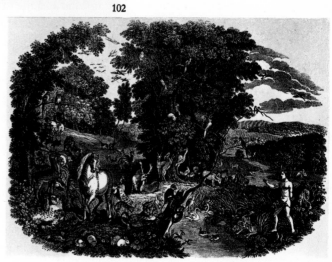

105

101 Physiologie de Buveurs, *after Honoré Daumier (1808–79). Original wood block. Museum of Fine Arts, Boston*

102 Les Amateurs d'estampes, *after Honoré Daumier (1808–79), engraved by F. L. Schmied. Wood engraving. Philadelphia Museum of Art*

103 Illustration from Lewis Carroll, *Through the Looking Glass, after John Tenniel by Dalziel. 1872. Wood engraving, 4 × 3 3/16"*

104 Art Students and Copyists in the Louvre Gallery, Paris, *after Winslow Homer, from* Harper's Weekly, *Jan. 11, 1868. Wood engraving. National Gallery of Art, Washington, D.C. (Rosenwald Collection)*

105 Alexander Anderson (1775–1870). Creation. *Wood engraving. Philadelphia Museum of Art*

PLATES 107, 109

exile in Tahiti and the Marquesas. These prints were hacked, scratched, and scraped out of pieces of tropical wood; they conveyed impressively the somber drama of life in paradise lost. It is disappointing that Gauguin's contemporaries, Van Gogh, Degas, Renoir, and Cézanne, though interested in printmaking, never tried their genius on wood. Manet, Pissarro, and the Millet brothers made some half-hearted attempts, but their work was at best ephemeral.

When Gauguin died, another great and lonely artist, long an admirer of Gauguin's work, had already turned his attention to the wood block. Edvard Munch (1863–1944) of Norway made his first woodcuts about the turn of the century and continued to experiment in this and other graphic media. He was committed to supreme control of a graphic process from conception to final proof. No inter-

COLORPLATE 18

mediary was permitted to interfere; Munch elevated printing by hand to an art in itself. The selection of the proper wood and the accidents of its natural grain played an important part in the total effect of the print. Proofing the blocks in different colors led Munch to the multicolor wood-block print, quite rare at that time. There is a deep mystique in his work which often eludes interpretation. His first woodcut, *Panic*, made in Paris in 1896, carries his own comment (in French) on the first red color proof: "Nature seemed dipped in blood, and men walked like priests." More than any other artist of his time Munch succeeded in lifting the woodcut out of reproductive triviality and allowed it to compete with its more glamorous confreres in the graphic arts.

The wood-block print had a social and political role to play, as well as an aesthetic one. The French Revolution had considerably accelerated the publishing of gazettes. In France no fewer than seven hundred fifty appeared during those eventful years. With the new burst of freedom, Germany soon followed suit, producing sixty newspapers between 1847 and 1850. This period saw the beginning of the satirical magazine and the growing importance of the political cartoon, which often took the

PLATES 106, 108, 110

form of a woodcut or wood engraving. The *Kladderadatsch* in Berlin, the *Kikeriki* in Vienna, *Charivari* in Paris, and *Punch* in London brought the artist to the fore as a political force, attacking, exposing, and ridiculing the sacred cows of the day.

They were followed by many minor publications, *Rive, Le Canard Enchaîné, L'Assiette au Beurre, Fliegende Blätter*, and others; but none of them reached the eminence of the *Simplizissimus*, founded in Munich in 1898 and laid low by Hitler in 1933. Its artistic and literary contributors represent an honor roll of wit and talent; among them were T.T. Heine, Gulbransson, Bruno Paul, Wilke, Pascin, Feininger, and such fine writers as Knut Hamsun and Wedekind.

The political cartoon, which can look back on a glorious past in the hands of Hogarth, Rowlandson, Daumier, and Goya, has been emasculated. The time now seems ripe for a revival such as we see in the political posters produced by students and faculty during the Sorbonne riots in 1968 or in the United States in connection with the campus killings at Kent and Jackson State Universities in 1969. There is so much to be concerned with and relatively little involvement or interest among the important artists of our time, aside from such highlights as the Picasso prints *The Dream and Lie of Franco* and the *Dove of Peace* and his mural *Guernica*.

In France at the turn of the century the woodcut was again cultivated as an enhancement of the pages of great books. Enlightened publishers such as Vollard and Skira commissioned distinguished artists to interpret important literary works. So it

106 *Leopoldo Méndez.* Vision. *1945.*
Wood engraving, 4 × 5". Collection
the author

107 *Paul Gauguin.* Nave, Nave Fenua
(Wonderful Earth). 1893–95. Original
wood block. Museum of Fine Arts,
Boston (bequest of W. G. Russell
Allen)

108 The Power of the Press, *from*
Harper's Weekly, *Nov. 25, 1871.*
Wood engraving (with portrait of Thomas
Nast at upper right). New York
Public Library, Astor, Lenox and Tilden
Foundations (Prints Division)

109 *Paul Gauguin.* Nave, Nave Fenua.
1893–95. Woodcut, 13 5/16 × 8".
Museum of Fine Arts, Boston (bequest
of W. G. Russell Allen)

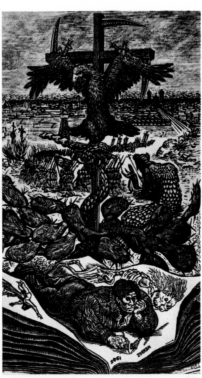

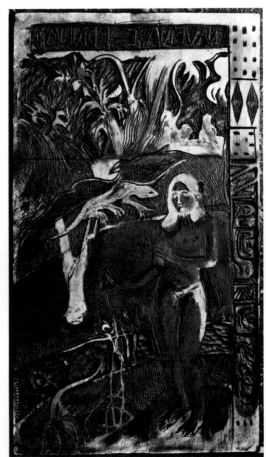

106

107

108

109

PLATES 113, 114

happened that Maillol illustrated Vergil, Ovid, and *Daphnis and Chloë* with woodcuts of classic simplicity. Dufy and Derain used the medium for the poetry of Apollinaire, Jacob, and others. The lightweight woodcuts of Vallotton fall into a special category; unaffected by the school of Paris, they tend to be cartoons, in a simplified Beardsley manner. Rouault and Matisse mainly confined their efforts to etching and lithography; Chagall made only a few woodcuts. Perhaps Picasso's lively and inventive linoleum cuts must fill that gap in the history of the relief media. His cutaway method, deceptively simple, enabled him to make a complicated four-color print from only one plate.

In 1905 a group of maverick artists in Dresden founded Die Brücke (The Bridge), prompted by the urge to counteract the entrenched academicians of the Romantic Realist school and the desire to attract, in the words of the founders, "all revolutionary elements in ferment." Led by Erich Heckel and Karl Schmidt-Rottluff, the group included E. L. Kirchner, Emil Nolde, Max Pechstein, and Otto Müller and lasted for eight full productive years. The main graphic efforts of these artists were devoted to the woodcut, which in their hands became a vigorous and convincing instrument of expression, of a strength which has never been surpassed. Considered shockingly primitive and "Negroid" by the public and later repressed by Hitler as "degenerate," the work of this potent group has survived all fads and fashions. Other devotees of the print—Franz Marc, Max Beckmann, Christian Rohlfs, and Heinrich Campendonk—belonged in spirit to the world of Expressionism and helped to inspire a new enthusiasm for the graphic media, in which the woodcut occupied a place of honor.

PLATES 112, 115–117, 119

PLATE 120
COLORPLATE 19

Two other German artists outside the Brücke group, Käthe Kollwitz (1867–

110 Jacob Landau. The Question. 20th century, n.d. Lithograph, 15 × 20 1/4". Courtesy Pratt Graphics Center, New York

111

111 David Hammons. Injustice Case. 1970. Mixed media, 60 × 40". Los Angeles County Museum of Art (Museum Associates purchase)

1945) and Ernst Barlach (1870–1938), also favored the rugged wood block; they too were singled out for persecution, Kollwitz for her compassion for the downtrodden, Barlach for his sympathy with the Slavic *Untermensch*, despised by Hitler.

The Belgian Frans Masereel (1889–1971), who transformed the woodcut into a silent language in his novels without words, belongs in a class by himself. His work carries the message of a humanitarian ceaselessly fighting for mankind's best—and often lost—causes.

Wassily Kandinsky (1866–1944), born in Moscow, was responsible for starting the Blaue Reiter (Blue Rider) in 1909, a group which in its daring could still be considered avant-garde today. Around him he gathered a group of highly articulate and intellectual artists, reared in the spirit of the Jugendstil (Art Nouveau), who tried

PLATES 118, 121

PLATE 124

112

112 *Ernst Ludwig Kirchner. Bahnhof
Konigstein. 1916. Woodcut, 13 ×
16 5/8". Fogg Art Museum, Harvard
University, Cambridge, Mass.*

113 *Felix Vallotton. L'Averse. 1894.
Woodcut. Brooklyn Museum, New
York*

113

114

115

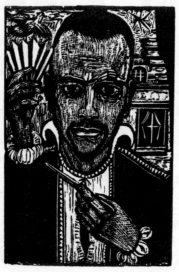

116

117

114 *Raoul Dufy.* Dancing. *1912. Woodcut, 12 5/16 × 12 7/16". Museum of Modern Art, New York*

115 *Max Pechstein.* Exhibition poster for Die Brücke. *1909. Woodcut. Fogg Art Museum, Harvard University, Cambridge, Mass.*

116 *Erich Heckel.* Portrait of Paul Klee. *1956. Woodcut, 15 × 9 7/8". Fogg Art Museum, Harvard University, Cambridge Mass.*

117 *Karl Schmidt-Rottluff.* Girl Before a Mirror. *1914. Woodcut. Philadelphia Museum of Art*

118 Käthe Kollwitz (1867–1945). Death with a Woman. *Woodcut. National Gallery of Art, Washington, D.C. (Rosenwald Collection)*

119 Emil Nolde. Flirtation. 1917. *Woodcut. Philadelphia Museum of Art*

120 Franz Marc (1880–1916). Animals. *Woodcut. National Gallery of Art, Washington, D.C. (Rosenwald Collection)*

118

119

120

121

121 Ernst Barlach. Burial. 1919. Woodcut, 10 1/4 × 14 1/4". Yale University Art Gallery, New Haven, Conn.

to break away from "content" and concentrate on "pure form and color." Among this Munich group were Paul Klee, Lyonel Feininger, Franz Marc (who died in World War I), and Alexei von Jawlensky, artists who exerted a strong influence on future generations through their pedagogical work at the famous Bauhaus in Dessau. Again the woodcut played an important part in the founding years of this group, as many of its publications will show.

 Gerhard Marcks, sculptor and graphic artist born in 1889, who also taught at the Bauhaus, should be mentioned here by virtue of the large *oeuvre* of woodcuts which supplements his Neo-Gothic sculpture. Jean (Hans) Arp (1887–1966), active in the Blaue Reiter and Dada groups, also preferred the woodcut for his pure abstract forms.

 The Dutch artist Maurits Cornelis Escher (1898–1972) used the woodcut to create a unique world of magic *trompe l'oeil* which deceives the eye while exposing it to a series of puzzling optical shocks.

 Russia, cradle of abstract art at the beginning of the twentieth century, has not yet acknowledged her own offspring—pioneers such as Malevich, Lissitzky, Rodchenko, Tatlin, and others now famous in the West for their epoch-making innovations. The artist there is still a servant of the state, conforming rather than performing within an official pattern, faintly reflecting the vitality of a great nation. The *images populaires* of Czarist Russia, broadsides commemorating popular events, find their successors in earthy woodcuts showing the traditional Russian landscape or eulogizing the industrial and political achievements of the socialist state.

 Among the best-known Russian artists of the 1920s one reserves a place of honor for the old master engraver Vladimir A. Favorsky and several of his pupils, A. I. Kravchenko, Fyodor Konstantinov, S. Goncharov, Peter Staronossov, and others.

PLATE 125

PLATE 122

PLATE 126

122

123

124

125

126

122 *Jean (Hans) Arp (1887–1966).* Christ on the Cross. *White-line woodcut. National Gallery of Art, Washington, D.C. (Rosenwald Collection)*

123 *László Moholy-Nagy (1895–1946).* Abstraction. *Woodcut, 5 3/4 × 6 7/8". Yale University Art Gallery, New Haven, Conn. (estate of Katherine S. Dreier)*

124 *Wassily Kandinsky.* Kleine Welten VI. *1922. Woodcut. Fogg Art Museum, Harvard University, Cambridge, Mass.*

125 *Lyonel Feininger.* Gables in Luneberg. *1924. Woodcut, 9 3/4 × 16". Museum of Modern Art, New York (gift of Julia Feininger)*

126 *Maurits Cornelis Escher.* Tetrahedral Planetoid. *1954. Wood engraving. National Gallery of Art, Washington, D.C. (Rosenwald Collection)*

Their appeal, unfortunately, is limited to their own country, although they should have a legitimate claim on international recognition. These fine artists have mastered the wood block with surpassing skill, mostly in an illustrative fashion.

The woodcut still shows traditional strength in the Soviet sphere of influence—in Hungary, Czechoslovakia, Poland, and Yugoslavia, countries with great graphic traditions of their own. Yet most of the eastern European artists have begun to move culturally into the western orbit. Some of their graphics, shown at the Ljubljana Print Biennale in recent years, measure up to and sometimes surpass the quality of work produced in the West.

Printmaking in the Far East today presents a rather confusing picture. It follows more or less European and American trends, with abstract forms prevailing and the fads of the New York school predominating. In Japan something distinctly Japanese, though thoroughly contemporary, has emerged in the woodcuts of Shiko Munakata. His strong, decorative motives, cut vigorously into soft wood, are partly concerned with the archaic imagery of the ancient Orient, partly with the spirit and humor of a new Japan.

Ansei Uchima, now living in New York, shows perhaps the happiest blend of

PLATES 127–130

PLATE 131

127

128

129

127 *Vladimir A. Favorsky. Illustration from Gogol,* Schponka and the Fly, *1931. Wood engraving, 4 3/4 × 4″*

128 *Fyodor D. Konstantinov. Illustration from M. Y. Lermontov,* Mtsyri, *1963. Wood engraving, 6 11/16 × 4 7/8″*

129 *A. I. Kravchenko.* Stradivarius. *c. 1920–30. Wood engraving, 7 × 5 1/4″*

130 *Peter Staronossov. Illustration from P. Kershenzev,* Life of Lenin, *1936. Wood engraving*

the two worlds in abstractions of natural forms, delicately printed in transparent inks. His is a delightfully poetic *haiku* art, creating moods rather than telling stories. Japanese printmakers have once more come into their own, and the honors list of performers is a long one. Large color woodcuts impress with their dash and brilliant technique. Among the best-known practitioners are members of the Yoshida family, Junichiro Sekino, Kunihiro Amano, Kiyoshi Saito, Fumio Kitaoko, Hideo Hagiwara, and Naoko Matsubara (who now lives in Canada).

COLORPLATE 20

The many distinguished contemporary printmakers of Latin-American derivation attest to the long-established tradition of relief printing in that part of the world. European artists, mostly Spanish, moved to Lima in the wake of the Conquest and established workshops and studios, merging Catalonian Gothic forms with those of indigenous Indian art, bastardizing both. The first print shop was opened in 1539 by the Italian Giovanni Paoli in Mexico City. Woodcuts were produced for the glory of the Church and the Spanish throne—and for the ever-popular card games. These mingled strains of influence continued for centuries to produce prints and book illustrations of a distinctive Latin-American flavor.

PLATE 133

The Taller Grafica Popular, founded in Mexico in 1937, carried on the tradition of José Guadalupe Posada (1852–1913), who had made his simple, untutored metal cuts and relief etchings a fighting instrument in Mexico's social revolution. Although he died in 1913, his influence is still strong in the work of Leopoldo Méndez, Alfredo Zalce, and others of the Taller. But it was Orozco, Siqueiros, and Rivera who used the print media for more than passing issues and achieved international acclaim with

PLATES 134, 137

PLATES 106, 138

131 *Shiko Munakata.* Dancers. *1968. Woodcut, 14 × 11 1/2". Collection the author*

132 *Unichi Hiratsuka.* Stone Buddha at Usuki. *20th century. Woodcut. Brooklyn Museum, New York*

EL PURGATORIO ARTISTICO
EN EL QUE YACEN LAS CALAVERAS
De los Artistas y Artesanos.

En este Purgatorio sin segundo Los artistas se ven de todo el mundo.

He aquí el cuadro que nos representa palpablemente lo que es el principio de la vida y lo que es su inexorable fin. —"Hoy por tí y mañana por mí.

 Cobijados están por un sudario
Artesanos y artistas á millares,

 Y es seguro hallarás al que buscares
Por orden singular de abecedario.

AGUSTINILLO EL ALBAÑIL.

Tú fuiste un buen albañil,
Cargaste sobre tus hombros
Los adoves, los escombros
Con dificultades mil.
Pusiste el tejamanil
Con una destreza rara,
Cargaste con tu cuchara
Al pasar á la otra vida,
Y hoy tu cara es convertida
En calavera muy rara.

CARPINTERO DE AFICION.

Tú hiciste muchos primores,
Como fueron malas puertas
Unas torcidas ó tuertas
Y otros malos mostradores,
Pero en fin, tus valedores
Que te quisieron de veras,
Vienen todos con sus ceras
Y muy piadosos á verte,
Que estás por tu infausta suerte
Entre tantas calaveras.

ENCUADERNADOR DE FAMA.

Una biblioteca entera
A un doctor encuadernaste,
Y con él muy bien quedaste
Con obra tan placentera.
Y tu fama por do quiera
Con gran éxito brilló;
Todo el mundo la admiró,
Y en el libro de la muerte
Por la desdichada suerte
Tu calavera se vió.

GRABADOR INTELIGENTE.

Tú serías buen grabador,
Pero toda tu destreza
No te libró de que fueras
A la tumba de cabeza.
Sacude allí la pereza
Y deja de ser lo que antes,
Que aburrías á los marchantes,
Y ahora en tu sepulcro labra
Con buriles elegantes
En tu obsequio una palabra.

BARBERO DE BARRIO.

Muchos prodigios hiciste
Con el pelo y con la barba,
Por eso no sé te escarba
La losa en que sucumbiste.
Algunas cortadas diste
A la gente pasajera,
Mas ahora por tu tontera
Yaces dentro una mortaja,
Con tijeras y navaja
Para tuzar calaveras.

DORADOR IMPERTINENTE.

A los hombres opulentos
Más de mil cuadros doraste
Y en todos muy bien quedaste
Y ellos también muy contentos.
Pero tuviste momentos
De tal torpeza y manera,
Que ninguno lo creyera
Pues hoy tienes en tus manos,
Los asquerosos gusanos
Royendo tu calavera.

FUSTERO ARRINCONADO.

A un hombre muy caporal
Famoso fuste le hiciste,
Pues por tu suerte tuviste
Una madera inmortal.
Así no quedaste mal;
Mas al dar una carrera
En su llegua pajarera
Un golpe mortal se dió,
Por eso te acompañó
A ser cual tú, calavera.

HERRERO SIN FUERZA.

A ti no te irá tan mal
Si estás en el purgatorio,
Porque es muy cierto y notorio
Que tu oficio es congenial.
En la caberna infernal,
No tendrás ningún trastorno
Revisarás en contorno
A todos tus parroquianos,
Y así echarás con tus manos
Las calaveras al horno.

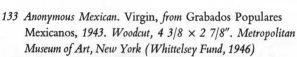

El que quiera imponerse de estos esqueletos
Cinco centavos pagará completos.

134

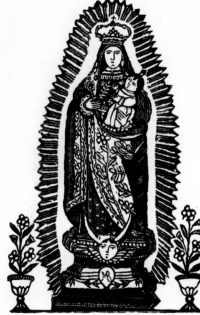

133

133 *Anonymous Mexican.* Virgin, *from* Grabados Populares
 Mexicanos, 1943. *Woodcut, 4 3/8 × 2 7/8″. Metropolitan*
 Museum of Art, New York (Whittelsey Fund, 1946)
134 *José Guadalupe Posada (1852–1913).* Calavera of Artists and
 Artisans. *Metal relief print*

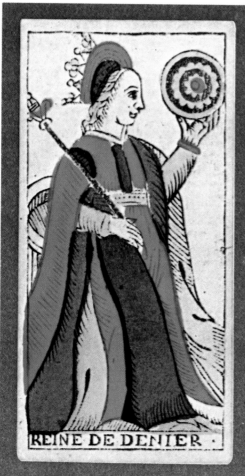

REINE DE DENIER ·

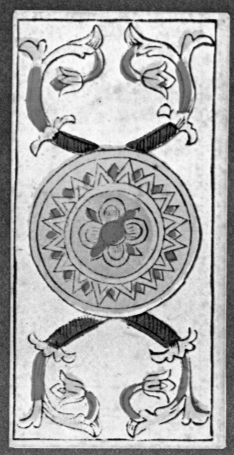

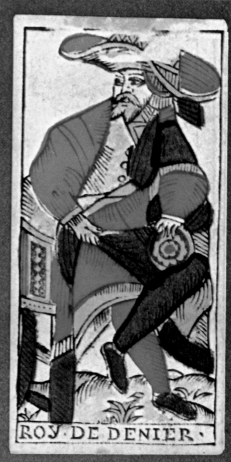

ROY · DE DENIER ·

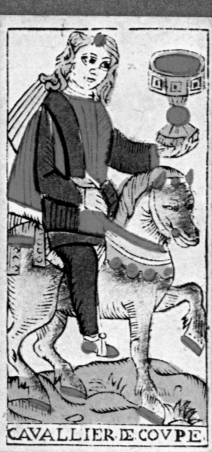

CAVALLIER DE COVPE

*10 Anonymous Swiss. Playing cards. 1745.
Colored woodcuts, each c. 4 3/4 ×
2 3/8". Museum of the Consolidated
Altenburger and Stralsunder Playing Card
Factories, Stuttgart*

VLRICHVS VARNBVLER ZC.M.D.XXII

11 *Anonymous Bavarian.* The Annunciation. *Early 15th century. Colored woodcut, facsimile, 10 1/2 × 7 1/2″. Collection Lord Spencer*

12 *Albrecht Dürer.* Portrait of Ulrich Varnbühler. *1522. Chiaroscuro woodcut, 16 7/8 × 12 5/8″. National Gallery of Art, Washington, D.C. (Rosenwald Collection)*

13 *Albrecht Altdorfer.* The Madonna of Ratisbon. *Early 16th century. Color woodcut. Graphische Sammlung Albertina, Vienna*

12

14

ОХОТНИКЪ МЕДВЕДА КОЛЕТЪ АСАБАКИ ГРЫЗУТЪ

14 Georg Lemberger. St.
Mark, *title page from
Luther's Bible. 1524.
Colored woodcut. Graphische
Sammlung Albertina, Vienna*

15 *Russian popular print. 18th
century. Colored woodcut*

16 *Anonymous French.* La
Liberté, *issued by Jean-
Baptiste Letourmy, Orléans.
Early 19th century. Colored
woodcut. Museum of Fine
Arts, Boston*

17 *Anonymous French.*
Nostradamus, *printed by
Pellerin, Épinal, 1822.
Colored woodcut, facsimile,
15 × 11". Collection the
author*

15

16

17

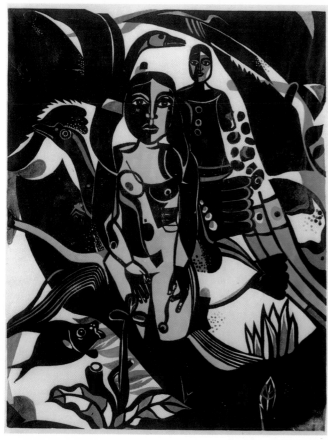

19

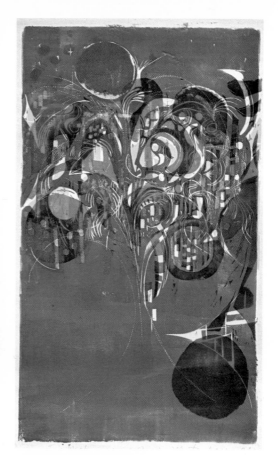

20

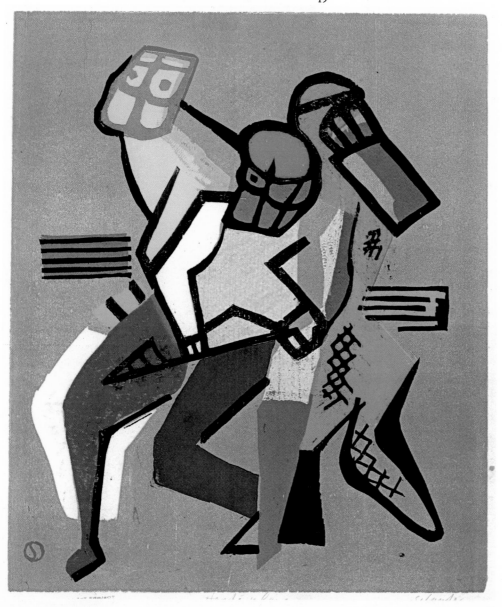

21

18 Edvard Munch (1863–1944). Male
Bather. *Color woodcut, twelve
examples inked by the artist in different
colors. Munch Museum, Oslo*

19 Heinrich Campendonk (1889–1957).
Composition. *Color woodcut.
National Gallery of Art, Washington,
D.C. (Rosenwald Collection)*

20 Naoko Matsubara. Fireworks. 1966.
*Color woodcut, 17 × 10". Collection
the author*

21 Louis Schanker. Hockey Players.
*1930s. Color woodcut, 14 × 13 3/4".
Yale University Art Gallery, New
Haven, Conn. (gift of Mrs. Gertrude
van Allen)*

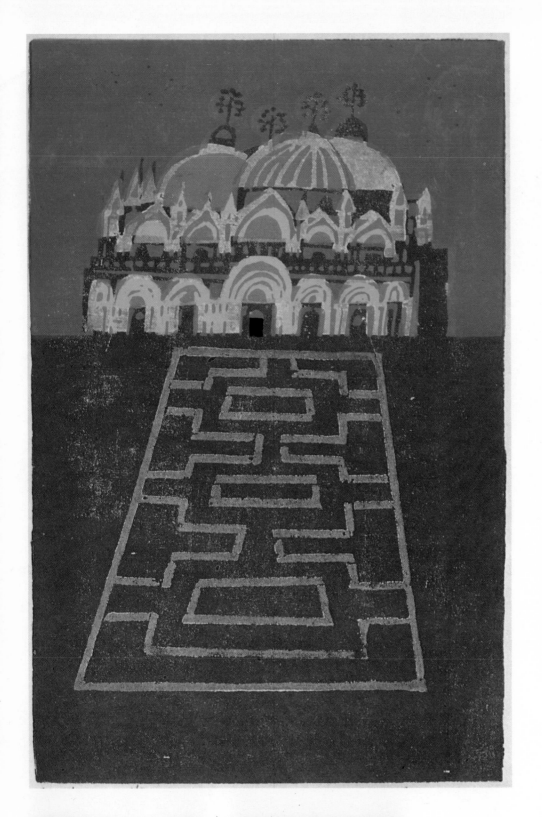
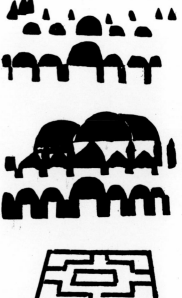

22 Antonio Frasconi. San Marco. 1969. Color woodcut, 9 1/4 × 6″, with progressive proofs 1–5. Courtesy the artist

135 *Lorenzo Homar. Illustration from Ricardo E. Alegría,* Los Renegados, *1962. Wood engraving, 4 5/8 × 2 3/4"*

136 *Jean Charlot. Seated Nude. Woodcut, 5 3/4 × 5".
Metropolitan Museum of Art, New York (gift of Jean Charlot, 1960)*

137 *José Guadalupe Posada (1852–1913).* The Execution of Captain Calapiz. *Relief print. Courtesy Pratt Graphics Center, New York*

138 *Leopoldo Méndez. Illustration from Heine,* Gods in Exile, *1962. Wood engraving, 5 × 4". Courtesy The Castle Press, Pasadena, Calif.*

135

136

137

138

their exciting murals, recounting the turbulent history of Mexico, the end of colonial rule, and the rise to independence.

In North America the woodcut was only rarely used as an instrument of social or political commentary in the early history of the medium. Emphasis was placed on education, both religious and secular, and the woodcut was used to illustrate informational material about the topography and natural resources of the New World. An amateur, John Foster, produced perhaps the first wood blocks in the colonies, among them a portrait of the Reverend Richard Mather (c. 1670). Art was considered by the early settlers to be a luxury, by the Puritans to be sinful. In general, utilitarian motives prevailed in the publication of pictorial material.

PLATE 139

Paul Revere's engraving *The Bloody Massacre* (1770), depicting a pre-Revolutionary episode in Boston, perhaps typifies the rather self-conscious use of the print medium in the colonies. The early wood engravings of the New Yorker Alexander Anderson, about a quarter of a century later, are also amateurish in comparison with the fine work in the same medium of the roughly contemporary Thomas Bewick. In short, the country was not yet ready for a great flowering of printmaking.

PLATE 105

Even the brilliant cartoons of Thomas Nast and the Civil War pictures by Winslow Homer were only incidentally made into prints, executed by professional wood engravers.

PLATE 108

Perhaps printmaking as an independent art received its first powerful impetus during the Great Depression of the 1930s, with the creation of the Federal Arts Project of the W.P.A. Some of the work, on closer scrutiny, may seem to lack imagination and to have a dated look, as art with a "message" will when it has lost its relevance, but fine artists such as Stuart Davis, Arshile Gorky, and Louis Schanker produced prints which heralded new art forms, under government patronage.

COLORPLATE 21

As the United States passed from depression to prosperity, from provincialism to the aspirations of a world power, American art matured and prospered too.

Among the artists who adopted the wood block as their most favored medium, Antonio Frasconi has probably done the most for the propagation of the color woodcut. Coming from Uruguay to the U.S.A. in 1941, he made the woodcut popular and raised hand-printing to an art. The selection of the proper wood, the utilization of its grain and texture, and the skillful use of opaque and transparent inks play an important part in the success of his final prints. He is one of the rare artists totally dedicated to one medium. His woodcuts range from tiny black-and-white miniatures to giant triptychs composed of half a dozen color blocks. He functions successfully as artist, designer, and publisher of a long list of exquisite books.

COLORPLATES 22; 23

Carol Summers has cultivated a new kind of woodcut technique that might be more appropriately called a "rubbing," since the ink is applied to the back of the paper instead of the surface of the block. Treated with a spray of solvents, the print glows with suffused color and is not mirror-reversed as in a conventional print.

COLORPLATE 32

Edmond Casarella's paper cuts established a new variety of relief printing related to the wood block. He works with paper cutouts mounted on wood or cardboard and varnished or sprayed with shellac. It is an extremely economical and adaptable medium, which can be used to great advantage in graphic workshops with economy budgets.

COLORPLATE 30

A revival of engraving on end-grain wood occurred when the artist again discovered in an obsolete medium a most attractive and original means of creative

PLATES 141-146

139

140

139 John Foster. Mr. Richard Mather.
1670/71. Woodcut, 8 × 6". Princeton
University Library, Princeton, N.J.
(Sinclair Hamilton Collection)
140 Milton Avery (1893–1965). The
Dancer. Woodcut, 12 × 9 1/2".
Courtesy Associated American Artists,
New York
141 Rockwell Kent. Northern Light. c.
1928. Wood engraving, 5 7/8 ×
8 1/8". Courtesy Associated American
Artists, New York

141

142

143

142 *Valentin Le Campion. Illustration for Aleksander Pushkin,* The
Captain's Daughter, *1952. Wood engraving, 5 7/8 × 3 7/8".
Collection the author*

143 *Eric Gill. Breitenbach marriage announcement. 1938. Wood
engraving, 2 1/2 × 1 1/2". Collection the author*

144 *Emil Ganso. At the Seashore. 1932. Wood engraving, 8 ×
12". Yale University Art Gallery, New Haven, Conn.
(gift of Mrs. Paul Moore)*

145 *Michael Horen. Illustrations for Marshall Henrichs,* The
Pterodactyl and the Lamb, *1962. Wood engraving; left,
5 3/4 × 4 7/8"; right, 5 1/8 × 4 3/8". Courtesy Pratt
ADLIB Press, New York*

144

expression. This revival started with artists such as H.A. Müller and Walter Rössing in Germany; Imre Reiner in Switzerland; Le Campion in France; John Farleigh, Agnes Miller Parker, Eric Gill, and Buckland Wright in England; Vladimir Favorsky and his disciples in the U.S.S.R.; and Lynd Ward, Clare Leighton, Rockwell Kent, Rudolph Ruzicka, Fritz Eichenberg, and others in the U.S.A.—all using wood engraving mostly for the purpose of book illustrations. It was not until the print in general gained popularity as an independent art medium that wood engraving launched out into a larger format, competing with the ever-growing size of prints in other media.

The American sculptor Leonard Baskin gave new impetus to engraving on wood. His works range from tiny vignettes of insects to the large, scroll-sized cut of the suffering *Man of Peace*, done with the skill of a Renaissance master. Misch Kohn's large and intricate prints of tigers and samurai added new textures and new dimensions to the art of engraving on boxwood.

PLATES 147, 149

PLATE 148

The medium seems to intrigue the more introspective artists of our generation, as witnessed by the prints of Stefan Martin, George Lockwood, James Grashow, J. Hnizdovsky, J. Hubler, E. Mecikalski, and others.

The borderlines between black-line woodcut and white-line engraving, between side grain and end grain, and between the various types of tools appropriate to each medium have become so blurred that even the artists themselves are hard put to give the proper "definition" to their block prints. And it really doesn't matter, except for the inevitable difficulties of classifying prints in exhibitions, collections, and catalogues.

Many substitutes for wood have been found and explored recently. Linoleum used to be the only alternative, soft and crumbly as it is. Now various kinds of

146 *Tranquilo Marangoni. I Picchettini. c. 1950. Wood
engraving, 11 × 9 1/4". Collection the author*

147 *Leonard Baskin.* Children and Still Life. *Wood
engraving. National Gallery of Art, Washington,
D.C. (Rosenwald Collection)*

148 *Misch Kohn.* Barrier. *1954. Wood engraving, 17
1/2 × 27 1/2". Courtesy the artist*

149 *Leonard Baskin.* Death of the Laureate. *1959. Wood
engraving, diameter 11 3/4". Collection the author*

146

varnished cardboard, pressboard, vinyl tiles, plaster and Masonite, Lucite, Plexiglas, and other plastics are used to produce prints by cutting, scratching, scraping, engraving, and even etching into their surfaces.

Of growing interest today is the combination of relief printing, in which the surface of the block or plate is inked, with intaglio printing, in which the depressions are inked. This development, along with the incorporation of "found objects" and of various textures and surfaces, as well as the use of congealing and hardening agents, has produced such specialized forms as the "collagraph" and "collograph," both terms referring to variations on the principle of collage. These techniques are more fully treated and are illustrated in the chapters on intaglio.

If the print has developed into a major contemporary art form, it is largely due to the opening of new frontiers in technique. The introduction of new materials and concepts has led to a blurring of all dividing lines between traditional graphic media. In the relief categories printable surfaces can now be produced in many ways. With new fine gouges one can produce minute lines on side-grain wood; with electric drills one can create pointillistic, lacelike patterns on a piece of maple or pine wood; with plastic materials one can eliminate once and for all the difference between end grain and side grain. With plaster, Lucite, and gesso serving as a surface for all kinds of tools, who is to say what is engraved, what cut, what scratched, and what drilled? And who can prevent an artist from printing his intaglio plates in relief, or vice versa?

What makes the result art is that mysterious essence which can be neither bought nor produced synthetically. Too many restrictive rules about what constitutes a print can hamper the artist in his search for new ways of expression; yet complete removal of all restrictions might effectively eliminate the original print altogether.

147

148

149

150

151

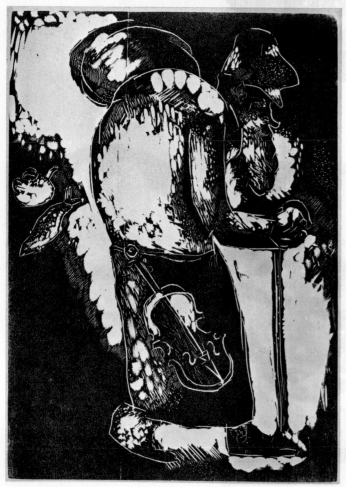

150 *Max Weber. Things. 1960. Woodcut, 5 × 6". Courtesy Pratt ADLIB Press, New York*

151 *Pablo Picasso. Buste de Femme. 1905/06. Woodcut, 8 3/4 × 5 3/8". National Gallery of Art, Washington, D.C. (Rosenwald Collection)*

152 *Marc Chagall. Beggar with Violin. 1924. Woodcut, 11 × 7 15/16". Museum of Modern Art, New York (Larry Aldrich Fund)*

152

CHAPTER 6

THE RELIEF PRINT

TECHNIQUE

Perhaps it is idle to speculate on the methods by which early wood blocks were printed. The experts are divided. Some suspect that the inked block was laid down on a hard surface and that the paper, perhaps dampened, was put on top and forced into contact by hammering, rolling, beating, or rubbing with suitable instruments. Others insist that the paper was put down first and the inked block pressed upon it by hand, with as much force as a body could muster. A third opinion is that there may have been some primitive presses before Gutenberg, which supplemented the muscle power. Whatever the method, it is the result that counts. It is significant that some printmakers in the present age of technology still prefer to pull their prints by rubbing the back of the paper with a spoon. Max Weber is known to have printed some of his small color woodcuts, cut into cigar-box wood with a penknife, in a singularly primitive way. He put the inked block on the floor, placed a piece of paper and the New York telephone book on top, and, jumping up and down on it vigorously, came up with just the kind of print he desired.

COLORPLATE 23

Wood has a texture that shows its provenance, its age, and its character. It is a living organic growth, nourished by the earth, sun, and air—qualities that are lacking in metal, stone, or synthetic materials.

Woodcutters, wood engravers, wood carvers are people with a special affinity for the characteristic qualities of their material—a bond that usually lasts through a *PLATE 153* lifetime. This author speaks with conviction because his infatuation with wood has continued undiminished all through his adult life. To handle a beautiful piece of wood is sheer sensual delight, to cut into its surface a never-ending adventure, to search for its hidden qualities always exciting.

Woodcuts

The woodcutting process itself is utterly simple; it requires no press, no large work space, no expensive tools, no chemistry, no fancy equipment. There are as many approaches to the wood block as there are to any other object of one's love.

First in importance is the selection of the proper wood—cut side-grain, that is, lengthwise, from the plank. It should be straight, its surface well finished, if lines are the important thing. It may have the grain you desire or no visible grain at all. It may also be weathered, crooked, or full of knots or wormholes, if the resulting effects fit into your design. If you use a printing press, the block must be level and type-high. If you print by hand, spoon, or baren, it can be warped or as thin as plywood. If you want soft wood, easy to cut, you might choose poplar, linden, or white pine, especially if wood texture is desirable. Slightly harder are sycamore, pear, apple, and cherry, and harder still, maple or mahogany. Well-seasoned pearwood, often used by the great woodcutters of the past, is evenly grained, can be cut in any direction, and will produce very fine lines without breaking. If you look for unusual textures and are willing to experiment, you may discover some more unorthodox material on which to break your tool.

Woodcutting is a battle between steel and wood. The weapons you choose are of major importance. You may prefer the sharp edge of a knife, which cuts away at either side of a black line or area; or you may find it easier to cut a white line with a V- or U- shaped gouge. In either case your weapons had better be razor-sharp or you will fail. For sharpening hard steel, use an Arkansas oilstone; for softer metals a

153 Fritz Eichenberg. The Night Watch. 1962. Woodcut, 13 × 13". Collection the author

special whetstone that will not spoil the temper. Larger white areas may be chipped away with a chisel and mallet or a routing tool.

Having prepared your surface and your tools, you may prefer to make a careful drawing on tracing paper and then transfer it, upside down, with carbon or graphite paper onto the wood block. Or you may want to draw directly on the block with charcoal, crayon, or brush and ink. Or perhaps you are so sure of yourself that you assail the wood spontaneously with your tool and take your chances. You may prefer to work on the natural color of the wood, or you may darken it slightly with printer's or India ink in order to see more clearly every stroke you make—light against dark.

Fix your block in a firm and convenient position by nailing or gluing some wooden braces on your workbench to prevent it from slipping; this is especially important when you are using chisel and mallet. Now you cut (watching out for your left hand and keeping Band-aids ready), pulling toward you with the knife, and taking care not to undercut your lines, or pushing away from you if you use gouge or chisel.

Today gouges come in all sizes, down to the finest V-shaped ones, which can produce a hairline as thin as any graver could make it. If you want to create some extraordinary patterns and textures which neither knife nor gouge can produce, go to a hardware store and you will find rasps, files, cookie wheels, sandpaper, wire netting, punches, and nails with which you can attack the wood. You might also want to try an electric drill with different bits, but be careful that it does not run away from you.

Your cutting finished, you want to pull your first proof. Have a piece of strong glass, metal, or plastic handy on which to spread your ink with a brayer, which may be made of rubber or composition material, depending on whether you want it hard or soft. Test the ink first to see that it has the quality you want, which may vary from mat to glossy. Avoid over-inking because this will obscure the texture of the wood; do not under-ink, because you want to show the full strength of your design.

Choose your paper carefully. If you want it to be absorbent and not too textured, you will probably select an unsized paper, most likely one of Japanese origin, made of durable mulberry fiber. The Japanese papers come in many varieties, textures, weights, and colors, and are often misleadingly called "rice paper."

Now you ink your block evenly with the brayer, after having made sure that no chips are left on it which could get into the ink and spoil the block and the print. Do not overload your brayer.

Place your block on a piece of cardboard on which you have marked the margin you desire, lower the paper within the marked lines, and rub the back patiently, inch by inch, with a spoon, baren, or any other smooth, flat instrument. Lift the paper around the margins from time to time to see whether every line and area has printed clearly and cleanly. When it has done so, lift the paper off completely, and your first "artist's proof" is done. Mark your first satisfactory print "Artist's Proof." If you decide that corrections or additions are needed, wipe the block clean and dry, without flooding it with solvent, in order to preserve the whiteness of your cuts; this makes later corrections easier.

For color prints transfers of wet proofs are made from the first to successive blocks, one for each additional color. Two unobtrusive pinholes can be made into the first, or key, block and then transferred from that to the others so as to guide the registration of one color on top of another as the artist inserts a pin through the paper and into the hole before each printing. (There are several other methods of registering color, such as leaving raised corners on the block, as in Ukiyo-e printing.) If the separation of color areas is distinct, two or more colors may be printed from one block; the colors are inked on separately by dabbing, by using small rollers, or by using stencils for each area.

Stencils can also be used for coloring prints by hand, a method frowned upon by contemporary experts, curators, and juries, who maintain that no print can be hand-colored exactly like another, and uniformity is judged important in ordering prints from the artist for sale in the galleries or to collectors. Collecting prints does not equate with collecting stamps, where the slightest variation in the printing shoots the value of a stamp sky high, but to this observer it seems that variety is not only the spice of life but also an essential part of an artist's creative freedom.

We could consider ourselves lucky, indeed, if the quality of well-seasoned wood available to Dürer and Cranach were still obtainable. Many of the old blocks have

survived the centuries in superb condition. The same holds true if we examine the old tools of hand-forged iron and steel, which could outlast a lifetime of use. Not even the shape of the tools has changed substantially. For the woodcutter the traditional straight-edged, slanted blade set into a convenient wooden handle is still used by printmakers from Japan to Germany to the U.S.A.—and so is the engraver's burin, a steel rod with a sharp-pointed lozenge tip, a tool adopted from the gem cutters and goldsmiths of ancient times. For these, and for the chisels used to clear away larger areas, no satisfactory substitutes have yet been found—unless one prefers the electric drill, with its risks caused by speed and vibration.

By the same qualitative evidence the early prints would hardly have weathered centuries of physical abuse and climatic change had they been printed on today's chemically polluted papers. Even the rather simple formula of oak or iron gall, lampblack, or carbon, mixed with certain oils, used for printing ink centuries ago, seems to produce more brilliance and permanence than most of our all-purpose modern inks will. This fact becomes strikingly evident when we examine mint copies of Dürer's, Cranach's, or Holbein's prints.

154

154 Wood engraving tools, illustration from Gilks, The Art of Wood Engraving, *London, 1881*

Wood Engravings

PLATES 154–157

Engraving on cross-grain (end-grain) hardwood may have been practiced long before Thomas Bewick, commonly proclaimed "Father of Wood Engraving," made it popular. J.B.M. Papillon, in his *Traité historique et pratique de la gravure en bois* (1766), mentions a frontispiece in a Dutch book of 1729, done in white-line engraving on end-grain wood. Arthur M. Hind, in his work on the history of woodcut, refers to an Armenian wood engraving in a book entitled *Agathangelos*, printed in Constantinople as early as 1709. It is, of course, possible that this technique was practiced even before that date, with images cut in relief on some rather soft metal and printed from the surface like a woodcut in the manner of the fifteenth-century dotted prints.

The wood engraver differs in temperament, it seems, from a woodcutter. The work is more demanding and more detailed, requiring more concentration and deliberation. Less spontaneous than woodcutting, it invites contemplation and a craftsman's skill and patience.

The wood engraver's tools, gravers, and burins are roughly divided into PLATE 154 straight-line tools, multiple-line tools, elliptic tint tools, and square and round scorpers. They come with many different points and in various widths, depending on their purpose, and have to be sharpened and handled with extreme care in order to keep them in top condition.

The advantages of working with engraving tools on a smooth surface are obvious to artists with a penchant for detail. The fine point of a burin allows the creation of an infinite variety of textures, composed of a multitude of dots, lines, and jabs. The tool digs in and produces a white line shallow enough to allow the graver to glide easily through the wood but deep enough not to fill in when inked and printed. This is the essence of the white-line engraving, exemplified in an early wood block by Urs Graf, the famous *Unterwalden Standardbearer* of 1521.

There is not a great selection of woods to choose from. The boxwood commonly used in eighteenth- and nineteenth-century wood engravings came from Turkey, whence it was imported in shiploads. It takes its time to cure, ideally from four to seven years to make it warp-proof. Since boxwood grows slowly and never to a

large circumference, most pieces larger than 3 to 4 inches are made from small sections glued together (or, better yet, doweled) tightly, then sanded and polished to an ivory-like surface most agreeable to the touch of the hand and the bite of the tool.

Nowadays, with the demand for boxwood dwindling to insignificant proportions, sources have shrunk too. Whatever is now available is most likely to come from the Balkans or some Central American country and, being seasoned in a kiln rather than allowed to age naturally, is more apt to warp and split. Although not entirely satisfactory, end-grain maple, which is not so close-grained, is used as a substitute. The number of proofs that can be pulled from a good boxwood block is almost unlimited. The work of Thomas Bewick often went through dozens of editions, and he testified to well over 900,000 impressions from blocks then still in sound condition. Bewick perfected the difficult printing of fine lines by lowering their level slightly with gentle abrasives. His blocks, dispersed and occasionally turning up at auctions, are still being printed for and by collectors.

In the heyday of commercial reproductive wood engraving, before the introduction of photoengraving at the turn of the century, larger blocks, the size of a double spread in *Harper's Weekly*, were bolted together with long wooden screws in order to guard against cracks or splits. Quite often, in the case of an assignment with a rush deadline, several xylographers would work on one subject by sharing sections of the block among them. Since the artist's drawings were transferred meticulously, either by pasting them onto the block or by tracing, the engraver's work was more or less mechanical.

The transferring of the design to the block depends on the artist's inclination. If the artist is also the engraver, he may prefer to make only the roughest sketch directly on the block with brush or pencil and to let the wood inspire his strokes; he may even want to sail right into the wood, without a transferred design, to preserve the greatest amount of freedom of action. Some engravers apply to the block a thin coating of lead white mixed with gummed water, which, when dry, facilitates drawing directly on the block. Others may cut through a drawing pasted onto the block in the traditional Japanese manner or may trace a drawing onto the block with carbon paper. Engraving done on a block darkened with a thin layer of black printing ink will

PLATES 155, 156

155 *Fritz Eichenberg. Illustration for Dostoevski,* The Grand Inquisitor. *1948. Drawing, 5 3/4 × 9″. Collection the author*

156 *Fritz Eichenberg. Illustration for Dostoevski,* The Grand Inquisitor. *1948. Wood engraving, 5 3/4 × 9″. Collection the author*

155

156

show up more clearly as white lines on black, making it less necessary to check the progress of the work by pulling frequent trial proofs.

Prints or drawings can also be transferred by coating them with a thin gum solution, putting them face down on the block, then dampening the paper and peeling it off, leaving the lines on the block's surface. This method may have been used as early as the fifteenth century to make several copies from the same wood block. Senefelder certainly used it in the 1790s in his experiments on the lithographic stone (see Chapter 13). It is even possible to make a photographic transfer by sensitizing the surface of the block.

The block with your design is now ready to be tackled. Place it on a pivot, either the traditional circular, sand-filled leather bag or a heavy book safely wrapped in paper, so that the block will easily turn and swivel when your tool describes curved and weaving lines. This device also keeps your left hand safely out of your tool's range, should it accidentally slip.

There are many ways of holding a tool and of determining its angle in relation to the block's surface. Naturally the slant should not be so shallow that the tool will slip out of its groove, nor so steep as to prevent it from moving forward. Aside from that, the holding of the tool depends entirely on the anatomy of the artist's hand and his feeling of ease and comfort in creating a line. The direction of the graver is away from the body, and the block rather than the tool is turned in anticipation of its direction. An electric drill can be used to clear larger areas, and also to create textures not unlike aquatint (by skipping the drill over the surface).

With a brush the block is cleaned of all its chips; the inking is done carefully with a tacky ink, first spread on a slab to the desired consistency, then rolled on the block sparingly, to avoid over-inking and the filling in of the white lines.

For hand printing it is advisable to use a texture-free, fairly thin, sized paper, such as Japanese vellum, *shizuoko, hōsho*, or others, which come in different weights from tissue-thin to fairly heavy but are transparent enough to show the effect of the rubbing or burnishing before the print is lifted off the block. For printing in a press one can use heavier, opaque paper, such as the British Basingwerk, which is smooth and sized but less interesting than Japanese papers.

Several artist's proofs may be desirable, and corrections may be made accordingly before the final *bon à tirer*; the block should be wiped dry and not washed, so as to preserve the white lines for easier corrections.

Dotted Prints (Schrotblätter, Manière Criblée)

The arts of the goldsmith, the gunsmith, and the harness maker were highly respected in the Middle Ages, when a decorated sword or breastplate, a necklace, or a ring was the outward sign of rank and affluence. For a short while during the latter half of the fifteenth century some printmakers experimented with metal plates, perhaps to produce a relief printing surface more durable than wood.

PLATES 158, 159

Their "dotted prints" were engravings on copper or brass, and perhaps also on pewter or bronze plates, decorated with a variety of the ornamental punches used by goldsmiths and bookbinders, and printed from the surface like a relief block. This short-lived process, resembling closely white-line wood engraving, produced a mere handful of prints of extraordinary beauty and richness in pattern and design. The thin metal plates were mounted on wood blocks to be printed in a press with type. Among

PLATE 160

the best-known of these rare prints are the *Calvary* (or *Three Crosses*), identified by a heraldic workshop mark and thus ascribed to the so-called Master of the Clubs; a *St. Jerome*, a *St. Christopher*, a *St. Barbara*, a *St. Roch*, and several Madonnas; as well as a series of twelve called *The Oxford Passion*. Most of them were probably produced in Cologne during the last third of the fifteenth century.

The dots on the metal surface resembled indentations made by tiny pellets and probably gave those prints their German name, derived from *schrot*, meaning small shot used in fowl shooting. One could speculate that the metal did not hold up so well as wood in the press or in the rubbing; otherwise such an attractive method of printmaking would not have been discarded so quickly, never to be revived again.

In this same period "paste prints" were produced and also disappeared in a short while. Some of the dotted metal plates were pressed face down into a doughlike substance spread on paper, often covered with thin gold leaf or other decorative textures, thus creating a built-up relief image after it hardened.

Only a few hundred examples of these fragile prints have been preserved—multiples in relief—perhaps intended for liturgical purposes or votive offerings in lieu of paintings.

Linoleum Cuts

Long used as an elementary and inexpensive print medium in primary schools and arts and crafts workshops, or in places where proper wood is difficult to obtain, the linoleum cut has been ennobled by Picasso's inventive use of the long-abused material. He demonstrated what a superior artist can do with any medium, be it ever so humble. He used an imaginative elimination method, in turn cutting away and printing in rapid stages from the same block until the multicolored edition was completed. To a small degree this maligned medium has been adopted successfully by other contemporary printmakers.

Metal Relief Prints

No survey of the relief media would be complete without the inclusion of relief etching on zinc or copper. There is an ancestor, the metal cut, which goes back to the ancient *Schrotblatt*. The early prints in the dotted style could, of course, also be printed in intaglio. For that matter, any relief print could be printed without any trouble in intaglio, a fact which may cause some confusion among the uninitiated. The simple fact is that relief printing always means that printing is done from the raised surface area of the block, with cut-away parts left white on the print; whereas intaglio is printed by rubbing ink into the incised or recessed areas, with the raised surface cleaned off to show as white on the print, which is produced on dampened paper in an etching press.

William Blake possibly conceived of relief etching as a laborsaving device, supposedly through the spiritualist intervention of his deceased brother, Robert. Following Robert's mystical yet practical advice, Blake drew his design with varnish on copper and etched the rest away. Thus the *Songs of Innocence and Experience* (1794), *Tyger, Tyger*, and other small and beautiful books came into being, printed page by page on a hand press and laboriously colored by hand. To Blake they were financial failures; to us they are priceless treasures in great collections. However, not much was

OPPOSITE PAGE:
157 Max Ernst. Illustration from Une Semaine de Bonté, ou les sept Éléments capitaux, *Paris, 1934. Collage of wood engravings from various sources*

COLORPLATE 24

PLATE 161

COLORPLATE 27
PLATE 162

COLORPLATE 25

158

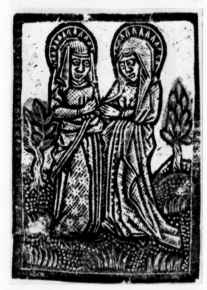

159

158 *Anonymous German. The Expulsion.*
c. 1460–80. Colored dotted metalcut, c.
2 × 1 1/2". National Gallery of
Art, Washington, D.C. (Rosenwald
Collection)

159 *Anonymous German. The Visitation.*
c. 1460–80. Dotted metalcut, c. 2 ×
1 1/2". National Gallery of Art,
Washington, D.C. (Rosenwald Collection)

160 *Anonymous Netherlandish. The*
Crucifixion. c. 1480. Colored dotted
metalcut, 9 1/2 × 7". National Gallery
of Art, Washington, D.C. (Rosenwald
Collection)

160

made of Blake's technique by other artists at the time, perhaps because it looked to them too primitive.

Perhaps S. W. Hayter must be credited with picking up this medium where Blake left off over a century earlier. In his Atelier 17 in Paris Hayter began to experiment with relief etching along the lines followed by Blake. Miró, Peterdi, Hayter, and others in his group produced a few interesting relief prints on copper. They discovered how Blake inked his shallow etchings by offsetting them onto another inked plate, from which he then printed. Hayter also began printing intaglio and relief from the same plate, a process which he perfected in later years.

161 *Pablo Picasso*. Picador. 1959. *Linoleum cut, 20 7/8 × 25 1/4". National Gallery of Art, Washington, D.C. (Rosenwald Collection)*

162 *Walter Brudi (cut by Erwin Roth). Windmill. 1967. Linoleum engraving, 4 1/8 × 3 11/16". Courtesy Institut für Buchgestattung, Stuttgart*

The Swiss artist Max Hunziker adopted the medium for his own purposes, most successfully in his illustrations for *Simplicius Simplicissimus*. By using aquatint dust and acid resist applied with a brush to zinc plates, and having these deep-etched by a team of experienced photoengravers, he succeeded in producing plates etched deeply enough to be printed together with the type in a flatbed press. The results were exemplary but, surprisingly, did not find many imitators, except in the graphic workshops of some schools and colleges. It is a medium most suitable for giving artists complete control over an edition of their work, from the original conception to the final printing, very much in the manner of Blake. This method has been used successfully in experimental print shops such as the Pratt Adlib Press, student-controlled and faculty-supervised, which was started by this writer in 1953.

Examples will show that the metal relief print, like the woodcut or wood engraving, is the perfect partner for a good type face in the production of fine books.

It would be sad, indeed, if the inventiveness and imagination of an artist were stopped by technical limitations and artificial restrictions. New ideas are sprouting in workshops and universities such as MIT, where artists, scientists, and engineers experiment together and often come up with fresh ideas which may lead to new dimensions in printmaking.

The conventional use of wood and metal has yielded with time to the preparation of relief plates or blocks in many other materials. In addition to the linoleum medium discussed above, paper, stone, rubber, plaster, and a variety of synthetics, as well as "found" materials and ready-made textures, have been effectively adopted at the borderline where relief meets intaglio.

COLORPLATE 26

PLATES 163–165

163

164

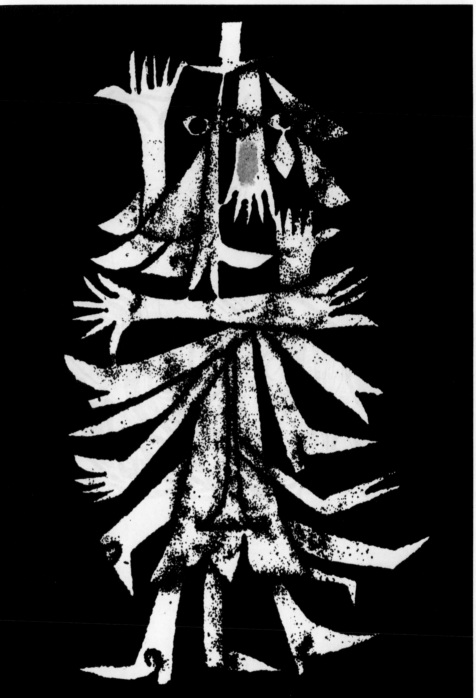

165

163 *Mungituk (contemporary Eskimo). Man Carried to the Moon.* Stone relief
print. *Brooklyn Museum, New York*

164 *Diter Rot. Prints from Bok 4a. 1961. Rubber cuts, surprinted units, 15 3/4 ×
11". Collection the author*

165 *Yasuhide Kobashi. Man in a Flurry. 1958. Cardboard cut, 9 1/8 × 6 9/16".
Collection the author*

CHAPTER 7

NOTES ON RELIEF MEDIA

BY PROMINENT PRINTMAKERS

In this chapter and those similar to it, following the general historical and technical discussions of each of the major print categories, several artists of widely differing points of view have contributed comments on their favorite media and studio methods in their own words or in those of their close associates. (Translations by the author.)

FRANS MASEREEL
My Woodcuts

PLATE 166

When I started working on wood, I used end-grain boxwood, which I engraved with a burin. Later I never used anything but pearwood (plank), which I cut with a gouge. I have always sought to simplify my work, both in technique and expression, summing it up in black and white without the intermediate grays. Woodcutting is not painting!

I proceed in the following way: after having made a sketch or India-ink drawing, more or less precise, I "decalque" (transfer) the sketch onto the wood and redesign it in reverse, roughly, with the help of a mirror. Finally I cut the wood with gouges. In the end it is the tool that corrects, transforms, and finishes the work. When the cutting is finished, I pull a trial proof, which will permit me to proceed with the

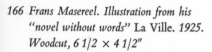

166 Frans Masereel. Illustration from his "novel without words" La Ville. 1925. Woodcut, 6 1/2 × 4 1/2"

166

eventual corrections. That done, I pull my proofs in a print shop with the aid of a professional printer.

[NOTE: Translated from a letter sent to the author shortly before Masereel's death in 1971.]

H.A.P. GRIESHABER
Notes on My Woodcuts

The woodcutter with his knife is like a farmer with his plow, like a gardener with his spade, like a butcher with his cleaver, protected in his actions by the law of his *métier*. This law does not permit boundless, irresponsible adventures.

COLORPLATE 28

Marvelous tools exist for cutting in wood: gravers made of Ruban steel, with which xylographers used to cut around the finest lines on end-grain blocks; V- and U-shaped gouges for side-grain, which helped the Expressionists to indulge their impetuousness; and punches and rasps for more subtle effects in printmaking.

In the beginning my knife was my agony. I had no money for expensive tools, but since I worked in a machine shop, I was able to hone a steel spring into a blade, which I jammed between two pieces of wood. I still use this knife, which accidentally looks like the kind that the early woodcutters used in the Middle Ages. It adapts itself just as easily to a line cut in the manner of the incunabula as to a flat style of cutting large figures. My knife has always been faithful to me—cutting neither too coarsely nor too finely, but just right, obeying my own plowing method.

The wood I use has been, *faut de mieux*, always whatever fell into my hands: old doors, headboards, dressers, barn doors. Walnut is real holiday wood. While you cut, it permeates you with its sweet smell. The grain is long and even, the cut decisive. Alas, walnut was used for gunstocks, and all of a sudden it disappeared. The formcutter of the fourteenth century loved pear and apple trees. The *Biblia Pauperum* was cut into pear. Sometimes I seem to discover Gothic folds in the texture of pearwood.

Perhaps I was fortunate in not always being able to find perfect wood, but more often using the unvalued beech planks from the Alpine meadows or pinewood from the Black Forest. Once a storm dropped an ash tree in my lap, so to speak. For a long time I dug into its iron-hard wood (mostly used for ax handles and cartwheels). At that time flat areas appeared for the first time among my Gothic folds, perhaps out of laziness! Once you adjust to your limitations, you learn to do with less and less, in a mixture of pride and stubbornness.

Paper never bothered me. I took what I found. Once I printed whole block books on filter paper from a hospital. If the paper was too brittle, more ink or pressure came to the rescue. Even wrapping paper can look like old silk if you know how to treat it. Of course, the art market insists on handmade paper, on centering the print on it nicely, in a convenient format. In general the print is expected to look as valuable as a stock-market certificate. Ironically, the paper used by artists of Die Brücke, today of highest value, was at the time the cheapest paper the Expressionists could find in Dresden.

The poor artist looks for white elephants, remnants on the shelf. Accidents in printing may lead to new discoveries; lifting the sheet of paper off the block often reveals encouraging surprises.

My press is old. You see these old relics everywhere. They belong to the period

of oil lamps, sewing machines with foot pedals, and easels for painters. It always delights people who visit my workshop; they consider it an asset!

[NOTE: Adapted from *Genesis of a Woodcut*, a catalogue of a Grieshaber exhibition arranged by the German Art Council (*Deutscher Kunstrat*) in Latin America in 1966. The catalogue shows Grieshaber at work in a series of fascinating photographs: The first shows him as a giant with a tape measure, dwarfed by an enormous tree trunk, which he surveys for a proper slice to be used for one of his oversized woodcut murals. Then he is shown sketching on his entrance door a design, which he later transfers to a more manageable wood block. The block is darkened first, then attacked with a heavy mat knife, which makes fine slashes and incisions; the larger areas are chipped out with a mallet and chisel. The block is inked and put into the ancient flat-bed press, made by G. Sigl, Berlin und Wien, 1880, and still going strong. It takes a strong man to pull the lever that applies the pressure, but H.A.P. is equal to it. What the press misses is finished by a little spoon rubbed on the back of the paper, and "that's all there is to it," Grieshaber says.]

ANSEI UCHIMA
My Use of Japanese Woodcut Techniques

I started making woodcuts in Japan about 1945, learning the Japanese method of printing with watercolors. In my recent work I employ a technique traditionally called *bokashi*, which provides dark-to-light color gradations such as those seen in the landscape prints of Hokusai and Hiroshige and in many other Ukiyo-e prints.

COLORPLATE 31

My basic materials are as follows: I use 1.4-inch blocks faced with birch on both sides. They are carved on both sides and are well sandpapered before and after cutting. My pigments are Winsor and Newton gouache or opaque watercolors, plus *sumi* paste (black) and stick *sumi* ink, all water-soluble. The brushes with which I apply the watercolors to the blocks are made of horsehair and generally shaped like shoe brushes. I use about twenty brushes in assorted sizes and break them in when they are first purchased; the hairs are singed around the edges over a candle flame and then rubbed vigorously across stretched sharkskin in order to soften and split the tips.

My paper, similar to that used in Ukiyo-e prints, is *kizuki-bosho*, a handmade mulberry paper imported directly from Fukui, Japan. This paper is sized on both sides before it is sent to me.

All printing is done by hand with two Japanese barens—medium and fine. The bamboo sheath covering the baren is replaced when worn out, usually once every two months. I use Japanese cutting tools (knife, several gouges, and a couple of chisels). Since these blades are of laminated iron and steel and are softer than Carborundum, Japanese stones are used for sharpening, and water is used instead of oil lubricants.

The design is sketched with pencil directly onto the block. In order to avoid a reversed image, I first make a small sketch on tracing paper and then view the design from the back, using it as a guide for the sketch on the block. The first block is completely finished before the second is started. Tracing paper is then placed over the first block, aligned carefully with the bottom corner and bottom edge of the block, and the outlines cut on the first block are traced in pencil. The areas to be cut on the second block are then marked on the tracing paper and transferred by means of carbon paper to a second block of the exact size of the first block.

24

From Camberwell to Highgate where the mighty Thames shudders along.
Where Los's Furnaces stand, where Jerusalem & Vala howl:
Luvah tore forth from Albions Loins, in fibrous veins, in rivers
Of blood over Europe: a Vegetating Root in grinding pain.
Animating the Dragon Temples, soon to become that Holy Fiend
The Wicker Man of Scandinavia in which cruelly consumed
The Captives reard to heaven howl in flames among the stars
Loud the cries of War on the Rhine, & Danube, with Albions Sons.
Away from Beulahs hills & vales break forth the Souls of the Dead.
With cymbal, trumpet, clarion; & the scythed chariots of Britain.

And the Veil of Vala, is composed of the Spectres of the Dead.

Hark! the mingling cries of Luvah with the Sons of Albion.
Hark! & Record the terrible wonder! that the Punisher
Mingles with his Victims Spectre, enslaved & tormented
To him whom he has murderd, bound in vengeance & enmity
Shudder not, but Write, & the hand of God will assist you!
Therefore I write Albions last words. Hope is banishd from me.

24 *Anonymous German.* St. George. *Last quarter of 15th
century. Paste print with flock, facsimile, 10 1/4 ×
7 1/2". Collection the author*

25 *William Blake. Illustration from his* Jerusalem, *1804–
18. Colored relief etching. New York Public Library,
Astor, Lenox and Tilden Foundations*

26

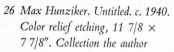

26 *Max Hunziker. Untitled. c. 1940.*
Color relief etching, 11 7/8 ×
7 7/8". Collection the author

27 *Joseph Low. Queen Anne. c. 1945.*
Color linoleum cut, 6 1/2 × 5 1/8".
Collection the author

28 *H. A. P. Grieshaber.* Death and the
Artist, *from his* Totentanz von
Basel, Dresden, 1966. *Color woodcut,*
17 3/4 × 13 3/4". Collection the
author

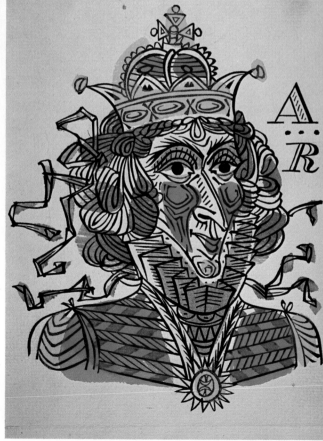

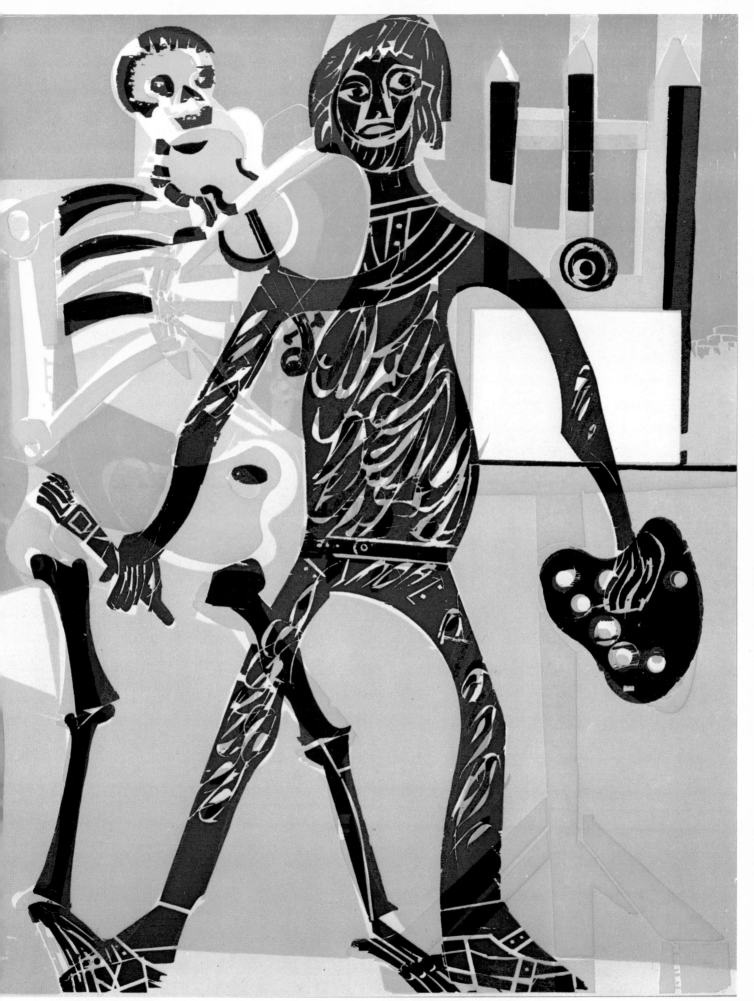

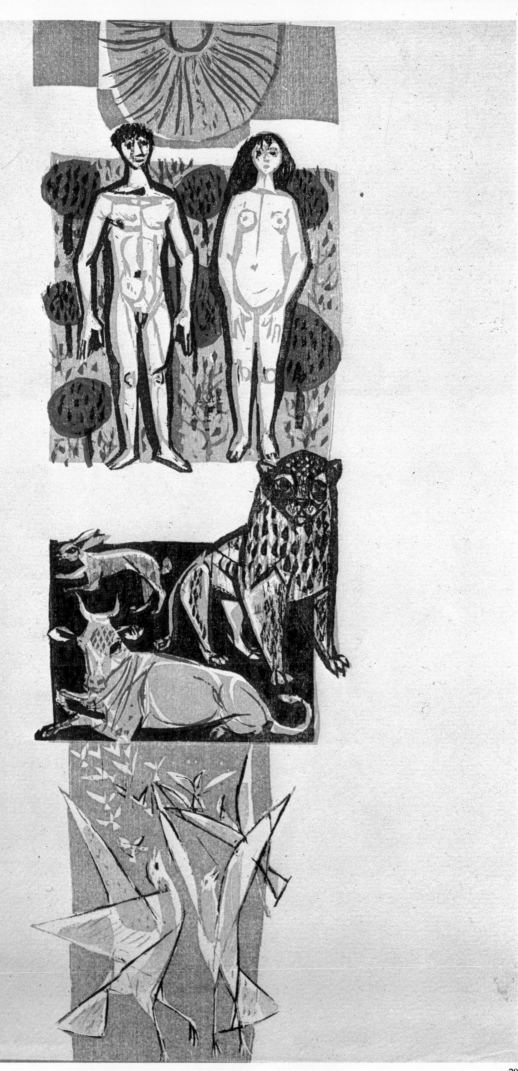

29 *Felix Hoffmann.* Adam and
Eve. *1959. Color woodcut,
9 5/8 × 3". Collection the
author*

30 *Edmond Casarella.* Rock
Cross. *1955. Color paper
relief cut, 22 × 25". Courtesy
the artist*

31 *Ansei Uchima.* Time, Space—
Horizontal B. *1969. Color
woodcut, 9 × 19 5/8", with
progressive proofs 1–3.
Courtesy the artist*

30

31

This method is followed through with all the subsequent blocks until all color areas are cut. In my recent work there are usually about four blocks for each print. If color areas are clearly separated, more than one color can be inked in and printed from the same block.

For printing, the first block is fixed to my printing board (about 36 by 43 inches) with nails strategically driven in around the edges of the block. Cardboard markers are also nailed down flush against the bottom edge and corner of the block. These markers will serve as my registration for the blocks, and they are left in place. Subsequent blocks are nailed in exactly the same position as the first, after it has been printed and removed. Two more markers are stapled to the printing board about 1 1/2 inches below the first markers—an L-shaped marker (cut from mat paper) and a small rectangular marker along about three-quarters down the bottom edge. These are for registering the paper. In other words, two sets of markers are fixed to the printing board—one set for the blocks and the other for the paper. These markers can be left in place for printing the blocks of other prints more or less of the same size.

The paper is dampened by placing it for about twenty minutes between well-moistened newspapers. If the paper dries up between printing stages, it is reinserted between the newspapers for a few minutes. The pigment (watercolor) is applied to the block with brushes. Please note that my pigments are ordinary watercolors or gouache watercolors—the kind that come in tubes. I do not use water-soluble, block-printing inks, which have been developed as substitutes for oil-based pigments and can be used with brayers. White library paste (which may be substituted for the traditional rice paste) is mixed in to give the pigment some body. Diluted watercolors lack body; therefore the mixing in of the paste is important. The paper is registered and placed over the colored block and burnished with the baren. Color gradations are achieved by using two brushes—one carrying pigment and the other moistened only with water. In smaller areas the gradation may be done simultaneously with one brush; that is, pigment is applied to one portion of the brush while the other portion is moistened with water. The crucial problems in printing are the proper moisture of the paper, the consistency of the paste, pigment, and water, and the effective handling of the baren. If any correction in color value becomes necessary, it is possible to go back to any block and reprint it, properly registered, to intensify the color. After printing, the prints are dried and stretched. Small prints are dried between clean white blotters.

When one satisfactory proof is pulled, it is matted and used as a model for subsequent printing. Unless a whole edition is commissioned, I usually print about two to five prints at a time. My editions are generally set at thirty to fifty. I usually print five "artist's proofs" before the numbered edition.

FELIX HOFFMANN
Color Woodcuts for Book Illustration

I am not concerned here with the single, large, color woodcut, impetuously attacked with the gouge, inked with abandon, printed with the spoon, greatly enhanced by various attractive textures cut into the block. I am talking about the woodcut conceived for the illustrated book, which must be designed and cut in a

OPPOSITE PAGE:

32 *Carol Summers. Fontana. 1965. Color woodcut printed on both sides of the paper. 15 3/4 × 20 3/4". Smithsonian Institution, Washington, D.C. (Division of Graphic Arts). Above, left: Black block printed on back over partial white areas previously impressed, dried, and sprayed to create transparency for other colors. Right: Back of print showing strike-through of blue and sepia added on front by rubbing method. Below, left: Separate proof of yellow-and-ocher block for front. Right: Final print after impression of yellow-and-ocher block and addition of dark blue cloud by rubbing method on front. (See page 155.)*

COLORPLATE 29

manner that makes possible the printing of large editions in an automatic press. This means that there are great limitations in its effects, along with a loss of some "artistic freedom." If a freely conceived print may be compared with an easel painting, the woodcut illustration for a book may be likened to a mural or a stained-glass window, which must fit into a given architectural concept. After all, does not an illustration have something in common with opening a window in the architectural structure of a text, opening new perspectives which even the author has never thought of, since they are in the domain of the visual artist?

With what elation, with what confidence, one attacks a new assignment to illustrate a book with woodcuts! One sketches long and thoroughly; one lines up the sheets along the wall, eliminating, changing, seeking a rhythmic harmony, sequence, and color scale, until one finds that they close ranks pictorially. Now one may think that there is only the little matter of woodcutting left, a mere rendering; but again, with the same old excitement, one discovers that now the real act of creation begins, with all its mental ups and downs. How different the cut and printed lines look from the drawn or painted ones! They show mercilessly what was wrong with the preliminary plans, with the composition—whether the colors are right in scope and intensity and will fall into place as visualized in the final print.

At the start the blocks of lindenwood are lined up along my studio wall, to be looked at and carefully considered. I am not a novice, and I have no illusions about a quick success. I usually tackle first the illustration closest to my heart. My first block is cut to bring out most of the basic lines of my composition, and the first wet proofs are offset on four or five other wood blocks for further colors.

One can follow the Japanese method of making simple black-and-white outlines which can be filled in with various colors. I find it more interesting, however, to pass along some structure of the drawing from one color to another.

Like the old lithographers, I make my register marks with two pin points on each block, as a guide for each further printing, and proceed with cutting only after each completed block is proofed with the previous one. Some parts are left identical on several blocks, and I decide later, during the proofing, which color should prevail. I usually aim for a simplified solution, without too much superimposition, favoring a light, transparent orchestration.

In my studio I have a small etching press which has hardwood guide rails that raise the level of the upper cylinder so as to adapt it for relief printing. Five or six ink slabs are waiting for various inks. I leave the choice open, and the scale becomes more definite only as the proofing proceeds. What the pressmen call "color scale" and want for their press runs I cannot give them. Neither can I, on the primitive hand press, produce a complete and definite set of color proofs. Therefore, whenever possible, I am in the shop when the press run begins.

I am always astonished at the reaction of printers when they are confronted by the artist and delighted by their devotion to the difficult task of working with him, because so often they have been trained to fill their inkwells with prescribed, standard-color inks and are unaccustomed to mixing unusual tones.

I find it exciting to scavenge the bins for discarded misprints, for here I see my own blocks printed helter-skelter over each other without sense or meaning, but so charmingly that I begin to wonder whether I have missed something in the original planning. After all, pure accident can sometimes contribute to success. Similarly, one

often finds unexpected effects in old veneers and pine crates, scrutinized for interesting knots and textures. To make effective use of such accidents of material one must avoid the danger of mistaking decoration for art and never allow them to take precedence over the creative idea itself.

CAROL SUMMERS
Making the Woodcut *Fontana*

This small print was made by utilizing various printing techniques. The first block was inked rather heavily with white ink and printed on the back of the paper. It covered the white areas and the ocher areas of the ground, the black lines of the pedestal having been scratched out of the block. Being printed on the back, the block produced a positive of the image. After that dried, a black impression was printed from another block, covering the white areas, as well as the heavy blacks on the ground and the green of the trees that appear in the finished print. This block too was inked and printed from the back. After printing, the paper was sprayed with Varnoline through an atomizer. This slightly dissolved the ink so that it would soak through the paper. The spotting in the fountain and ground was produced by the infiltration of black ink through the small holes in the white-ink coating, which acted as a stopout.

COLORPLATE 32

The next printing was from a block that provided the grained areas of the tree trunks and the water of the fountain. I found the kind of grain I wanted on a large sheet of Plyscord (unsanded fir plywood) and cut out the shapes with a jigsaw. The pieces were positioned and glued in place on a piece of Masonite, registered with the other blocks. This block was placed under the print, in the same manner as the previous blocks, but now the ink was applied with a roller directly on the surface of the print. The block had been brushed with a steel brush to scrape away the softer areas and accentuate the grain.

Japanese papers have a rough and a smooth side. I used the rougher side for the face of the print, so that this surface printing picked up some of the texture of the paper, as well as the texture from the wood grain underneath. The two color areas, sepia and blue, were easily printed from the same block, because they do not touch.

The next colors were the ocher and yellow, printed from an inked block and applied to the front surface of the print. This block was a reverse of the other blocks, but still registered with them. The trees were printed transparent yellow, which appears green when superimposed over a black. The ocher is the same transparent yellow with slight additions of red and black. The block was printed very heavily, and the tone of the color was controlled by counterprinting some of the ink off on newspapers afterward. Both inks being transparent, the shade of color depends on the thickness.

The last color was the blue of the cloud. The ink was rolled thinly on the paper, with the controlling positive block underneath, and was sprayed heavily afterward so that it would run and lose the hard edges.

[NOTE: Adapted from *Carol Summers: Woodcuts 1950–1967,* catalogue of an exhibition at the San Francisco Museum of Art, Nov. 28, 1967, to Jan. 7, 1968.]

JOZEF GIELNIAK
Engraving on Linoleum

From the point of view of technique, my work is extremely simple and conceals no

167

167 *Jozef Gielniak. Bookplate with self-portrait. 1965. Linoleum engraving, 3 × 2". Collection the author*

PLATE 167

secret. Many people think I work with a magnifying glass and with special tools. My "mysterious" tool is quite simply a wood engraver's burin (No. 3), which I have used for fourteen years. It can be sharpened to any angle, oblique or acute.

I cut directly into a linoleum block, without a drawing or preliminary sketch, working by improvisation, seeking to realize a vision, and giving it all the time and patience it demands—often several months. While working, I very rarely make test proofs.

When the work is finished, I make a first trial proof and make minor corrections on the block when necessary. I pull all the proofs carefully by hand, using fine Chinese or Japanese papers. The printing ink must be tacky enough for the paper to adhere well to the surface of the block while I print. I clean my blocks with gasoline, which preserves the linoleum so well that they have lost not the slightest bit of their fine detail, either in printing or with the passing years.

PLATE 168

My method of work is a slow elaboration without compromises or any sort of shortcut; it is entirely subordinated to a total vision, in which are gathered all the experiences of my life, of a world lived and imagined.

It is through necessity that I devote myself to linoleum engraving; I have been in a sanatorium for the past seventeen years—for the most part bedridden—and this was a technique approved by the doctors, one that I could practice lying down.

That, very simply, is all I can tell you about my craft.

WILLIAM KENT
Slate Relief Prints

My slate prints have been developed from 1962 to the present. In the early 1950s I had begun using 1-inch-thick black slate slabs to make carvings that were an end in themselves. In the early 1960s I began to make prints from some of them on Japanese paper, using the traditional woodcut printing technique. A variation was added by wetting the paper *after* it was placed on the inked slate. The paper was then carefully pressed down into the carved-out sections with a shaving brush. When dry, the paper was removed, and an intaglio effect resulted.

PLATE 169

In 1963 I started carving larger pieces of slate, using blackboards approximately 3/8 inch thick and of a maximum size of about 4 by 6 feet. (One-inch-thick slate in these sizes would be unmanageable in a printmaking technique.) I carve these large slates by hand with ordinary stone-carving tools. I have also used the sandblasting technique. For the latter a 3M-brand Scotch Sandblast Stencil is glued to the slate with a special 3M-brand adhesive. The design is traced on the rubber stencil and cut out with a sharp knife. When sandblasted the cutout portions of the rubber mat are below the printing surface. I have found this to be a very speedy, although rather expensive, way of doing very elaborate designs that would take months to carve by hand. With hand carving, however, effects that would be impossible in the sandblasting process or in the linoleum-cut technique can be obtained.

The slate plates are extremely permanent aside from accidental breakage and do not deteriorate in the slightest degree. Theoretically an infinite number of prints of exactly the same quality can be made.

Since 1965 I have printed exclusively on fabric, mainly cotton (Indian Head, 45 inches wide), acetate satin (45 inches wide), and *peau de soie* (50 inches wide). These materials come in many colors, of course. Aside from the completely different effects

168

that can be obtained, as compared with paper, my main reason for using fabric is the large size of the prints. My average print is now 42 inches wide by 5 to 6 feet long.

My printing inks, mainly Day-Glo, from Sinclair & Valentine, are applied with a brayer. I use ink bases, mixed with a reducing compound, with oil of cloves added to reduce the drying speed.

The Paper Relief Cuts of
EDMOND CASARELLA
by Bernard Chaet

Edmond Casarella has developed an unusual color relief-print technique in which the plates themselves are made from cardboard.

To begin, Casarella makes a "rough" gouache sketch, which will continually be transformed through each step in the process. The sketch is then analyzed and tracings

168 Jozef Gielniak. Improvisation for Grazynka. *1963–64. Linoleum engraving, 7 5/8 × 10 5/8". Collection Andrew Stasik, New York*

COLORPLATE 30

are made for the color separations. At this point decisions are made concerning the number of colors to be used on any one block and the juxtaposition of opaque and transparent overlays. One sheet of tracing paper is prepared for each block—as many as eight blocks containing sixty colors have been used.

With the tracing paper used as a blueprint, the blocks are cut from heavy-weight chipboard, and shapes corresponding to the color areas, but slightly larger in size than the tracings, are cut from double-weight illustration board. These shapes are carefully glued into place with rubber cement, on their respective blocks, and the exact shapes are traced onto them. The tracing is reversed so that the print does not become a mirror image of the gouache sketch.

When each block has been prepared cutting can begin. The exact shapes are scored with a single-edge razor blade or a mat knife, cutting at a slight angle away from the shape. The excess illustration board peels away easily in layers. As Casarella says, "I can decide whether to incorporate the second level of the shape by the depth of the cut. If I decide to print the edge of the oversized shape as a secondary shape or ghost, I cut only halfway through the cardboard. Texture can be produced by breaking the surface with an ice pick or nail, but these areas must be reinforced with a surface coating of Elmer's Glue or shellac."

In printing, the blocks with the largest shapes, usually inked with opaque colors, come first. As the blocks are printed one after the other, the paper is carefully registered. Inks used are International Printing Inks and offset industrial ink. I.P.I. "transparent white," a jelly-like liquid, is used to reduce any color to a glaze. The blocks can be inked with oil inks without prior coating of glue or shellac and can be cleaned with turpentine. Water and water-based inks will destroy the illustration board. If water is avoided the blocks can withstand a sizable edition.

Gelatin rollers in a variety of sizes, some constructed by the artist, are used for inking. Wooden spoons are employed to hand-rub the ink on the paper. After the printing of each block the proofs are allowed to dry for twenty-four hours before an overlaid or adjacent color is printed.

The paper best suited is Mulberry or Troya (from Andrews-Nelson-Whitehead). For very large prints one can use a paper produced on rolls by the Technical Paper Co. (Boston, Mass.).

[NOTE: Adapted from Bernard Chaet, *Artists at Work,* Webb Books, Inc., Cambridge, Mass., 1960, pp. 136–141.]

169 William Kent. Leave the Moon Alone. *1964. Slate relief print, 48 × 32". Courtesy the artist*

169

CHAPTER 8

RUBBINGS

BY AVON NEAL

PLATES 170–178

The rubbing as a print technique is one of the oldest forms of art reproduction, far earlier than the woodcut or the comparatively modern processes of etching, engraving, and lithography. Instructions for making rubbings are found in Oriental texts dating back nearly two thousand years, and according to some authorities it was the ancient Chinese scholars' practice of taking rubbings from carved stone inscriptions that directly led the way to the making of books by inked impressions from wood.

The history of rubbings is inextricably linked with the development of stone relief carving. From earliest times man has recorded significant events and portrayed a host of images on stone monuments, which have stood through the ages as testimony to human history and progress and have lent themselves particularly to the techniques of rubbing.

By the time history was being recorded in China, the practice of carving on stone and wood had already developed into a fine art. One finds stated in the annals of the Han Dynasty that as far back as A.D. 175 the text of the Confucian Classics was cut on stone in order to insure permanence and accuracy.

The art of rubbing coincided with the invention and manufacture of paper. Until this time silk and bamboo were in limited use as writing materials, but silk was expensive, and bamboo was heavy and bulky. Buddhist missionaries experimenting with various methods of duplication soon took the logical step toward making tracings or rubbings from venerable stone carvings. It was the surest, most expedient means of copying calligraphic inscriptions and low-relief designs carved or incised on stone, bone, clay, metal, or wood. In time, the technique of rubbing was developed and refined. It ultimately became an art which has flourished without interruption for centuries. Rigid standards of excellence soon prevailed, and inevitably some aspects of the art became ritualized.

As early as the second century A.D. rubbings were used to disseminate information. For nearly two thousand years rubbings in China performed some of the functions of our modern photographs; they were collected into archives for study, hung in temples, and used as interior decoration. Temples often employed their own rubbings masters, and to this day masters of the art are sometimes maintained to make rubbings for visitors to purchase as mementos.

Whole families have followed this highly specialized art and have passed along some well-guarded techniques for generations. The rubbings of masters commanded

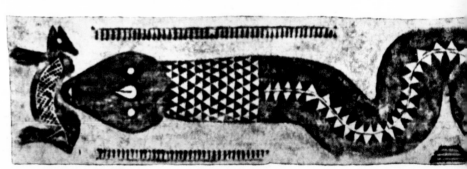

170

high prices and were sometimes considered more valuable than the objects from which they were taken. Quite often a rubbing is all that remains as a record of some delicate ivory carving or embossed terra-cotta roof tile.

The Oriental technique, the most common method of making a rubbing, begins with the careful application of one of the many varieties of Oriental hand-laid paper to the surface of the carving. It is water-dampened and then, with a stubby bristle brush, carefully tamped into all the depressions and crevices, where it molds itself over the carving and is allowed to dry. Black or red inks are traditionally used for rubbings in the Orient. The black or "India" ink was originally Chinese and is made in part from lampblack; the red ink or "cinnabar red" is a compound of sulphide of mercury. With a silk pad the ink is dabbed repeatedly with a gentle rubbing motion over the paper until the image becomes clearly defined.

From the river-valley civilizations of the Nile, Tigris-Euphrates, and the Indus, from countless migrations and military conquests, from the heritage of Greek and Roman art, the Western world developed its own stone-carving traditions. Gradually these spread northward through Europe to Scandinavia and across to the western isles

170 *Avon Neal. Ink rubbing from a Bush Negro carved wood panel, Surinam (19th century). 6 1/4 × 39 1/4". Courtesy the artist*

171 *Anonymous Siamese. Rubbing from stone, Ship, c. 1800. Collection Avon Neal, North Brookfield, Mass.*

171

of Britain. Huge monoliths covered with incised line drawings and runic inscriptions were erected in Norway and Sweden to commemorate warrior chieftains, while along the rocky coasts of Scotland and Ireland the Picts and Celts carved symbolic slabs and great stone crosses. In many parts of Europe it was the custom to commemorate dead priests, knightly lords, and highborn ladies with carved stone grave slabs, placed flat over burials in the floors of churches. During the thirteenth century in England this practice was refined by the introduction of monumental brasses from Europe. Some were small, others nearly life-size plaques with highly stylized figures incised to depict a casual likeness of the personages who lay buried beneath them.

PLATE 173

Presenting a smooth intaglio surface, these tomb carvings lent themselves ideally to the rubbing process which became known as the Western or English technique of brass rubbing. Used in Europe for centuries, it is essentially a wax and hard-paper technique, which differs from the Oriental in both method and materials. Unlike China, England had no great tradition of fine papers and inks. It was easier, because of the smooth surface of brass, to approach rubbings in a different way. A tough paper, preferably sized and durable, was required. The coloring agent was a hard, waxy substance called "heelball," a pigmented cobblers' wax composed of beeswax and lampblack and similar to the modern wax crayon.

A form of rubbing closely related to the English brass technique was practiced by Western craftsmen during the fifteenth century, when line engraving developed from the incised niello work of goldsmiths, who rubbed paper against alloy-filled engravings to record their designs.

PLATES 172, 174–178

The contemporary approach to making a rubbing departs from tradition in concept, in method, in materials—even in content. The artist has a wide range of surfaces and designs to choose from, as well as an infinite variety of papers available. Almost any thin, pliable paper will serve for making a rubbing. Silk or coarse cotton cloth can also be used; in some instances where the details are not so important even velvet has taken the place of paper, with somewhat startling results. Pigments include a multitude of special inks and dyes, graphite, wax crayons, heelball, and various combinations of these coloring agents. Brushes, rollers, tamping pads, or bits of cloth can be used to apply the color. Each artist finds through experimentation the method with which he can work best. Unlike most other print techniques, the rubbing has no catalogue of commercially available tools specifically designed for its practice; each artist determines his particular needs and makes his own tools.

Compared to other print processes, the making of a rubbing is relatively simple. The first step is one of selectivity, since the artist generally approaches a preconceived image, that is, a carving made by someone else. A good example might be an early New England gravestone. When the artist has decided which stone he will rub, a sheet of paper is stretched tightly over the surface of the carving, centered, and attached at the edges with masking tape to secure it against movement. This is essential, for if the paper moves during the rubbing operation, the image becomes blurred. Unless the whole stone is involved, the artist should establish guidelines or mask off the desired area so as not to smudge color onto the rest of his paper. Now the pigment—ink or wax crayon—can be applied over the section to be rubbed. Crayon is easier to manage and presents fewer problems than fluid pigments.

If he is using crayon, the artist will brush over the surface lightly, building up color at the points of the design which register, emphasizing them by repeated

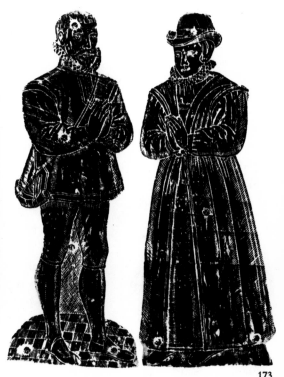

172 Avon Neal. Ink rubbing, Priest with Offering, based on a Mayan temple carving, Palenque, Chiapas, Mexico (recarved in plaster mixed with sand and stone particles). 29 1/2 × 66 1/2". Courtesy the artist

173 Anonymous. Heelball rubbings from English memorial brasses (16th century). Mid-19th century. Height of each figure 17 1/2". Collection Avon Neal, North Brookfield, Mass.

174 Avon Neal. Detail of ink rubbing from pre-Inca carving on facade of "Gate of the Sun," Tiahuanaco, Bolivia. 7 1/2 × 8". Courtesy the artist

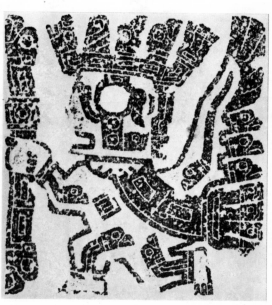

175

goings-over. Thus, when this is done carefully, brushing inward from the edges and avoiding rubbing beyond the margins, the paper will gradually take on the substance of the design. This procedure is continued until a satisfactory graphic reading is achieved. Depending on the object rubbed and the skill of the rubber, this will require from a few minutes for a quick impression to several hours. The completion of a rubbing from a large stone carving can take all day or as long as several days.

Ink techniques are much more complicated, depending on specialized equipment and the availability of water if a dampened squeeze is to be attempted. Silk pads are used to apply color; a pad is first saturated with ink, then wiped clean of all excess until it is barely moist to the touch. It is then brushed gently over the surface until, after repeated inkings, the design appears. Working out of doors can become difficult, because ink in damp weather is hard to control; atmospheric humidity causes the paper to rub through in spots and the ink to run. Or, if the air is too dry, the paper absorbs ink too rapidly, which leads to a tendency to overwork the rubbing. Ideal working conditions generally prevail inside a studio or a museum, but the artist must work wherever the carvings happen to be, and this is frequently out of doors, in remote areas with severe climates.

Regardless of the medium used, the artist must exercise care not to tear the paper or rub it through. Excessive rubbing with crayon or the application of too much ink results in smudging and, usually, a spoiled rubbing. Also, care must be taken not to stain or otherwise damage the surface one is working from. Oil-base inks must be used with the utmost caution. As with any print technique, a fine rubbing

177

175 Avon Neal. *Ink rubbing from a house-shaped stone tomb of the Bogomile sect, central Yugoslavia (probably 14th-15th century). 26 1/2 × 55 1/2". Courtesy the artist*

176 Avon Neal. *Ink rubbing from an Irish gravestone (18th century). 16 1/2 × 29 1/2". Courtesy the artist*

177 Avon Neal. *Ink rubbing based on an "Adam and Eve" stone in an old churchyard in Scotland (recarved in soft material for studio rubbing). 20 1/2 × 22 1/2". Courtesy the artist*

178

178 *Avon Neal. Ink rubbing from a gravestone in the old cemetery, Wakefield, Mass. (18th century), with "halo effect" produced by depth of carving. 7 1/2 × 17". Courtesy the artist*

depends largely upon the individual who is making it, and the matter of interpretation cannot be overestimated.

In recent years artists experimenting with rubbings as a print medium have carved their own designs into wood, stone, metal, Lucite, or plaster, cutting them by hand or with power tools, and have discovered the advantages of working directly from a non-reversed image. They have worked with oil- and water-base pigments in various combinations, applied heat to rubbed wax for softened images, and used rubbings as integral parts of collages.

As a recording device the rubbing offers some decided advantages over other media. So sensitive is the Oriental ink technique that scholarly researchers are able to decipher practically nonexistent inscriptions on worn surfaces and to reproduce accurately the most subtle textures. Rubbings, as in the eighteenth and nineteenth centuries, still play an important role in archaeological investigation. In an area where drawings seldom suffice and quite often a camera fails to capture the subtleties of badly worn or eroded carvings, a rubbing is faithful to size and material and reproduces the most intimate details of carving and surface. Equally important, when space is at a premium, rubbings, because of their compactness, are easily stored. It is possible, for instance, to house the design and calligraphic records of an entire New England burying ground in as little space as it might require for the cast of a single gravestone.

As an educational aid the rubbing has been put to good use for instructing school children, who, in art and nature studies, take great delight in rubbing pressed flowers and leaves. Genealogical students find the rubbing a quick and efficient method of copying ancestral tomb inscriptions. Engravers and stonecutters use the rubbing as a practical means of filing designs for future reference.

Rubbing has been restricted too long, perhaps, by rigid rules and tradition. Lately it has been favorably reconsidered in the light of the expanding horizons of printmaking. Graphic arts curators have overcome former prejudices and are now adding rubbings to major print collections. It is an exciting medium and has a tremendous potential for the artist who is willing to explore its possibilities.

III
THE
INTAGLIO
PRINT

CHAPTER 9

THE
INTAGLIO
PRINT

HISTORY

Opposite: *Enlarged detail of plate 271*

PLATES 179, 180

At the dawn of history men scratched and incised lines into pieces of bone, soft stone, skin, or bark. This technique was continued by the seal and gem cutters of ancient Mesopotamia and Egypt, by Greek coin designers and mirror engravers, and by the Etruscans and Romans; it was brought to a point of great refinement by the artisans who embellished medieval weapons and armor. From that point developed the meeting of two kinds of creative endeavor, that of the skilled engraver-artisan and that of the artist, collaborating in their efforts to produce a multiple image, a print.

As we have seen, there were some artists in the beginning of the sixteenth century to whom the woodcut may have seemed rather coarse and primitive. Perhaps they observed goldsmiths taking a rubbing from an armorial or liturgical design by applying pigment to the metal and rubbing the back of a piece of paper laid over it. These first attempts would have been relief prints, showing the engraved lines white against black. We do not know who first conceived the ingenious idea of rubbing ink *into* the lines and coaxing it out by pressing a dampened sheet of paper against the metal surface.

The Early Engravers

All the early engravers are anonymous, sometimes known only by their chop marks

PLATES 181–217

179 *Byzantine patera with scenes from the Old Testament. 4th century. Engraving on glass, diameter 9". Hermitage, Leningrad*
180 *Anonymous German.* The Fourth Beatitude. *12th century. Impression (19th century) from a Romanesque engraved metal lantern found at Aix-la-Chapelle. Philadelphia Museum of Art*
181 *Master E. S.* The Knight and the Lady. *c. 1460–65. Engraving, c. 5 5/8 × 4 1/4". National Gallery of Art, Washington, D.C. (Rosenwald Collection)*

179

or initials, or arbitrarily named by art historians for the work or subject matter that was most characteristic of them.

The earliest dated intaglio print bears the date 1446, a *Christ Crowned with Thorns,* of which only one known copy survives. At the same time charming copper engravings of beasts, birds, flowers, and people turned up, part of a card deck by which the Master of the Playing Cards became known and famous.

It is understandable that pictures of local patron saints, as well as the kings and queens on playing cards, became best sellers at country fairs and church festivals—or wherever saints and sinners congregated. These early prints became a steady source of income for enterprising artists, engravers, and publishers.

One of the most influential of the early artist-engravers was the Master E.S. (active 1450–1467), presumably a pupil of the Master of the Playing Cards, whose work was widely admired and imitated. Aside from his great skill as a draftsman and engraver, his prints display a light and gracious humor, as in his *Liebesgarten,* and a Gothic delight in the absurd, as in his *Fantastic Alphabet.*

The Master of the Housebook, active toward the end of the fifteenth century, added the drypoint—"the cold needle"—to the engraved line, perhaps to escape from the more demanding and formal discipline of the burin.

Among the first great name painters identified with engraving was Martin

PLATES 185, 187

PLATES 181–183

PLATE 184

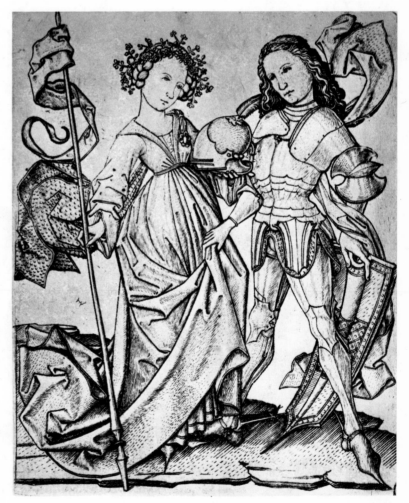

182

182 Master E. S. Virgin and Child with a Bird. *c. 1465–67. Engraving printed in relief, diameter 4 1/4". National Gallery of Art, Washington, D.C. (Rosenwald Collection)*

183 Master E. S. The letter K from the *Fantastic Alphabet. c. 1464. Engraving, height c. 5 1/2". National Gallery of Art, Washington, D.C. (Rosenwald Collection)*

184 Master of the Housebook. Two Peasants Fighting. *Late 15th century. Drypoint or engraving, c. 2 3/4 × 2 1/4". National Gallery of Art, Washington, D.C. (Rosenwald Collection)*

185 Master M. Z. Aristotle and Phyllis. *c. 1500. Engraving, 7 × 5". Courtesy William H. Schab Gallery, New York*

183

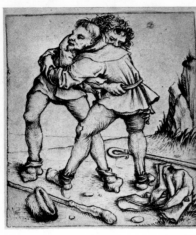

184

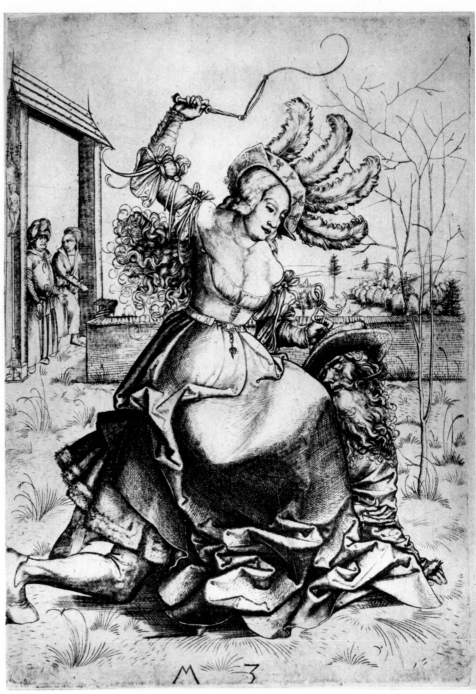

185

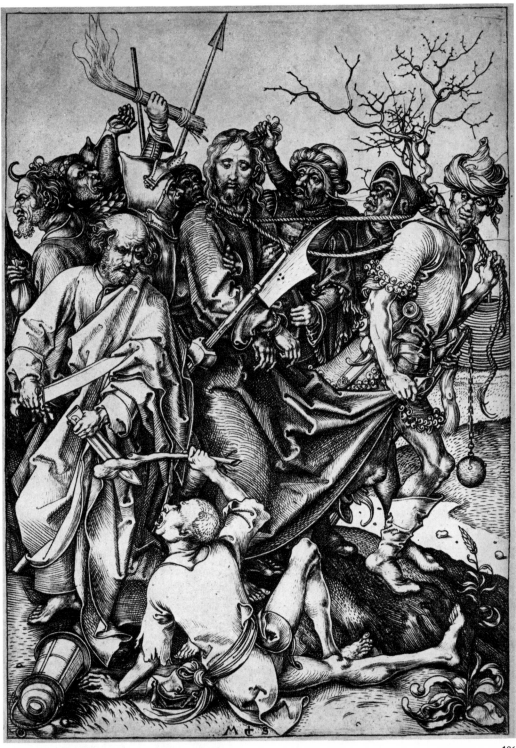

186

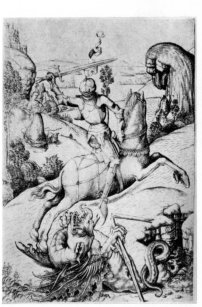

187

186 *Martin Schongauer.* The Betrayal of Christ. *Late 15th century. Engraving, 6 5/8 × 4 1/2". National Gallery of Art, Washington, D.C.*

187 *Master F. V. B.* St. George and the Dragon. *Late 15th century. Engraving, 7 1/8 × 5". National Gallery of Art, Washington, D.C. (Rosenwald Collection)*

PLATES 186, 192

Schongauer (c. 1435–1491), who had a major influence on the young Dürer. Working in the "Broad Manner," his burin plows deeply and forcefully through the copper. In him we can trace the transition from an austere northern Gothic style to the exuberance and richness of the southern Renaissance. Of his 116 known engravings perhaps the most unforgettable are the soaring, Bosch-like *Temptation of St. Anthony* and the great *Christ Carrying the Cross*.

Having its origins in the jeweler's or goldsmith's workshop, metal engraving seemed the appropriate medium for the display of a wealth of texture and graceful ornamentation and the rich detail of dress and landscape that the Renaissance cherished.

PLATES 188, 191

The work of Israhel van Meckenem the Younger (c. 1450–1503) shows the enthusiasm with which the European artist embraced the new print medium. Some 570 prints are identified as his, many of them reworked plates of Master E.S., whose pupil he was. Van Meckenem's self-portrait with his wife Ida is one of the first plates ever engraved in copper. He also worked over plates by Schongauer and Dürer, whose prints had become so popular that the plates wore out too quickly.

The hunger for the printed image must have been great. This new device for multiplying art enabled European artists and artisans not only to study the work of their colleagues but also to imitate it and use it freely wherever decoration was needed, on jewelry, pottery, textiles, or metalwork. There was no stigma attached to copying the work of great artists; it even tended to increase their popularity.

PLATES 189, 190

In Italy the art of engraving was concentrated in Florence, the center of the goldsmith's art. It got its impetus through the intimate knowledge of a technique known as "niello," of which the Italians were masters. Foremost among them was Maso Finiguerra (1426–1464), who is credited by Vasari with its invention. In niello, engraved lines on gold or silver plates were filled with a black mixture of copper, silver, lead, and sulphur, a procedure very much like inking an intaglio plate, which may have led the artists to the pulling of proofs and using them ultimately as "prints."

Out of this technique developed the so-called "Fine Manner," a light-handed, fluid style for which Maso Finiguerra also claimed to be responsible. It was most suitable for the reproduction of delicate lines, like those in Pisanello's master drawings. But soon a more rugged style made its appearance in Florence about 1470;

PLATES 193–196

188 Israhel van Meckenem the Younger. Coat of arms with tumbling boy. c. 1480–90. Engraving, 5 5/8 × 4 5/8". National Gallery of Art, Washington, D.C. (Rosenwald Collection)

189 Anonymous Florentine. Chastisement of Cupid. c. 1465–80. Engraving. Graphische Sammlung Albertina, Vienna

188

189

190

191

190 *Master A. D. Niello ornament. 1608. Metropolitan Museum of Art, New York (Rogers Fund, 1919)*

191 *Israhel van Meckenem the Younger. Christ Crowned with Thorns and Mocked. c. 1480. Engraving, 8 1/4 × 5 5/8". Museum of Fine Arts, Boston*

192 *Martin Schongauer. The Foolish Virgin. Late 15th century. Engraving, 4 3/4 × 3 1/8". Yale University Art Gallery, New Haven, Conn. (Weeks Fund)*

192

based on the German "Broad Manner," it was more suited to the strong, flowing lines popular with the professional engravers trained by goldsmiths and jewelers.

It is amazing that at the very beginning of a new graphic medium which required such painstaking skill two great artists, Mantegna and Pollaiuolo, could achieve such mastery in so short a time. One of the monuments of that period—or for that matter of any period in printmaking—is the *Battle of the Ten Nudes,* attributed to Pollaiuolo (c. 1432–1498) and perhaps the only engraving he ever did. In its carefully staged choreography, in its measured movements and almost audible clash of arms, it has the quality of a Surrealist dream image. Intimate knowledge of the human body is revealed through dazzling use of the burin, hardly ever surpassed.

Closely related to Pollaiuolo in style and also a virtuoso in the handling of a copperplate, Andrea Mantegna (1431–1506) must be considered one of the greatest masters in a generation full of outstanding talents. Some twenty-five plates have been attributed to him, perhaps a third of them engraved by his hand, if we use brilliance of performance as a key to identification. His intricate technique is worthy of close study. It never obscures or overshadows the grandiose dimensions of his powerful figures. Engravings after his paintings must have been much in demand in his own lifetime. He bitterly fought unauthorized copiers and is said to have beaten two of them, leaving them half dead in the streets of Mantua.

PLATE 197

The free borrowing of designs from artists of the North, Schongauer and Dürer foremost among them, had become a lucrative industry among Italian engravers. They rarely gave credit to the source of their prints.

PLATE 200

Engraving had become a flourishing business, exploited by skillful interpreters of the great and popular masters. Marcantonio Raimondi, born in Bologna in 1480, started as a goldsmith's apprentice and came to engraving by way of niello. His skill

PLATES 199, 201–203

193 *Master of the Beheading of St. John.*
Combat of animals in the presence of a man
with a shield. c. 1500. Engraving.
Brooklyn Museum, New York (gift of
W. G. Russell Allen)

193

195

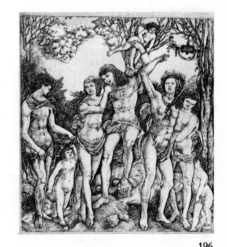

194

196

194 *Benedetto Montagna. St. George. 16th century. Engraving. National Gallery of Art, Washington, D.C.*
(*Rosenwald Collection*)

195 *Anonymous Italian. The Hellespontine Sibyl. Late 15th century. Engraving. National Gallery of Art,*
Washington, D.C. (Rosenwald Collection)

196 *Cristofano Robetta. Allegory of the Power of Love. Early 16th century. Engraving, c. 7 1/8 × 6 3/4".*
Courtesy William H. Schab Gallery, New York

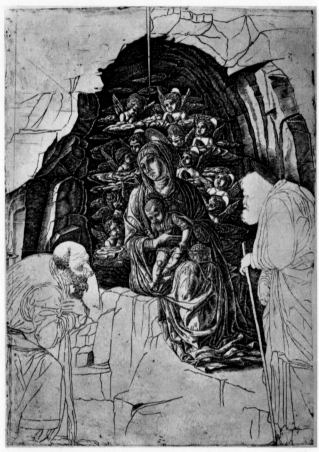

197

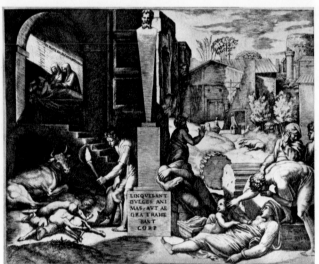

198

197 *Anonymous engraver after design of Andrea Mantegna.* Adoration of the Magi. *Late 15th century. Engraving. National Gallery of Art, Washington, D.C. (Rosenwald Collection)*

198 *Marcantonio Raimondi (after Raphael).* The Plague in Phrygia (Il Morbetto). *c. 1520–34. Engraving, c. 9 3/4 × 10 1/8″. Davidson Art Center, Wesleyan University, Middletown, Conn.*

199 *Domenico del Barbiere (after Michelangelo).* Apostles and Other Saints. *c. 1540. Engraving, 9 7/8 × 6″. Courtesy William H. Schab Gallery, New York*

200 *Anonymous Italian.* Death Surprising a Woman. *16th century. Engraving, 9 3/16 × 6 1/2″. Courtesy William H. Schab Gallery, New York*

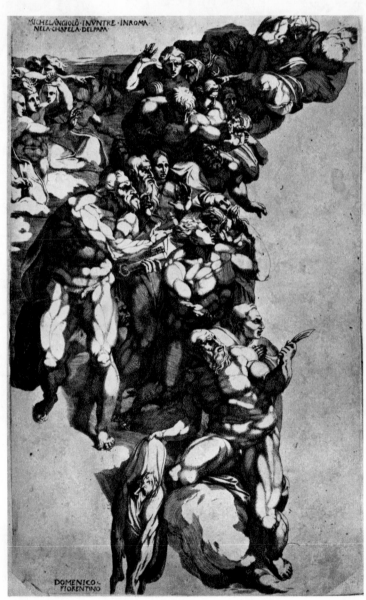

199

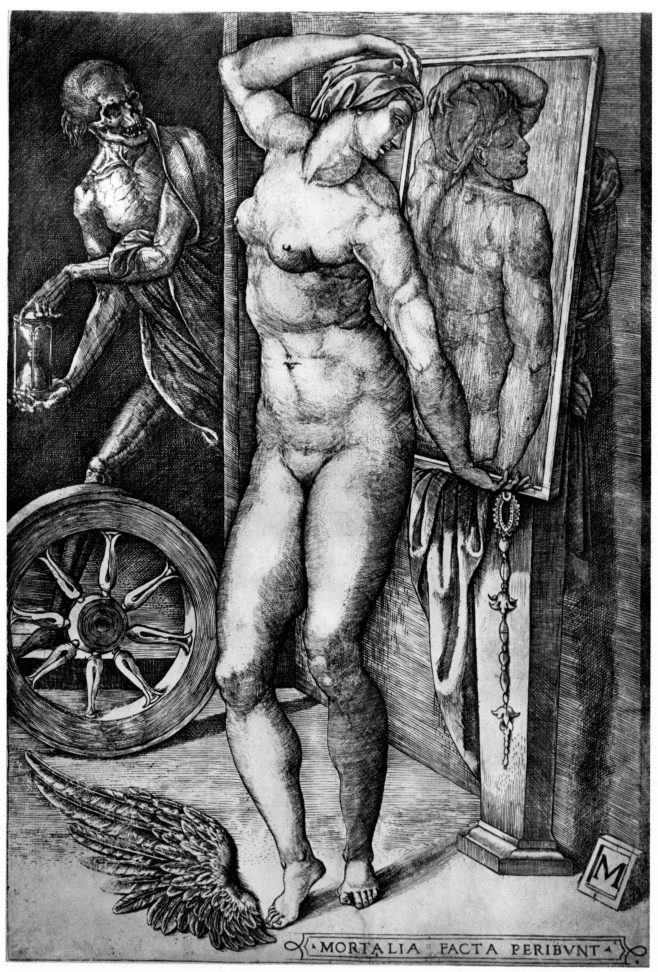

·MORTALIA·FACTA·PERIBVNT·

200

PLATE 198

developed rapidly, mainly through prolific borrowing from the works of Michelangelo, Campagnola, Dürer, Lucas van Leyden, and Titian. Raphael saw the great commercial value of reproducing his work by employing an engraver capable of doing justice to a master's art.

These often devious practices have confused the experts and will continue to do so. Which, if any, of the plates that show the genius of Leonardo da Vinci can safely be attributed to the hand of the master? The *Profile Bust of a Young Woman* in the British Museum, the *Young Woman with a Garland,* or the *Three Heads of Horses?* We simply do not know. It may be safer to assume that the engravings which show less brilliance of skill but more the strokes of a genius might have come directly from Leonardo's hands.

Even the great Dürer admitted borrowing freely from his favorite artists across the Italian border. He greatly admired Jacopo de' Barbari, and he certainly used Mantegna's and Pollaiuolo's designs in some of his prints, translating them into his personal style and integrating them into his own compositions. Even so, he made a special trip to Venice to protest the pirating of his own work by Marcantonio Raimondi.

201 Domenico Campagnola. Battle of Naked Men. 1517. Engraving. Fogg Art Museum, Harvard University, Cambridge, Mass.

202 Lucas van Leyden. Mohammed and the Monk Sergius. 1508. Engraving, 11 3/8 × 8 1/2". Courtesy William H. Schab Gallery, New York

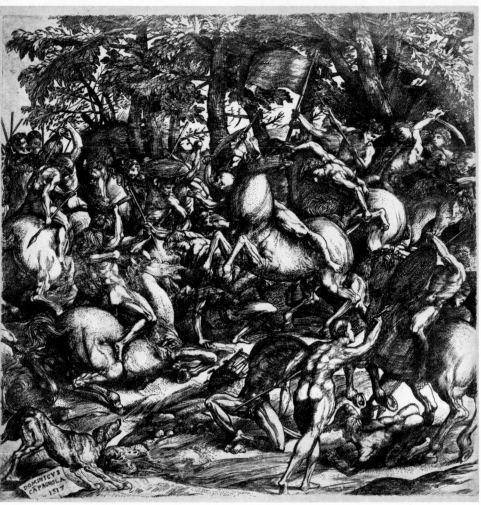

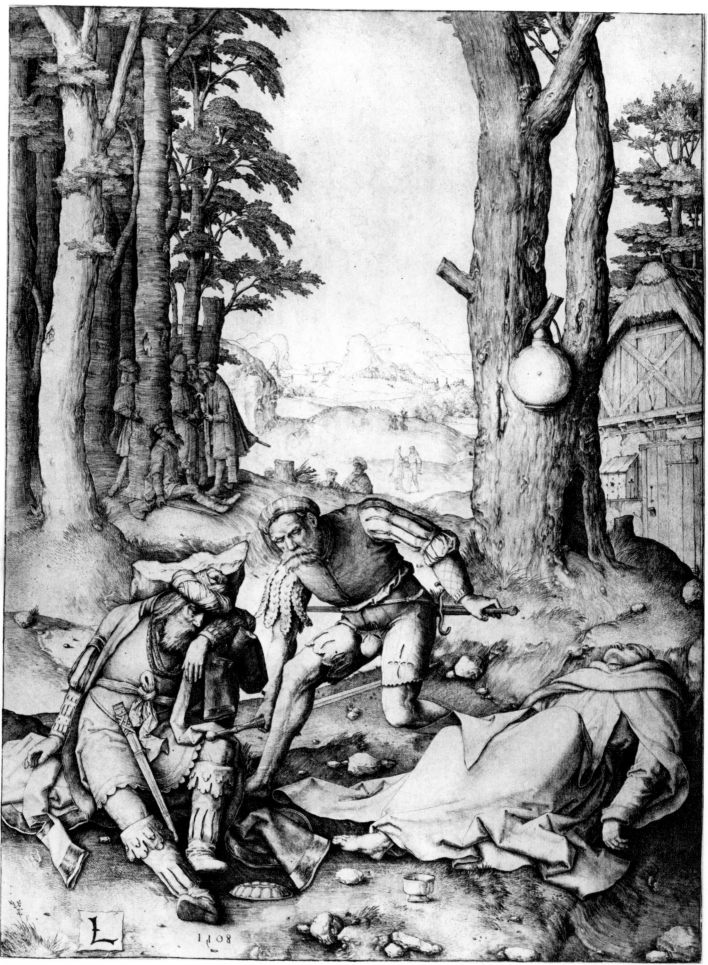

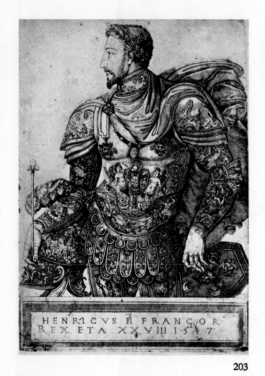

203

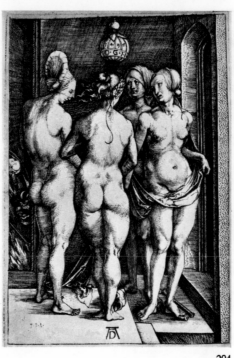

204

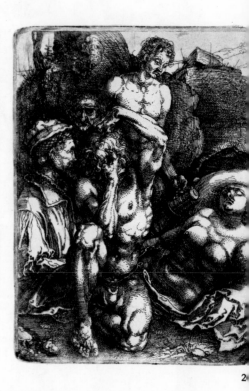

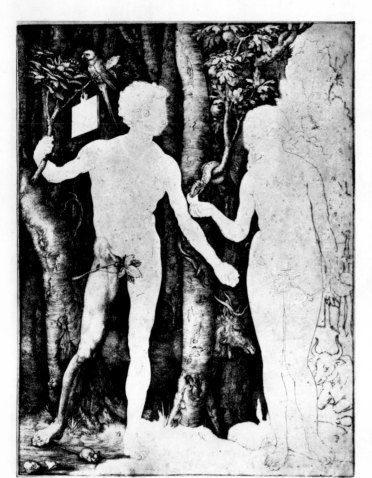

206

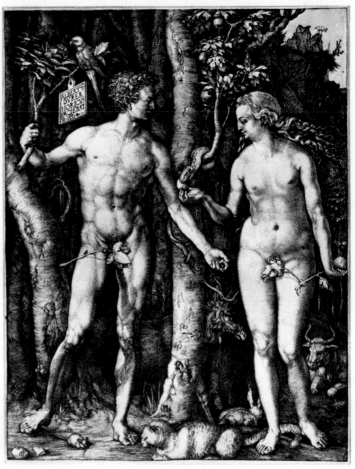

207

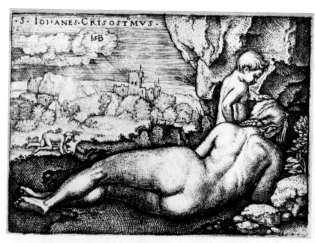

208

Yet Albrecht Dürer (1471–1528) was the undisputed giant of his time, sovereign in every medium of his art. His achievements have already been discussed in the field of the wood block, where he was to a large degree at the mercy of the formcutters. He demanded of them faithful translation of a complicated drawing, with a network of crosshatchings difficult to reproduce with a knife on wood.

Engraving freed Dürer from this dependence. His graver could roam freely over the copper plate and create the finest textures, dots, and lines crossing in any direction, without interrupting the flow of the line. Here the artist could surrender himself completely to his magnificent obsession by telling a story in terms of infinite detail— be it the skin of a woman, the fur of a cat, the bark of a tree, the glint of a helmet, or the soft folds of silk or velvet.

His fecundity is awe-inspiring. During the years 1497–98, at the age of twenty-six or -seven, he is credited with having published not only the woodcut series of the *Great Passion* but also his first notable copper engravings, among them the *Madonna with the Monkey, The Mermaid, The Prodigal Son, The Doctor's Dream*, and a few lesser ones of considerable quality.

His major works were still to come, among which the *Knight, Death, and the Devil* (1513) and the *Melencolia* (1514) have certainly received the greatest universal acclaim and recognition that any print could ever achieve. Aside from their unsurpassed technical brilliance, they convey an air of spiritual depth, of mystery and brooding thought which stirs the imagination.

Among his other outstanding engravings one must mention the admirable *St. Eustace* of 1500 and the *Great Fortuna* and *Great Hercules* of the same year; his incomparable *Adam and Eve* of 1504; and his small copperplate *Passion* of 1514. There followed engravings of Madonnas, saints, and peasants and some remarkable portraits, the *Pirkheimer* of 1524, the renowned *Erasmus of Rotterdam* and the *Philipp Melanchthon* of 1526.

To convey an idea of the scope of Dürer's life and work one must consider the profusion of woodcuts, drawings, and paintings, his experimentation with drypoint, his etchings on iron, his trips to the Netherlands and Italy, and his extensive writings —a breathtaking spectacle of a Renaissance artist's unending search for perfection.

Prominent among his followers were the Kleinmeister (little masters)—the

PLATE 204

PLATES 206, 207

PLATE 205

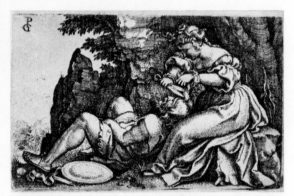

209

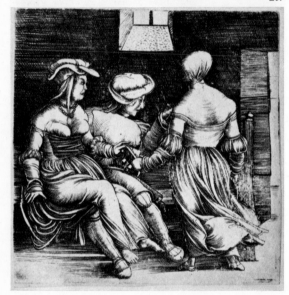
210

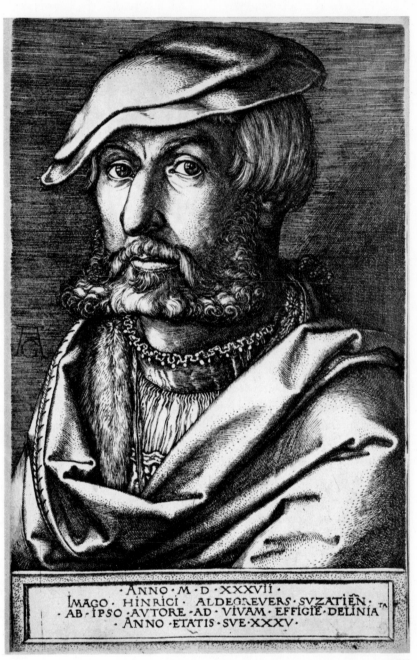
211

209 *Georg Pencz (1500–50).* Delilah Cutting
Samson's Hair. *Engraving, 1 15/16 ×
3 1/16″. Philadelphia Museum of Art*

210 *Erhard Altdorfer.* Young Man with Two
Maids. *c. 1508. Engraving, 3 1/4 ×
3 3/8″. National Gallery of Art,
Washington, D.C. (Rosenwald Collection)*

211 *Heinrich Aldegrever.* Self-portrait Aged
Thirty-five. *1537. Engraving, 7 7/8 ×
5″. Graphische Sammlung Albertina,
Vienna* PLATES 208–211

Brothers Beham, Georg Pencz, Albrecht and Erhard Altdorfer, and Heinrich Alde-
grever. There was nothing small about their work except the format. They were all
consummate draftsmen and storytellers, skilled in the use of the burin. The first four,
all from Nuremberg, became embroiled in the battles of the Reformation and suf-
fered for their revolutionary convictions. Albrecht Altdorfer's interest turned early
to the landscape. Aldegrever, who left more than three hundred engravings, almost
reached Dürer's and Holbein's mastery in his exquisite portraits and his *Dance of
Death.*

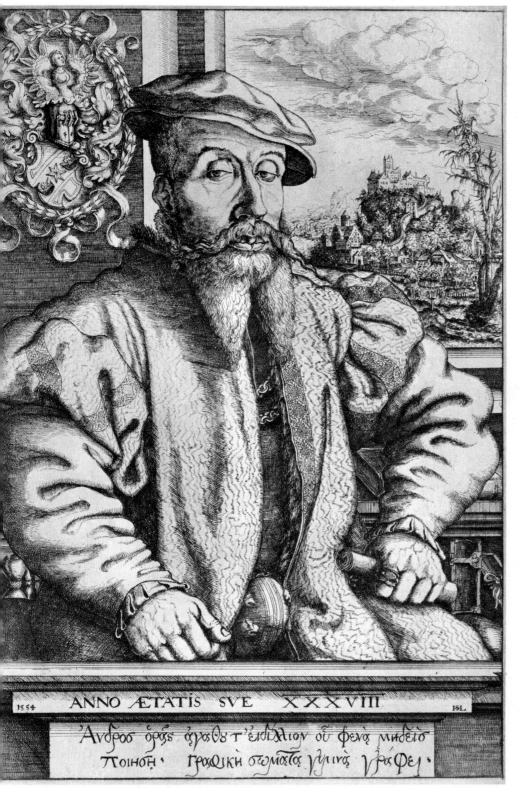

213

212 *Hans Lautensack.* Dr. Georg
 Roggenbach. *1554. Etching and engraving.*
 Philadelphia Museum of Art
213 *Urs Graf.* Landsknecht Seated on a
 Stump. *1513. Engraving. Museum of*
 Fine Arts, Boston (Samuel P. Avery Fund)

214 *Giorgio Ghisi (1520–82).* Venus and Adonis. *Engraving after a design by Teodoro Ghisi, 9 9/16 × 6 11/16". Courtesy William H. Schab Gallery, New York*

215 *Jost Amman.* Portrait of Hans Sachs. *1576. Engraving. New York Public Library, Astor, Lenox and Tilden Foundations (Prints Division)*

216 *Jean Duvet.* Duvet Studying the Apocalypse. *1555. Engraving, 11 7/8 × 8 1/2". Philadelphia Museum of Art*

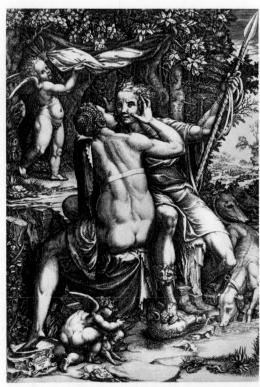

214

215

216

In contrast to Dutch and German heaviness in thought and style, the Italian engravers of the late sixteenth century developed a Latin flair for a swirling, theatrical display of virtuosity. Giorgio Ghisi (1520–1582), with his sons and pupils, Italianized *PLATE 214* grandiose scenes of antiquity into stage spectacles, starkly lit and overpopulated but brilliantly executed. Closely related to this tendency toward Mannerism is the work of Jean Duvet (1485–c. 1561), precursor of the school of Fontainebleau, which drained *PLATE 216* art of its spirit but profaned it elegantly. The Baroque made its boisterous entrance with Federico Baroccio (c. 1525–1612) as its figurehead.

Hendrik Goltzius (1558–1616) represents perhaps the peak of technical per- *PLATE 217* fection that can be achieved with the tip of a burin. His admiration for the most famous artists of his time, from Lucas van Leyden to Michelangelo, tempted him to improvise interpretations of their work which he euphemistically called *Masterpieces of Goltzius*. However, they surpass technically anything ever tried by Marcantonio Raimondi, culminating in the scintillating muscle play of the *Farnese Hercules*.

Peter Paul Rubens (1577–1640) himself hastened the commercial exploitation of engraving and its decay as a free creative medium by fostering a school of pro- fessional engravers subservient to him and to the ever-increasing demand for repro- ductions of his paintings. Lucas Vorstermans, a Goltzius pupil, later immortalized in the famous portrait by Van Dyck, became one of Rubens's most brilliant interpreters.

The Rise of Etching

It is said that Dürer first became interested in etching after seeing some prints by his *PLATES 218–228* Augsburg neighbor, Daniel Hopfer (c. 1493–1536), whose etched portraits—of *PLATES 218, 219* Hieronymus, nephew of Pius III, and of Kunz von der Rosen, buffoon of Maximilian I—have a strange whimsical quality unlike the stately engraved portraits done by his German contemporaries. Hopfer is actually credited with being the "inventor" of etching, a distinction he may have to share with Urs Graf, whose earliest etching is *PLATE 224* dated 1513, the first known dated print in this medium.

Perhaps the use of acid on metal, first employed by armorers and goldsmiths, gave the artist a much needed release from drudgery. It certainly must have been a revelation to trace a flowing line easily through wax ground and see the acid do the rest of the work. The effect of the bitten line was, of course, different from that of an engraved one. It looked casual against the precisely controlled line cut deeply with the point of a graver.

However, that must have been exactly the attraction etching had for such artists as Augustin Hirschvogel (1503–1553), in love with roaming and sketching his native *PLATE 222* countryside. His restlessness is further manifested by the fact that he was also a potter, astronomer, cartographer, mathematician, and enameler. One can visualize him sitting in a landscape with a grounded metal plate on his lap.

It is always interesting to speculate who influenced whom in this competitive game of printmaking. Dürer experimented with etching, an exciting new medium, between 1515 and 1518 and produced altogether five etchings on iron, among which the *Great Cannon* is certainly the most remarkable. Perhaps he was dissatisfied with the irregular bite and the fuzzy lines, since he gave up etching afterward; but he is said to have passed on his knowledge to Lucas van Leyden, whom he met later in Antwerp.

This is turn may have resulted in Lucas's famous portrait of Maximilian I, in

which he not only used etching on copper for the first time but also mixed his media by engraving the face of the Emperor with the burin, discovering, no doubt, that copper was easier to etch than iron. The iron plate of Hans Burgkmair's *Mercury and Venus,* preserved in the British Museum, gives us an opportunity to study that hard and stubborn material and its reaction to acid.

In Italy the new informal medium immediately achieved a popularity which it held for several centuries. Leading the way was the painter Parmigianino (1503–1540)—a man "with the soul of Raphael," according to Vasari—whose early etchings show a freedom of line unusual for that period.

PLATE 225

His fellow countryman Federico Baroccio used etching in a more formal style, but his *Annunciation* has a lovely looseness that could hardly be achieved with a graver.

PLATE 227

Baroccio lived in the shadow of the great Caravaggio (1573–1609), who did not entirely approve of the informal style fostered by his pupil Ribera (1588–1652), an artist whose etching technique was widely admired and imitated by later generations of artists, led by the Tiepolo family, and studied by such masters as Rembrandt, Castiglione, and Goya.

From here on disciplines were freely mixed; the drypoint and the burin took over whenever an etched plate needed strengthening or emphasis, and the distinctions were often as fine as a hairline. Now etching burst into its great flowering, pushing engraving, which had deteriorated into a reproductive medium, off the stage.

PLATES 229–243

Callot and His Influence

Independent artists seized upon etching as the medium of freedom and fluency. An important exponent appeared on the scene in the person of Jacques Callot (1592–1635). An adventurous man of many facets, known mainly through his etchings,

PLATES 229, 231

Callot has not lost any of his fascination and glamour through the centuries. His work reflects the turbulent time in which he lived. A native of Nancy, capital of Lorraine and a pawn in the battles between France and the Holy Roman Empire, Callot saw war and its unspeakable atrocities at close quarters. He was trained in Rome as a hack engraver but soon established himself as an independent etcher in Florence under the patronage of the Medici. Experimenting with the hard varnish of lutemakers, he created his first series of small etchings, the *Capricci* (1618), based on the characters of the *commedia dell' arte,* of a brilliance and precision in detail which previously only a master's burin could have produced. It was the prelude for an avalanche of prints, more than 1,400, which included the gigantic panorama of the *Siege of Breda* (consisting of six large folio plates); his most famous series, *The Miseries of War;* and an odd assortment of Christian pieties and savage grotesqueries: hunchbacks *(The Gobbi)* and beggars, Christ's Passion and gypsy caravans, lovers and martyrs, the Life of the Virgin, and scenes of torture. During his short life, cut off at forty, he worked at everything with a detached intensity, with a reporter's eye for detail, and, it seems, with a complete lack of sentimentality. His great *Impruneta,* dedicated to Cosimo de' Medici, shows a crowd enjoying the pleasures of a country fair combined with a public hanging; it contains, by some art historian's head count, 1,138 figures, 45 horses, 67 donkeys, and 137 dogs!

Callot's work has survived, undiminished in popularity, for three centuries. Van Dyck painted his portrait; princes and kings competed for his favor; Hogarth col-

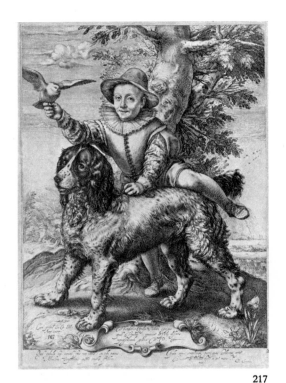

217

217 *Hendrik Goltzius.* Portrait of Master de Vries. *1597. Engraving, 13 3/8 × 10 1/4". Metropolitan Museum of Art, New York (Harris Brisbane Dick Fund, 1926)*

218 *Daniel Hopfer.* Proverbs of Solomon. *Early 16th century. Drawing. Philadelphia Museum of Art*

219 *Daniel Hopfer.* Proverbs of Solomon. *Early 16th century. Etching. Philadelphia Museum of Art*

218

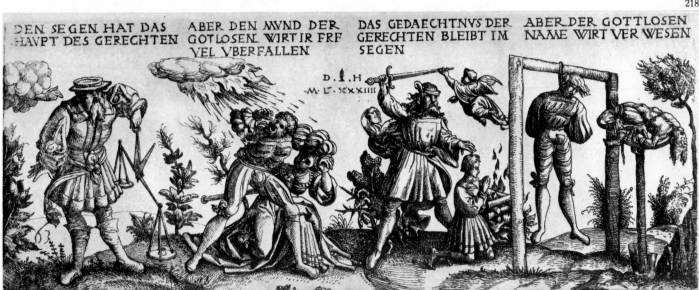

DEN SEGEN HAT DAS HAVPT DES GERECHTEN ABER DEN MVND DER GOTLOSEN WIRT IR FRE VEL VBERFALLEN DAS GEDAECHTNVS DER GERECHTEN BLEIBT IM SEGEN ABER DER GOTTLOSEN NAME WIRT VER WESEN

219

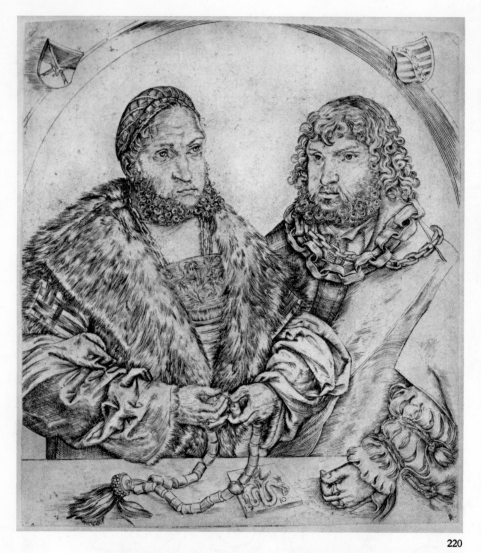

220

221

224

222

223

225

226

227

220 *Lucas Cranach the Elder.* The Two
Electors: Albrecht the Courageous and
His Son, Heinrich the Pious. *1510.
Engraving, 5 1/8 × 4 5/8". Museum of
Fine Arts, Boston*

221 *Hieronymus Hopfer.* Pope Alexander VI.
*Early 16th century. Etching.
Philadelphia Museum of Art*

222 *Augustin Hirschvogel.* Self-portrait.
*1548. Engraving. Staatliche Graphische
Sammlung, Munich*

223 *Conrad Buno.* Ferdinand Albert, Duke of
Brunswick. *16th century. Etching and
engraving. Philadelphia Museum of Art*

224 *Urs Graf.* Woman with Her Foot in a
Basin. *1513. Etching (heliotype from
original impression). Museum of Fine Arts,
Boston*

225 *Federico Baroccio.* St. Francis in His
Chapel. *1581. Etching. Museum of Fine Arts,
Boston (gift of Mrs. Lydia Evans Tunnard
in memory of W. G. Russell Allen)*

226 *Franz Anton Maulbertsch (1724–96).*
St. Florian. *Engraving. Metropolitan
Museum of Art, New York (Whittelsey
Fund, 1949)*

227 *Jusepe de Ribera.* St. Jerome Reading.
*1621. Etching. Fogg Art Museum,
Harvard University, Cambridge, Mass.*

228

229

228 *Giovanni Benedetto Castiglione (1616–70).* Tobit Burying the Dead. *Etching, 7 3/4 × 11 1/2".*
 Collectrion the author

229 *Jacques Callot.* Les Deux Pantalons. *1621. Etching. New York Public Library, Astor, Lenox and
 Tilden Foundations (Prints Division)*

230 *Wenzel Hollar (after Meyssens).* Portrait of Hollar in His Workshop. *17th century. Etching,
 6 3/8 × 4 1/2". Museum of Fine Arts, Boston*

230

231

231 *Jacques Callot. Soliman: Act V. 1620.
Etching and engraving. National
Gallery of Art, Washington, D.C.
(Rosenwald Collection)*

232 *Wenzel Hollar. Elements of costume
from the series Muffs. 1647. Etching.
Museum of Fine Arts, Boston*

232

lected his work; Goethe, Sir Walter Scott, and Anatole France were fascinated by him; Mahler composed a *Death March* in his honor. Rembrandt may have been influenced by his technique, as were Wenzel Hollar, who copied his work, and Abraham Bosse, who studied with him.

Hollar (1607–1677) is described beneath his portrait print as a "gentleman born at Prague [who] was by nature much inclined toward the art of miniature." Working in London, he left about three thousand plates of assorted subject matter, from views of the city and perceptive portraits to exquisitely etched small subjects such as muffs and seashells. He excelled in representing every sort of texture. Yet, despite his skill and diligence, he died in poverty.

PLATES 230, 232

Abraham Bosse (1602–1676), known for his *Traicté des Manières de Graver*, published in 1645, and his series *The Five Senses*, etched in the conventional ornate manner of an engraver, somehow defeating the unique advantages etching offered.

PLATE 234

Callot had established a way not only of etching deeply but also of cutting through the ground into the copper in order to obtain larger editions of his plates; this practice was continued by his students and admirers, including Bosse.

PLATE 233

Perhaps less influenced but much impressed by Callot was Stefano della Bella (1610–1664), a Gallicized Florentine who had studied with Callot's teacher, Cantagallina. Della Bella's subject matter followed that of the master—sieges, battles, fetes, and caprices—but in some instances he surpassed Callot in feeling and intensity.

PLATE 236

A compatriot of Callot's was Jacques Bellange (1594–1638), product of the school of Lorraine, a skillful and prodigious etcher specializing in feminine pulchritude. He managed to make the *Three Maries at the Tomb* look like harlots discussing their sordid business. Imbued with an air of elegant corruption, his work provided inspiration for a host of lesser Mannerists.

PLATE 240

Another famous Lorrainese, Claude Gellée, known as Claude Lorrain (1600–1682), distinguished himself as a landscape artist, with a legacy of about thirty fine etchings based on his own paintings.

PLATE 238

His work seems related to that of the moody Dutchman Hercules Seghers (c. 1589–1633/38), a man obsessed with the mysterious spirit that inhabits forests and hills, rocks and trees. Never satisfied with the mere outward appearance of things, he tried to change nature into something enchanted that only he could see. Some seventy of Seghers's etchings are left—many of them unique. He was the first etcher to experiment extensively with colored inks, colored paper, opaque white on dark ground, and printing on linen. A tortured soul, finding no recognition in his time, he drowned his sorrow in drink and died in a fall downstairs. Nevertheless, he gained the distinction of being admired by Rembrandt, who collected Seghers's prints and paintings and even worked over some of his plates, changing Seghers's brooding *Tobias and the Angel* into an equally moving *Flight into Egypt*.

PLATES 242, 243

Set apart in a niche of its own is the *Iconography* of Sir Anthony Van Dyck (1599–1641), a private hall of fame consisting of 128 prints, of which he began to etch sixteen. The rest were finished by professional engravers under his guidance. By far the most impressive are Sir Anthony's unfinished portraits of his more or less illustrious colleagues and friends, whose faces and characters he preserved for posterity.

PLATES 244–263

Rembrandt and His Times

Rembrandt van Rijn (1606–1669) is the etcher we approach with awe. There is no comparable phenomenon to measure against him. The son of a miller, without much of an education, never leaving his native environment, he rose to rare heights of humanity through living, working, rejoicing, and suffering as a man of the people. Collecting art treasures, running through a small fortune, abandoned by his patrons, living in the ghetto, ending as a pauper, he poured his soul into his work, where it has continued to shine through the ages. In his later years the Bible became his world, peopled with Dutch burghers in Oriental costumes, with the patriarchal Jews who were his neighbors, with beggars, squalling children, gossiping housewives—all observed in the narrow streets of Amsterdam.

It seems presumptuous in this small space to evaluate the work of a genius, distilled in the crucible of life, forever growing, developing, maturing. One of Rembrandt's first etchings, a portrait of his mother dated 1628, is a small masterpiece by a twenty-two-year-old prodigy; his last one, *Woman with the Arrow*, dated 1661, is a farewell to what he cherished most in life. Thirty-three years were devoted to the

233

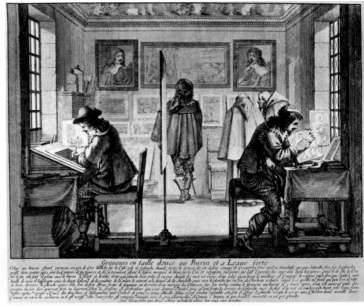

234

235

236

233 *Stefano della Bella.* The Plague, *from the series* Five Deaths. *c. 1660. Etching. Philadelphia Museum of Art*

234 *Abraham Bosse.* Engravers and Etchers. *1643. Etching, 10 × 12 3/4". Courtesy William H. Schab Gallery, New York*

235 *Willem Buytewech.* English Nobleman. *Early 17th century. Etching, 7 11/16 × 2 3/4". Metropolitan Museum of Art, New York (gift of A. Hyatt Mayor, 1953)*

236 *Jacques Bellange.* St. John. *c. 1602–17. Etching, 11 1/4 × 6 1/2". Museum of Fine Arts, Boston*

237 *Giovanni Battista Bracelli.* Bizarre Figures. *c. 1624–49. Etchings. National Gallery of Art, Washington, D.C. (Rosenwald Collection)*

238 *Hercules Seghers.* The Rocky Valley. *Early 17th century. Etching printed in brown on brown-tinted paper, 4 1/4 × 7 1/2". National Gallery of Art, Washington, D.C. (Rosenwald Collection)*

239 *Hendrik Goudt (after Adam Elsheimer).* Tobias and the Angel. *1608. Engraving, 11 1/2 × 15 5/8". National Gallery of Art, Washington, D.C. (Rosenwald Collection)*

240 *Claude Lorrain (Gellée).* Dance Under the Trees. *Mid-17th century. Etching, c. 5 3/8 × 7 1/2". Museum of Fine Arts, Boston*

237

238

239

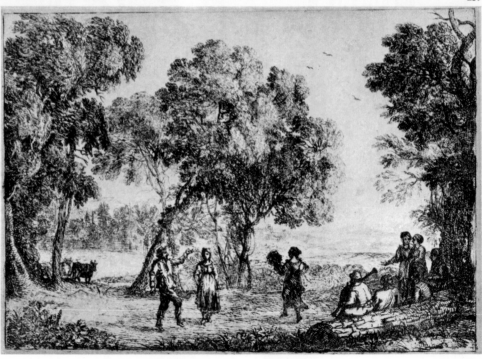

240

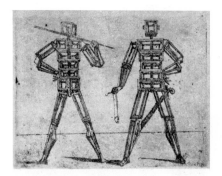
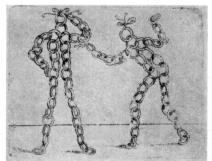
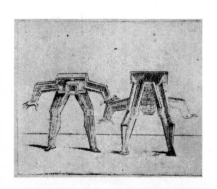

241 *Claude Mellan*. Sudarium of St. Veronica.
*1649. Engraving, composed of a single unbroken
line, 17 1/8 × 12 1/2″. National Gallery
of Art, Washington, D.C. (Rosenwald
Collection)*

242 *Anthony Van Dyck*. Pieter Brueghel the
Younger. *c. 1634. Etching (lightly etched
state). National Gallery of Art, Washington,
D.C. (Rosenwald Collection)*

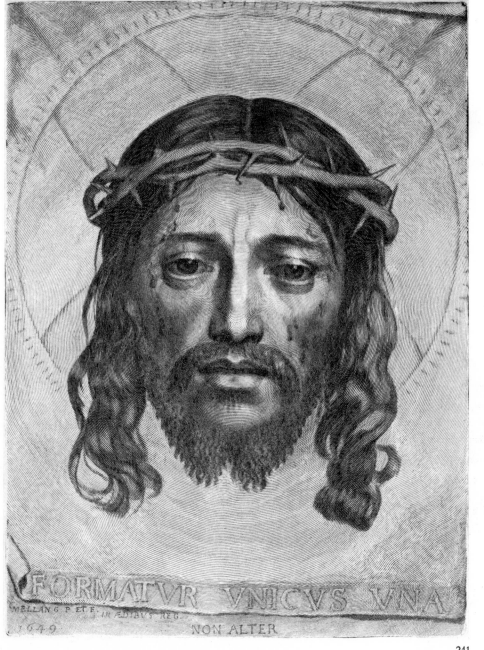

241

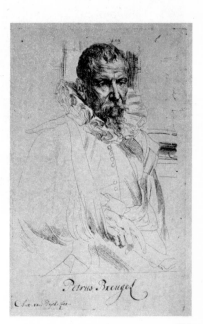

242

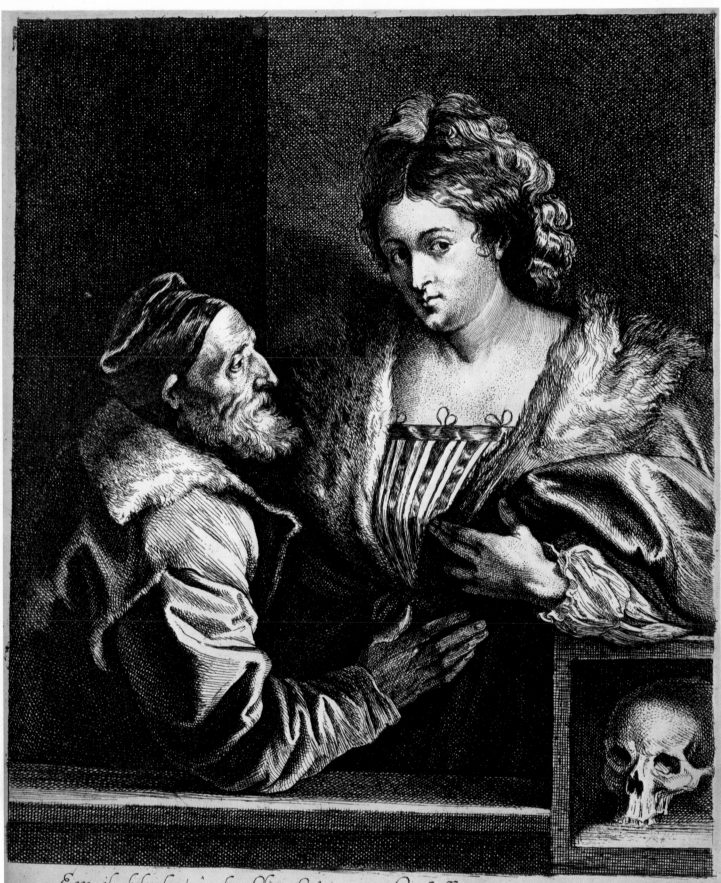

Ecco il belveder! ò che felice sorte! Ma ch'ella porte, ò me, vita et morte piano
Che la fruttifera frutto in ventre porte. Demonstra l'arte del magno Titiano.

Al molto illustre, magnifico et osseruandis.^{mo} Sig.^r il SIG.^R LVCA VAN VFFEL, in segno d'affection et inclinatione
amoreuole, como Patrone et singularis.^{mo} amico suo dedicato il vero ritratto del vnico Titiano Ant. van Dyck.

pursuit of a medium to a point of absolute perfection, attempted by many after him but never reached by anyone.

Though his etchings have been scrutinized and classified relentlessly by so many experts, one is not sure of their number. There are so many states and trial proofs; there were so many pupils working in his studio, often copying his prints; there were many imitators on the outside. Some critics believe that of the two to three hundred etchings only a third can safely be attributed to the master. There are restrikes and worked-over plates, printed after his death. Leaving aside the problems of scholarship, we are free to enjoy what moves us most: the kaleidoscope of his self-portraits, from dashing swain to craggy oldster; the brooding landscapes; the stark drama of Christ's Passion; the deft and sensuous nudes; the deep faith that shines through the scenes of the Old and New Testaments, culminating in the "Hundred Guilder Print." These prints are treasures belonging to the world, speaking to many human needs in universal terms of simplicity and beauty.

What were his tools and how did he reach such perfection? We do not know who—if anyone—taught him the rudiments. He was not beholden to any trend or school; he etched as he drew. He used the then conventional soft ground made up of wax, asphaltum, and mastix on thin, cold-hammered copper plates which, if treated well, would permit well over fifty good prints. His ground may have been white, on which he could trace or draw in black quite easily. He also might have used the more traditional smoked plate, on which the exposed line would shine copper red against black. No records are left as to the acid he used, but it must have been a potent mixture, possibly of saltpeter, vitriol, and alum. After a quick and deep biting, the drypoint and burin went into action to achieve the decisive darks, the velvety shadows. Often the burnisher would flatten out whole parts to be replaced or changed to strengthen the composition.

Recent investigations by staff members of the Rijksmuseum, the British Museum, the Pierpont Morgan Library, and the Boston Museum of Fine Arts have revealed that Rembrandt used a great variety of papers: in the beginning European (German, Swiss, or French), the grayish cartridge paper, later Indian, and the warm, more yellowish Japanese mulberry paper of various weights. In rare cases he printed on very thin vellum. All the handmade papers were readily available in the great seaport of Amsterdam, which also boasted many publishing houses and print shops, consumers of large amounts of fine paper also suited for Rembrandt the etcher. Printmaking had become a thriving business, and many of Rembrandt's Dutch fellow artists tried to profit by it, none of them reaching the master's heights. They stayed on the safe side of things, pleasing the burgher's simple tastes.

Adriaen van Ostade (1610–1684) showed the bucolic life of the peasant; Adriaen van de Velde (1636–1672) and Karel Dujardin (1622–1678) presented Holland's pride, complacent well-fed cattle; Jacob van Ruisdael (1628/9–1682) turned out prints of the majestic trees and forests which had made his paintings famous.

The demand for prints seems to have been extraordinary. There was a network of enterprises spreading across Europe which promoted and satisfied the popular demand for maps, portraits, religious prints, political broadsides, and illustrated books. The pioneer among these mercurial publishers and printsellers was the Dutchman Hieronymus Cock (c. 1510–1570), who was also a skillful etcher and engraver. Pieter Bruegel was one of his most valuable "properties." It was the practice among

243 Anthony Van Dyck (after Titian). Titian and His Mistress. c. 1626–32. Etching, c. 9 1/4 × 12″. British Museum, London

PLATES 250–255

PLATES 244–248

PLATE 249

PLATES 258, 260

COLORPLATE 33

PLATES 261–263

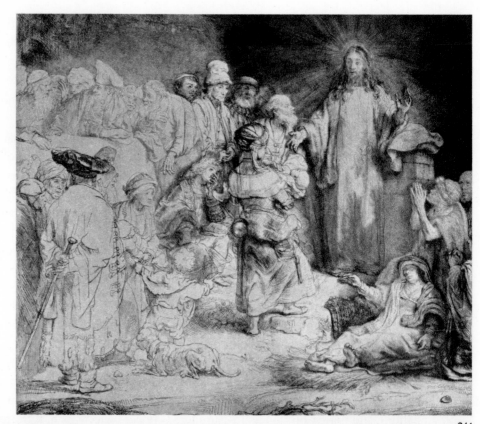

245 Rembrandt. *"The Hundred Guilder
Print"* (Christ with the Sick). *1649.
Etching, 11 1/16 × 15 1/2". National
Gallery of Art, Washington, D.C. (gift
of R. Horace Gallatin)*

244, 246–248 Rembrandt. *Details of "The
Hundred Guilder Print"*

244

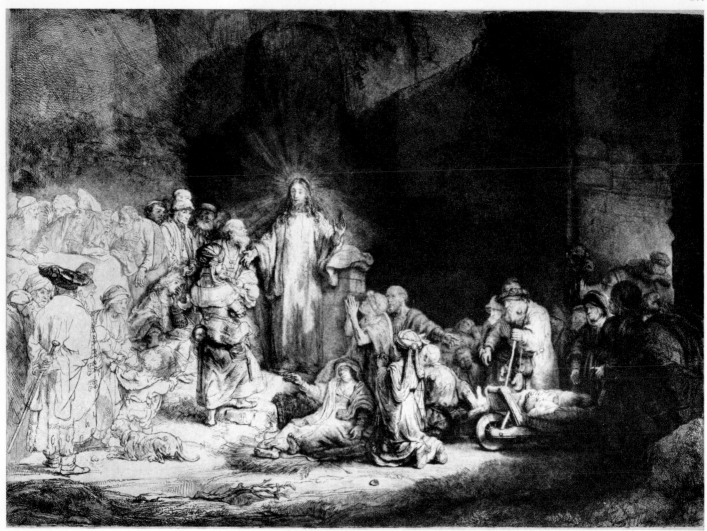

245

246

247

248

249

249 Rembrandt. The Artist and His Model.
*1639. Etching, 9 × 7 1/8″. National
Gallery of Art, Washington, D.C.
(Rosenwald Collection)*

printsellers in those days to buy the original plate from the artist-engraver. They would then pull as many prints as the traffic would bear and, if necessary, have the worn-out lines reworked by a stable of artisans, often distorting the original work beyond recognition. Many were family enterprises such as those of the Galles and the Passes in Holland, the Flemish Sadelers and the Custos, and the Salamancas in Italy, who sent their emissaries across Europe to set up shop wherever business seemed promising.

The market for the popular print in Europe was steadily expanding, as roads became safer and commerce increased. Travelers liked to take home picturesque maps, views of exotic new discoveries, portraits of famous people, broadsides of popular attractions, political pamphlets, pictures of saints and sinners—all skillfully engraved and reasonably priced.

With rising literacy went the greater consumption of books, devotional and secular, by a public educated through exposure to a great variety of prints.

The Italian Scene

PLATES 264–268

Giovanni Battista Tiepolo (1696–1770), the last of the old Venetian painters, decorator extraordinary, established his own school and dynasty of etchers. His skill was unquestioned, his taste often scurrile, his themes ambiguous. His style of etching, however, somewhat modeled after that of G. B. Castiglione (1616–1670), Rembrandt's disciple, is light, airy, and competent.

PLATE 264

Of Tiepolo's two sons, Giovanni Domenico (1726–1804), born in Madrid, was the abler and a great help to his father, whose designs he copied. However, his own series of twenty etchings, variations of the *Flight into Egypt,* show him as an imaginative inventor on his own.

PLATE 265

Antonio Canale (1697–1768), also called Canaletto, another Venetian in love with the charm of his city, left some thirty etchings full of surface delight, dedicated

PLATE 267

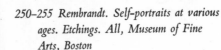

250–255 Rembrandt. Self-portraits at various ages. Etchings. All, Museum of Fine Arts, Boston

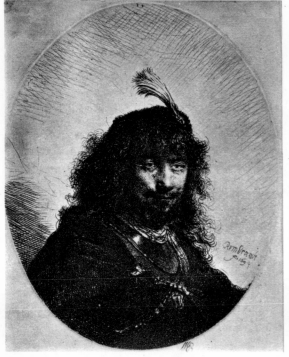

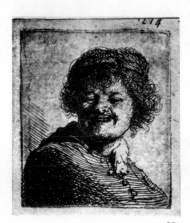

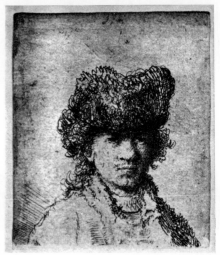

to the glory of Venice. With him a vivid interest in architecture came to the fore in Italian printmaking.

Giovanni Battista Piranesi (1720–1778), a Venetian who had moved to Rome, gave his lifetime to the recording of that city's illustrious past. An enterprising man, amateur architect and archaeologist, he published altogether twenty-seven volumes on Rome's antiquities, with a profusion of plates. By necessity he sought the assistance of a large staff of helpers, among them his two sons, Francesco and Pietro, and his daughter, Laura. He left nearly two thousand plates, not all of the first quality, often corrected, embellished, and reprinted.

PLATES 266, 268

His most important work remains the two editions of the *Invenzione Capricciosa di Carceri*, known as *The Prisons*. Here a feverish imagination bursts forth with un-Venetian abandon; meandering staircases lead nowhere under vast and useless vaults; suggestions of unspeakable horrors hover in the swinging ropes, chains, and pulleys. These prints must have fascinated Kafka as they did Melville, Coleridge, and Poe. Their unusually large format adds to their hypnotic power; they display the imagery of a disturbed mind, a grand preview of the theater of the absurd.

The Ancien Régime in France

It was natural that the self-indulgent court of the *Roi Soleil,* Louis XIV, would foster the portrait for its own aggrandizement. In the tradition of Van Dyck and Claude Mellan, Robert Nanteuil (1623–1678) raised the engraved portrait to the rank of art, officially so endorsed by edict of the king. More than two hundred portraits of the great and semigreat of his time issued from his hands, well observed, tightly engraved, and elaborately "framed" and documented calligraphically.

PLATES 269–280

PLATES 269–271

Among these figures was Cardinal Mazarin, the great intriguer, who must, however, be credited with a genuine love for prints. In 1644 he started a collection which in twenty years grew to more than 120,000 in number and became the

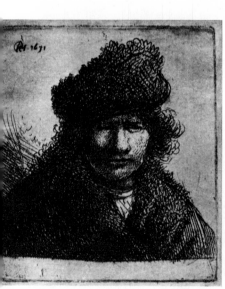
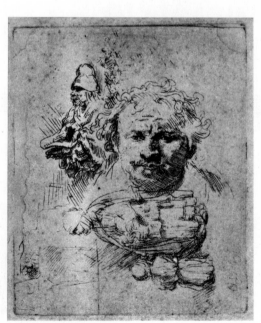
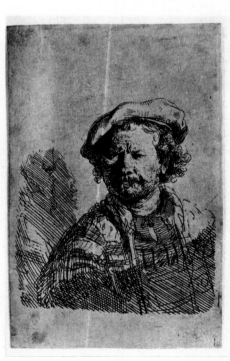

253 254 255

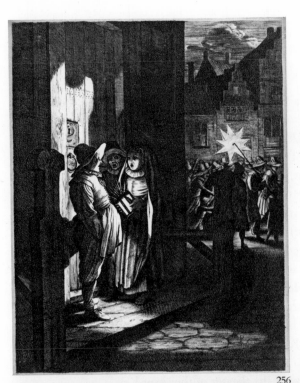

256

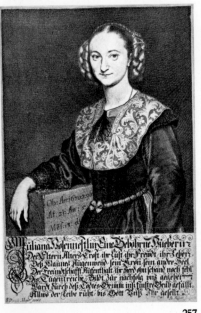

257

258

256 *Jan van de Velde*. Star of the Kings. *Mid–17th century. Etching. Fogg Art Museum, Harvard University, Cambridge, Mass.*

257 *Bartolome Kilian (after J. Ulrich Mayr). Juliana Rosennestal. 1670. Engraving. Philadelphia Museum of Art (Charles M. Lea Collection)*

258 *Adriaen van Ostade*. The Singers. *Mid–17th century. Etching. National Gallery of Art, Washington, D.C. (Rosenwald Collection)*

259

260

259 *Dirk Vellert.* The Deluge. *1544. Engraving. National Gallery of Art, Washington, D.C. (Rosenwald Collection)*

260 *Adriaen van de Velde.* Shepherd and Shepherdess with Their Flocks. *1653. Etching. Museum of Fine Arts, Boston*

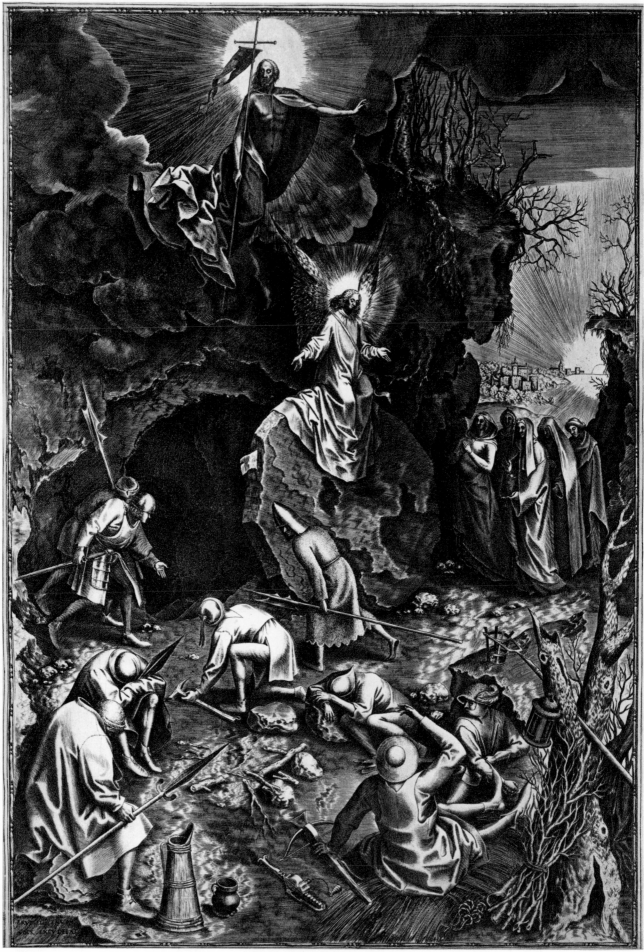

261 Resurrection *(after a drawing by Pieter Bruegel the Elder, engraved by Philip Galle?)*, published by Hieronymus Cock, 1559. Engraving. National Gallery of Art, Washington, D.C. *(Rosenwald Collection)*

262 Hieronymus Cock *(after Hieronymus Bosch)*. Shrove Tuesday (Dutch Kitchen with Wafer Bakery). *1567.* Engraving. Philadelphia Museum of Art

263 Hieronymus Cock *(after Pieter Bruegel the Elder)*. Faith, *from the series of* The Seven Virtues. *1559–60. Engraving, 8 7/8 × 11 5/8". National Gallery of Art, Washington, D.C. (Rosenwald Collection)*

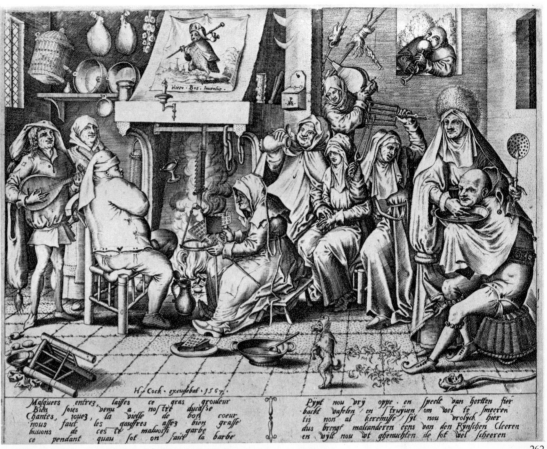

262

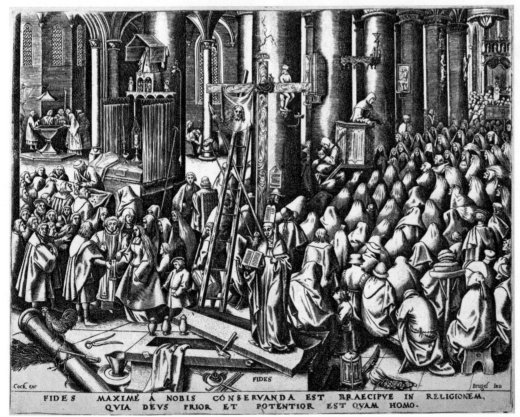

263

264

264 *Giovanni Battista Tiepolo.* Punchinello Talking to Two Magicians, *from Scherzi di Fantasia, published 1775. Etching, 9 1/8 × 7 1/4". Yale University Art Gallery, New Haven, Conn. (gift of the Associates in Fine Arts)*

265 *Giovanni Domenico Tiepolo.*
Rest on the Flight into
Egypt. 1753. Etching.
Museum of Fine Arts, Boston
266 *Giovanni Battista Piranesi.*
Temple of Castor and
Pollux. 1746. Etching.
Museum of Fine Arts, Boston
267 *Antonio Canale (Canaletto).*
The House with a Date.
1741. Etching (one of three
known impressions taken
before the plate was cut in
half). Fogg Art Museum,
Harvard University,
Cambridge, Mass.
268 *Giovanni Battista Piranesi.*
The Appian Way near
Albano. Published 1764.
Etching. National Gallery of
Art, Washington, D.C.
(Rosenwald Collection)

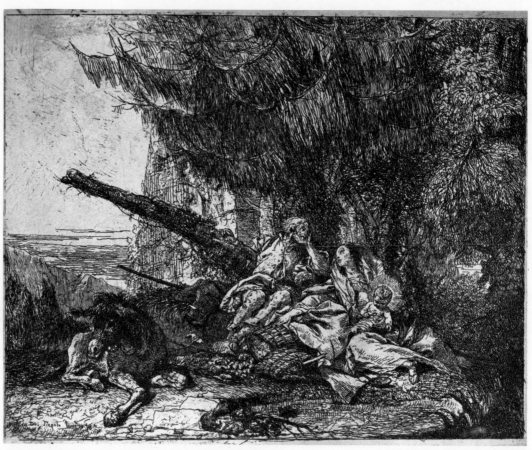

265

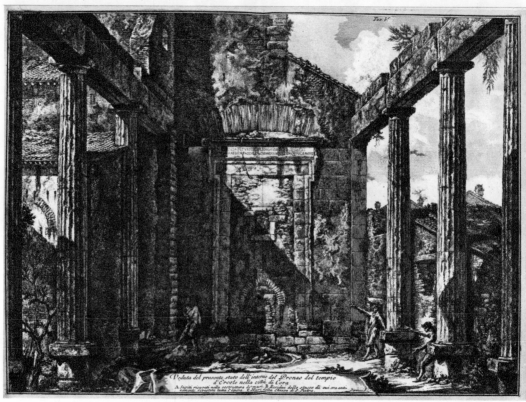

266

nucleus of the world's largest and perhaps finest print depository, the Bibliothèque Nationale in Paris.

There were, of course, other artists of that period worth mentioning, among them Moreau le Jeune, Eisen, St. Aubin (Gabriel, Germaine, and Augustin), Niclas Lafrensen (Lavreince), and Nicolas Delaunay.

PLATE 277

Great strides were made in the manner and methods of engraving. Etching had been very much influenced by its undisputed master, Rembrandt, and his Italian followers, but it had not achieved a greater degree of perfection. It began to serve rather as a point of departure in the preparation of an engraved plate, a kind of sketch on metal.

As collectors of drawings became more numerous, new methods of reproduction

267

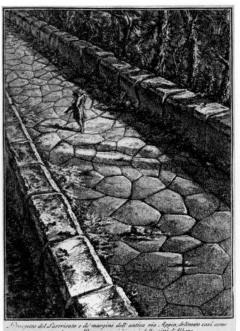

Prospetto del lastricato e de' margini dell' antica via Appia, delineato così come si vede verso Roma poco più in qua della città d'Albano.

268

were investigated. The Belgian Demarteau developed the roulette technique, which came close to duplicating the crayon line on copper; it was most successfully used in reproducing Boucher's drawings, often in various pastel colors. The German Le Blon perfected engraved color prints in London and Paris; he made a famous portrait of Louis XV, using a separate plate for each color.

The stipple technique competed with the "crayon manner" in imitating drawing textures. The mezzotint (see Chapter 12), beginning in the seventeenth century, had made great strides in England for the reproduction of paintings, mostly portraits, but had found little acceptance in France. By the 1760s several people, including J. -B. Le Prince, were claiming credit for the invention of a method of accurately reproducing watercolors by aquatint.

COLORPLATE 34

It is difficult to look back from the vantage point of a rational, computerized, and tough-minded society to the frivolous and rose-colored fool's paradise of aristocratic eighteenth-century France and be objective. Antoine Watteau (1684–1721)

PLATE 278

left a few fine etchings, strongly influenced by the techniques of Tiepolo and Piranesi, and many volumes of engravings made after his paintings and drawings. They show the "beautiful people" at play, as if Versailles were the center of the world, as if no Turkish army were laying seige to Vienna and no Swedes invading from the north. One unusual exception to his favorite subject matter is his etching *Recruits Joining Their Regiment*.

François Boucher (1703–1770), according to Renoir "Master of Breasts and Buttocks," was court painter and Director of the Académie des Beaux-Arts, quite evidently a busy man. He could also employ skilled engravers to translate his popular

PLATE 279

paintings and drawings into prints; they were much in demand in elegant French boudoirs. Illustrated books had become the rage, and Boucher, like many others aided by the efforts of professional engravers, designed thirty illustrations for the works of Molière, published in 1734 and engraved by Laurent Cars, who descended from a long line of distinguished engravers and was something of an artist in his own right.

Charles-Nicolas Cochin (1715–1790) also came from a famous family of engravers. He not only excelled in engraving the work of others but also created a volume of creditable prints and illustrations under his own name. Engraving, in fact, had become so fashionable that the nobility and well-to-do bourgeoisie took it up with a vengeance. Witness the efforts of Madame de Pompadour, who, aided by

269

270

271

269 Robert Nanteuil. Marin, Cureau de la Chambre de Médecin.
 Drawing. National Gallery of Art, Washington, D.C. (Rosenwald
 Collection)
270 Robert Nanteuil. Marin, Cureau de la Chambre de Médecin.
 Third quarter of 17th century. Engraving. National Gallery of Art,
 Washington, D.C. (Rosenwald Collection)
271 Robert Nanteuil. Louis, Dauphin of France. *1677. Engraving.*
 Philadelphia Museum of Art
272–274 Pierre Lombart (active 1648–81; after Van Dyck). *Equestrian*
 portrait: third state, lightly engraved with head of Louis XIV; fifth state,
 Cromwell on Horseback; sixth state, with head of Charles I
 substituted. Engraving, c. 21 × 14". All, British Museum, London

272

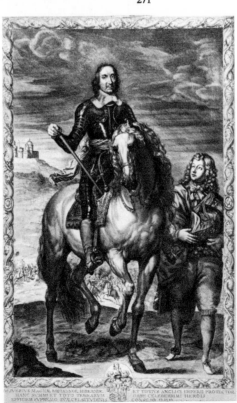

273

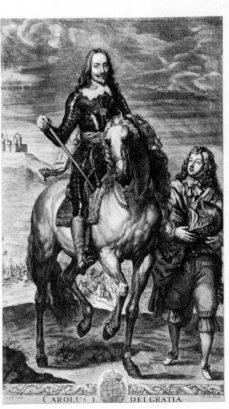

274

PLATE 275

Cochin, produced fifty-two etchings after Boucher and saw them through their printing in 1760.

Jean-Honoré Fragonard (1732–1806), strongly influenced by his teacher Chardin and his elder friend Boucher, represents most tellingly the frivolity of the close of the *ancien régime*. As an etcher he is perhaps most admirable in his Venetian-influenced etchings, the satyr scenes done during his early years of study in Italy.

By the mid-eighteenth century, prints had become big business; to sell an edition was more lucrative than to sell the original painting. Artists such as Greuze and Chardin had begun to organize engraving studios and distribution networks for their own work.

British Satirists and Visionaries

In England quite a different school of etchers and engravers, initiated by William Hogarth (1697–1764), entered the arena of social and political life. We think of Hogarth mainly as an engraver, the creator of a notable series of moralizing prints showing *The Harlot's Progress, The Rake's Progress, Industry and Idleness,* and *Marriage à la Mode,* through which he preached and admonished, exposing the foibles of British society with no holds barred. His engravings were based on paintings he could not sell; through his prints he gained popularity. In his later series he had the help of professional engravers who shared the credit with him.

PLATES 281–283

It is likely that he started on many of his engraved plates with lightly etched guidelines. He promoted the subscription of his series with etched invitations which show him in his best, less heavy, style. The scathing portrait of Lord Lovat is an

275

275 *Madame de Pompadour (after Boucher).* Child. 1760. *Etching. Bibliothèque Nationale, Paris*

276 *Matteo Ripa.* Fragrant Water, *from* Thirty-six Views of Jehol. *1713. Etching, 10 3/4 × 11 3/4". Philadelphia Museum of Art*

277

278

277 *Charles-Germaine de St. Aubin (1721–88).*
Papilloneries Humaines: Théâtre
Italien. *Etching. Museum of Fine Arts, Boston*

278 *Antoine Watteau.* Les Habits Sont Italiens.
*Early 18th century. Etching. Bibliothèque
Nationale, Paris*

279 *Gilles Demarteau (after Boucher).* Venus
Couronnée par les Amours. *1773. Engraving
(crayon technique). Philadelphia Museum of
Art*

279

280

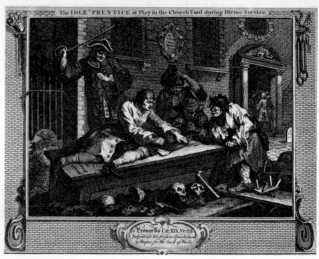

280 *Daniel Chodowiecki.* Cabinet d'un Peintre
(Chodowiecki and His Family). *1771. Etching,
9 × 7 1/8". Museum of Fine Arts, Boston*

281 *William Hogarth.* The Idle Apprentice: Plate 3. *1747.
Engraving, c. 10 1/4 × 13 1/2". New York Public
Library, Astor, Lenox and Tilden Foundations (Prints
Division)*

281

especially good example of Hogarth's quality as an etcher. One of the lasting by-products of his activities as a printmaker was an Act of Parliament passed at his instigation in 1753; it protected artists' work from being copied or pirated.

The British Royal Academicians, artists of the establishment, turned to the peace of the English countryside in their printmaking; not a trace of political turmoil can be detected in the soft-ground etchings and aquatints of Thomas Gainsborough (1727–1788) or of J. R. Cozens (c. 1752–c. 1799) and his father, Alexander (c. 1716–1786), drawing master at Eton. The father's claim to distinction is a remarkable series of forty-three aquatints which he made with a combination of soft and lift ground, very much in the manner of modern printmakers. J. M. W. Turner (1775–1851), the flamboyant painter of turbulent land- and seascapes, used the etched line more or less as a guide for the mezzotint, notably in his study book, *Liber Studiorum*. Of his contemporary, John Constable (1776–1837), we have, alas, only two or three etchings which show his fresh and unmannered style to best advantage.

PLATE 284

PLATES 285, 286

Thomas Rowlandson (1756–1827) took on the evils of Albion with less severity and more humor than Hogarth, perhaps because he had exposed himself to the gay life of an art student in Paris and continued his Bohemian revelries in London. His work had a distinct elegance, and, having exhibited at the Academy at the early age of twenty, he could have become a Royal Academician like Sir Joshua Reynolds. But he chose to have fun with his fellow men—at their expense. He was a superb etcher and watercolorist, working on his own plates in the popular medium of aquatint and having them hand-colored according to his directions. Intimately acquainted with the haunts of both upper and lower classes, he depicted with authority the social and political gambols of his time.

PLATE 287

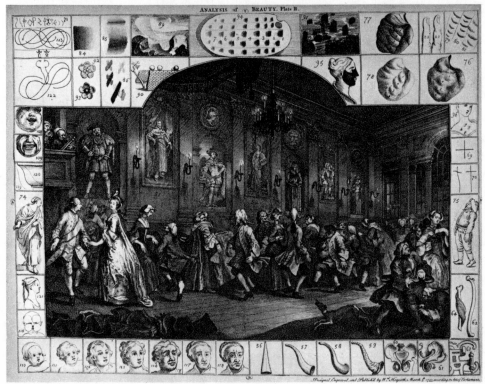

282 *William Hogarth.* Analysis of Beauty: Plate 11. *1753. Engraving, 14 3/4 × 19 1/4". New York Public Library, Astor, Lenox and Tilden Foundations (Prints Division)*

282

COLORPLATE 36

He was helped to popularity by an enterprising German publisher, Rudolph Ackermann, who maintained a "Repository of the Arts" on the Strand in London, and for whom Rowlandson produced the bulk of his prints, single sheets as well as countless magazine and book illustrations. Best known among them are the peregrinations of the famous *Dr. Syntax, The Dance of Life,* and *The Vicar of Wakefield*—all in all a stupendous production for a man so heavily embroiled in London's social whirl.

He was intimately associated with the like-minded artists of his day, among them Debucourt and Gillray, whom he undoubtedly influenced.

James Gillray (1751–1815) worked in the same medium, lambasted the same

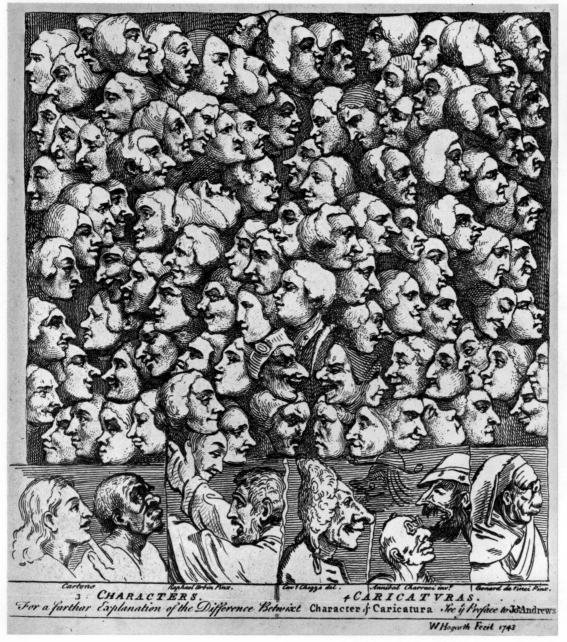

283 William Hogarth. Characters and Caricatures. 1743. Etching, 9 × 8 1/8". *New York Public Library, Astor, Lenox and Tilden Foundations (Prints Division)*

284 Alexander Cozens. A Blot, *from* A New Method of Assisting the Invention in Drawing Original Compositions of Landscape, *1785. Lift-ground aquatint, 9 1/2 × 12 3/8". Beinecke Rare Book and Manuscript Library, Yale University, New Haven, Conn.*

285 J. M. W. Turner. The Stork and the Aqueduct, *from* Liber Studiorum. *1806–19. Etched state. Fogg Art Museum, Harvard University, Cambridge, Mass.*

286 J. M. W. Turner. The Stork and the Aqueduct, *from* Liber Studiorum. *1806–19. Etching and mezzotint. Museum of Fine Arts, Boston*

shibboleths—with more single-minded ferocity—but lacked the elegance of Row-
landson, mixing more venom into his acid. His attacks on royal personalities were
fierce, and his fury mounted as Napoleon's menace appeared on the British horizon.
After George III, "Little Boney" became Gillray's second favorite target, and he lived
to see Bonaparte's star disappear on the little island of Elba. Gillray's capacity to
produce was enormous, aided and abetted by popular printsellers such as Miss
Humphrey of St. James's Street, who also provided for him a refuge to live and a
place to work.

COLORPLATE 35
PLATE 288

A good deal of sensuality is mixed into both Rowlandson's and Gillray's prints;
sometimes racy, often crude, they were in keeping with the bawdiness of Georgian
England, prevailing both in the gutter and in the salons of high society.

George Cruikshank (1792–1878), the mildest of the trio, but working in the same
tradition, started as a teenage etcher, tutored by his father, Isaac, and his elder brother,
Robert, and left a legacy of several thousand etchings. The world is familiar mostly
with his illustrations to Dickens's early novels, populated with unforgettable charac-
ters, etched into copper and into readers' memories.

COLORPLATE 37

The personality of William Blake (1757–1827) presents a sharp contrast to these
satirists. He lived in the rarefied sphere of the spirit, somewhat removed from the
social and political issues of his time, an austere mystic, visionary, and poet who
was unique in his day, as he would be in ours.

Though trained as an engraver, he must be credited with the invention of
etching in relief, an inexpensive graphic method revealed to him by the posthumous
advice of his brother Robert, who appeared to him in a dream. Using an acid-resisting
liquid on a copper plate, then etching it into relief, he produced plates which enabled
him, with the assistance of his wife, to print both handwritten poetry and illustrations
without benefit of type or a letter press. His *Songs of Innocence* (1789) and his later
Songs of Experience, The Marriage of Heaven and Hell, and *Jerusalem,* conceived in
poverty and finished in poverty, are now priceless items for both their literary and
their artistic values.

PLATES 289–292

Among his few contemporary admirers were Edward Calvert (1799–1883) and
Samuel Palmer (1805–1881), who were very much inspired by Blake's romantic

PLATES 293, 294

285

286

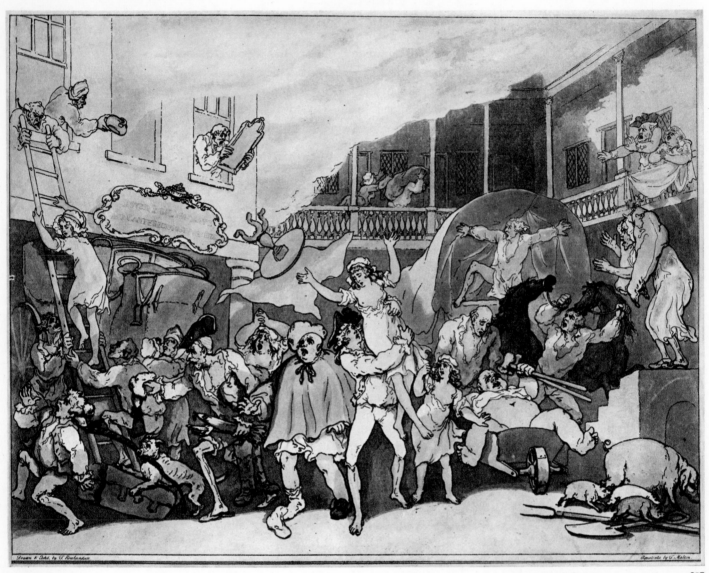

287

mysticism. Palmer left only thirteen delicate, small, but masterful etchings; Calvert, a handful of enchanting bucolic prints which have achieved a singular place of distinction and affection in the history of the print.

It seems strange that Blake's contemporaries across the Channel were Fragonard and Philibert-Louis Debucourt (1755–1832), so far removed in spirit from him.

PLATES 295–297

French Jeunesse Dorée
France had become the center for professional engravers, highly skilled and well respected. The number of artists working in the vein of the masters, from Tiepolo to Rembrandt to Boucher, was legion—not of very great consequence in the history of printmaking, though tremendously popular with collectors. A handful of titles tells the piquant story of their subject matter: Fragonard's *La Chemise Elevée*, St. Aubin's *At Least Be Discreet!*, Lavreince's *Poor Pussy, Why Am I Not in Your Place?*, Delaunay's *The Indiscreet Wife*, or Moreau le Jeune's *The Farewell*.

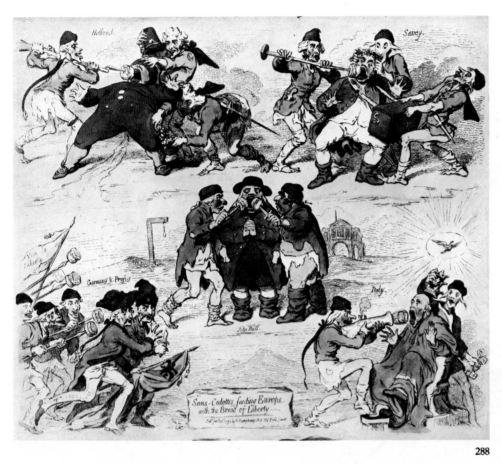

288

287 *Thomas Rowlandson.* The Fire in the Inn Yard. *Early 19th century. Colored etching and aquatint. National Gallery of Art, Washington, D.C. (Rosenwald Collection)*

288 *James Gillray.* Sansculottes Feeding Europe with the Bread of Liberty. *1793. Colored etching. New York Public Library, Astor, Lenox and Tilden Foundations (Prints Division)*

Because he was more critical of his time, the prints of Debucourt seem to have more lasting significance to us. His *Galerie du Palais Royal* shows Rowlandson's influence and gives us a cross section of the "gay set," the *jeunesse dorée,* of Paris, superbly etched and colored. But then the Revolution rang down the curtain and threw the Royalist printmakers off the stage. What followed was a weak attempt, by government decree, to produce propaganda prints extolling the ever-changing revolutionary junta and the virtues of the guillotine.

Few of these prints attained any distinction. Most of them were anonymous; many had their captions changed after the restoration. Such, alas, is human nature. That Debucourt tried to fall into line is evident from his print *Réception du Décret du 18 Floréal,* following the official order of the day, and his first mezzotint, of the Marquis de Lafayette, which appeared after the Revolution. Turncoats there were many. Jacques-Louis David, later court painter to Napoleon I, was first commissioned by the Convention to produce large editions of anti-Royalist prints. He finished two, for which he received 6,000 livres. Expediency paid well!

A revolutionary law was passed in 1793 from which the Bibliothèque Nationale still profits: the Dépôt Légal obligates every French artist to deposit one copy of each print he makes in its archives.

The Spanish Giant

On the other side of the Pyrenees there appeared during these fateful years a colossus

PLATE 295

PLATE 297

PLATES 298–302

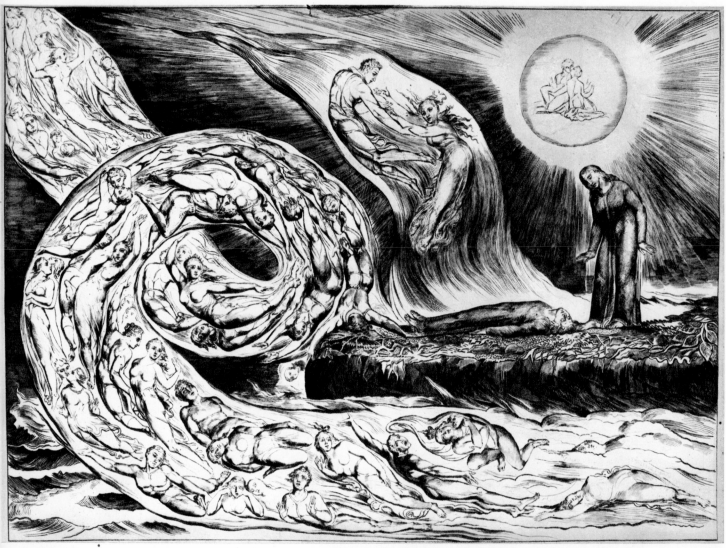

289

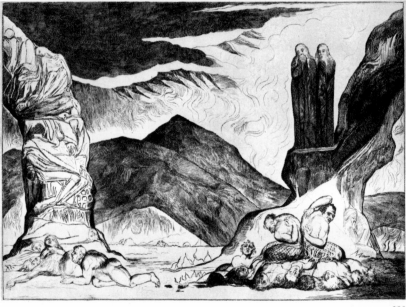

290

289 *William Blake*. The Circle of the Lovers,
 illustration for Dante, The Inferno. *1826.*
 Engraving. New York Public Library, Astor, Lenox
 and Tilden Foundations (Prints Division)
290 *William Blake*. The Circle of the Falsifiers,
 illustration for Dante, The Inferno. *1826.*
 Engraving, 9 1/2 × 13 3/8". National Gallery of
 Art, Washington, D.C. (gift of W. G. Russell
 Allen)

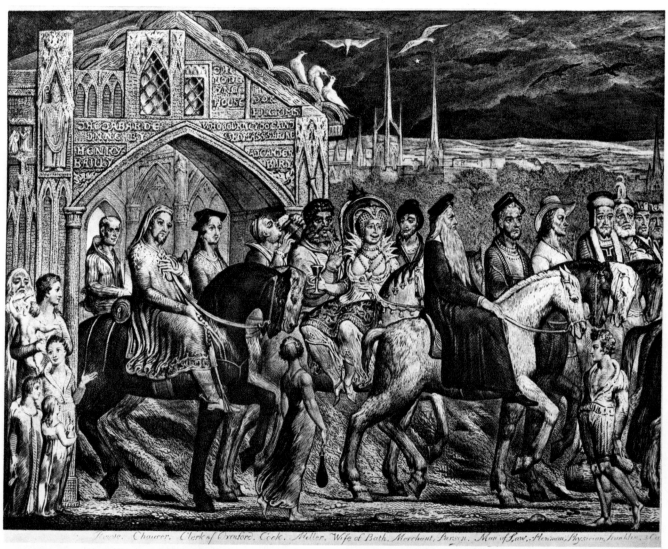

291

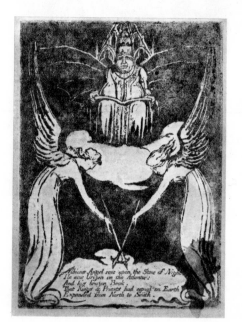

291 *William Blake.* Canterbury Pilgrims, *detail
of fourth state, left side. 1810. Engraving.
National Gallery of Art, Washington, D.C.
(Rosenwald Collection)*

292 *William Blake.* Albion's Angel, *from* Europe—a
Prophecy. *1794. Relief etching. Philadelphia
Museum of Art*

292

whose genius seized upon the issues of violent change, of revolution, war, and barbarity to create memorable prints that still speak powerfully to our time. Francisco de Goya's life (1746–1828) ran the gamut from tempestuous youth, passionate lover, and brilliant court painter to disillusioned old man, raging against Church, state, and society, and ending in loneliness and death in exile. What he saw, felt, and experienced is all hauntingly visible in his etchings. While his life was full of contradictions, his work is not.

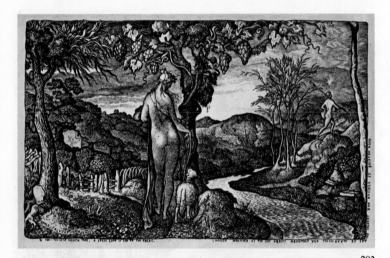

293

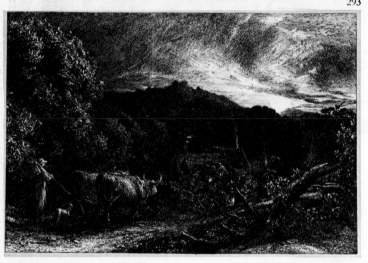

294

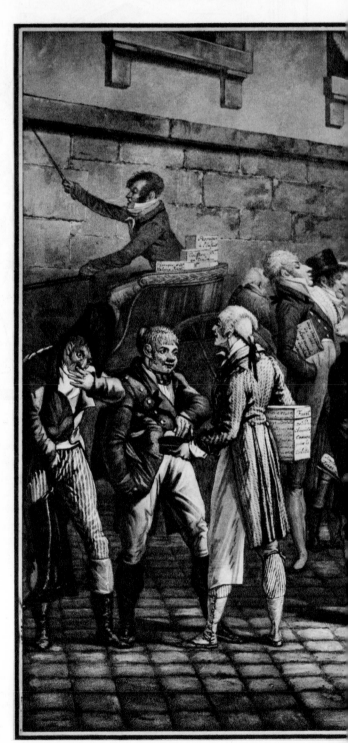

293 *Edward Calvert.* The Bride. *1828. Engraving. Museum of Fine Arts, Boston*
294 *Samuel Palmer.* The Herdsman. *Mid-19th century. Etching. National Gallery of Art, Washington, D.C. (Rosenwald Collection)*

In 1778 he began to experiment with etching, rather in the manner of Tiepolo. He found the perfect medium to suit his dark thoughts in the aquatint, which may have been used as much as a century earlier by Jan van de Velde and was revived in Goya's time by Jean-Baptiste Le Prince. Its velvety blacks gave Goya the mysterious and dramatic backgrounds which highlighted the actions and character of his actors.

Perhaps it was the intoxicating air of the French Revolution blowing across the border which made him forsake painting and turn his genius to the *Caprichos*, a set of

295 Philibert-Louis Debucourt. Les Courses du Matin, ou La Porte d'un Riche. 1805. Aquatint. Philadelphia Museum of Art

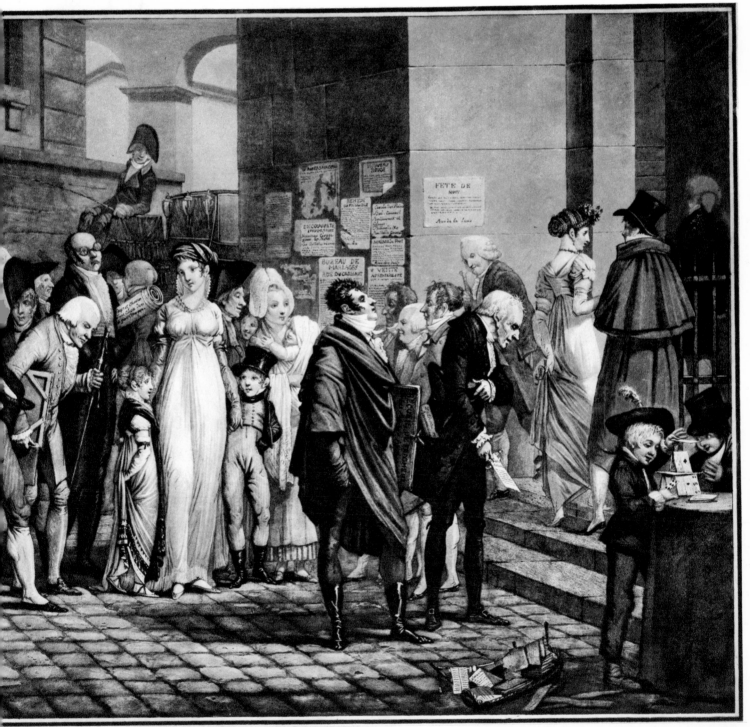

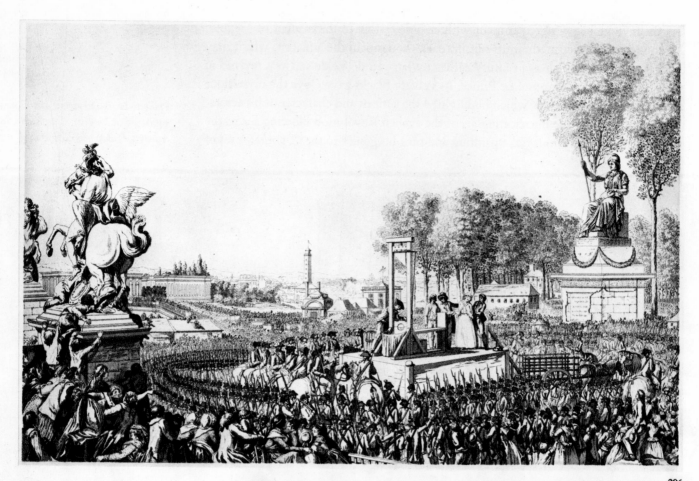

296

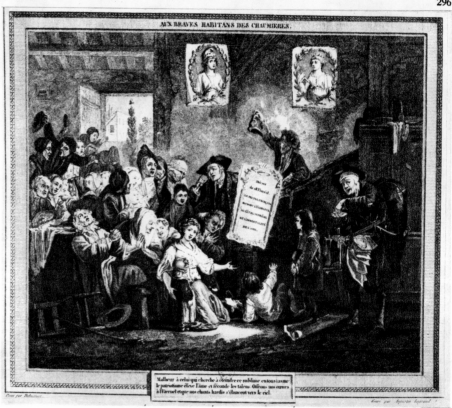

297

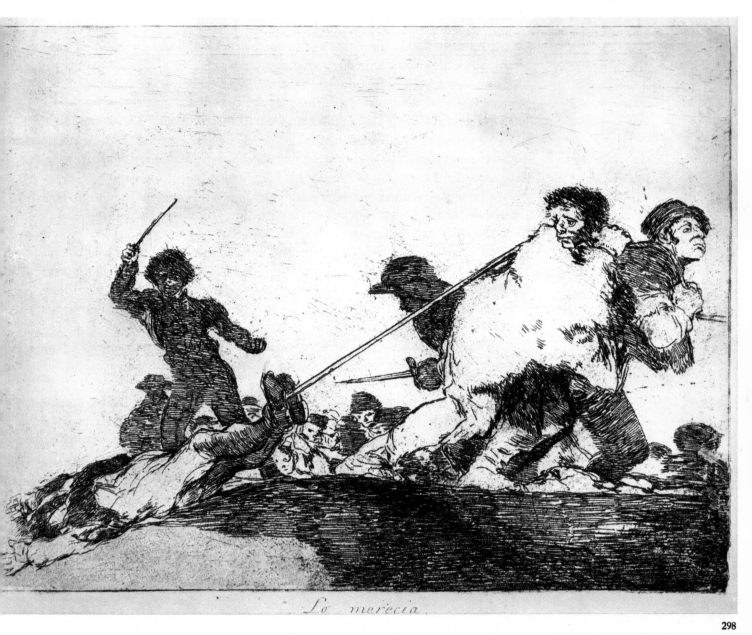

Lo merecia.

298

296 *Monet-Duclos.* Execution of Queen Marie Antoinette. *Late 18th century. Engraving. National Gallery of Art, Washington, D.C. (Rosenwald Collection)*

297 *Augustin Legrand (after Debucourt).* Réception du Décret du 18 Floréal. *Late 18th century. Engraving. Bibliothèque Nationale, Paris*

298 *Francisco de Goya.* Lo merecia (He deserved it), *from* The Disasters of War, *Plate 29. After 1808. Etching and aquatint, 5 7/8 × 7 15/16". National Gallery of Art, Washington, D.C. (Rosenwald Collection)*

PLATES 298–301

PLATE 302

eighty aquatints which exposed many follies, the heavy hand of the Inquisition, the intrigues at court, and the vanity and hypocrisy of Spanish society. He must have known that the censor would try to suppress the publication, which bore his arrogant self-portrait as a frontispiece. Sardonically he dedicated the *Caprichos* to the king, Charles IV, who must have gritted his teeth as he graciously ordered it deposited—or buried—in the Calcografía Nacional. The year was 1797. Ten years later Napoleon crossed the border into Spain, providing Goya with a ringside seat to observe and record the bestialities of war, crystallized in a series of eighty-two aquatints, *Los Desastres de la Guerra*. They were to admonish mankind forever, in Goya's words, "to stop being inhuman to each other." Though these prints, which were not published until thirty-five years after his death, have not fulfilled Goya's hopes, they are still haunting us with their message.

Deaf and disillusioned, Goya poured all his wrath against mankind's follies into another series of eighteen prints, the *Proverbios,* or *Disparates* (1810–15), which were not to be published before 1848, twenty-six years after his death. No wonder—they are full of strange and mysterious allusions to the inexplicable and self-destructive antics that society engages in.

These were followed by his least controversial work, thirty-three plates portraying the excitement, gore, and daring of Spain's great national obsession, the bullfight, published as the *Tauromaquia* in 1815.

Perhaps most symbolic of Goya's power is his *El Coloso,* his only known mezzotint, which exists in only six copies. It seems that he could master any medium on first sight, as he did lithography in his last days. Unfortunately, many of his plates have been hopelessly abused in later years by careless reprinting and retouching. The plates, in the possession of the Calcografía in Madrid, have been reissued so often that it is sometimes difficult to establish which are the early editions and which have been tampered with later. Goya often used a combination of etching, with aquatint applied

299 Francisco de Goya. Aun podrán servir *(They will be fit for further service), from* The Disasters of War, *Plate 24. After 1808. Etching and aquatint, 5 1/8 × 8 1/4". Boston Public Library (Wiggin Collection)*

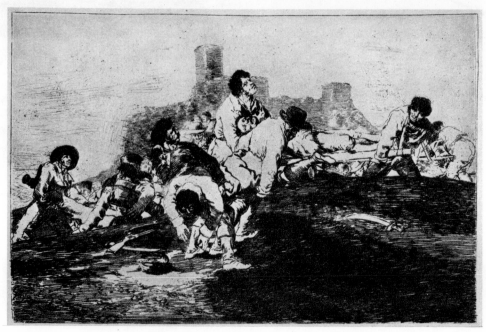

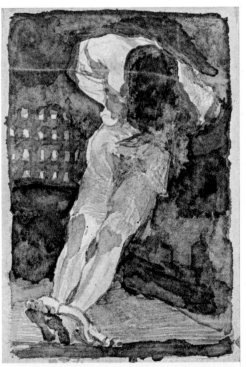

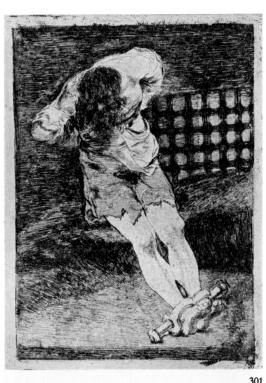

300

301

300 Francisco de Goya. *The prisoner tortured, study for the etching. After 1808. Brown wash. Boston Museum of Fine Arts (bequest of W. G. Russell Allen)*

301 Francisco de Goya. *The prisoner tortured, from* The Disasters of War, *Plate 83. After 1808. Etching and aquatint, 3 5/8 × 2 5/8″. Boston Museum of Fine Arts (bequest of W. G. Russell Allen)*

302 Francisco de Goya. Dancing Nonsense, *from Los Proverbios, Plate 12. c. 1810–15. Etching and aquatint. National Gallery of Art, Washington, D.C. (Rosenwald Collection)*

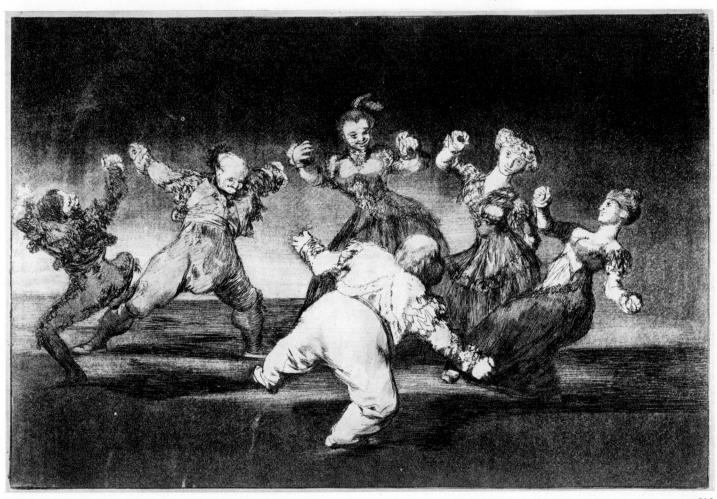

302

later, as well as drypoint and graver to deepen the lines, confounding the experts who try to date and authenticate his overworked and worn-out plates. But then the man himself, perhaps the last colossus among the great etchers, remains an enigma to his many admirers.

Plein-airists and Others

PLATES 303–315

It is quite a step from Goya's dark world to the *plein air* prints of the Barbizon school, although J. B. Corot (1796–1875), its greatest exponent, straddled the same centuries and must have been exposed to some of the same influences. Corot's etchings are rustic, unheroic, unproblematic. The spirit of retreat to nature is also reflected in the work of his companions: Jean-François Millet (1814–1875), a farm boy from Normandy, whose frugal peasants and peaceful landscapes he eulogized in some twenty popular etchings; Théodore Rousseau (1812–1867); and a host of less talented nature lovers who had settled around the forests of Fontainebleau. To them the copper plate was the most congenial medium, easy to carry around and easy to sketch on in the open air.

PLATE 307

Their interest in the medium was shared by Victor Hugo (1802–1885), a man of many accomplishments—writer, politician, journalist—who also certainly qualifies as an artist of considerable ability. In his own time he was compared to Goya and Redon, as one might now discover in him the spirit of Paul Klee or Saul Steinberg. Many of his books were illustrated with etchings and engravings after his own work. We know also that in 1864 he acknowledged in a letter to Philippe Burty both the receipt of a copperplate and his passion for etching.

PLATE 306

Yet the lithographic stone, with its new and more effortless possibilities, had lured away the Romantic revivalists Delacroix and Géricault; the great caricaturists Daumier and Gavarni; Napoleon addicts such as Raffet, the Vernets, and the Charlets; Toulouse-Lautrec and Redon, the Surrealist dreamer. Redon's teacher, Rodolphe

PLATES 303–305

303 *Rodolphe Bresdin.* Intérieur flamand. *1871. Etching, 8 1/4 × 4 1/4″. National Gallery of Art, Washington, D.C. (Rosenwald Collection)*

304 *Rodolphe Bresdin.* Intérieur flamand. *1871. Transfer lithograph, 6 1/4 × 4 1/4″. National Gallery of Art, Washington, D.C. (Rosenwald Collection)*

303 304

305

307

305 Honoré Daumier. Etching with studies by Rops, Harpignies, Taiée, and Daumier (upper left). 1872. Museum of Fine Arts, Boston (bequest of W. G. Russell Allen)

306 Victor Hugo. L'Éclair. 1868. Etching. Bibliothèque Nationale, Paris

307 Jean-Baptiste-Camille Corot. Italian Landscape. c. 1865. Etching. Philadelphia Museum of Art

306

PLATES 309, 310

Bresdin (1825–1885), worked with equal facility in both lithography and etching, often transferring images from one medium to the other in a puzzling interchange.

Camille Pissarro (1830–1903) somehow stands by himself on the strength of some one hundred fifteen etchings; he was one of the few etchers of his time who experimented successfully with color.

Best known as a prolific etcher of volatile temperament is the American Anglophile J. A. M. Whistler (1834–1903), ex-West Pointer, writer, and dandy, studied art in Paris and settled in London, where he made his reputation. Among his famous works are the *Thames Set* (1871), beautifully etched and printed impressions of

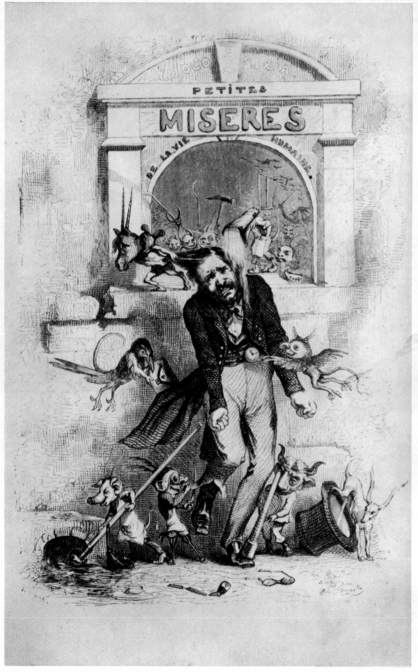

309

310

308 Grandville (Jean-Ignace Gérard).
Illustration from Petites Misères de la
Vie Humaine, *1843. Engraving, 7 × 5".*
Collection the author

308

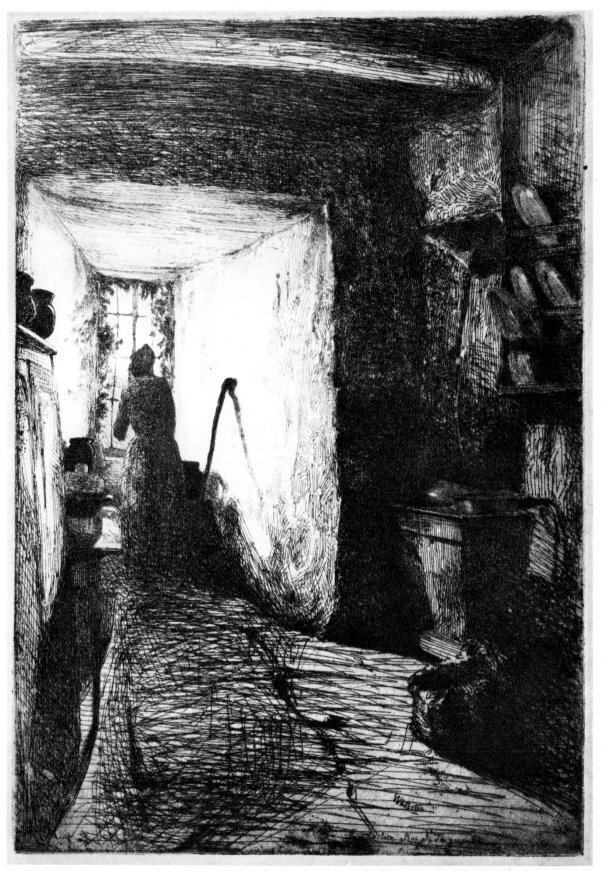

309 Camille Pissarro. Cours Buëldieu á Rouen. *Late 19th century. Etching, 5 3/4 × 7 1/2". Courtesy Associated American Artists,* New York

310 Camille Pissarro. Self-portrait. *c. 1890. Etching (first state). Museum of Fine Arts, Boston*

311 James A. McNeill Whistler. The Kitchen. *1885. Etching and drypoint, 8 7/8 × 6 1/8". Boston Public Library (Wiggin Collection)*

312

PLATES 311, 312

London, and his two *Venice Sets* (1880 and 1886), printed with so many tricks of wiping and leaving tonal values that they look almost like aquatints. His graphic oeuvre consists of 460 etchings and 160 lithographs, proof positive that the man-about-town did not shun the dirty work at the printing press.

PLATE 313

Whistler's brother-in-law, Sir Francis Seymour Haden (1818–1910), developed from a well-known surgeon and a little-known amateur artist into the leading etcher of his time. A doctor escaping his patients, he eulogized the British countryside in more than two hundred etchings, usually bare of visible human life. It was Haden who started the Society of Painter-Etchers, which greatly added to the prestige and popularity of his favorite medium. Among the many followers of Whistler and

PLATE 314

Haden were Walter Sickert, D. Y. Cameron, and Muirhead Bone, respected and respectable minor artists of the later Victorian era. It seems that in those days of bourgeois affluence no printmaker loomed larger than life. It was the same almost all over Europe.

In the work of Anders Zorn of Sweden (1860–1920), who practiced his etching skill with little variation for forty years, we see nature epitomized in healthy, glowing female bodies; he was an Impressionist par excellence, avidly collected by well-off citizens. Jozef Israëls in Holland tried to perpetuate the Rembrandt tradition in his landscapes and interiors. Hans Thoma (1839–1924) celebrated the soft light and the

PLATE 315

rolling hills of south Germany in his etchings, while Wilhelm Leibl (1844–1900) portrayed the solemn, picturesque dignity of the Dachau peasants. Art seemed to have retreated into the woods and villages.

The Human Drama

PLATES 316–335, 337

Perhaps Max Klinger (1857–1920) was the exception or the prelude to a new interest in the human predicament. His series of etchings were actually dramatic cycles, as their titles indicate: *Ein Leben* (*A Life*), *Dramen* (*Dramas*), *Eine Liebe* (*A Love*), *Vom*

PLATES 316, 317

Tode (*Of Death*). They were often ponderously melodramatic renderings of passion, jealousy, adventure, and death. The technique was a skillful combination of etching, drypoint, graver, mezzotint, and whatever could help the artist to create the Goya-esque lights and darks which would heighten the dramatic impact of his scenes.

318

319

320

318 *Käthe Kollwitz.* Fight in the Castle Armory. *Charcoal drawing.*
National Gallery of Art, Washington, D.C. (Rosenwald
Collection)

319 *Käthe Kollwitz.* Fight in the Castle Armory, *from the* Peasant War
Cycle, *1902–08. Etching and soft ground. National Gallery of Art,*
Washington, D.C. (Rosenwald Collection)

320 *Käthe Kollwitz.* The Young Couple. *c. 1912. Etching and aquatint,*
c. 7 1/4 × 7 1/8″. Courtesy William H. Schab Gallery, New York

321

322

and drypoints owe much to the Dutch landscape school of Jozef Israëls, with whom he studied. As Germany's last great Impressionist and co-founder of the Berlin Sezession, he gathered around him such artists as Slevogt and Corinth, strong etchers both, whose work, often illustrative, seemed to presage the advent of Expressionism.

Meanwhile there had sprung up in France a breed of social commentators, largely influenced by Daumier's example but none of them measuring up to the stature of the master. Although lithography remained popular with most of them, the copperplate began to claim attention. Perhaps this interest was sparked by a vocal literary elite, headed by Baudelaire and Gautier and implemented on the technical side by passionate promoters of etching, including Bracquemond, and superb printers such as Delâtre. They were responsible for the founding of the Société des Aquafortistes in 1862, which attracted the elite of the copperplate *aficionados*, includ-

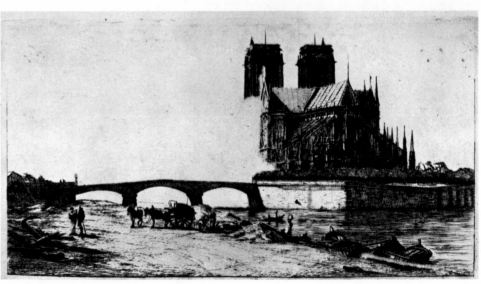

323

ing such luminaries as Degas, Whistler, and Pissarro. Among the first portfolios published for the Society by Cadart we find etchings by Corot, Manet, Delacroix, and Meryon, mixed with such lesser lights as Ribot and Millet.

PLATES 323, 324

The artists, as well as their literary friends, engaged in spirited discussions on the finer technical and aesthetic points of etching and on the merits of the artist's controlling his prints from start to finish (as Whistler and Forain did), rather than turning his plates over to a professional printer (as did Corot, Manet, and many of their colleagues). Yet public interest was lagging, and print collectors were scarce. It seems unbelievable that *Du Jour et de la Nuit,* a publication started by Degas, including Pissarro's, Mary Cassatt's, and his own work, folded up after one issue appeared in 1880.

The first etching by Edgar Degas (1834–1917), a self-portrait dated 1855, shows him at the age of twenty-one, an instant master. A perfectionist, he carried most of his plates through many carefully considered states and bitings, with the addition of drypoint, aquatint, and burnisher. He dramatically worked out his chiaroscuro effects until his figures came to life against a subtly darkened background. We can study the evolution of a Degas print in his *Mary Cassatt at the Louvre,* because he has left us numerous different states which show how he slowly developed his imagery with any kind of interesting tool or medium within his reach—soft-ground, sandpaper, varnishes, and all kinds of scrapers and steel points. Degas's ethereal technique is uniquely his own and can hardly be traced to any outside influences, though he studied Rembrandt and Velásquez intimately.

PLATE 326

PLATES 328, 329

In contrast, the etchings of Édouard Manet (1823–1883) invite immediate comparison with Goya, from whom he could never dissociate himself. His *Olympia* is closely related to Goya's *Maja*; his use of etching, drypoint, and aquatint resembles just as closely Goya's technique. Manet's body of seventy-five etchings shows his great interest in this medium and his efforts to master it. Yet the indifference of the public, collectors, and critics prompted him to give up printmaking altogether, as did Renoir, Rodin, Cézanne, Monet, and other important Impressionists after a few promising attempts. A catalogue issued by Cadart in 1878 lists Manet's *Gypsies*

PLATE 327

PLATE 330

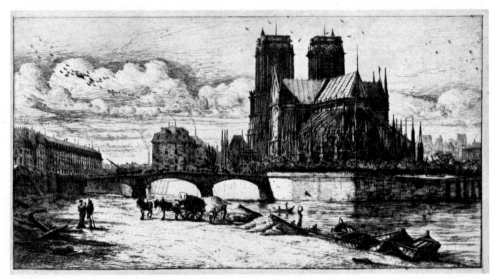

324

325

for 6 francs, six etchings by Delacroix for 30 francs, artists' proofs by Haden and Meryon for 15 francs each, whereas collectors at that time were willing to pay 5,000–10,000 francs for dull reproductive engravings by nonartists such as Gaillard!

It seems, however, that the potential of the copperplate attracted a new breed of storytellers and social commentators, inspired perhaps by Meryon's mystique and Bresdin's macabre "surrealism."

Félicien Rops (1833–1898), a skillful etcher of the risqué, or often the pornographic, developed his own cachet of decay that tickled the taste of the jaded *boulevardier*. However, some of his prints show a keen awareness of the social and political issues of his day.

James Ensor (1860–1949), a Belgian who was by heritage related to the world of Bosch and Bruegel, left nearly one hundred fifty etchings peopled with rattling skeletons, masked crowds, demons, and monsters. His mordant wit was hardly appreciated during his lifetime, and he gave up printmaking in 1904. His apocalyptic vision was certainly a projection into our time.

In 1889, long after the demise of the Société des Aquafortistes, Bracquemond, that tireless advocate of the art of etching, started the Société des Peintres-graveurs. Again there was a spurt of activity among artists and writers to celebrate the copperplate and to transmit their enthusiasm to collectors and publishers. There was no lack of big names—Rodin, Degas, Bonnard, and Vuillard among them—accompanied by a long list of virtuosos with minor talents, now almost forgotten.

There were also several gifted women artists active in Paris. Mary Cassatt (1845–1926), friend of Degas, was enamored of the prints of Utamaro, of women and chil-

PLATE 331

PLATES 334, 335

326 *Edgar Degas.* Loge d'Actrices. *Late 19th century. Etching and aquatint. National Gallery of Art, Washington, D.C. (Rosenwald Collection)*

327 *Édouard Manet.* Au Prado. *1865. Etching and aquatint (second plate), c. 8 1/2 × 6". Davidson Art Center, Wesleyan University, Middletown, Conn.*

328 *Edgar Degas.* Mary Cassatt at the Louvre: Museum of Antiquities. *c. 1876. Etching and drypoint (second of six states, probably unique), 10 1/2 × 9 1/8". Art Institute of Chicago (Carter H. Harrison Fund)*

329 *Edgar Degas.* Mary Cassatt at the Louvre: Museum of Antiquities. *c. 1876. Etching and drypoint (sixth state), 10 1/2 × 9 1/8". Bibliothèque Nationale, Paris*

326

dren in intimate yet innocent poses. She experimented extensively with color etchings in a distinctly Japanese style and left a solid body of work, among which her 200 etchings take an important place. A contemporary, Suzanne Valadon (1867–1938), was also a Degas protégée, as her subject matter and soft-ground technique clearly reveal. Berthe Morisot (1841–1895), influenced by some of the great names surrounding this charming artist, left eight drypoints which show her feminine touch.

Another trio, often mentioned together because of their related interest in the social and political scene, walked in the footsteps of Daumier and Goya: J. L. Forain (1852–1931), A. T. Steinlen (1859–1923), and Adolphe-Léon Willette (1857–1926). Perhaps the best artistically is Forain, whose etchings are incisive, harsh, always pointing an accusing finger. Steinlen, the advocate of the workingman, is a bit mawkish, yet solidly French. Willette, light as good champagne, is pert, naughty, and as patriotic as most good Frenchmen are—even if they are critical of their own institutions.

It was the end of an era, paralleling the Victorian Age on the other side of the Channel—well heeled, well motivated, and slightly stuffy.

PLATE 332

PLATE 333

PLATE 337

327

The Great Publishers and Their Artists
The turn of the century saw the rise of several farsighted and enterprising publishers, among them the fabulous Creole, art dealer and friend of France's great artists, Ambroise Vollard; Daniel-Henry Kahnweiler, German-born connoisseur of art and poetry, long-time confidant and dealer of Picasso; and Albert Skira, Swiss-born lover

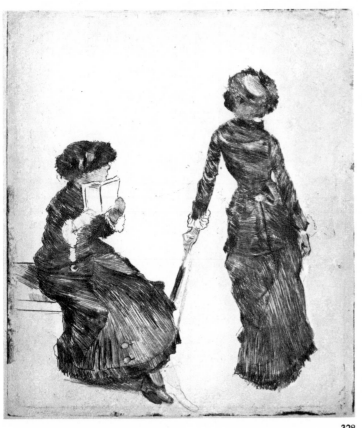

328

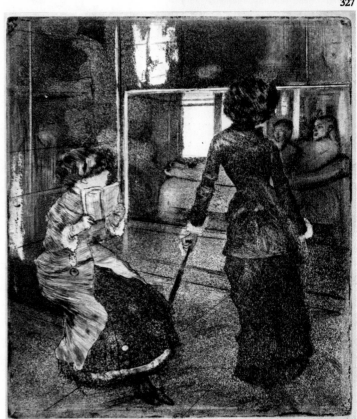

329

330

330 *Auguste Rodin*. Cupids Guiding the
World. *Late 19th century. Etching (on the
back of a plate by Legros). Bibliothèque
Nationale, Paris*

331 *James Ensor*. Death Pursuing a Group of
Humans. *1876. Etching. Fogg Art
Museum, Harvard University, Cambridge,
Mass.*

332 *Suzanne Valadon*. Toilette des Enfants
dans le Jardin. *1910. Drypoint.
Philadelphia Museum of Art.*

333 *Berthe Morisot*. La Leçon de Dessin. *c.
1890. Drypoint, 7 1/4 × 5 1/4". Courtesy
Associated American Artists, New York*

334 *Mary Cassatt*. In the Omnibus.
*Preliminary drawing. National Gallery
of Art, Washington, D.C. (Rosenwald
Collection)*

335 *Mary Cassatt*. In the Omnibus. *Late
19th century. Drypoint, soft ground, and
aquatint, in color. National Gallery of
Art, Washington, D.C. (Chester Dale
Collection)*

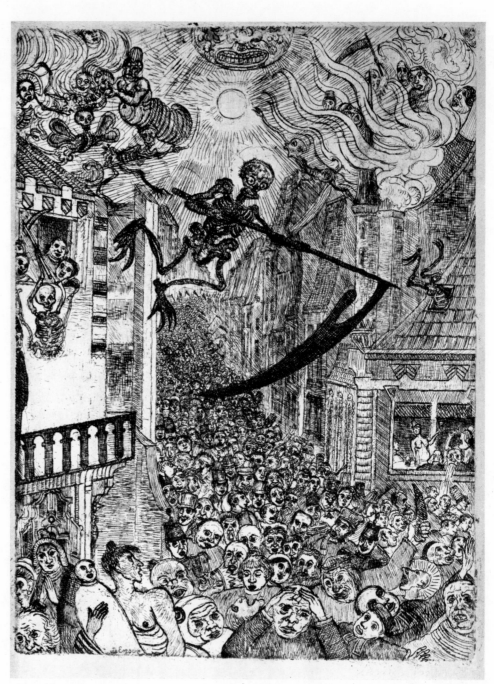

331

PLATES 336, 338–340

of books and publisher of genius. In their wake followed lesser ones: Tériade, the
Gonin brothers of Geneva, Maeght, and a number of societies, circles, and galleries
devoted to the book illustrated with original graphics.

Foremost, no doubt, was Vollard, a resourceful man of infinite patience, vision,
and good taste, who could gather around him the finest artists, painters, and sculptors
and inspire them to try their hands on litho stones and copper plates. He raised the art
of the book to new heights. From 1900, when he published his first, Verlaine's
Parallèlement, with Bonnard's lithographs, until his death in 1939, he produced
landmarks of books and portfolios, with Biblical patience and relentless search for

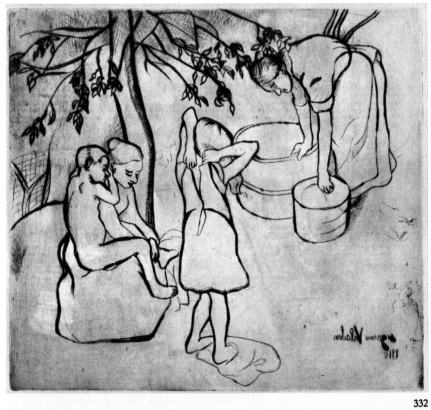

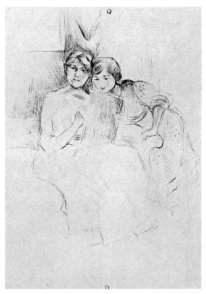

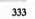

332

333

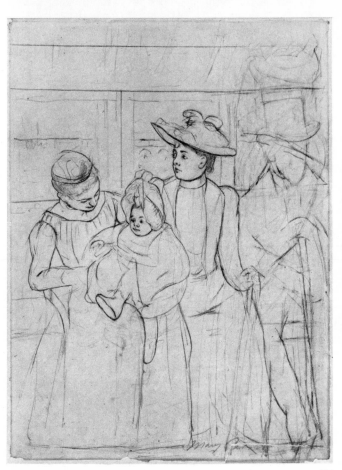

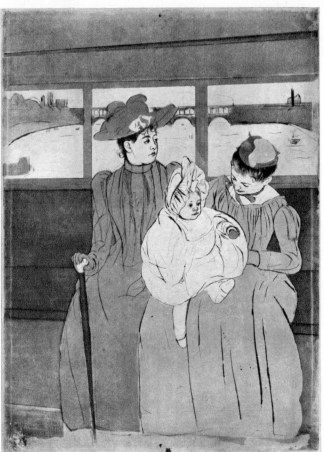

334

335

336 *Pablo Picasso.* Vollard Suite, No. 100: Portrait of Vollard III. *1937. Etching. Philadelphia Museum of Art*

337 *Jean-Louis Forain.* L'Avocat Parlant au Prévenue. *c. 1908–10. Etching (first plate, second state), c. 9 1/2 × 12". Boston Public Library (Wiggin Collection)*

338 *Pierre Bonnard.* Portrait of Ambroise Vollard with Cat. *Early 20th century. Etching. Museum of Fine Arts, Boston*

339 *Jean-Louis Forain.* Ambroise Vollard. *Early 20th century, n. d. Lithograph, 10 1/4 × 9 3/4". Museum of Modern Art, New York (gift of Larry Aldrich)*

340 *Raoul Dufy.* Ambroise Vollard. *c. 1930. Etching, 8 1/2 × 6 7/8". Museum of Modern Art, New York*

336

337

338 339 340

perfection. Strange as it seems, they were financial failures in his lifetime, although they have proved to be a gold mine on the art market of our time.

The favorite medium of Pierre Bonnard (1867–1947) was color lithography. In 1902 *Daphnis et Chloé* followed the Verlaine. In 1924 he tried his hand at etchings for O. H. M. Mirbeau's *Dingo*. In *La Vie de St. Monique* he boldly combined etching, lithography, and wood engraving in a unique and successful orchestration. In 1931 Picasso (1881–1973) illustrated Balzac's *Chef-d'Oeuvre Inconnu* with classical etchings and Cubist wood engravings cut by Georges Aubert; it is an odd, unique, and most intriguing combination of Picasso's most important periods between the covers of one book!

In 1931 Vollard urged Chagall to undertake the illustration of the Bible. One hundred five plates were finished after Vollard's death. Chagall's 100 etchings for Gogol's *Dead Souls,* begun in 1923, were also published much later by Tériade. In 1934 Maupassant's *La Maison Tellier* was published with Degas illustrations; a year later Vollard used Degas's truly "unique" monotypes for Louÿs's *Mimes des Courtisanes,* engraved and etched superbly by Potin. In 1930 Raoul Dufy (1877–1953) created seventy-seven etchings for Montfort's *La Belle Enfant.* But perhaps Vollard's crowning achievement lay in his power of persuasion, which induced Georges Rouault (1871–1958) to devote nine years of his life to the monumental *Misérère et Guerre.* First planned for a book by Suarès, with a hundred large prints, it ended up as a portfolio of fifty-seven etchings, produced with drypoint, scraper, roulette, aquatint, and acid over a photographic transfer of a gouache on a copper plate (1916–18 and 1920–27). In 1926–27 Rouault illustrated Baudelaire's *Les Fleurs du Mal* with seventeen etchings (yet unpublished). The *Réincarnation du Père Ubu,* with twenty-two etchings and 104 wood engravings, was begun in 1916 and issued in 1932. *Cirque de l'Étoile Filante,* with eighty-two wood engravings cut by Georges Aubert and seventeen etchings in color (dated 1934 or 1935), was printed in the great Imprimerie Roger Lacourière by a team of great craftsmen who also collaborated in producing *Passion* by Suarès, issued in 1939 (the year of Vollard's death), a mixture of etchings and wood engravings.

Kahnweiler, son of a German banker, arrived in Paris in 1907, at the age of twenty-two. He met Picasso, Juan Gris, and Braque, the three much-maligned *Indépendants,*

PLATE 343

PLATE 341

COLORPLATE 38

opened a little boutique on the rue Vignon, gave Braque his first one-man show, and published his first book, the beautiful but unsalable *Enchanteur Pourrissant* by Guillaume Apollinaire, with illustrations by André Derain. Of 100 copies, fifty-eight were still available five years later, but it launched another great team of artists, poets, printers, and a publisher on a most distinguished career. A trilogy by the poet Max Jacob followed. The first book (1911), *Saint Matorel,* illustrated by the young Picasso with four etchings, was also a first for both the artist and author. The second, about the same saint, had wood engravings by André Derain; the third (1914), *Le Siège de Jérusalem,* had three etchings, again by Picasso. They met with the same failure, and the war closed down Kahnweiler's establishment. He returned from exile in Switzerland in 1920 and started from scratch again, surrounded by his friends —artists, poets, musicians. Maurice de Vlaminck, Juan Gris, Fernand Léger, Henri Laurens, Braque, and André Masson illustrated their first books for him until another world war interrupted once again the extraordinary career of a great publisher.

PLATE 345

Albert Skira shared with Vollard his tenacity in persuading great artists to produce magnificent books. Going to Paris from Switzerland in 1928, practically penniless, he had the gall to commission Picasso to illustrate Ovid's *Metamorphoses* with fifteen etchings. It was Picasso's first major book, published after long delays in 1931 in an edition of 145 copies. It proved to be unsalable at the time, though it was a landmark in bookmaking and is worth a king's ransom now.

Skira's next target was Henri Matisse (1869–1945), who was persuaded to illustrate Mallarmé's *Poésies* with twenty-nine etchings. Always close to financial disaster, Skira published this book, another first by a great artist, in 1932. Matisse noted in a commentary that "he makes no difference between the construction of a book and that of a painting." The result is a masterpiece.

It is difficult to overestimate the importance of these publishers, of the standards they set, and the inspiration and encouragement they imparted to the *peintres-graveurs* of the École de Paris.

They spawned in turn innumerable smaller ventures aimed at satisfying the growing demand for original graphics in books and portfolios. Etching was undoubtedly the most wanted medium, and there were enough excellent printers—Lacourière, Leblanc, Haasen, and Delâtre—to advise and assist the artists. At this time we see Dali's first etchings for the *Chants du Maldoror* (1934), Miró's etchings for Hugnet's *Enfances* (1933), Pascin's etched color plates for *Ferme la Nuit* (1925), and Jacques Villon's first illustrations for Corrard's *Poésies* (1937), the beginning of his long and distinguished career as one of France's finest etchers and engravers.

COLORPLATE 39

Another great etcher of our time, though less known outside France, André Dunoyer de Segonzac, published his first book with etchings, Dorgelès's *Les Croix de Bois,* in 1921. Working directly on the plate, completely dedicated to that medium, Segonzac produced an oeuvre of etchings that covers five decades and consists of several thousand plates.

Comparisons with these unparalleled accomplishments are perhaps not quite fair, for they were achieved through the happy circumstance of a profusion of talents and a unity of purpose that welded together poets, artists, publishers, editors, and printers into great teams.

Germany, between 1900 and 1933, tried to reach heights of perfection in the field of graphics. There were enlightened dealers such as Fritz Gurlitt, who published for

342

341 *Georges Rouault.* Face à Face, *Plate 40 from the series* Misérère. *1927, published 1948. Intaglio, 22 1/4 × 17 1/4". National Gallery of Art, Washington, D.C. (Rosenwald Collection)*

342 *Georges Braque. Illustration from Hesiod,* Theogony, *1930. Etching. National Gallery of Art, Washington, D.C. (Rosenwald Collection)*

343 *Marc Chagall.* At the Easel, *from the series* My Life. *1922. Drypoint, 9 3/4 × 7 7/16". Museum of Modern Art, New York*

344 *Georges Braque.* Study of a Nude. *Early 20th century. Drypoint. Fogg Art Museum, Harvard University, Cambridge, Mass.*

341

343 **344**

345 André Masson. Sysiphus. Early 20th century. Etching and aquatint. Courtesy Associated American Artists, New York

346 Henri Matisse. Apollinaire, Rouveyre, Matisse. c. 1930. Aquatint, 13 5/8 × 10 15/16". Museum of Modern Art, New York (gift of Mr. and Mrs. Armand P. Bartos)

347 Henri Matisse. Torso au Collier. Etching. Brooklyn Museum, New York

345

346

347

many years the portfolios of drypoints and lithographs of Lovis Corinth for *Martin Luther, Reynard the Fox,* and *Goetz von Berlichingen*—vital graphic statements that are narrative in the best sense; the delightful illustrations of Max Slevogt for *The Magic Flute, Don Giovanni,* and other romantic tales, expertly done on plates and stones; the mysterious, scurrile fantasies of the prolific Alfred Kubin; Kokoschka's illustrations of his own poetry and his interpretations of a Bach cantata; Renée Sintenis's spirited etchings of young human and animal bodies. These were perhaps the highlights of Germany's most promising decades. Bruno Cassirer, Kurt Wolff, Count Kessler, J. B. Neumann, and the Marées-Gesellschaft published portfolios of etchings and lithographs by the painter Max Beckmann, the sculptors Ernst Barlach and Wilhelm Lehmbruck, and the satirist George Grosz; but perhaps even more significant were the graphics produced and published by the Bauhaus in Weimar. These included the prints of Lyonel Feininger, Paul Klee, Gerhard Marcks, Oskar Schlemmer, Kurt Schwitters, Franz Marc, and others.

The famous Expressionist group Die Brücke issued their own *Jahresmappen,* annual portfolios of prints devoted mostly to individual members of the group. From 1906 to 1912 the Brücke published the work of Kirchner, Heckel, Nolde, Schmidt-Rottluff, Pechstein, and Otto Müller—etchings, lithographs, and woodcuts whose rugged strength time has not diminished.

However, looking back to France's era of Vollard, one becomes at once aware of its overpowering quality, based on the stature of the artists, the taste and devotion of the publishers, and the brilliance of the printers.

It is difficult to review objectively the first seven decades of the twentieth century while our feet are still firmly planted in it. We need perspective, a vantage point from which to survey those turbulent years as dispassionately as we can, while a profusion of isms are parading by at a dizzying pace.

PLATE 358

PLATES 355, 359

PLATES 360, 361

PLATES 362–365

348 *Henri Matisse.* Self-portrait. *1903. Etching. Fogg Art Museum, Harvard University, Cambridge, Mass.*

348

349

350

351

352

349 *André Dunoyer de Segonzac.* Portrait of Colette. *1935. Etching, 9 1/8 × 8 1/4".*
 Museum of Modern Art, New York (gift of Peter H. Deitsch)
350 *Salvador Dali.* St. George and the Dragon. *1947. Etching, 17 5/8 × 11 1/4".*
 Museum of Modern Art, New York (Larry Aldrich Fund)
351 *Jacques Villon.* En Visite. *1905. Drypoint, 11 1/2 × 15 1/2". Courtesy*
 Associated American Artists, New York
352 *Joan Miró.* Composition. *Color etching. National Gallery of Art, Washington, D.C.*
 (Rosenwald Collection)
353 *Jacques Villon.* M. D. Reading. *1913. Drypoint, 15 3/4 × 11 5/8". Art Institute of*
 Chicago (gift of Mr. and Mrs. William O. Hunt)

353

354 Edvard Munch. Moonlight. 1896. Etching, 1 5/8 × 1 7/8". National Gallery of Art, Washington, D.C. (Rosenwald Collection)

355

356

358

357

355 Max Beckmann. Dostoevski. 1921.
Drypoint, 6 3/4 × 4 5/8". National
Gallery of Art, Washington, D.C.
(Rosenwald Collection)

356 Edvard Munch. Christiania Boheme II
(with self-portrait at extreme left).
1895. Etching (second state), c. 11 ×
14 3/4". Fogg Art Museum, Harvard
University, Cambridge, Mass.

357 André Dunoyer de Segonzac. "Come
hither," illustration from Vergil, Les
Georgiques, Vol. I, 1944–47. Etching.
National Gallery of Art, Washington,
D.C. (gift of the artist)

358 Lovis Corinth. Double Portrait
with Skeleton. 1916. Drypoint,
3 15/16 × 5 7/8". Fogg Art Museum,
Harvard University, Cambridge, Mass.

PLATES 369–405 *The Twentieth Century in America*

We have seen what had set the European art world on its ear during the first quarter of the century; it was the Fauves (the "wild beasts") of the École de Paris. America was still fast asleep. *September Morn,* a pink nude wetting her feet, was the great attraction at the Metropolitan Museum of Art, and the robber barons of Wall Street collected etchings of French cathedrals and flying ducks, with perhaps a Whistler view of Venice or an Anders Zorn nude thrown in.

Then, like a whirlwind, the Armory Show of 1913 burst upon the New York scene. Initiated by frustrated American painters, including Arthur B. Davies and Walt Kuhn, it threw into the public's and the art critics' faces works by Cézanne and Gauguin, Rodin and Brancusi, Kirchner and Kandinsky, Matisse and Picasso, Signac and Redon, Braque and Duchamp—names they had never or only vaguely heard of

360

361

362

363

359 Max Beckmann. Landscape with Balloon. *1918. Etching and drypoint, 9 3/16 × 11 9/16". Yale University Art Gallery, New Haven, Conn. (gift of Mr. and Mrs. Walter Bareiss)*

360 Paul Klee. The Pergola. *1910. Drypoint, 3 13/16 × 5 1/8". Museum of Modern Art, New York (gift of Kurt Valentin)*

361 Paul Klee. Drinker. *1910. Etching, 8 9/16 × 6". Museum of Modern Art, New York (gift of Victor S. Riesenfeld)*

362 Ernst Ludwig Kirchner. The Model. *1924. Drypoint. Collection Carl Zigrosser, Philadelphia*

363 Erich Heckel. Insane People at Mealtime. *1914. Drypoint. Philadelphia Museum of Art (Ars Medica Collection)*

364 *Otto Dix*. Ration Procurement at Pilken. *1924. Etching and aquatint, 9 3/4 ×
　　11 9/16". Fogg Art Museum, Harvard University, Cambridge, Mass.*

365 *Emil Nolde.* Sick Man, Doctor, Death, and the Devil. *1911. Etching, c. 11 3/4
　　× 9 5/8". Brooklyn Museum, New York*

366 *Jacques Lipchitz.* Theseus. *Etching and aquatint. Fogg Art Museum, Harvard
　　University, Cambridge, Mass.*

367 *Kurt Seligmann.* Meditation. *1950. Etching and aquatint, 19 3/4 × 13 7/8".
　　Museum of Modern Art, New York (John B. Turner Fund)*

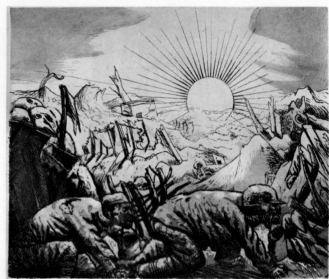

364

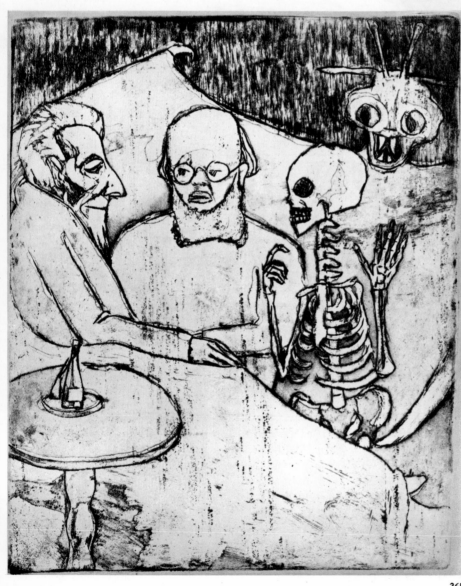

366

365

368

PLATE 370

PLATES 372, 373

368 Anthony Gross. Pujol. 1932. Etching and engraving. Brooklyn Museum, New York

—and works they had surely never seen. Kenyon Cox, an artist long since forgotten but for his vocal virulence, called the show in *Harper's Weekly* (March 15, 1913) "heartrending and sickening"; Cézanne "without talent"; Gauguin "a decorator tainted with insanity"; and Matisse's painting "leering effrontery." The exhibition sent its shock waves from coast to coast and woke up artists, critics, and the public alike.

The Museum of Modern Art was not to open until sixteen years later, but there were some enlightened collectors: the Cone sisters, John Quinn, Walter Arensberg, Dr. Barnes, and a handful of others not known to the general public. In 1908 Gertrude Vanderbilt Whitney had started a small gallery, a haven for the young independents, which grew in later years into the more formidable Whitney Museum.

Etching as a popular medium had taken a dominant place among graphics, vigorously promoted by the Brooklyn Society of Etchers, founded in 1915 by Ernest Roth, John Taylor Arms, and a group of etching enthusiasts and super-realists who adored and emulated Whistler, Haden, and Meryon. It included many well-established artists, among them Frank Benson, of duck-hunting fame; Ernest Haskell, etcher laureate of Maine; Kerr Eby; and others with the same devotion to detail.

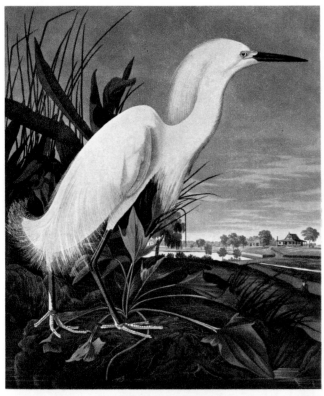

369

370

371

369 Robert Havell, Jr. (after John James Audubon). Snowy Heron,
or White Egret. *Published 1827–38. Colored engraving
and aquatint. National Gallery of Art, Washington, D.C.
(gift of Mrs. Walter B. James)*
370 John Taylor Arms. Limoges. *1932. Etching. National Gallery
of Art, Washington, D.C. (gift of Addie Burr Clark)*
371 Winslow Homer. Perils of the Sea. *1888. Etching, 16 3/8 ×
21 7/8". Brooklyn Museum, New York*

The Society developed and expanded later into the Society of American Graphic
Artists, which finally embraced all the other print media.

The counter-revolution started with John Sloan (1871–1951), whose 225 etchings
show him as a keen observer of the seedier side of the American scene, lined with ash
cans and Bowery bums. Edward Hopper (1882–1967) produced between 1915 and
1928 about fifty-two etchings and drypoints, traditional, yet in a ruggedly American
style all his own. A complete break with realism came with John Marin (1870–1953),
who embraced a vibrant Expressionist style in his etchings, spaced over a period of
forty-four years (1905–49).

The National Academy was still considered the supreme arbiter of the American
art world, rejecting "unsuitable" work such as that of Robert Henri and his friends
George Luks, William Glackens, Ernest Lawson, Everett Shinn, Maurice Prender-

PLATE 375

PLATES 377, 378

PLATE 380

PLATE 376

gast, and Arthur B. Davies. It is hard now to conceive of their work as avant-garde, but they formed their own protest group—The Eight, later called "The Ash Can School" or "The Revolutionary Black Gang" by unfriendly critics.

There was another group which deserved the epithet "rebels" even better. Alfred Stieglitz, whose Gallery 291 on New York's Fifth Avenue had dared to show some Matisse, Picasso, and Cézanne drawings and prints a few years before the Armory Show, had collected a group of remarkably different American artists—John Marin, Max Weber, Charles Demuth, Marsden Hartley, Stuart Davis, Alfred Maurer, and Arthur Dove. Most of them had breathed French air and somehow established a link between the school of Paris and the Ash Can School of New York.

There were also the homespun artists who had separated themselves from mere academism without losing their attachment to things American, and were much more acceptable to the critics and the public. There were Joseph Stella's new vision of

373

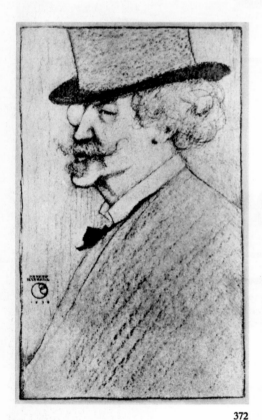

372

372 *Ernest Haskell.* Whistler. *1898.*
 Soft-ground etching, 10 1/2 × 6 5/8".
 Yale University Art Gallery, New Haven,
 Conn. (gift of Mrs. Laurent Oppenheim)

373 *Kerr Eby (1889–1946).* Day's End—
 Driftway. *Etching, 9 × 15 1/2". New*
 Britain Museum of American Art,
 New Britain, Conn.

374 *Childe Hassam.* Vermont Village—
 Peacham. *1923. Etching. Brooklyn*
 Museum, New York

374

Manhattan with its swinging bridges, Georgia O'Keeffe's bleached skulls and giant blossoms, Edward Hopper's haunted street scenes, Kenneth H. Miller's buxom housewives, George Bellows's, Raphael Soyer's, and Reginald Marsh's narrations of the little man's U.S.A.

Things had begun to stir in American art, accelerated by the Armory Show, stopped short by World War I, and set in motion again by expatriates' enchantment with Paris and its art-saturated atmosphere. In 1933 the Great Depression struck; there was no money for art, not even for paint and canvas, until the Federal Art Project stepped in as the new patron of the unemployed artist. Surprisingly, this experience proved to be a boon to the arts, or not so surprisingly if one looks at the roster of artists, from the more conservative Boardman Robinson, William Gropper, and George Biddle to the young firebrands, Stuart Davis, Arshile Gorky, Ben Shahn, Philip Guston, Jacob Lawrence, Milton Avery, Willem de Kooning, Jackson Pollock,

375 John Sloan. Memory *(with self-portrait). 1906. Etching. Philadelphia Museum of Art*

PLATE 379

376

377

378

379

376 *Arthur B. Davies (1862–1928).* Torment. *Etching and aquatint,*
8 × 12". Courtesy Associated American Artists, New York

377 *Edward Hopper.* The Railroad. *1922. Drawing. Philadelphia*
Museum of Art

378 *Edward Hopper.* The Railroad. *1922. Etching. Philadelphia*
Museum of Art

379 *Jackson Pollock.* Untitled. *1945. Engraving and drypoint, 14 15/16*
× 17 5/8". Museum of Modern Art, New York
(gift of Lee Krasner Pollock)

380 *John Marin.* Downtown, the El, *first version. 1921. Etching.*
Philadelphia Museum of Art (John and Celeste Golden
Collection)

380

381

381 *Henry Moore.* Standing Leaf Figures.
 1951. Etching. National Gallery of Art,
 Washington, D.C. (Rosenwald
 Collection)

382 *Mauricio Lasansky.* España. *1956. Intaglio.*
 Brooklyn Museum, New York

382

and others who rose to fame when prosperity returned to America. Mediocrity, of which there was a considerable amount, fell by the wayside.

The image of rural America became popular in regional art—the Kansas wheat-fields of Joe Jones, Grant Wood's pastoral Iowa, Thomas Benton's rugged Missouri, John Steuart Curry's epic scenes of insurrection. This was perhaps the American artist's last stubborn attempt to hold on to the pioneer, frontier vision of life in the U.S.A. It was short-lived.

Since then the horizons have widened; speed has conquered space; communications have become instant; and another World War shifted power, wealth, and influence from Europe to this continent. It seems to many observers that "art power" is now in the hands of the Americans, that artists all over the world keep their eyes glued on the latest New York happenings—and take it up from there! The print has been swept up in this surge of vitality and has finally come into its own. It was rescued from its former preciousness by the new concept of the *peintre-graveur*.

Hayter's Atelier 17, founded in Paris almost half a century ago, and active in New York during and after the war years, introduced the art of intaglio to many artists, great and small.

The workshop idea of close cooperation between *peintre-graveur* and printer, so superbly practiced in France for a century, had come to America and spawned other workshops along the way. In 1945, Mauricio Lasansky, Argentine printmaker, set up *PLATE 382* an intaglio shop at Iowa University. In 1947 Alfred Sessler, W.P.A. alumnus printmaker, started a graphics workshop at the University of Wisconsin, now conducted by Warrington Colescott, well-known for his satirical intaglio color prints.

That same year the author began to set up the first graphics department at Pratt Institute in Brooklyn; this culminated in the establishment of the Adlib Press and, in 1956, of the Pratt Graphic Art Center in Manhattan (now the Pratt Graphics Center). Simultaneously the author founded *Artist's Proof,* now an annual of printmaking devoted to "creating a better understanding of and establishing higher standards for the contemporary print; to give its creator, the graphic artist, a chance to present and discuss his work, his philosophy, his technique; to encourage experimentation and the establishment of new graphics workshops here and abroad; to promote the print as a means of cultural communication between nations; and to stimulate the interest in prints among private collectors and public institutions."

Gabor Peterdi has headed the graphic workshop at Yale University since 1952. His disciples now teach and work in institutions all over the country: Robert Birmelin at Queens College, Michael Mazur at Brandeis, Peter Milton at Maryland Art *PLATES 383–386* Institute, Richard C. Zieman at Hunter, Walter Rogalski at Pratt Institute.

The Tyler School of Art at Temple University has had a traditional interest in printmaking since its founding in 1935. Its present workshops are headed by Romas *PLATE 387* Viesulas, whose main interests are lithography and etching.

There is hardly a university or art school from coast to coast without a graphics workshop, many of them producing excellent work with emphasis on the intaglio print. The list is vast. Chapter 20, *Workshops,* discusses the work of these and other shops and studios in greater detail.

There are still some masters of metal engraving around, including Armin Landeck and Norma Morgan; and there are intaglio veterans such as Minna Citron, Peter Takal, Ernest Freed, Misch Kohn, John Paul Jones, Moishe Smith, James Mc- *PLATE 394*

383

385

*383 Walter Rogalski. Homage to a Technique. 1968. Engraving, 25 1/2 ×
22". Courtesy Associated American Artists, New York*

*384 Michael Mazur. Figures Fixed on Figure Falling, from the Closed
Ward series. 1965–66. Etching, drypoint, and aquatint, 30 3/4 ×
22 3/4". Courtesy the artist*

*385 Richard C. Zieman. Winter Tree. Etching, 24 × 18". Courtesy
Associated American Artists, New York*

386

386 Peter Milton. Julia Passing. 1967. Etching
and engraving, 18 × 24". New Britain
Museum of Art, New Britain, Conn.
387 Romas Viesulas. Self-portrait as a Potato.
1967. Intaglio with embossment, 29 ×
39 1/4". Courtesy Weyhe Gallery, New
York

387

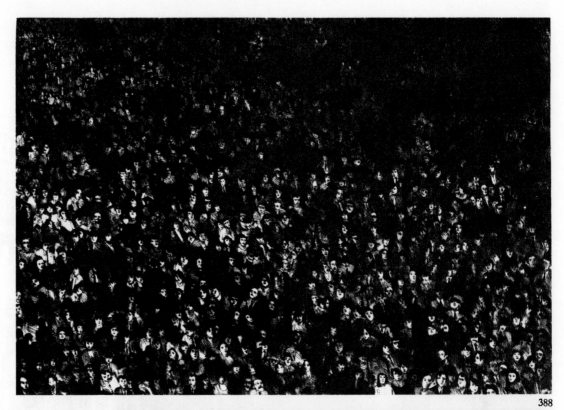

388

389

390

388 Gerson Leiber. The Crowd. *1967. Etching and aquatint, 25 × 35". Courtesy Associated American Artists, New York*

389 John Paul Jones. Landscape Woman. *1961. Etching. Brooklyn Museum, New York*

390 Karl Schrag. Night by the Sea. *1965. Etching and aquatint, 20 × 24". Courtesy Pratt Graphics Center, New York*

391

392

393

394

391 Terry Haass. Illustration for Walt
 Whitman, Leaves of Grass. 1966. Color
 etching, 4 × 2 3/4". Courtesy
 Associated American Artists, New York

392 George Lockwood. The Real Cricket. c.
 1966. Color intaglio, 2 3/4 × 2 1/8".
 Collection the author

393 James McGarrell. Game. Etching.
 Brooklyn Museum, New York

394 Peter Takal. Growth. Drypoint, 27 ×
 20 1/2". National Gallery of Art,
 Washington, D.C. (Rosenwald Collection)

PLATE 391

Garrell from Indiana, and Al Blaustein and Vasilios Toulis from Pratt. Terry Haass and Bernard Childs are commuters between New York and Paris. Sergio Gonzales Tornero and his wife Adrienne Colum, Sigmund Abeles, Jerome Kaplan, and a score of others represent the younger set.

The variety of approaches to the intaglio print is truly amazing and ever-widening. The plates are becoming larger, sometimes gigantic, and the color more lavish, in competition with painting.

Has it reached its limits, exhausted its forms with metal collage in the manner of Rolf Nesch and Michael Ponce de León? With uninked intaglio as practiced by Josef Albers, Omar Rayo, Angelo Savelli, and their many imitators? With shaped prints like Jack Sonenberg's and Luis Camnitzer's? With slashed or pricked prints like Hans Haacke's or Lucio Fontana's?

PLATES 396, 397

Perhaps even as we read this, the momentum is again swinging away from the intaglio print toward the multiple conceived by the artist but produced by vacuum machine, offset press, or silkscreen process, or as a three-dimensional object. What the next trend will be is anyone's guess.

395

396

397

398

399

395 *Jim Dine.* Self-portrait, *from the portfolio New York 10. 1964. Etching, 17 5/8 × 13 15/16". Museum of Modern Art, New York (Law Foundation Fund)*

396 *Jack Sonenberg. Of Minos. Cast paper print, 27 1/2 × 18 1/4". Courtesy Associated American Artists, New York*

397 *Luis Camnitzer.* Portrait of Johnny. *1965. Woodcut and polyester mold, printed on surgical plaster bandage, 26 × 22 1/4". Courtesy Pratt Graphics Center, New York*

398 *Jasper Johns.* The Critic Sees. *1967. Embossment. Philadelphia Museum of Art*

399 *Bernece Hunter.* Wild Sea Birds. *1967. Color intaglio, 8 1/2 × 9". Courtesy Pratt Graphics Center, New York*

400 *Marjan Pogačnik. Gardener's House. 1963. Intaglio with embossment, 15 × 12 1/2". Collection Andrew Stasik, New York*

401 *David Hockney. Print from the suite* The Rake's Progress. *1961. Etching and aquatint. Courtesy Pratt Graphics Center, New York*

400

401

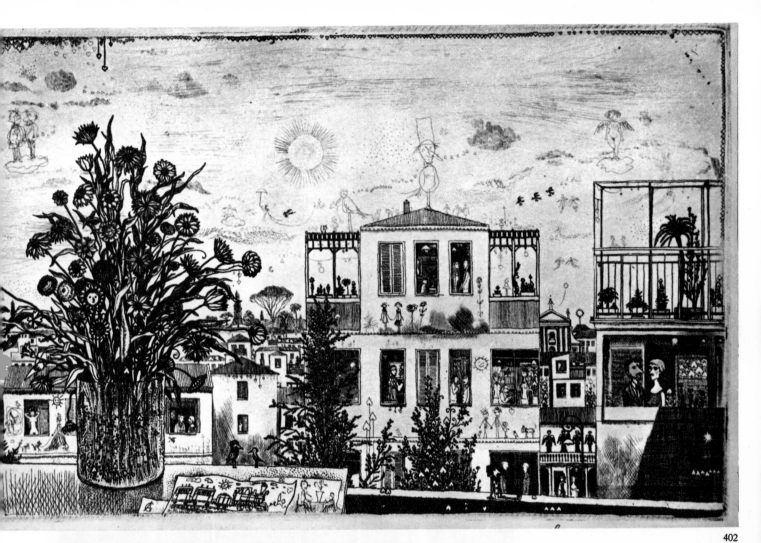

402 *Arnold Gross*. Small Italian Town. *1966.*
Color etching, 5 1/4 × 10". Hungarian
National Museum, Budapest

403 *Béla Kondor*. Apocalypse with Puppets
and Machines. *1956. Etching,*
7 1/8 × 9 1/2". Hungarian National
Museum, Budapest

404

404 *Jyoti Bhatt. Baroda. 1967. Intaglio,*
 printed on a sheet of brass, 14 1/2 × 12".
 Courtesy Pratt Graphics Center, New
 York

405 *Shiou-Ping Liao. Festival of Moon.*
 1936. Etching. Brooklyn Museum, New
 York

405

CHAPTER 10

SURVEY OF INTAGLIO TECHNIQUES

PLATE 406

The popularity of a graphic medium is subject to vacillations, very often dependent on psychological rather than economic or technological factors. The intaglio media, it would seem, have a fascination that sometimes derives from the intricacies of the material and the challenges it presents: the bite of the acid, the accidents of chemical reaction, the surprises arising from the inking or wiping of ink into the grooves, and the ultimate revelations of the first proof, leading through various states to the climax of perfection.

The story of intaglio began with the engraver's tool cutting a design into a medieval knight's armor or a lady's belt buckle, cold steel working on a piece of precious metal. Then came, more or less by accident, the idea of rubbing printers' ink into the incised lines and coaxing it out under pressure onto a piece of damp paper to prove the design—the birth of the intaglio print.

The first etching must have been the result of some artist's brainstorm—the idea of covering the metal with an acid-resistant coating, running a needle through it lightly to draw his design, and pouring acid into the exposed metal to eat out the lines and strokes formerly cut by a tool. With this invention the intaglio process was put at the disposal of the artist. The grounded metal would accept with comparative ease a casual, sketchy line and yield dramatic depths of black as well as dazzling

flashes of light. If desired, the lines could be reinforced with the point of a needle or burin and the backgrounds covered with powdered rosin to produce the grainy velvet of the aquatint—a range of effects that modern artists have continued to develop and exploit.

PLATE 407–409

In intaglio the ink, instead of being pressed into the paper, as in the relief print, is coaxed out of the depressions in the plate to stand up on the paper in slight relief, inviting the touch of the fingertips. The bevel of the copper plate, impressed into the paper and framing the image, somehow adds to the pleasure of owning an authentic etching or engraving, for a long time the most prized of all the graphic media.

The mezzotint, a latecomer of the eighteenth century, deserves a special chapter (Chapter 12). Specifically, the mezzotint image is burnished or polished out of a roughed-up copper plate, so that it is neither an etching nor an engraving, though it is still an intaglio printed on an etching press.

It was only a matter of short steps from the copper plate, which allowed only limited impressions, to the steel plate or to the steel-faced copper plate, which did not substantially change the image but made much larger editions possible. Now, in our own age of synthetic substitutes, great changes have been made and may further be expected in the still-popular intaglio media.

406 Ludwig Michalek. Test plate of intaglio techniques. Late 19th century. Graphische Sammlung Albertina, Vienna

406

The modern etching presses are not substantially different in construction from those used by Piranesi and Abraham Bosse, except for the addition of electric power and hydraulic pressure as needed. The inks and papers of that past era, however, have never been equaled—we wish we had them today. Some artists still prefer copper, but zinc has now become popular because it is less expensive. As for grounds, tools, and acids—they have remained practically the same through the centuries.

Nevertheless, we have seen a revolution that would make Rembrandt turn over in his pauper's grave. Ever since Stanley William Hayter and his associates, working in his Atelier 17 in Paris in the early 1930s, reawakened interest in a nearly dormant art form, the intaglio print has been undergoing a conceptual and technological renaissance. New materials, photography, and skills developed in other print categories, such as photoengraving, lithography, and the silkscreen, are being utilized by many contemporary intaglio artists. Three-dimensional prints, prints of enormous scale, plastic plates and prints on plastic, image repeats and offset images, cutouts, plaster blocks, molded paper, inkless embossed prints, the use of power tools and com-

mercial presses—these and endless other devices suggest that we have only begun to explore the possibilities of the intaglio medium.

The collage game has made jigsaw puzzles of metal plates, enabling the artist to ink a dozen different pieces in a dozen different colors and still produce a print with one run through the press. By rearranging the pieces and changing the colors, he can produce a variety of "states" of prints, often with astonishing results. Cardboard and other materials have invaded the field as a substitute for metal, witness the amazing and ingenious collo- or collagraph, which may consist of a happy marriage of gesso and glue, plus any number of foreign objects embedded in the mixture. When hardened and varnished, these may produce intaglio plates second to none, except for their limited durability. The inexpensive and flexible epoxy print is a boon to underdeveloped school workshops and low-budget operations, though, of course, an etching press, blankets, ink, and paper are still required.

Finally there are those works loosely described as incorporating "mixed media," a term that often denotes the inability to define accurately what the artist has wrought. In this sense "intaglio" may be anything printed on an etching press, involving materials of all sorts combined in any media known to the printmaker. Some of our eminent practitioners have discussed their experiments more fully in Chapter 11.

The remainder of the present chapter is concerned with the basic intaglio techniques that are essential to an understanding of old or modern prints in the medium, dealing first with the various ways of creating the image on the plate and, in the last two sections, with printing. For the summary of procedures representative of general practice the author is indebted to Vasilios Toulis, of the Art School of Pratt Institute, a versatile and experienced printmaker and educator.

These techniques are described separately, but contemporary printmakers seldom

407 Pablo Picasso. Untitled sketch sheet. 1937. Etching and aquatint. Philadelphia Museum of Art

408 Pablo Picasso. Le Viol. 1931. Etching, 8 11/16 × 12 1/4". New York Public Library, Astor, Lenox and Tilden Foundations (Prints Division)

409 Pablo Picasso. Les Deux Saltimbanques. 1905. Drypoint. Philadelphia Museum of Art

408

409

confine the creation of their images exclusively to one method. An artist may begin perhaps with a preliminary line engraving or etching. Examination of his first proofs will excite his imagination and suggest procedures that he had not thought of before. He may carry the work forward by using different methods of producing lines and tonal values, by adding textures and deeper biting to certain areas, or by making changes with scraper and burnisher. The development of the image may proceed through many laborious reworkings from the first concept to the finished print.

Metal Engraving

PLATE 410

In the discussion of print media an attempt has been made to describe more or less consistently methods which will allow printmakers to travel different roads to reach the same goal—that of making a fine print. In the case of metal engraving (or line engraving), however, there are a few ground rules that must be strictly observed. The first requirement is a burin sharpened to absolute perfection for cutting the design into the plate. With the second—the use of a suitable plate to match the burin—a certain divergence begins.

To quote two outstanding exponents of this medium: S. W. Hayter says (*New*

410 Philip Galle (after Stradanus). The Engravers. 1600. Engraving. New York Public Library, Astor, Lenox and Tilden Foundations (Prints Division)

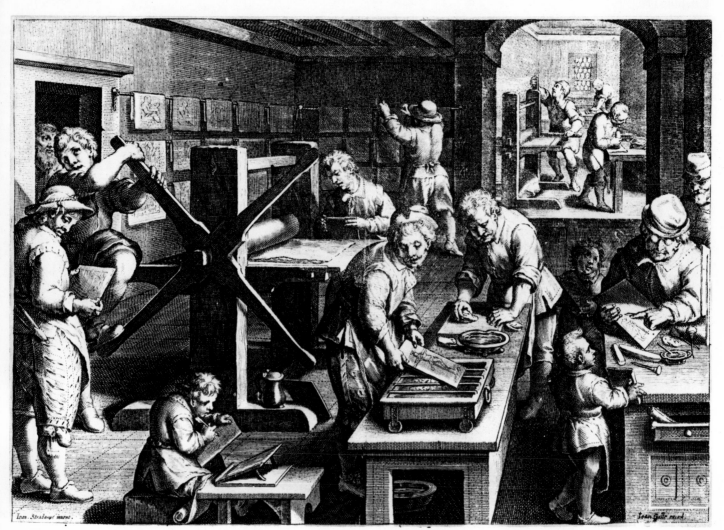

Ways of Gravure, Pantheon, 1949, p. 54 ff.): "Copper is always used, in plates of 18 or 16 gauge. . . . Zinc plates should never be used for burin engraving, as the metal is soft and crumbles when pressure is used against the tool." Yet Gabor Peterdi, who studied with Hayter in Paris, says (*Printmaking, Methods Old and New,* Macmillan, 1959, p. 12 ff.), after mentioning copper as the best all-round metal for engraving: "I have used zinc plates extensively for engraving in the past ten or twelve years and have found them not only satisfactory but even preferable when bold free cutting is desired." The choice is not even limited to metals. Arthur Deshaies seems to prefer engraving on Lucite, which both Hayter and Peterdi despise.

Both of the latter recommend working on a plate slightly dulled by a weak nitric-acid or other mordant bath to remove the glare of the polished plate. But whereas Hayter prefers making his drawing with a pencil directly on the plate or tracing it through a carbon paper, Peterdi considers wax crayon or china-marking pencil better than soft pencil, which latter smudges easily. He also approves of etching lightly over the acid-resistant wax crayon to retain a permanent guideline on the plate.

These examples point out that there are no immutable dogmas—even among printmakers proficient in the same medium. Variation in method will lend spice to a print medium.

At the next stage, the actual engraving—how to dig the tip of the burin into the plate, how to level it off and make it glide along without slipping, gouge out the right amount of metal, and achieve finesse and elegance or force and ruggedness—again depends entirely on the temperament of the artist and the effect he desires. He may also choose his tool according to the width and depth of line he desires, for burins are available in many sizes with cutting faces that may be lozenge-shaped, rectangular, rounded, elliptical, or serrated to create multiple lines.

Success may even depend on the convenient height of the work table and the surface on which the plate rests. It should turn easily on a polished surface, on glass or Lucite, against the driven tool, perhaps with a piece of cardboard slipped under the center of the plate.

No excessive force should be used by the hand that holds the burin. Engraving requires a disciplined mind and a sure hand, and only continued practice can tell whether medium and artist are meant for each other.

Drypoint

In this direct and simple process the image is scratched into the plate with a steel or gemstone point. Despite its simplicity, the drypoint is capable of much beauty and subtlety; it is probably the most autographic of all intaglio processes, because the drawing is made directly and very freely.

PLATES 411, 412

As the point (or needle) moves across the plate, it leaves a groove, or furrow. The depth and strength of the resulting line depend on the material of the plate, the point used, the pressure exerted, and the angle at which the tool is held. The point raises a burr of metal at the edges of the furrow, which catches ink during printing and provides the characteristic velvety line that is commonly associated with the drypoint medium. The burr is easily diminished in the process of inking, wiping, and printing. As a result, drypoint plates are somewhat frail and are usually limited to the printing of fairly small editions; otherwise the later prints will show increasing variation. If

411 *Jack Levine. Death's Head Hussar. c. 1969. Drypoint, 11 5/8 × 8 7/8". Brooklyn Museum, New York (Dick S. Ramsay Fund)*

412 *Jiri John. Autumn. 1967. Drypoint, 15 3/4 × 19 5/8". Collection Andrew Stasik, New York*

413 *Masuo Ikeda. Fashion. 1969. Lithograph and drypoint, 21 × 16". Brooklyn Museum, New York (Carll H. De Silva Fund)*

the burr is removed with steel wool or scrapers before printing, leaving only the grooves to hold the ink, the plate may yield many impressions but with a harder, sharper line.

The best points are those tipped with an industrial diamond, preferably set in rubber in a steel shaft; they travel freely in any direction and cut more deeply than other points, and with less effort. A carbon-steel engineers' scribe is also effective, if kept properly sharpened to avoid facets that would cause it to stumble on the metal and travel erratically. Reshaped and sharpened dentists' tools and, in fact, any point of good hard steel that is not too brittle may be adapted for use. Some excellent drypoints have been made by using electric tools with burrs and punches; for example, an electric vibrating tool that stipples at high speed and can be adjusted for depth of stroke will make thousands of miniature craters which hold up well in printing.

Copper, which combines ease of drawing with good resistance to wear, is the traditional metal for the plate, but the present-day artist may develop his own preferences from a choice that includes zinc, aluminum, brass, tin, soft steel, magnesium, plastics, phenolic sheets, laminates, vinyl tiles, Masonite, and many others.

The more vertically the point is held in drawing, the stronger and more resistant to wear the resulting line will be. As the work progresses, intaglio ink softened with oil (or a bit of oil mixed with charcoal) may be rubbed into the lines to reveal more clearly the progress on the plate. Corrections may be made by pushing down the burr of the furrow or by polishing with fine steel wool or emery paper.

The drypoint technique is frequently utilized in connection with the other intaglio processes, and it has also been successfully combined with other print media. Masuo Ikeda, for example, made effective use of a drypoint impression in his print *Fashion*, otherwise executed by lithography.

PLATE 413

411

412

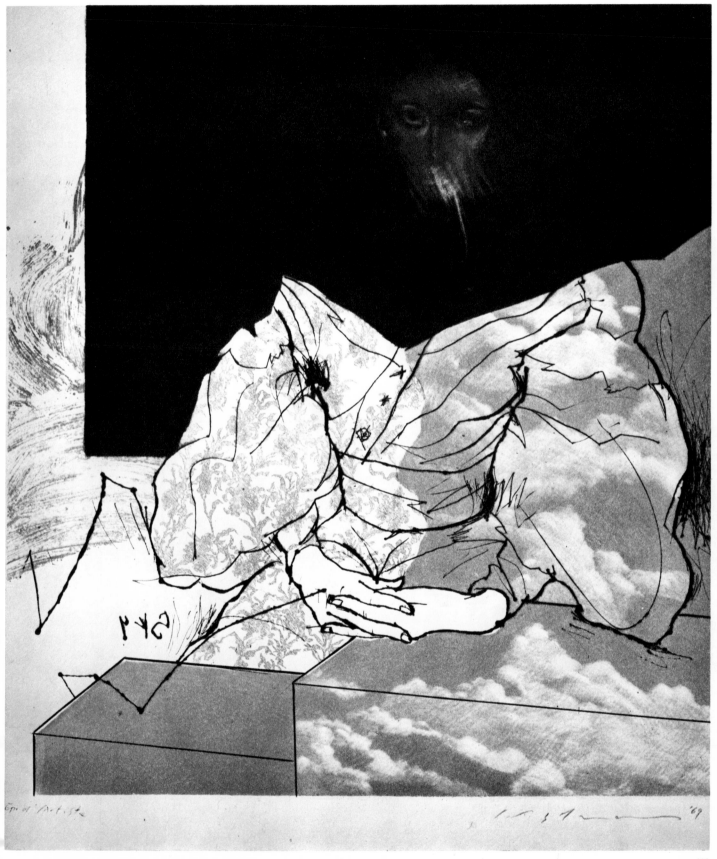

Etching

PLATES 414–417

Probably the most common of all intaglio processes, etching inscribes the image into the metal plate by the use of acid instead of a cutting tool. It is capable of a wide range of individual applications and expressive possibilities. The plate is protected (or grounded) with an acid-resistant coating through which the artist may freely draw with needles or other instruments to expose the metal of the plate. The acid acts upon these exposed lines, eating them into the metal. The depth of the biting and the resulting strength of the lines and marks are dependent upon the strength of the acid bath, the length of time bitten, and the temperature. Practice and experience, rather than total reliance on formula, generally prove to be the most reliable means of determining the best results.

Zinc, copper, and brass are the metals most often used. The back of the plate must be protected with a coating of lacquer, shellac, asphaltum, or some other acidproof substance, which should be brushed on, if not already applied by the manufacturer. The face of the plate is thoroughly but gently cleaned with pumice, kitchen scouring powder, or a mixture of ammonia and whiting. It is then given a ground when dry.

414

415

414 *Giorgio Morandi.* Still Life. *Etching. Fogg Art Museum, Harvard University, Cambridge, Mass.*

415 *Edgar Degas.* Portrait of the Engraver Joseph Tourny. *1856. Etching. Bibliothèque Nationale, Paris*

416 *Alfred Hrdlicka.* Haarmann Was Born Under an Unlucky Star, *from the* Haarmann Cycle. *1965. Etching, 19 11/16 × 19 5/8". Courtesy Marlborough Fine Art (London) Ltd.*

A substance known as "hard ground" is used to coat the plate for most line etching. (Soft-ground etching, which can produce quite different effects, is discussed in the following section.) It may be used in either of two forms, ball or liquid, which are applied differently, though they may be identical in composition except for the addition of benzine or some other solvent to dissolve the liquid ground. Ball ground,

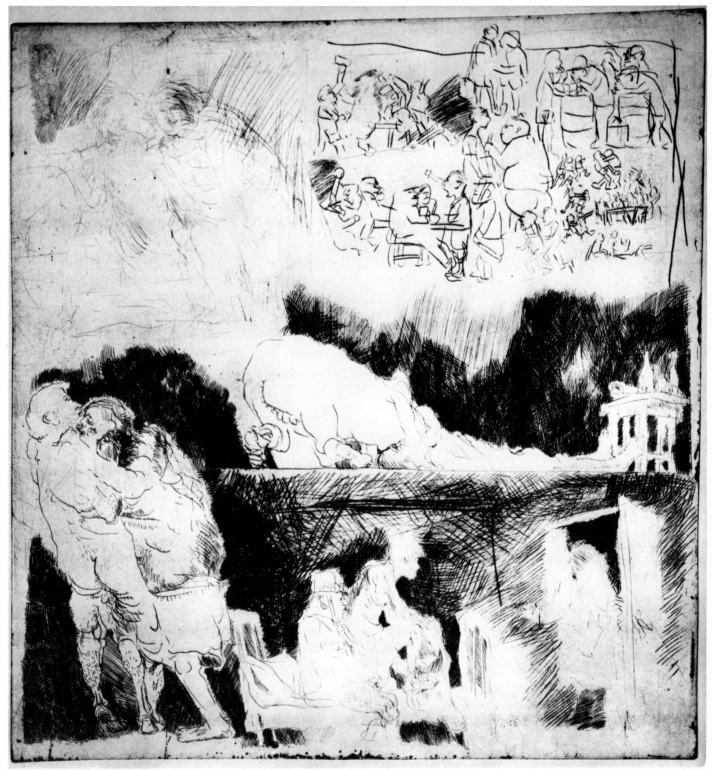

416

417

in the form of a small ball about the size of a walnut, is rubbed in sufficient quantity across the plate (which has been warmed on a stove or hot plate) and then evened out, either by dabbing it gently with a leather-covered "dauber" (or pad) or by rolling with a hard-rubber or leather-covered brayer until a uniform and even coating is laid. Liquid ground is brushed or painted on the plate as evenly as possible.

Hard grounds may vary somewhat in ingredients and proportions. However, a typical and reliable ball ground may be made by melting 2 parts of beeswax in a double boiler, adding 2 parts of Egyptian asphaltum and then 1 part of dammar or gum mastic, and stirring the mixture well. About 3 ounces of it are poured into a basin of water and shaped into a ball as it cools. The ground may be made softer by adding more wax, more brittle by adding asphaltum, or more transparent by adding rosin. For a more rapid-drying ground, lacquer thinner may be added.

It is customary, though not essential, to smoke the ground by holding the plate upside down in a hand vise and passing it over the smoky flame of twisted tapers or a kerosene lamp. After several passes the heat softens the ground somewhat, and the soot from the tapers or the lamp merges with the ground, producing a shiny black surface which is most pleasant to draw upon. When the plate has cooled, the image may be needled directly, or a preliminary drawing may be transferred to it as a guide for needling. If the preliminary drawing has been made on a nonabsorbent paper with soft graphite pencil, it may be transferred by laying it face down against the grounded plate and passing it through the press with a pressure slightly less than that used for printing.

The image must then be drawn into the plate, exposing the metal under the ground. Any instrument which accomplishes this purpose may be used. Etching needles may be purchased ready-made or may be improvised from pins or needles affixed to a pencil, broken dentists' instruments, a stylus, or other tools.

There are two methods of achieving different depths of line. Some printmakers needle only the deeper lines first, allow them to etch for a period of time, then add

lighter lines and etch again; the added lines, being etched for a shorter time, will be shallower. Others needle the entire image before immersing the plate in the acid bath, then remove the plate from the bath periodically and "stop out" the lines that are to be lighter, allowing the lines that are to be deeper to etch longer. The "stop-out varnish" that is applied to lines to prevent further etching in the bath may be composed of shellac tinted with dye, or of rosin dissolved in tinted alcohol.

The acid solution in which the plate is bitten is commonly called the "mordant" or the "acid bath." Nitric acid, which is most often used, works equally well on copper, zinc, and brass. The strength of the acid bath is varied according to the metal used and the effect desired. The following proportions are generally practical for etching zinc plates: 1 to 10 (that is, 1 ounce of nitric acid in 10 ounces of water) for delicate, controlled line work; 1 to 8 for general work in line, when a moderately rapid bite is desired; 1 to 4 for deeply bitten lines and robust parts. Much stronger baths are used for corresponding work on copper plates: 1 to 5, 1 to 3, and 1 to 2 respectively. Mixtures for brass are made slightly weaker than those for copper. The stronger acid used for deeply bitten lines tends to eat somewhat corrosively into the edges of lines and shapes.

Nitric-acid bubbles will form along the lines during etching. They must be brushed away from time to time; otherwise they will influence the quality of the bitten line, leaving it coarser and less clean. A bath in which zinc has been bitten should not subsequently be used for copper or any other metal, and vice versa; an uncontrollable electrolytic action could easily result, spoiling the ground, the plate, and the acid.

Dutch mordant is a slower, more cleanly biting acid that may be used for either copper or zinc. If the bath is kept warm (about 80 degrees), it will etch more rapidly with no appreciable coarsening of lines. To make a bath for zinc plates, 2 ounces of potassium chloride crystals are dissolved in hot water, and cold water is added to bring the total amount of water up to 88 ounces; finally 10 ounces of hydrochloric acid are added. The corresponding proportions used on copper are 3, 77, and 10 ounces—though all proportions may be altered a bit if desired. Some etchers find it useful to add a small amount of nitric acid to Dutch mordant; this causes the formation of bubbles, which enable them to judge the progress of the etching more easily.

Perchloride of iron is another slow, cleanly biting acid, preferred by some artists for etching on copper. The bath is composed of 1 part of perchloride of iron (saturated solution) and 1 part of water. Biting must be done with the plate submerged upside down in the bath and resting on strips of glass or plastic. This allows the sediment that forms to fall out of the lines; if the plate were bitten face up, the sediment would accumulate and slow down or restrict the biting action. It is advisable to remove the plate from the bath frequently to examine the lines; each time the plate should be washed with water under pressure before it is returned to the bath.

When the etching is complete, the plate is cleaned with a solvent (such as benzine, kerosene, or turpentine) and is then ready for printing. After the first proofs are pulled, the whole process may be repeated in order to make additions, alter lines, or intensify parts that are judged to be weak.

Soft-ground Etching
This technique, while similar in principle to etching through a hard ground, is

PLATE 419

executed with a ground that never fully hardens and will remain sensitive to pressure. Textures pressed into the ground will produce a pattern and expose the metal so that the texture can be etched into the plate. Lines drawn into soft ground will etch, as do lines drawn through hard ground, but they will have a coarser, more dotted character. Lines drawn through a paper overlay onto the plate will impart the texture of the drawing paper to the plate and will etch with a somewhat crayon-like effect. Tonal areas may be achieved by pressing woven or meshed materials such as cheesecloth, silk, or nylon through the soft ground, and then etching and stopping out those areas when the desired depth of tone has been attained.

Soft ground is available commercially from dealers both as paste and in ball form. A liquid soft ground may be made by dissolving the ball or paste in naphtha or benzine until it has the brushing characteristics of liquid hard ground. It may also be compounded by adding a small amount of cup grease, tallow, Vaseline, lard, or machine oil to liquid hard ground, experimenting until the mixture is adjusted to the degree of softness desired.

To apply soft ground in paste or ball form a generous quantity is rubbed onto a warmed plate and rolled out evenly with a brayer or roller (preferably a leather one used only for this purpose). As soon as an even, dark-brown coating is attained, the plate is removed from the heat and allowed to cool. Liquid soft ground is applied in the same manner as liquid hard ground, by painting the mixture on the plate with a brush. It is advisable to warm the plate after the application, because the heat drives out the volatile solvents and causes the ground to level into a more even coating. As soon as it has cooled, the plate is ready for working.

Some artists like to draw through an overlay. In this case a thin paper is laid over the soft-grounded plate, with a margin of about 2 inches folded over onto the back of the plate and taped down on one edge, so that the registration of the work is maintained but progress can be checked from time to time. Drawing is done directly on the paper with a pencil, ball-point pen, or stylus. The point of the drawing instrument will remove ground from the plate wherever pressure is applied. (The hand should not rest too heavily on the overlay, for its pressure too will affect the soft ground.) When etched, the drawn lines or marks print with a grainy, crayon-like texture, coarse or fine depending upon the paper used. If a preliminary drawing seems desirable, it can be made on tracing paper in red ink, flopped over so that the drawing is reversed, and attached to the grounded plate. The red ink can be seen through the tracing paper and will serve as a guide for the final drawing that penetrates to the plate.

Transfers for soft-ground plates may be made by drawing the image on a sheet of thin, hard paper (such as tracing paper), using liquid soft ground or litho rubbing ink as a drawing or painting medium. This image on paper can be transferred to the clean plate simply by running it through the press. Rubbings made with a soft, waxy ink or a grease crayon can be transferred to a plate in the same way.

The textures of woven fabric, bark, string, aluminum-foil papers, and other materials may be imparted to a print by laying them down on the soft-ground plate, placing a sheet of waxed paper over them, and passing the plate through the press with slightly less pressure than is used for printing. After being pressed through the soft ground, the textured areas can be redefined or modified by stopping out or further drawing before the plate is etched or during the etching process.

418

419

418 *Eugène Delacroix*. Un Forgeron. *1833.*
Aquatint (early state). Philadelphia
Museum of Art
419 *Roseann Drew. Untitled diptych.*
Soft-ground etching and aquatint, 15 1/4 ×
6 5/8". Courtesy Pratt Institute,
Brooklyn, New York

When the image is completed, the plate is etched in the manner described for hard-ground etching. Parts may be covered with stop-out varnish or liquid hard ground, and, as the work proceeds, additions may be made whenever necessary.

Aquatint and Mass Tonal Areas

A large open area (or even a very broad line) etched into a plate will hold no appreciable amount of ink except along its borders. It certainly will not print as a solid tonal area with predictable results, because the ink will be at least partly removed when the plate is wiped for printing. In order for a mass area to hold ink and print a tone, a device must be used to break up the surface into minute peaks and valleys (a texture somewhat like sandpaper) that can hold ink. Tonal effects can be achieved in several ways. The most popular technique is called "aquatinting." The aquatint, with its great range of tonal values, is capable of effects similar to those achieved by lithographic crayon or wash techniques.

420 *Chaim Koppelman.* On Meeting Beauty
II. *Aquatint, 14 1/2 × 17 3/4".*
*Courtesy International Graphic Arts
Society, New York*

421 *Franz Kline. Illustration from* 21 Etchings
and Poems, *Morris Gallery, New
York, 1960. Etching and aquatint.
Philadelphia Museum of Art*

422 *Willem de Kooning. Illustration from* 21
Etchings and Poems, *Morris Gallery,
New York, 1960. Etching and aquatint.
Philadelphia Museum of Art*

420

Poem

I will always love you
though I never looked you
a boy, smelling faintly of weather
looking up at your window

the passion that enlightens
and stills and cultivates, gone
while I sought your face
to be familiar in the likeness
or to follow your sharp whistle
around a corner into my light
that was love growing fainter
each time you failed to appear
I spent my whole life searching
loves which I thought was you
it was mine so very briefly,
and I never knew it, or you went

I thought it was outside disappearing
but it is disappearing in my heart
like snow blown in a window
to be gone from the world

I will always love you

Frank O'Hara

421

In most aquatints the principal lines of the composition are established first, by means of etching or engraving, after which the plate is cleaned well and degreased with ammonia or vinegar. It is then ready to receive the "aquatint ground," which will provide the various tones desired; this is composed of a fine, medium, or coarse layer of pulverized rosin, which is dusted over the plate and then heated to make it fuse with the metal.

Powdered rosin is available commercially, but it never seems to work well, perhaps because the grains are too fine. Therefore artists tend to use lump rosin, which they pulverize themselves by placing it in a bag and crushing it with a hammer or stone until it is reduced to a state somewhat like that of granulated sugar. About a

cupful of the powdered rosin is then placed in a cloth bag (or a square of cloth about the size of a kerchief, tied up with string). Almost any fabric can be used for the bag; most printmakers keep several bags on hand, ranging from a coarse to a fine mesh to suit the density of tone they prefer for a particular print.

The rosin may be dusted over the entire plate (in which case the areas where a tone is not wanted must be stopped out before etching), or it may be dusted only over the areas where a tone is desired. The bag is simply held a few inches above the plate and joggled. Needless to say, this operation should be performed in an area that is as draft-free as possible. Some artists prefer to insert the plate in an aquatint dusting box within which the powdered rosin is circulated by a fan, bellows, or blower so as to fall on and cover the plate evenly.

The dusted plate should be examined by holding it up at eye level to determine whether more rosin is needed or whether (if the coating is too thick or uneven) the plate should be blown clean and a fresh start made. The ideal coverage is achieved when 40 to 45 percent of the plate's surface is occupied by individual minute grains of rosin, leaving bare the intervening valleys that will receive the etch and hold the ink. A lesser coverage will produce a structurally weak and unpredictable aquatint. Too much rosin, on the other hand, will prevent the plate from etching properly. For predictable, even tonal areas the layer of rosin dust should have the appearance of an even field of slightly yellowed snow when seen at eye level. In practice, however, the printmaker may prefer to dust more plentifully or sparsely in specific areas, and for textural variety he may use both fine and coarse rosin on a single plate.

A rosin ground applied in liquid form may be rather difficult to control. For this purpose 4 to 5 ounces of rosin are dissolved in a pint of alcohol, or further diluted with alcohol to increase the fineness of the grain. The liquid mix is floated across the plate one or more times, and the excess is allowed to run off into a tray. Handled properly and at moderate temperature—not too hot or too cold—this method can produce the most delicate tonal effects.

The rosined plate is then heated from the bottom until the grains directly over the heat show the first signs of turning transparent; at this precise moment—not a half-second later—the plate is moved so that another area is brought over the heat. The purpose of the heat is not to melt the rosin so that it flows and runs, but merely to soften it so that it will stick to the plate. If a plate has been erratically heated or overheated, it can be cleaned off with a liberal amount of alcohol solvent and a fresh start made. The plate must be allowed to cool before it is etched.

The rosin, as mentioned earlier, is composed of numerous small peaks and valleys. During the etching, the depth of the valleys, and consequently the tonal depth of the area, will increase in proportion to the length of time the plate is allowed to remain in the acid bath. In other words, the greater the etching time, the darker the tone will be in the final print; beyond a certain maximum time, however, the peaks begin to be undercut by the etch and the plate begins to revert toward a lighter tone. An aquatint done on zinc will reach this maximum (that is, the darkest tone or black) in about 16 to 20 minutes when etched in a solution of 1 part nitric acid to 9 parts of water. It is unwise to use a solution stronger than 1 to 8 for aquatint because the etch becomes cumulatively more rapid and erratic as heat is generated by the action of the acid on the metal. Weaker solutions (1 to 10 up to 1 to 20) are used by some printmakers, and some prefer to use other acids, such as Dutch mordant. There

423

423 Herbert L. Fink. The Back Shore.
*Etching and aquatint, 12 × 18". Courtesy
Associated American Artists, New York*

PLATE 423

are variables to be reckoned with here, depending not only on the type of acid and its strength and the metal used but also on temperature, the amount of mass being etched, and other factors.

In practice the artist generally prepares a sketch of the areas that are to be white, middle gray, dark gray, and black. (This may be done on a proof of the major lines etched or engraved into the plate at the outset.) Two, three, or perhaps four tones are most often used—rarely more. Experience indicates that ultra-subtle transitions become somewhat meaningless in the print, as they tend to diminish the visual strength attained with three or four distinct tones. However, some artists' work is deliberately based on finer gradations.

Before etching, the areas that are to remain white are protected with stop-out varnish or liquid hard ground so that they will receive no biting at all. When the stop-out has dried, the entire plate is etched for the length of time required for the lightest tone in the scheme. Once that has been done, the plate is rinsed in water and dried, and those lightest areas are stopped out. The plate is then returned to the acid for the additional etching required for the next (darker) tone.

The artist concerned with controlling his tones exactly will probably make, before etching, a "time-tone scale," by which he may gauge the etching time for each tone desired. Such a scale may be made by applying a rosin ground to a strip of

the plate metal and then etching it in bands at various time intervals ranging from 0 (stopped out for white) to 16 minutes (at which time the darkest tone, or black, is usually produced). A final 32-minute band is useful because it indicates the extent to which the ground begins to deteriorate with overetching.

When all the tones have been etched, the rosin ground is washed thoroughly with alcohol or lacquer thinner to eliminate any excess particles that might flaw the proof or the print. The tones may then be altered, softened, or blended by the judicious use of a scraper, burnisher, sandpaper, or steel wool. In modern printmaking they can also be worked over by painting into the area with a moderately viscous liquid, such as lacquer, dilute plastic aluminum, plastic steel, or a diluted polymer medium; with these materials several applications are often necessary, and proofs should be pulled frequently to check for an overapplication, which may be removed by the appropriate solvent.

While aquatint is the most familiar method, there are various other means at the artist's disposal for achieving the configuration of peaks and valleys that is essential to printing a tone from an intaglio plate. For example, spray enamel, available in pressurized cans, may be applied to the plate, and, provided the coverage creates individual dots of enamel with tiny gaps of unprotected metal in between, it will approximate closely (though not exactly) a rosined ground. In fact, any acid-resistant liquid, such as diluted liquid hard ground, shellac, emulsified wax, or lacquer, may be sprayed or atomized onto a plate and will achieve similar results. Granulated sugar may be mixed with hard ground and painted onto the plate; when dry, the plate is immersed in warm water and the sugar dissolves, leaving a pebbled surface. A plate that has been given a coat of hard ground may be worked over by stippling, wire brushing, or crosshatch needling, or by employing a roulette or mezzotint rocker, so as to produce tonal areas; or it may be passed through the press several times with sandpaper (shifted in position before each pass) so as to produce a "sand grain" that will etch and print well. The textures that may be impressed into a soft ground (discussed under that heading) may be of such a nature that they print as an overall tone. In fact, any device that will produce a rather fine pattern of peaks and valleys on the plate will print tonally.

Lift-ground, or Sugar-lift, Aquatint

Unlike most processes in intaglio, the lift-ground technique allows the image to be drawn or painted positively rather than in reverse, and it lends itself admirably to very free brushwork and pen lines of a calligraphic character.

A water-soluble pen or brush drawing is made on the plate with a solution containing sugar water or syrup. When the image has dried, a coating of dilute liquid hard ground, shellac, or stop-out varnish is applied over the entire surface of the plate. When this coating has dried, the plate is immersed immediately in a tray of warm water or, preferably, held under a stream of running warm water. The water penetrates through to the areas drawn or painted with the sugar solution and causes them to swell and dissolve or "lift" away, leaving exposed metal in precisely those areas. The rest of the plate remains protected by the coating and will not etch or print. The exposed areas (unless composed only of very fine lines) must then be aquatinted or otherwise textured so as to hold ink properly.

Various mixtures are used for the "lifting ink" with which the drawing or

painting is made. Two simple formulas that work well are (1) a half-and-half mixture of sugar water (or syrup, such as ordinary corn syrup) and India ink, and (2) about 25 percent by volume of sugar water or syrup added to ordinary tempera or poster paint (not acrylic). The addition of a few drops of liquid soap will improve the solution. Other substances, such as glycerine, gum arabic, and dextrose, may also be used in working out varying formulas to suit individual techniques.

An artist may sometimes work on an uncleaned or oily plate if an erratic or creeping quality of line is desired. For absolute control, however, the plate must be well cleaned and degreased either with a mixture of whiting and ammonia or by immersion of the bare plate for three or four seconds in a weak acid bath (e.g., 30 percent acetic acid). The acid bath will provide the surface with a slight tooth, which takes the pen or brush better but is not strong enough to darken the white areas of the print; after one or two prints the plate will be just as smooth as before.

Errors may be carefully removed as they are made by cleaning sugar solution away with water and a tipped cotton swab. (An invisible film of the solution may remain, however, and cause erratic lifting at this point.) Failure of the drawing to lift can usually be traced to one of the following: (1) insufficient sugar in the solution, (2) too thick an application of the coating, or (3) a delay of several hours (especially in hot, dry weather) before lifting the drawing. When a complicated work involving many hours of drawing is to be done, it is advisable to make a trial run on a scrap of plate metal to test the lifting; the solution may then be improved or the coating thinned, as needed. It is possible to do an elaborate work spanning many days' time if the plate can be sectioned or compartmented so that each area can be carried through the steps of drawing, coating, and lifting in one session.

Multilevel Plates

Intaglio printing involves, in actuality, a form of molding or casting. The plate into which the image has been cut or etched becomes a "mold" and the dampened paper forced into it under pressure becomes a "cast," with the print showing inversely the depths to which the image penetrated the metal—in other words, the areas most deeply incised or etched will stand most forward in the paper when the print is made. Thus, in every intaglio print the factor of dimensionality is added to its other visual aspects.

Plates may be worked in such a way as to utilize many different levels and to increase this three-dimensional quality—a potentiality that has increasingly attracted the interest of printmakers. The plate may be bitten into more deeply (even to the point of actually making holes in it and producing a maximum of high-white embossment), or it may be "built up" above the normal plate level by various devices. The resulting multilevel plates have provided some of the striking innovations in contemporary intaglio and have resulted in prints that sometimes seem to be on the borderline of sculpture.

In the deep-etch technique only the areas intended to remain as original plate surface are protected with an acid-resistant ground (as contrasted with ordinary etching, in which the entire surface of the plate is first so protected). The remainder of the plate is left exposed for biting. In addition to the familiar hard ground commonly used in etching, artists now may employ a variety of other acid resists, such as crayons, paints, and glues, each contributing its individual character to the print—

and they may apply them not only as brushed or rubbed-on coatings but also with the aid of stencil, transfer, or silkscreen techniques.

At intervals the plate is removed from the acid bath and stopped out (blocked from further biting by the acid) in those parts which have reached the desired depth. The process of biting and stopping out is continued until the deepest level has been attained, and final work in line or tone may then be also added. Stronger acid is usually preferred for deep biting because its action is faster. However, the plate subjected to a strong bath must be examined frequently in order to avoid erratic overbiting, which is always a potential hazard when much metal is exposed to strong acid. The action of biting generates heat, which in turn increases the speed of the biting, and if this heating-up process is left unattended, the action of the acid may become so violent as to lift the resist and destroy the plate.

For the fabrication of built-up plates artists commonly make use of a thin, tough paperboard or of plastic or metal sheets. (Paperboard must be sealed with some material such as spray enamel or shellac; plastic and metal require no sealing and may be printed in the usual way.) The image may be created either by cutting out shapes and attaching them to the basic plate or by forming a plate of several sheets, parts of which are then cut away and cut down to the various levels desired. Plates are also built up by actually modeling on them with any thick substance that will harden, or by adding a variety of found objects, which may be either adhered to the basic plate or simply rolled through the press, lying free on top of the plate. While some found objects, such as pieces of cloth, serve mainly to add texture, others provide both shape and increased depth.

PLATE 424

These ingenious and versatile devices, and others, have given rise to a new terminology in the labeling of print categories, a notable example being the "collagraph" or "collage print," examples of which are shown in the following chapter. Prints with a strongly sculptural effect are commonly called "embossments"—and they are sometimes printed without ink, purely for the embossed or stamped effect, as in the case of the "inkless intaglio." For normal printing on the etching press the total thickness of the multilevel plate is generally kept to 1/8 inch. However, much thicker plates are also used, some printed by hand tools or on special presses. Even when the plate is held to a 1/8-inch limit, the effect of embossment is often striking.

Photo-intaglio

The potential for photo-intaglio (that is, technical knowledge of the photographic process) has existed for more than a century, and it has long been utilized in commercial photoengraving and rotogravure, with plates produced daily by the score for mechanical printing on high-speed presses. It is only within the last few years, however, that artists working in intaglio have begun to investigate this commercial process for adaptation to their own ends. The prints they make are called

PLATES 425, 426

"photo-intaglio" to distinguish them from process "photoengraving" (the latter being, in any case, an inaccurate term).

While photo-intaglio is a bit tricky, it is not beyond the capabilities of any artist with average printmaking experience, especially nowadays when the necessary chemicals are readily available. Failures on the first attempts are usually caused by insufficient attention to the detailed requirements of the process.

The image is created by means of a transparent positive. Unlike the common

424 Vasilios Toulis. Moon Bra. 1970. Embossment with rolled-on color, 15 × 13 3/4". Courtesy the artist

425

photographic negatives or positives, the "transparent positive" is a film (or a sheet of plastic, glass, or translucent tracing paper) whereon the image to be printed is completely opaque, and the areas that are not to print are transparent. The image may be created either by photography or by the more direct and spontaneous method of making an opaque drawing on a transparent or translucent sheet. In practice, both methods are often combined, and the image may be assembled from several transparent positives with elements related or superimposed as desired.

The artist who possesses photographic skills and equipment may easily make a transparent positive by using Kodalith Ortho Film, which, when developed, renders the image opaque on a transparent film. (Otherwise, he may take his art work to a qualified photographer, photostat house, or photoengraver and have the photography done for him.) The image created directly by drawing is usually done on a sheet of mat acetate with an opaque India ink especially formulated for drawing on

425 *Joseph Way. Untitled. Photo-intaglio,*
13 3/4 × 17". Courtesy Pratt Institute,
Brooklyn, New York
426 *Vasilios Toulis. Blind Lunar Head.*
Photo-intaglio, 25 3/4 × 17 5/8".
Courtesy the artist

426

plastic, or with any other completely opaque medium that will not cause buckling of the acetate or add any appreciable thickness to the film. (Lumps or excessive thickness in the drawing medium will cause light to "spill under" and give a faulty "take" of the drawing.) Commercial transfer sheets, such as Zip-a-Tone, Letraset, Ben-Day, and other printed line-and-dot patterns, may also be incorporated into the work. If the transparent positive is kept free of excessive thick spots, the artist can flop it instead of drawing the image in reverse at the outset.

The transparent positive, when completed, is placed on a photosensitive (i.e., light-sensitive) plate, which may be purchased already prepared or may be made by applying a photosensitive coating to an ordinary intaglio plate (usually zinc). The plate is then exposed to light and developed, in the manner of a photograph. (A photographic darkroom is not necessary, though the workroom must be fairly dark.) At this point the plate is ready for etching in the acid bath unless the artist wishes to add work, which may be done by the usual intaglio techniques; he may decide, for example, to stop out certain portions with liquid hard ground or stop-out varnish, or to perfect or add areas by needling. For visual control the developed image may be dyed by swabbing it with a bluing solution, methyl-violet dye, or ordinary gentian violet.

A number of photosensitive coatings, accompanied by the suitable developer for each, are available from manufacturers. A recent one, which has become popular and is simple to use, is called KPR. The instructions for handling these various products may differ somewhat, but in general the procedures are similar. The following method is described for the use of cold-top enamel.

The plate is first made immaculately clean by scouring with cleanser, powdered pumice, trisodium phosphate, or powdered whiting to remove every trace of oil or grease. It is then rinsed well with water and a wad of clean, wet cotton. (If the water beads in any area instead of forming an even film, the plate is not sufficiently clean.)

A quantity of the photosensitive enamel is poured onto the plate, which is held slightly tipped so that the enamel runs as evenly as possible across the surface and produces a uniform coating. The excess is allowed to run off into a tray and is returned to its container. If coverage is incomplete, bubbly, or uneven, the plate may be washed immediately with water and a new coating applied. The plate is then allowed to dry or is speed-dried with a heater or fan. As the plate dries, it becomes light-sensitive, and from this point on the process is carried through in subdued light.

A second thin coating of the photosensitive enamel is applied by the same method as the first. The plate is then heated to about 220 degrees (uncomfortable to the touch) and placed, face or coated side up, over a padded backing on a table. A light source is arranged so that, when turned on, it will fall directly on the plate. For this purpose a carbon arc lamp or a No. 2 photo-flood in a reflector is commonly used, though a plate may also be successfully exposed to direct sunlight or to a daylight fluorescent fixture.

The transparent positive is placed on the plate and covered with a sheet of plate glass slightly larger than the image. (More convenient, if available, is a vacuum table, in which the plate with the transparent image may be placed and firmly held.) The plate with the art work is then exposed to the light. Some experimentation in exposure time will be necessary, because it depends not only on the strength of the light source and its distance from the plate but also on the density of the particular image used and such variables as the temperature and humidity prevailing at the time.

After exposure, the transparent positive is removed, and the plate, held only at the side edges, is submersed in the developing solution in a glass, rubber, or plastic tray. The tray is gently rocked for one to three minutes. (The exact time needed can be judged by eye, since it is possible to see the development taking place.) After development the plate is washed under a stream of water, with gentle swabbing or

"teasing" of the image to remove all soluble shellac. It is allowed to air-dry and then heated slightly (about 200 to 250 degrees) to toughen the resist. After the plate has been etched and printed, the photosensitive coating may be removed with a caustic lye solution in warm water.

In another procedure, the glue-enamel process, the artist may prepare his light-sensitive coating by dissolving 6 ounces of process glue in 10 ounces of cool distilled water and (separately) 1 ounce of ammonium bichromate in 6 ounces of cool distilled water. The two solutions are then mixed together and stored, prior to use, in an absolutely clean, opaque plastic bottle. The coating is applied in the fashion described above, and, when dry, should have a glossy, translucent, varnish-like appearance. Development is done under running water at about 68 to 75 degrees F. Afterward the dried plate is heated or baked (but not overheated) until the coating acquires a deep chocolate-brown color.

Printing the Plate

Intaglio printing is very much a part of the total art of producing a fine print and should be considered as such—not as a separate process. It is easy enough to pull a fair proof on the first attempt. It is quite another matter to print consistently clean impressions, closely identical to each other, which will reveal the optimum of the image that lies below the surface of the plate. There are many variables in the selection of inks and papers, in press impression, wiping techniques, and other factors. Only after much experience will the artist-printmaker fully realize the plate's inherent possibilities and be able to use them in a way most consistent with his own image.

Most etching presses are constructed to print with a squeezing-rolling action. The press bed, which holds the plate, printing paper, and blankets, is driven between an upper and a lower roller which exert tremendous pressure on the blankets and paper, forcing them against and *into* the marks and depressions that make up the image in the plate. Good presses are essential to quality printing. Lightweight models lack the needed pressure, and, though they may give fair results when economy is a factor, they cannot do the work of heavier presses with rollers 6 to 9 inches in diameter. The larger presses, with a bed over 16 inches wide, are customarily reduction-geared to make the driving of the bed through the rollers less exhausting. Smaller presses are usually operated with the direct action of a turning handle attached to the upper roller. When much printing is done, it is wise to have the press motorized and geared.

PLATE 427

Pressure screws with strong springs and packing allow the pressure of the rollers to be increased or diminished on either side of the roller, as adjustment is required. Pressure is tested by running through the press an uninked plate (of the same thickness as the plate to be printed) with a sheet of dampened paper covered by the blankets, which are stepped, or staggered, about an inch at the ends. The press is turned or cranked slowly to the point where it meets resistance from the plate. The resistance should be slight but definite. If too much or too little resistance is encountered, the screws are turned either clockwise to increase pressure or counterclockwise to decrease pressure. When the pressure seems right, the bed is run through the rollers, the blankets are lifted, and the paper is examined while still lying against the plate. The embossment of the plate edges into the paper should be definite and even on all sides. If it is weaker on one side, the pressure screw controlling that end of the roller

427 *Etching press, from Erich Rein,* Die Kunst des manuellen Bildrucks, *Otto Maier, Ravensburg, 1956*

427

is adjusted downward. When an artist prints on his own press, using plates of the same gauge, very little, if any, adjustment is needed once the proper pressure has been attained. In workshops, however, and in printing collographs or plates not of standard gauge, it soon becomes imperative that the artist develop a "feel" for the correct pressure. Presses with micrometer adjusting screws, which allow the pressure to be read and recorded, are available.

The blankets assist in the intense, yet sensitive compression of the damp paper against the plate. They should be considerably larger than the plate and paper, and are engaged under the roller 2 or 3 inches in advance of the paper. Blankets are critical in the pulling of good impressions. They should be made of a fine grade of woven felt, and must be kept clean and free of creases and cuts. Usually two sets are kept on hand, and they are washed in warm water with a mild detergent as soon as any hardening, due to the sizing from the paper, becomes apparent. Printmakers usually have their own preferences as to the number (ranging from three to five) and

type of blankets they prefer. In common practice three blankets may be used: one of a very fine woven felt 1/16 inch thick, which lies directly on the paper, with two of lesser quality, 1/8 and 1/4 inch respectively, above that.

The printing action is similar to taking a cast in paper from the "mold" created by the design in the plate. The blankets and paper are forced into intense contact with the face of the plate and driven into the grooves and other surface irregularities. When an uninked plate is pulled through the press, all the depressions of the plate can be clearly seen standing out in relief above the surface plane of the dampened paper. This mold-cast effect is also apparent when the plate has been inked and wiped, this time with ink added in varying amounts to those areas of paper brought into contact with it. Some printmakers who are interested particularly in deep embossment have fashioned hydraulic-action presses which operate on the same principle as hydraulic stamping machines, eliminating the rollers of the typical etching press altogether.

Printing is best done on fine, all-rag (or nearly all-rag) papers. As there are scores of papers to choose from, the printmaker will, by experiment, familiarize himself with a number of brands and make his selection according to the characteristics most suitable for his work. Vasilios Toulis, for example, generally makes his choice among the following: Morilla, BFK Rives, Copperplate, Copperplate Deluxe, Papier D' Arches, American Etching Paper, German Etching Paper, Arches White, and Arches Buff. Proofs are not necessarily made on the stock used for printing an edition; a 90-pound white index stock proves well, though it is not a fine quality paper, and it represents a considerable economy, especially when numerous proofs are required in the development of a plate.

Papers must be properly dampened if they are to print well. The dampening softens the sizing and renders the paper most sensitive to the printing action characteristic of intaglio. As papers vary in composition, sizing, and other characteristics, no two require the same amount of damping. Generally speaking, however, the stronger the sizing the more damping is needed. There are two widely used methods. When only one or two prints are to be pulled, it is most expeditious to soak two or three sheets of paper in a large tray of water. The time required may vary from about ten minutes for index paper to as long as an hour or more for dense, heavily sized papers. Just prior to printing, a sheet is removed from the bath, drained, and placed flat between two blotters. The top blotter is tamped with a roller to remove surface moisture from the paper, which is then ready for printing. When many prints are to be pulled, all the sheets required for the printing session (plus two or three spares) are wetted well on front and back, but not soaked. They are stacked while wet in a neat pile, which is then wrapped in plastic sheeting, placed on a flat surface, and weighted down with a heavy board. In time the moisture distributes itself evenly throughout the mass of paper, wetting each sheet uniformly—a process that may take from a half hour to overnight, depending upon the paper.

Inks may be purchased from dealers or made by the artist himself. In either case the knowledgeable printmaker understands inks and how they are made. Even if he does not grind his own, he will often adjust the ready-made product to his needs; he may, for example, alter an ink made for lithography or letterpress by adding oil to make it more liquid or by regrinding it with powdered pigment to make it more viscous. Ink may be made by mixing dry pigments on a glass or stone slab, mixing in a small amount of raw linseed oil with a spatula, and then grinding with a flat-

bottomed glass muller, gradually adding oil in trifling amounts as needed. (A little plate oil is sometimes mixed in as a softener.) One formula for compounding black calls for 1 part each of vine and ivory black and 4 to 5 parts of Frankfort black; other powdered pigments may be used, provided they are chosen from a list of permanent colors. The grinding is continued until the ink is of a viscous, yet fluid consistency; it should drop slowly from a spatula and not run off in a thread or stream. The ink is left to stand overnight in a covered container, and then, if not satisfactory, may be reworked with added oil or pigment.

Before printing begins, the plate bearing the image must be well cleaned with the solvents appropriate for the removal of whatever acid resists have been used (e.g., alcohol or lacquer thinner to remove rosin; kerosene or other petroleum solvent to remove hard ground; lacquer thinner to remove spray enamel). Residual solvents are removed with toweling or with soap and water. The back of the plate and the bed of the press are also cleaned. The edges of the plate are beveled with a fine-toothed rasp or file to an angle of about 45 degrees and finished with fine sandpaper or steel wool. Beveling is important in that it minimizes the likelihood of cutting into the printing paper or the blankets.

The plate is warmed slightly on a hot plate (fitted over with a 1/4-inch sheet-iron cover) or an electric warming tray. A sufficient quantity of ink is placed on the ink slab (a plastic, glass, or stone surface), and the ink is then applied to the plate. This may be done by rolling the ink on with a hard-rubber brayer, by scraping or squeezing it on with a square of stiff cardboard, or by dabbing it on with a dabber, or "dauber." (The dabber may be purchased, or it can be made by rolling a piece of scrap felt into a cylinder about 1 inch in diameter and 5 inches long, binding it with tape or string, and trimming the ends flat.) The ink, starting with a small amount, is rolled, squeezed, or dabbed several times in all directions across the entire surface of the plate, with more ink added as required. It must penetrate all the depressions in the plate, fill in all the lines, and cover the entire surface. Plates with delicate surfaces, such as drypoint, are inked gingerly and delicately with a softer ink and with the use of the dauber only.

Inking is a very sensitive process, and so is the wiping that follows, which must remove the ink from the surface and leave the depressions filled. Wiping is customarily done with tarlatan, wadded or folded into pads about the size of half a grapefruit and having a smooth, flat bottom side. The tarlatan should be somewhat stiff but not rigid, and it may be kneaded in the hands a bit to soften it if it is excessively stiff with sizing. Three pads are generally used successively: The first is heavily saturated with intaglio ink kneaded into the weave before wiping begins, the second is moderately saturated, and the third has only a trifle of ink on its surface. The plate is not scrubbed but gently wiped in all directions with sweeping, circular strokes. (It is kept warm during the process by returning it to the hot plate if necessary.) The first pad is used until the color of the metal is generally visible under the film of ink, and the second until the metal (especially in the unworked areas) is fairly clear. The final pad will continue to remove streaks and smudges and the remaining ink on the surface of the metal—except for a very thin "surface tone" of ink, which remains on the unworked metal surfaces or "whites." This very slight surface tone is often invisible on the wiped plate, but it will be revealed in the white areas of the print. It is characteristic of the medium itself and is usually desirable for the depth it adds to the print.

If, however, the artist wishes to diminish the surface tone and to bring the whites out in brighter contrast, wiping may be continued by moving the side of the hand gently across the surface with sweeping strokes that begin and end off the edges of the plate, with the hand cleaned on a towel during the process. The hand wipe may be further refined, with the whites further brightened, by rubbing a minute amount of stick chalk on the hand; care must be taken, however, to avoid pulling the ink from the lines or depositing chalk in them. Finally, some printmakers flick a slightly inky cloth lightly across the image to pull ink out over the edges of the lines. This process, called "retroussage," yields a slightly richer print.

Once the surface of the plate has been wiped, the edges and the back are wiped clean with toweling and the plate is again warmed slightly. It is placed on the bed of the press with the dampened paper and then the blankets laid over it, and printed while still warm.

The prints must be allowed to dry thoroughly. The paper will air-dry in 3 to 10 or more hours, depending upon humidity, but the ink needs about two days to surface-dry sufficiently for easy handling without danger of offsetting. Inks, since they contain linseed oil, continue to oxidize for several months; this does not affect the print materially, except in the case of inks (usually home-made) that have been compounded with an excess of unincorporated oil.

Prints may be dried quickly by attaching them to a board with staples or gummed paper tape; as they dry, they will contract and flatten out. When prints are dried in this way, however, the edges of the paper are sacrificed, since they must be cut to remove staple marks or tape, and this is a loss when deckle-edged paper has been purposely used. There is also some loss of embossment, and this can be critical when embossment is an important part of the overall image. To avoid these problems, prints may be dried by laying them flat upon a table and slip-sheeting them with tissue, newsprint paper, or blotters. If they are not allowed to shift laterally, several prints may be stacked together. After one to two days they are restacked, interleaved with fresh tissue, newsprint, or blotters, and placed under a weighted board for another day or two, which is usually sufficient to make them flatten out without appreciable loss of embossment or plate mark. Prints that have dried with a stubborn waviness may be rewetted, placed between blotters, weighted, and redried in the same manner.

Intaglio-relief and Color Printing

Any intaglio plate can be printed to produce a relief print; that is, the ink, instead of being forced into the *depressions* in the plate with the surface wiped clean, may be applied with a roller or brayer, as it is in the woodcut, to the *surface*. In effect, two different prints are possible from an intaglio plate: one (intaglio-printed) will reveal the image in black on a white ground, and the other (relief-printed) will show it in white on a black ground. There are various examples of prints from an earlier generation of printmakers that appear in both versions. A relief-printed intaglio plate may still be easily distinguished from a woodcut; in addition to the difference in style resulting from the metal and the techniques with which it was worked, it will retain the "mold-cast" or embossed effect typical of prints produced from the etching press.

The possibilities inherent in the combination of intaglio and relief printing from a single plate have been extensively explored by contemporary printmakers, and they

COLORPLATES 40-43

have facilitated (and to an extent made possible) some of the remarkable new developments in multilevel and color printing. In its simplest form, a combined intaglio-relief print might, for example, show the image intaglio-printed in the normal way in black with color added by printing from all or parts of the surface. Such prints are sometimes described as intaglio with "surface-printed" or "rolled-on" color. Almost limitless variations can result when impressions from both the surface and the depressions of the plate are combined in a variety of tones and inks.

A color print may, of course, be made by the familiar method of preparing the image for each color on a separate plate and running the plates successively through the press. Many artists still prefer this technique. However, it is common nowadays to produce multicolored prints from one, or perhaps two, plates. An important step in this direction was taken with the experiments in Hayter's Atelier 17 based on the differing viscosities of inks. By the use of certain types of ink that will not mix, it is possible to roll various colors on the plate in adjoining or overlapping areas and then to print in one run through the press. In addition, the development of cutout plates has served to liberate the use of color. Individual cutout elements can be inked separately and then printed together or at different runs, as desired. They are easily shifted, and the artist may freely develop his design by proving them in different positions and different colors. In this way he can sometimes produce different editions from the same basic plate. Stencils may be used in applying color to specific design areas of the plate, or color may be applied by silkscreen, transfer, or offset techniques. Also, a number of rollers can be used, varying not only in size but also in hardness or softness. Soft-roller and hard-roller inking will deposit ink on different levels of the plate, producing variations where colors meet and blend.

Today's innovations make it difficult to analyze, without an explanation from the artist, exactly how a print was made and how its technique should be labeled. While some of the new methods may have been invented as timesaving devices, it seems evident that artists are also seeking new means of expression responsive to the trends of our times.

33 *Cornelis Ploos van Amstel.* River with Town in Distance. *Mid-19th century. Color etching and aquatint, with etched state shown in black and white (opposite page). National Gallery of Art, Washington, D.C. (Rosenwald Collection)*

34 *Carlo Lasinio (after Labrelis).* Giovanni Battista Salvi. *Early 19th century. Color aquatint. National Gallery of Art, Washington, D.C. (Rosenwald Collection)*

35

36

35 *James Gillray.* The First Kiss This Ten Years!
c. 1800. Colored etching, 8 7/8 × 6 3/4".
Collection the author

36 *Thomas Rowlandson.* The Stern Preceptor, *from*
The Dance of Life. *1817. Colored etching and*
aquatint. New York Public Library, Astor, Lenox
and Tilden Foundations

37 *George Cruikshank.* The Piccadilly Nuisance.
1835. Colored etching, 9 1/4 × 13". Collection the
author

OVERLEAF:

38 *Georges Rouault.* The Clown, *from* Le Cirque de
l'Étoile Filante. *1934. Color etching and*
aquatint, with progressive proofs 1, 2, and 3. National
Gallery of Art, Washington, D.C. (Rosenwald
Collection)

39 *Jacques Villon.* Color Perspective. *1917. Color*
etching, 19 3/4 × 13 1/2". Yale University Art
Gallery, New Haven, Conn. (Collection Société
Anonyme)

40

40 *Janet McMillan.* Abstraction. *1969.*
Mixed-media color intaglio, 19 1/2 ×
18". Courtesy Pratt Institute,
Brooklyn, New York

41 *Janice Willcocks.* With North over
the Barn. *1969. Etching with*
stenciled color, 11 × 23". Courtesy
Pratt Institute, Brooklyn, New York

42 *Fay Dorman.* Pastiche from
Gauguin's "Yellow Christ." *1969.*
Deep-bite intaglio with locally applied
color, 15 3/4 × 12 5/8". Courtesy
Pratt Institute, Brooklyn, New York

43 Greyburg. Untitled. 1969. Intaglio with color applied by stencil and roller, 12 3/4 × 9 7/8". Courtesy Pratt Institute, Brooklyn, New York

CHAPTER 11

NOTES ON INTAGLIO MEDIA

BY PROMINENT PRINTMAKERS

The personal statements that follow will indicate the wide variety of procedures open to contemporary printmakers in the intaglio medium and the qualities of innovation and imagination that have revolutionized the field in our times.

ARMIN LANDECK
Handling the Burin and the Needle

My most recent plates have all been engraved exclusively with the burin, but some years ago I experimented with several so-called "mixed" techniques and found that a combination of drypoint and engraving proved most satisfactory for my purpose. First I worked over the entire plate with a drypoint needle, developing a tonal pattern and indicating textures with very fine, closely laid lines, then removing the burr with a scraper. Next I worked over this tonal base with the burin, cutting deeper lines, developing accents, and providing clearer definition. Last I used the needle again, but this time I left the burr along the lines to add emphasis to the print.

PLATES 428, 429

I like straight lines; even the impersonal character of ruled lines becomes interesting to me when contrasted with less rigid, more freely engraved areas. The burin is the ideal tool to take a straight course, cutting clean, precise lines that range from the very finest to the deepest and broadest. Three or four deep lines, one next to the other, produce heavy dark areas. By cutting across a series of such deeply incised lines and digging down to an even deeper level still darker black areas can be created. I make much use of these different levels of cutting. Because of the unique character of intaglio printing, the lines actually project above the surface of the paper. (The damp

428

paper, passing under the roller of the press, is forced down to the bottom of even the deepest cuts in the plate.) These slightly raised lines cast shadows across the paper and enhance the color and variety of blacks. As long as there is copper left, one can continue to cut deeper, knowing that, if carefully printed, all these different levels will appear in the print.

Naturally the burin can also be made to change its straight path and cut a clean, precise, curving line. It can also easily cut a swelling and diminishing line. I use such lines not only for variety but also to suggest movement and space. Flicks, short lines, and dots can produce a great range of textures. By cutting across a series of spaced lines (crosshatching), one can develop many interesting patterns. I sometimes cut long radial lines starting from a common center and intersect them with other systems of radial lines starting from different fixed centers, simultaneously constructing space and suggesting light.

Traditionally engraving has been roughly divided into the Broad Manner and the Fine Manner. Most engravings are a combination of both. When working in the Broad Manner, I study closely the proportion and shape of the white areas between the black lines, whereas in the Fine Manner I am most concerned with the variety of textures resulting from different closely cut lines and leading up to white areas.

I never work from a finished drawing but start instead with a diagram defining the main areas of the composition. Drawing drypoint lines across the plate—diagonals and parallels, mathematically spaced—helps me to "get the feel" of the proportion and size of the surface and of the space beyond.

428 *Armin Landeck.* Rooftop and Skylights. *1968. Engraving (first state). Courtesy the artist*

429 *Armin Landeck.* Rooftop and Skylights. *1968. Engraving, 17 7/8 × 20 1/2″. Courtesy the artist*

429

Since it can be disconcerting to find oneself continually looking at one's own reflection in the polished copper plate, I rub down the entire surface, using oil and the end of a tightly rolled piece of felt to dull that mirror-like shine.

A solid steel anvil (12 inches square, highly polished on one side, and about 3/4 inch thick) is very useful when one wishes to hammer up from the back of the plate and thus remove or diminish lines on the engraved side. By hammering with a variety of round, square, and irregularly shaped punches, again working on the back side, one can introduce white shapes within areas of closely engraved lines on the front side. The punched shapes or areas will project well above the level of the surrounding engraved surface and will appear whiter than the white printed from the normal surface of the plate. Conversely, by using the punch directly on the engraved side, one can introduce such shapes to hold ink and print black.

A dentist's cable drill is practical for grinding and polishing out lines from the engraved surface. After grinding, which lowers the surface, I hammer up from the back against the anvil to restore the normal level of the front or working surface. Drill points can also deepen and widen lines, give variety to large areas of black, or produce textures contrasting with the work of the burin.

I prefer to do my own printing, and I never try to make each print exactly like the others. Certainly every plate offers more than one or two good possibilities. My only standards are clarity and transparency in each print.

NORMA MORGAN
Making the Line Engraving *Dark Vision*

PLATES 430, 431

Dark Vision is a line engraving which, from the technical standpoint, was executed by relatively simple means. A polished copper plate, three burins or gravers, a scorper, an oilstone for sharpening the burins, and a fine emery polishing paper were the materials required. My design, based on sketches done beforehand, was drawn onto the copper with a black china-marking pencil—a grease pencil that will not scratch the fine, highly polished plate surface.

After the design was successfully transferred to the copper, important areas were faintly outlined with the burin. Tones were then added until the image was gradually developed to the depth of the middle tones. Only then were the darkest areas cut into the plate, with the white areas left completely untouched.

I build tones up by the old method of crosshatching, with weblike lines crossing at regular intervals, or by parallel cutting, which creates a richer black than crosshatching. Dark tones can be developed by any means an artist can devise, and much of the satisfaction results from an imaginative variety in achieving tone and texture.

Finer grays are obtained by stippling with the burin. By increasing the angle of the graver to the plate, shorter lines or dots are produced. I attempt to balance extreme, rich darks with stippled warm gray tones.

During my work I ink the plate daily to make the image more clearly visible, and I use a screen to diffuse the overhead light, eliminating glare on the polished copper surface.

For *Dark Vision* three trial proofs were made in three different states. The first was pulled in order to see how the plate was progressing and whether the dark areas

430

431

were sufficiently black. At the second state I decided to lighten certain areas. The third proof represents the final state.

LEONARD LEHRER
Engraving with a Power Burin

Classical Landscape is a variation on a wash drawing by Nicolas Poussin in the Uffizi Gallery. The pencil sketch for it was one of a number made from a reproduction of the Poussin drawing. Another pencil drawing was done directly on the zinc plate.

The image was made entirely with a power burin, an electric engraving tool used by commercial engravers. The tool I used (the Dremel Electric Engraver) has a carbide point and operates by an in-and-out vibrating movement. The speed of the vibration can be regulated by a dial, from an almost imperceptible vibration (for delicate, unwavering lines) to a heavy staccato vibration (for heavily textured areas). The carbide point literally gouges a line into the metal plate, leaving a slight burr that catches the ink and gives the print its particularly soft, almost drypoint-like quality.

430 *Norma Morgan. Dark Vision. 1961. Engraving (first state). Courtesy the artist*

431 *Norma Morgan. Dark Vision. 1961. Engraving, 25 3/8 × 16 3/8". Courtesy the artist*

432

433

PLATE 432

In the *first state* the entire schema was established with the electric engraving tool operating at its minimum speed. Then, using a variety of speeds, I developed the upper two-thirds of the plate. The lower portion of this first state shows the delicacy of line that can be achieved with the tool.

In the *second state* whole segments were considerably lightened with a scraper and burnisher (the arches of the facade, the windows and the vertical tree on the right, and other areas) and the general form of the lower part of the landscape was introduced.

PLATE 433

In the *third state* the areas scraped in the second state were given a crosshatched effect that allowed the texture of the scraping to bleed through the newly engraved lines. A network of horizontal, vertical, and diagonal lines was superimposed on the architecture, and the extreme lower portion of the plate received a band of lines and scraping to establish a new texture and value.

For the *fourth state* some additional modeling of the trees and the lower plane of the plate constituted, I felt, the conclusion of *Classical Landscape*. However, for the *final state* I eliminated the existing areas of light from the lower horizontal band so that the remaining white areas would be concentrated on fewer and more elevated planes.

PLATE 434

The work was printed in 1967 from a zinc plate on heavy-weight Arches paper by my wife, Ruth Lehrer.

GABOR PETERDI
Some Experiments in Etching and Other Intaglio Techniques

I started making prints in 1934. I was then living in Paris and studying with Stanley William Hayter. At that time his Atelier 17 was the graphic center of the Surrealist movement. Besides being fanatically devoted to line engraving, Hayter had already started experimenting with various etching techniques, as well as a simplified method of color printing that combined surface-rolled colors with the intaglio plate. Although I followed all these experiments with great interest, my first love was line engraving. For several years I did only engraving, and my first serious attempts at etching and color printing started only after I came to New York in 1939.

Once I began to etch, I became intensely involved in experimentation. I was

434

432 Leonard Lehrer (after Nicolas Poussin). Classical Landscape. 1967. Power burin engraving (first state). National Gallery of Art, Washington, D.C. (Rosenwald Collection)

433 Leonard Lehrer (after Nicolas Poussin). Classical Landscape. 1967. Power burin engraving (third state). National Gallery of Art, Washington, D.C. (Rosenwald Collection)

434 Leonard Lehrer (after Nicolas Poussin). Classical Landscape. 1967. Power burin engraving. National Gallery of Art, Washington, D.C. (Rosenwald Collection)

particularly interested in expanding the vocabulary of that medium, as I found that the linear and textural variations possible with the etching needle were too limited for my temperament. I tried every kind of tool I could possibly use to draw on the plate. Eventually this search led me to the use of electric drills. First I used an ordinary 1/4-inch drill with rotary files of various sizes. The drill functioned like a big, clumsy etching needle—it was hard to control, but it gave me exactly what I was looking for. By using various bits and manipulating the drill—sometimes drawing with the rotation, sometimes against it, moving it slowly or fast—I could get an incredible variety of marks. This, together with the conventional needle and line-engraving tools, gave me a very wide range of graphic possibilities (*Apocalypse, 1952*). PLATE 435

Simultaneously I started to explore how the biting itself could be used more as a part of the creative process. I played around with acids of various strengths. Eventually I worked out a method of deliberate "false biting" that I could control, which produced a craggy, eroded line similar to that of Seghers's etchings.

In the color prints made during the forties and early fifties I worked mostly with stenciled colors, although I made also a few intaglio color plates. At first I stenciled all my colors onto the intaglio plate, so that I would need only one printing, thus eliminating the problems of registering. Obviously there were limitations on the number of colors I could print in this way, but in spite of this I used as many as twelve colors on one plate, as in *Germination I, 1952*. In the early fifties I started to stencil some colors on the paper, overprinting them with colors stenciled on the plate. This increased the richness and depth of the color; it produced an effect similar to that of glazing in painting. Eventually I was led to the accidental discovery of a means of printing with stencils to produce luminous, soft colors, as in an aquatint; a critical factor in this technique is the control of the timing in the overprint (*Still Life I, 1956*). COLORPLATE 44

During this time I was also experimenting with mixed-media color prints. I overprinted color linocuts with intaglio plus stencils, as in *Miracle in the Forest, 1948*. I PLATE 436
then found that a more luminous, diffused effect could be achieved by offsetting color from a linocut onto the intaglio plate (*Massacre of the Innocents, 1954*).

In 1953 I first began to work with cutout, movable color plates; a large print, *The Vision of Fear*, was made with this technique. On the large master plate I super-imposed four small cutout plates; in addition, offset colors were printed on the plate

from synthetic rubber casts. For years I did little with this idea, but in the late fifties I resumed work with it, feeling more and more the need to emphasize the three-dimensional quality of the intaglio print. The ambiguity existing between the physical reality of the relief pattern and the contradictory visual effect of the print fascinated me and became a crucial preoccupation in the prints made after my 1964 trip to the Arctic (*Arctic Night IV*, 1965).

COLORPLATE 45

Parallel with my work using cutout plates, I began to investigate the way in which different printing materials affect space and surface tension in the print. I became interested in combining two opposite working procedures; in one matter is removed (by etching or engraving into the metal); in the other a surface is built up (by applying various plastics and glues either to cardboard or to metal). Most of my latest color plates are printed from these combinations.

In 1967 I became involved in making monoprints, first with the casual idea of using this method as sketches for new print ideas. As I worked, I began to realize that the method has its own distinct possibilities, totally different both from painting and from traditional printmaking. I was not interested in producing a printed painting. I was using printing materials, tools, and processes to evolve my images. Printing from improvised surfaces, offsetting from one surface to another, at times combining cutout plates with these improvisations, I arrived at something radically different from the conventional monoprint. The freedom of this method had its influence also on my other color plates as it extended the range of my controls.

Lest my frequent mention of "experimentation" be misleading, I should add that I have never made an experiment for its own sake; I was always pushed into the search for new means when the available traditional methods failed to offer me sufficient freedom of expression. I consider craft, technical control, and content inseparable. My constant and only aim is to create significant images.

435 *Gabor Peterdi.* Apocalypse. *1952. Etching and engraving, 23 1/4 × 35".* *Brooklyn Museum, New York*

436 *Gabor Peterdi.* Miracle in the Forest. *1948. Color linocut overprinted with intaglio and stencils, 24 × 20". Courtesy the artist*

437

EDWARD A. STASACK
Making Prints from Masonite Plates

PLATE 437 The Masonite-intaglio process was developed as an alternative to conventional etching techniques to produce a plate that could be worked without the use of acid. Its distinctive feature is the use of Masonite, alone or as a support for silk, to achieve a substantial range of linear and tonal effects.

The surface of a 1/8-inch tempered Masonite plate is prepared by applying several coats of a mixture consisting of 1 part white glue to 2 parts of water. (The edges of the plate should first be beveled and the surface polished with 4/0 emery paper.) Lines can be cut with ordinary wood chisels, knives, or other tools; both engraved lines and the equivalent of a drypoint line can be achieved. After lines are cut, the surface is "fixed" with two or three coats of a thin glue-water mixture. The plate is inked and wiped in the same manner as a metal plate.

Thread, string, and drippings of full-strength white glue can be used to achieve various kinds of line. Sandpaper, bits of cloth, textured papers, and other materials can be glued to the surface and will hold ink and print. Soft papers or textiles must be given one or two coats of thinned glue to prevent them from breaking down after a few impressions.

438

A full range of values can be attained in a painterly technique on a plate that has been covered with silk (the same grades as used for silkscreen). First a mixture of about 2 parts glue to 1 part water is brushed carefully on the plate (leaving no bubbles) and allowed to dry. Again the same mixture is brushed on, and after about 2 or 3 minutes the silk is laid on the plate and smoothed down. The untreated silk, if inked and printed, would yield a solid black, since the ink is held in the interstices of the weave. The application of full-strength glue closes these interstices and will make the silk print as white. Various mixtures of glue and water can create a range of light to dark grays.

Normally a plate will be good for an edition of at least twenty-five prints. However, I was able to pull an edition of 200 from the plate for my print *Hula-Hula*.

MISCH KOHN
Aquatint with Sugar-lift and Offset Images

Nearly all the etchings I have done were drawn with a sugar-lift method either in part or wholly. A plate is cleaned in the usual manner, and the drawing is made with a sugar-lift solution applied with brush, pen, stick, or plastic squeeze bottle.

My formula for the solution is: 50 parts Karo syrup or any thick sugar syrup; 25 parts black fountain-pen ink; 7 parts granulated laundry detergent; and 3 parts gum-arabic solution. Depending upon the thickness of the syrup, more ink can be added to make the drawing flow more easily.

After the drawing is allowed to air-dry, a thin solution of Korn's asphaltum etch ground is poured over the plate and drained off by leaning the plate slightly off the vertical and moving it from time to time so that no puddle remains at the bottom. When the asphaltum ground is dry, the plate is soaked in a tray of lukewarm water, which causes the sugar drawing to lift, exposing the copper. The plate can then be aquatinted in the usual manner. Aquatinting is necessary for the type of drawing generally executed by the sugar-lift method, because any line should be bitten twice as deep as it is wide, and this cannot be done with a very wide brushstroke.

437 Edward A. Stasack. Temptation of St. Anthony. 1963. Masonite intaglio, 28 × 40". Courtesy the artist

438 Misch Kohn. Dark Bird. 1970. Lift-ground. Courtesy the artist

PLATE 438

439

439 Misch Kohn. Figure. *1968. Etching, 17 ×
13 3/4". Courtesy the artist*

PLATE 439

I have found that allowing the sugar solution to dry somewhat or to become syrupy and thick will give a nice variation in drawing quality. The syrup, when it is very viscous, can be dropped off the end of a stick. When the drawing is nearly completed on the plate, additional quality may be given by painting areas with oleum or benzine; this causes the lines or brushstrokes subsequently drawn on them with the watery sugar solution to bead up into little dots.

As a variation of the usual aquatint process, I have sometimes used the offset method. Objects, surfaces, or textures may be rolled with etcher's ink, applied with a gelatin or rubber brayer. Then the ink is removed from these surfaces with a clean gelatin brayer and offset upon a plate ready for aquatint, where it will act as an acid resist, blocking the plate. This method was employed in my print *Two Generals,* 1965; I used photoengravings of motor parts combined with diagrams which, when offset onto the plate, created a white-line drawing. I completed the drawing with asphaltum and immersed the plate in acid in stages, biting for 30 seconds, then painting out with asphaltum and biting again until I reached a deep black.

I have also used an offsetting technique to transfer an image from one of my

intaglio plates for use in a lithograph. For this procedure I inked up the intaglio plate with a soft lithographic printing ink (Korn's transfer ink may be used), then lifted the desired image from the plate with a clean gelatin brayer and rolled it onto a freshly ground litho stone. Crayon drawing and tusche washes were then applied to complete the lithograph, which was then processed in the usual manner.

SERGIO GONZALES TORNERO
Intaglio-Relief Printing

A typical example of my technique would be an impression taken from a single 16-gauge zinc, copper, or brass plate, bearing all the necessary ink colors at once and capable of being printed in one operation through the press, a procedure I learned at Hayter's Atelier 17.

COLORPLATE 46

The plate is a kind of bas-relief, with various modulated levels. The idea comes first; then follows a simple line drawing which is developed into a precise design, done directly on the plate with a felt pen. With asphaltum varnish used as a stop-out, the basic design is given a succession of deep etchings, alternating with much scraping, polishing, aquatinting, drilling, battering, sawing, and cross-scraping. As long as there is metal, there is hope.

Most of such plates are rather beautiful in themselves, and one is tempted to stop there, without making a print. However, inking the plate and passing it through the press is not only an exciting way of producing a multiple image but also an opportunity for scanning the plate and arriving at an image in color which is latent in the work.

I try to find the right way of inking and printing by experimenting with different inking combinations. For instance, for intaglio printing, one color can be wiped into the design on the whole plate, or two or more colors can be applied in separate areas of the plate. Over the plate thus inked for intaglio, surface colors can then be added in various ways: One thin film of colored ink may be rolled on with a roller large enough to cover the whole plate in one pass, or two different thin films of ink may be rolled over the plate successively with two rollers; one of these rollers has a hard surface so that the color is deposited only on the higher areas of the plate, while the other, made of rubber or a gelatin-like composition, can deposit ink at every level. When two colors are rolled on successively, they may mix or not mix; or a color that is already on the plate can reject or pick up a color that is passed over it. The reactions depend on the relative viscosities of the inks.

Proceeding in this way, or in other ways that may occur to me, I pull trial proofs until I find the best possible manner of printing the plate—or if I find it unprintable, I may throw it away. At this point I enjoy the excitement of having "discovered" the print. Then the printing of an edition becomes a question of time and hard labor, since I print all editions myself.

WARRINGTON COLESCOTT
Color from Additive Plates

I produced silkscreen prints from 1948 through 1958, and the methods I devised in that medium influenced much of my work when I finally turned to etching. From the beginning I was interested in color, and I thought in terms of a sequence of additive impressions; this was in opposition to the Atelier 17 doctrine of viscosity

PLATE 440

440 Warrington Colescott. Self-portrait. 1970. Drypoint with mixed media, 9 1/2 × 5". Courtesy the artist

printing, with everything drawn on one plate and run once through the press. To use several ink-bearing surfaces and print them one after the other seemed to me an easier and more controllable method of achieving color density, and it still does. In my earlier intaglios I experimented with combinations of silkscreen color and etched plates, and I still use screens occasionally to put color areas on a plate, but my general conclusion is that there are easier ways to get the same effect.

I define an intaglio print as an impression from any surface produced by an intaglio press. This means that the plates to be incised, etched, scored, cut, built up, and inked are not limited to copper, zinc, aluminum, steel, and so on, but may include a variety of other materials, such as cardboard, Masonite, plywood, Formica, or Plexiglas. The intaglio design cut into the plate is one aspect of the work; the surface of the plate is the other. For the surface I ink with rollers, squeegees, or sprays, through paper or silkscreen stencils, or with a template. The intaglio is daubed and wiped by hand or with paper, rag, or *à la poupée.*

My drawing base is usually on two plates, developed together in counterpoint, proofed experimentally, gradually subdivided into groups of smaller plates by cutting —sometimes to erase, sometimes to separate colors, sometimes to inject a double-entendre commercial image into the sequence, sometimes for the pleasure of bringing in an area of embossed white space.

My press is a powered Meeker-McFee model. The number of times the sheets are run through the press is dependent only on whim and emphasis, rather than muscle power. The greatest advantage of this press for my work is that it has grading by micrometers, which allows me to alter printing pressure quickly and accurately when I am printing several surfaces in sequence. I can run whatever sequence of thicknesses I choose (e.g., 16-gauge, 18-gauge, type-high) by simply turning the dials to the predetermined gauge numbers.

Essentially my prints are narrative, and my line drawing carries the narration. Ideas stem from drawings on paper, continued on metal plates with drypoint tools. As the plates develop, elaborations are carried forward with line and deep etching, and textural areas are stated in soft-ground. A continual and remorseless color proofing begins, as the narrative is dramatized, designed, and refined.

A next step is to bring in more flexible and softer materials (such as Plexiglas or wood), which can be cut and carved so that color areas can be transferred by brayer or offset and can take their place in the sequence. Photography is inserted by fitting in letterpress plates, either made up for me by a photoengraver or salvaged from the scrap of a commercial printer. Photography is normally subordinated to my drawing; it interests me only as a foil to the drawn image, presenting reality as a stylistic aberration in the context of my hand's work. The etching press is a superb instrument for welding this kind of collage statement into an embossed unity.

COLORPLATE 47

In the progressive proofs shown for my color print *Patrioticks,* the first includes work executed by a combination of etching, soft-ground, and aquatint. In the second, an additional plate with drypoint was overprinted and a photo inset added. In progressive proof 5, the plates had been further shaped, and colors were added with rollers for relief printing. The final state shows considerable color modification, together with the addition of roulette work to the plates.

I feel that this kind of devised technique has value only in relation to the wit with which the original ideas are conceived. The mind behind the print is for me the

motivating force, the logic that can carry its vigor into the technical handling. When the quality of the idea stimulates the ingenuity of the technique, the printmaker is no longer the pawn of his machinery but is using his shopful of tools and heaters and presses and rollers as if it were one small, cohesive drawing instrument to give tangible form to the image in his mind.

VASILIOS TOULIS
Acid Resists for Deep Etch

Quite a range of substances may be used as acid resists to protect the various areas and levels in a deeply bitten plate, among them being liquid hard ground, liquid asphaltum or Gilsonite, shellac, lacquer, epoxy paint, spray enamel, rubber cement, model-airplane cement, wax crayons, lithographic crayons, rubbing ink, autographic ink, marking pens having a shellac-type waterproof ink (such as Magic Marker), and many others. Their effectiveness as resists will vary according to their individual

441 *Vasilios Toulis.* Necrophiliac. *1964.*
Tape collage and aquatint, 23 × 17".
Courtesy Pratt Graphics Center, New York

441

characteristics and the strength of the acid bath. Weaker resists such as litho crayon will stand up well in a somewhat weaker bath (about 1 to 10 nitric acid).

PLATE 441

Pressure-sensitive tapes and plastic pressure-sensitive papers, cut through with a stencil knife, provide an ideal resist for etching clean, sharp shapes. In my recent work, which involves hard-edge imagery, I have made use of this material as follows: The plate is cleaned well with a kitchen type of scouring powder and fine steel wool, which slightly dulls the surface. The design is drawn on the plate with a pencil or ball-point pen. A sheet of transparent contact paper is pressed down over the drawing, and an extra inch of margin is left on all sides, which is wrapped around to the back of the plate. Since the paper is transparent, I can see the original drawing underneath, and it thus serves as a guide for cutting. The areas to be bitten are then cut away with a sharp stencil knife and removed. This pressure-sensitive plastic cuts cleanly and peels away easily, leaving very precise edges. All areas to be etched may be stripped away at once, or they may be removed at different time intervals in order to attain different levels. After the plate has been etched and proofed, the remaining contact paper, which acted as the resist, is stripped away.

I have also used a silkscreen acid resist, screen-printed onto the plate; this is a dense and strong acid-resistant ink formulated for the etching of circuits in the silkscreen industry.

A resist may also be applied by transfer. This technique, which was apparently first tried by William Blake, allows the drawing to be made without having to work in reverse. The image is drawn on a sheet of transfer paper with a mixture of asphaltum and rosin dissolved in benzine. When dry, the transfer is placed face down on a clean, slightly warmed plate and passed through the press. The plate with the transfer sheet still sticking to it is placed in a bath of warm water, which will cause the paper to detach itself, leaving the resist image on the plate. The plate is then etched to whatever depth is desired.

OMAR RAYO
Inkless Intaglio

PLATE 442

I have tried various metals for my embossed intaglio plates but have always preferred copper. It is ductile and compact and best suited to the action of the acids. The plates used for this type of work must be from 1 1/2 to 2 inches thick, as this will determine the height of the embossment.

The plate must be varnished in the same way as any type of aquatint, but, as this plate will be undergoing the corrosive action of the nitric acid for a much longer time, very thick layers of varnish must be used to withstand the many hours under the destructive biting power.

The recessed parts of the image, where a cavity is desired, are left free of varnish, as in an aquatint. In this case, however, the plate is left in the acid until it breaks completely through. The crucial process of biting must be supervised constantly in order to preserve the original plan and idea. Every hour or two, depending on the strength of the acid, the plate is removed from the acid bath and dried carefully. Borders exposed to the acid are covered with liquid varnish. Areas where the varnish has begun to crack and yield to the acid are also covered again. The plate is then returned to the acid bath, and the process is repeated until the cavities have reached

442 Omar Rayo. My Size. *1969*. Embossment.
Courtesy the artist

442

the desired depth. Nitric acid is used because it bites vertically; any other mordant will bite diagonally and will eventually destroy the plate.

When the biting is completed, the plate is removed and thoroughly cleansed and dried, with care taken not to mar the surface. Then the edges of the plate are beveled with a fine file to prevent the pressure of the press from cutting the paper. Any irregular edges broken by the acid are filed straight. When the plate is absolutely clean, it is ready for printing.

The amount of humidity in the paper is especially important when making an embossed impression, since the image can be affected by expansion or contraction. The paper should not be too wet when it goes through the press, and it should be dried immediately after printing. Paper is ready for use when it has been dampened to the consistency of firm wax and will penetrate easily into the cavities of the plate when pressed by felt and cylinder. A heavy paper should be used (my preference is 300-pound Arches). When great depth of relief is desired, it is possible to print by hand, using the fingers, the palm, and various instruments with rounded ends to apply added pressure. The print should be taken from the press without separating

the paper from the plate. A heavy cardboard is placed over the paper until it is dry; it will then be quite rigid and can be easily removed from the plate.

The "Metal Prints" of
ROLF NESCH
by Michael Ponce de León

Rolf Nesch, a German-born Norwegian artist, was an early pioneer in some of the innovative techniques now used in intaglio. He was the first to make holes in the plate itself, a device he elaborated on the basis of a chance discovery in 1925, and by 1932 he had begun to experiment with the use of found objects in printmaking. His "metal prints," as he named them, consist of welded pieces of metal, wire netting, and other textures applied on an aquatinted base plate. Very often he uses free pieces in his compositions, moving them around like a chess player to create different arrangements, for he seldom makes two prints alike.

He inks his plates by hand, rarely uses rollers, and seldom overprints. He makes his own inks, and instead of etched lines or soft grounds he uses drypoint needles, chisels, and hammers. His main concern is texture, not relief, which is automatically obtained by the methods he uses.

For making aquatints he pours almost pure nitric acid on the plate instead of etching with the usual slow bite in a tray. This procedure gives his plates a rough-hewn surface. He beats and makes holes in his copper plates in the same way a silversmith hammers his material. His techniques are unconventional, but they seem only to add strength and impact to his work. His fantasies are not preconceived but are discovered in the process of working.

Though a shy man, Nesch radiates generosity and warmth. His studies under Kirchner and the influence of Edvard Munch and German Expressionism are still visible in his work, along with echoes of primitivism and folk art. He divides his time between printmaking and sculpture. In his sculpture there are interesting combinations of metal, stone, and colored glass, which he sometimes melts with a torch.

BORIS MARGO
The Cellocut

The graphic process which I named "cellocut" is, in brief, the use of a varnish consisting of sheet celluloid dissolved in acetone on a plate designed to be printed on an etching press. Diluted to pouring consistency, the celluloid mixture is applied as a coating to any firm surface, such as a metal plate, Prestwood, or heavy cardboard. In my prints of the 1930s I often obtained textured areas in this coating by placing textiles, wire, string, crumpled tracing paper, and other materials on the plate while the varnish was still tacky and then running them through the press. Later I used thicker solutions of the varnish to build up higher areas on the coated plate. On these, as in my 1946 *Carnival,* I combined intaglio inking with relief inking, employing rollers of different degrees of firmness. This technique permits complex, modulated colors achieved in the following way: the plate is first inked and intaglio-wiped in one or more separate color areas; next other colors are applied to the surface from gelatin rollers, which are soft enough to coat the raised contours of the cellocut far down their flanks; finally still other colors are added over the same raised areas, this time from rubber rollers, hard enough so that the ink does not reach far down the slopes.

PLATE 443

443 *Rolf Nesch.* Garde Offizier. *Color metal-collage print. Philadelphia Museum of Art*

PLATE 444

These roller-applied colors blend where they impinge on one another, with subtle gradations occurring along the flanks of raised areas.

444 Boris Margo. Great Wall. 1964. Cellocut, 22 3/8 × 36 1/4". Courtesy the artist

A medium as versatile as this can easily respond to an artist's changing requirements. Since my invention of the cellocut in 1931, I have employed a number of variations of it, to suit the concepts that have engaged my attention at any given period. During the past ten years I have been building up my plates with still higher relief and printing them uninked, or occasionally with a pale background of muted color, allowing the image to be revealed by the light and shadow cast on the paper from the raised forms.

Recently my interest in complex technical approaches has decreased. I have been involved with concepts conveying serenity, calm, and peace; for this reason the statements I now find appropriate are the ones that are as simple as possible.

The Printmaking Techniques of
ARTHUR DESHAIES
by Ruth Dryden Deshaies

One of the first prints to show a break with the traditional geometric shapes was Arthur Deshaies's *Fish,* which was made at the Indiana University Workshop in 1952. The print was pulled from an intaglio copper plate which had been cut into the shape of a fish, with additional pieces in the shapes of fins. Subsequent experimentation resulted in inking adjacent cutout pieces in relief and intaglio and printing everything together (by assembling all the pieces on the press bed) with one press run.

Probably as a result of his earlier experiments with offset stencil printing, Deshaies then combined intaglio color with colors applied to the surface of the plate

PLATES 445–448

and printed both at the same time in one press run. He went on to develop a series of heavily embossed prints made from plates cut into many pieces. Some were blind-stamped, some were inked in relief, others in intaglio—all assembled on the press bed and run once through the press.

PLATE 449

In 1960, in an effort to find a large surface that could be engraved spontaneously, he developed the plaster block, which allowed him to make prints of almost any size. The block was made of fine-gauge, quick-setting molding plaster, cast within a reinforced frame on a large sheet of Lucite to yield a glass-smooth surface. It was worked with traditional woodcut tools, as well as motorized grinders, rasps, drills, and wire brushes. The plaster was particularly appealing because it could be easily worked while moist but was firm enough to cause very little material resistance and permitted fast, spontaneous treatment, almost like the action of painting. Wanting to keep a linear graphic effect, Deshaies developed a set of multiple-line tools appropriate to very large blocks.

These blocks were printed on Tableau paper, a commercial filter paper made by a firm in Boston. Because it came in large rolls, prints of any length could be made. The actual inking of the block was done in the traditional relief manner, except that the large size necessitated doing one area at a time. The ink was black IPI commercial printer's ink, applied with a hard-rubber roller. A clean hard-rubber roller was used for printing.

Earlier in his career Deshaies had become fascinated by relief engraving on end-grain wood blocks. When he had exhausted the size possibilities of ready-made end-grain blocks (by juxtaposing two or more of the largest blocks made), and when he had suffered the frustration of having blocks break under the heavy pressure required to print clear black details and embossed whites, he began to look for another material. Lucite was the answer. His first relief print on that material was equal in quality to any he had made from boxwood blocks, with an added advantage: the transparent plastic permitted engraving directly over a prepared drawing.

PLATES 450, 451

Next he sought to make intaglio prints from Lucite. Engraving tools could be used quite successfully, but there seemed to be no way to add grays or tonal areas, because the Lucite did not respond to acids. After considerable trial and error, it was discovered that grays could be achieved by treating the Lucite with sandpaper and other abrasives. Rich blacks could be produced by gluing tarlatan, stockings, or other materials to the plate's surface.

445–448 Arthur Deshaies. Fish. 1952. Etching and engraving (states 1,3,4, 5), 4 1/4 × 11 1/4". Courtesy the artist

At this time Deshaies began to experiment with motorized tools: grinders,

445

446

449

449 Arthur Deshaies. Cycle of a Large Sea: Unbeing Myself. *1961. Plaster relief engraving. Brooklyn Museum, New York*

447

448

450

451

450 *Arthur Deshaies. J. H. I Love You.*
 1965. Original cutout Lucite plate with
 power-tool engraving. Courtesy the artist
451 *Arthur Deshaies. J. H. I Love You.*
 1965. Lucite engraving with embossment
 38 × 26". Courtesy the artist

drills, and Carborundum wheels. Eventually the flexible-shaft drill proved to be the most versatile electric tool. After learning to control it, the artist can work on a Lucite plate with the ease of drawing with a pencil. Band saws and jigsaws are used for cutting the plastic into multiple-piece plates.

MICHAEL PONCE DE LEÓN

Notes on My Working Methods

My graphics are the result of composition rather than of drawing. They are not made just for the eye but as a means of penetrating and alerting the other senses. I choose demanding problems as my motivation, for I feel excited only when I am faced with obstacles that appear impossible to overcome. Cutting, hammering, etching, and handling materials as objects gives me a greater satisfaction than traditional drawing and painting. In reality, what I make is not a print but an imprint of objects, shapes, and textures that leave their tangible physical form impressed in the heavy paper I use.

I usually start with a model, a miniature collage construction made of cardboard. This limitation compels me to strip the project of all nonessentials. Most of my work is the result of several ideas in conflict, of the search for a resolution of contradictions. My metal constructions are a complex of many raised and depressed metal motifs,

some soldered, others free, but all fitted together like a jigsaw puzzle. My materials, aside from *objets trouvés,* are zinc, copper, aluminum, bronze, steel, and corroded tin cans. Each metal has its particular chemical properties and reacts to acids, hammers, and other tools in a unique way. The same can be said of the manner in which it accepts color inks and printing paper.

Some of my surfaces are hammered and modeled into orchestrations of concavities and convexities. The concavities on the back are always filled in with aluminum solder so as to retain their shape throughout the printing. Objects too soft for printing are cast in metal. I do my own casting for metals that melt at less than 1,000 degrees F.; harder materials are cast for me at a foundry. Some shapes are modeled in wax or plaster, from which metal castings are made. Because castings are usually higher than the other shapes, the latter must be built up by backing them with metal or plastic. Walls of lines or areas over 1/8 inch in depth are beveled to a 45-degree angle; by this process the paper, when compressed, reaches every inked, V-shaped concavity.

To print from my high plates I had to design a new type of hydraulic press that stamps with 10,000 pounds of pressure. The operational principle of this machine is the hydraulic jack. It is to me what a piano is to a pianist, for with it I am able to extract every nuance of color and depth from the matrix. There are several advantages to this press: I can leave the paper and plate under compression for any length of time needed to obtain better embossment; I can stamp over areas that I wish to reprint without mashing any previously printed relief; and with verticality of motion there is no danger that unfastened pieces will shift.

I make my own inks and use a variety of oils and other media to attain a good range of transparencies, densities, and consistencies. Inking is done mostly by patting with the fingers and the palm of my hand. My paper, one of the most important features of the work, is specially made for me by Douglass Howell, some pieces being the result of much cooperation between us. Generally I use 1/2-inch-thick paper made of long-fibered linen, which is stretched to the limit of its cohesion and embraces the matrix in all its details. Each sheet of paper absorbs 2 quarts of water. The water is mixed with a solution of plaster of Paris and gelatin, which hardens the paper after drying.

The adjustment of the backing blankets and the application of countermolds is a very exacting procedure. In general I stamp the work once, then remove the blankets and fill in all the depressed areas on the back of the paper with wet paper pulp, creating a form of papier-mâché countermold. This operation helps to equalize the different levels so that, with a second stamping, every untouched area of the plate is reached. After the plate is taken from the press and the packing removed, I force every inch of the paper into the mold with a burnisher.

In *Succubus* the spiraled shape was first carved out of a single plank of wood, from which a negative wax mold was made for the casting of an aluminum matrix. That single section, measuring 19 inches in diameter and 3/4 inch in thickness, was aquatinted and worked over in order to make it receptive to subsequent inking. The square bas-relief used as background for the concentric piece was made of zinc plate. The raised areas were etched deeply, and the depressions were produced by build-ups in order to create an interaction in depth. For the central piece an ordinary sewer drain cover was used.

COLORPLATE 48

For my "shaped paper" a sculptural mold was constructed in the form of a spiral staircase. The mold was dipped into a deep vat filled with water and raw linen pulp and was then raised to the surface with the 1-inch-thick spiraled paper contained in it. The paper was built up in several layers. After the second layer, strips of linen were attached to the raw pulp; they served later to suspend the shape in front of the bas-relief background. The drying of this paper stock took two weeks, with two molds used to make ten sheets for my edition.

The print was made in three operations with two pieces of paper. First the black square background was printed; then, in the center, the sewer piece was printed in blue on the same piece of paper. For the spiral, twenty-eight colors were used to ink up the many rings, with the warm colors moving centripetally and the cool colors centrifugally, to create an optical reverberation. An extra inner plate was required to print the inside section of the overlapping spiral.

Very often, after my plates have fulfilled their purpose with the printing of an edition, they are allowed to seek a new destiny. What started as a printing plate is transformed into a full-fledged sculpture, with sounds, lights, and movements added to some pieces. In an effort to explore and extend the possibilities of printmaking in our vast realm of technology I have recently developed a kinetic print with an electric shutter device that changes images as it moves. As with most of my other prints, I make an edition of ten.

GEORGE A. NAMA
A Built-up Intaglio Plate with Silkscreened Color

My color intaglios have been evolved to satisfy my needs as a painter and sculptor as well as printmaker. Inking and printing the plate is a painterly activity, and for this I have found that the combination of two processes—intaglio and silkscreened stencil—allows me more graphic freedom; I can use color as freely and as fluidly as in painting and can incorporate textures with no more limitations than painting imposes. At the same time, as a sculptor, I regard my plate as a three-dimensional object occupying space. The plate itself, be it metal, Masonite, or wood, acts as a "middle ground" on which I build with modeling paste and textures and into which I engrave with power and engraver's tools.

COLORPLATE 49

For *Computer Landscape No. 6* an untempered Masonite sheet was coated with gesso and polymer medium, brushed on heavily to create brushstroke textures. After these layers hardened, the plate was engraved, partly with power tools. Then sections were built up with modeling paste and left to dry, after which small circles were drilled through the Masonite to create openings that would print white. After being sealed with a thin coat of polymer, the plate was ready to be printed like any etching or engraving in an intaglio press. A warm black ink was used for the intaglio printing (first progressive proof).

From this point on, the stencil process was used to develop the print. After the print had dried, an even, transparent blue was stenciled over some areas by silk-screening (second progressive proof). Then a transparent magenta (deep red) was stenciled, followed by a transparent sienna (fourth progressive proof). A variety of opaque colors was then applied in the central area of the print to intensify the color and feeling of "light." The final state was a series of runs of warm and cool colors, both transparent and opaque, to create a prismatic color-and-light form.

BERNARD CHILDS
Large Editions on a High-speed Press

The print *Tropical Noon* is one of an edition of 5,000, created on a Miehle letter press COLORPLATE 50
that can pull 3,500 impressions an hour. The press is built for the finely calibrated
adjustments that commercial printers make to guarantee uniformity and clarity of
impression at high speeds. Each one of its movements is a mechanical imitation of a
human movement that every printmaker recognizes instantly. Everything he does
the press can do—but with multiple, electrically driven hands. The moment the
printmaker understands that, all he has to learn is what it can and cannot do. Then
he can use it for his own purposes.

A fundamental requirement for any press is a plate it can print. The letter press
prints a relief surface by contact. The contact point is "type-high," that is, the printing
surface is exactly. 918 inches above the bed of the press. Deviations above and below
this level, which the machine actually can register, are the bane of commercial print-
ing, but for the artist they are invaluable. One printer stated it succinctly: "For us
they're murder, for you they're art." Although these deviations measure in thou-
sandths of an inch, they open up amazing potentials, from the most delicate accents to
out-and-out intaglio effects. The only limitation is the artist's own ingenuity in creat-
ing plates to exploit this potential. The possibilities can encompass any and all draw-
ing, painting, sculpture, collage, engraving, and etching techniques in any combina-
tion whatsoever.

For *Tropical Noon* I started with two zinc plates on which the figures were drawn
and painted. Epoxy was the medium. For textured areas, Carborundum particles were
sifted over the glue. When cured for 20 minutes in a 270-degree oven, the plates
were printable. However, I had to consider the beating they would take under the
tremendous pressure of the press cylinder for a 5,000 run. Furthermore, I still wanted
two more plates (skeletons) to define the images and permit a richer fusion of light
and color. I therefore had electrotypes made up, two of each original plate. The
electro is an exact metal duplicate, and its copper surface is perfect for further de-
velopment of the print. Two of the electros were transformed into skeletons, and two
were used for base plates. I modified the electros with power tools, burins, and files.

Two plates were used for each of two press runs and necessitated simultaneous
printing of colors. The first run required gradations of yellow on the upper plate,
viridian on the lower plate. The second run, using the skeletons, required uniform
applications of red on the upper plate, vermilion on the lower.

The press mechanism that contains and controls the flow of ink is called the
"fountain." A divider was inserted to split the fountain so that it could hold two
different inks at once. Keys, set about an inch apart the length of the fountain, were
adjusted to control the even and uneven flow of ink desired for each set of plates.
Oscillation of the rollers was cut down to the minimum, and a color separator was
mounted to keep a close control on the division and blending of colors. All colors
were successfully held in place for the entire printing.

The most critical, costly—and rewarding—stage of preparation for proofing
and printing is the make-ready. Among other things, this involves underlaying to
adjust the level of the plates on the press bed. The distribution of pressure that can be
achieved through make-ready provides what is really a sculptural modulation of the
inks. In commercial printing, the purpose is to level out the impression and sustain it

for a long run. My purpose was to attain a play of levels, light, color, and accents that would make clear the creative concept inherent in my plates while keeping the impression uniform for the 5,000 run. By working with the pressman on make-ready, it was possible to create the print directly on the press. For me this is the only way to get a *bon à tirer* that works and that has an original quality unique to the machine's technology.

To arrive at a *bon à tirer* can be as devilishly evasive on this as on any other press. The process is a natural carry-over from experience on the intaglio press, but in a commercial shop I have found two differences. One is that I am not on my own. Only the pressman can touch the press. The other is that the meter is running. That press and every movement it makes is costing so much each minute.

Whenever possible, I stick to standard methods with which the pressman is familiar. His hands must be mine. I listen carefully because his experience is invaluable, and we both must speak the same language. Any proposals I make that appear to be innovations must be within the range of what his machine can do. Like many men in his industry, the master pressman is as interested as the artist in finding out something new.

What I learned on the commercial press led me to new discoveries on the old intaglio press, which is my first and lasting love.

With contemporary presses establishing new quantitative levels for an original print, hallowed concepts, evolved from the technological limitations of the past, as to what is an edition, its signing and identification, need fresh thinking. The beautiful values of prints made on the old presses will continue, but it should be remembered that the old presses were the commercial reproductive machines of their day. It was the artist who made them creative instruments. The roaring new monsters can also be tamed.

[NOTE: Adapted from an article in *Artist's Proof.*]

GLEN ALPS
The Collagraph
The basis for my collagraph plates is a piece of wallboard, cut with straight edges, which are filed and sanded until smooth. The edges and the back of the plate are given three coats of clear brushing lacquer, white lacquer, or glue to ensure easy removal of any excess ink that might collect on them.

I begin by doing a charcoal drawing to clarify visually the concept I intend to express. Triangles are cut out of each corner of the drawing, before it is transferred, for purposes of registration. The drawing is placed face down on the unlacquered surface of the plate and rubbed firmly. A sufficient amount of charcoal comes off so that the image can easily be seen as a guide in the manipulation of all the component parts of the collage.

The image area of the plate is dampened (to prevent the moisture in the glue from being absorbed too quickly), and Elmer's glue is brushed on as evenly as possible. Stencil paper is then adhered to the plate, and additional work is done on this paper. Glue, used as a drawing medium, is applied directly to the plate from its container.

I developed a method of sprinkling ground-up walnut shells over the entire glued area while it is still wet and pressing them into the glue with a small piece of

cardboard. The excess is removed and saved to be used again. Walnut shells in this form can usually be purchased in hardware and paint stores. A belt sander is used to smooth off the peaks of ground shell in areas where a grayer tone is desired. Other portions are left unsanded to carry a deeper and more even blackness.

A number of other materials that can be used in the making of a collagraph plate are: gesso, modeling paste, clear lacquer, Liquitex, Silver Magic (an auto putty), Durham's putty, white lacquer, plastic wood, brush bristles, wood shavings, sawdust, pencil shavings, string, and various kinds of paper and cloth. When sawdust is used, it should be coarse for the darker areas and finer for the lighter ones.

An additional charcoal drawing can now be transferred to a sheet of pebble-finish mat board as a guide in cutting various shapes to be incorporated into the plate. It is very important that the edges be beveled away from the center of the shape, to keep ink from collecting underneath and squashing out during printing. Tinsnips are excellent tools for cutting shapes in heavy paper or cardboard.

To further enrich the surface, white lacquer can be brushed on in juxtaposition to some of the cut shapes. To continue building up the plate, Durham's putty mixed with Elmer's glue may be applied with knives or brushes. Modeling paste can be worked with the fingers directly into areas sprinkled with coarse sawdust. Foil can be pressed into the wet modeling paste to add still another texture to the surface. Plastic wood, used from the tube and worked into the plate with a knife or finger, provides a surface that can then be sanded or scraped. Sharp-pointed tools are used to produce line in any of the media, wet or dry; lacquered or glued areas form a fine base for cutting or engraving lines.

As a trial proof a blind embossment may be printed by using heavy felts and extreme pressure.

To ink the plate a 4-inch scrub brush is used. Plastic gloves should be worn to keep the hands clean for later handling of proofs. A special collagraph ink, which is very smoothly ground, very black, and quite buttery in quality, is used. It is scrubbed vertically, horizontally, and diagonally to ensure complete integration of the ink with the plate.

A tight wad of cloth, smooth on the bottom, is wiped all across the inked plate. The rag is rewadded, the plate rotated, and the wiping continued as needed until, finally, the plate is briskly wiped in all directions with a rather hard clean cloth, carefully wadded; this pulls up the brilliance of the plate. It is important to wipe off thoroughly any excess ink that may have collected on the edges.

A clean, dry sheet of newsprint is placed on the bed of the press, and the plate is positioned in the center. A sheet of dampened printing paper, held on opposite corners so that it will not buckle, is then centered on the plate, and another sheet of dry newsprint is placed over it to help keep the felts dry and soft. One or more thick felts are put into place, and the proof is pulled.

When the day's printing is finished, the plate must be cleaned with kerosene, so that there will be no ink left to dry and spoil the detail of the work. If proper care is taken, twenty to fifty proofs can be pulled from a plate of this type.

Collagraph No. 12 was developed as a collage on 1/4-inch Upson board with the use of mat board, lacquer, glue, textured materials, a water putty, pressed wood, and crushed walnut shells. The plate was inked with master black MPS and printed in intaglio.

PLATE 452

452

453

PLATE 453

White Necklace is a three-color, two-plate collagraph. The black areas were developed by adhering crushed walnut shells to an Upson board plate. The white areas were achieved by drawing with white lacquer on the crushed-walnut texture. In the upper rectangle the crushed walnut shells were sanded with a belt sander to lighten the area. Under this area a separate plate, inked in red and gold in relief, was printed. The main plate was printed in black, in intaglio. The embossment was achieved by cutting shapes in another plate to correspond to the white areas and running them through the press at high pressure.

[NOTE: Glen Alps, as a teacher at the University of Washington, began using the term "collagraph" in 1956, and his *Collagraph No. 12* was shown in the Brooklyn National Print Exhibition the following year. The term is used by a number of other artists for prints involving collage devices, though their techniques are not necessarily similar.

PLATES 454, 455

PLATE 456

Bill H. Ritchie, for example, makes plates with sectors of 18-gauge copper. For his *Chickens with the Blue Stones* he used a separate piece of such copper for each of the four sectors of the plate. The paddle shapes were additional pieces of metal, cut to fit into slots on the master plates. The "stone" images were printed from separate pieces of copper textured by forging from natural stone surfaces. These were mounted on a plate of galvanized steel, and each could be inked in a different color, if desired. He used techniques of viscosity printing based on the methods of Atelier 17.

PLATE 457

Within this field of printmaking some artists have defined their work as "collage prints." Others (see the following pages) have adopted the spelling "collograph," which derives from the Greek and Latin words for "glue," rather than directly from the French *collage*. When collage evolved as a sophisticated art form in France early in this century, it was largely associated with "pasted papers," but since then its meaning has encompassed many materials other than paper and paste or glue.

The methods and materials of the various artists tend to be highly individual, even when they are labeled by the same term.]

454

455

452 *Glen Alps.* Collagraph No. 12. *1958.*
Collagraph with crushed walnut shells,
plastic wood, and matboard, 22 1/2 ×
33 1/4". Courtesy the artist

453 *Glen Alps.* White Necklace. *1969.*
Color collagraph with crushed walnut
shells, white lacquer, and cardboard,
19 1/2 × 19 1/2". Courtesy the artist

454 *Jim McLean.* Tondo. *Color collagraph,*
diameter c. 18". Courtesy the artist

455 *Junichiro Sekino.* Collagraph No. 3.
1965. Color collagraph, c. 22 × 30".
Collection Glen Alps, Seattle, Wash.

456 *Bill H. Ritchie.* Chickens with the Blue
Stones. 1970. Color collagraph.
Courtesy the artist

456

457

457 R. Feddler. Untitled. Collage print, 11 1/2 × 10 1/2". Courtesy Pratt Institute, Brooklyn, New York

JOHN ROSS
My Collograph Technique

The materials I use in making a collograph are easily obtainable: cardboard (one- or two-ply chipboard), mat board, papers of various thicknesses and textures, sand (for dark, aquatint-like effects), and flat found objects such as watch or machine parts, coins, or washers. All may be glued to a base plate of mat board with polymer gesso or Elmer's glue. (Gesso is preferable because it is flexible, even when dry, and therefore does not chip.) If a shape is too thick, I may insert it into the base plate by removing a layer or two of cardboard. In general it is not wise to have too great a difference in height between the highest and the lowest surfaces of the plate. About 1/8 inch is the maximum variation that permits easy printing. Objects that are too high may puncture the paper and blankets when run through the etching press, and surfaces that are too low receive too little pressure for a clean print.

The paper should be heavy, long-fibered, and capable of withstanding much abuse. It must be well dampened with water to soften the fibers. The papers I most often use include Rives BFK, Murillo, Italia, German Etching, J. Barcham Green, and Fabriano Classico in the 300-pound weight. Because the color is applied in several ways, by both intaglio and relief, the inking is complicated and may take up to an hour for each print.

I often use two plates, each inked with five or six colors and printed wet on wet, one over the other, with the least interval of time possible between printings. After the first plate is printed, the paper is kept damp with wet newsprint and blotters until the second plate is inked and printed in register on top of the first impression. The colors merge and blend into a great variety of values and hues. As a register control I sometimes use a thin mat taped to the bed of the press, which receives each plate in turn. The plates must, of course, be of the same size.

COLORPLATE 51

For bright, strong base colors I use intaglio inks, thick and viscous. They are wiped by hand and with crinoline. Less viscous letter-press ink (IPI Everyday in tubes) may be applied with brayers onto the raised surfaces of the plate. Great care has to be taken in inking, with certain rollers used for specific shapes, in order to achieve uniform editions and to produce the precise technological forms which make up a major part of my images.

CLARE ROMANO
My Collograph Technique

My experiments with the collograph evolved from using cardboard as a relief plate. In my search for a more flexible material than wood, I began to cut into three-ply chipboard with X-acto knives and razor blades and to peel away layers of the material. Sometimes I glued cardboard, papers, found objects, and various adhesives to the plate, inked them in relief, and printed them on Japanese paper as cardboard relief prints.

In 1965, when I was in Yugoslavia for the U.S.I.A., I began to use cardboard for combined intaglio and relief plates. Geometric forms suggested by the Yugoslav architecture became my images, and I found them conducive to the use of cut cardboard and paper forms. The flexible collage plate was especially interesting to me, because I could change a design easily by simply cutting out an undesired area and regluing it. During this period I first used photo-offset metal plates inserted into the

cardboard plates in a collograph called *Ljubljana Night*. I have continued to use photoengravings made from my own photos and from existing cuts as integral parts of my plates.

My general procedure is either to cut into three-ply cardboard, peeling layers of various depths, or to glue cuts of cardboard, paper, cloth, or found objects to a two-ply piece of mat board, using gesso or Elmer's glue as an adhesive. Generally I do not exceed the thickness of two pieces of two-ply mat board, because the plates are printed on an etching press.

After the parts are glued securely, the entire plate, front and back, is coated thinly with gesso, Elmer's glue, or polymer to protect the surface. It is important to keep the protective coating thin if you want to use brushstrokes. After the plate is dry, a film of plastic spray will further seal the surface and facilitate wiping and cleaning. Sometimes found objects are glued to the plates; sometimes copper and zinc plates, traditionally etched, are inked separately and dropped into position. Photoengraving plates in relief are also inked separately before being inserted.

COLORPLATE 52

My plates are printed in a combined intaglio-and-relief process, exploiting the viscosity of the inks and the depths of the plates in order to achieve as many interesting nuances of color as possible. Most of my experimentation comes through laborious proofing, undertaken to develop the quality of color. The plate is inked in intaglio, with a selected color of stiff etching ink as the base, then wiped in the traditional manner with tarlatan and by hand. Additional color is applied with rollers of various sizes and inks of different viscosities to the recessed and raised areas respectively. Sometimes two or three layers of ink are applied to one surface. In order to exploit brilliant color I have cut my recent plates into two, three, or even four separate sections, inking each with strong colors applied to both intaglio and relief areas.

The plates are printed on a Brand motorized etching press having a 30-by-50-inch bed. The choice of papers depends on the printing and color quality desired. Among the fine rag papers Murillo and Italia are the ones I use most often, but Rives BFK and others have been serviceable. Ordinary felt etching blankets are used. However, if the plates are uneven in surface, foam rubber of various thicknesses is used to avoid damaging the blankets.

CHAPTER 12

THE
MEZZOTINT

HISTORY AND TECHNIQUE

The mezzotint is one of the few graphic techniques which can be accurately traced to its inventor. He was Ludwig von Siegen, born of good family in Utrecht, Holland, in 1609. Perhaps to avoid the horrors of the Dutch Civil Wars of the period, he settled in Germany and spent most of his career as an officer in various private armies of Hesse. He received some education at the Rittercollegium in Kassel and is known to have dabbled in portrait painting and metalwork. He remained at Kassel for some years at the court of Landgrave William IV.

An interest in engraving led Von Siegen to develop what he considered to be an entirely new method. By the use of small spiked wheels called "roulettes" he roughened those areas of his copper plate which he intended to be dark. The wheel's tiny teeth, cutting into the plate, would throw up a slight burr, which held the ink and printed a deep, rich black tone. White areas of the design remained smooth on the plate, and for grays and highlights the burr could be smoothed down with a scraping tool. In this way he created continuous transitions from dark to light and delicate halftones beyond the means of ordinary line engraving. The mezzotint was to prove excellently suited to the reproduction of paintings and watercolors.

PLATE 458

Only seven prints by Von Siegen are known; some of these show mezzotint combined with lines, dots, and stipple done with various engraving tools.

Von Siegen is known to have spent several years in Amsterdam in the early 1640s and must have seen the work of his great contemporary, Rembrandt. Despite the deep, smooth blacks of prints such as the *Jan Six* of 1647, there is no evidence that Rembrandt himself ever resorted to the roulette technique.

AMELIA ELISABETHA, D.G. HASSIÆ LANDGRAVIA etc.
COMITISSA HANOVIÆ MVNTZENB:

Illustrissimo ac Cel Pr: ac Duo Duo WILHELMO VI D.G. HASSIÆ LANDGR etc hanc Serenissimæ Matris
et Incomparabilis Heroinæ effigiem, ad unum a se primum depictam novoq: jam sculpturæ modo expressam dedicat conse-
cratq; S. i S Ao Dni cIɔIɔCXLIII.

459

It was probably in Belgium in 1654 that Von Siegen met Prince Rupert, Pfalzgraf vom Rhein, grandson of James I of England and Royalist general in the civil war against Cromwell. Forced to flee England after the Puritan victory, Rupert found time to indulge a long-standing interest in art. He had already produced several fine etchings in the manner of Callot and Rembrandt and responded with enthusiasm to Von Siegen's account of the new technique. We know of twelve mezzotints produced by Rupert, the earliest dated 1657; these include a head of Titian, a self-portrait, a Mary Magdalene, and, perhaps his finest, *Head of the Executioner,* after a painting by Jusepe de Ribera (Lo Spagnoletto). Like Von Siegen, Rupert worked from light to dark and sometimes mixed graver work with rouletting.

PLATE 459

The restoration of the English monarchy in 1660 brought with it a reinfusion of lightheartedness and luxury into English culture. Prince Rupert was among those Royalists who returned to England. There he established himself as a semirecluse and pursued his artistic interests. Fortunately for the history of mezzotint, the prince divulged the secrets of the new process to a select few, including the dilettante art collector John Evelyn, who published a few enigmatic hints about the new medium in his *Sculptura* of 1662 and promised to deposit a full account with the Royal Society. His description never appeared in the archives of the Society, but still the news of "mezzo tinto" spread, even earning a mention in Pepys's diary of 1665.

So well suited was the technique for reproducing the lush portraits of Caroline beauties, trailing their satins and velvets against mistily romantic landscapes, that a craze soon grew up for reproductions of the works of Lely, Kneller, and other court

458 Ludwig von Siegen. Portrait of Amelia Elizabeth, Landgravine of Hesse. *1643. Mezzotint. Paul Mellon Center for British Art and British Studies, Yale University, New Haven, Conn.*

459 Prince Rupert. Head of the Executioner. *1658. Mezzotint. National Gallery of Art, Washington, D.C. (Rosenwald Collection)*

460 William Faithorne the Younger (after Philippe de Champaigne). Time, Glory, and Death. *Late 17th century. Mezzotint. Paul Mellon Center for British Art and British Studies, Yale University, New Haven, Conn.*

460

The Effigies of Barbara the Wife of John
Michael, taken in the 27.ᵗʰ Year of her Age.
She was ij Daughter of Balthazar & Anne Ursler.
Born at Ausburg in upper Germany in ij Year 1629.

Vera Effigies Barbaræ Uxoris Johannis Michael,
Natæ Augustæ vindelicorum in Germania supe-
riori vulgo Augsburg é Parentibus Balthazare &
Anna Ursler Anno Chr. 1629 Ætatis 27.

Printed for and sold by Tho: Bowles Map & Printseller next the Chapter house in S.ᵗ Pauls Church Yard.

461

462 463

461 *So-called "Bearded Lady," Barbara, Wife of John Michael, born in Germany, 1629. c. 1656. Mezzotint, printed for Bowles in England. Library of Congress, Washington, D.C.*

462 *Wallerant Vaillant. Portrait of Prince Rupert. Mid-17th century. Mezzotint. Paul Mellon Center for British Art and British Studies, Yale University, New Haven, Conn.*

463 *Wallerant Vaillant. Portrait of the Artist. Mid-17th century. Mezzotint. Paul Mellon Center for British Art and British Studies, Yale University, New Haven, Conn.*

artists. By feeding the hunger of the public for cheap portraits of noble or notorious personages, the mezzotint triumphed in England and became known as *la manière anglaise*.

 Prince Rupert himself had taught the art to William Sherwin, whose portrait of Charles II is the earliest dated English mezzotint. The crude texture of Sherwin's prints bears out the report that he sometimes used a half-rounded file, probably combined with roulettes and the barrel-shaped "engine," which could be rolled across large areas of the plate.

 Wallerant Vaillant (1623–1677), a Frenchman thought to have been an assistant of Prince Rupert's on the Continent, went to England and turned out more than two hundred plates, among them a portrait of Rupert with an inscription wrongly identifying him as the inventor of the process. This statement, along with remarks to the same effect by Evelyn, was the source of much later confusion.

 Abraham Blooteling, a Dutch engraver working in the 1670s, is credited with the invention of the rocker, a tool with many fine teeth on its curved surface. A uniformly roughened surface is produced by rocking it slowly over the entire plate in many directions. The plate is then worked from dark to light by the painstaking use of the scraper and burnisher. Blooteling's portrait of Erasmus (1671), after Holbein, illustrates the smoothness of texture, velvety darks, and halftones achievable with the rocker. This method was soon universally adopted and brought mezzotint its nickname, *la manière noire*.

 A school of Dutch mezzotinters, some followers of Blooteling, grew up. Among them were Nicolaes Verkolje, Paul Van Somer, and Allart Van Everdingen, who added mezzotinting to his etched plates for *Reineke Vos* (*Reynard the Fox*), possibly the first instance of the mezzotint used in book illustration.

 The mezzotint became a popular vehicle for the news of the day. In 1710 four Indian chieftains were taken to England with great fanfare in an effort to enlist their support for England's struggles against the French in Canada. They became the subject of curiosity, and a set of mezzotints of them was done after paintings by Verelst.

PLATES 460, 461

PLATES 462, 463

PLATE 464

PLATE 465

464 *Abraham Blooteling. Ceres. 1676.*
Mezzotint, c. 6 1/4 × 5 3/8". Courtesy
William H. Schab Gallery, New York

464

PLATE 466

Then the technique, as well as the prints themselves, traveled to America. The first American mezzotint was done by Peter Pelham, who founded a school of painting and engraving in Boston and became the teacher of John Singleton Copley. Pelham's portrait of the famous preacher Cotton Mather was done from life in 1727. Early American painters often used mezzotints of fashionable English portraits as models for their own work, copying poses and backgrounds and frequently shortening wigs or simplifying costumes to suit the American styles.

PLATES 467, 468

The mezzotint continued as the major reproductive technique in England. Such artists as Francis Place, Edward Luttrell, J. MacCardell, Richard Earlom, Valentine Green, and John Raphael Smith did prints after Reynolds, Gainsborough, Hoppner, Lawrence, and others. Reynolds, particularly, employed numerous mezzotinters and is said to have remarked that their prints would immortalize his work. John Raphael Smith, a competent painter himself, was one of the relatively few mezzotint engravers of this "golden age" (i.e., the last half of the eighteenth century and the first decades of the nineteenth) to create significant original designs. Perhaps the finest

465

465 John Simon (after J. Verelst). The Indian Chief Ho Nee Yeath Taw No Row. c. 1710. Mezzotint. New York Public Library, Astor, Lenox and Tilden Foundations (Prints Division)

466 Peter Pelham. Cotton Mather. 1727. Mezzotint, 11 7/8 × 9 3/4". Museum of Fine Arts, Boston

467 Richard Earlom. A Concert of Birds. 1778. Mezzotint. Brooklyn Museum, New York

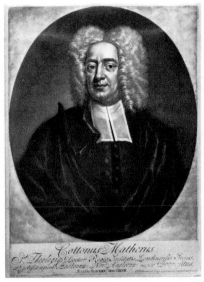

466

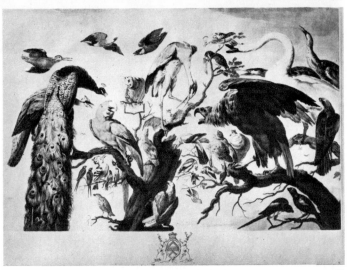

467

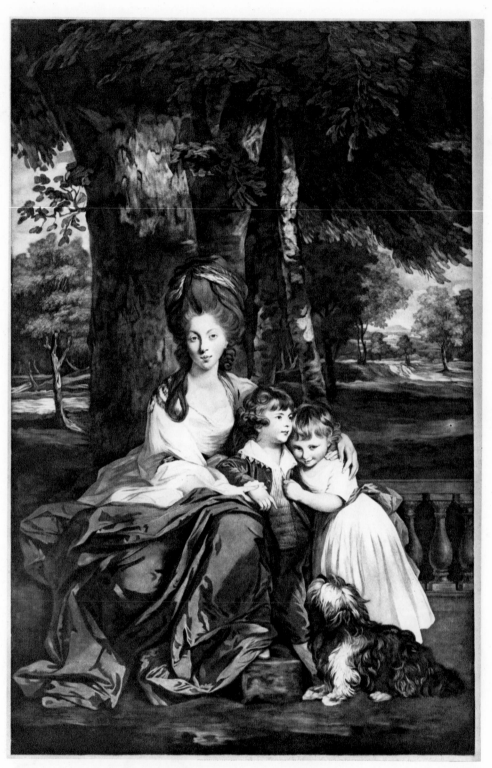

468

PLATE 469 technician was William Pether, who mezzotinted the spectacularly lit paintings of Joseph Wright of Derby. It can hardly be imagined that the mezzotint could reach a higher level of technical perfection than in Pether's work.

As before, artists mixed the technique with etching and engraved lines for accent. Color was at first added by hand. Jacob Christophe Le Blon first experimented with color printing from several plates. He used Newton's method of basic colors—blue, yellow, and red—to which he later added black for emphasis. He received royal patents for color mezzotinting in London in 1720 and later in Paris, but died bank-

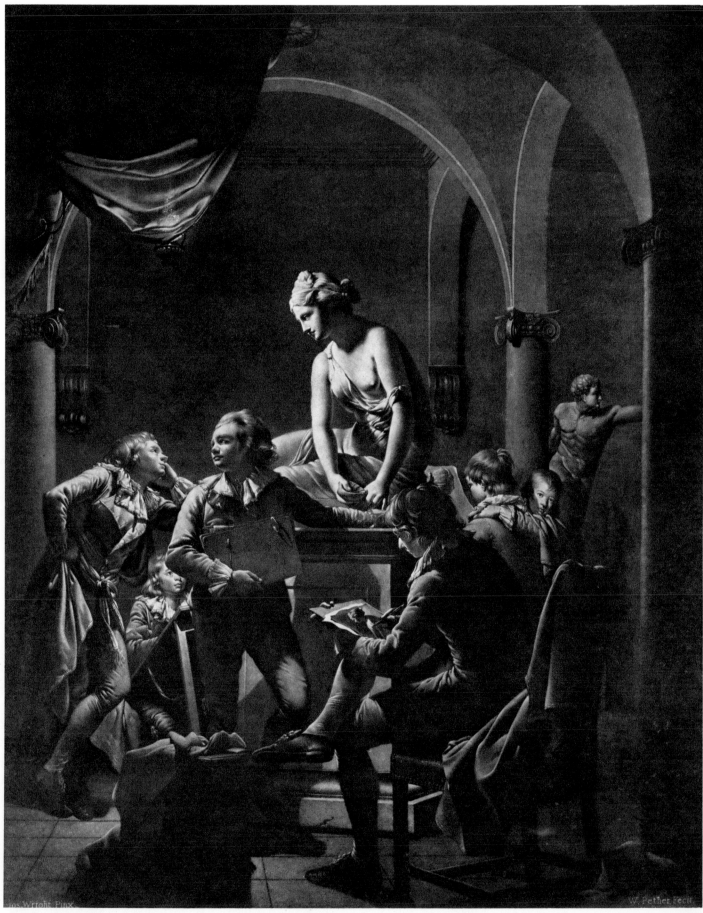

469

rupt. His studio was taken over by Gautier Dagoty, who claimed credit for the process and demonstrated it for Louis XV. "Five turns of the press," he is supposed to have said, "and six minutes later the picture emerges complete." A *Cours Complet d'Anatomie*, published in Paris in 1773, contains large color mezzotints by G. Dagoty II, which are masterpieces of almost Surrealist power.

A number of mezzotinters copied the work of J. M. W. Turner, in the *Liber Studiorum, The Harbours of England, The Rivers of England,* and numerous individual subjects. Among them were T. G. Lupton, W. Say, S. W. Reynolds, and Charles Turner, who is noted for his combination of aquatint with mezzotint. The painter himself used mezzotint in the ten plates he prepared for the *Liber Studiorum*.

The landscapes of Constable were brilliantly copied by David Lucas. Despite Constable's admiration of his efforts, Lucas's work never gained him commercial success. He died in 1881, embittered and the object of public charity.

Before the nineteenth century the mezzotint was very rarely used for book illustration. Those few volumes which appeared were very limited editions, often on subjects such as anatomy, which could appeal only to a narrow audience. One reason for this was the very rapid deterioration of the delicate burr of the copper plate. It has been estimated that no more than about fifty prints could be pulled successfully—although cheap second runs of up to several hundred were sometimes circulated, often after reworking of the plate.

It may have been William Say, in his small portrait of Queen Charlotte done in 1820, who first used a steel plate for mezzotinting. T. G. Lupton carried the experiment further, using a softer steel and making the regular production of editions of over a thousand possible. The increasing harshness of tone, as well as the general decline in quality of mezzotints after the 1820s to 30s, can perhaps be attributed in part to the use of the steel plate. There were fewer skilled engravers willing to put in the many days of wearing and ill-rewarded labor necessary to produce one plate.

The virtual demise of the technique can probably be traced to a number of causes, not least among them the advent of several new, inexpensive means of reproduction—lithography, wood engraving, and photomechanical processes.

In our own day the efforts of a dedicated and patient few have given the craft a modest rebirth, this time as a full-fledged creative medium. Rouault did some of his early prints in a mixture of mezzotint and etching. For such a plate as Picasso's *PLATE 470* *Blind Minotaur,* Vollard Suite 97, which has an aquatint ground, one might make a case for using the term "mezzotint," since the tools and methods used to achieve the gradations of whites and grays were most likely those employed in the mezzotint *PLATES 471, 472* process. More recently such artists as Reynold Weidenaar, Jozef Gielniak, Hamaguchi, Mario Avati, and Judith Foster have consistently devoted themselves to the revival of mezzotint.

Mezzotint: Technique

Structurally the mezzotint plate bears some resemblance to the drypoint in its use of tooth or burr brought up above the surface of the plate to hold ink.

The technique imposes a burden of hard work simply in the preparation of the plate. The hard steel grounding tool, called a "rocker," has a sickle-shaped convex edge ridged with many fine teeth. The size or fineness of a rocker is measured in teeth per inch, commonly from 50 to 100. The tool is rocked from side to side while

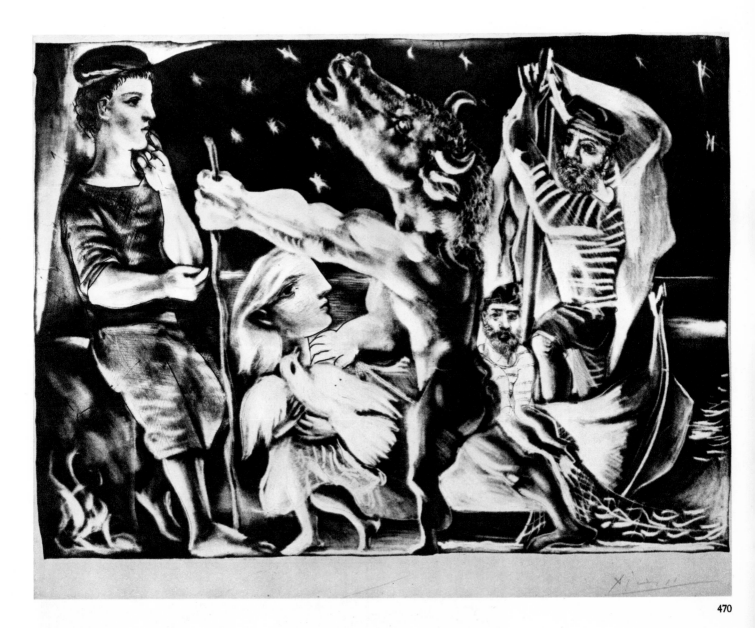

470

a gentle pressure is exerted to make it move slowly forward over the plate, starting from each of its four sides and then diagonally in each direction. This procedure is repeated over and over, until the tool has been rocked from fifty to a hundred or more ways. The fine teeth plow up the plate, each little burrow surrounded by a slight burr that will hold the ink. The properly rocked plate should be able to produce deeply black, velvety dark areas which can hardly be achieved by any other grounding method. A scraper will be used to flatten out the burr wherever half-tones are desired. For pure white areas the burnisher is used, leaving no rough spots to hold the ink.

The steel plates of the early nineteenth century, though resistant to wear, were quite difficult to work and often gave the prints a somewhat harsh appearance. The discovery of the process of steel facing has made it possible to cover the copper plate with a fine coating of steel. If this is carried out with sufficient care, the quality of the original tone will not be impaired.

Transferring the design can be a difficult process. It may be best to draw directly on the grounded plate with litho crayon. Scraping is then begun, slowly, deliber-

470 Pablo Picasso. The Blind Minotaur. 1935. Aquatint in mezzotint manner. Philadelphia Museum of Art (Louis E. Stern Collection)

471 *Jozef Gielniak. Untitled. 1968.*
 Mezzotint, 7 5/8 × 6 1/4". Collection
 Andrew Stasik, New York

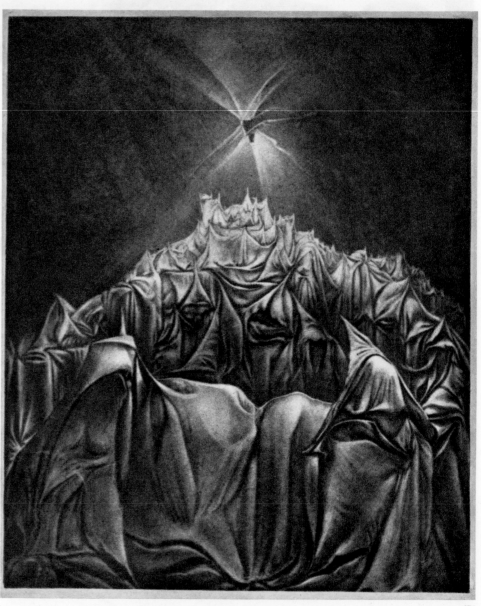

471

ately, and with an even gentle pressure. All tools used should be of the best quality and must be kept extremely sharp. The burnisher must be kept free from dust and highly polished. A variety of shapes and types of scraper may be used—the "willow-leaf," the sword-shaped type, the triangular, and so on.

PLATES 473, 474

Mixed techniques have long been used to give sharper edges and accents. Lines and stipple may be added with graver or etching needles. To give different shades of halftone, one may want to add aquatint or etched lines. Little spiked wheels called roulettes help to create grainy, crayon-like lines or can be used to reground very small areas where corrections are needed.

A variation of the traditional method is to etch or engrave the major line work of the design, rocking only those areas which are to print the rich, solid black and working from light to dark and dark to light simultaneously. Rubbing a bit of ink

into the plate as the work progresses aids in controlling the gradual development of tonal values.

Still another approach is to produce a finely bitten aquatint which would print solid black or to achieve an allover finely pitted surface by the use of soft-ground texture, wire-brushed hard ground, finely needled crosshatch on hard ground, or sandblasting the plate itself. An even simpler method is to grain the surface (as a litho stone is grained) with No. 80 Carborundum powder.

Composite mezzotint plates can be made by cementing fine-grain emery paper to a plate, Masonite, or cardboard, with the grain side up. Number 320 grit is a

472 *Judith Foster.* Benign and Hostile Forms. *c. 1962. Mezzotint and silkscreen, 12 3/4 × 9 3/4″. Collection the author*

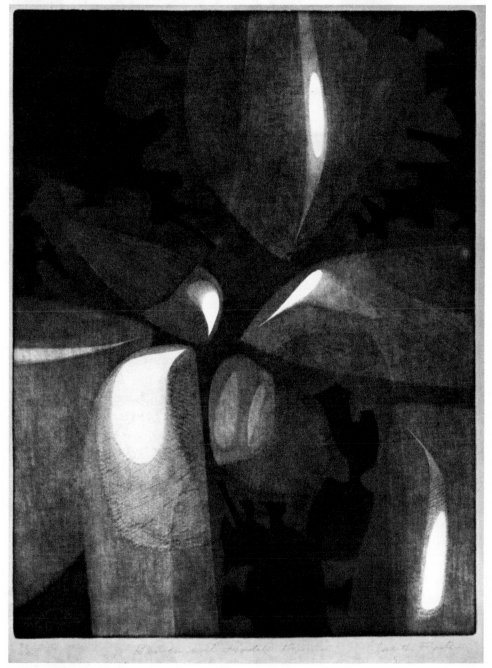

472

473

474

473 *Ernesto Fontecilla.* Last Sunday Evening.
 1970. Aquatint in mezzotint manner,
 9 × 9". Courtesy Pratt Graphics Center,
 New York

474 *Leonard Marchant.* Vivary. *1969.*
 Mezzotint, 13 3/8 × 10 3/4". FAR
 Gallery, New York

particularly good one; however, experimentation will determine which brand and grade is most suitable for the individual artist.

The light or white areas are "filled in" by painting them with several coats of a viscous paint such as polymer medium, lacquer, plastic steel, or plastic aluminum, model-airplane "cement," or any other tough medium which will dry hard and be impervious to the solvent action of printers' inks or mineral spirits.

The ink used must be heavy, yet amenable to hand-rubbing. It is worked well into the rough ground of the plate with a dabber or roller and then wiped, first with tarlatan, then with some smoother material—silk or nylon—and finally by hand. Care must be exercised throughout to avoid damaging the delicate surface texture of the plate. Printing is done on an etching press, under heavy pressure.

MARIO AVATI
Mezzotint Methods

COLORPLATE 53

Mezzotint is usually done on copper. The main tool is the rocker, made of very hard steel. When well sharpened, every point is ready to attack the copper plate.

The mezzotint process is made up of two separate operations. The first is the grounding, or preparation with the rocker. This consists of covering the copper with an incalculable number of tiny scooped-out depressions. Each depression with its accompanying burr will retain ink when the plate is being printed.

To get a good ground, the surface of the copper must be worked over entirely at least sixty times, but an artist who has the patience to do even more will be well rewarded. The finer the rocker (e.g., eighty to one hundred scored lines per inch), the larger the range of grays obtainable.

The first operation is not only a bore but also very hard on the nerves. It requires constant attention and physical effort for a repetitive movement which never quite becomes automatic. Anyone who is tempted to have his plates grounded by the village idiot, or even to hire an expensive assistant to do the job, will be disappointed with the results. It is only the artist himself who can get the quality and intensity of black that he needs for his own work.

The best solution, therefore, is to listen to music during the endless rocking of a plate. Although *Rock Around the Clock* would be the ideal theme song for the mezzotint artist, classical music rather than rock and roll is to be recommended for a sustained effort.

The second operation of mezzotint is the reward for the patient completion of the first, because it consists of engraving the chosen subject on the grounded copper. It's here that the magic quality of the medium becomes apparent. In other intaglio processes the artist starts with a light zone and creates shadows. In mezzotint he brings light out of darkness, creating whites and grays by crushing the rough-grounded surface of the plate to the necessary extent with the help of scrapers and burnishers.

During the engraving, the artist can reground sections of his plate with rockers of different finenesses, depending on the desired texture. To increase the intensity of the blacks, it is a good idea to go over pure black sections before the last state with a coarser rocker than the one originally used.

In the beginning, mezzotint was used mainly as a method of reproducing paintings. To speed up the output, grounding of the plates was mechanized and several models of rocking machines were developed in the eighteenth century. They did nothing to enhance the fine medium of mezzotint. On the contrary, the results of this mechanization were always mediocre, giving grayish blacks and an excessive lifeless regularity to the grounded surface.

A few decades ago, something rather better than rocking machines was available in Paris. It was mezzotint plates rocked by members of the *Garde Républicaine,* the presidential guard that any visitor to Paris has seen in full dress uniform, mounted on spirited horses, making their way through heavy traffic after an official ceremony. These guardsmen, so the story goes, padded out their pay during nights on duty by rocking mezzotint plates.

They now have either better pay or more pleasant ways of spending their idle hours. An enterprising mezzotint artist who was tired of rocking paid a visit to their barracks a few years ago with a pile of copper plates on his arm. He came out fast and indignantly reported that they thought he wanted to enlist. He has since turned to making lithographs.

Many experiments have been made with techniques not too far removed from mezzotint to achieve comparable results, while spending less time on preparation. These substitutes are sandblasting the copper plate, grounding it with aquatint, and covering it with a fine net of drypoint lines. But none of these experiments has been completely successful. Although there is no reason to condemn them, the final result is something quite different from mezzotint and the purity that makes it so compelling.

On the other hand, the combination of these related techniques with mezzotint can, in certain cases, give favorable results. This can be done in two ways: either by

superimposing one medium on the other, or by using them side by side to form different elements of the subject matter.

There is no special problem involved in printing a mezzotint plate, provided it has been properly grounded. The pressure of the press must be stronger than that used for other intaglio processes, and the blankets must be thick and of good quality so that the paper can absorb the stiff ink that has been deposited in the incisions of the plate.

Inking and wiping are done in the usual manner. Either an inking dabber or a roller can be used, although a little more oil should be added to the ink. As usual, the plate is wiped with tarlatan cloth, then with the palm of the hand. But in order to get pure whites, it is wise to go over it lightly with a silk cloth before a final hand wiping.

The proofs must be left hanging in the air to dry as long as possible. Then they are remoistened and put between two sheets of heavy cardboard and weighted down. The air-drying is done to harden the ink and make the prints less fragile; the fragility of mezzotint is its only weak point. Collectors must be warned to handle these prints even more carefully than any others, for the slightest scratch damages the print beyond repair. Unfortunately, the deep velvety surface easily attracts exploring fingers which inevitably leave a shiny streak across the velvet.

The best kind of paper for mezzotint is pure rag with a very light sizing. Printing on Japan paper usually does not yield good results if it is too absorbent, except for Hosho or similar quality Japanese paper. But it is possible to get good proofs on *chine collé*, or China paper applied to a sheet of ordinary pure rag.

Normally a mezzotint plate cannot yield more than twenty or so very good proofs. But steel-plating makes it possible to print a bigger edition. Here again, the fragility of mezzotint is a problem. The grounded copper plate is so delicate that the steel-plating by electrolysis must be carried out with special care. But this process is done by enterprises whose principal activity is the chrome-plating of faucets. It is very hard to explain to these specialists the difference between a faucet and a work of art.

Mezzotint is a medium fraught with technical difficulties and requiring patience, skill, and dedication. But for those willing to master it, it is a source of excitement and never-ending delight.

46

46 *Sergio Gonzales Tornero.* Peace on Earth.
 *1970. Color intaglio, 19 5/8 ×
 23 3/4". Courtesy the artist*
47 *Warrington Colescott.* Patrioticks. *1970.
 Color intaglio, 19 7/8 × 23 7/8",
 with progressive proofs 1, 2, and 5. Courtesy
 the artist*
48 *Michael Ponce de León.* Succubus. *1966.
 Cast-paper color intaglio, 26 × 26".
 Courtesy the artist*

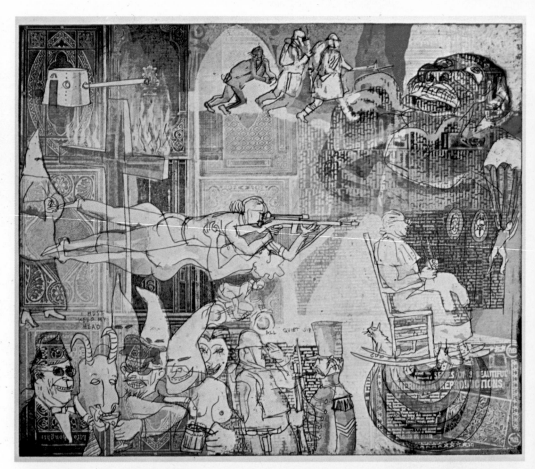

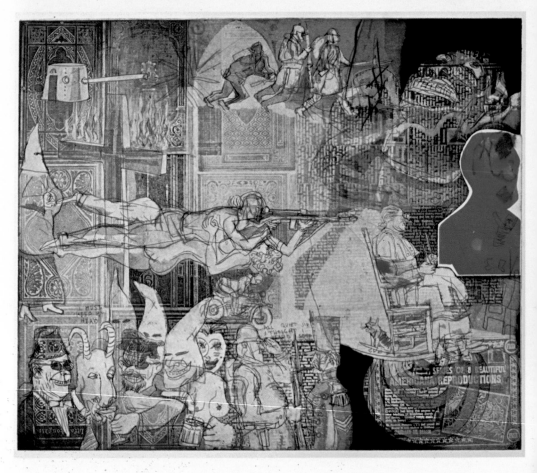

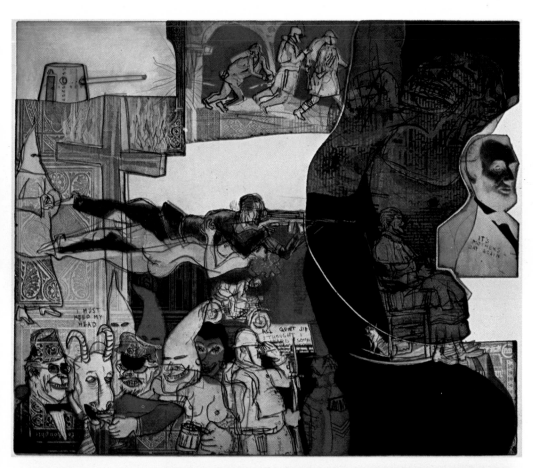

49 George A. Nama. Computer Landscape No. 6. *1970.*
Color intaglio, 19 1/2 × 16 5/8", with progressive
proofs 1, 2, and 4. Courtesy the artist
50 Bernard Childs. Tropical Noon. *1970. Color intaglio,*
6 7/8 × 6". Collection the author

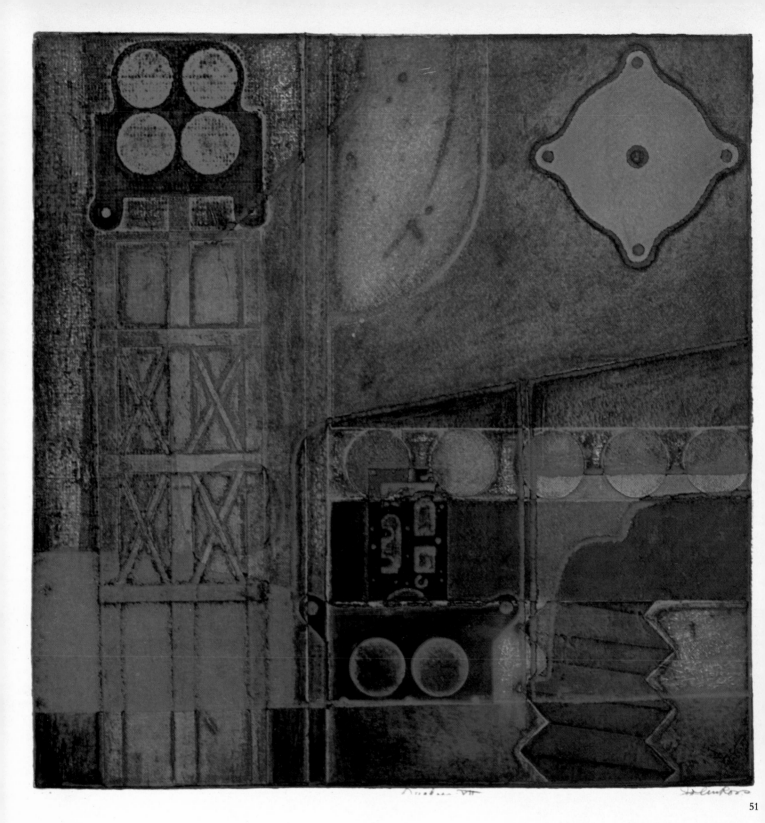

51 John Ross. Quadros XII. *1970. Color collograph, 20 1/2 × 20 1/2", with progressive proofs of first and second plates (opposite page). Courtesy the artist*

52 Clare Romano. Cape View II. *1970. Color collograph, 20 5/8 × 15 5/8", with progressive proofs 1 and 2 (dated 1968). Courtesy the artist*

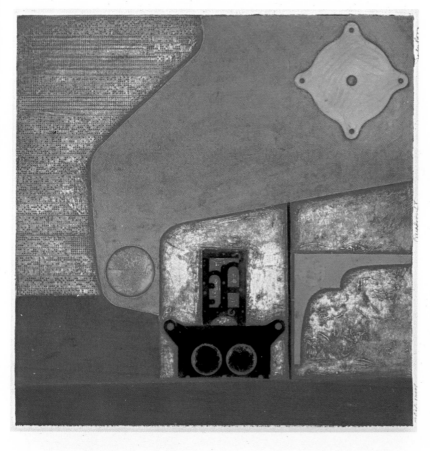

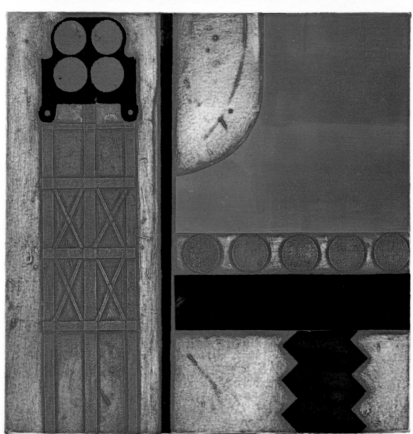

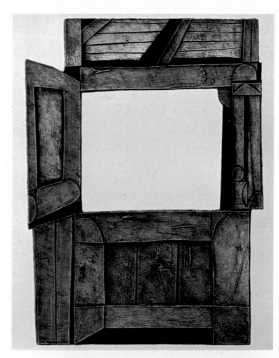

53 *Mario Avati*. Il est 3 heures, Madame. *1969.*
Color mezzotint, 9 1/2 × 12". Courtesy
Associated American Artists, New York

IV
THE
LITHOGRAPH

CHAPTER 13
LITHOGRAPHY

HISTORY

PLATE 475

Lithography, along with the mezzotint, is one of the few graphic media which can be traced to its origin with comparative certainty. Like most inventors Alois Senefelder went through years of agony and deprivations, but with tenacity and by trial and error he perfected a technique of "chemical printing" which has not changed substantially to this day.

There were some forerunners who had etched on stone before. The Bavarian priest and teacher Simon Schmid had found a description of stone etching in an old Nuremberg textbook. He experimented with wax on stone, producing images of plants, maps, and anatomical subjects, which he etched with aqua fortis and actually printed by hand in 1787–88, some ten years before Senefelder began his first explorations on stone.

Nevertheless, we accord full honors to Senefelder, whose revolutionary chemical process made possible fast and economical printing of quickly produced images. He also constructed, undaunted by many failures and lack of money and recognition, a workable printing press capable of turning out editions of accurate reproductions at very low cost. Senefelder's long search for a printing process was not motivated by artistic curiosity. Born in Prague in 1771, the son of an actor, interested in the theater and in music, he wrote a play at the age of eighteen and soon became obsessed with the idea of establishing his own print shop, mainly for the purpose of reproducing his plays inexpensively.

Always short of funds, he first experimented with etching his texts on steel and impressing the letters on a layer of sand, clay, flour, and coal dust. When this impression had fully hardened, he filled the letters with a mixture of warm sealing wax and gypsum.

In this laborious way he produced a printable type and came close to inventing the process of stereotyping. Without money to perfect the process, he had to look for cheaper materials. He tried using copper and zinc plates "requisitioned" from his mother, made his own ink from wax, soap, and lampblack, succeeded in etching the design in relief, and pulled some impressions on a borrowed copper-plate press. Regrinding these plates, however, presented endless difficulties. Then fate brought him together with a piece of limestone from the nearby quarry of Solnhofen (Bavaria). At first he treated the stone with the same inks and etching materials he had used on copper and zinc, with little more success.

It was an accident which turned his efforts in an entirely new and fruitful direction. One day in 1798 he was sitting with a freshly prepared stone before him when his mother asked him to write down a laundry list. Not having paper and pencil handy, he quickly wrote the list on the stone with his own home-made ink, intending to copy it off later on. Before washing it off, he became curious to see the effect of acid on the inked stone. He etched it for five minutes with a mixture of aqua fortis and ten parts water. Making several false starts at inking the stone, he began to wash off the ink with soap and water. He discovered that the untouched parts of the stone, which had remained damp, rejected the ink because of the natural antipathy of water and grease. The letters, which retained traces of the greasy ink, repelled water and attracted additional ink from the roller.

The first lithographic print was born, and Senefelder was on his way to fame, if not to fortune. But countless difficulties seemed to block his way. He could not afford to buy stones, paper, and tools. He also needed the materials to produce a

workable press and somehow had to obtain commissions to finance and publicize his venture. Failing in all these attempts, he tried to sell himself as a substitute for a conscript in the Bavarian artillery. This ended in failure too, when, as an alien he was rejected by the local authorities.

By a lucky chance he got his first commission from Franz Gleissner, a court musician whose compositions Senefelder copied on stone and printed in 120 copies on a home-made etching press. The job was done in two weeks, at a profit of seventy guilders.

The word of a new inexpensive printing process spread rapidly, and commissions poured in. The old copper-plate press was scrapped and replaced by a new one of his own design. But endless trouble arose; the wooden cylinders split and inexperienced pressmen did the rest. Two years of misery and poverty followed, until a press of a different principle, using pressure moving laterally across the stone, was developed.

Since Senefelder was concerned mostly with the reproduction of text pages and musical scores, drawing on the stone in reverse became a problem. He sought a transfer method which would enable him to transmit images to the stone without reversing. He took an ordinary printed page, dipped it in a thin gum solution, then sponged it with a light mixture of oil and paint, which stuck to the printed letters but left the rest of the paper untouched. By laying a sheet of clean paper over it and pulling both through the press he was able to obtain a clean offset image in reverse. In fact, he was able to pull more than fifty prints from the same sheet without the benefit of a printing plate. This could have led to what we now call offset printing, or to printing from paper plates. But his restless mind led him back to the Solnhofen stone, in which he had discovered the quality of absorbing grease as freely when dry as it rejected it when wet.

He took a freshly polished stone, wrote on it with a piece of soap, poured on a thin solution of gum arabic, and wiped it with a sponge dipped in black oil paint. After dipping the sponge in water and rewiping several times, he found that the black adhered to the written lines but was easily wiped off the wet areas. By wetting the stone after each printing he could pull as many impressions as he desired, especially after replacing the sponge with a more efficient leather roller stuffed with horsehair. He also found that by etching the stone with a light acid solution he could raise the letters to a slight relief, which rendered inking and printing much easier.

He finally arrived at the following method: He washed the stone lightly with soap and water, dried it, drew the design on it with wax ink, etched it with aqua fortis, and poured on a gum solution to make the stone more receptive to grease and absorbent of water. This process has been passed on almost intact to the present generation of lithographic artists and printers.

Senefelder continued to experiment. He could reverse his process by pouring oil over the stone instead of water and using a watercolor ink. Then the oily areas would reject the color, while the wet areas absorbed it. By combining the two methods on one stone, using various inks and solutions, he could use relief, intaglio, and planographic methods simultaneously. (In principle this complex process is similarly used today in metal intaglio by S. W. Hayter.)

After years of hardship, supported by his faithful friends the Gleissners, and hardly taking time out to eat and sleep, Senefelder was finally able to document and

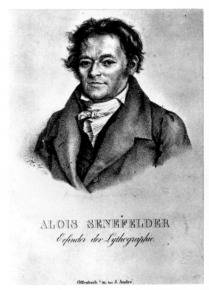

475

475 *Heinrich Ott.* Portrait of Alois Senefelder. *Early 19th century. Lithograph. Philadelphia Museum of Art*

deposit his invention in the British and Austrian patent offices. He also received a fifteen-year franchise from the Bavarian king, which at last gave him full protection in his own country.

Now the world became aware of Senefelder's work. The first bonanza was brought on by the visit of a wealthy music printer and publisher from Offenbach, Herr Johann André, who was much impressed by a demonstration which produced seventy-five printed sheets in a quarter of an hour—clean, fast, and economical. For the lordly sum of 2,000 guilders Senefelder was commissioned to set up a print shop in Offenbach and to train craftsmen in all manipulations of the process.

Next he succeeded in transferring a print from an etched copper plate to the stone and was able to get thousands of sharp impressions from this transfer method (later used again in France by Rodolphe Bresdin, Odilon Redon's teacher).

He established the fact that "chemical printing," as he called it, could be used on wood, metal, *and* paper. If the inks were treated properly, they could even be made to reject other inks through the addition of acids or alkaline solutions. Even wax, shellac, or rosin could be made to resist oil-based inks.

This again led the inventor to further experiments, which produced "stone paper," a substitute less costly and less fragile than stone. After trying various mixtures, he worked out a composition of clay, chalk, linseed oil, and metallic oxides which formed a stonelike coating on paper, linen, wood, metal, and other surfaces and proved more resistant than the actual litho stone. Years later the artist Géricault heard of this "stone paper" formula while on a visit to London and produced several successful pen lithographs in the medium.

A request for color printing made Senefelder think of a stencil method. Rollers, to which were attached felt, cloth, or leather pieces in the shape of the color areas, were inked and rolled over the stone. The shades of color could even be varied with the textures of the applicators. To the color roller was attached another one serving as an ink font. The font in turn was fed from a little feeder box containing ink and mounted atop the second roller, in much the same system, in miniature, as is used today on our big automatic printing presses.

The following ten years read like the Lamentations of Jeremiah, as Senefelder relates them in his *Lehrbuch,* published in 1818—a little too late for his own good. It is the story of a kindhearted and dedicated man, gullible and trusting, constantly betrayed by family and friends, utterly incapable of conducting business affairs, and at the mercy of countless imitators and greedy investors who were eager to exploit his invention for their own ends.

His odyssey took him first to London, then to Vienna, where he became involved in schemes of stone printing for the cotton industry, in squabbles with dealers and publishers over the reproduction of art work, and in unsuccessful attempts to establish lucrative music "printeries."

He continued, however, to pursue his experiments. He studied intensively the chemistry of color, perfected lithographic inks and acids, tried aquatint and crayon processes, printed color from several plates, and developed a process of etching directly into the stone and copper cylinders used in textile printing presses.

Meanwhile lithography gained in popularity and spread across Europe, without paying substantial dividends to its inventor. In 1809 Gottlob Heinrich von Rapp, a gifted Bavarian amateur, published *Das Geheimnis des Steindrucks . . . (The Secret of*

Lithography . . . , Tübingen), giving away the secrets of the invention to anyone for the price of the book.

Soon print shops were established all over Europe, in London, Paris, Vienna, Prague, Madrid, Barcelona, St. Petersburg, and Moscow. They also appeared in Senefelder's own backyard, in German states beyond Bavarian jurisdiction.

In 1809 a modest and belated recognition came to Senefelder when he was appointed director of the Royal Tax Commission's print shop in Munich "by his most gracious King Maximilian Joseph." This enabled him to dedicate himself again wholeheartedly to improvements in his invention. He sums up his achievements and aspirations at the end of Section I of the famous *Lehrbuch*.

The Lithograph as an Art Medium

PLATES 476–487

François Johannot, a cousin of Johann André, the Offenbach printer, is credited with having been the first to encourage artists in the use of the new medium for purely artistic purposes. Among those whose prints he published as early as 1801 in his

477

476 *Karl Schinkel.* Lovely Melancholy. *1810.*
 Pen lithograph. Philadelphia Museum
 of Art
477 *Joseph Hafner.* Angel. *1823. Lithograph,*
 10 3/4 × 8 1/4". Collection the author

PLATE 478

PLATE 479

PLATES 482, 486

Offenbach print shop was Wilhelm Reuter (1768–1834), a Prussian court painter of some talent. In 1804 Reuter published a portfolio of pen and crayon lithographs by "outstanding Berlin artists," including Schadow, Mitterer, Genelli, and others.

In England several well-known artists contributed to a series entitled *Specimens of Polyautography* published by Philipp André in 1803. Only two groups of six prints each appeared, although six groups were originally planned. The artists who contributed included the American expatriate Benjamin West, the Swiss Heinrich Füssli, and some thirty others, with "original drawings made on stone purposely for this work."

In France it was apparently Napoleon himself who early recognized the importance of the new medium. He probably acted on the advice of his new Director General of the Paris museums, Dominique Vivant Denon, himself not a bad artist and lithographer. Frédéric André, twenty-two-year-old brother of Johann, received a patent from the French government in 1802 for this *"nouvelle méthode de graver et imprimer."*

Now lithography was established as a fine arts medium, to reach its peak in France with the work of Toulouse-Lautrec nearly a century later. It seems amazing that these early and rather competent experiments in lithography were made more than fifteen years before the publication of Senefelder's textbook. Napoleon's officers frequently "invaded" German print shops and returned home with materials and technical details of the new invention, acting as "industrial spies."

In 1816 Godefroy Engelmann and Charles de Lasteyrie opened a lithographic print shop in Paris which attracted a number of prominent French artists, among them Carle and Horace Vernet, Baron Gros, Pierre Guérin, teacher of Géricault, and Auguste Raffet. Their reputations became established in the afterglow of the Napoleonic era, with prints full of heroic exploits romanticizing the *Grande armée* and its campaigns.

Achille Dévéria (1800–1857), who created more than three hundred lithographs,

478

479

478 *Benjamin West. This Is My Beloved Son. 1802. Pen lithograph, 12 5/8 × 8 3/4″. Library of Congress, Washington, D.C.*

479 *Dominique-Vivant Denon. Allegory of Time (with self-portraits). 1818. Lithograph. Museum of Fine Arts, Boston*

480 *Antoine-Philippe d'Orléans, Duc de Montpensier. Portrait of the Artist and His Brother. 1805. Lithograph. Museum of Fine Arts, Boston*

481 *Nicolas-Toussaint Charlet (1792–1845). "Je suis innocent!" dit le conscrit. Lithograph, 22 × 28″. Museum of Fine Arts, Boston*

480

481

482 *Horace Vernet.* Portrait of Carle Vernet.
*1818. Lithograph. Museum of Fine
Arts, Boston*

483 *Achille Dévèria.* Victor Hugo. *1828.
Lithograph, 6 3/4 × 5 1/4". Bibliothèque
Nationale, Paris*

484 *L. Berger.* Intérieur d'une Chambre
Militaire. *Early 19th century. Lithograph.
Philadelphia Museum of Art (Ars Medica
Collection)*

485 *Anonymous French.* Vue de l'Imprimerie
Lemercier, 7 rue de Seine, Paris. *c. 1845.
Lithotint. Philadelphia Museum of Art*

486 *Auguste Raffet.* Self-portrait. *1848.
Lithograph. Museum of Fine Arts, Boston*

482

483

484

later became Conservateur of the Cabinet des Estampes of the Bibliothèque Nationale, an appointment which shows the esteem artist-lithographers had attained. He portrayed many of his friends, Mérimée, A. Dumas, Walter Scott, Géricault, David, Constant, and others, and helped make the lithographic portrait popular.

PLATE 483

Lithography was dabbled in by noblemen and their ladies and promoted by kings and emperors. Louis Bonaparte, brother of Napoleon, drew the "Four Men of the Imperial Guard" on stone in a Munich workshop in 1805. Louis-François Lejeune, adjutant general to Marshal Berthier, and a painter in his own right, has left us a number of competent lithographs.

The European Masters

Géricault (1791–1824), at the urging of his friend Charlet, traveled to London in 1820 for the exhibition of his painting *The Raft of the Medusa,* which was creating a sensation. The prints of his English sojourn were concerned mainly with the London scene, from prize fights in Soho to the lower depths of the slums (*Great English Suite* —twelve lithographs). But, of course, Géricault achieved his greatest fame with battle scenes, full of spirited horses and gallant warriors, drawn in an accomplished crayon technique.

PLATES 488–565
PLATE 488

In a similar vein Eugène Delacroix (1798–1863) began to try his hand in the new medium with the lithographed studies of the Elgin marbles, done in 1825. The seventeen lithographs for Goethe's *Faust,* published only three years later, received the highest praise from the author himself. "Delacroix," he said, "has surpassed my

485

486

own imagination in scenes which I created myself; how much more will they come to life for the average reader and exceed *his* imagination." Although rejected by the French public, these lithographs in their technical perfection are considered a milestone in book illustration. In later years Delacroix illustrated many other important books with lithographs, among them *Hamlet* and works of Scott and Byron, but these prints never quite reached the dramatic impact of the *Faust*.

In 1819 José Maria Cardano founded the first lithographic workshop in Ma-

PLATE 490

487

488

487 *Joseph Odevaere*. Portrait of the Artist Drawing on Stone. *1816. Lithograph. Fogg Art Museum, Harvard University, Cambridge, Mass.*

488 *C. Hullmandel (after Théodore Géricault)*. Shipwreck of the Medusa. *1820. Pen lithograph, for the catalogue of the London exhibition. Bibliothèque Nationale, Paris*

489 *Eugène Isabey (1804–86; attrib.)*. Mont St. Michel. *Lithograph. Museum of Fine Arts, Boston*

490 *Eugène Delacroix*. Weislingen Attacked by Goetz's Followers. *1834. Lithograph. National Gallery of Art, Washington, D.C. (Rosenwald Collection)*

489

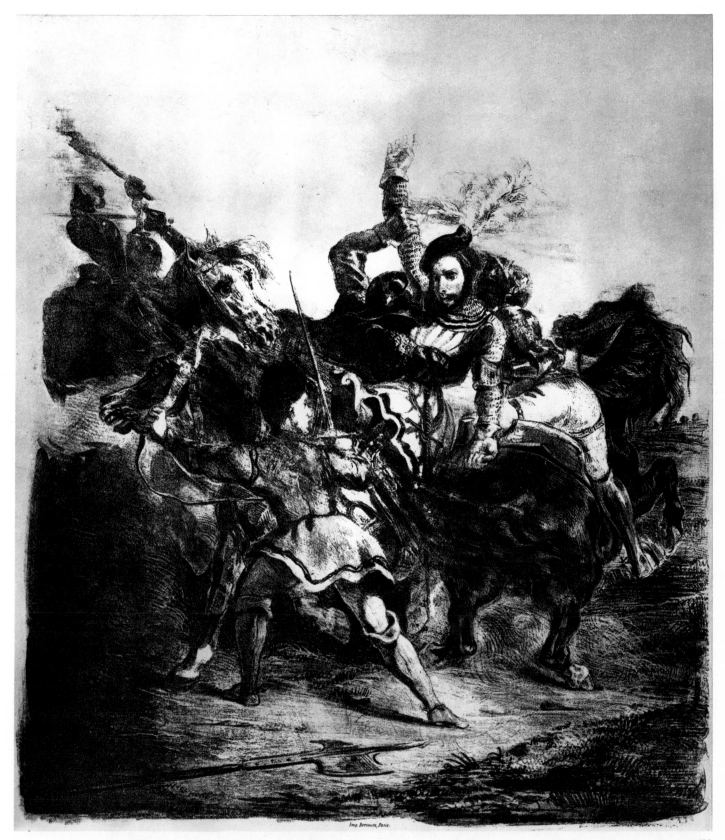

Imp. Bertauts, Paris.

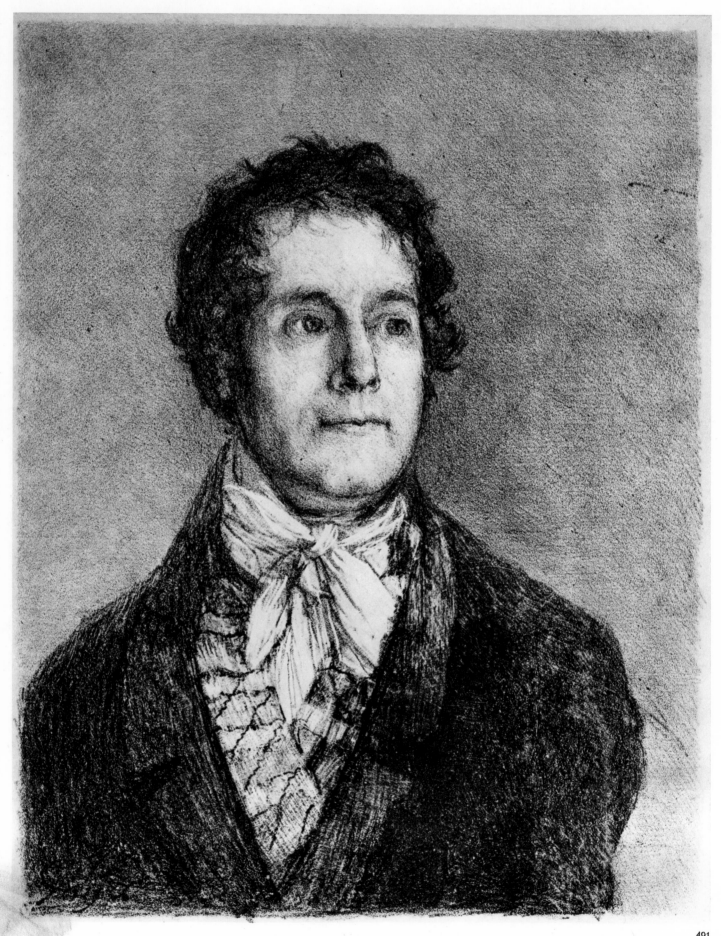

491 Francisco de Goya. Portrait of Cyprien-Charles-Marie-Nicolas Gaulon. *1825. Lithograph, 10 5/8 × 8 1/4". Davidson Art Center, Wesleyan University, Middletown, Conn.*

drid, followed by another one in Barcelona, through which Goya became familiar with the new technique. Senefelder's textbook had just been translated into English and French when Goya's first lithographs appeared, among them *The Monk, The Duel,* and *The Descent to Hell,* in very small editions and now extremely rare. His experiments were forcibly cut short by his exile to France in 1822. There, three years before his death, he created the four great lithographs *The Bulls of Bordeaux,* a high point of artistic and technical achievement in the history of graphics.

PLATES 491, 492

In 1808, in Marseilles, Honoré Daumier, another giant of the lithograph, was born. No other artist has achieved such fluency on the stone; no other has devoted himself so wholeheartedly to the lithograph as a vehicle for his concern with the burning issues of the day. An avalanche of four thousand lithographs issued from his workshop onto the pages of *Le Charivari* and *La Caricature,* and from there into thousands of homes all over France. The influence of this keen observer of public life was tremendous, and reaction in the high circles which he attacked was instantaneous. Daumier truly belongs to our age of protest, and many of his lithographs

PLATES 493–497, 499

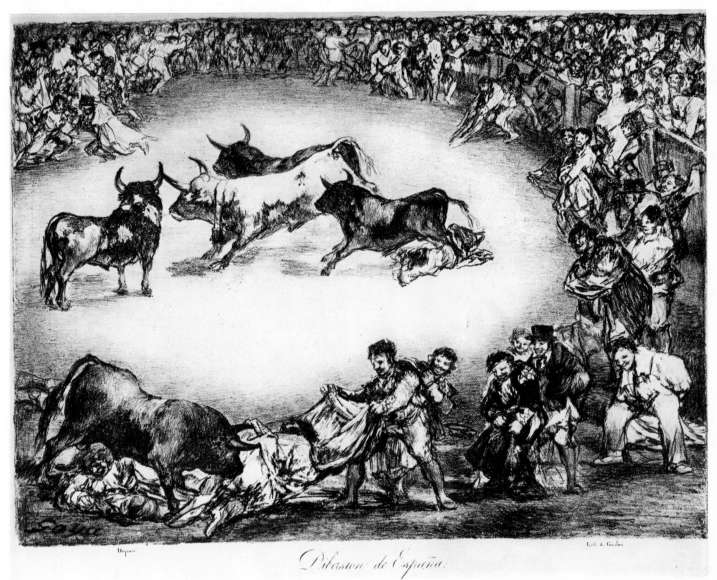

492 Francisco de Goya. Spanish Entertainment, *from* The Bulls of Bordeaux. *1825. Lithograph, 11 3/4 × 16 1/8". National Gallery of Art, Washington, D.C. (Rosenwald Collection)*

492

493 *Honoré Daumier*. A Literary Discussion in the Second Balcony. *1864. Lithograph, 7 3/4 × 7 1/8". Collection the author*

494 *Honoré Daumier*. Souvenir de Sainte-Pélagie *(with self-portrait). 1834. Lithograph. Museum of Fine Arts, Boston*

495 *Honoré Daumier*. Scène de Tribunal (Court Scene, or The Verdict). *c. 1830. Drawing, 13 13/16 × 16 1/2". National Gallery of Art, Washington, D.C. (Rosenwald Collection)*

496 *Honoré Daumier*. Lafayette Done For. *1834. Lithograph. National Gallery of Art, Washington, D.C. (Rosenwald Collection)*

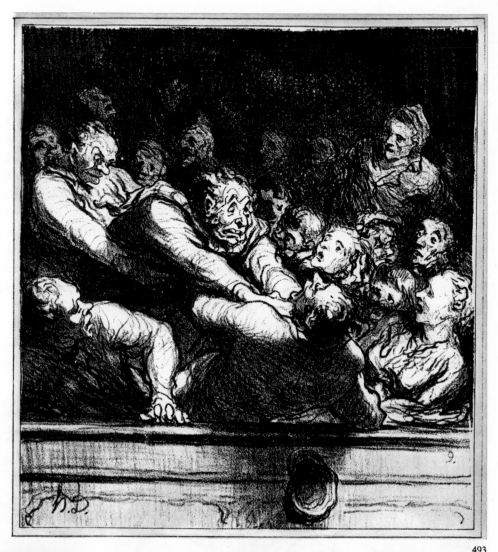

493

494

495

poignantly reflected France's social and political unrest, from the last days of Napoleon to the end of the Franco-Prussian War.

Charles Philipon, left-wing editor of the weekly *La Caricature* and the daily *Le Charivari,* shared the spotlight with Daumier, who worked closely with him from 1832 to 1872, with brief interruptions caused partly by Daumier's urge to paint and partly by a prison term for *lèse-majesté*. It was Philipon who was allegedly responsible for many of the biting captions which accompanied Daumier's prints. In a forty-year period the artist produced an average of one hundred lithographs a year, not to speak of countless drawings, paintings, and pieces of sculpture, until cataracts blurred his penetrating eyes in 1872. Death followed seven years later. His body was saved from a pauper's grave by the efforts of his old friend Corot.

COLORPLATE 54

Around Daumier worked a group of talented young artists, though perhaps none as daring and incisive as the master in the use of the print as a political weapon. There was the elegant Gavarni, worshiping feminine beauty; the prolific Grandville, camouflaging human frailties in animal skins and costumes; there was Monnier, lambasting the bourgeoisie and the politicians; and Pigal, Cham, and Traviès,

PLATES 500–502

497 *Honoré Daumier.* "Pardon Me, Sir, If I Disturb You a Little," *from* The Bluestockings. *1844. Lithograph. National Gallery of Art, Washington, D.C. (Rosenwald Collection)*

498 *Louis Dupré.* Louis-Philippe, Duc d'Orléans. *1830. Lithograph, 10 1/2 × 9". Collection the author*

499 *Anonymous (after Honoré Daumier).* La Poire. *1831–33. Wood engraving, 7 3/8 × 6 7/8". Collection the author*

500 *Paul Gavarni.* Avoir la Colique—le Jour de Ses Noces. *1838. Colored lithograph. Philadelphia Museum of Art (Ars Medica Collection)*

501 *Paul Gavarni (1804–66). Print from* Études d'Enfants. *Lithograph. Courtesy William H. Schab Gallery, New York*

497

498

499

producing a flood of pointed lithographs that inundated the country and strongly influenced political opinion.

It also occurred at the very beginning of Daumier's career that two other lithographers, Daguerre and Nièpce, made their first breakthrough into another chemical printing process, photography, through the use of lenses and by sensitizing glass or paper with silver nitrates. Nadar, Bayard, Talbot, and D. O. Hill share with them the honor of creating a process of reproducing documentary images inexpensively. Without their invention today's news media and instant mass communication could not function.

Photography, however, did not sidetrack many artists. Some became increasingly attracted by the hitherto unexplored possibilities of the lithographic stone, the textures of its surface, and its chemical reactions.

Manet, strongly influenced by Goya, created memorable prints of passion and violence, among them lithographs for E. A. Poe's "The Raven" and *La Barricade,* from *Scène de la commune de Paris*. To Degas the lithograph provided another medium to celebrate the female body. Odilon Redon, trained by Bresdin, who used pen on stone so masterfully, constantly explored new ways of reaching the deepest, richest blacks. Like no one else of his time he conjured out of the stone a "surrealist" dream world, full of mysterious symbolism.

In Fantin-Latour, Félicien Rops, Willette, Steinlen, Forain, and Maurice Denis,

PLATES 503, 504

PLATES 507, 508

PLATES 506, 509–511

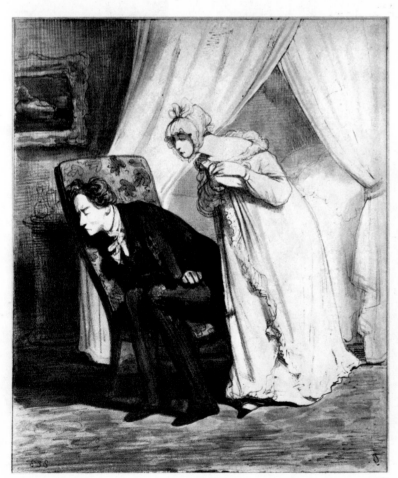

500

501

503

504

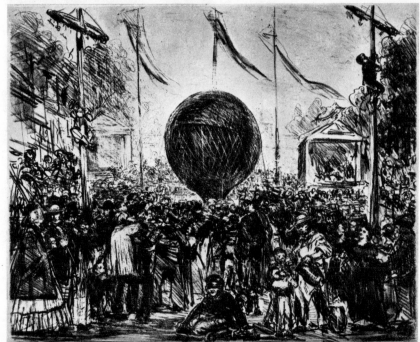

505

502

502 Paul Gavarni. Bal Masqué. *Lithograph. National Gallery of Art, Washington, D.C. (Rosenwald Collection)*

503 Anonymous (after Gustave Doré). *Illustration for E. A. Poe, "The Raven." 1884. Wood engraving, 8 7/8 × 13". New York Public Library, Astor, Lenox and Tilden Foundations (Prints Division)*

504 Édouard Manet (1832–83). *Illustration for E. A. Poe, "The Raven." 1875. Lithograph. New York Public Library, Astor, Lenox and Tilden Foundations (Prints Division)*

505 Édouard Manet. The Balloon. *Lithograph. Fogg Museum of Art, Harvard University, Cambridge, Mass.*

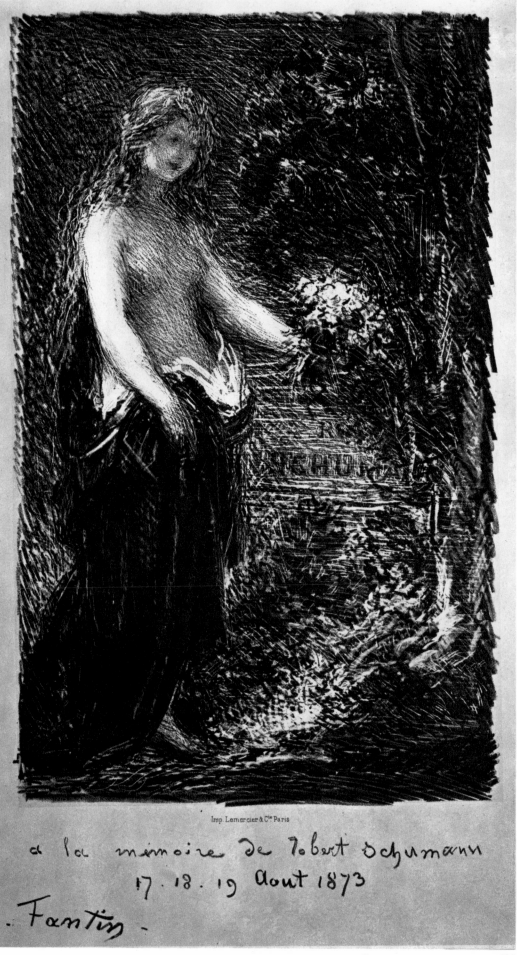

506 Henri Fantin-Latour.
À la Mémoire de
Robert Schumann.
1873. Lithograph
(scraping technique).
Museum of Fine Arts,
Boston

Imp. Lemercier & Cie Paris

à la mémoire de Robert Schumann
17. 18. 19 Aout 1873

. Fantin -

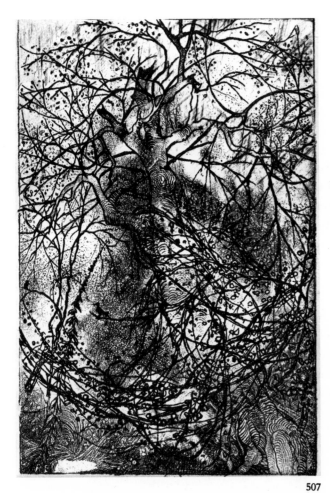

508

507 *Rodolphe Bresdin. Branchage. c. 1856. Lithograph, 4 1/8 × 2 3/4".*
 Bibliothèque Nationale, Paris

508 *Odilon Redon. "Je vis dessus le contour vaporeux d'une forme humaine," from*
 La Maison Hantée. 1896. Lithograph, c. 9 × 6 1/8". Courtesy William
 H. Schab Gallery, New York

509 *Félicien Rops (1833–98). Le Quatrième Verre du Cognac. Lithograph.*
 Collection Walter Bareiss, New York

510 *Maurice Denis. Ce Fut un Religieux Mystère. 1898. Color lithograph.*
 Brooklyn Museum, New York

507

509 510

competent artists and lithographers all, one can detect the beginning of a decadence in both technique and subject matter. They concerned themselves with sex, politics, and social injustice without ever reaching the grandeur of a Daumier.

As the turn of the century neared, Henri de Toulouse-Lautrec (1864–1901), a Bohemian aristocrat, crippled early in life, appeared on the scene in a burst of brilliance, wit, and vitality. He combined in his person many diverse and fascinating talents. His passion for the performing arts, his compassion for the dancers and singers and their satellites, the streetwalkers of Montmartre, whom he befriended, opened a beguiling world fashion. He created a new art form in its service—the poster, for which he found the most appropriate medium in the color lithograph, raising that medium to new heights. There is no difference of artistic quality between his paintings and his graphic works. His first color lithograph, *La Goulue at the Moulin Rouge,* appeared in 1891. There followed a series of inspired posters and prints in a medium he never abandoned until illness laid him low in 1895. Even at the sanatorium in Neuilly, one year before his death, he created one of his finest series—thirty-nine crayon drawings on the theme of the circus *(L'Âme du Cirque),* which, alas, he could never put on a litho stone. Three hundred seventy lithographs, countless drawings, book illustrations, pastels, and paintings give testimony to an intense and compassionate life, burned out in thirty-six years.

Ancourt's print shop, where Toulouse-Lautrec had worked for many years, was the ideal meeting ground for artists, craftsmen, and publishers, working together in harmony. During these same years Pierre Bonnard (1867–1947) reached the peak of perfection in his treatment of the color lithograph, with a gay and lyrical touch, undoubtedly influenced by the first invasion of Japanese prints. He, like his friend

COLORPLATE 55

PLATES 512–514

COLORPLATE 56

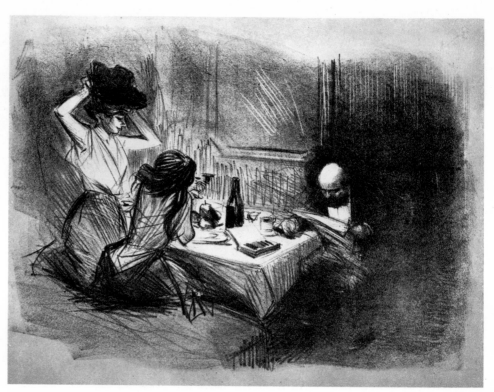

511 Jean-Louis Forain (1852–1931). The Private Salon. Lithograph. National Gallery of Art, Washington, D.C. (Rosenwald Collection)

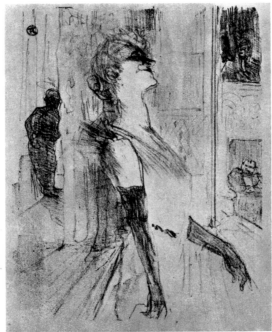

512

513

512 *Henri de Toulouse-Lautrec.
Yvette Guilbert (Sur la Scène).
1894–98. Lithograph. Fogg Art
Museum, Harvard University,
Cambridge, Mass.*

513 *Henri de Toulouse-Lautrec.
Miss Loïe Fuller. 1892. Color
lithograph with watercolor and gold
powder. Bibliothèque Nationale,
Paris*

514 *Henri de Toulouse-Lautrec (1864–
1901). Cléo de Merode.
Lithograph, 11 1/2 × 8 3/8".
Courtesy Associated American
Artists, New York*

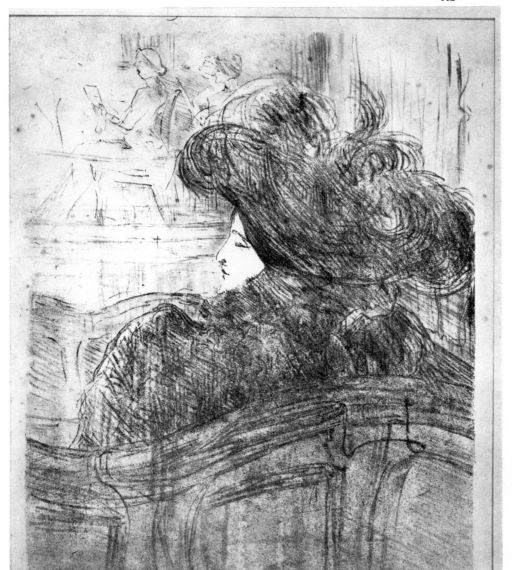

514

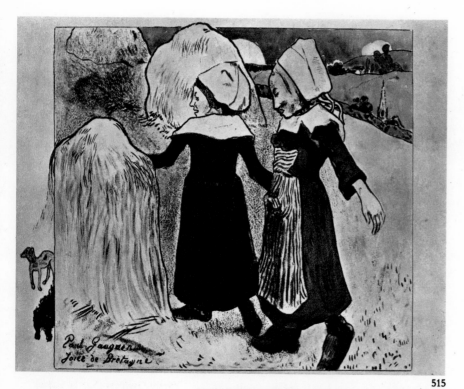

515

515 Paul Gauguin. Joys of
Brittany. *c. 1888. Lithograph.
Museum of Fine Arts, Boston*
516 Edgar Degas. Après le Bain.
*c. 1890. Lithograph, 9 1/8 ×
9 1/16". Museum of Fine
Arts, Boston*
517 Vincent van Gogh. The
Potato Eaters. *1885.
Lithograph, 8 1/2 × 12 3/8".
Museum of Modern Art,
New York (gift of Mr. and
Mrs. A. A. Rosen)*

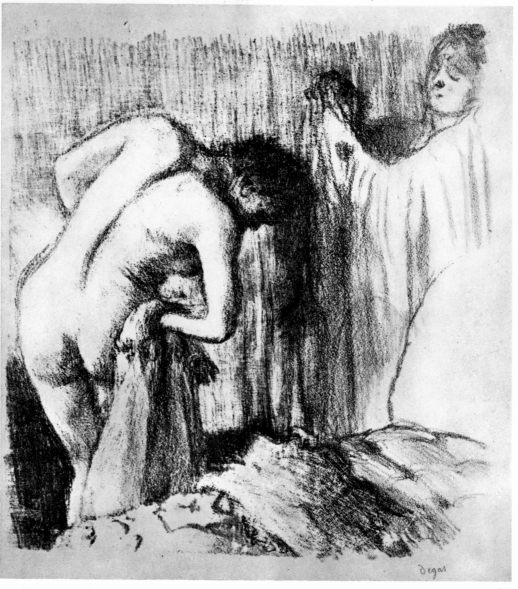

516

Edouard Vuillard (1868–1940), was interested in the poster, the book, and the little incidental graphics which grew out of an intimacy with a congenial medium.

 It seems quite evident that the knowledge and experience of the painter dealing with color and light is essential to the success of the printmaker. How much more exciting are the prints of the great painters who became interested in graphics as an extension and not as a reproduction of their paintings! Cézanne's, Gauguin's, and Renoir's few lithographs bear witness to that—especially if we contrast them with the work of Steinlen, Forain, and others, journalists of the stone.

 In Norway Edvard Munch created a vast body of prints, mostly inspired by his paintings. He experimented with woodcut, etching, and lithography, but it seems that it was the last which appealed to him most. He got his start in Paris at Auguste Clot's workshop, where he met Bonnard and Vuillard; but his moody, Nordic style is distinctly his own.

 Among the lesser lights of the nineteenth century who worked on stone were Eugène Carrière in France and Adolf von Menzel in Germany, who experimented with a kind of mezzotint-lithograph, *à la manière noire*. The stone was covered with tusche and the high lights scraped and scratched out of the dark surface.

 Though the Russian tradition in graphics has always favored the woodcut and

COLORPLATE 57

PLATES 515–520
COLORPLATE 58

PLATES 521, 523

PLATES 522, 524

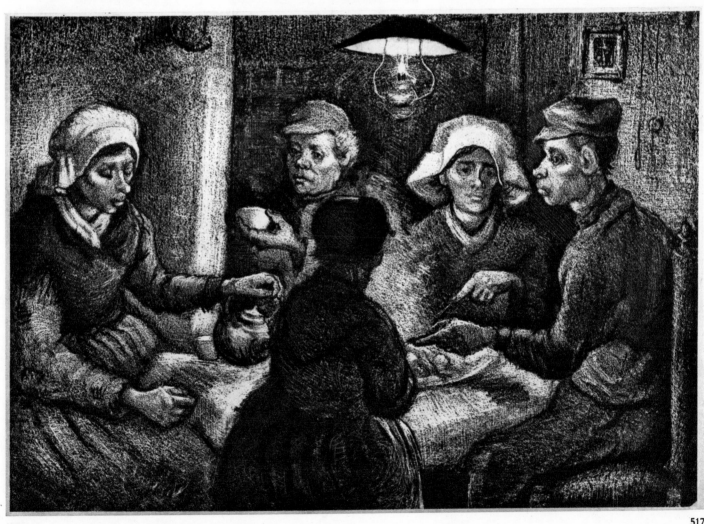

517

518 *Auguste Renoir.* Portrait of Cézanne. *1902. Lithograph, c. 6 1/8 × 4 7/8". Courtesy William H. Schab Gallery, New York*

519 *Camille Pissarro.* Paul Cézanne. *1874. Etching. Philadelphia Museum of Art (Louis E. Stern Collection)*

520 *Paul Cézanne.* Self-portrait. *c. 1890–94. Lithograph. Fogg Art Museum, Harvard University, Cambridge, Mass.*

521 *Edvard Munch.* Title page of La Critique. *1896. Lithograph. Brooklyn Museum, New York*

518

519

520

521

wood engraving, lithography must be considered a strong second. Largely inspired by the lithographs of Daumier and Gavarni, a group of creditable satirists, led by P. M. Boklevski and A. I. Lebedev, portrayed the turbulent Russia of the 1860s in historically interesting prints.

The post-revolutionary generation followed rather closely this narrative vein, as may be seen in the competent lithographs of B. M. Kustodijev and A. N. Samochvalov. The best work, perhaps, was produced in children's books by Tsharushin and V. Lebedev in the 1920s. The Experimental Graphic Workshop, set up in Leningrad under A. L. Kaplan, was chiefly responsible for a revival of interest in lithography. The work was competent but actually far from experimental.

Far more exciting for Western taste were the earlier graphics of the Constructivists, a bold, inspired group whose movement started shortly before the Revolution and, unfortunately, ended shortly after it, being too intellectual and iconoclastic for the party bosses. Their work has lost none of its sparkle and inventiveness. Finest among those working experimentally on the stone were Archipenko, Jawlenski, Larionov, and Gontcharova, but the truly pioneering works were Kandinsky's *Kleine Welten* and El Lissitzky's portfolio *Victory over the Sun* (1923).

Perhaps the commercialization of lithography as a means of producing cheap

COLORPLATE 59

522 *Adolph von Menzel.* Brush and Scraper. *1851. Lithograph. Staatliche Graphische Sammlung, Munich*

523 *Edvard Munch.* Bear and Omega. *1909. Lithograph, 10 × 8 1/2". Courtesy Associated American Artists, New York*

524 *Eugène Carrière.* Sleep. *1897. Lithograph (scraping technique). Philadelphia Museum of Art*

PLATES 525, 526

522

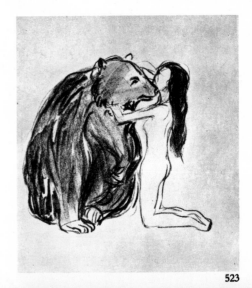

523

524

posters, wine and cigar labels, barroom decorations, postcards, and calendars, mostly done in chromolithography, caused its decline as a creative medium. It was to be brought to life again with the birth of German Expressionism and with Ambroise Vollard, an inspiring example for enterprising publishers and artists everywhere. He initiated in Paris his superb and daring publishing venture, which, in thirty years, encompassed all the important artists of his time. With them he created great books and portfolios of an artistic and technical quality never reached before and hardly ever achieved thereafter.

In Germany such publishers as Kurt Wolff and Bruno Cassirer gave impetus to a new interest in prints as a medium for artists. Beginning with Max Liebermann at the turn of the century, the lithographic stone became a source of inspiration to such artists as Lovis Corinth, Max Beckmann, Ernst Barlach, Käthe Kollwitz, and Oskar

PLATES 527–530

525 *El Lissitzky*. Foam Machinery, *Plate 1 from* Electro–Mechanical Spectacle. *1923. Color lithograph. Brooklyn Museum, New York*

526 *Alexander Archipenko*. Two Nudes. *1921. Lithograph, 19 3/4 × 13 3/8″. Courtesy Mrs. Frances Archipenko, New York*

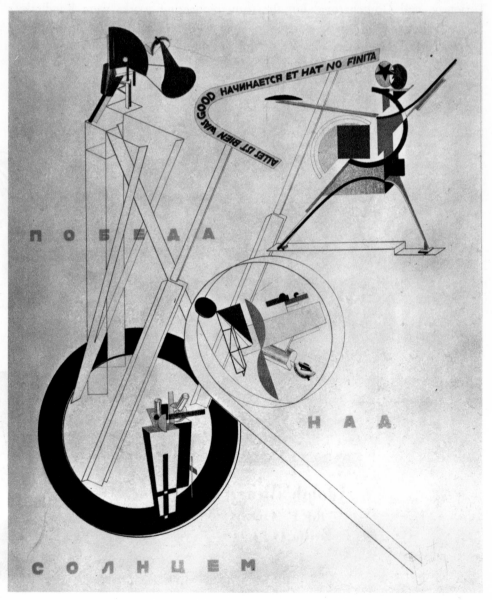

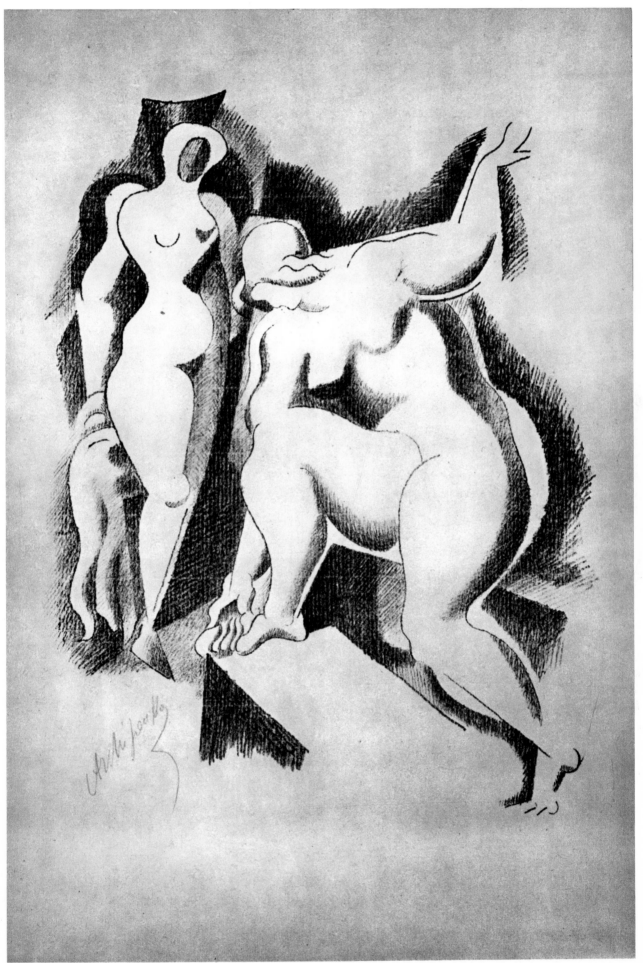

527

528

*527 Käthe Kollwitz. Self-portrait. 1938. Lithograph, 18 3/4 ×
11 1/4". National Gallery of Art, Washington, D.C.
(Rosenwald Collection)*

*528 Käthe Kollwitz. Self-portrait—Left Profile. 1898. Lithograph,
5 7/8 × 5 7/8". Museum of Fine Arts, Boston*

*529 Käthe Kollwitz. Self-portrait. 1924. Woodcut, 5 7/8 ×
4 3/8". National Gallery of Art, Washington, D.C.
(Rosenwald Collection)*

*530 Käthe Kollwitz. Self-portrait. 1934. Lithograph. Museum of
Fine Arts, Boston (Helen and Alice Colburn Fund)*

529

65/80

531

532

533

534

535

536 *Lovis Corinth.* Karl Liebknecht *(from a death mask). c. 1919. Lithograph. National Gallery of Art, Washington, D.C. (Rosenwald Collection)*

537 *Emil Nolde.* Tingel–Tangel III. *1907. Color lithograph, 12 3/4 × 19 1/16". Philadelphia Museum of Art*

538 *Otto Müller (1874–1930).* Three Nudes, Two Lying in the Grass. *Lithograph. Philadelphia Museum of Art*

539 *Erich Heckel.* Acrobat. *1916. Lithograph, 11 × 8". Courtesy Associated American Artists, New York*

537

539

538

541

540

540 *Kurt Schwitters (1887–1948)*. Abstraction. *Lithograph. Philadelphia Museum of Art*
541 *Paul Klee*. A Man in Love. *1923. Color lithograph. Philadelphia Museum of Art (Carl Zigrosser Collection)*
542 *Josef Albers*. Self-portrait. *c. 1918. Lithograph, 18 1/8 × 12 3/4". Library of Congress, Washington, D.C.*
543 *George Grosz*. Self-portrait for Charlie Chaplin. *1919. Lithograph, 19 1/2 × 13 1/8". Philadelphia Museum of Art (Carl Zigrosser Collection)*
544 *George Grosz*. Storm Clouds, Cape Cod. *1949. Lithograph, 8 3/4 × 13". Courtesy Associated American Artists, New York*

542

543

544

545 546

Kokoschka. Then the artists of Die Brücke, founded in 1905, made the print again a popular art form, avidly published and collected. Schmidt-Rottluff, Otto Müller, Kirchner, and Heckel took up lithography two years later, never to relinquish it.

Many of these artists preferred to work on lithographic transfer paper, which could be handled like a page in a sketchbook, without bothering with the reversal of the image. The crayon and tusche, however, lose in the transfer; unless they are worked over on the stone, they often appear gray and flat.

Lithography has been recognized as an ideal medium for the painter, because it allows great freedom in "painting on stone," and it provides a receptive surface with an infinite variety of tonal values through the use of washes, crayon and tusche, rubbing inks, acids, and scraping tools. Lithography is now firmly established in all the art centers of the world. The master printer has become part of an honorable tradition carried over from the early nineteenth century. Perpetuated in the Paris workshops of Fernand Mourlot, Desjobert, and others, this tradition has been transplanted to other countries as the popularity of the medium skyrockets.

Lithography in America

Lithography came to the New World probably in 1818, when Bass Otis, a portrait

545 Henri Matisse (1869–1954). Le Boa Blanc. *Lithograph. Fogg Art Museum, Harvard University, Cambridge, Mass.*

546 Henri Matisse. Arabesque. *Lithograph. Brooklyn Museum, New York*

547 Pablo Picasso. Portrait of Kahnweiler. *1957. Lithograph. Fogg Art Museum, Harvard University, Cambridge, Mass.*

548 Pablo Picasso. The Dancers. *1954. Lithograph. Fogg Art Museum, Harvard University, Cambridge, Mass.*

547

548

549

550

549 Pablo Picasso (after Victor Orsel).
L'Italienne. 1953. Modified
photolitho plate, 17 1/2 × 13 7/8".
Collection Alexander Dobkin, New York

550 Alberto Giacometti (1901–66). Two
Nudes, from Derrière le Miroir,
Maeght, Paris. Lithograph. Brooklyn
Museum, New York

551 Pablo Picasso. Study of Profiles.
1948. Lithograph, 28 7/8 × 21 5/8".
Museum of Modern Art, New York
(Louise R. Smith Fund)

553

552 Jules Pascin (1885–1930). Le Lever. Lithograph, 10 × 7 1/2". Courtesy Associated American Artists, New York
553 Salvador Dali. Portrait of Dante. c. 1966. Lithograph, 27 1/2 × 21 1/4". Courtesy Associated American Artists, New York

552

556

557

558

554

*554 José Orozco. Rear Guard. 1929. Lithograph. Philadelphia
 Museum of Art*

*555 David Siqueiros. Peace. 1947. Lithograph, 11 3/4 × 9".
 Courtesy Associated American Artists, New York*

*556–561 Jean Dubuffet. Figure in Red. 1961. Color
 lithograph, 26 × 20". Museum of Modern Art,
 New York (gift of Mr. and Mrs. Ralph F. Colin)*

556 Progressive proof of first five colors

557 Proof of sixth color

558 Proof of seventh color

559 Progressive proof of first seven colors

560 Proof of eighth color

561 Final print

555

559

560

561

562

563

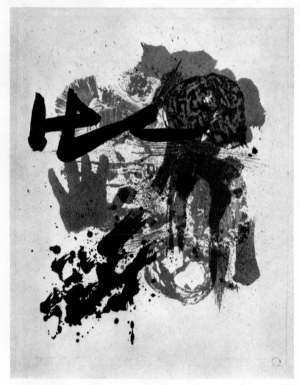

564

565

562 *Maurits Cornelis Escher.* Drawing Hands.
 1948. Lithograph. National Gallery of Art,
 Washington, D.C. (Rosenwald Collection)

563 *José Luis Cuevas.* Lo Feo de Este Mundo
 III. *Lithograph, 21 1/4 × 27 1/8".*
 Courtesy Pratt Graphics Center, New York

564 *Chizuko Yoshida.* Impression from India.
 1960. Color lithograph. Courtesy Pratt
 Graphics Center, New York

565 *Maurits Cornelis Escher.* Hand with
 Reflecting Globe *(self-portrait). 1935.*
 Lithograph. National Gallery of Art,
 Washington, D.C. (Rosenwald
 Collection)

566 *Rembrandt Peale. George Washington. 1827. Lithograph. Philadelphia Museum of Art*

567 *Bass Otis. Landscape. 1819. Lithograph. Philadelphia Museum of Art*

568 *William H. Brown (1808–83). Daniel Webster, from the series Portrait Gallery of Distinguished American Citizens. Lithograph. Brooklyn Museum, New York*

566

567

568

painter from Philadelphia and pupil of Gilbert Stuart, began to experiment with the new medium. His illustrations for the *Analectic Magazine,* done in the manner of a copperplate, are probably the first lithographs done on American soil. The first book so illustrated was Smith's *Grammar of Botany,* published by James V. Seaman, New York, 1822, and printed by the first lithographic print shop in New York, Barnet and Dolittle.

Rembrandt Peale, well-known portrait painter, commemorated the Father of His Country on stone, for which he won a medal from the Franklin Institute in

PLATE 567

PLATE 566

569 Thomas Moran (1837–1926). Forest Landscape. Lithograph. Museum of Fine Arts, Boston
570 William Rimmer (1825–74). Odalisque. Lithograph. Museum of Fine Arts, Boston

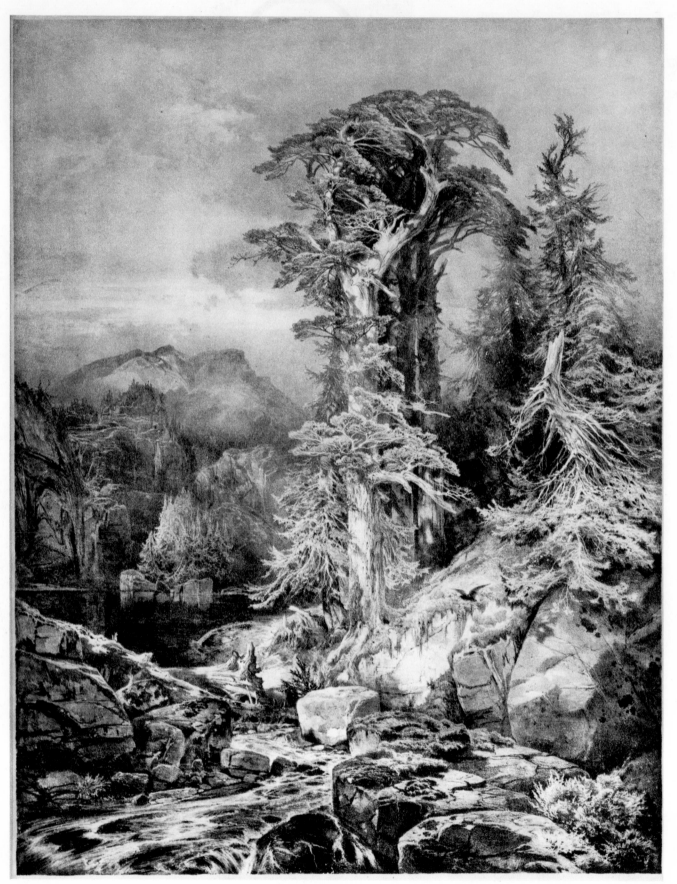

569

Philadelphia in 1827. This lithograph was printed by the pioneers of the new medium, the brothers Pendleton, at 9 Wall St., New York.

It was John Pendleton who had brought over from France a ton of lithographic stones, transfer paper, ink, and crayons. More important, he imported a French artist and pressman, thus enabling him to open a print shop in Boston in 1825. He was also instrumental in interesting other enterprising men, such as Kearny and Childs in Philadelphia, Peter Maverick of New York, and a French artist and former naval officer, Anthony Imbert, in the new medium. A few years later John Pendleton sold out to Nathaniel Currier, a former apprentice at the Boston print shop. This was

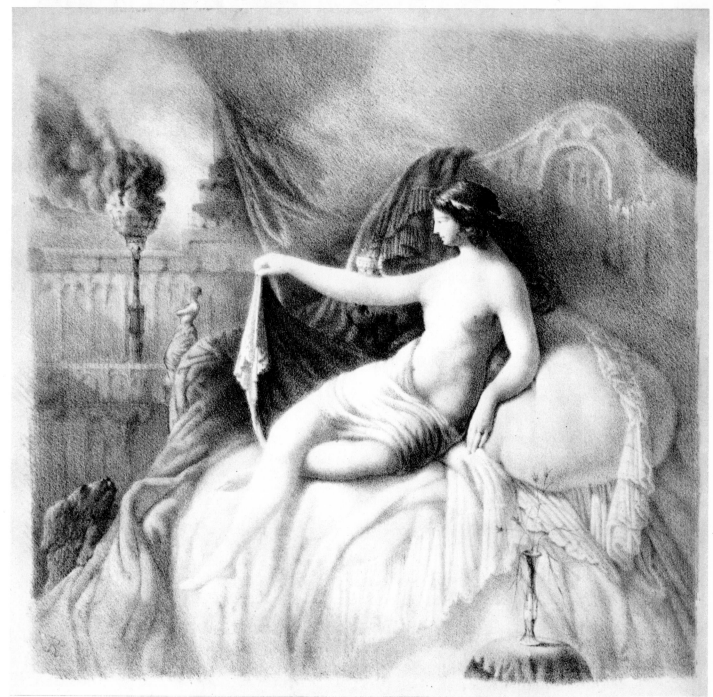

571

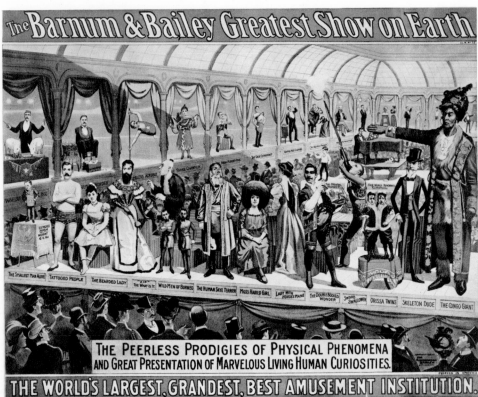

572

573

the beginning of the famous firm later known as Currier & Ives. Currier started his business in 1834 in Boston but moved to New York two years later. James Merritt Ives joined the firm as an accountant and artist in 1852 and became a partner in 1857. The famous establishment lasted until Nathaniel Currier's son sold out in 1907, after photography had dealt the final blow to documentary lithography.

It was not so much the artistic quality of Currier & Ives's lithographs as the fact that they recorded mid-nineteenth-century American life with such flamboyance and in such loving detail that made them documents of continuing historical interest. They depicted nearly every aspect of the American scene—famous views, great disasters, pioneer life, Indian fights and buffalo hunts, political events and cartoons, portraits of celebrities, historic episodes, homely domestic scenes, sentimental, humorous, and patriotic subjects, popular riverboats, trains and racehorses, and sporting events. It is estimated that the Currier & Ives output may have totaled seven to eight thousand prints. The smaller ones sold for six cents wholesale, with larger prints and folios priced from fifteen cents to three dollars. Mr. Currier and Mr. Ives had found the lucrative secret of appealing mostly to a wider middle-class audience. Prints were sold on the streets of New York by hawkers and from pushcarts, but eminent customers, such as the Prince of Wales or P. T. Barnum, were also accommodated at the popular Nassau St. shop.

A group of artists, often selected for their special gifts for portraying particular subject matter, was employed at very low rates, and no royalties were paid. But then ten dollars may have been a handsome sum in those days for the outright purchase of a plate.

Lithography in America remained popular to some extent even after the decline of Currier & Ives, mainly in the form of posters on billboards and as political cartoons in magazines such as *Puck* and *Harper's* and *Leslie's* weeklies.

When photoengraving began to make its inroads as a quicker and more faithful

COLORPLATE 64

PLATES 572–574

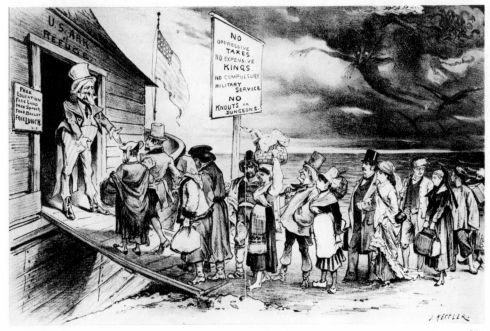

571 *Winslow Homer (1836–1910).* The Letter from Home. *Lithograph. Philadelphia Museum of Art*

572 *Anonymous American.* Poster for Barnum & Bailey circus. *Late 19th century. Color lithograph. Library of Congress, Washington, D.C.*

573 *Anonymous American.* Bird's-eye View of the Great New York and Brooklyn Bridge and Grand Display of Fireworks on Opening Night. *1883. Lithograph. Brooklyn Museum, New York*

574 *Joseph J. Keppler (1838–94).* Welcome to All!, *from Puck. Lithograph. New York Public Library, Astor, Lenox and Tilden Foundations*

PLATES 569, 571, 578

method of reproduction about the turn of the century, lithography was kept alive as an art medium by some well-traveled and well-known artists, including Whistler and Joseph Pennell. Marsden Hartley and Max Weber followed suit, but the artists of the so-called "Ash Can School" of social comment, John Sloan, Everett Shinn, George Luks, and others around them, seemed to prefer the more incisive etching.

PLATE 579

PLATES 576, 577
PLATES 580, 581

Nevertheless, powerful shadows of Daumier's work reached across the decades. George Bellows led another generation of *engagé* artists with a series of powerful lithographs (ably printed by George Miller); William Gropper, Hugo Gellert, and others on the left took up the political cudgel; Raphael Soyer covered the sweatshops of the garment district; Reginald Marsh, the Bowery; Ben Shahn, the militant labor unions (he had served as a lithographic apprentice in his younger days).

PLATE 583

Adolf Dehn devoted his whole life to exploring his favorite medium, lithography, in which he recorded his travels around the world.

PLATE 582

During the Depression the Federal Art Project saw Stuart Davis, Louis Schanker, Yasuo Kuniyoshi, Louis Lozowick, and others lifting the lithograph to a more prom-

575 *Robert Riggs.* Psychopathic Ward. *1945. Lithograph. Philadelphia Museum of Art (Ars Medica Collection)*

576 *Raphael Soyer.* The Mission. *1933. Lithograph, 12 1/8 × 17 5/8". Philadelphia Museum of Art (Carl Zigrosser Collection)*

577 *Raphael Soyer.* Self-portrait. *1933. Lithograph, 13 1/4 × 9 3/4". Yale University Art Gallery, New Haven, Conn. (gift of Mrs. Laurent Oppenheim)*

578 *James A. McNeill Whistler.* The Thames. *1898. Lithograph, 10 1/2 × 7 5/8". Philadelphia Museum of Art*

579 *George Bellows (1882–1925).* Hungry Dogs. *1916. Lithograph. National Gallery of Art, Washington, D.C. (Rosenwald Collection)*

576

577

578

579

580

PLATES 584, 585, 588

PLATE 586

COLORPLATE 65

PLATES 587, 592

inent place in the graphic arts. The trio of regional artists, Thomas Hart Benton, Grant Wood, and John Steuart Curry favored lithography for their rustic revival of homespun scenes of Middle America. The medium had become respectable. Charles Sheeler used it in his austere portraits of the industrial and urban landscape, as Stow Wengenroth celebrated bucolic New England.

Artists such as Rico Lebrun, Ivan Albright, Emil Weddige, and Benton Spruance greatly contributed to the resurrection of the medium as well. Today it has found its rightful place again through the evangelistic zeal of such devotees as June Wayne of the Tamarind Workshop and Tatyana Grosman of Universal Limited Art Editions. The most prominent artists of today, from Vasarely to Oldenburg, have been initiated into the mysteries of the stone or plate with often impressive results.

581

582

580 Reginald Marsh. Bowery. 1928.
Lithograph, 8 1/4 × 11 3/4". Yale
University Art Gallery, New Haven, Conn.
(gift of the artist)

581 Ben Shahn. Years of Dust. c. 1936. Color
lithograph, 38 × 25". Library of
Congress, Washington, D.C.

582 Yasuo Kuniyoshi (1893–1953). The
Cyclist. Lithograph, 13 1/2 × 9 1/4".
Yale University Art Gallery, New Haven,
Conn. (gift of Mrs. Laurent
Oppenheim)

583 Adolf Dehn. All for a Piece of Meat.
Lithograph. Brooklyn Museum, New York

583

584

585

584 *John Steuart Curry. The Plainsman.*
1945. Lithograph, 16 1/2 × 10 1/4″.
Courtesy Associated American Artists,
New York

585 *Grant Wood. Shriners' Quartet. 1939.*
Lithograph, 7 7/8 × 11 3/4″.
Courtesy Associated American Artists,
New York

586 *Charles Sheeler. Regatta. 1924.*
Lithograph, 8 1/2 × 10 3/4″. Courtesy
Associated American Artists, New
York

587 *Ivan Albright. Self-portrait: 55 East*
Division Street. 1947. Lithograph,
14 1/4 × 10 1/8″. Courtesy Associated
American Artists, New York

588 *Thomas Hart Benton. Cradling Wheat.*
1939. Lithograph, 9 3/4 × 12″.
Philadelphia Museum of Art (Carl Zigrosser
Collection)

589 *Jackson Pollock. Harvesting Scene. 1937.*
Lithograph, 9 1/2 × 12 3/4″. Courtesy
Associated American Artists, New York

587

588

589

590 *Grace Hartigan*. Inside—
Outside. *1962. Lithograph.
Brooklyn Museum, New York*
591 *Robert Gwathmey*. Matriarch.
*c. 1963. Color lithograph.
Brooklyn Museum, New York*
592 *Rico Le Brun*. Moonlit Earth.
*1945. Lithograph. Brooklyn
Museum, New York*

590

591

592

593 *Jim Rosenquist. Bunraku. 1970. Color lithograph, 32 × 23 1/2". Courtesy Castelli Graphics, Inc., New York*

594 *Paul Jenkins. Untitled. 1967. Color lithograph, 28 × 20". Courtesy Pratt Graphics Center, New York*

595 *Philip Pearlstein. Nude. Lithograph. Courtesy Pratt Graphics Center, New York*

593

594

595

596

596 Richard Lindner. Untitled. 1964.
 Color lithograph. Collection
 the author
597 Frank Stella. Black Series II.
 1967. Lithograph. Philadelphia
 Museum of Art

597

CHAPTER 14

LITHOGRAPHY

TECHNIQUE

Although the basic principle involved in the making of a lithograph is the antipathy of grease to water, the quality of the finished print is actually determined by the delicate, complex relationship between the materials used and by the skill with which the artist can manipulate and control the various chemical reactions. In addition, the printmaker must concern himself with problems of cleanliness, adequate space for working, drying, and storing, control of climate and temperature, and so on. The slightest intrusion of grease or dampness in the wrong place or at the wrong time can result in the ruin of the finished print.

PLATE 598

The press is the focal point of the workshop, with inking slabs, water supply, paper, and storage space arranged conveniently around it. The sink used for the graining of stones should be well away from both greasy materials and clean paper and proofs. The size and weight of the stones make it necessary to have work surfaces of a comfortable height, and often a fork lift is used to move stones from one place of action to another.

Preparing the Stone
The best lithographic limestone comes from Solnhofen, in Bavaria; it has been found to be relatively free from flaws and resistant to cracking in the press. The slabs, varying in thickness from 2 1/2 to 4 inches, depending on the size of the printing surface, can be grouped in three grades of hardness. The yellow stone is softest; its grain tends to deteriorate under pressure. The gray is of medium hardness. The bluish stone, almost as hard as slate, is well suited for work involving fine detail, such as pen drawing and engraving.

The texture of the grain is determined by the abrasive agent used in preparing the stone surface. Even a new stone will have to be grained for the particular type of work to be done. In the case of a reused stone all traces of the old image must be removed and a new grain established. The "ghost" of the old image can often be seen if the stone is examined closely; the graining process must be repeated until every trace is eliminated.

The stone is placed in the graining sink, generally a wooden structure lined with lead or fiber glass. The stone rests on a wooden rack at the bottom of the sink. The edges of the stone must be beveled slightly with a file; this prevents ink from accumulating at the edges during printing. The actual grinding can be done either with a levigator, a cast-iron disk with a wooden handle, or with another litho stone of manageable size. The surface of the stone is thoroughly dampened and sprinkled with one or two spoonfuls of Carborundum (silicon carbide) grit (No. 180 is recommended for the first graining). If a stone is used for the grinding, it should be moved evenly, without pressure, over the entire surface of the stone to be prepared. Care should be taken to grind all parts of the surface uniformly. After a few minutes a creamy sludge is formed, and the graining stone becomes harder to move. At this point the top stone should be moved slowly to one edge of the bottom stone and removed. Both stones are now thoroughly washed and checked for scratches and, with a metal straight edge, for flatness. A few oversized grains mixed in with fine grit will cause ugly scratches in the stone's surface. This process is repeated until no "ghost" is visible and finished off with a graining of very fine (No. 220 F or FF) grit. After washing, the stone will appear quite smooth, but a microscope would reveal a surface of tiny pits and crags. When the artist is satisfied with the surface, the stone

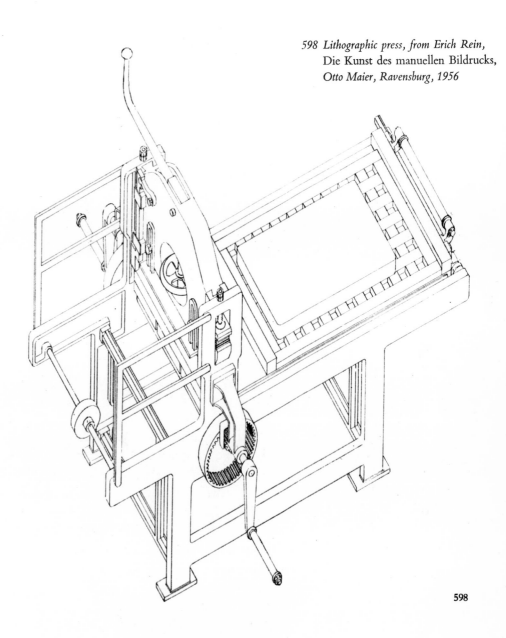

598 *Lithographic press, from Erich Rein,*
Die Kunst des manuellen Bildrucks,
Otto Maier, Ravensburg, 1956

598

should be propped at an angle and washed down. The clean, freshly grained surface is extra-sensitive to both grease and water at this point. If the stone is not to be used immediately, a clean sheet of paper should be taped over the surface to protect it.

Drawing on the Stone

As Senefelder discovered, almost any greasy substance can be used to draw on the litho stone; in fact, he showed that the image can be drawn even in water-soluble ink, the stone desensitized to water, and the printing done with water-base ink. The drawing materials most often used today are litho crayons, tusche, and rubbing ink. Both crayons and tusche are composed of a mixture of carnauba wax (hard), beeswax (soft), lampblack, and castile soap. Crayons come in various shapes and sizes and range in hardness from No. 00 (very soft) to No. 5 (called "copal," very hard). Tusche comes in both premixed liquid form and solid. Solid tusche can be mixed with turpentine, gasoline, or water to the desired consistency. Rubbing ink, containing a

PLATES 599, 600

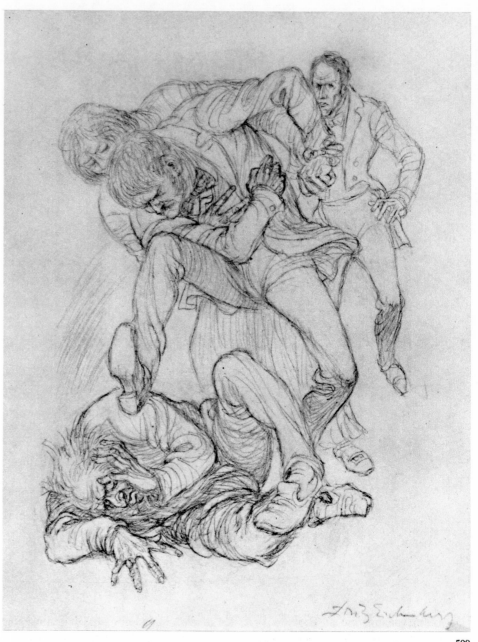

599

high proportion of beeswax, is soft and can be applied directly to the stone with the fingertip. Tusche thinned with distilled water and applied with a brush produces a wash effect.

High lights can be erased or scraped out of dark areas with razor blades, needles, knives, or steel wool. The range of effects that can be achieved by these means is literally limitless. (See Chapter 15.) In variety of line, tone, and texture lithography offers perhaps the widest possibilities of any print medium.

For tracing a design on the stone, the back of the paper may be covered with Conté powder or crayon (red). The paper is laid upside down on the stone, and the design traced with pencil. The impression on the stone can then be worked over with grease crayon or tusche. Emil Weddige refers to a gum-arabic-coated paper which

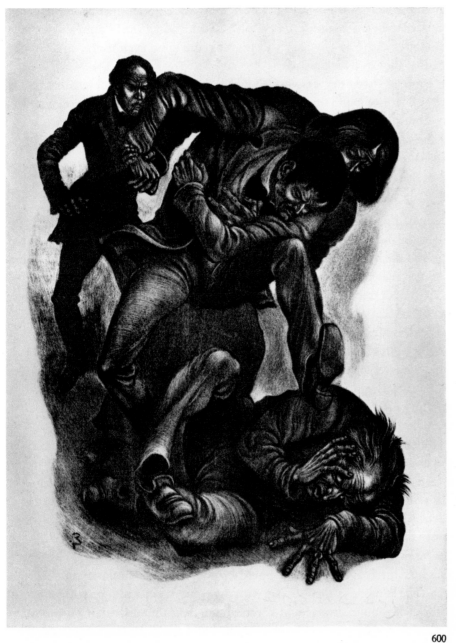

599 *Fritz Eichenberg. Illustration for*
Dostoevski, The Brothers Karamazov.
1949. Drawing, 8 1/2 × 6 1/2".
Collection the author

600 *Fritz Eichenberg. Illustration for*
Dostoevski, The Brothers Karamazov.
1949. Lithograph, 8 1/2 × 6 1/2".
Collection the author

600

can be drawn on with crayon or tusche. When slightly dampened with a sponge or damp book and run through the press several times, the paper will leave a reversed image on the stone and will have automatically desensitized blank areas to grease. One disadvantage of this procedure is that it makes additions or corrections impossible, unless certain areas are resensitized or resurfaced. Transfer papers without the gum-arabic coating can be used in the same way.

The transfer method is preferable for subjects that should not be printed in reverse (such as lettering). It is also practical because corrections can easily be made on the paper; areas can be cut out or blocked out by painting over with Chinese white before the image is transmitted to the stone.

Throughout the drawing stage great care should be taken to prevent soiling

blank areas and margins. Fingerprints may show up as black marks on the print. Areas intended to be pure white can be protected with a mixture of gum arabic and a small amount of nitric acid, which will prevent smudging even if crayon or tusche is accidentally applied over the gum.

The completed transfer drawing should be dusted with French chalk, applied with a clean cloth or puff; this coats the grease image and makes it resistant to the etch. A second dusting with powdered rosin effects a greater affinity between the etch and the surface of the stone. The excess powder should be carefully dusted off; only a fine, almost invisible, layer will remain.

The Etch

Lithography is a planographic process; the image is neither cut into nor significantly raised above the surface of the stone. The printing is achieved by chemical treatment of the image and the blank areas of the stone, which makes the drawing attract ink and the blank areas reject it. The term "etch," applied to treatment of the surface with a mixture of gum-arabic solution and acid, seems somewhat misleading. Gum arabic, a product of the acacia tree, is usually obtained in the form of solid lumps, which are dissolved with enough water to produce a syrupy solution. Strained through cheesecloth to remove impurities, this solution is mixed with a small amount of nitric acid. Lithographers differ in their "recipes" for the etch (Peter Weaver, 50 to 1; Jules Heller, 1 1/2 ounces gum and 5 to 15 drops acid; Emil Weddige, 8 drops acid to 1/2 cup gum). Since the reaction is influenced by such factors as temperature, humidity, and the condition of the stone, some testing or experimenting is advisable.

The function of the gum is to "set" the drawing, freeing the grease in the crayon or tusche and allowing it to be absorbed deeply into the stone. The greasy areas become more water-resistant, and the entire surface of the stone hardens slightly. The nitric acid opens the pores of the stone, cleans it of minute deposits of dirt, and further desensitizes the blank areas to grease. The more grease there is in the drawing, the stronger should be the etch. Fine or grainy crayon lines will be destroyed if the etch is too strong.

Enough etch to cover the stone should be poured either on the margin or in a blank area. The solution is then spread with the palm of the hand, or with a 3-inch brush if the etch is quite strong, and kept moving over the surface for several minutes. More etch can be poured on, if necessary, and the spreading continued. The etch should produce a mild, rather than a violent, foaming action on the surface. After the stone has been spread with gum and the excess wiped or blotted off, the process is repeated and the gum finally rubbed down to a thin coat. The gum is fanned dry and the stone left to stand overnight.

Washing out the Drawing

After the gummed stone has been allowed to stand for twelve hours, the gum is washed off completely. The surface of the stone should feel very smooth. Now the drawing is lightly sprinkled with turpentine while the stone is still wet, and the black pigment is washed out with a clean cloth. The stone is kept damp by flooding it with water, and more turpentine is sprinkled on as needed. The pigment is washed out until there remains only a faint image on the stone.

Rolling up the Image

Lithographic ink should have body and should be rather slow-drying. If it is too easily soluble in water, it will scum over the drawing when the stone is dampened with a sponge. It must be sufficiently greasy to be attracted by the greasy drawing. The basic components of litho inks are the pigment, a drying agent, a binder, or vehicle, which may be varnish, and linseed oil. In order to adjust the ink to the specific job at hand, it is necessary to understand the properties of the various additives. Linseed oil, for instance, will increase the grease content of the ink; varnish will thin the ink and add tackiness.

A small quantity of the very stiff ink should be placed on the inking slab, thinned slightly with varnish, and worked over with a palette knife until it flattens slowly when gathered together into a pile.

The roller used for inking the stone consists of a wooden core covered with heavy flannel and an outer layer of leather, nap side up. The roller is often used with cylindrical leather "cuffs" over the handles to facilitate rolling and ease friction on the hands.

Rollers must be kept in top condition at all times. A new roller must be conditioned before use. It should be smeared generously with litho varnish, then scraped with a dull table knife or spatula, first against the grain and then with it. The seam of the roller's leather cover should not be scraped, for that causes it to leave a noticeable line on the inked stone. After scraping, the roller should be rubbed with varnish again, this time a harder varnish (No. 6 or 7), which should be worked in with the hands. The roller should then be rolled a few times over a clean ink slab, scraped, and rolled again, until no more nap can be scraped off. Next a small amount of ink should be placed on the slab and the roller rolled over it for 15 to 20 minutes, then scraped, and rolled again. Any roller not in use for a week or more must be protected with aluminum foil or other wrappings or coated with a layer of thick grease, such as Vaseline. This must be scraped off completely before the roller can be used again. If necessary, an old, dried-out roller can be wire-brushed to raise the nap.

The inking of the stone can now begin. The stone is placed in the bed of the press and dampened evenly with a sponge. No excess water should be allowed to remain in pools on the surface, but the stone should never be completely dry during inking. The sponge must be perfectly clean. The roller is charged with ink by rolling it several times back and forth on the ink slab. Then the stone should be dampened again with the sponge and rolled up several times, with only the weight of the roller and with care to start rolling each time at a different place. The roller should also be turned end-to-end from time to time, to insure even inking of the stone. As this procedure—charging the roller, dampening the stone, and rolling up—is repeated several times, the image will slowly "come up" until it appears to have reached full strength. At this point the drawing can be checked for corrections. Unwanted lines must be ground out with pumice or grit, and more work can be added to blank areas if they are first counter-etched, or resensitized with a solution of acetic acid (40 percent) or a saturated solution of alum. The new work must be given an etch and rolled up before printing can proceed.

After the first inking Weddige recommends treating the image with French chalk and rosin and gumming thinly. The stone is placed in a rack for 4 to 6 hours before the printing of the edition proceeds.

The inked drawing may be further "set" or "etched" by burning. Fine asphalt powder is sprinkled over the inked stone; this is then burned in with a special blow-torch. The result is a highly etch-resistant layer covering the drawn areas. The stone is then very strongly etched until the image appears in slight relief. A stone thus prepared will withstand much pressure and can be used for printing unusually large editions, but the prints will show a harder line and less delicate texture than can be achieved without burning.

Printing

The best papers for lithography must have enough body to withstand dampening. They should have softness, a pure texture, and longevity. Among those recommended by contemporary practitioners are Arches, Rives, Basingwerk Parchment, Fabriano Book, Umbria, Shogun, Kochi, and Inomachi. The paper should be prepared for printing by stacking it between damp blotters, wrapping in oilcloth or plastic sheeting, and placing all between two boards overnight. Dampened paper will take ink evenly and deeply.

The press used is essentially of the same scraper type as the one Senefelder constructed. The type most common in Britain and America has a side pressure lever, while a top-lever model is mostly used in Germany. To begin printing, select and put in place a scraper that is larger than the drawn area but not wider than the stone. The wooden scraper, with its edge covered by a strip of leather, must be well greased with tallow or butter. The tympan, or pressboard, is also greased to ensure a smooth passage of the stone through the press.

The pressure is adjusted by moving the stone under the scraper, pulling the lever to ten-o'clock position, turning the top screw until it touches the stone, releasing the pressure, and giving the screw one or two more turns. The stone can now be returned to its original position, and rolled up with ink. The roller must be rolled over the ink slab and onto the stone at least five or more times for each inking. When the image appears fully inked, the sheet of paper is carefully lowered onto the stone, covered with several blotters or sheets of newsprint and the tympan, and pressure is applied. The stone is cranked evenly through the press until the scraper rests on the back margin of the stone. If the scraper is allowed to move suddenly off the edge of the stone, the stone may break. Now the pressure is released, the bed pulled back, and the backing and print removed, one layer at a time. As the print is removed, the stone should be dampened with a sponge. It is now ready to be reinked and printed again. The first few proofs should be pulled on newsprint. Adjustments in inking can then be made until the first acceptable proof appears. The first proofs pulled on good paper will often print light. Since the precise and skillful dampening, inking, and pulling through the press determine the final quality of the print, care should be taken to standardize each step of the process as much as possible, once a good proof has been pulled. Careful attention should be paid to the number of times the roller is applied to the ink slab and to the stone in order to achieve uniformity in the prints.

The stone must remain damp throughout inking and printing, and only a few seconds can elapse between rolling up and pulling the proof. When hot weather

threatens to make it impossible to keep the stone damp enough, many lithographers add a small amount of stale beer to the water to retard evaporation.

As the desired number of proofs is pulled, a constant watch should be kept to ensure that all prints are up to the standard of the first good proof. When the printing of an edition has been finished, the stone may be canceled by rubbing, scraping, or scratching the image. The prints may be hung up or placed under a press to dry.

The possibilities for individual experimentation are endless; the artist is limited only by his imagination and by the skill with which he can control his materials and equipment.

Metal-plate Lithography

As Senefelder realized, many substances other than stone can be adapted for lithography. Ready-grained zinc and aluminum plates, usually 1/5 to 1/4 inch thick, are popular, because they are relatively cheap and are lighter and easier to store and handle than stone. Since the supply of fine-grained limestone from Bavaria seems to be nearly exhausted, and demand for lithographic materials is rising sharply, metal plates will come more and more into use. The advantages of zinc and aluminum plates, however, are somewhat offset by the extra care needed in working on them. Certain techniques, such as scratching and scraping, cannot be used on metal at all.

Before drawing on the plate, the artist must subject the surface to a counter-etch, to make the metal sensitive to grease. The plate is immersed in a saturated solution of powdered alum and water, sometimes with a small amount of nitric acid added. The solution is kept moving over the surface of the plate for several minutes. Then the plate is washed with clean water and dried immediately to avoid oxidation, which would render the plate insensitive to both grease and water.

The procedure from this point parallels stone lithography, except that in the formula for the gum etch small amounts of chromic and phosphoric acid are substituted for nitric acid.

The gum etch, the grease crayon, and the water all lie on the surface of the metal plate rather than penetrate it, as they would a litho stone. (Great care must be taken not to disturb their somewhat tenuous hold.) Some lithographers suggest a second etch, after the first roll-up with ink, to clean and fully desensitize the plate.

The printing proceeds exactly as in stone lithography.

Color Lithography

The first departure from simple monochrome lithography was Hullmandel's "Lithotint" process, developed in his London workshop. The image was printed from two or more stones in neutral colors, in effect imitating a wash drawing. Godefroy Engelmann, in Paris, began printing in "chromolithography," in which a separate stone was used for each color, creating an endless variation by overprinting.

This color process was soon adopted by commercial lithographers with spectacular, though often garish, results. Ironically, while mass-produced chromolithography signaled the temporary demise of lithography as a creative medium, many outstanding lithographers, from Toulouse-Lautrec to Wunderlich, have worked most successfully in color lithography.

COLORPLATE 66

The basic procedure is the same as in monochrome. The artist can range as widely as his knowledge of color and of the chemistry of inks will allow. Some contemporary lithographers, including Christian Kruck, have printed several colors from one stone, either in succession or simultaneously.

The artist must first analyze his proposed design, visually breaking it down into its component colors. He must consider possibilities of overprinting, noting the various degrees of opaqueness or transparency of his inks, and must remember that the order in which the colors are printed will have a great bearing on the final result. A lengthy period of experimentation with various inks and with sequences of printing is of primary importance.

The overall outlines of the design are first drawn or transferred onto a stone, a blue proof is pulled with watercolor ink, and this in turn transferred to as many stones as are to be used. Registration marks, in the form of small crosses, usually placed in diagonal corners of the stone, are included in the drawing.

Now the stone is drawn, etched, and inked with the first color, often the dominant or most prominent one in the design. The roller used is not nap leather but rubber-covered, generally over an aluminum core. Enough proofs of the first color are pulled to make up the desired edition. Another stone is drawn and inked for the next color, and the proofs are registered on the stone by cutting or punching a small circle at the intersection of the cross marks or a triangle enclosed within adjacent arms of the cross to indicate edge limits. The paper can be laid on the stone so that one cross lies exactly over the other. Another method is to pierce the center of the crosses on the paper with pins or needles mounted in wooden handles and, centering the needle points on the stone's registration marks, to lower the paper gently in place.

Most lithographers prefer to use dry paper for color printing, because paper will stretch unevenly when dampened, making accurate registration difficult, if not impossible.

The production of a uniform edition of color lithographs requires the utmost precision in each step of printing; each motion must be closely duplicated. The rigid discipline of the technique has led most artists to entrust the production of their color editions to skilled professional printers.

CHAPTER 15

NOTES ON LITHOGRAPHIC TECHNIQUES

BY PROMINENT PRINTMAKERS

Ranging from traditional procedures to the adoption of highly unorthodox methods and of recently developed devices, the procedures outlined below exemplify some of the diversity of styles and effects practiced today by artists in the lithographic medium.

STOW WENGENROTH
Crayon Lithography

PLATE 601

I spend nearly as much time on the preliminary drawing as in working on the stone. The first drawing I do directly from nature, in dry-brush watercolor to give broadly the same effect as that produced by a lithographic crayon on stone. The drawing is considerably larger than the finished print, so that I have more freedom and ease of execution.

Finally the subject is ready to be redrawn in pencil, in outline only, exactly the size of the print to be, traced onto the stone, and strengthened with a hard pencil. These lines will not print; they serve only as a guide for subsequent work with the lithographic crayon.

There are, of course, many ways of working on the stone. All my lithographs have been done entirely with crayon; I never use tusche washes, scraped tones, wiped tones, and so forth. This is purely a personal preference. I use Korn lithograph crayons in the pencil form, Nos. 1, 2, and 4; the softer ones (Nos. 1 and 2) are used for the darker tones and black areas; No. 4 is for light tones and fine lines.

601 Stow Wengenroth. Lobster Buoys. Lithograph. Boston Public Library (Wiggin Collection)

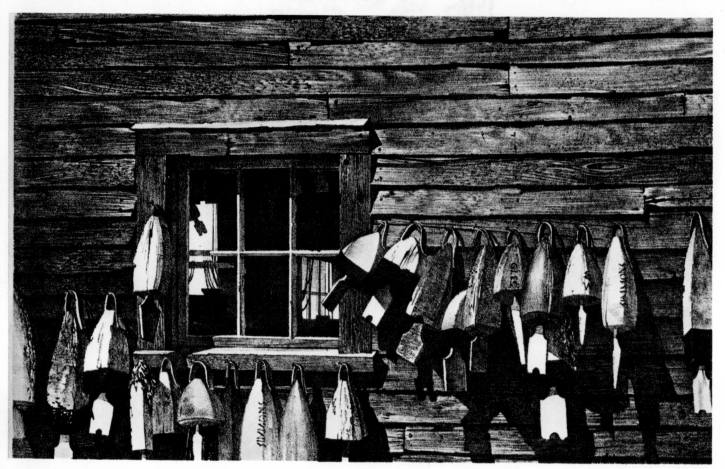

Whatever method is used, one should keep in mind that the superb drawing surface of the limestone affords a texture finer than any other material. It is sensitive to the subtlest gradations of line or tone, from the lightest grays to deep black, and can be worked over and over without losing freshness and bloom. As tones are re-worked and slowly darkened to the desired values, the original drawing is developed and enhanced: Textures can be kept fine or deliberately roughened up.

Occasionally a tone must be cleaned up in areas where the crayon has piled up and enlarged some of the dots that make up the tone. These can be picked out with an etching needle.

I am always conscious of the wonderful surface qualities of the stone, and this accounts for my great love of lithography. For me, a print is a work more profoundly conceived, more carefully executed, and, I hope, more successfully and richly completed than a drawing. This, I believe, should be the overriding reason for making a print—be it intaglio, relief, or planographic. The prime concern of printmaking should not be just multiplication and its economic advantages, but rather the special qualities and characteristics by which each medium can enhance the work of the artist in its own way.

PAUL WUNDERLICH
Lithography

The idea for the print *Models in the Studio* came from a photograph of nude models in my studio in Hamburg. I made the lithograph on one stone and four zinc plates in the workshop of Jacques Desjobert in Paris.

COLORPLATE 67

I began drawing with black crayon on the stone until a certain composition emerged. I then worked on the zebra-skin area with tusche and brush and spray gun, still in black. I disturbed the perfection of the sprayed tusche somewhat by scratching and with a few drops of benzine. I find working on a stone with such freedom a great pleasure.

The second color was violet, on a zinc plate. The whole background had to be filled with tusche from edge to edge—quite a laborious task!

On another zinc plate I laid in the ocher-gray area which would form the light part of the zebra skin. On the next I did the blue shading of arm, belly, and thigh with a movable stencil. On the last plate I added the tiny spot which luxuriously picks out the bright turquoise highlight in the upper left-hand corner.

The opaque violet background was printed first, a very difficult operation. Then the ocher-gray, blue, and turquoise plates were printed, in that order. Last was the black on stone. Although the black ink printed alone on damp white paper would produce many richer nuances than it does superimposed over several other colors, in this case, unfortunately, that could not be done!

I generally prefer to use Rives paper because of its whiteness. As for inks, Lorilleux Lefranc, formerly the best, have been disappointing in the last few years. Desjobert has been testing a new ink from a small firm whose name I don't remember; I have tried only the black, which proved to be excellent.

ERICH MOENCH
Lithography Techniques

In my work I prefer to use the rarer gray-blue litho stones, which are usually free

PLATE 602

*602 Erich Moench. Small Magic Zodiac.
1967. Lithograph, 13 7/8 × 13 7/8".
Courtesy the artist*

from flecks of chalk. For graining, glass-, silver-, or quartz-sand may be used, each giving an increasingly finer grain to the surface.

The tusche I use is a mixture of wax, tallow, Marseilles soap, and lampblack. Solid tusche freshly rubbed and mixed with distilled water is better than the kind already prepared in bottles.

In tracing a drawing on the stone with a stylus, care must be taken to ensure that

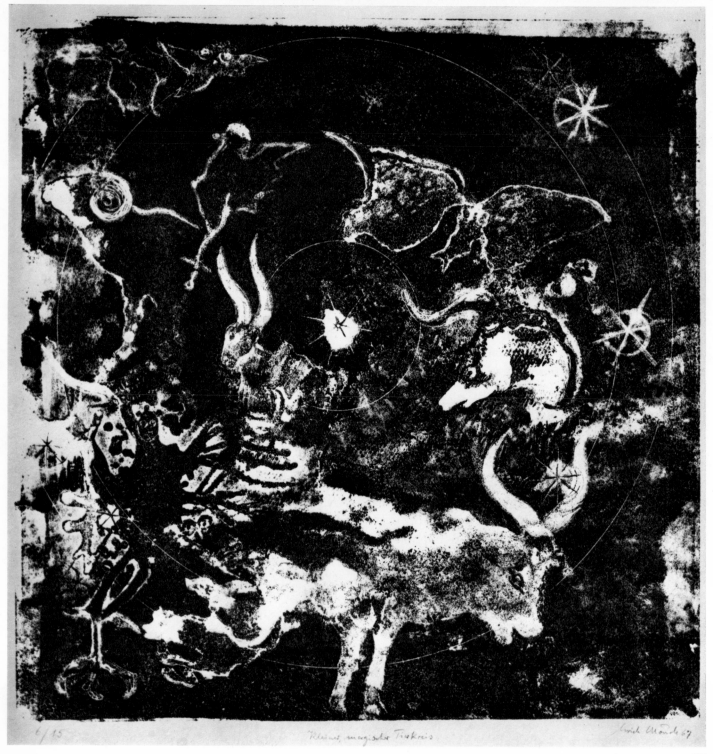

the tracing paper is grease-free. When the work on the stone with tusche or crayon is finished, the design is gummed and left to stand for about 6 hours.

Washes and Fine Lines

With more delicate work, such as washes and fine lines, a second gumming after inking may be necessary. The stone should be etched in separate parts, the darker areas more strongly than the lighter ones. If the design becomes too dark and closes up, it must be washed out with benzine and inked again lightly. Then it is washed with water. With a soft brush dipped in acid one can touch up the spots that seem to close up.

Washing, drying, dusting with resin and talcum, and gumming with 2 to 3 drops of etch follow in that order. Sometimes one can go quickly over the stone with a blowtorch to turn the resin and ink into a glass-hard surface. The roller should be scraped and the ink slab cleaned during printing whenever necessary. Rubber rollers should be cleaned *immediately* after use.

Generally speaking, offset inks are not stiff enough for stone lithography. A somewhat stiffer ink will have less tendency to close up the textures. Litho ink is transparent in comparison to letterpress ink. To increase this quality, transparent white or varnish is sometimes added to the ink. Opaque white should be avoided, and all inks should be used sparingly.

Various Other Techniques

For crayon work the stone should stand for several hours after the etch. If the lines appear weak, one can roll up the stone directly on the crayon work before the second etch without washing out. Again, the work should be burned in if necessary.

Rubbing tusche is used for soft shadings and is best put on with a piece of chamois or nylon. For spattering I use a metal sieve with a handle, a toothbrush, and very thick tusche. Blank areas are masked out with gum arabic, tinted with black tempera for better visibility. The gum must be allowed to dry thoroughly. It is advisable to test spattering first on a piece of paper.

White chalk can be used for drawing directly on the stone. A piece of inked paper is placed on the stone face down and pulled through the press. After the paper is removed, the stone is dusted and gummed, washed off after 5 hours, the ink removed with turpentine, and the image etched several times as above. This method produces an interesting chalklike white-line design.

Nature Structures and Other Textures

PLATES 603–609

The stone is inked thoroughly and the margins marked off with gum. Dry plants and other textured objects such as fabric or string are arranged on the stone and covered with a piece of strong white cardboard, with several sheets of newsprint on top. A piece of composition board is laid on the newsprint and over this a thin, greased metal sheet. Now the stone is pulled through the press several times, first under light pressure, which is gradually increased. The objects leave an impression on the dark surface. They are carefully removed after being gummed and allowed to stand for an hour. Then the stone is washed out with turpentine and inked with a heavy ink. Corrections can be made with litho tusche. The work should be inked and etched several times, after an interval of 5 to 6 hours each time. The textures will appear almost as photographic negatives and should be delicate but very sharp and clear.

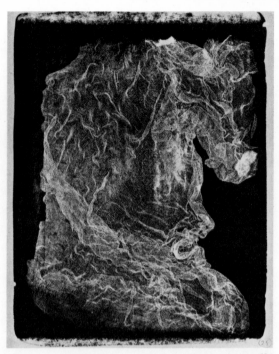

603

604

603–609 *Test lithographic proofs, various textures.*
Collection Erich Moench, Tübingen, Germany
603 *Crumpled aluminum foil pressed onto inked stone, run*
through the press, and then removed
604 *Gauze*
605 *Plants*
606 *Wood inked and transferred to stone*
607 *Feathers*
608 *Wood pressed onto inked stone*
609 *Tusche on transfer paper*

605

606

607

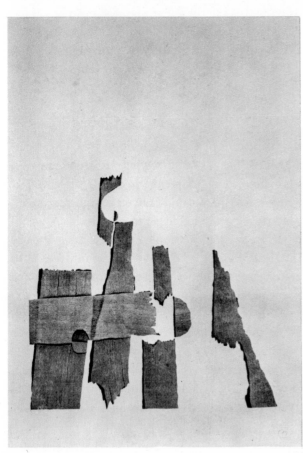

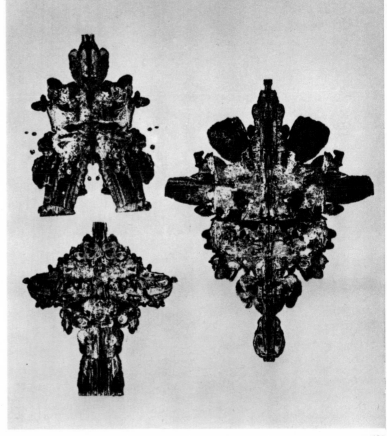

608

609

Ball-point pens, which contain a greasy substance, can also be used to create an image. The stone is first washed with turpentine and the drawing made on the clean stone. It is dusted, gummed, and left standing for 6 hours, after which it is washed off. Now the stone is inked, dusted, etched, and again allowed to stand for 6 hours. After the third etch the stone is ready to be printed.

Transfer Technique

PLATE 610

Home-made transfer papers may be preferable to commercial ones. Any kind of textured paper can be used, if dampened slightly and stretched tightly with tape on a board. Ordinary laundry starch, boiled for 5 minutes until it has the consistency of thin pudding, is spread with a brush or sponge on the paper in a thin layer. The paper must then be dried and kept free of dust. Transfer paper can also be made with a fine coating of Chinese white tempera. On this paper one can use crayon, pen, brush, and washes. The lines or textures should not be overloaded with crayon, because they might squash on the stone during transfer. The stone should be dry and slightly warm. The pressure of the scraper should be very light, and the tympan must be well greased. The drawing is dampened and placed on the stone with four or five sheets of dampened newsprint over it (damp but not wet). It is pulled through the press several times, and the paper is remoistened with a sponge. Then, under somewhat increased pressure, the stone is pulled through again. Remoistening and increasing the pressure are continued. If the pressure is too strong, the paper will tear. The drawing is then soaked with water for about 4 minutes. After the water is mopped off, the corners of the paper may be lifted to check the transfer. If it is satisfactory, the paper is pulled off and the stone dried with a fan. In a few minutes it can be dusted with talcum, gummed, and left to stand for 6 hours. Then the gum is washed off, and the stone is sponged with water, inked sparingly, and given two or three etches.

GERTRUD J. DECH
Notes on Lithography

PLATE 611

Stone etching resembles technically the process of etching on metal (zinc or copper) but differs from stone engraving in that the line is not incised into the stone but stays on its surface as in any other lithographic process. After the stone is grained finally and is thoroughly dry, a thin coat of fresh gum arabic (old gum etches more strongly) is applied with a brush. The thin solution of gum arabic is mixed with black or red tempera color to make drawing easier. As soon as the stone is dry, the image can be drawn on it with an etching needle. Printing ink is rubbed strongly into the open lines with a piece of cloth. The stone is washed under a strong jet of water, which dissolves the gum arabic and leaves the inked lines on the stone.

One can experiment with interesting textures by interrupting the washing, with some of the ink still clinging partly to the stone and partly to the gum around the lines, so that new, delicate tone structures are formed. After washing, which may take half an hour, the stone is dried. The grease settles on the stone. It is dusted with resin, burned in with a blowtorch, and gummed. The burning and gumming are repeated after 12 hours. The ink and resin melt together and harden to give the surface the same stability as tusche.

Only now can the stone be etched, gummed, washed, and printed in the usual

611

610 *Erich Moench. The Moon. 1969.*
Photolithograph, 17 1/2 × 11". Courtesy
the artist
611 *Gertrud J. Dech. The Hunter from*
Kurpfalz. 1968. Stone etching, 15 × 13".
Courtesy the artist

610

way. Dampened paper is recommended. Stone etching is easy to print and resembles in character a zinc or copper etching without the tone.

Sludge Patterns on Stone
The lithographer who fully understands the characteristics of the litho stone and is interested in its creative possibilities may be confronted during the graining with an

interesting natural phenomenon that can be utilized for expressive purposes. Between the two stones rotating against each other, wave patterns are formed in the creamy sludge of grit and water. These patterns can often be preserved by a quick lifting of the top stone. One can easily work additional lines and patterns into the wet sludge or remove certain parts of it with fingers, wooden sticks, or similar means. After a thorough drying of the gritty surface, a piece of strong cardboard is rolled up with printing ink, placed face down on the stone, and run through the press under strong pressure. The stone accepts the ink wherever the dried sludge does not cover its surface, and the pattern emerges white on black. After the proper gumming, the sludge is removed with a thorough washing. The rest of the procedure follows the steps of burning in, etching, and gumming, as described above for stone etching.

Drawing on Stone with Asphalt
The method of drawing on the litho stone with asphalt does not involve the traditional chemical reactions of fat, water, and acid usually associated with stone lithography. The stone in this case will be affected by the acid only on the blank, untouched areas, and the asphalt itself will serve as the receiver of the printing ink. Instead of litho tusche, asphalt lacquer (thin or undiluted) is used on the freshly grained stone and can be manipulated with pen, brush, fingers, or wooden sticks, creating interesting relief effects. The design completed, the asphalt is left to dry, burned in strongly, and etched.

The stone can now be printed immediately, instead of waiting the usual period after the gumming. The burning melts the asphalt, and the drying afterward creates the most unusual structural patterns. The asphalt lacquer accepts the printing ink and, in addition, imparts to it a delicate brown tint, which may be compared in brilliance to the glaze of ceramics. It is very important to observe that although the stone is wet during the inking, it must be completely dry during the printing, and the paper must be dry and well sized.

FEDERICO CASTELLON
Lithographic Lifting Technique
In my own work I have favored the technique of lifting lights out of solid blacks. In *The Traveler* I used primarily washes of tusche. The first wash, which covers the entire image area including buildings and mermaid, was very light in tone but heavy with water. If such a wash is allowed to dry thoroughly, the texture becomes crinkly, and, for this print, it seemed too obvious and superficial. I therefore allowed the grays to settle slowly by letting the wash evaporate for about half an hour, and before any portion had dried I applied another wash, this time quite a bit darker but still as liquid. This time I had to allow the wash to evaporate for a good forty-five minutes—to the point of being just damp. I then laid down the third and last wash, about half as wet as the second and almost black, and let the stone dry thoroughly.

Next I totally blackened the area that was to become the mermaid. While that area dried, I worked in the darker washes at the base—the cities—and finally returned to the mermaid, which I was going to "lift."

In this technique you work the lights or lighter areas into a completely black surface. If the area is black, water is used; if the tone is less than black or the black too stubborn, gasoline can be used. However, the gasoline wash is sometimes too

PLATE 612

612

612 *Federico Castellon*. The Traveler.
Lithograph. Philadelphia Museum of Art

slick and lacking in character. In order to make the city less real and solid-looking, I used gasoline to lighten some of the buildings to give them the appearance of being an extension of the sky. The mermaid is floating in the sky, lost in the immensity of the world, symbolizing the loneliness of all travelers.

Perhaps the most important step in this process is to select the proper stone. The extremely hard blue stones and the soft yellow stones are almost useless for this technique. Both seem to hold the black wash against all attempts to lift it. Sometimes the tusche clings so relentlessly that any further attempts to remove it seem to fix it to the stone even more. I have had the most success with white or grayish stones, but even these have presented problems at times.

The first tusche wash should be as close to black as possible. If the primary wash is a middle gray or lighter, it seems to remain fixed, when dry, and though a subsequent black wash will lift, it will usually expose only the first immovable wash. Even if one has been fortunate enough to lay what seems to be a totally black first wash, it is safest to give the stone a second wash of very dark gray.

Sometimes mixing water into the tusche results in a foam with extremely fine bubbles, which seem to disappear with the drying of the wash. In reality, minute pinpoints have resulted, and, when the stone is etched, they attract small concentrations of etch and eventually appear in the printing as large snowflakes.

Once the black wash is ready to work, one should bear in mind that the longer it stays on the stone, the harder it is to lift. However, if the stone is to be finished in about two days, there should be no difficulty.

In lightening the black to achieve all variations of tone from white to deep grays, experience will be the best teacher.

Individual areas should be lifted in one action; otherwise, two distinct sections with an irremovable seam between them will be created. For this reason a soft sable brush large enough to hold the water necessary to lift a certain area should be used. If a change of value is desired, one begins with the brush full of clear water in the part of the area designed to be the lightest. The tusche will dissolve easily and allow the eventual exposure of the stone. As the brush is worked over darker parts of the area, it will thicken with tusche until finally the dissolving process ceases.

If the earlier part of the lifting has tended to dry a bit, one should rewet it with fresh water and dab the area with facial tissue to lift the dissolved tusche. After removing the tissue, one may find that details need further drying. For this a wad of tissue is used as a blotting dabber.

For stark white highlights in already lifted areas gasoline can be used to further dissolve the tusche. Gasoline should be handled carefully, and, because of its volatility, one must work with speed. If minute spaces need lightening, one can use a razor blade or ink eraser.

To darken a large space a wad of tissue containing wash can be used to retain the texture of the print. Sometimes after lifting some areas will be heavily spotted or the entire space will seem too deep. It is wiser not to correct this until several trial proofs have been pulled. The stone often has a tendency to darken in certain areas or to build up tones where none existed, because even though the blacks have been removed, a residue of grease remains. After a few proofs this residue may have reached its limit, and one can then make final decisions on tones. If the entire surface has darkened, a sponge full of table wine washed over the inked stone will often be enough to lighten it; if stronger lightening is needed, a few drops of etch can be added to the wine. It may be necessary to repeat this procedure after each of the next few proofs. This lightening mixture should always be cleaned off with a sponge full of clear water soon after it is applied.

CHRISTIAN KRUCK
"Stone-painting" Lithography Technique

COLORPLATE 68

I developed my painting on stone as a very personal art expression, specifically a painterly one. Through experimentation with different materials as substitutes for tusche I found a lacquer that could be easily manipulated and at the same time was very acid-resistant. It is an acetone-shellac-alcohol solution which produces, depending on its rate of dilution with alcohol, light or dark values just as in conventional tusche lithography. For better visibility aniline dye is added to the lacquer.

I always print a complete edition of one color before proceeding to the next one on the same stone.

Of course this precludes the possibility of pulling an artist's proof, since the edition has to be printed in its entirety as it was planned beforehand. The size of the edition can vary; I generally keep my editions to about fifteen, to reach a little faster the end result of my stone painting. For art societies and publishers I have often pulled editions of 100 to 200 prints, and they always came out with the same sustained quality. The technique can also be used with a power press for even larger editions at an experienced establishment such as Mourlot's in Paris.

The stone can easily be changed and corrected in the press; this makes the work more enjoyable, since one is in a position to complete an edition of 200 in many colors in two or three days.

A prerequisite of this technique is an absolutely accurate knowledge of materials and color combinations. I use a soft stone of yellow color, which is slightly grained to give the lacquer a better grip on the surface. I do my rendering on the stone with ordinary writing ink, which penetrates the stone and remains visible even after correction with an abrasive but does not print.

Afterward the ink is washed off, and the stone is counter-etched for about one minute with a 5 percent vinegar solution. After the stone is dry, I paint with lacquer, either undiluted or thinned down with alcohol. Since I usually start with the brightest color, I underpaint everything that is compatible with that color. I print this color, then work over the image with snakestone, brushes, knives, and so forth. In order to make changes and additions the stone has to be opened up again by counter-etching.

The lacquer can be dissolved in alcohol to change its density and can be manipulated like litho tusche. Water, ether, or benzine may be added to it to produce different textures. Additional variations of texture can be created with soft metal brushes.

If burned in after completion, the image assumes a different structure from that produced by allowing it to dry slowly. After drying, it is further burned in with a blowtorch and then etched with a very strong gum solution. It is imperative that after any correction or addition to the drawing burning in must be repeated. Then the stone is treated as usual—washed out, rolled up, and printed.

After one color has been printed, the stone is washed out so that the design remains visible but does not accept ink. Then the second color is drawn on the stone and printed over the first. And so on until the edition is completed.

JOHN ROCK
Xylene Transfers in Lithography

The xylene transfer has been a useful extension of printmaking techniques on the lithographic stone. Commercial xylene (xylol), a mixture of isomeric colorless hydrocarbons found in coal, wood tar, and certain kinds of petroleum, is used as a solvent to transfer reproductions from printed materials to the stone.

One of the materials xylene readily dissolves is offset ink. Limiting factors that will affect the transfer are the presence of driers in the ink, the kind of paper the images were printed on, the age of the ink, and the methods used to effect the transfer. The best results are obtained from sources that were printed by offset on coated stock with no driers in the ink.

Better control is maintained if the material to be transferred is placed face down

on the stone with a thin, dense paper mat between it and the stone, to limit the size and shape of the image. These materials can be taped lightly in position so that they will not move but can be lifted slightly to observe progress. With two small pads of cotton, one dry and one soaked with xylene, the transfer is made. By alternately rubbing the back of the image with the two cotton pads, the xylene is carefully forced through the paper, loosening the ink from its supporting paper and applying it to the stone. Obviously, too much xylene will make the ink run or smear. Also, a damp stone will impair the quality of the transfer; therefore, any stone that has been stored in a room without humidity control must be dried.

613 Maltby Sykes. Galaxy. 1967. Lithograph from trimetal plate, 21 3/4 × 15 5/8". Courtesy the artist

613

614 *Maltby Sykes.* Moon-Viewing House.
1967. Lithograph from bimetal plate,
29 3/8 × 20". Courtesy the artist

614

Burnishing devices other than cotton include pencils, fingernails, coins, and spoons, but these tend to stretch or warp the paper, making it more difficult to apply additional xylene and continue rubbing. With patience and care, however, a good sharp transfer is the result.

After the xylene evaporates from the stone and the ink is dry, drawing can be added to the stone if desired. Etching and proofing of the stone must be done carefully, and the method must be consistent with the type of work on the stone. For light images it may be advisable to delay etching the stone for several hours to ensure a better fix of the image to the stone. The etch must suit the drawing, and in proofing one must decide whether it is best to roll up or rub up the image; this can be determined with experience.

The entire procedure lends itself to interesting possibilities and variations. Some of my students have achieved impressive results by combining the xylene transfer with photoengraved cuts from local newspapers and by drawing directly on the stone.

MALTBY SYKES
Multimetal Lithography

Multimetal plates differ from single-metal plates in that they consist of two or more layers of metal, one of which is receptive to grease and another to water. Some metals, such as copper, have a natural affinity for grease. Others, such as aluminum or

PLATES 613, 614

stainless steel, have a greater affinity for water. If a printing image, which is to hold the ink, is put on the copper layer in the form of an acid resist, it protects the copper during the subsequent etching process. Unwanted copper is etched away, exposing the aluminum or stainless steel. Either aluminum or stainless steel is easily made receptive to water, establishing a nonprinting area. In printing, the copper image accepts ink and prints, while the aluminum or stainless steel accepts water and rejects ink.

Trimetal plates work by the same principle. Chromium, the top metal, accepts water more easily than grease. For this reason, it is used to form the nonprinting areas. The printing image is etched through the chromium to expose the copper, which will accept printing ink, and the image is therefore tonally reversed or negative. The base metal is simply a support and plays no part in forming the printing image unless one cuts through the copper layer in the engraving process described later.

The plates most commonly marketed in the United States fall into two basic categories: bimetal plates composed of stainless steel plated with copper or of aluminum plated with copper; and trimetal plates of stainless steel plated with copper and chromium, or mild steel plated with copper and chromium, or aluminum plated with copper and chromium.

Multimetal plates are generally available in thicknesses ranging from .012 to .025, though small plates may be of a lighter gauge. For large plates, heavier gauges are easier to manipulate. However, light gauges have certain advantages. They may be cut with shears or other instruments for metal collage, embossing, or special effects. Also, they are cheaper.

The artist may create his image on multimetal plates with any acid-resisting material. Lithographic crayons, tusche, rubbing ink, wax crayons, and grease pencils all work well. So do spray enamels or lacquers, asphaltum, powdered rosin, and all acid resists used in intaglio printmaking. Trimetal plates on a mild-steel base may be engraved with a burin or diamond point, and half tones may be obtained with the roulette, carborundum grit, snakestones, or any abrasive.

The advantage of multimetal plates lies in the fact that the image and nonimage areas are permanently fixed in grease-receptive and water-receptive metals. The image will not fill in or become blind if properly processed. If scum develops, it is easily removed without disturbing the image. If copper refuses to take ink, it may be made to do so by simple methods. Deletions are simple for multimetal plates; additions are more complicated but possible. Manufacturers furnish instructions for replating local areas on a plate.

Processing Multimetal Plates

Manufacturers supply processing instructions for their plates, and these should be consulted whenever possible. The proprietary processing materials marketed by manufacturers for their plates should also be employed for best results. However, these processing instructions are for photomechanical platemaking, and must be interpreted by the artist-lithographer to meet his needs.

The steps in the procedure are as follows: first, cleaning and counter-etching; second, creating the image; third, etching to establish image and nonimage areas for

PLATE 615

615 Multimetal plates

BIMETAL PLATES: Copper is top metal and forms printing image. Copper etch eats away unwanted copper to expose non-printing base metal of aluminum or stainless steel.

TRIMETAL PLATES, ETCHED: Chromium is top metal and forms non-printing surface. Chromium etch eats away unwanted chromium to expose copper for printing image. Corrections may be made by etching through unwanted copper to expose non-printing base metal of aluminum or stainless steel.

TRIMETAL PLATES, ENGRAVED: Base metal must be mild steel or zinc, both of which accept ink. Engraving tools cut through chromium to expose copper printing image. If copper layer is penetrated, base metal still holds ink.

615

printing; fourth, washing out and rubbing up; fifth, desensitizing and gumming; sixth, rolling up; and finally, printing.

Cleaning and Counter-etching

The plate is placed in an acid tray or sink and rinsed with water. It should be scrubbed lightly with a soft bristle (not nylon) brush, rag, or paper wipe to remove the protective gum coating applied by the manufacturer. Then the plate is flushed with the appropriate counter-etch solution and allowed to stand for 30 seconds.

Counter-etching both cleans and sensitizes the plate, making it receptive to grease, water, or gum, depending on which is applied first. Counter-etches actually dissolve some of the metal forming the plate surface, and, if left too long on the plate, will eat away some of the grain; a period of 30 to 60 seconds is usually enough.

Suggested formulas for counter-etches are: For aluminum-base bimetal plates, 2 ounces nitric acid to one gallon of water. For stainless-steel-base bimetal plates, 2 ounces nitric acid and 2 ounces phosphoric acid to one gallon of water, or 2 1/2 ounces sulfuric acid to one gallon of water. For trimetal plates having a base of stainless steel, mild steel, or aluminum, 2 1/2 ounces sulfuric acid to one gallon of water.

Stubborn spots of grease or oxidation are rubbed with FFF pumice. Finally the plate is rinsed with water and fanned dry.

Creating the Image

The image may be drawn, painted, transferred, or otherwise produced, but it must be done directly after the cleaning process. If the plate is allowed to stand before using, it will oxidize and have to be counter-etched again. The acid-resisting image will print as a positive from bimetal plates and as a negative from trimetal plates. To engrave trimetal plates, simply clean the plate surface, cut through the chromium with engraving tools or abrasives to expose the copper, rub up the image, and print.

If tusche or spray paints have been used, they must be allowed to dry or set.

An optional procedure is to shake a half-and-half mixture of rosin powder and talc over the image and remove the excess with a dust brush.

Etching for Image and Nonimage Areas

The term "etch" is a misnomer in stone or single-metal lithography, since the litho etch desensitizes, rather than eats away, the surface of the plate or stone.

In multimetal lithography both the desensitizing etch and the true etch are employed. For example, with a bimetal plate, unwanted copper is actually etched away with acid to expose the nonimage area. Then the exposed nonimage area is given a plate etch to desensitize it as completely as possible and increase the hydrophilic nature of the metal.

First the plate is covered quickly and evenly with etch. To move the etch over the surface the tray is rocked or the plate manipulated. A developing pad is convenient but not essential.

With bimetal plates, the base metal will begin to show through the copper within a minute or a minute and a half, usually about 80 seconds. When this occurs, the plate is removed from the etch and rinsed with water. The old etch is poured off and fresh etch applied. The base metal should become clear of copper quickly (usually

from 20 to 30 seconds), forming the nonimage area. Etching may be repeated, if necessary, followed again by thorough rinsing with water.

With trimetal plates, the copper will appear through the chromium. As chromium dissolves, it will form bubbles and then discolor. Copper will begin to show through the chromium in 50 to 80 seconds, depending on the type of plate. When this occurs, the plate is removed from the etch, rinsed with water, and inspected. The old etch is then poured off and fresh etch applied to the plate. The copper should clear in about 30 seconds. The plate is removed from the etch immediately and again rinsed with water.

Proprietary etches are provided by manufacturers under several trade names. The usual etches for bimetal aluminum plates are basically ferric nitrate, whereas etches for stainless-steel bimetal plates generally contain ferric chloride. Neither of these two etches has particularly objectionable fumes. When used on the plates for which they are intended, they remove only copper and do not attack the base metal.

Most etches for chromium contain hydrochloric acid, and very irritating fumes are produced. Down-draft ventilation or a respirator with acid filter is required in using these etches. The chromium etch manufactured by Printing Developments Incorporated is nonfuming and may be used without special ventilation. Chromium etches do not attack copper or the base metal, and copper etches do not attack chromium.

Many mordants prepared by the artist for etching copper intaglio plates may be used for bimetal plates. The following are examples: For etching aluminum-base bimetal plates, 1 part nitric acid to 3 parts water may be used, or, if desired, a stronger or weaker solution. To activate the etch, a little old etch may be added or a penny may be left in the etch until it takes on a bluish color. An alternative mixture is a 47-degree Baumé solution of ferric nitrate. To decrease the speed of the etch water may be added.

For etching stainless-steel-base bimetal plates, nitric acid is used in the same way as for bimetal plates, or a 43-degree Baumé solution of ferric chloride, with water added to slow the speed of the etch, as described above. A third mixture suitable for these plates is Dutch mordant (1 ounce of potassium chlorate in 27 ounces of very hot water with 5 ounces of hydrochloric acid). To increase the speed of the etch the proportion of water may be decreased.

Neither Dutch mordant nor the ferric chloride solution is suitable for etching aluminum-base bimetal plates.

For trimetal plates (either aluminum-base or stainless-steel-base), the following nonfuming etch is recommended by the Graphic Arts Technical Foundation (formerly Lithographic Technical Foundation) in *LTF Research Progress,* No. 17: 3 quarts aluminum chloride solution, 32-degree Baumé; 5 1/2 pounds granular, technical-grade zinc chloride; and 5 ounces 85 percent phosphoric acid. The zinc chloride is dissolved in the aluminum chloride solution. The resulting solution should have a Baumé of at least 55 degrees. If the Baumé is higher than 55 degrees, the solution must not be diluted with water. If the Baumé is lower than 55 degrees, more zinc chloride is added to bring it up to 55 degrees and then the phosphoric acid is added. Total volume of the finished solution is about one gallon.

If any difficulty is experienced in obtaining the aluminum chloride solution or granular, technical-grade zinc chloride from local supply houses, they may be

55 Henri de Toulouse-Lautrec. Poster for the portfolio
 Elles, *published by G. Pellet, Paris, 1896.*
 Color lithograph, 20 3/8 × 15 3/4". Museum
 of Modern Art, New York (gift of Abby
 Aldrich Rockefeller)
56 Pierre Bonnard. Portrait en Famille. *1893–94.*
 Color lithograph, 8 1/2 × 10 1/2". Courtesy
 Associated American Artists, New York

57 *Édouard Vuillard (1868–1940).* Les Deux
Belles Soeurs. *Color lithograph, 13 3/4 × 11 1/8″.*
Courtesy William H. Schab Gallery, New York
58 *Paul Cézanne.* The Bathers *(small plate). 1897.*
Color lithograph, 9 1/8 × 11 3/8″. Courtesy
Associated American Artists, New York

59

59 *Ivan Lebedev*. Red Army Soldier and Sailor. *1922.*
Color lithograph, c. 8 1/8 × 7″. (From Werner
Schmidt, Russische Graphik des XIX und XX
Jahrhunderts, *Leipzig, 1967)*
60 *Fernand Léger*. Marie, the Acrobat. *1948. Color*
lithograph, 21 11/16 × 16 13/16″. Museum of Modern
Art, New York (gift of Victor S. Riesenfeld)

61 *Georges Braque*. Chariot III. *1955. Embossed color lithograph, 12 5/8 × 16 5/8″. Museum of Modern Art, New York (gift in honor of René d'Harnoncourt)*

62 *Pablo Picasso*. Figure au Corsage Rayé (The Striped Blouse). *1949. Color lithograph, 25 1/2 × 19 3/4″. Museum of Modern Art, New*

HH/75

Miró.
1948

63

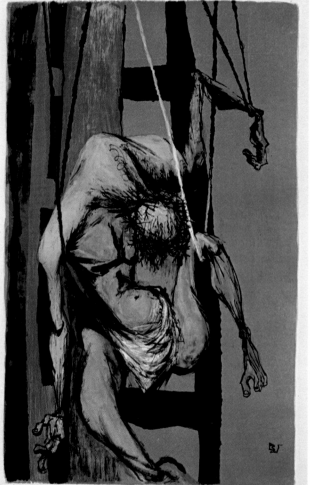

63 *Joan Miró.* Acrobats in the Garden at Night. *1948. Color lithograph, 21 3/4 × 16 1/8".* Museum of Modern Art, New York

64 *Charles Parsons.* Central Park, Winter: The Skating Pond. *Second half of 19th century. Colored lithograph, published by Currier & Ives. New York Public Library, Astor, Lenox and Tilden Foundations (Prints Division)*

65 *Benton Spruance.* Black Friday. *1958. Color lithograph, 21 1/4 × 12 1/2".* Yale University Art Gallery, New Haven, Conn. *(gift of George H. Fitch)*

66 *Tadeusz Lapinski*. Mother Nature.
1970. Color lithograph, 24 × 12",
with progressive proofs 1 and 2.
Courtesy the artist

67 *Paul Wunderlich*. Models in the
Studio. *1969. Color lithograph.*
Collection the author

68 *Christian Kruck. Untitled (final print, with progressive proofs 1–4). Color lithograph, 22 7/8 × 28 3/8". Courtesy the artist*

25.1 70

69 *Reginald Neal. Red Circle Moiré No. 2.*
1965. Color lithograph, 11 5/8 × 11
5/8". Courtesy the artist

obtained from any of the following: Grasselli Chemical Division of the E. I. duPont de Nemours Co., Wilmington, Del.; General Chemical Corporation, 205 S. 16th St., Milwaukee, Wisc.; or Mallinckrodt Chemical Works, 2d and Mallinckrodt Sts., St. Louis, Mo.

Washing Out and Rubbing Up
First the plate is flooded with counter-etch solution. It is kept wet with the solution while the acid-resisting image is washed out with turpentine or other appropriate solvent. Then it is flushed clean with water.

When the copper image area has been made ready for inking, the image is "rubbed up" with an ink prepared for that purpose. This is accomplished with two rags, one wet with the counter-etch solution and another with rub-up ink. With one rag an area is dampened with the counter-etch solution, and the other rag is charged with a small amount of rub-up ink. It is better to put a drop or two of turpentine on the ink rag prior to inking it. While the area to be inked is still damp, the ink rag is rubbed over it with a circular motion. The dampened nonimage area will reject ink, while the copper image area will accept it. If the copper does not take ink well, it is rubbed with dilute phosphoric acid (8 ounces of 85 percent phosphoric acid to a gallon of water) or dilute sulfuric acid (2 1/2 ounces to a gallon of water) and a little fine pumice. There are also preparations made by most manufacturers to activate the copper. If the nonprinting area takes ink, rubbing with counter-etch solution and pumice should clean it.

The process of dampening and rubbing up small areas is continued until the entire image is inked.

Desensitizing Etch and Gumming
This step is carried out immediately following the preceding one. A plate etch consisting of 1 ounce of 85 percent phosphoric acid to 32 ounces of 10-degree Baumé gum-arabic solution is applied with a brush or viscose sponge. Gradually the etch is smoothed out with a dry rag or paper wipe and rubbed to a thin, dry film. This also serves as final gumming.

The plate may now be either stored or printed. The rub-up ink is washed out of the image with asphaltum and the plate rubbed dry. If the plate is to be stored, it should be left under asphaltum. If printing is to proceed, the dried etch is sponged off with water, the plate is rolled up with printing ink, and the process goes forward.

Printing
Multimetal plates can be printed under felts on an etching press, as in intaglio printing. Best results are obtained by soaking the paper.

To print multimetal plates under the scraper on a lithographic press, a lithographic stone slightly larger than the plate itself is needed as a support. The back of the plate and the surface of the stone are both dampened. When the plate is placed on the stone, it will adhere firmly. Printing then proceeds in the usual manner.

[NOTE: Adapted with permission from Maltby Sykes, copyright © 1969, and Pratt Institute, Brooklyn, N. Y., copyright © 1968.]

REGINALD NEAL

COLORPLATE 69 Notes on the Photolitho Process

3M(R) Presensitized Aluminum Plates

3M presensitized aluminum plates come from the manufacturer coated on both sides with a light-sensitive emulsion. Therefore, *plates must be protected from light and moisture,* because light hardens the emulsion, making it receptive to ink, and moisture destroys the emulsion.

For working directly on the plates, the work light must not be stronger than a 25-watt incandescent bulb. Natural daylight and fluorescent lights are too strong. The emulsion on plates is very slow and requires strong photo flood or arc light for exposure, but, even so, long exposure to any light will eventually affect the emulsion.

Drawings can be made directly on the plate with any material that will adhere to the smooth surface and at the same time prevent light from reaching the emulsion underneath the drawing. Soft litho crayon, tusche, or photographer's red opaque paint work well. Opaque materials such as black paper stencils or small flat objects (coins, washers, etc.) can be laid on the plate. When objects of different thicknesses are used to block out light, exposure cannot be made in the vacuum table. Instead, a photo flood No. 2 bulb in reflector is held 18 inches above the plate for an exposure of 5 to 8 minutes. The direct method will produce essentially black-and-white images (no half tones). Exposure must be made long enough to produce solid blacks and whites. *Cutting down on exposure to obtain gray areas is not satisfactory.*

Removing the emulsion locally by scraping or by the use of a solvent will produce a white printed area. Thus, a white-line drawing can be obtained by scratching through the emulsion with an etching needle or other sharp tool. Larger areas of emulsion can be removed by the use of an abrasive such as a "scotch hone" or emery paper. When working directly on presensitized plates, it is essential to work as rapidly as possible in a subdued light. The surface of the plate must never be touched with the hand, for grease and moisture from the skin will damage the emulsion.

Handmade negatives for black-line drawings may be prepared as follows: A piece of clear (or frosted) acetate is coated with black acrylic paint, brushed or rolled on in several coats until no light can penetrate and allowed to dry thoroughly. Then, with sharp tools (razor blades, etching needles, dental tools, or knives) the paint is removed, exposing the acetate. If large white areas are desired, paint may be removed with solvent.

A large selection of textures and half-tone effects can be created by the use of Zip-a-Tone papers to break up the pattern of exposure on the emulsion. These may be used directly on the metal plate or incorporated in the handmade negatives if a pattern is desired instead of a black line.

Photo negatives (as opposed to handmade negatives) offer greater possibilities. These can be made from original line drawings, from printed half-tone material, or from the incorporation of Zip-a-Tone in the original art work. The finished art work (usually on illustration board) is made into a line negative, which is then placed in the vacuum table for exposure on the 3M plate.

A full range of values (from subtle grays to solid blacks) can be achieved by employing the photo screen method. This requires that the original art work be photographed through a screen, which breaks up the image into minute dots. The

screens are referred to by the number of lines per square inch: 60-line, 100-line, 150-line, on up to 300 or more lines. The greater the number of lines, the greater detail. Half-tone negatives may be incorporated with any of the previously described methods or used for the entire image on the presensitized plates.

ST Grained Aluminum Plates

The coating solution is prepared by adding all of the ST Super-D powder to the ST base solution. The liquid must be shaken vigorously until the powder is dissolved. In this form, the solution will keep for one week at normal room temperature.

ST plates are ready for use and do not require any treatment prior to coating. Care should be exercised in handling the plates to avoid smudges or fingerprints that may reproduce. The plate is placed on a table, over waste sheets somewhat larger than the plate itself. A small amount of ST coating is poured on the plate and spread evenly with ST wipes. Other wipes may leave lint, which can cause pinholes or otherwise damage the work area. The wiping strokes are alternated first from side to side, then up and down, to obtain a uniform, smooth coating. The plate is then dried thoroughly with fresh ST wipes. The operation must be performed in subdued light (yellow or gold fluorescent lights are recommended), and plates should be coated, exposed, and finished the same day.

Exposure of the ST plate is done in the usual manner. A Solid Step 6 on the L.T.F. exposure guide will provide a satisfactory print.

The Super-D developer must be shaken well before use. A sufficient amount is poured onto the plate and worked over the entire plate area with a damp sponge. When the plate is completely developed, the image will have an intense color. Excess developer is then rinsed off, and the cleaning operation is completed with a cotton swab under running water.

Excess water must be drained by tilting the plate (not squeegeed). Following this, Super-D A.G.E. is poured on the wet plate and, with a damp cellulose sponge, rubbed over the entire plate, with special attention to the image area. This operation will give an extremely water-repellent surface to the image area. The A.G.E. is not rinsed off the plate when it is taken out of the sink.

The final step is to add a little Super-D gum etch, spread it around with a damp cheesecloth, and dry with a soft cloth, as if the gum etch were a gum-arabic solution.

MISCH KOHN

Photolithography

The photographic method in both stone and metal-plate lithography is a useful addition to the hand-drawn processes and may be used along with them. However, the photo elements should be put on the stone or plate first.

The four chemicals used are the standard ones prepared for aluminum-plate lithography: sensitizing solution, powdered sensitizer, red lacquer developing solution, and A.G.E. solution (asphaltum gum etch).

Steps in the procedure are as follows:

The stone is ground as usual. (The finer the grain, the closer the texture of the image.)

In a small container such as a baby-food jar 1 ounce of sensitizing solution is mixed well with 1/4 teaspoon of sensitizing powder. The concentration should stain

an intense yellow. This mixture will not keep and must be prepared fresh each day.

A part of the solution is poured on the stone and spread with a small piece of sponge to cover it at once. It must be wiped thin and without streaks, and then allowed to dry. (As the solution is spread thin, it dries in about a minute.) Lint particles should be dusted off. The stone will be stained yellow; it is now light-sensitive but reacts very slowly; it can be left uncovered for several minutes without being affected.

The photographic negative is laid, emulsion side down, on the plate or stone. This has to be a high-contrast Kodalith negative or a negative with a half-tone screen built into it. A continuous-tone negative will not work. Instead of the photo negative, a drawing in ink or soft pencil on tracing paper or acetate plus Zip-a-Tone dot-and-line screens may be used to form a collage image.

The borders are blocked off with aluminum foil, and a glass plate is pressed down on top of the negative with care to ensure a good contact.

A light source is necessary to expose the stone; the best is an arc lamp. However, it is possible to use a mercury-vapor sun lamp or photo floodlights; even sunlight will do, but it takes much longer. The light source should be suspended 18 to 24 inches above the stone. The exposed bright yellow of the stone will have dulled somewhat after 5 minutes; to check this the light must be removed. The color will appear as a grayed orangish green, depending on the natural hue of the stone. If the change in color is not very apparent, another 3 to 5 minutes should complete the exposure. It is difficult to overexpose a stone.

After sufficient exposure the stone is placed on the sink, and a wipe-on developer is applied. The bottle should be shaken well before use. A small pool about 5 inches across on the stone should be adequate to cover the entire image. It is then wiped with a small piece of clean sponge, worked back and forth with smooth, even strokes. The developer will begin to stick to the image; as wiping pressure is increased, the image will pick up more and more lacquer. The image should be a solid red at all points when fully developed.

The stone is then rinsed well with cold water and allowed to dry. All excess red developing lacquer should be rinsed off.

A bottle of A.G.E. should be shaken vigorously and a few ounces poured on the stone. With a clean sponge the image part of the stone is covered and rubbed fairly hard. Then the A.G.E. is wiped thin and left to dry like a normal gum etch. (The A.G.E. contains a mild gum etch and asphaltum, leaving a greasy deposit and making the image receptive to ink.)

After the stone has thoroughly dried, it is again rinsed with water, wiped with a sponge, and rolled up as if it were a drawn image. The lacquer stays on the stone throughout printing. The stone may be resensitized with acetic acid, and further drawing can be done around, within, or over the photographic image.

Etching is done in the normal manner for stone (10 drops of nitric acid plus 3 drops of phosphoric acid in 1 ounce of gum). If part of the photo image is not wanted, it can be scratched away with a knife edge or pumice stick before the etch.

JAMES LANIER
Photosensitizing Metal and Paper Plates

PLATES 616, 617

Photographic Litho Plates
There are many different types of metal plates available to the artist. It has been my

617

616 Robert Rauschenberg. Kiesler. 1966.
Color offset lithograph, 33 15/16 × 22".
Museum of Modern Art, New York
(John B. Turner Fund)

617 Allen Jones. She's Real, He's Real. 1964.
Color offset lithograph. Philadelphia
Museum of Art

616

experience that the presensitized plate offers the best all-round service with the greatest dependability. The stability of presensitized plates, together with the elimination of the several chemicals necessary for sensitizing, makes them well worth the additional cost. Many different presensitized plates are available in the United States. My own choice has been the 3M brand S plates. They are very easily worked and long-lived. Only two chemicals are needed to develop and gum them.

Whatever the choice, the manufacturer's recommendations, included in each package of plates, should be followed.

Such plates may be printed either on an offset press or on a stone litho press. The offset press derives its ink impression from a rubber blanket on an intermediate cylinder. Therefore, through a double transfer, the image appearing on the plate is printed exactly as it shows there. If the plate is printed directly on a litho press, only one transfer is effected and the image is reversed.

Art work for platemaking is prepared on any transparent material and may be composed of combinations of line and half-tone copy.

Proper equipment for the making of plates is essential. The items are: a copy camera, used for making line and half-tone negatives; a vacuum frame to effect complete contact of the plate emulsion with the copy, which prevents light leakage around the edges and resulting distortion; and a light source. For this last requirement the carbon arc is the best choice, but photo flood bulbs, ultraviolet lamps, xenon lights, or daylight fluorescent tubes will give satisfactory results. If a vacuum frame is not available, a piece of glass held securely in place over plate and copy will serve reasonably well.

When printing the plate on a litho press, I use a mixture of 1 ounce of 3M brand fountain concentrate to 1 ounce of gum arabic and 1 gallon of water for dampening the plate. Offset inks give excellent results but may have to be thickened with corn starch or other materials.

Aluminum plates oxidize if not protected by gum. Plates should never stand unprotected for more than a few minutes without gumming.

Direct-image Paper Plates

Paper offset plates offer an inexpensive method of producing single- or multicolored prints. The Remington Rand Company produces a plate called Plasti-Plate that can be drawn on directly with several media. The same company makes a ball-point pen obtainable in fine, medium, and broad points. Higgins violet ink works very well for any method of application. Litho crayon and pencil can also be used, as well as thinned tusche.

The major problem in the use of paper plates is the necessity of printing them on an offset press. One must either have one available or find a printer who will print for him. The plate must be cut specifically for the press that is to print it, and the margins must be provided for on the plate.

There are available photosensitive paper plates which permit the incorporation of a photo image together with the drawing. On these the photo plate is produced first and the image is then drawn on it.

[NOTE: Adapted with permission from *Artist's Proof*]

V
THE SILKSCREEN PRINT OR SERIGRAPH

CHAPTER 16

THE SILKSCREEN PRINT OR SERIGRAPH

HISTORY

Silkscreen is the most recent of the printmaking processes to attain the status of an art form, having suffered in the past from unfavorable association with the commercial uses of the medium. The low regard in which screen prints were held for more than a quarter of the present century is indicated by the coinage of a new name, "serigraphy," attributed to Carl Zigrosser, in order to distinguish art prints from the screen-processed images mass-produced for commerce and industry.

The basic principle of the technique was that of forcing color through the interstices of a silk fabric left open around images cut out of paper and attached to the silk, thus printing the design on a surface laid underneath. In the beginning the stencil was essentially a simple silhouetted design serving to block the passage of color to the printing surface. Later improvements included many radical changes in the basic material of both the resistant stencil and the porous mesh that supports it, as well as chemical sensitizing of the screen fabric to permit the transmission of photographic images.

The stencil process cannot be traced to any one inventor; its antecedents are lost in the remote past. In some of the earliest art periods there appears the "stenciled hand," a motif evolved by prehistoric artists who sprayed color around the spread fingers of a human hand on rock surfaces. In primitive societies stencils may also have been used to tattoo the human skin.

In the Orient stencil patterns have appeared since ancient times. Chinese cut-paper designs were used not only as an independent art form but also to transfer patterns to cloth for embroidery. In Japan the stencil method achieved notability in the Kamakura period, when samurai leather armor and horse trappings were embellished in that manner, and later, in the seventeenth and eighteenth centuries, when silks were printed through silkscreened stencils. The Japanese developed a unique solution for one of the major technical problems involved in the process—that is, how to hold together the parts of the stencil that become separated when the silhouette forms are cut out. In general this was accomplished by leaving strips of paper or "bridges" connecting the "islands" of the design, a device frequently seen in the stenciled lettering on present-day bales and crates. The Japanese held the sections of their delicately cut stencil elements in place with hair or slender silk fibers, which formed bridges so inconspicuous as to be almost invisible in the printed image.

In America, from colonial times on, furniture, tinware, fabrics, walls, and other surfaces were decorated by stencil—a technique that not only facilitated the labor of the craftsman but also permitted a system of "repeats" for allover patterns. Prized by collectors of folk art are also the "theorem paintings" (often flower and fruit motifs hand-colored through stencils on velvet), the painstaking work of schoolgirls and leisured ladies of the nineteenth century.

In England, some sign painters at the beginning of this century must have used the silkscreen method for their trade but attempted to keep their procedures a secret for many years. About 1900 the usefulness of the technique to industry had become fully apparent, and patents were taken out for specific uses in England and the United States (c. 1907 and 1915). Banners, posters, show cards, billboards, and labels were issued in vast quantities. In consequence, the medium was viewed as a commercial process for mass production. Artists and printmakers gave it a wide berth, instead of welcoming it as a new form of graphic expression, as earlier artists had embraced or revived engraving, mezzotint, and lithography. Aggravating the situation were

certain biases of established print organizations and juries, which often held the silkscreen ineligible for admission to exhibitions.

Very rarely some artists early in the century found in the stencil process a tool for creating prints that added a new idiom to their graphic vocabulary. The *Seated Cat* by Théophile Steinlen, a Swiss-born artist who lived in Paris and died in 1923, stands out as one of the finest early examples of the long-neglected silkscreen medium.

In the United States it was the Great Depression of the 1930s and the efforts of the WPA Federal Art Project that prompted a group of artists, headed by Anthony Velonis, to experiment with silkscreen for artistic purposes. In those difficult times the inexpensiveness of the equipment needed for the process offered an important economic advantage over the other print media. The materials were easily assembled, constructed, and operated without heavy investment in copper plates, presses,

PLATE 618

618 *Théophile Steinlen. Seated Cat. Early 20th century. Color stencil print, 14 × 11 1/2". Boston Public Library (Wiggin Collection)*

618

619

stones, wood blocks, and the other paraphernalia of the relief, intaglio, or lithographic media.

At the bedrock level of expense, the nucleus of a serigraph print shop needs only the following basic materials: a wooden frame covered by a piece of fine-meshed silk tightly stretched in the manner of a canvas and attached with hinges to a baseboard; stencil paper or other masking material from which to cut out the image elements; a squeegee or similar device for squeezing the color through the silk mesh; special inks or paints; paper for printing the editions; and either a rack or the time-honored clothesline with clothespins for drying the prints. Depending on the adhesive properties of the colors used, the silkscreen process can be applied to almost any surface, including glass, metal, plastics, textiles, ceramics, and synthetics of virtually any shape and texture. Special high-quality paper is not essential, nor is the size a crucial factor, for the frame can be made in almost any dimensions to accommodate the image without great difficulty. And finally, silkscreen printing can easily produce very large editions. This fact enabled artists during the Depression to reach a wide, low-income public ready to buy inexpensive original prints.

For such reasons some American artists of distinction turned their talents in the
PLATE 619 1930s to experimentation in the medium, among them Ben Shahn, Robert Gwath-

619 Ben Shahn. All That Is Beautiful. *1965.*
Silkscreen, 26 × 39". New Britain
Museum of American Art, New Britain,
Conn. (Stephen Lawrence Fund)
620 Marcel Duchamp. Self-portrait. *1959.*
Color silkscreen, 7 7/8 × 7 7/8". Museum
of Modern Art, New York (gift of Lang
Charities, Inc.)

620

mey, Harry Sternberg, and others with a social conscience, who tried to refine or redefine this commercially abused process. The traditional methods had generally presented areas of unmodulated color, faintly textured by the grid of the screen, defining forms and shapes with little subtlety. Those artists attempted to impart to this seemingly inflexible and somewhat mechanical medium some of the painterly quality of their own individual styles and, with it, their concern with the social and political issues of their time.

This kind of effort to "personalize" the silkscreen print and improve its visual quality continued to some extent with the artists of the 1950s, including the Abstract Expressionists and Action Painters, such as Jackson Pollock, who explored the medium without becoming enamored of it. Even anti-artist Marcel Duchamp, never very active as a printmaker, tried his playful hand at the serigraphic *Self-portrait* shown here. PLATE 620

In Germany, ironically, interest in the medium was generated as late as the end of World War II, when American airplanes landed in Cologne, their fusilages decorated with screened decals of the lusty, comic, and vainglorious emblems that proclaimed the group spirit of their crews.

Not until the late 1950s and early 1960s, however, did serigraphy develop into the generally acclaimed and accepted medium of the so-called avant-garde, producing a plethora of exhibitions and a cross-breeding with other media that breached and finally broke down long-established barriers and definitions. The responsibility for this turn of events rests largely upon the new concepts of certain popular art movements and the advancement of technology in silkscreen printing, utilizing photographic devices.

Pop art, for example, moved in with a widespread adoption of found objects and of images from the mass-communications media. Op art worked by means of concentrating on colors and shapes chosen to induce optical illusions in color and motion. The so-called "hard-edge," "stripe," "color-field," and "sign" paintings found their footing in bold and clear-cut shapes and contrasts of rather flat color; and Minimal art made use of ultrasimplified forms and almost indistinguishable modulations of color or texture. Often the aim was to obliterate the artist's personality, his individual brush stroke, the handmade touch that would single him out from the mass culture he wished to represent.

PLATE 628

The same visual qualities that were objectionable to the artists who first approached the silkscreen made it a "natural" for the "cool," impersonal product, as well as for the faithful reproduction of photograph elements from the mass media for collage purposes. In addition, the adaptability of the silkscreen to shaped, three-dimensional surfaces of depth and volume fitted conveniently into the growing tendency to confound the traditional categories and boundaries of painting, sculpture, and printmaking.

Many well-known artists identified with these movements have turned to serigraphy, among them Pop artists Robert Rauschenberg, James Rosenquist, Andy Warhol, and Roy Lichtenstein; Victor Vasarely and Richard Anuszkiewicz, conspicuous as Op exponents; and Josef Albers, the patriarch of hard-edge imagery, along with such younger men as Robert Indiana, Frank Stella, Nicholas Kruschenek, Jack Youngerman, and others.

PLATES 621, 622

COLORPLATE 70

The technical developments that went hand in hand with these approaches to art were not all entirely new. Photography, for instance, had long been used in the commercial screen process. It was the eagerness of artists to adopt more mechanical, less autographic modes of expression that brought to the fore a number of unconventional materials and procedures. One great advantage of the stencil method has always been that the image created on the screen does not have to be prepared in reverse by the artist. By sensitizing the screen and applying to it a photographic positive film, one can also develop the screen into a negative and produce a positive image on the final print. The film, of course, can be prepared from either the artist's own design or any image from other sources.

COLORPLATE 74

New substitutes for the paper stencil have been thin metal foil, heavily varnished papers, plastics, adhesive films and tapes, and masking fluids. The use of these fluids, which can be freely brushed on the screen, eliminates the rigidity of outline originally associated with the knife-cut stencil and opens the way for more spontaneous painterly effects, once so difficult to achieve in this medium.

Instead of silk for the screen, one can use stainless-steel mesh or synthetic gauze so fine that it allows considerable detail in half-tone and continuous-tone images, thus freeing the serigraph from some of its original textural limitations. Also available are thermo-electric screens, which produce a print that dries almost at the instant of contact. Many silkscreen printing plants have motorized equipment and can print several thousand impressions per hour on rotary and mechanized flat-bed presses.

With the availability of so many new tools and materials, and with the preoccupation of many artists with mass communication, it was inevitable that the former criteria of printmaking should be severely questioned. The Print Council of America, for example, had decreed that a print could be considered original only if it had been

621 Robert Rauschenberg. Signs. 1970. Photo silkscreen, 43 × 34". Courtesy Castelli Graphics, Inc., New York

622 Andy Warhol. Banana. *1966. Color silkscreen, 52 × 24". Courtesy Castelli Graphics, Inc., New York*

622

prepared, produced, and executed by the artist. But for a new breed of artists the technical aspects of producing silkscreen prints were of interest only in the conceptual stage—the problems of composition and juxtaposition, choice of photographic images, color schemes, and interpretation of the source materials conveyed through size, placement, repetitions, and textural manipulations. Unskilled or uninterested in the minutiae of the technical procedure, they preferred to turn over to workshop technicians their detailed instructions, images, and color notes, and stand by for consultation or leave the execution entirely to the printing professionals. It seems that the print totally made by the hand of the artist is on the way out; in fact, it had not always been in. Even in the distant past of printmaking the great German wood-

cut artists had relied on the skill of their formcutters, as many of the great French artists of our time have depended on their master printers. Collaboration had existed throughout the centuries between artists and workshop technicians. The twentieth century has extended such teamwork even further.

Sharp controversy has greeted the use of material such as photographs and images transferred from the printed mass media. If the images were not created by the artist and no part of the print was executed by his hand, why should the result be called an original print? However, artists today may claim that their contribution is as original and valid as the assemblages, collages, environments, and *objets trouvés* that have been exhibited as art in the heyday of Dada, Surrealism, and Pop—and their point of view has found general acceptance today.

The silkscreen thus brought into sharper focus some of the disputes over stand-ards and definitions that had been troubling the print field for some time. The sig-nature itself gave rise to more argument. Formerly each print was supposed to be hand-signed by the artist, but if the edition runs to thousands, the handling of the signature presents serious physical problems. In such cases the artist has sometimes consented to have his name added by rubber stamp, a questionable practice which may throw the whole problem of the value of the artist's signature and of the signed and numbered print into a cocked hat.

It will take time for these new concepts in printmaking to be reconciled with traditional ideas, and much of today's output of serigraphy must still bear the stigma of its commercial past. The fact remains that serigraphs are now "in" and singled out for popular exhibitions because so many prominent painters, sculptors, and experi-enced printmakers, for better or for worse, have taken the medium to their hearts.

In France, Vasarely's Paris workshop has been instrumental in spreading the silkscreen process for both artistic and commercial purposes. The complex collages of Eduardo Paolozzi, an artist of Scottish and Italian ancestry, and Ronald Kitaj, an expatriate American, have made a considerable impression both in England and in America. Their prints have often been labeled "literary," for they frequently combine verbal matter, puns, and word allusions with diverse clippings and sometimes esoteric images from the repertory of the printed media. Both have acknowledged their indebtedness to the skill and ingenuity of the printer Christopher Prater, who has the technical abilities to bring their ideas to realization. Another Englishman, Joe Tilson, has entered into the realm of mixed media with screen-printed reliefs on a foundation of vacuum-formed plastic sheets.

COLORPLATE 71, PLATE 623

Artists who prefer to work closely with landscapes and natural objects, such as Robert Burkert and, more abstractly, Steve Poleskie, have, in very different ways, adapted serigraphy to their subject matter. The figural painter and sculptor Ernest Trova has found the medium versatile enough for the many variations of his "falling man" motif. Corita Kent (Sister Mary Corita), whose subject matter is predominantly of a religious and humanitarian nature, has used silkscreen for both figural com-positions, such as *The Lord Is with Thee* (illustrated in the next chapter), and for her calligraphic messages, done with the casualness of graffiti. Clayton Pond and Ken Price have made effective use of flat, brilliant colors in compositions of indoor and outdoor scenes posing as still lifes.

PLATE 624

COLORPLATE 72

Among the well-known printmakers whose work in other media is illustrated elsewhere in this volume, Carol Summers, Andrew Stasik, and Misch Kohn have

PLATE 625

also worked successfully in serigraphy. Japanese-born Norio Azuma explores both textural and structural possibilities of hard-edge color squares in endless variations of the medium.

It is interesting that the stencil process, which had its earliest roots in primitive and prehistoric art, has returned to its origins in modern programs of art teaching among Eskimos and American Indians. In recent years, under the initial guidance of Canadian artist and writer James Houston, Eskimos in their West Baffin Cooperative Workshop have produced amazingly fine prints from stencils cut out of sealskin. In the studios and workshops of the so-called "developing" countries the silkscreen, with its low production cost and increasing prestige in the Western art world, is bound to play a more and more significant role.

Obviously, not all stencil methods result in prints (or in multiples), and not all screen-processed images are made from cutout stencils. *Pochoir,* a reproductive process developed in France, makes use of stencils, with color brushed directly onto the paper. Paintings, drawings, and watercolors by such artists as Blake, Severini, Klee, Kandinsky, Rouault, and Miró have been successfully reproduced in this medium. Because of their handmade appearance, *pochoir* reproductions have been used in limited editions of books and in print portfolios, often honestly identified as reproductions and not original prints.

PLATE 626

623 *R. B. Kitaj.* Bullets, Die gute alte Zeit. *1969. Silkscreen and collage, 41 × 26 3/4". Reproduced from catalogue, Galerie Mikro, Berlin (© 1969, Michael S. Cullen)*

624 *Ernest Trova.* Four Figures on an Orange Square, *from the* Falling Man Series. *1965. Color silkscreen, 25 1/16 × 25 1/16". Museum of Modern Art, New York (John B. Turner Fund)*

624

PLATE 627

Individual paintings by Robert Rauschenberg and other contemporary artists have sometimes had incorporated elements executed by silkscreen, and three-dimensional objects akin to sculpture have had color applied by silkscreen, whether or not they were produced as multiples. In recent years serigraphy has so frequently been combined with lithography, intaglio, and other media that the resulting prints, sometimes embossed with found objects and linked with electronic components, can only be appropriately described as "mixed media." This is the twilight zone of contemporary printmaking, and it will confound the experts and critics for years to come.

From the inception of printmaking one aim of the artist has been to make his work available to the art-conscious public with a slim purse. The so-called "art explosion" of recent years, with its seller's market, has somewhat negated this time-honored objective. The astronomical sums commanded by unique art objects are now approximated by the values placed upon rare prints by masters old and new, which, because of their age or their small editions, have inestimable scarcity value.

626

625 *Andrew Stasik.* State of the Union. *1970.*
Lithograph, silkscreen, and stencil,
24 × 31". Courtesy the artist

626 *Nivisksiak (20th-century Eskimo).* Man
Hunting at a Seal Hole in Ice. *Stencil*
print. Brooklyn Museum, New York

627 *Lucas Samaras.* Book. *1968. Silkscreen on*
die-cut plywood. Museum of Modern
Art, New York

627

No such factors affect the silkscreen print, which is capable of supplying any conceivable demand by the public if produced with the capacities of a mechanized modern workshop. Yet the large sums paid for multiples signed by "famous brand" names indicate an artificial scarcity created by planned limitation, so that the high cost of mechanization, labor, and overhead in the print shops is not offset by means of mass distribution. Perhaps it is the humble, truly handmade print, designed, produced, and printed in the artist's workshop, that in the end will survive and become the highly priced—and prized—"old master."

For the present, the silkscreen process as an art medium has proved its usefulness beyond a doubt. In some respects it has offered to the twentieth century what the first woodcuts did for the fifteenth—a relatively quick, creative way of disseminating ideas and images across the world.

628 Miroslav Šutej. Untitled. 1965. Silkscreen, 18 × 15 5/8". Collection Andrew Stasik, New York

CHAPTER 17
SILKSCREEN

TECHNIQUE

PLATES 629–635

Making the Screen

Although satisfactory screens can now be purchased ready-made, many artists still prefer to construct their own, which can be built quite inexpensively. The wooden members of the frame must be strong enough to withstand long use and must remain absolutely rigid under considerable pressure, to ensure accuracy of registration. The silk (or other mesh material) must be strong and not inclined to ripple or stretch. Nylon and other synthetic fibers, while usable, tend to be more expensive and more prone to stretch than silk. Even fine metal mesh can be used; it provides an extremely rigid surface for very fine line work but can easily be dented.

The best silk can stand the greatest abuse and may last through many cleanings and several editions, if carefully handled. The closeness or coarseness of the mesh determines to some extent the texture of the print, and must be decided on the merits of each individual artist's intentions. Silk is graded from 6x, coarse, to 20xx, very fine; 12x is a versatile medium grade.

The size of the screen frame and baseboard depends on the maximum paper and image size desired and is limited by the width of silk available (allowing for a comfortable overlap).

The sides of the frame can be constructed from 1-by-2-inch or 1-by-3-inch pieces of smooth, medium-hard wood. These should be cut to the desired length and then staggered the width of the member to allow for interlocking corners. The corners are then securely screwed together; they must be checked against a square-edge to ensure perfect right angles and can be further strengthened with metal braces.

The silk, which should be slightly larger than the maximum dimensions of the frame, is then laid on and centered. The center of one side is then tacked or stapled in two or three places. With the fabric pulled very tight, the opposite side is similarly tacked to the frame. The same procedure is followed with the remaining two sides. Tacking continues from the center toward the corners, alternating sides, with constant pulling on the fabric. When completely tacked down, the fabric should be perfectly smooth and as tight as a drumhead.

At this point the area where silk meets wood may be reinforced with a tape margin. The frame should be turned over, silk side down, and a strip of gummed paper or cloth-backed tape attached to the silk all around the edge of the frame. The tape should be folded to extend part way up the wood to prevent seepage of ink between silk and frame.

A baseboard is then constructed of 1/2-inch-thick plywood. It should extend about 2 inches beyond the frame on each side, with a slightly wider overlap, if necessary, on the hinge side. In order to obtain an absolutely smooth printing surface, the plywood should be covered with a sheet of Masonite, nailed to the baseboard along its four edges. As an alternative to Masonite a sheet of Formica may be glued on.

The screen is attached to its baseboard with two movable-pin hinges to allow easy removal of the screen for cleaning.

Two alignment blocks (to keep the frame from shifting position during printing) can be attached to the baseboard at the right and left of the frame near the front corners; these are essential for proper registration in multicolor printing.

Now the frame, taped margin, and baseboard (unless Formica has been used) should receive several coats of shellac or plastic finish, sanded lightly between coats.

Various types of handles and props may be added to the frame to increase the efficiency of the printing procedure.

The Squeegee

The squeegee consists of a thick but flexible rubber or synthetic blade mounted in a wooden handle; it is used to force ink through the open mesh of the prepared silk-screen onto the paper. A wide variety of blades and handles are available commercially; these may be purchased either separately or already assembled. A process of trial and error will enable the artist to find the proper blade type and handle shape for his particular needs.

The blade must be flexible enough to ensure close contact with the paper and yet stiff enough not to bend excessively or wobble during printing. An unmounted blade may be tested by holding it between thumb and forefinger and trying to double it over. It should resist doubling, even at great pressure, and should always spring back into shape upon release.

The usual type of handle extends the full length of the blade and should be high enough for the fingers to be comfortably extended during printing. The squeegee should be at least an inch longer than the narrow dimension of the maximum image size to be printed. Some shorter squeegees come equipped with a vertical handle at the center of the blade holder; these are used by pushing rather than pulling across the screen.

In assembling a squeegee, the handle is cut to desired length, and the blade is worked into the socket and tapped against a flat surface to drive the blade in. A few nails or screws should be inserted on either side of the handle to hold the blade firmly in place. The handle may then be shellacked. The blade should be kept sharp and nick-free by rubbing on fine sandpaper.

Drying Equipment

A safe, clean method for drying freshly printed sheets must be provided. It may consist of a simple clothesline with clips or pins, or more elaborate fixed or mobile racks. If a line is used, the clothespins or other clips must swing freely and be moved along the line easily. This allows the prints to hang vertically at all times and makes for flexibility of arrangement. Adequate space must be left between prints to guard against touching one another in the passage of air currents. Light, heat, and moisture should be controlled to ensure slow, even drying.

If a rigid wooden frame or rack is constructed (to hang from a wall or be mounted on rollers like a mobile coat rack), the clips should be allowed to swivel freely by means of a nail driven through their central hole or some similar device.

Preparing Paper Stencils

The format should be planned to allow for a generous margin in relation to both the screen surface and the paper size. The image areas (open areas of the stencil) should be small enough to allow the squeegee to pass over them in one stroke without impinging on the tape margin.

Although many types of paper may theoretically be suitable for making stencils, certain characteristics are essential for trouble-free printing. The paper should be very thin, though strong and impermeable. It should cut cleanly with a sharp stencil knife

and not be prone to wrinkling or expansion under changing atmospheric conditions. Some very serviceable papers are lightweight bond paper, artists' "visualizer" paper, and lightweight vellum. Vellum and "visualizer" papers have the added advantage of transparency, which allows stencils to be cut more accurately in sequence.

Usually a separate stencil is cut for each color area of the design. However, when there is ample space between open areas, several forms may be cut into one stencil, each representing a separate color. During printing, secondary paper stencils are placed underneath the master stencil to block out areas which are not to print. These secondary stencils are removed and rearranged as printing progresses from color to color.

The artist may decide to use a working copy in the form of a master drawing or full-color sketch, which will guide the preparation of the stencils. On a piece of heavy white stock the maximum dimensions of the image are marked in strong line; the image is then drawn or transferred to this sheet. If, in the course of stencil-making or printing, the design or printed image deviates markedly from the original drawing, it may be necessary to substitute one of the printed proofs for the original drawing. This print then becomes the working copy, on which the subsequent stencils are based.

Preparing Lacquer-film Stencils

The lacquer-film stencil consists of a layer of lacquer laminated to a backing of transparent paper or Mylar plastic. The transparency is needed so that working copy may be placed underneath to serve as a guide in cutting the design. The image is cut through the lacquer layer only, with a light touch and a very sharp stencil knife. Areas intended to print are stripped away as soon as they are cut. The screen to which the stencil is to be attached should be cleaned with either lacquer thinner or soap and water before the stencil is placed. To ensure perfect adhesion of the film stencil, the screen must be entirely free of soil, sizing, or oily residue.

To attach the film stencil an adhesive fluid and some soft cotton rags are required. The usual procedure is as follows: First, the cut stencil is attached to the underside of the screen (film or lacquer side toward the silk) by means of three or four small pieces of masking tape to hold it temporarily.

Next, a soft, even padding, or "build-up," is placed on a level tabletop. Several sheets of newsprint should be adequate. The screen, with stencil held temporarily by masking tape, is placed face down on this padded surface to keep the stencil in close and firm contact with the screen.

Then two small soft pads are made by folding the cotton rag to a size of about 4 by 4 inches. One of these will be a "wet" pad; the other will be "dry." One is held in each hand.

The "wet" pad is moistened with adhesive fluid and applied briefly to an upper corner of the screen so that it penetrates to a small area of the lacquer film. About 4 by 5 inches should be wetted, then rubbed dry (gently) with the other pad. The adhering proceeds, area by area, with alternate wetting and drying until the entire film has been attached. As adhesion takes place, the softened lacquer moves upward into and between the interstices of the silk, becoming visibly deeper in color in the process. This deepening of color serves as a reliable indication of whether an area has been sufficiently treated. Caution and judgment must be exercised to avoid too much

629 Carol Summers. Fuji. 1971. Color silkscreen, 40 × 30". Courtesy Associated American Artists, New York

or too little moistening. Too many applications to one area will "dissolve" the adhesive, resulting in softened, imprecise edges in the final print.

Upon completion of this process, the screen is allowed to dry for about 10 minutes before the paper or plastic support backing can be stripped off. To remove the backing, a corner is gently lifted with a fingernail and peeled slowly and cautiously away. It should come away clean and intact, with no lacquer clinging to it. Margins beyond the film area are masked or blocked in with glue, and the stencil is ready to print.

To remove a lacquer-film stencil, lacquer thinner or destenciling liquid is used.

Preparing Glue Block-out Stencils

The liquid block-out stencil is the most painterly, autographic, and calligraphic means of stencil making. The nonprinting (negative) areas are blocked, or stopped out, by brushing on the screen a liquid which, when dry, will resist the solvent action of the printing ink. Such stencils have the advantages of ease of application and removal, a wide range of stylistic possibilities, and excellent durability for large editions. Vegetable or animal glues (such as LePage's Liquid Strength Glue), mucilage, and water-soluble gums are ideal for the block-out. White polymer emulsion glues should be avoided, as they are very difficult to remove. Lacquer and commercial silkscreen block-outs are also very useful.

With the liquid the artist paints on the screen (including the margins) a negative of his intended image. By adding or removing glue as the print progresses, he can build upon or cancel the forms created on a basic glue stencil. Some artists tint the block-out glue with tempera to keep a visual record of their manipulations of the stencil in the screen. Gauging the ultimate result, especially when a number of screens are to be overprinted, can become a rather complex matter. Trial and error is the only solution until sufficient experience is gained. Once the uncomfortable feeling of working in negative rather than positive forms is overcome, the glue block-out stencil becomes one of the most sensitive and versatile of stencil techniques.

Textural effects in silkscreen may be achieved by applying glue to a textile or other textured material and pressing it onto the screen surface.

Liquid block-out stencils can sometimes be reused for printing subsequent colors by either adding glue or by subtracting it from certain areas with solvent. This practice is particularly useful when overprintings of several transparent colors are desired.

Preparing Tusche-and-Glue Stencils

A variant of the glue block-out stencil is the tusche-and-glue stencil. In this method the positive image is drawn or painted directly into the silk with a glue resist. Greasy, oil-based resists such as lithographers' crayons, rubbing ink, oil pastels, grease pencils, asphaltum, or liquid tusche are used. A very heavy coverage of grease is required to ensure success.

Once the positive grease image is completed and dry, the screen is propped up horizontally an inch or two above the table surface so that the silk does not touch at any point. A glue mixture of about the consistency of heavy cream is prepared for blocking in the screen. The most popular mixture is 5 parts of LePage's Liquid Strength Glue, 4 parts of water, and a few drops of vinegar or acetic acid. A small

amount of glycerine may be added, if necessary, to increase the flexibility of the dried glue. With a thin, lightweight card (about 3 by 4 inches) a small amount of glue is carried to the inside of the screen and gently carded across the silk to get a thin, even coating. More glue is added in small amounts until the entire screen has been thinly covered. This is allowed to dry while the screen remains horizontal. As soon as the glue is dry (in about 30 minutes), the screen is lifted and examined for pinholes or gaps in the glue. It may be necessary to repeat this glueing-in process, always with a minimum of glue.

After the glue is dry, several layers of newspaper are placed on the work table and wetted liberally with kerosene, turpentine, or benzine. The screen is then placed (silk side down) on this padding of solvent-soaked papers and rubbed down against it from the inside with rags and more of the same solvent. It takes a few minutes for the solvent to work against the grease image from the underside of the silk. Then more solvent is rubbed on with rags from above. This should dissolve the grease image, taking with it any glue sitting on top of the grease. When the grease resist has been removed with the solvent, the screen is dried with rags or newspaper and examined against the light. The areas that were drawn in with grease should be clean and open and ready to print. After printing is completed, the glue stencil can be removed by washing with warm water.

Photographic Stencils
Photographic stencils of light-sensitive gelatin may be purchased in kit form with the chemicals necessary to develop them. Lights, photographic exposure frames, and trays for developing must be added to the ordinary silkscreen equipment if photo techniques are to be used. A fascinating range of effects can be attained by combining photographic positives and negatives with drawn elements. Indeed, almost the whole gamut of traditional silkscreen methods can be used with photographic images by

*631 Keith Milow. Print A. 1969. Color
silkscreen, 20 1/4 × 30 1/4″. Museum
of Modern Art, New York*

632

632 *Jack Perlmutter.* Coming and
Going, *1976. Color silkscreen.
Venable/Neslage Galleries,
Washington, D.C.*

633 *Roy Lichtenstein.* Fish and Sky,
from the portfolio Ten from Leo
Castelli. *1967. Color silkscreen
on photograph with laminated
textured plastic, 11 1/16 × 14".
Museum of Modern Art, New
York (gift of Mrs. Rosa Esman)*

633

635

634 *Andrew Stasik.* The Night Game. *1970.*
Litho–silkscreen–stencil, 30 1/4 × 22 1/4".
Courtesy the artist

635 *Eduardo Paolozzi.* Wittgenstein in New
York, *from the portfolio* As Is When,
Editions Alecto, London, 1965.
Color silkscreen, 30 × 21 1/8". Courtesy
Museum of Modern Art, New York

634

drawing directly on the gelatin film, exposing drawings done on acetate sheets, or
adding images directly to the screen after the photo-stencil has been affixed.

Papers and Inks
Although silkscreen prints can be made on any kind of paper, artists generally prefer
a fairly heavy, smooth, full-rag paper, because, in addition to ease of printing and

handling, longevity of the finished print is an important factor. A cheaper paper of lighter weight should be on hand for trial proofing. Extra sheets of the paper for an edition should be on hand to allow for the inevitable waste and imperfect proofs; one should add at least ten extras for an edition of fifty.

A wide variety of printing inks, artists' oil colors, and screen-process colors (which come in both mat and glossy types) can be used in silkscreen printing. They will print from opaque to highly transparent, depending on the admixture of transparent base, toner base, and thinning varnish. For an extremely transparent hue, highly concentrated pigments such as tinting colors should be mixed with a relatively high proportion of extender. The addition of toner base and varnish to the thick transparent base should take place before the pigment is introduced. The proportions will vary according to the thinness and flexibility required, but the transparent base should make up at least 50 percent of the mixture.

First the pigment itself should be worked on an ink slab with small amounts of the base mixture added from time to time until the two are thoroughly mixed. This will prevent the formation of lumps of concentrated pigment in the final mixture. Color and tone of the ink may be tested by dabbing or rubbing it on a scrap of the edition paper, but the manageability of the ink can be revealed only in trial proofing. It may be necessary to thicken or thin it slightly by adding more transparent base or thinning varnish.

A generous amount of each color needed should be mixed to ensure a uniform edition. Excess ink may be stored in covered tins for several months.

Printing

For printing, the screen and baseboard should be placed on a table of comfortable height, with easy access to the entire screen surface. The screen itself must be checked before printing to make sure that there are no pinholes in the blocked-out areas or obstructions in the open areas.

If several colors are to be printed, accurate registration can be accomplished by using register tabs. These can be constructed from small strips of heavy paper. The working proof is then placed in position on the baseboard and taped down. Two tabs are fitted against each of two adjacent sides of the proof and securely taped down. The work proof can now be removed and the first piece of proofing paper inserted within the tabs. Tabs of plastic or metal should be used for very large editions or when unusually heavy stock is to be printed.

A generous amount of ink should be poured in a line along the margin of a short end of the screen. Standing at the opposite short end with the screen braced against his body, the artist then pulls the squeegee firmly across the screen. Enough ink for several pulls may be poured at one time, but care should be taken to replenish before the supply on the screen becomes too scant to print evenly across the whole surface.

After the squeegee has been drawn across the screen, excess ink should be deposited in the margin by gently tapping the squeegee once or twice. The screen is now lifted, the first proof removed, and the next sheet eased into place against the tabs. For the second squeegee stroke the artist moves to the opposite end of the screen and draws the excess ink back across the surface.

Trial proofs should be carefully checked for evenness of printing and all necessary alterations made to the stencil before edition printing begins.

When a full run of one color is finished, the screen should be thoroughly cleaned of ink. First the heavy deposit of excess is scooped off with a spatula to be stored or discarded. Then the paper stencil (if used) is removed. The tape border is also stripped off if it has received ink (this border may be cleaned and reused). Newspaper is placed beneath the screen and paint thinner or other solvent is poured over the silk to liquify all traces of ink. The silk is rubbed with a rag, forcing the solvent and ink onto the paper below. Rubbing is continued, with more rags if necessary, until the screen is dry and free of ink. Persistently clogged areas may be scrubbed gently with a small brush. When the screen is clean and dry, the papers are removed and the baseboard dried. The squeegee, of course, should also be thoroughly cleaned with solvent.

Unless the glue stencil is to be saved, it should be washed out by immersing the screen in warm water or by hosing. A brush and soap may be used to expedite the washing. The clean screen should be dried and checked to see that the mesh is completely open.

A special destenciling fluid or lacquer thinner will remove film stencils. It is critically important that all vestiges of ink be removed at the completion of the day's printing. Inks allowed to harden in the mesh of the silk can be removed only by strong solvents or paint removers and much rough scrubbing, which leads to runs and tears and shortens the life of the silk.

NOTES ON SILKSCREEN TECHNIQUES

BY PROMINENT PRINTMAKERS

The personal preferences and methods described and illustrated below present only a brief sampling of the possible variations on the silkscreen process as it is utilized by today's printmakers.

The Silkscreen Technique of
NORIO AZUMA

Azuma prefers oil paint, chiefly Shiva or Windsor & Newton, to silkscreen inks. He uses 12- to 15-gauge silk, and for a stopping-out medium, instead of varnish, a mixture of ordinary LePage's glue diluted with 40 percent water, 8 percent white vinegar, and 2 percent glycerine, for a total of 50 percent glue. He finds that this is a very flexible and effective medium, with which he can produce any kind of stroke, fine or broad.

COLORPLATE 73

For texture he uses a mixture of sugar and water applied to the silk. It is easily washed out and leaves a slight pebbly grain, which he finds agreeable for his type of work. For his hard-edged shapes he uses paper stencils, and in order to create a kind of three-dimensional effect his squeegee has two edges, one rounded and one sharp, which builds up a rim of pigment on the edges of certain stenciled shapes.

His largest silkscreens are not printed on paper but on stretched linen canvas. He brushes them first with a coat of white oil paint, which is allowed to dry for several days. He then puts on the first shape, then another, and so on, building up a slight three-dimensional effect, with three or four shapes overlapping.

The editions on paper are usually limited to twenty for the larger prints and up to a hundred for the smaller ones.

ROBERT BURKERT
My Serigraphs

COLORPLATE 75

My ideas come from many sources, primarily from a direct study of nature through sketching trips, color photos and magazine clippings of objects or scenes that intrigue me. This body of material is spread around my studio and slowly assimilated. Over a year may pass before my visual ideas for a new serigraph edition take shape.

Most of my printing is done in the warmer months, because my studio needs a lot of ventilation during the printing and drying. When spring comes, I slow down on the painting that occupies me in the winter, and I make sketches for the four or five prints that I plan for the summer and fall.

I make a study sheet for each print, visualizing it in thumbnail sketches and quick color studies for each of the intended prints. My serigraphs average eight to twelve color runs. I usually print an edition of sixty, with fifteen artist's proofs and an additional fifteen to provide for the inevitable errors. The misprints are destroyed after the edition is completed. This makes a total run of ninety prints. Although I occasionally use others, my favorite paper is Tuscan Cover in Antique White.

Starting with a freshly cleaned silkscreen, usually 12xx in mesh count, I block in with water-diluted LePage's glue the first color run. This is generally a primary color, light and very transparent, with lots of silkscreen transparent base. The first two or three color runs are of transparent primaries, akin to underpainting, in broad abstract patterns. The first three runs, if they are variations on red, yellow, and blue, give me a rich textural surface of colors which will mix optically to give browns, greens, violets, and grays. These runs also tend to block out the large basic forms of

sky, earth, water, grass, and so on. But it is *very* important to me that I can still modify and shift as the print progresses.

In this imaginary landscape I might print the sky with an overtone of semi-opaque blue-gray, with lots of white in it. This will cool the sky down and appreciably modify the texture and color of the preceding three runs. The sky shape can be achieved with a cut-paper stencil made from smooth newsprint.

The fifth run might be a linear band of trees on the horizon in the upper middle of the print. This is drawn on a fine screen (16xx) with Maskoid (liquid rubber cement) applied directly to the silk with a carefully blunted ruling pen. When this band is drawn and dry, two coats of water-thinned glue are pulled slowly but firmly over the Maskoid-drawn trees. The first coat should dry before the second glue-up is pulled over it. When both coats are dry, the Maskoid is rubbed out and the tree band printed in a brownish gray. The next color run may be semitransparent triangular white snow shapes in the foreground and perhaps soft yellow-white patches of cloud in the lower sky. The snow will be drawn on the screen with glue block-out and the cloud forms softened with glue applied by cellulose sponges to create a broken, stippled texture. When the glue is dry, I proceed to mix two colors for a "rainbow" type of printing procedure. The yellowish white goes in the upper part of the screen; the bluish, very opaque white goes in the lower part. The colors are squeegeed from left to right to ensure accuracy of position in the edition. I have been using this "rainbow" effect more and more, as it gives me more colors with less work and creates the desired atmosphere.

Next I might draw windswept grass and weed patterns in ocher between the snow patches. These are also drawn with Maskoid, which I find the best medium for linear detail. Some textures are created by rubbing with litho crayon or spattering Maskoid with a toothbrush. Water-thinned glue is pulled over the screen, and when the glue dries, the Maskoid and crayon are washed out with turpentine or mineral spirits. If sharper detail is needed, the glue resist can be touched up with glue and a very fine brush over a light-table.

The sixth color might be printed in a silkscreen enamel paint to give a bit of relief to the lines. As enamel tends to clog the detail in printing, the screen may have to be washed out several times.

If the print needs some verticals and diagonals, perhaps some scrubby, stunted tree forms to bridge the horizontals of tree bands and sky, Maskoid is used on a newly cleaned screen. (I work with only about four or five screens.) After gluing and washing out, as before, printing is done with a "rainbow" of dark brown enamel at the base of the trees to olive-green enamel at the top.

For the last run a semigloss mixture of transparent base and multiprint varnish (half and half), with just a tint of violet color, is spread over the entire print. This gives a cool atmosphere of evening and also a silky sheen over the print when dry, which finishes it and protects the surface. The completion of this hypothetical serigraph would require eight printings with ten colors.

For the self-portrait, *39 at '70,* in the unusual technique of silkscreen drawing, only *one* screen was used. The similarity to a pencil or chalk drawing comes from the use of pencils directly on the screen. The method is as follows:

First the margins of the screen are glued up to the desired size of the final print. The frame is then locked in register and a piece of paper placed in proper position beneath it.

636

636 Robert Burkert. 39 at '70. 1970.
Silkscreen (pencil technique), 24 1/4 × 21".
Courtesy the artist

PLATE 636

Soft (ebony) pencils, graphite sticks, powdered graphite, and colored pencils can be used to draw the image on the screen; a lot of the "dust" is left on the screen mesh and openings. Erasers may be used to make corrections and rub in tones, with care to keep the dust from being knocked off the screen.

Glue block-out is used to draw in highlights, as in a chiaroscuro drawing.

A very pale transparent base, either clear or with a dab of color, is pulled over the drawing. A maximum of pressure is required, and it is necessary to go over the drawing with the squeegee several times. Each print pulled gets successively lighter, and one must pull the squeegee over the screen repeatedly to get a strong image. The greatest number of prints obtainable is probably five to eight.

The principle of the method seems to be that the transparent paint lubricates the graphite, dissolves it somewhat, and lets it through the mesh to the paper. The base also locks the pencil marks into the paper so that they cannot be rubbed or smeared.

STEVE POLESKIE
My Silkscreen Methods

I learned the technique of silkscreen printing from a pamphlet put out by one of the paint companies to advertise its product. My first silkscreen frame was second-hand, given to me by a friend who worked in a stained-glass studio. The year was 1959, and I was working in the basement of my parents' home in Pennsylvania.

COLORPLATE 76

Technically, nothing outstanding distinguishes my work. All my current prints are done in a straightforward way with lacquer film, a technique found in any basic textbook on silkscreen printing. I begin with an exact-size line drawing and work out the colors as I go along. In general I do not print a complete proof before I begin, but prefer to work out changes as the print is being completed. Since I usually start with a rather clear image of the print in my head, this method prevents me from losing interest in it as the work proceeds. I usually work with assistants who handle most of the details of the printing.

For several years I worked as a printer, and founded and ran my own silkscreen shop, the Chiron Press in New York City. From 1963 to 1968 we printed the work of many of the prominent artists of the time. During my collaboration with these artists I learned a great deal from them, as I hope they, in turn, learned something from me.

Most of the artists knew little or nothing about silkscreen printing, so that it was necessary for me to give them a brief introductory course before we could begin. Some became interested in the technique and attempted to learn the steps necessary to prepare their own stencils. A few, however, had no interest in anything but the finished product and came around only when it was time to sign the prints. For these artists I did what tradition normally would have demanded of them. I prepared the stencils and mixed the colors, but, contrary to tradition, was not above changing a color or a line if I thought it would improve the print. No one ever complained.

I have never met a printer who wanted only to be a printer, and I was no exception. The ego of an artistic individual is too strong to endure for long the self-negation demanded by the printing of images created by others. I bore the situation for several years, attempting to work out a parallel career as a creative artist. My reputation as a printer, however, seemed to have spread at such a rate as to overshadow all my efforts to build an audience for my own images. This, plus my distaste for the

economic end of the business, caused me to sell the press and take a job teaching at Cornell University.

I intend to develop in my own work both an awareness of the past and an understanding of the present, to comprehend the spontaneity of the moment and the timelessness of the craft. I have found the technique of silkscreen ideally suited to this endeavor.

I am interested in the world around me. For a time, being unable to afford models, I painted my own face and figures from photographs. The figures moved in a never-never land. I lived in the city and thus could not see the land, but it was there—in the advertisements, behind the cars, the soda pop, the cigarettes. As I had stripped the clothes from the figures to create nudes, I stripped away the embellishments of the land to make it land again, free from the desecration of mankind.

In the city I painted the landscape as a blind man paints a scene remembered or one described by someone who has seen it. When I moved to the country, I was confronted by a whole new experience. Now I was *in* the landscape; it surrounded me—miles and miles of it. I tried to finish a few of the pictures I had begun in the city and found them lacking. The colors were wrong, artificial; they were acid and smelled of city air.

My object now is not to re-create the picture as I have already perceived it, but to startle myself, to destroy the image in translation, to cause some mutation to occur during the picture's birth, so that when I perceive it in reality, it is an object strange and foreign to me—fresh, baffling, and exciting.

MISCH KOHN
A Silkscreen Variation on *Chine Collé*

A variation on the *chine collé* technique was employed in my sugar-lift aquatint *End Game*. After the etching was completed, I pulled a proof on wet paper and allowed it to dry. It shrank about 3/8 inch in length.

COLORPLATE 77

I then placed the proof under a silkscreen and traced the areas for the orange background that I wished to print on oatmeal-colored Japanese paper. A white was printed as a second color on the orange.

The dried silkscreen prints were then trimmed to the edge of the image area and dampened between blotters in a damp-book wrapped in plastic.

The backing sheet for the print, a heavyweight Rives paper, was also dampened and placed in the damp-book at the same time. A few drops of formaldehyde in distilled water (as much as a thimbleful per gallon of distilled water) allows the paper to stand as much as two weeks' dampening without danger of mold.

I then used the etched proof to design the additional colors, the gold leaf, red, blue, and green papers. Using a tracing sheet as a template, I scored through it with an etching point onto the various papers. These I placed in the damp-book shortly before printing.

The etching was inked in intaglio, and the surface was cleaned with paper towels over a smooth 3-inch-by-3-foot block.

Next a white library paste was thinned with water to the consistency of thick coffee cream. The trimmed screen print and the colored papers were turned upside down on damp blotters and washed lightly with the thinned paste, applied with a

1 1/2-inch-wide soft paintbrush. Then each piece of colored paper was laid in position on the plate with the paste side up. (It is necessary to lay those which are to be on top first and so on in succession.) Finally the trimmed silkscreen print was laid on the plate and stretched to reach all the corners. The Rives backing sheet with a wide border was laid on the plate in position, the blanket placed upon it, and the print pulled.

JAMES LANIER
The Preparation of Photographic Silkscreens

COLORPLATE 78

The screen is prepared as for any other serigraphic method. Cleanliness is essential. Even if new, the screen should be thoroughly scrubbed with some cleanser such as Ajax and rinsed carefully. Some screen materials are not suitable for film emulsion, and one should check this point with the manufacturer before using them.

The art work may be composed of film positives or other designs prepared on a transparent base.

The screen is sensitized with a prepared liquid emulsion, or it is adhered to a film emulsion cut to size, with an allowance for overlap beyond any printing area. The liquid emulsion should be applied according to the manufacturer's instruction. Usually the workroom should be semidark; the mixture is poured onto one edge of the screen and squeegeed across to form a thin, even coating. This is wiped and then fanned dry.

The screen or film is exposed to light according to the instructions of the manufacturer. It is my experience that only an arc light gives excellent results, but I have also obtained satisfactory results with exposure to the sun, to photo flash bulbs, or to an ultraviolet sunlamp. Timing of the exposure depends upon the intensity of the light and the type of emulsion used.

Afterward, the washing out or development of the screen or film should proceed as recommended by the manufacturer. When film is used, two steps are required in developing the film. First, a special developer is used, and then the film is washed out in 115-degree water. The temperature is critical in this procedure. Then the film is fixed in cold, fresh water.

While still wet, the developed film is placed on several sheets of newsprint, face up on a flat surface, and the screen is lowered in exact position on the film. Several more sheets of newsprint are laid on top of the screen and pressed firmly with the side of the hand, working from the center to the edges, so that the film is firmly adhered to the screen. The newsprint both over and under the screen should be changed as frequently as necessary until dry.

Four to six hours drying time is required for the film method. When dry, the acetate backing of the film is peeled off. The emulsion is then cleaned with a soft cloth and benzine applied without pressure.

The screen is now ready for any blocking out that may be necessary.

VI
THE
MONOTYPE

CHAPTER 19

THE MONOTYPE

HISTORY AND TECHNIQUE

The monotype is often thought of as a halfway stage between painting and printmaking and has sometimes been subject to discrimination as a "bastard" medium. The process is simple: The artist paints, rubs, and wipes his design directly onto a plate, using a fairly slow-drying oil paint or ink. The fleeting image must be printed before the ink dries. If a second or third proof is attempted, each image will be a fainter impression of the preceding one. Printing may be by hand or press, and, as the name "monotype" implies, one can usually get only one strong impression. The effect must be guessed right from the start; there will be no trial proofs or different states unless the design is redrawn for a second impression.

The monotype may have a legitimate claim to the title of print. The action of the press and the transfer process, from surface to paper, create the final image. Yet an important element of most other printmaking processes is lacking: the various steps and procedures to produce a printing surface which makes possible a multiplication of impressions. However, here is a medium which allows a printmaker unusual freedom and spontaneity.

COLORPLATE 80

The finest examples of monotype clearly confirm the creative possibilities of the medium; they can be bold or delicate, resembling a watercolor, pastel, or oil painting or showing textures and tonal qualities all their own. There is little doubt that the few artists who have worked seriously with the monotype saw it both as an experimental tool for exploring interesting color combinations, textures, and printing methods and as a sketchlike prelude to other works, often producing a print with a validity based on its unique quality.

PLATE 637

Giovanni Benedetto Castiglione (1616–1670) is said to have been the first to experiment with this medium. The subject matter of his known monotypes is mainly religious or allegorical and very closely related to that of his etchings. He used various kinds of brushes and scraping instruments on both dark and light backgrounds. His monotypes have an agitated, impressionistic effect unusual for the period; it seems that his attempts had few, if any, imitators. The practical artist-craftsmen of the seventeenth and eighteenth centuries confined themselves to the more profitable printmaking techniques that permitted large editions. By the end of the eighteenth century the monotype was so unfamiliar that the great cataloguer Bartsch could only describe Castiglione's works as "in the aquatint manner."

William Blake, another inveterate experimenter, has also left us a few monotypes.

Degas was the medium's next and greatest devotee; in his more than three hundred known monotypes we can study every nuance of the technique, pushed almost to its very limits. He was introduced to the medium by his friend Vicomte Ludovic Lepic, an amateur etcher who assisted Degas in his first attempts.

Degas composed his monotypes, usually in black and white, in broad areas of light and shadow. Very often he supplemented them with pastel, his favorite medium. Fully one-fourth of his pastels give evidence of a monotype base. Sometimes he transferred a monotype to the stone as a base for a lithograph. He worked with a sure hand into the dark ground, wiping highlights with a rag or his fingers. He also used the light-ground manner, drawing his design with a brush on the copper plate. Occasionally his fingerprints show up clearly in certain areas. Now and then he used clear celluloid so that by turning it over he could observe the image reversed.

PLATE 643

His monotypes span the whole range of his favorite subject matter—dancers, café and theater life, nudes in shadowy interiors, portraits, and so on—and have a

unique place in his oeuvre. Only in the monotypes do we find scenes of the brothel, ranging from the poignant to the erotic. It is possible that some of the dozens of monotypes destroyed by his executors depicted the more "offensive" subjects. In 1890 he produced a series of monotype landscapes, returning to a subject he had abandoned more than twenty years before. They are freely drawn and strangely evocative; he called them his *paysages imaginaires*.

Several groups of Degas's monotypes were reproduced by Vollard as book illustrations; others were commissioned but never published.

Both Munch and Gauguin made monotypes, each in his characteristic style. Gauguin worked on both plates and stones and sometimes added details in watercolor. He devised an ingenious technique of laying a sheet of paper over a roughly drawn monotype plate and tracing details by "drawing" with a pointed stick on the back of the sheet.

Picasso tried the monotype at least twice during his early years but never really pursued it. About 1914 Matisse made approximately a dozen monotypes, in a white-line technique in which he scraped with a brush handle on a solid black ground. Rouault, too, tried the medium but apparently soon lost interest.

Chagall did a series of color monotypes on both metal and Plexiglas plates, processed and printed by Jacques Frélaut in intaglio.

COLORPLATE 79

637 Giovanni Benedetto Castiglione. The Animals of Noah's Ark. 17th century. Monotype, 9 3/4 × 14 5/16". Metropolitan Museum of Art, New York

PLATE 640

PLATES 638, 639, 641, 642

Maurice Prendergast, in the 1890s, became America's most prolific monotypist. He sought a light watercolor effect in his more than two hundred monotypes, predominantly landscapes. A few American painters, including John Sloan, "Pop" Hart, and Abraham Walkowitz, took up the medium with varying degrees of success. Among contemporary artists Gabor Peterdi, Harold Town, Mark Tobey, Adja Yunkers (using Masonite and plastic plates), and Matt Phillips have made significant contributions. Helen Frankenthaler, Carol Summers, and Robert Broner have combined monotype with lithography, woodcut, and collage intaglio respectively.

The monotype can play a unique role in the development of a printmaker, whether it is approached as an end in itself, as a basis for another medium, or as a series of valuable explorations into the reactions of various pigments pressed in direct contact with all kinds of paper surfaces—preludes to printmaking.

638

638 *Musialowicz*. Reminiscence XII. *1970. Monotype, 20 × 15". Courtesy the artist*

639 *Oldrich Hamera*. Origin of Matter, II. *1969. Monotype, 13 5/8 × 9 1/4". Courtesy the artist*

640 *George O. ("Pop") Hart (1868–1933).* Man Stirring the Contents of a Frying Pan over a Fire. *Monotype, 6 × 8". New York Public Library, Astor, Lenox and Tilden Foundations*

639

640

641 Josef Hampl. Cycle, "Document IV". 1966. Monotype, 22 × 16 1/4".
Courtesy the artist

642 Fritz Eichenberg. Angel. 1960. Color monotype, 12 × 16". Collection the author

OVERLEAF:

643 Edgar Degas. La Famille Cardinale. Late 19th century. Monotype. Fogg Art Museum, Harvard University, Cambridge, Mass.

641

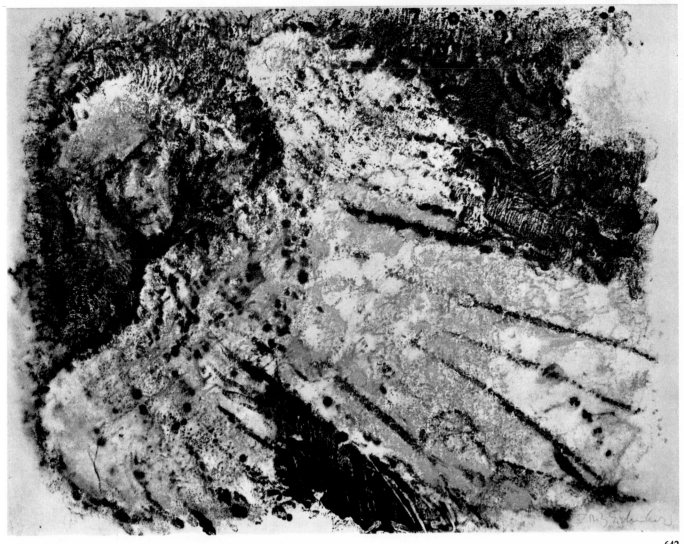

642

Degas

VII
WORKSHOPS

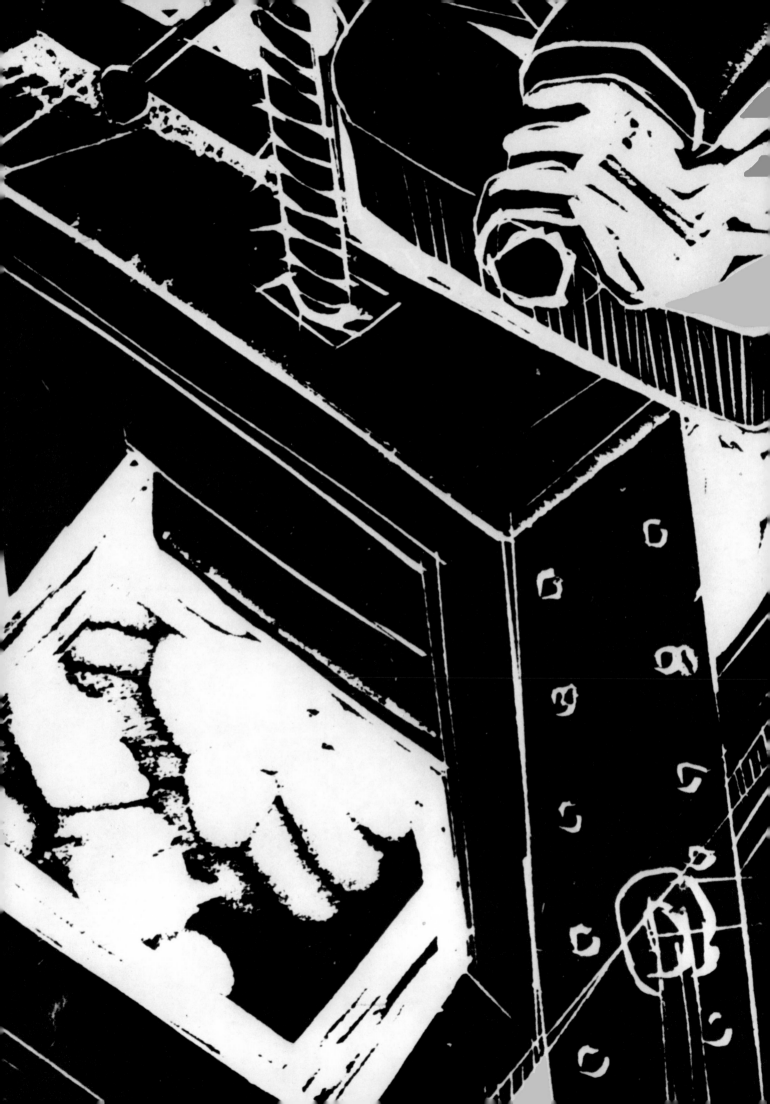

CHAPTER 20

WORKSHOPS

There is something about the atmosphere of a workshop that inspires the artist to adopt the attitudes of an artisan. The very air he breathes is filled with the invigorating smell of turpentine and printing ink. There is a spirit of comradeship and competition, for teams of people depend on each other's skills and experiences, which they must share with each other.

What went on in Koberger's or Dürer's workshops, in Abraham Bosse's or Senefelder's, was probably not much different from the situation prevailing today at Tamarind or at the Pratt Graphics Center, nor has the equipment changed appreciably. The hand is still the main tool, along with the single-minded dedication to the achievement of perfection in a graphic medium.

It is difficult for an artist to pull editions of lithographs or intaglio prints in the solitude of his studio, although many do it. The workshop shared by many is valuable not only for exchanging experiences but also for economy.

Good workshops proliferate. They spawn others by sending out disciples across the country and overseas to start other nuclei in the far-flung spaces of India, Southeast Asia, Latin America, or the cities of Europe. Some of these offshoots come and go, often lacking sufficient support for long-term continuity but stimulating enough interest in their communities to be revived again at some more propitious time.

The following list is far from complete. It simply reviews the background of some workshops that have operated successfully for some time on what may be hoped to be a fairly permanent basis.

Imprimerie Lacourière

The Imprimerie Lacourière (since 1957 Lacourière-Frélaut), in its more than forty years of existence, has produced some of the masterworks of twentieth-century intaglio printing. It was founded in 1929 by Roger Lacourière, engraver and master printer, who sought to maintain the *rigeur ancestrale* of a craft practiced for centuries in his family. Since 1951 the studio has been under the direction of Madame Roger Lacouriere and the master printers Jacques and Robert Frélaut.

The workshop is located in the shadow of Sacre-Coeur in Montmartre in a rather bizarre looking building which housed the "Panorama of Jerusalem" of the Exposition of 1900. The atmosphere of the workshop, with its hand presses and strong aroma of printer's ink, is little different from that of Bosse's or Callot's day. The printer of etchings and engravings, and of the newer embossments and collage prints, is more than simply an artisan; he is the artist's collaborator from the time of the preparation of the plate to the final printing.

COLORPLATE 81

Among the celebrities whose work has been printed at Lacourière's are Picasso, Braque, Rouault, Derain, Miró, Dali, Giacometti, Calder, Moore, Masson, and Matisse. There is a constant stream of young artists who seek out new forms and techniques with the assistance of the Lacourière staff.

PLATE 644

Picasso, who introduced Lacourière to Vollard in the early thirties, produced his Vollard Suite and a number of magnificent illustrated books, including the *Histoire Naturelle* of Buffon and the *Tauromaquia* of Pepe Illo, at the workshop. Vollard, in turn, sent along Maillol and Rouault, the latter to execute some of his most famous and elaborate graphics at Lacourière's, among them *Le Cirque de l'Étoile Filant, Les Fleurs du Mal, Passion,* and some plates from *Miserere*.

The Swiss publisher Skira used the presses of Lacourière for most of his limited

editions: Matisse's *Poèmes* of Mallarmé, Dali's *Chants de Maldoror,* and Derain's *Pantagruel,* which took more than three years to print from wood blocks laboriously inked by hand in several colors. Masson, who did here his two-color etchings for *Soleil des Eaux* of René Char, became a familiar figure at the shop and spent many hours of experimentation over the acid trays.

At present the studio has one large printing room containing nine hand presses, one of which was enlarged in 1969 to print a plate of Christian Fossier that measured about 59 by 35 1/4 inches. Also in this room are a ferric chloride bath and a paper dampening sink. The nitric acid baths are set up separately on the entrance porch. One room is reserved for paper, with damping boxes for each artist, drying stacks, and lines. A small back room provides important artists with a quiet place to work on plates. In a narrow room, with space for about five artists at a time, facilities are available for grounding and otherwise preparing plates. Finally there is the office of Mme. Lacouriere herself, the business hub of the shop, where every trial proof must be approved and where successful editions are toasted in champagne.

The workshop no longer makes its own inks but uses the products of Lorilleux and Charbonnel. Rives, Arches, and "japon" papers are used, as well as a thin, hard-textured paper obtained from Richard de Bas, Papier d'Auvergne, 73 bis Quai d'Orsay, Paris 7e.

644 *Pablo Picasso.* Bullfight, *illustration for José Delgado (Pepe Illo),* La Tauromaquia. *1959. Lift-ground aquatint. Collection Lessing J. Rosenwald, Jenkintown, Pa.*

645

Among the recent works of the studio have been prints by Moore and Chagall, published by Cramer of Geneva. Jacques Frélaut flew to England and to the south of France to work on the plates under the artists' direction. To judge from the results, the glorious Lacourière tradition is alive and flourishing.

Atelier 17

COLORPLATE 82

PLATE 645

Stanley William Hayter, born in 1901 in London of a long line of distinguished painters, studied to be a chemist and geologist and worked in this capacity for the Anglo-Iranian Oil Company. He filled his spare time with painting and printmaking and moved in 1926 into the art world of Paris, where he met with young avant-gardists—Miró, Giacometti, Arp, and Calder—soon to be internationally known. He also encountered Joseph Hecht and became intrigued with his skill as an engraver.

A year later Hayter started a studio-workshop devoted to the exploration of the intaglio medium. In 1933 he moved to 17 rue Campagne-Première and called his workshop Atelier 17, a name to become famous in the print world.

Many of the great artists of our time have passed through it to pick up Hayter's incredible knowledge of the ways of the burin and the chemistry of intaglio inks and their interaction. Picasso, Dali, Miró, Masson, Max Ernst, Kandinsky, and Tanguy

646

have looked over his shoulder, and legions of young artists have passed through his hands. The personal experiences of a number of artists who received aid and inspiration at Atelier 17, both in Paris and during the period when it functioned in New York, are related elsewhere in this book.

Hayter has been decorated by the Legion of Honor and the Order of the British Empire and has had scores of exhibitions, including a large retrospective at the Victoria and Albert Museum in 1967.

His two books, *New Ways of Gravure* and *About Prints,* have become almost standard textbooks in graphic workshops around the world.

Atelier Mourlot

The name Mourlot has become a household word among printmakers and collectors, synonymous with perfection in the printing of lithographs. No wonder, for the workshop has a tradition of more than a century of solid craftsmanship behind it. It started in the Paris of the 1850s, with Jules Mourlot, and has continued under the direction of his son, Fernand, at 43 rue Barrault. It has attracted to its dim and cluttered interior and intriguing atmosphere the great artists of the century, from Braque, Matisse, Utrillo, Léger, and Derain to Chagall, Picasso, Miró, Villon, Henry Moore, Calder, Shahn, and many others, eager to work on the stone under the guidance of great and dedicated craftsmen.

The Atelier Mourlot has stimulated the making of the once-despised poster to such a degree that this medium has been raised again to the status of an original work of art, widely admired and collected.

At Mourlot's Picasso did his finest lithographs, the symbolic white *Dove of*

PLATE 646

Peace, and the eleven states of the evolution of a bull, from its realistic strength to its abstract essence.

Mourlot has branched out from the craft of printing to professional publication of posters, prints, books, and portfolios. His master printers have become legendary figures; Messieurs Tuttin, Sorleir, Deschamps, and others of their caliber are sought out and courted by great artists.

Atelier Desjobert
by Federico Castellon

In midsummer of 1961 I was introduced to the famous Atelier Desjobert at 10 Villa Coeur de Vey, Paris, by Adolf Dehn and his wife, who had worked there off and on since the mid-twenties.

The print shop on the second floor of the two-story atelier, a room approximately 50 by 30 feet, held ten lithographic hand presses, six printers, and a small chorus of working artists. (Since then one press and one printer have been removed.) Naturally the most flexible element has always been the artists, varying from as many as fifteen to one. Fortunately, the number is usually between four and seven. With more than seven, bottlenecks seem to develop, and printers become too harassed to be easily available. The best period for working in Paris is either the summer or the period immediately following Christmas.

On that first visit, after being introduced to the founder, M. Edmund Desjobert, and his son Jacques, the present director, I was assigned a work table which has remained mine ever since. A stone was placed on it, together with materials, and a relationship started that will probably last all my life.

Edmund Desjobert began his career at the turn of the century, printing for such artists as Forain and Steinlen. He opened his own atelier before World War I and did work for most of the great artists of that period. He printed Picasso's first lithographs, worked for Matisse, Rouault, Dufy, Pascin, Van Dongen, Léger, Arp, and did prints for many Americans, including Kuniyoshi and Reginald Marsh. Upon the death of his father, M. Jacques Desjobert took over the directorship in 1964.

In addition to the upper floor, with its presses and printers, the atelier houses on its lower floor two large power-driven, flat-bed presses which are run by three more printers, one or two of these being apprentices who will eventually graduate to the upstairs hand presses. The power presses also print directly from the artists' plates or stones and can pull about two hundred fifty proofs per hour. They are used mostly for posters or for large editions economically pulled. This street-level floor also stores archives of completed stones, held in reserve for possible reissues of illustrated books, and a great number of stones, cleaned and ready for use, of many types and sizes.

Because of the great store of stones, the artist is rarely under pressure to release accumulated stones with his work before he has decided to pull trial proofs or print editions. This accommodation can be of extreme importance to a visiting artist who may have to send trial proofs back home for the approval of his publishers.

Among the printers at Desjobert's, there is always a master printer, a title of respect conferred by his fellows, and age and experience are not necessarily the criteria. The *maître* is usually the one who solves all problems in printing and in the mixing of colors. Naturally, the services of the master are much in demand, and this creates a

problem in diplomacy. It often seems that the services of the *maître* are booked solidly for many years ahead. Yet it very often happens that another printer is more sympathetic or better able to handle a certain technique. Some artists, such as Paul Wunderlich, have preferred the services of a printer other than the master.

I owe much to Desjobert and his workshop, and I have been in love with Paris since I began working there in the mid-1930s. I find it a welcome escape from New York's tensions, pressures, distractions, and small dissipations of one's time.

George C. Miller & Son

George C. Miller (1892–1964), considered for some time the only great lithographic printer in the United States, was apprenticed at fourteen to the American Lithographic Company. There he came into contact with artists who were experimenting in their studios with lithography. Miller spent many evenings helping one of them, Albert Sterner, print his stones and, as a result, soon found himself called in for consultation on printing lithographs by George Bellows, Joseph Pennell, Arthur B. Davies, and others.

Recognizing the need for a fine lithographic printer in America, Miller, just after World War I, set up his own workshop on East 14th St., New York, which became for the next thirty years a center for many prominent artists working on stone.

By the 1930s he was producing not only fine prints but also limited editions of books, printed by direct transfer from the artists' stones or plates. At that time the college and foundation-sponsored printmaking workshops had not yet emerged, and Miller was the only expert printer to whom professional artists and novices in that medium could turn. Among the hundreds known to have worked in his studio were such famous artists as Bellows, Thomas Benton, John Steuart Curry, Grant Wood, Rockwell Kent, and Reginald Marsh, who helped to keep printmaking going, particularly in the Depression years.

The workshop is still in operation, now at 20 West 22d St., under the direction of the son, Burr Miller, who was trained by his father. Early clients such as Stow Wengenroth and the Soyers, as well as younger artists, still have their editions pulled on an old hand press that has served to produce fine work for more than fifty years.

Tamarind Lithography Workshop

The conception of the Tamarind Lithography Workshop goes back to 1958, when June Wayne, on her way to a Paris atelier to do some lithographs, met an official of the Ford Foundation in New York. She outlined for him the plight of fine-art lithography in the United States—the lack of master printers, the scarcity of materials, the dearth of workshops. The result was a series of very generous grants which have supported the Tamarind Workshop since its beginning in 1960. The intention was to establish a studio, entirely devoted to lithography, where printers could be trained and where artists would be invited to create editions. After a decade of existence Tamarind could claim as alumni about sixty-five printers and almost a hundred and fifty artists, as well as many more students, curator-trainees, and assorted visitors who have benefited from the facilities of the shop.

Every aspect of the creation of a print is subjected to a well-thought-out system. The Workshop imports hand- and mold-made papers from abroad, some specially

COLORPLATE 83

commissioned. Pigments are mixed to the specifications of each artist. Lithos are drawn on both stone and metal plates. Each print is a product of close and constant collaboration between the artist and a master printer. When the two agree on the *bon à tirer,* an edition limited to twenty-nine prints is pulled. The *bon à tirer* belongs to the printer, and twenty prints go to the artist to be sold through his regular dealer. The remainder become the property of Tamarind and are sold to raise funds for special projects. The Workshop has a number of "patron" customers, distinguished collectors who have pledged to buy one copy of every print produced.

Keenly aware of the vicissitudes and requirements of the art market, the Tamarind staff has initiated a series of studies on the cost-accounting aspects of both running a printshop and setting up an art gallery. A group of publications giving the results of this research and describing many aspects of the Workshop are available from Tamarind.

PLATE 647

Artists come to Tamarind by invitation, for two-month stays, during which they may produce from twenty to forty lithos. Experienced printers may spend a three-month training period at the Workshop. Student printers receive fellowships for a complete course of study, moving up in a system of "grades."

Under a new program of curator traineeships, aspiring museum employees can familiarize themselves with both the technique of lithography and the thorough Tamarind curatorial system. Every print is given a serial number, and a detailed record is made of paper, ink, and techniques used, along with all other incidentals of its production.

Since a favorite format of a number of Tamarind artists is a completely covered sheet with no margin, the documentation sometimes appears on the back of the print. A copy of each print goes into the Workshop archives. When the edition has been completed, a "cancellation" proof is pulled and the stone erased. Problems of matting, framing, and storage are studied, and experiments are carried out to test various papers for strength, lightfastness, and other characteristics. Tamarind's vast files and logbooks of hundreds of unique individual production experiences will prove invaluable to artists and art historians.

The many famous artists who have worked at Tamarind include Sam Francis, Lipschitz, Tamayo, Cuevas, Frasconi, Albers, Nevelson, Misch Kohn, John Paul Jones, Rico Lebrun, Ikeda, Hockney, Walasse Ting, and many others. More than 2,500 editions have been created at Tamarind since its inception.

Part of the Tamarind philosophy is the conception of the "original print" as one in whose printing the artist has actively participated. The Workshop requires artists to do their own drawing on the stone or zinc. Standards are very high, and the slightest smudge, wrinkle, or printing imperfection causes the print to be rejected and destroyed.

In 1970 the Tamarind Institute was established in Albuquerque, N.M., in cooperation with the University of New Mexico, as a permanent professional center for the creation and production of original lithographs and as a training place for master printers and curators. The Institute, which will also do edition printing for artists, dealers, and publishers on a contractual basis, is under the direction of Clinton Adams and Garo Antreasian, both on the faculty of the University and associated with Tamarind since its inception.

647

Universal Limited Art Editions

Shortly after moving to West Islip, Long Island, in 1955, Tatyana Grosman founded in her home the graphics workshop, Universal Limited Art Editions. Her background had prepared her for this creative endeavor. A powerful influence came from her father, a Russian newspaper publisher. He had instilled in his daughter a love of books and a reverence for the printed word.

Another strong inspiration was her husband, Maurice, a painter whom she met while studying drawing in Germany. Together in the early 1930s they moved to Paris, where they were to establish close friendships with members of the school of

PLATE 648

PLATE 649

648 *Lee Bontecou. First Stone. Lithograph. National Gallery of Art, Washington, D.C. (Rosenwald Collection)*

Paris, which flourished between the two world wars. Their circle included such artists as Lipschitz, Loutchansky, Soutine, and Zadkine.

Through her workshop Mrs. Grosman had persuaded leading artists of the New York school to work, often for the first time, on lithographic stones. Her choice of artists and writers to collaborate on various graphic projects has included Lee Bontecou, Jim Dine, Sam Francis, Helen Frankenthaler, Fritz Glarner, Grace Hartigan, Jasper Johns, Marisol, Barnett Newman, Larry Rivers, Frank O'Hara, Edwin Schlosberg, Tony Towle, and Terry Southern.

The following remarks by Tatyana Grosman are based on a question-and-answer interview conducted by Mildred Lee in West Islip, April, 1971:

I have always loved books—to hold them as objects, to turn the pages that I already knew and look at them again, to find a particular paragraph, sentence, or illustration. I especially love illustrated books—the word combined with the image. Truly

649

*649 Larry Rivers and Frank O'Hara. Page VII
from* Stones. *1958. Lithograph.
Courtesy Universal Limited Art Editions,
West Islip, N.Y.*

creative books are brought to life by the artist and writer together. The artistic unity from cover to cover interested me most, so I decided to publish illustrated books.

For my first publishing project I went to see Larry Rivers in Southampton and asked him to choose a poet to collaborate with him on a portfolio. Coincidentally, Frank O'Hara was a guest at Larry's home at that time. The three of us discussed this project, Larry and Frank accepted it with great enthusiasm, and everything fell into place very naturally. We carried the stones back and forth between Larry's studios in Southampton and New York, and *Stones* was finally published in 1959 after two years' work.

Everything connected with lithography was a revelation for all of us. The stone itself is a beautiful natural element, and each stone has its own individual textures and qualities. Larry's smudges and accidental marks, the edges of the stone, were always respected.

From the beginning, Larry would experiment with small stones while waiting for Frank. Thus Universal Editions started publishing single editions of graphics.

After that experience I wanted to work with artists who had never worked in lithography before. I first took the stones to the artist's studio so that his initial encounter with the new medium would be made alone in his own surroundings. My hope was that some day the artist's achievements in graphics would be crowned by the publication of a book or portfolio.

In my role as a publisher I have great respect for the artist. I feel that each print must have its *raison d'être*. I am much interested in the discovery and revelation of the work. It requires work and experimentation to fulfill the *raison d'être*. The print should be fully matured and presented in the most interesting way: the paper, the ink—everything—should be truly excellent. There are times when we stop working and wait until the idea matures in the mind of the artist and in all our minds.

But also as a publisher I am conscious of the public. From the beginning I have always been aware that a lithograph or etching is printed matter—not unique like a painting. The impressions of editions of graphics should reach many people, be dispersed as widely as possible. The releasing of a print is a very serious matter, and quite different from the completion of a painting.

An artist can sometimes recall a painting and work on it further, but once a print is released, it goes out of the artist's hands and lives its own life. It is a final statement. The Museum of Modern Art's exhibition of Jasper Johns's working proofs showed the wonderful play of possibilities that goes on in the graphic work before the final edition is established.

A proof is personal: I think of it rather like a letter someone writes to a loved one. But the final edition must have a certain formal aspect: to me it is more like a love poem that is being published. I always want to show the final edition first to a person who will really appreciate it and respond to it—a person whose opinion I cherish.

Ever since I founded my workshop, paper has been important to me because it is the material on which the lithograph or etching appears. The texture and the margins are crucial. The paper is part of the artist's work.

When we did our first portfolio, Larry's *Stones,* the idea that our experience should be printed on commercial paper seemed to me unthinkable. I went to Douglass Howell and asked him to make special paper for this project. His craftsmanship allowed him to make only thirty sheets a week, if there was no rain! And when we came to the problem of the cover, I recalled that Larry and Frank always wore blue jeans when they worked (a kind of uniform), so I asked Howell if he could make paper from denim. Larry gave me his blue jeans to experiment, and the lithographs were enclosed in blue denim.

I compare the graphic artist's choice of paper to the sculptor's choice of material. The sculptor may see a piece of marble and know immediately that he wants to work with it. I remember that Zadkine had a tree trunk in his garden, and he kept it because he already saw a piece of sculpture in the tree. Jim Dine feels the same way about paper. When he sees a piece of paper, he may say: "That's for me." He knows what he will do for it and with it. Barnett Newman printed one stone of his *Cantos* with a large margin; it is very classical. He printed the same stone without a margin; it became absolutely tragic.

Barnett Newman understood very well the role of the printer in the production process. He said once, "The artist is a composer, and the printer is like a performer."

I feel that the artist should work undisturbed, alone with the stone. Later, the printer not only has to be a good technician, but he must also have the virtuosity to interpret the stone and to bring it to life. When he etches the stone and prepares to print, he must prepare himself emotionally, like a performer.

This is why we try to print each stone in one day. If the printer continues printing the same stone on the following day, his emotions, the colors of the ink, the quality of the print, and the temperature of the studio would all be so different that he would spend most of his time adjusting his second day to the first.

There is no doubt that some artists work best with particular printers. The rapport between the artists and the printers is a most important characteristic of my workshop. I pay homage to those printers who work creatively with the artist, such as Robert Blackburn, Zigmund Priede, Ben Berns, and Don Steward. They inspire the artists to work, and they are inspired themselves.

Hollanders Workshop, Inc.

In assessing the position of printmaking in the United States at the close of the sixties, one was struck by the proliferation of graphic production, particularly in lithography. Despite an increasing number of new graphic workshops and expansion of old ones, some printers preferred to maintain a small, single-artist shop. At Hollanders Workshop in New York, now closed, Irwin Hollander and Fred Genis, the two master printers considered it their major principle to facilitate collaboration with the artist and attend to his specific requirements.

Hollander believed that "it is only by operating on an intimate level that an artist can have the maximum freedom needed to create and produce." "At the same time," Genis said, "the printer can be deeply involved with the vision of each individual artist and can contribute experience, knowledge, and inventiveness in technical assistance." Moreover, the printer, through his technical know-how, may lead the artist into new areas of creativity and enlarge his personal imagery.

In 1969 Hollanders Workshop saw the completion of major works by musician John Cage and Pop artist Jim Rosenquist which exemplify the advantages of the small workshop.

Not Wanting to Say Anything about Marcel represents John Cage's first venture into the graphic arts, consisting of ten related works—two lithographs and eight silkscreened Plexigram sets—in numbered editions of 125. Each of the sets comprises eight Plexiglas panels supported by a walnut base. The images which appear in *Lithograph A* were taken from the subjects in the first four Plexigrams, while the images in *Lithograph B* were taken from all eight Plexi sets. The method which programmed the selection of all the sixty-four different images was based on the *I-Ching* (the Chinese *Book of Changes*); coins were tossed to determine which images would appear in the Plexis and reappear or disappear in the lithographs.

PLATE 650

When Cage came to the Workshop, he had in mind producing a graphic work involving words or word fragments suspended in space. The idea was finally expanded to include images as well as words, and the program of two lithographs and eight Plexi sets took form.

Because of the setup of Hollanders Workshop, this enormous undertaking came to fruition in a relatively short period of time. For approximately three months the

70 Josef Albers. No. VII (above) and No. X (below) from the portfolio Variants. *1967. Silkscreen. Collection Irving J. Finkelstein, Houston, Tex.*

PLATE 651

650 John Cage. Plexigram I. *1970. Color lithograph on Plexiglas, c. 14 × 24 × 14 1/2". Courtesy Hollanders Workshop, Inc., New York*

shop produced no other editions so that it could be totally dedicated to assisting Cage. In addition to technical and artistic collaboration, the shop made research assistance available. The result was a strong feeling of a shared experience among artist, printers, and others who contributed to the project.

Unlike Cage, Rosenquist had had experience in the medium when he came to the Workshop. Furthermore, he already had his imagery completely thought out. The idea he was involved with at this juncture was a four-sided experimental environment consisting of a square area enclosed by four monumental paintings—a light and a dark painting placed opposite each other and two walls of multicolored painted panels also facing each other. Jim brought sketches of the light wall, still unfinished, into the Workshop as a basis for his print.

The lithograph was planned as a seven-color diptych entitled *Area Code*; the halves each measure 26 1/4 by 28 1/2 inches and were meant to be framed separately and hung 2 inches apart. The numbered edition consists of eighty-six prints on J.B. Green paper. Reflecting the painting, the composition shows the wing of a bird in the upper left and a cut wire cable with its colorful inner wires splayed out from the right in the direction of the bird's wing. Behind this imagery are six multicolored horizontal bands whose graduated values are the result of the artist's use of a spray gun. Over these bands are colored wavy lines which generate energy and movement and were drawn on the plates with crayon and brush. The continuum of these bands

71 *Eduardo Paolozzi.* Universal Electronic
 Vacuum, No. 6863 (7 Pyramids in
 Form einer Achtelskugel). *1967.*
 Silkscreen, 40 × 27". Editions Alecto,
 London
72 *Clayton Pond.* Chair. *1966. Silkscreen,*
 8 1/4 × 6 3/8". Collection the author
73 *Norio Azuma.* Image E. *1969.*
 Silkscreen. Courtesy the artist
74 *Myeung-Ro Yoon.* Pantomime. *1969.*
 Photo-silkscreen, 5 7/8 × 6 7/8".
 Collection the author

72

73

74

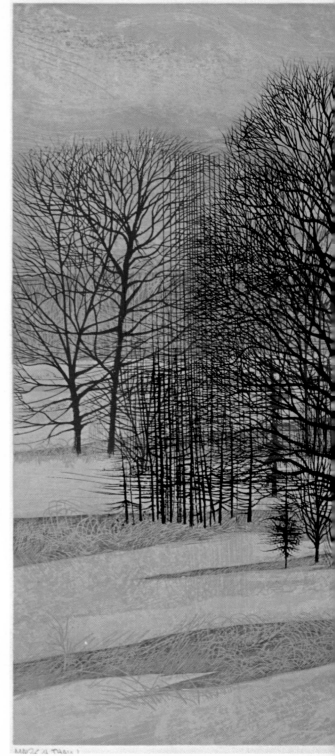

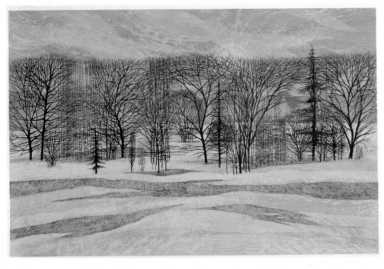

75 *Robert Burkert.* March Thaw. *(below)*
1962. Silkscreen, with progressive proofs
1, 2, and 3 (left), 20 3/4 × 32".
Courtesy the artist

OVERLEAF:

76 *Steve Poleskie.* Big Patchogue Bent.
1969. Silkscreen, with preliminary
drawing and progressive proofs 1 and 2,
20 × 26". Courtesy the artist

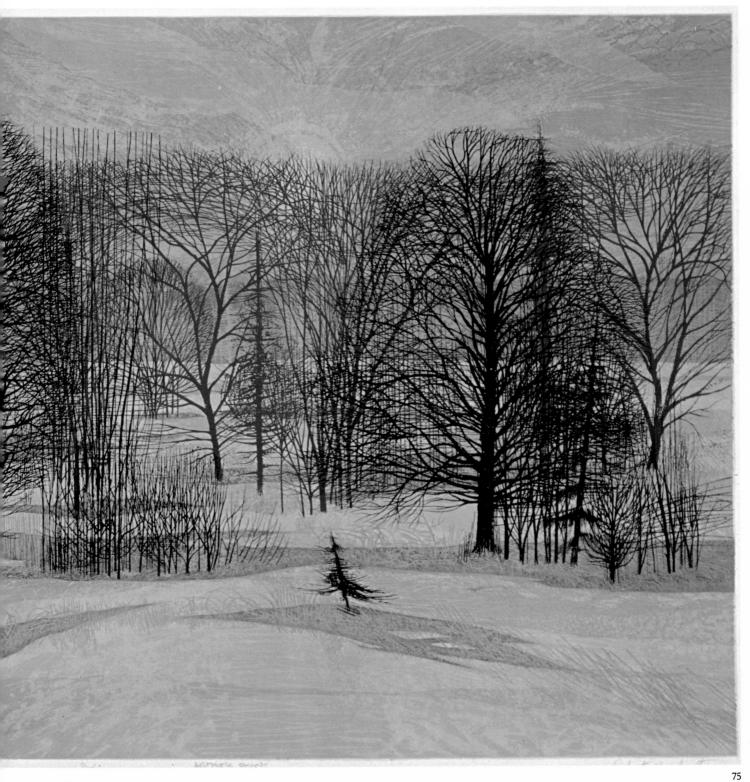

Drawing for Big Welcome East

FRESKE

77 *Misch Kohn. End Game. 1968. Chine collé, etching,*
 and silkscreen, 23 3/4 × 17 3/4". Courtesy the artist
78 *Helen Bozeat. Untitled. 1970. Photo-silkscreen, 15 ×*
 10 5/8". Courtesy Pratt Institute, Brooklyn, New York

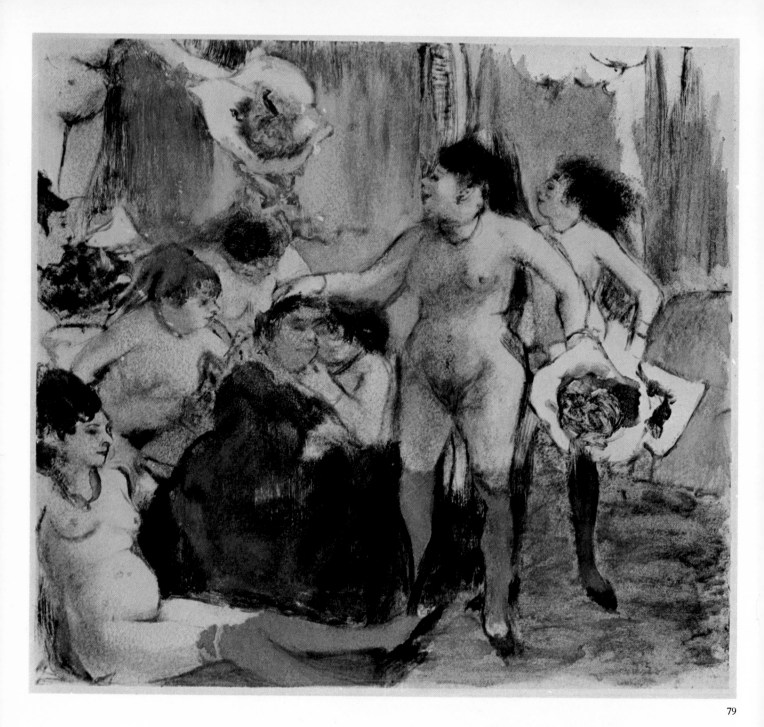

79 *Edgar Degas.* La Fête de la Patronne. *Late 19th century. Color monotype, 10 7/16 × 11 5/8". Private collection*
80 *Georges Rouault.* Clown with Monkey, *1910. Color monotype, height 24 3/4". Museum of Modern Art, New York (gift of Mrs. Sam A. Lewisohn)*

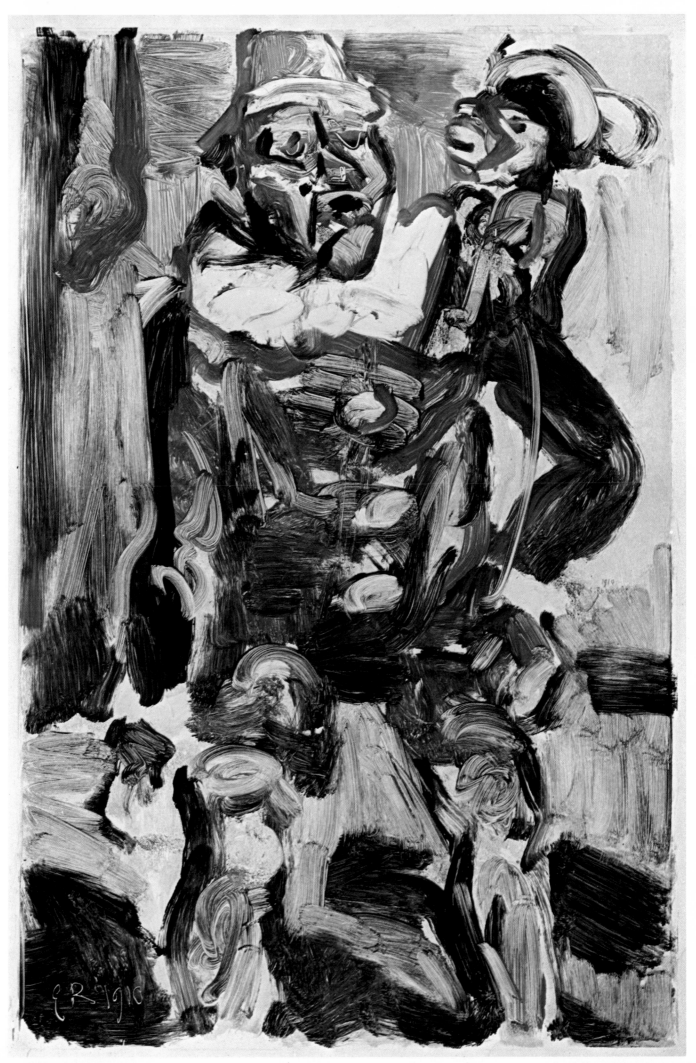

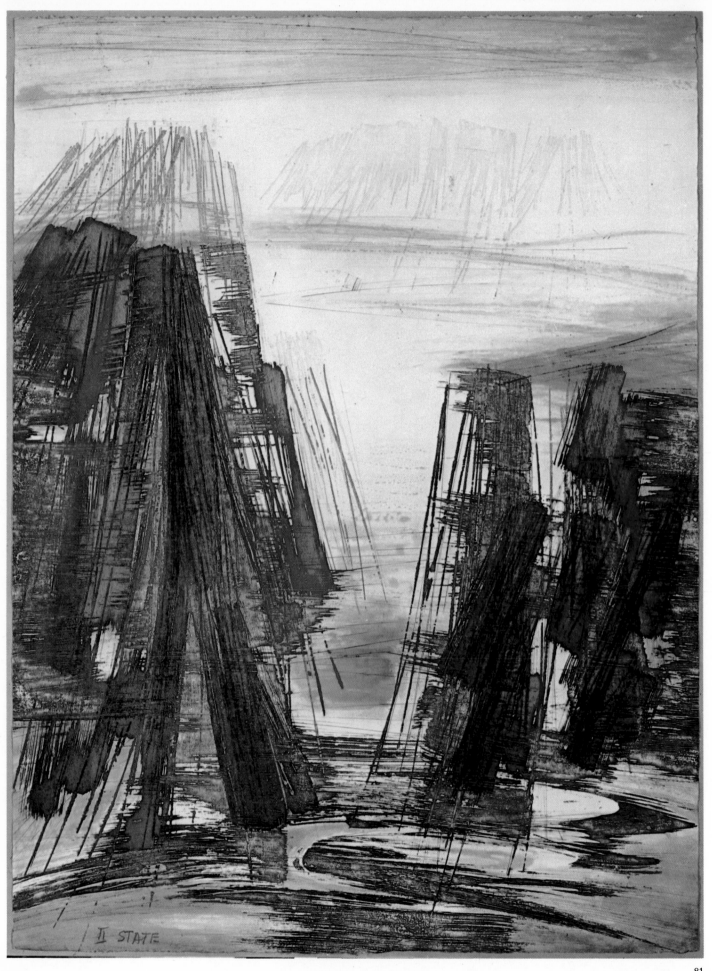

II STATE

81 Terry Haass. Untitled. 1970. Color etching, second state, 25 5/8 × 19 1/2″. Courtesy the
 artist
82 Stanley William Hayter. Composition. Etching with relief color, 15 1/2 × 9 3/8″. Yale
 University Art Gallery, New Haven, Conn. (gift of Herbert Fink)

83

84

83 *June Wayne.* Diktat, *from the series on the genetic code. 1970. Color
 lithograph, 23 1/2 × 39". Courtesy the artist*

84 *Roy Lichtenstein.* Cathedral 2. 1969. Color lithograph, 32 1/2 ×
 48 1/2". © Gemini G.E.L., Los Angeles*

85 *Jasper Johns.* Figure 0. 1969. Color lithograph, 38 × 31". © Gemini
 G.E.L., Los Angeles*

86

87

88

89

90

91

92

93

94

95

disappears in the center of the composition, creating a bubble-like area in white. Vertically divided in half, this white area forms the inside edges of the diptych.

From his sketches, Rosenquist drew his image on seven aluminum plates, allowing one plate per color; but Hollander and Genis found that they could roll two colors per plate simultaneously, and, as a result, the planned colors suddenly doubled to fourteen. Instead of only one, there are two yellows, two pinks, two reds, two greens, two blues, a black and a green-black, and a cream and a white. By the time the final proofing had been completed, however, another red and a third blue had been added, producing a finished print in sixteen colors.

These subtle alterations of color were possible because the artist was allowed unlimited access to the plates. This meant that Rosenquist had the opportunity to continue to work and to create until the last moment before the actual printing began. Although this practice is not allowed in many workshops, both Hollander and Genis feel that it is vital for the artist, who "can get into the plate and thoroughly work his way out."

The concentrated work in another medium while he was painting gave Rosenquist the impetus necessary to complete the painting in his environment, thereby reversing the more usual order of creativity. The solutions worked out in the print changed the work on the large painting. His comments on working in a single-artist workshop express the advantages it offers: "The print then became a drawing for the painting, rather than being a notation of an earlier idea, and the litho became the point of departure for my future work instead of the reverse. Irwin, Fred, and I thought that we could make fire and smoke. It took a lot more work than we anticipated. The sketches became a lithograph and my painting was completed."

Gemini Graphic Editions Limited
by Joseph E. Young
In July, 1965, Kenneth Tyler, master printer, opened Gemini Ltd. in the small back room of a store-front building a few blocks from La Cienaga Boulevard, Los An-

86–95 Prints in various media produced for Pratt Graphics Center, Miniature Print Competition, 1966. General size 2 × 2". Courtesy Pratt Graphics Center, New York
86 James Mellon. Untitled. Etching
87 Rudy Pozzatti. Ruins 1. Etching
88 Liliana Porter. Four Misters. Etching
89 Michael Ponce de León. Self-portrait. Cast-paper print
90 Dennis Olsen. Kitchen. Etching
91 Ann Weisman. Lancashire Rooftops. Mezzotint
92 Bernece Hunter. Moon Wake. Intaglio
93 Jyoti Bhatt. Untitled. Etching
94 Nono Reinhold. Untitled. Etching
95 Seong Moy. Royal Archway. Intaglio

651 James Rosenquist. Area Code. 1969. Color lithograph, 28 1/2 × 52 1/2". Courtesy Hollanders Workshop, Inc., New York

geles, where some of the West Coast's most important galleries are located. He believed that lithography needed an infusion of technology into its craft and of contemporary thinking into its aesthetic in order to become a viable means of modern graphic expression. Tyler and his staff of two—his wife, Kay, and an assistant printer—received the fledgling print workshop's first commission in 1965 to print a lithograph by Nicholas Krushenick as part of the Arts Council's fund-raising drive for the newly opened Los Angeles County Museum of Art. Later the same year, David Hockney completed his series *A Hollywood Collection,* which incorporates elaborately drawn picture frames as part of its Pop imagery. Charles White, now internationally recognized as a black artist, produced two prints, each entitled *Exodus;* and John Altoon created *About Women,* a book of poetry and color lithographs which give a sensitive, biomorphic presentation of abstract Surrealism. At the close of 1965 Alberto Giacometti died, only a few days after he had signed his last print edition, *Nude in Studio,* which had been printed in the burgeoning Gemini workshop.

The following year, 1966, Gemini Ltd. acquired two new partners, Sidney Felsen and Stanley Grinstein, and a new name—Gemini Graphic Editions Limited. Kenneth Tyler's initial belief that "great artists make great prints—that is, *if* and *when* they get around to it" resulted in Gemini's commissioning Josef Albers, who produced *White Line Squares I* and *White Line Squares II,* two series of lithographs which give the visual impression of two colors, though only one was used.

Next came three enigmatic prints by Man Ray, two of which were silkscreened on Lucite and one lithographed on handmade paper. In the same year Edward Ruscha made a single lithograph entitled *1984.* In 1967 Robert Rauschenberg executed his memorable *Booster and 7 Studies,* of which the 72-by-36-inch *Booster* includes a full-length X-ray image of the artist. Gemini then printed Frank Stella's geometric, seven-colored *Star of Persia* series; these works, printed on graph paper, represent Stella's first important lithographs.

Claes Oldenburg, Jasper Johns, and Roy Lichtenstein were among the artists who worked at Gemini during 1968 and 1969 and produced highly innovative works. Oldenburg's *Notes* combines an imaginative text and a virtuoso exploration of contemporary lithographic techniques. Jasper Johns's 1968 *Figures,* a suite of ten black and gray numerals, presents a dramatic investigation of a more traditional draftsmanship. His *Color Numeral* lithographs of the following year challenged painting on its own aesthetic ground, reconciling the illusionism of color and drawing on a two-dimensional basis. Johns's subsequent lead-relief "prints" simulated commonplace objects such as the American flag, a flashlight, and even a piece of bread. These ambiguous images, delicately poised between printmaking and sculpture, move printmaking still further into a new aesthetic realm. Roy Lichtenstein's *Cathedral* and *Haystack* lithographs are brilliant parodies of Monet's famous series of paintings; they are among Lichtenstein's most ambitious graphic art to date.

Albers's 1969 *Embossed Linear Constructions* employed an engineering programmer, who used Albers's ink drawing studies to make digital tapes which directed an automatic engraving mill to cut metal plates. These plates were used in a hydraulic forming machine along with heat and pressure to emboss sheets of handmade watercolor paper. Another Gemini collaboration with technology resulted in Claes Oldenburg's *Ice Bag,* which has completely escaped the confines of the hand-printed lithograph, and yet this kinetic sculpture seems a logical result of both the artist's and Gemini's development.

COLORPLATE 85

COLORPLATE 84

More recently, Kenneth Price produced his strikingly colored *Figurine Cups,* a suite of six complex prints which seem almost in the tradition of California Post-Surrealism that first brought the California avant-garde to international attention nearly forty years ago. The more recent "hard-edge" prints of Ellsworth Kelly, like nearly all the Gemini productions of the past, are worthy of serious consideration.

Today, with a staff of twenty-two persons, a building of its own, international distribution of its production, and a reputation to be envied, Gemini G.E.L. has produced some of the most significant graphic art of the past decade.

The Pratt Graphics Center

The Pratt Graphics Center was born in 1956 out of a dire necessity. Very few open workshops existed then in this country, or anywhere else, for that matter. The Tamarind Lithography Workshop was just a twinkle in June Wayne's eye; Atelier 17 was W. S. Hayter's private fief in Paris, after an unsuccessful stint in New York. Artist Margaret Lowengrund had opened a gallery, The Contemporaries, in a private house on Lexington Ave., which also contained a tiny lithographic workshop with Michael Ponce de León at the press. That combination attracted the attention of the Rockefeller Foundation, which was willing to offer Miss Lowengrund a grant to expand the idea of a gallery-cum-graphics workshop into something more extensive. Needing a nonprofit partner to get her grant, she teamed up with Fritz Eichenberg, then Graphics Chairman of Pratt Institute.

The idea of establishing a highly experimental, internationally oriented workshop, open not only to students but to artists from all over the world who would share their experiences in the stimulating atmosphere of a great metropolis, was a new and intriguing one. That workshop opened officially in 1956 at Third Ave. and 77th St. as an extension of Pratt Institute, with its Rockefeller grant, a small staff of instructors under the direction of Margaret Lowengrund and Fritz Eichenberg, a handful of students, and three presses—two for lithographs and one for etching. At first the organization was called the Pratt-Contemporaries, being loosely connected with Pratt in Brooklyn and the Contemporaries Gallery at Lexington and 77th St.

Unfortunately, Margaret Lowengrund died a year later, but the Workshop flourished under Fritz Eichenberg, who functioned in the dual capacities of Director of the Workshop and Chairman of the Pratt Graphics Department. Through its gallery connection it attracted, as anticipated, many well-known artists, including Stuart Davis, Rufino Tamayo, Ben Zion, Joseph Hirsch, Raphael Soyer, and many others. Here every graphics medium had a chance to be explored. Famous artists rubbed shoulders with young art students; visiting instructors from Germany, France, England, and Italy contributed their knowledge to a common pool; exhibitions were arranged and traveled around the world. To top it off, a unique publication, *Artist's Proof,* designed to promote the contemporary print, was started under the editorship of Fritz Eichenberg. This periodical went to the remote workshops, galleries, museums, and print departments of the world, from Thailand to the U.S.S.R., bringing print aficionados together and promoting understanding of the print in its many different forms.

The Workshop (lately renamed the Pratt Graphics Center) soon outgrew its old facilities as its reputation spread from year to year. Now enrolling hundreds of

artists from practically every art-oriented nation of the world, it has moved from its cramped quarters to Broadway and 13th St., within easy reach of many artists' studios. Here Paul Jenkins and Richard Lindner did their first lithographs; Archipenko and Jim Dine worked at the presses; Dali dropped in to see what new things were going on in printmaking; David Hockney started his etchings for *The Rake's Progress.* Here Oldenburg, Ortman, Indiana, Barnett Newman, and Gottlieb worked at one time or another, together with a host of well-known artists from Latin America, Asia, Israel, and most of the European countries.

The Center's teaching staff consists mostly of short-term appointments, to bring a variety of viewpoints and experiences into play, enriched by invited guest artists, lecturers, and master printers. Among its early staff members the Center counted Arnold Singer, Michael Ponce de León, Walter Rogalski, Seong Moy, and Andrew Stasik (who advanced from Assistant to full Director after Fritz Eichenberg left Pratt to move to the University of Rhode Island in 1965). From Germany came Christian Kruck, Erich Moench, and Jürgen Fischer; Ben Berns came from Paris, Sorini from Italy, Izumi and Munakata from Japan, Delamonica and Camnitzer from Latin America. Al Blaustein, Bill Toulis, John Ross, and Clare Romano came from the Pratt campus to teach here. Portfolios of prints were published; the circle of Members of the Center grew to give it much-needed support. Frequent lectures, demonstrations, and exhibitions were held.

COLORPLATES 86–95 The Workshop has become truly a center for the printmaking world, sending out its disciples and spawning other workshops here and abroad.

University of Iowa Graphics Workshop

For a quarter of a century the graphics workshop of the University of Iowa has been under the domination of Mauricio Lasansky, who came from Argentina in 1945, armed with a strong will and considerable talent as an etcher. Well-known artists have profited by his tutelage, among them John Paul Jones, Moishe Smith, and Virginia Myers (who now heads the undergraduate printmaking studio). The excellently equipped plant is solely devoted to the exploration of the metal media—engraving, etching, and drypoint.

Indiana University Graphic Workshop

Since 1956 the printmaking department at Indiana has been under the vigorous direction of Rudy Pozzatti, a versatile and innovative graphic artist who conducts his classes in an informal yet efficiently organized way. Now in their own superbly equipped building, the workshops are devoted impartially to all graphic media—intaglio, relief, and lithography—categories in which Pozzatti himself feels completely at home. A fine museum and a good art history department give full support to the fine arts program.

Tyler School of Art Graphic Workshop

Located on the campus of Temple University, in Elkins Park, Pa., the Tyler School has developed a very active and intensive program in the graphic arts. Now under the chairmanship of Lithuanian-born Romas Viesulas, notable for his fine lithographs, the workshops teach everything from silkscreen and wood engraving to mezzotint.

Arthur Flory has contributed a great deal to the development of lithography in

the department. He started one of the earliest litho studios in Tokyo, under the sponsorship of the Ford Foundation.

The superb Lessing J. Rosenwald Collection nearby serves as an excellent background for the graphics curriculum, as does the fine Print Department of the Philadelphia Museum of Art.

Tyler maintains an extension in Rome at the Villa Caproni.

University of Wisconsin Graphic Workshop
Established in 1947 as a one-man affair by the late Alfred Sessler, the Wisconsin Graphic Workshop has grown into one of the most important graduate and undergraduate training centers in the country. The four media are taught by four experts: Warrington Colescott for intaglio, Dean Meeker for silkscreen and collagraph, Jack Damer for lithography, and Raymond Gloeckler for the woodcut and other relief media. Constant experimentation and cross-fertilization go on among the different media, as the high quality of student work shows.

Yale University Graphic Workshop
Long dominated by Josef Albers's strong personality as head of the Department of Design, Yale showed an early interest in creating workshops in both design and printmaking.

Gabor Peterdi, distinguished artist and etcher, who had sparked the workshops at the Brooklyn Museum and at Hunter College, moved to Yale in 1952. He now holds Yale's first full professorship in graphics. His vast experience in the intaglio medium is summed up in his book *Printmaking Methods Old and New*. Among his best-known former students are Robert Birmelin, Gerson Leiber, Michael Mazur, Peter Milton, Walter Rogalski, and Richard Ziemann.

The Printmaking Workshop
The Printmaking Workshop, 248 West 23d St., New York, has been under the able direction of Bob Blackburn since its inception. It is a self-supporting, nonprofit organization devoted to sharing work space, equipment, knowledge, and experience with serious artists interested mainly in etching and lithography. Many important artists have used the Workshop's excellent facilities, including Will Barnett, Bernard Childs, Minna Citron, Boris Margo, John von Wicht, and others.

Impressions Workshop, Inc.
Impressions Workshop, at 27 Stanhope St., in Boston, is devoted to the production and publication of fine original prints in lithographic and intaglio techniques. It was founded in 1959 by the late George Lockwood, artist, teacher, and printer, whose original concepts of the ideal atelier are still strongly felt in the workshop. Here artists may fully explore the possibilities of the various graphic media with skilled printers who give all possible technical assistance without intruding into the personal aesthetics of the artist.

Over the years Impressions has had a flexible structure, reflecting the changing interests and needs of its artists and craftsmen. While lithographic and intaglio media have always been of primary concern, extensive commitments have been made in the past to serigraphy, relief, and letterpress printing, and to bookbinding and res-

toration. For some years, in a separate but adjacent facility—the Experimental Etching Studio—evening classes have been conducted. This shop is fully equipped for all intaglio and related techniques, including differential-viscosity color printing, and is open to artists on a daily, weekly, or monthly basis.

Service printing is available to artists, galleries, and publishers. Lithographs are printed both from stones and from aluminum plates, with a maximum stone size of 30 by 40 inches and up to 66 inches for plate printing. Intaglio prints in color or black and white can reach a maximum plate size of 48 by 60 inches. Photo techniques, mixed-media printing, and *collé* processes are also available.

Over the years a wide range of artists has used the workshop, including Sigmund Abeles, Arman, David Aronson, Mirko Basaldella, Robert Birmelin, Bernard Childs, Naum Gabo, Sam Gilliam, Gyorgy Kepeš, Karl Knaths, Ed Koren, Ron Kowalke, Michael Mazur, Richard Merkin, Peter Milton, Aubrey Schwartz, Saul Steinberg, Harold Tovish, and many others.

Published prints represent the work of both new and established artists in a broad range of single prints, broadsides, portfolios of print suites interleaved with text, and books in limited editions.

The staff includes Stephen Andrus, Proprietor; Jane Larkin, Administrator; Paul Maguire, Head Printer, Lithography; Robert Townsend, Head Printer, Intaglio; Deborah Cornell and Gretchen Ewert, Instructors, Experimental Etching Studio.

VIII
PAPER

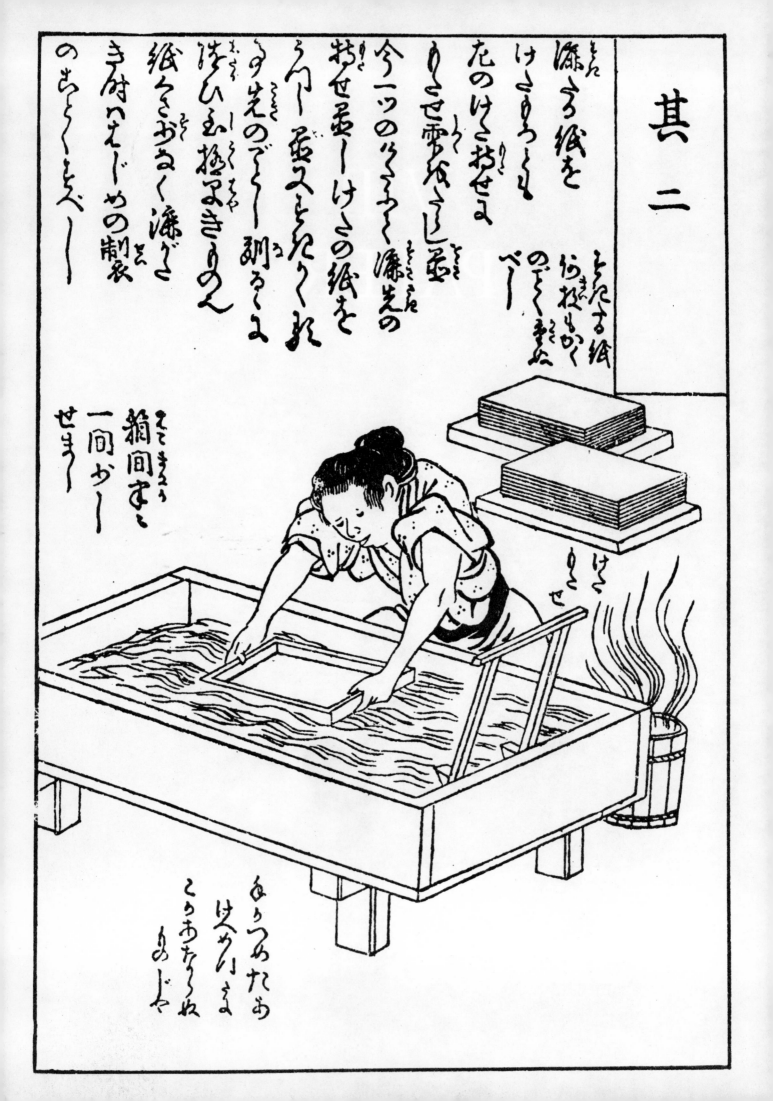

CHAPTER 21

PAPERMAKING

HISTORY

The success of a print depends to a large degree on the quality and character of the paper chosen for a particular purpose. The knowledge of paper, its history, its chemistry and characteristics, is therefore of vital importance to the printmaker, or, in fact, to anyone who uses this precious material for artistic purposes.

As a rule, however, one takes paper for granted, using whatever is easily available. It is for that reason that this chapter is included, honoring a material whose existence has been essential for the pursuit of art and knowledge during its two-thousand-year history.

Paper has served many purposes. The ancient Chinese and the first Arab paper-makers produced papers for fans, parasols, raincoats, household uses, wrappings, and various kinds of containers. Large sheets of especially strong *kōzo* paper, called *shōji* by the Japanese, served as windows and screens. But the making of fine papers for the purposes of calligraphy, drawing, and printing has always been the noblest test of the papermaker's craft.

Invention

Paper was first made in the Orient; its precise origins are obscure. Some form of silk-based paper may have been used very early in China. The first written reference to papermaking occurs in a chronicle of the Han Dynasty, which tells of the making of paper by Ts'ai-Lun, an official at the court of the Emperor Ho-ti at Lei-Yang in A.D. 105. He became widely known in China for his process, which involved the beating of rags, hemp waste, tree bark, and fishnets in a stone mortar. By the end of the fifth century paper had firmly established itself as an inexpensive substitute for silk scrolls throughout Central Asia.

An early example of Chinese paper was found at Tsakhortei in 1942; it was a coarse paper, covered with handwritten characters, and seems to date from about the time of Ts'ai-Lun. Many ancient scrolls and books have survived in remote Buddhist sanctuaries, in caves or shrines. In the Cave of the Thousand Buddhas in Tun-huang, which is known to have been in use as early as A.D. 366, over 15,000 paper scrolls were found by Sir Aurel Stein.

The secret of papermaking probably spread first to Korea, where paper made from mulberry bark was being used for wood-block printing in the eighth century.

Japan

The date of papermaking's introduction into Japan is uncertain. One chronicle gives the date as A.D. 610 and links the spread of the process with the influx of Chinese Buddhist missionaries. The Japanese quickly perfected their skill and began to produce the many varieties of fine paper for which they are still famous. The fibers of the *kōzo* (paper mulberry), *gampi,* and *mitsumata* (first used in the sixteenth century) were and still are the three basic papermaking materials of Japan. During the ninth century the government not only set up an officially sponsored paper mill but also encouraged provincial papermaking by demanding that certain taxes be paid in the form of paper. This tax system was eventually modified, but knowledge of the process spread throughout the countryside, and even today many of the fine Japanese papers are produced in rural villages in the winter, when the harvesting is over, although advancing technology and growing demands are slowly encroaching on this local industry.

PLATE 652

The first and most famous Japanese treatise on papermaking is the *Kamisuki chōhōki* (*Handbook of Papermaking*) published in 1798 in an attractive edition illustrated with woodcuts. The author was a paper dealer from Iwami province who explained his motivation for writing the book in this way: "Many are the kinds of paper made for the profit of the nation by women with a thought to utilizing time not spent in the fields. Here I shall relate in outline the making of hanshi paper in the hope that my book may serve as a guide to the earning of a livelihood. . . . Is it because they are unaware of the difficulties in making paper that people have so little regard for the wasting of it and so little fear of the Lord protector of this vocation?"

Paper made from the *gampi* fiber is lustrous and long-lasting; that of the *mitsumata* is very smooth and soft. Perhaps the most often used of the three, the *kōzo,* or mulberry paper, is famous for its strength. The more primitive method of papermaking, called *Nagasi-zuki,* involves pouring the pulp, which is often mixed with a natural mucilage taken from the roots of the *tororo-ai* (a kind of hibiscus) and other plants, into the paper mold. The commoner method, called *Tame-zuki,* uses a pulp vat into which the mold is dipped.

The traditional preparations for papermaking begin in late November, when the shoots of the *kōzo* tree are cut. They are steamed over a huge iron caldron of boiling water until the bark can easily be stripped off. The black outer layer as well as any knotholes or other flaws must be carefully removed. The whitened bark is then soaked, first in the caldron and later in a running stream. Much of this work is done by women, often working from dawn to dusk in the damp, piercing cold.

The bleached bark is again boiled with lye or caustic soda to soften it. The boiling must be carefully timed to obtain the proper consistency of the pulp, which should be neither too soft nor too stringy. Again the bark is soaked and worked over with chopsticks or fingers to remove the last impurities and placed on a flat board or stone to be thoroughly beaten with wooden rods or mallets. At last the pulp is placed in the wooden vat, water is added, and the solution is stirred with a large comblike agitator. The mold is dipped and shaken to obtain the desired thickness of the paper. When water and excess pulp have drained off, the sheets are placed on a platform, stacked up, and squeezed by a primitive press consisting of boards weighted with rocks. To complete the drying, the sheets are spread on boards with a soft brush and left to dry in the sun. The brushing also serves to smooth the surface of the paper and often eliminates the need for glazing or sizing.

It is doubtful whether the production of fine handmade paper in Japan will long survive the onslaught of the machine, since young people in the villages are increasingly unwilling to learn this ancient and difficult craft.

Trade Routes

Although paper found its way to the West along the caravan routes, knowledge of the process itself did not spread until the eighth century, when the Arab governor of Samarkand discovered two Chinese papermakers among the prisoners taken in a raid. The captives were made to divulge their secrets, and a paper mill was established at Samarkand about A.D. 751; another was started in Baghdad in 795 under the patronage of Harun al-Rashid. The Arabs built paper mills throughout their empire and guarded their own trade secrets as jealously as the Chinese had.

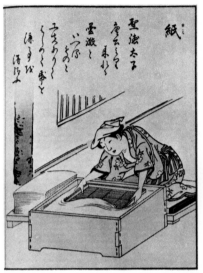

652

652 *Tachibana Minko.* Papermaking. *c. 1770. Color woodcut. Published in Charles Pomeroy,* Traditional Crafts of Japan, *Walker-Weatherhill, New York and Tokyo, 1967*

When the Moors invaded and conquered the Iberian Peninsula, papermaking finally got a foothold in Europe. Water-powered stamping mills at Xátiva and Toledo, Spain, were flourishing by the mid-twelfth century.

The typical Arab paper was soft, consisting largely of linen (or flax) fiber sized with starch. Sizing was employed as a means of closing up the minute spaces between the fibers, making the surface smoother to write on and keeping the ink from feathering. Animal-glue sizing was developed at the Fabriano mill in Italy about 1280. The firm is still well known as one of the finest and oldest European mills in continuous operation.

The Mold

In its beginnings in the Orient paper was dipped in a mold covered with coarse cloth; this was later replaced by a screen of fine strips of bamboo laced to an outer bamboo frame with silk thread. The Arabs, expert in the manufacture of fine brass wire, substituted a wire screen. The wire mold, with its closely spaced "laid lines" and, at right angles to these, the finer "chain" wires, creates the familiar pattern of "laid" handmade papers. "Wove" paper, formed over a fine wire mesh and without the distinctive line pattern, did not achieve popularity in Europe until, in the eighteenth century, printer John Baskerville of Birmingham decided that it would provide a more receptive surface for his delicate typeface.

The craft spread slowly—to France in the early fourteenth century, to Germany by mid-fourteenth century, to the Netherlands at the beginning of the fifteenth century, and to England sometime before 1495, when John Tate operated a mill near Stevenage, Herts. By this time paper had completely replaced parchment as writing material, and busy mills served the tremendous need created by the invention of movable type.

One of the first paper mills in Germany was founded in Nuremberg by Ullman Stromer, whose diary gives us the first written account of papermaking in Europe. His mill, nestling idyllically outside the city walls, appears in a woodcut from the *Nuremberg World Chronicle* of 1493.

European Method

PLATE 653

A fairly simple process continued in Europe for centuries with only minor changes until the invention of fully mechanized paper mills at the end of the eighteenth century. Rags, preferably clean and white, were gathered, sorted, and cut up, rolled into large balls, soaked, and allowed to stand and ferment for weeks. The portion not destroyed by the action of fermentation was then placed in a vat, mixed with water in a 30 to 70 proportion, and pounded, often by water-driven hammers, until the fibers were thoroughly dissolved.

The vat man then dipped his mold into the brew, letting excess water run off and shaking the frame rhythmically to ensure even distribution of pulp. A wooden frame, called a deckle, fitted over the screen and prevented the pulp from running off. The small amount of pulp which seeped under the edge accounts for the uneven "deckle edge," a characteristic of handmade paper now sometimes poorly imitated by machine.

The screen was passed from the vat man to the coucher, who carefully placed the sheet on a woolen felt, while the vat man dipped a second mold. When a large

653 Anonymous French. Scene in a paper mill. 18th century. Engraving. Published in Papermaking, Art and Craft, *Library of Congress, Washington, D.C., 1968*

653

stack of sheets had accumulated, it was squeezed in a hand press by the lay man. The partially dry sheets were then hung up to dry in "spurs" of four or five sheets. America's distinguished historian of papermaking, Dard Hunter, has estimated that a skilled three-man team could produce about five reams of paper a day.

If desirable, the paper might be finished by sizing or by glazing (smoothing the surface with a stone, a hammer, or mechanical rollers).

The first significant improvement was the invention of the Hollander mechanical beater (a wooden roll mounted with sharp blades and set into a pulp vat) in the late seventeenth century. It made Holland, and particularly Amsterdam, a center of the paper trade.

Watermarks

The practice of watermarking paper by mounting a design made of bent wire on the wire mold seems to have begun about 1270. Some of the earliest watermarks known are from the Fabriano mill. The more elaborate chiaroscuro watermark was invented in 1848 in England by William Henry Smith, who was seeking to make counterfeiting of banknotes more difficult. An electrotype of the design was pressed into a piece of wire mesh, which was then attached to the screen, producing an almost three-dimensional image.

Mechanization

The first true papermaking machine was invented by Nicholas-Louis Robert at Essonnes, France, in 1798. Based on a continuous wire mesh, or "web," it was able to turn out quantities of paper with a minimum of human intervention. The machine

got its name, the Foudrinier, from two brothers who patented it in England. In the turbulent years of the early Industrial Revolution papermaking machines were among the targets of angry craftsmen in fear of losing their employment. But the advance of technology was inexorable, and the development of wood pulp as an inexpensive and seemingly inexhaustible source of paper completed the triumph of the power-driven papermaking machine. It was also the beginning of the era of chemical bleaches and additives, and soon synthetic fibers began to appear. The artist and printmaker were shortly to bemoan the slowly disappearing handmade papers, still unmatched for their beauty, strength, longevity, and affinity for ink.

Papermaking in the Americas

A soft, paper-like material was manufactured by the Mayans, and later the Aztecs, using tree bark, soaked, beaten, and treated with lime to remove the sap and then roughly spread into sheets. A similar bark paper is still being made in the islands of the South Pacific.

The first European-style mill set up in the Western hemisphere was situated near Mexico City. It was founded by Spanish papermakers, with the encouragement of the Crown, sometime before 1580.

In North America William Rittenhouse, a German immigrant, started a mill near Germantown, Pa., in 1690. During the colonial period Boston became the second greatest publishing center of the British Empire, and there was an excellent market for American-made paper. The industry flourished, despite a shortage of trained craftsmen and in defiance of the British Board of Trade, which learned with some alarm in 1731 that £200 worth of paper was being made yearly in Massachusetts. They noted that the Colony had passed an act to encourage the manufacture of paper, "which law interferes with the profit made by the British Merchants. . . ."

Printers such as Benjamin Franklin, although continuing to import paper from England, enthusiastically supported the American mills. Appropriately, Paul Revere engraved and printed the banknotes of the Provisional Government on fine paper made just outside Boston. Soon the papermaking machine was widely introduced here, with the vast forests of the West and Canada providing the raw material. Americans today are by far the greatest producers and users of paper in the world, consuming a staggering 500 pounds per person per year!

CHAPTER 22

CARE AND PRESERVATION OF WORKS OF ART ON PAPER

BY DOUGLASS HOWELL

In our urban centers we suffer heavily from man-made pollutants. While such pollutants—at times in heavy concentrations—are bad for all animal life, such chemicals as hydrogen sulfide, nitrous oxides, lead oxides, and kerosene, given off by cars, trucks, and factories, are injurious to works of art as well.

Works of art breathe in their own way. They are affected by changes in the atmospheric pressure and by temperature, humidity, and pollutants. If the air in a room is warm and dry, the art works release a certain amount of humidity and they shrink; wood and paper especially are prone to contract and become too dry. The reverse is true when the air becomes too heavily laden with moisture. Atmospheric pressure varies from day to day, and it acts like a pump upon all artifacts of vegetable and animal matter with increasing or decreasing pressures. This pressure creates a movement which carries with it water vapor laden with any pollutants that are present.

PLATE 654

In our museums we have works of art on paper that date back to the fifth century and we have scraps of paper that date back almost two thousand years. This gives us an idea of the life span of some papers. Laboratory tests for papers for the fine arts should be based on a standard for a minimum life of a thousand years, and procedures should be governed accordingly. No paper is ever dry; all contains a percentage of water vapor. It takes a full hour in a special oven at 100 degrees C. before a piece of paper being tested for its water-vapor content is almost dry.

There is an old saying that a man is known by the company he keeps. This is also true for papers. Store and keep good papers with those of poor quality, and in time the worse will contaminate the better. When a very fine paper is in contact with a chipboard or a corrugated board, the contamination can become visible within a few years, but when a fine paper is in contact with one of slightly lower quality, the contamination may not become visible until perhaps a hundred years later. Most papers and cardboards or mounting boards made from wood pulp have remainders of chemicals in their makeup. These are manufactured in great quantities to a standard that meets cost-efficiency requirements for the economics of commerce. They are considered expendable items. Under variations of atmospheric pressure the chemicals in such papers and boards are in constant motion, contaminating whatever they touch.

In framing pictures too much attention is given by many to the frame and its expense, and not enough is given to how the work of art is mounted and placed in its frame. It is preferable to have a simple frame and good materials in the mounting of the work and the backing of the frame. Mat boards and mounting boards should be of 100 percent rag quality, such as is used by most museums today. The mat has the purpose of lifting the glass of the frame away from contact with the drawing, print, or watercolor. The matted work should be set into the frame for a close fit, with just enough space to insert underneath the molding a thin sliver of soft cotton felt around the four sides, which prevents dust from sifting through to the picture. Done properly, this is better than the usual practice of gluing the back with a piece of wrapping or kraft paper, which is chemically impure and soon becomes brittle and useless.

If works of art are not to be framed, they should be kept, mounted or not, in map cases specially made with all-rag board, the sides sealed with strips of raw linen, very similar to the slip cases made for rare books. These are then stored flat on shelves

654 *Hans Holbein the Younger.* The Knight,
from the series Dance of Death, *Lyons,
1538. Woodcut, printed from the
original block on handmade paper by
Douglass Howell, 2 3/16 × 1 11/16".
Collection the author*

654

or are laid flat in drawers or cabinets built for storing maps, prints, and drawings.

It is preferable to have all art work properly mounted to protect it from handling. Even clean hands affect the paper, for our skin exudes a fatty acid which causes deterioration of the paper. The textures of papers have a sensuous quality, which people like to feel and to touch, and the damage cannot be perceived until too late. One might even suggest handling works of art with cotton gloves, so as to avoid the destructive effects of fingerprints.

In the use of glues care must be exercised. One must determine what is time-tested, subjected to the experience of history. One might consider vegetable glues, such as those made from triple-ground wheat flour, some starches, or edible gum arabic; all these have a long history in use. The gluing operation is reversible; that is, with proper dampening these glues can be lifted off. Many modern adhesives are poison to papers; they do damage which cannot be repaired.

While one can mount a work with a bit of paste at its two upper corners, it is more advisable to use small paper hinges made from very thin, unsized paper, similar to that used for tea bags. Such hinges permit a slight expansion and contraction of the paper, thus supporting the art work under atmospheric changes.

Rare and costly prints, drawings, and watercolors should be mounted upon natural linen textiles. This woven linen should be thoroughly washed by hand in warm water with brown soap and then rinsed until the water is clear. After washing, the fabric is hung in the fresh air to dry. Then it is spread over a mounting board with gentle stretching, and the overlap only is glued to the back. The art work is then carefully centered, and with a needle and fine thread fixed to the linen support with but a single stitch at each of the two upper corners. This stitch is made in such a way as to permit a slight movement of the paper under atmospheric differences. A beveled support, properly mitered to fit the frame and covered with the same linen (not glued down but held in place by some small copper tacks), holds the glass away from the work of art. This acts as an extra filter within the molding of the frame. There should be a space of about 5/8 inch between the work of art and the glass; this permits the paper to curl a bit when weather conditions are on the dry side.

The restoration of works of art on or in paper is a very difficult matter. There is

not sufficient space here to discuss all the problems, but let it be said that any kind of chlorine bleach is ruinous to papers, and certainly to all fine handmade papers. Chlorine degrades flax fibers and cotton as well. It damages parchment, and it is destructive of all animal glues. Handmade papers, going far back into history, were all sized with animal glue, excepting papers from the Orient, which were sized with starches. Works of art from the Far East present especially difficult problems for the restorer; it is the part of wisdom to employ the Oriental philosophy of "working with nature" rather than trying to bend nature to his will.

CONTRIBUTORS

GLOSSARY

BIBLIOGRAPHY

INDEX

Contributors

Glen Alps, initiator of the collagraph, presently teaches in the Art Department of the University of Washington at Seattle, where he serves as Chairman of the Division of Printmaking. His work has won numerous awards, including sculpture commissions from the city of Seattle in 1960 and 1961. He has worked at the Tamarind Lithography Workshop under a Ford Foundation Grant. He has had more than eighty one-man shows and is represented in important collections here and abroad.

Mario Avati, born 1921 in Monaco, has been studying, working, and living in Paris since 1947. After exploring every conceivable graphic technique from woodcut to lithograph to etching, he discovered the mezzotint as his favorite medium and became its undisputed contemporary master. A prodigious worker, he has produced more than five hundred plates and illustrated some outstanding books with original prints. His work can be found in every major collection. In 1969 he received the President's Gold Medal at the International Print Exhibition in Florence.

Norio Azuma was born in Mie-ken, Japan, in 1928 and has been a resident of the United States since 1955. He studied at the Kanazawa Art College and later at the Chouinald Art Institute, Los Angeles. His paintings and unique textured serigraphs have won numerous awards and are in most major collections in the United States.

Robert Burkert, born and raised in Racine, Wisc., is married to Nancy Ekholm Burkert, an artist and illustrator. He holds an M.A. degree from the University of Wisconsin at Madison and has studied and worked in Mexico, Italy, France, and Spain. He is presently Associate Professor of Art at the University of Wisconsin, Milwaukee, and recently spent some time in Paris, where he worked on a combined lithography-silkscreen technique. He has been the recipient of numerous awards and is represented in major collections in the United States.

Edmond Casarella, born in Newark, N.J., in 1920, studied at Cooper Union and the Brooklyn Museum School, where he later taught. He developed the method of cardboard and paper relief prints over a period of ten years, but has recently turned to sculpture as his main interest. His prints have been shown in national and international exhibitions and are in important collections here and abroad. He has received a Fulbright Fellowship and a Guggenheim Grant to further his work.

Federico Castellon, born 1914 in Almería, Spain, came to the United States at the age of seven and was entirely self-taught. Fifteen years after his arrival he had one-man shows in New York and Madrid and had exhibited in Paris, together with Miró, Dali, and Picasso, in the early days of Surrealism. The richness of his imagination equaled his amazing capacity for work and his skill in his favorite media, aquatint and lithography, in which he proved himself to be a master. He traveled extensively in the Far East and in Europe and preferred to live in his two favorite cities, Paris and New York. He received two Guggenheim fellowships and a grant from the National Institute of Arts and Letters. The artist died after a short illness in New York in 1971. His widow Hilda is a talented artist in her own right.

Bernard Childs, born in Brooklyn in 1910, studied with Kimon Nicolaïdes at the Art Students League in New York and with the famous Danish silversmith Per Smed.

After wartime service in the Navy he studied with Ozenfant in New York, traveled extensively in the Far East, and then settled in Paris. He likes to use power tools on his metal plates. In his sculptural compositions he has explored the refraction of light, using transparent acrylic polarized plates. His work is in major collections here and abroad. He now lives and works in New York.

Warrington Colescott, born in Oakland, Calif., in 1921, now lives near Madison, Wisc., where he is Professor of Art at the University of Wisconsin. After studying art at the University of California, in Paris, and in London, on a Fulbright scholarship, he taught himself the serigraph technique with the help of commercial printers. In 1958 he turned to the intaglio media, which he frequently uses to express his social and political convictions. He has had numerous one-man shows and has participated in annuals and biennials here and abroad.

Gertrud J. Dech, born 1941 in Kaiserslautern, studied at the State Academy of Fine Arts in Stuttgart, with Professor Sonderborg in painting and Erich Moench in lithography. Beginning in 1968 she taught lithography and serigraphy, her special interests, for a number of years at the Academy, but now teaches in West Berlin.

Arthur Deshaies, born in Providence, R.I., now lives in Tallahassee and teaches at Florida State University. He is represented in major public and private collections and has won innumerable awards. Although he studied at Cooper Union and the University of Indiana, he claims to be essentially self-taught, having started at the age of ten to make drypoints on aluminum! He is known for his unique engravings on plaster and Lucite. In the print department at Florida State he introduced the idea of multiple-piece and cutout plates to his students in 1963 and has made the use of motor tools on Lucite common practice there.

Eugene Feldman, born in Woodbine, N. J., in 1921, is a pioneer in the creative use of photolithography. A graduate of the Philadelphia Museum College of Art, he now owns and operates the Falcon Press, an experimental offset print shop in Philadelphia.

Antonio Frasconi, born in Buenos Aires in 1919 and raised in Montevideo, Uruguay, came to the United States in 1945, and studied under Kuniyoshi at the Art Students League in New York. He is perhaps the best-known exponent of the woodcut in this country and has illustrated, designed, printed, and published many books, single prints, and portfolios in this medium. His work is represented in most of the major print collections here and abroad. Among the many important awards and honors he has won was a one-man exhibition at the Venice Biennale of 1968. His film *The Neighboring Shore,* showing his woodcuts for poems by Walt Whitman, won a Grand Prix at the International Film Festival in Venice in 1960. He lives and works in South Norwalk, Conn.

Jozef Gielniak, born in 1932 in Derain, France, studied at the École des Beaux-Arts at Valenciennes, and went to Poland in 1950, where he now works at the Sanatorium Bukowiec. He has mastered the art of engraving on linoleum to an amazing and

unique degree and has been honored by various awards at exhibitions in Kraków and Ljubljana.

H. A. P. Grieshaber, born in 1909 in Rot an der Rot, Upper Swabia, Germany, studied in Stuttgart, London, and Paris, traveled extensively in the Near East, but has spent most of his life on the Achalm near Reutlingen. He is considered one of the most articulate, gifted, and respected graphic artists in Germany today. A fighter for so-called lost causes, wherever they occur, he is very much involved in the problems of our time. The bulk of his work consists of color wood blocks, cut with power and spontaneity, yet with the sure hand of a master raised in the tradition of the great German woodcutters of the sixteenth century. Perhaps his most significant work to date is the series *Totentanz von Basel,* forty color wood blocks printed and published in Dresden in 1966. He won the coveted Albrecht Dürer Prize in Nuremberg, 1971.

Terry Haass, born in Czechoslovakia in 1923, studied art history and archaeology in Paris at the Sorbonne and the École du Louvre. She has worked with Hayter at Atelier 17 and with Lacourière-Frélaut in Paris and has taken part in archaeological expeditions in the Near East. She has had one-man shows in the United States, Germany, Israel, France, Italy, and Scandinavia and is represented in the collections of the Bibliothèque Nationale, the Victoria and Albert Museum, the Museums of Modern Art in New York, Haifa, and San Francisco, in the Brooklyn and Guggenheim Museums, and in the Basel Art Museum. Her permanent residence is in Paris.

Felix Hoffmann (1911–1975), of Aarau, Switzerland, came from a long line of music-loving, literary, and artistic Swiss. He studied at Karlsruhe under Ernst Würtenberger, and later under Hans Meid in Berlin, and became a consummately skilled artist and draftsman in almost any medium, extending from murals, stained glass, and stage design to every technique of the graphic arts. His favorite medium was the woodcut, which he used to illustrate many books, notable for their excellence in design and production. From 1935 until his death he lived, worked, and taught in Aarau.

Douglass Howell: Printmakers owe a debt of gratitude to Douglass Howell, of Locust Valley, New York, who for over thirty years has studied the art and science of making paper. In early boyhood Howell began his first serious research into the history of papermaking. By the time he reached college, making paper by hand had become his avocation. He has had access to many of the most notable archives in Asia and Europe, including the collections of the Uffizi and the Laurentian Library in Florence. Howell was aided in his one-man crusade by a Ford Foundation fellowship in the creative arts. He is compiling a history of papermaking and is engaged in a series of experiments involving the conservation, strength, and compatibility of his papers with various pigments. He also has emerged as an artist in a new medium, which he calls "synchronic drawing" or "papetries"—delicate fusions of fiber and strings, which have been shown at Betty Parsons, New York, the Boston Museum of Fine Arts, and elsewhere.

William Kent, born in Kansas City, Mo., attended the University of Illinois at Evanston and later studied musical theory with Paul Hindemith at Yale (1944–47). He

began to work as a sculptor in 1948 and as a printmaker in 1963. His unique prints produced on unusual materials have been exhibited in many New York galleries and print shows across the country.

Misch Kohn, born in 1916 in Kokomo, Ind., studied at the Herron Institute in Indianapolis and concentrated on experiments in every graphic medium. He began as a virtuoso wood engraver; later, he explored lithography and most of the intaglio techniques with great skill and inventiveness. His prints are in most of the important collections in the United States and abroad, and he has exhibited widely, receiving numerous awards. For many years he taught at the Illinois Institute of Technology in Chicago but now lives in Castro Valley, Calif.

Christian Kruck, born in Hamburg, Germany, in 1925, became a lithographic apprentice in Nuremberg at the age of fourteen. He studied there later at the Academy of Fine Arts and was encouraged by Erich Heckel after the war to continue as an independent painter and graphic artist. In 1952 he became head of the graphic department of the Städel Institute of Applied Arts in Frankfurt. He traveled widely in Europe and America and became well known for his unique method of "stone painting," which he explains in his *Technik und Druck der kunstlerischen Lithographie.*

He has taught as a guest instructor at the Pratt Graphics Center, had more than fifty one-man shows, and has his prints, paintings, and watercolors in many collections in Europe and America.

Armin Landeck, etcher and engraver, was born in 1905 in Crandon, Wisc. He studied at Columbia University, is a member of the National Academy and of the American Institute of Arts and Letters, and has exhibited widely. His many awards include the Morse Medal and the Wiggins Award. His home is now in Litchfield, Conn.

James Lanier, formerly instructor in the Department of Graphic Design, Pratt Institute, Brooklyn, operates a private press at Ulster Park, N. Y., and is an expert printer in most of the now-popular graphic media.

Tadeusz Lapinski, born in 1928 in Rawa Masowiecka, Poland, received his M.F.A. at the Academy of Fine Arts in Warsaw. Since 1968 he has lived in the United States. He has had one-man shows here, in Mexico, Brazil, France, Germany, Poland, Italy, and Yugoslavia, and is represented in art collections in most of these countries. Among his numerous awards is the UNESCO Prize he received in Paris in 1965.

Mildred Lee is the Director of the Lee Gallery in Belmont, Mass.

Leonard Lehrer, born in 1935, studied at the Philadelphia College of Art and at the University of Pennsylvania, where he earned an M.F.A. degree in 1960. His prints and paintings have brought him several awards, and he is also an accomplished photographer. From 1956 to 1970 he taught at the Philadelphia College of Art, as Co-Director of the Foundation Program. In September, 1970, he became Chairman of the Department of Art of the University of New Mexico at Albuquerque but now holds a similar position at the University of Texas.

Boris Margo was born in Russia and studied in Leningrad, Moscow, and Odessa. An American citizen since 1941, he now lives and works in New York. His work is in such American collections as the Brooklyn Museum, the Chicago Art Institute, and the Philadelphia Museum of Art, as well as in many of the major print cabinets of Europe.

Frans Masereel, born in Blankenberghe, Belgium, in 1889, fought for mankind's finest causes with unflagging conviction for half a century. A humanist in the best Erasmus tradition, he expressed his thoughts without compromise in thousands of wood blocks, in novels without words such as his *Book of Hours, The Passion of a Man, The Sun,* and *The City.* He also illustrated De Coster's *Ulenspiegel,* Rolland's *Jean Christophe,* the writings of Tolstoi, Villon, Hugo, Zola, Whitman, and others. Always interested in pacifist causes, he traveled across the world, showing his work in Peking, in Berlin, Paris, Moscow, Amsterdam, and Venice, where he won the International Grand Prix at the Biennale of 1950. Humboldt University in Berlin granted him an honorary doctorate in 1969.

He studied in Ghent, moved to Paris, had a studio in Avignon at the Palais des Papes, and finally settled in Nice, where he died in 1971. He was given a state funeral by the Belgian government.

Naoko Matsubara was born in 1937 in Tokushima, Japan, and studied at the Municipal Art College in Kyoto before coming to the United States on a Fulbright travel grant. She received her M.F.A. at the Carnegie Institute in Pittsburgh, has had one-man shows in Kyoto, New York, Boston, Puerto Rico, and in Europe, and is represented in the collections of the Fogg and Boston Museums, the Albertina, the Library of Congress, and many private collections. She has taught both in Kyoto and at the Pratt Institute in New York and has illustrated several books with woodcuts. Her recent work, apart from the woodcuts prepared specially for this volume, is a portfolio of color prints on Thoreau's *Walden* (Aquarius Press, 1971). She now lives in Toronto, Canada.

Erich Moench, a noted educator and lithographer, was born in 1905 in Rötenbach, Germany. He studied art with Professor Ernst Schneidler in Stuttgart and became head of the lithographic workshop at the Stuttgart Academy of Fine Arts (1950–70), where he worked with such artists as W. Baumeister and J. Bissier. During a stay in the United States he was a guest teacher at the Pratt Graphic Arts Center in New York and at Oregon State University. He now has his own lithographic workshop in Unterjesingen, near Tübingen, Germany.

Norma Morgan, born in New Haven, Conn., studied with Hans Hofmann and at the Art Students League in New York. She has lived and traveled in England and Scotland, attracted by the somber moors and eroded rocks which appear in many of her prints. She has received several fellowships, and her work is represented in the Library of Congress, the National Gallery, the Boston Museum, the Victoria and Albert Museum, and other important British and American collections.

George A. Nama, born in Pittsburgh in 1939, received his M.F.A. degree at Carnegie Tech and continued his studies at Hayter's Atelier 17. His prints, essentially an extension of his paintings and sculptures, are in many important American collections. He lives and works in New York City.

Ann and *Avon Neal* have formed a unique husband-and-wife working team. Ann Parker, born in England, studied at Yale and is an outstanding professional photographer. Avon Neal, a native Californian, majored in sculpture and printmaking and has considerable literary talents. Together they have roamed the world, specifically Yugoslavia, Mexico, Scotland, North Africa, and Scandinavia, in pursuit of gravestone and other stone carvings of historic and artistic importance. They have developed a remarkable rubbing technique and created several portfolios of rubbings which have been widely exhibited and purchased by museums and private collectors in many countries. They make their home in North Brookfield, Mass.

Reginald Neal is Chairman of the Department of Art, Douglass College, Rutgers University, in New Brunswick, N. J., and a prominent printmaker whose work is in many major collections here and abroad. He has also produced a much-acclaimed film on color lithography.

Gabor Peterdi, born in 1915 in Budapest, Hungary, had his first one-man show there at the age of fifteen. He studied in Rome and in Paris and became totally committed to the art of etching and engraving, which he mastered with unequaled skill and artistry. Since coming to the United States he has generously shared his great knowledge with generations of students at the Brooklyn Museum Art School, at Hunter College, and at Yale University. He has summed up his graphic experiences in two books, *Printmaking* and *Great Prints,* published in 1959 and 1969 respectively. His work has been exhibited and collected the world over and received many awards. He lives in Rowayton, Conn.

Steve Poleskie, who was founder and director of the Chiron Press in New York, where he worked with many of the famous avant-garde artists, teaches at present in the Art Department of Cornell University. His silkscreen work is represented in the collections of the Museum of Modern Art, the Massachusetts Institute of Technology, and others around the country.

Michael Ponce de León, born in Miami, Fla., in 1922, spent the early part of his life in Mexico. He studied at the Art Students League and the Brooklyn Museum School with Peterdi, won a Fulbright scholarship in 1956, and worked with Rolf Nesch in Norway. He traveled for the U.S. Government in Pakistan, Spain, and Yugoslavia and won numerous awards and research fellowships. He has taught at Cooper Union, Hunter College, and the Pratt Graphics Center.

Omar Rayo, born 1928 in Colombia, started as a painter, after studying in South and Central America. He has lived in New York since 1960 and is mainly known for his impeccable and inventive uninked relief intaglios. He has had many one-man shows in both Latin America and the U.S.A. and has participated in the Biennales in Venice, Mexico, and San Juan, P.R.

John Rock teaches lithography and other graphic techniques at the University of Washington at Corvallis.

Clare Romano (Mrs. John Ross), born in Palisades, N.J., studied at the Cooper Union School of Art, as well as in Paris and Florence. She has received numerous awards and grants, including a Fulbright scholarship and a Louis Comfort Tiffany Grant. She has taught at the Pratt Institute, The New School for Social Research, Manhattanville College, and the Art Center of Northern New Jersey. In 1965 she served as an artist-in-residence with a U.S.I.A. exhibit in Yugoslavia. Her work is represented in the major public and private collections of the United States. She recently completed the design for a 23-foot tapestry, commissioned by the Manufacturers Hanover Trust Co., New York, and has served as president of the Society of American Graphic Artists.

John Ross, a native New Yorker, has been the winner of several national and international awards. His work was exhibited in Constanta, Ploesti, and Bucharest, Romania, and in Ljubljana, Belgrade, and Zagreb, Yugoslavia. He is on the faculty of The New School for Social Research and has served as president of the Society of American Graphic Artists (1961–65) and as editorial director of the Aquarius Press. He is president of the U. S. Committee of the International Association of Art and chairman of the Art Department at Manhattanville College, New York.

Edward Stasack, born 1929 in Chicago, studied at the University of Illinois, where he received his M.F.A. degree in 1956. Since then he has been a resident of Hawaii, where he is a member of the University's Art Faculty. He has received three grants from the Tiffany and one from the Rockefeller Foundation. His main interest, aside from painting, is the collograph, which he has developed into a very personal medium.

Carol Summers, born in Kingston, N.Y., in 1925, received a B.A. degree from Bard College and continued his studies on an Italian Government travel grant and Tiffany and Guggenheim fellowships. His startling innovations in woodcut technique have found a numerous and enthusiastic audience. He has recently moved from New York to California.

Maltby Sykes was born in Aberdeen, Miss., and presently is Professor of Art at Auburn University, Auburn, Miss. He has studied with John Sloan, Diego Rivera, S. W. Hayter, and Fernand Léger and in 1966–67 was granted a Sabbatical Award of the National Foundation for the Arts and Humanities, which enabled him to experiment extensively in multimetal lithography.

Sergio Gonzalez Tornero, born in 1927 in Santiago, Chile, has studied in Chile, Brazil, the United States, and at the Atelier 17 in Paris as S. W. Hayter's assistant. He has exhibited widely, has been awarded several prizes, and is represented in many public collections in Europe, Latin America, the United States, Japan, and Australia. Since 1963 he has resided in New York State and is married to Adrienne Colum, a well-known printmaker in her own right.

Vasilios Toulis, who teaches at the Pratt Institute, Brooklyn, holds both a B.Des. and a B.F.A. degree. Born in Florida, he first studied at the University of Florida. After two years of military service he enrolled at Pratt Institute, where he majored in graphic arts and joined the faculty in 1961. His paintings and prints have been widely exhibited in this country.

Ansei Uchima, born in Stockton, Calif., in 1921, currently lives in New York City, where he has taught at the Pratt Graphics Center and at Sarah Lawrence College. From 1940 to 1959 he lived and studied in Tokyo. His work has been shown at the Tokyo and São Paolo Biennales and in numerous one-man shows and has won many awards.

Stow Wengenroth had his first exhibition of lithographs in 1931 and has remained faithful to the medium ever since. His prints, which show a consummate mastery of the crayon technique, are in nearly every important American collection, including the Fogg Art Museum, the Metropolitan Museum of Art, the Whitney Museum, and the Library of Congress. A series of studies on New England, published with a text by David McCord in 1969, displays his sensitivity to a theme which has long been a favorite with him.

Paul Wunderlich, born in 1927 in Berlin, painter and graphic artist, is one of the outstanding practitioners of color lithography today. He now lives and teaches in Hamburg and has gained a wide following as a result of many recent one-man shows in New York and Europe. His work is in major public and private collections the world over.

Joseph E. Young is Assistant Curator of Prints at the Los Angeles County Museum of Art.

Glossary

ACID: Biting agent for etching, usually (1) nitric acid, (2) perchloride of iron, or (3) Dutch mordant.

A.P.D.R.: *Avec Privilège du Roi* ("With the Permission of the King"), indication of license to publish, found on earlier French prints.

AQUATINT: *Aquatinta* (Ger.) A porous ground for etching tonal areas, made by dusting rosin powder on the plate and melting it; also, a print made by this procedure.

A.R.E.: Associate of the Royal Society of Painter-Etchers and Engravers.

ARKANSAS STONE: Hard stone used with oil for sharpening fine tempered steel tools.

ARTIST'S PROOF: *Épreuve d'artiste* (Fr.), *Probedruck* (Ger.) Originally, test or trial proof of different states. Today, one of a number of proofs, generally no more than ten, made for the artist's own use in addition to the numbered edition; often numbered with Roman numerals. Also, title of *Annual of Printmaking*.

ASPHALTUM: Acid-resistant tar product, used to ground etching plates and litho stones.

AUTOLITHOGRAPHY: The drawing of original work on the litho stone or plate by the artist himself (obs.).

AVANT LA LETTRE: Proofs pulled before lettering was added, especially in eighteenth-century engravings and mezzotints.

BAREN: A flat, bamboo-covered disk used to apply pressure in the hand-printing of Japanese wood-block prints.

BEN DAY: Mechanical tints, dots, and lines, available in sheets, which can be applied to drawings as well as to prints for added textures.

BENI-E: (Jap.) Hand-colored, early wood-block prints.

BENIZURI-E: (Jap., from *beni,* pink) Early two- or three-color prints, antecedent to full-color printing.

BEVEL: To cut or file the edge of a metal plate at an angle; also, the edge so cut.

BITING: In etching, the action of the acid eating into the metal plate.

BLOCK BOOK: Early printed book, before the invention of movable type, in which text and pictures were cut into solid wood blocks.

BLOCK OUT: To render certain areas of a plate, stone, screen, etc., impervious to an affecting substance (glue, ink, tusche, acid, pigments, etc.).

BON À TIRER: Artist's notation on final proof, indicating that the printer may proceed with finishing edition accordingly; also, a print so labeled.

BOXWOOD: A hard, compact, fine-grained wood, originally grown in Turkey; used crossgrain for wood engraving.

BRAYER: Hand roller for applying ink.

BROAD MANNER: A style of engraving characterized by long, widely spaced burin lines, adopted by Mantegna, Pollaiuolo, and others, which flourished in Florence 1450–1500. See FINE MANNER.

BROADSIDE: *Image populaire* (Fr.), *Flugblatt* (Ger.) Popular printed image, often of political or social satire or commentary.

BROCADE PRINT: See NISHIKI-E.

BURIN: (also GRAVER) Generic term for a variety of engraving tools, usually with pointed, elliptic, or lozenge-shaped tips.

BURNISHER: *Brunisseur* (Fr.), *Polierstahl* (Ger.) Smooth, curved steel tool used for polishing copper-plate surface, making corrections, or producing light areas in mezzotint or other intaglio techniques.

BURR: The irregular ridge of metal thrown up on either side of a scratched incision, holding the ink and giving the printed line a strong, fuzzy appearance, as in a drypoint; also, the roughened texture produced by the rocker in mezzotint.

CALCOGRAFIA: Official print depository in Italian or Spanish museum.

CANCELLATION: Defacing a plate, block, or stone after an edition has been printed, to make further printing impossible; also, a proof showing such defacement.

CARBORUNDUM PRINT: See SAND-GROUND AQUATINT.

CARDBOARD CUT: See PAPERCUT.

CELLOCUT: A print made with celluloid dissolved in acetone, applied to metal plate, and printed in intaglio or relief.

CELLULOID PRINT: A print made from an image scratched into a sheet of celluloid in drypoint manner and printed in intaglio.

CHIAROSCURO WOODCUT: *Clair-obscur,* or *en camaïeu* (Fr.), *Helldunkel Holzschnitt* (Ger.) The earliest form of color printing in Europe. A key block (outline) was printed first; then blocks in other colors were overprinted.

CHINE COLLÉ: (Fr.) Areas of thin colored tissue mounted on or glued to the surface of a print.

CHROMOLITHOGRAPHY: A nineteenth-century term for color crayon lithography, coined by G. Engelmann in 1817.

CLICHÉ VERRE: (Fr., "glass print") An image drawn with an etching needle on the darkened surface of a glass plate, from which a photographic print is made.

CLIPPED: Term applied to prints which have been trimmed off close to the edge of the printed area. In early intaglio prints the plate mark is often removed.

CODEX: An early manuscript, usually in book form and illuminated.

COLLAGRAPH: (Fr. *collage,* "pasting") A collage of various materials and objects attached to the surface of a plate and printed in either intaglio or relief.

COLLOGRAPH: (Gr. *kollo,* "glue") A print taken from a plate on which the image has been built up with glue, sometimes with objects embedded in the surface. Often used synonymously with COLLAGRAPH.

COLLOTYPE: (also, HELIOTYPE, PHOTOGELATIN) A photomechanical process involving a plate coated with gelatin, used often for high-quality reproductions.

COLORED PRINT: A print with color applied freely by hand or by stencil after printing.

COLOR PRINT: *Farbdruck* (Ger.) A print produced in color by using a separate plate for each color, by inking separate areas of the plate *(á la poupée),* by printing through stencils, or by using inks of different viscosities.

COLOR SEPARATION: Making a separate plate for each color to be printed (compare PROGRESSIVE PROOFS).

CONTÉ: (Fr.) Trade name for a special brown, red, or black chalk or crayon.

COUNTER-ETCH: To treat a litho stone or plate chemically to make it receptive to grease or to reopen a gummed stone for corrections.

COUNTERPROOF: An image made by transferring a wet proof to another sheet of paper; the design appears as it is on the original plate.

CRAYON ENGRAVING: (or CRAYON MANNER) A technique, popular in the eighteenth century, which by means of various roulettes and needles achieved the effect of a crayon drawing.

CREVÉ: (Fr.) An overbitten area in etching, where the metal surface between closely spaced lines is eaten away.

CUSHION: A leather bag filled with fine sand, placed under a plate or block to facilitate swiveling it when engraving curved lines.

DABBER: Inking pad, made of soft leather or cloth.

DECKLE: The irregular edge in handmade paper.

DELINEAVIT: (Lat., abbreviated delin., delt., del.) "He drew."

DÉPÔT LÉGAL: (Fr.) Compulsory deposit of a copy of artists' prints in certain national print collections.

DOTTED PRINT: *Manière criblée* (Fr.), *Schrotblatt* (Ger.) A print made by a fifteenth-century technique in which metal plates engraved and ornamented with a variety of goldsmiths' punches were printed in relief, resulting in a white-line image.

DRYPOINT: *Pointe sèche* (Fr.), *Kaltnadel* (Ger.) The intaglio process of drawing directly on a metal plate with a steel needle, creating a furrow and a rough burr which holds the ink and gives the printed line a velvety quality.

DUST BOX: A container used for dusting finely powdered rosin or asphaltum on a metal plate to produce a granulated resist ground for aquatint.

DUTCH MORDANT: A mild etching solution made of water saturated with potassium chlorate and hydrochloric acid, first used about 1850.

EDITION: The number of prints from one design authorized by the artist for distribution; usually double-numbered in sequence, as 25/50 (No. 25 of a total of 50).

EINBLATT DRUCKE: *Ichimai-ye* (Jap.) Single-sheet prints.

EMBOSSING: (also EMBOSSMENT) *Gauffrage* (Fr.), *Blinddruck* (Ger.), *Karazuri* or *Kimekomi* (Jap.) Printing by pressure to produce a raised, three-dimensional effect in the paper. BLIND EMBOSSING is done without ink.

END GRAIN: Cut across the grain of the wood block, as for wood engraving. See WOOD ENGRAVING.

ENGRAVE: To cut into wood, stone, metal, or plastic with a graver, burin, scauper, or electric engraving tool.

ETCHING: *Eau-forte* (Fr.), *Radierung* (Ger.) Biting into a metal plate or stone by means of the corrosive action of acid; also, a print made by this method.

ETCHING GROUND: Acid-resistant coating applied to a plate before the design is drawn into it with a needle and etched.

EXCUDIT: (Lat.) "He issued" or "published." A notation that sometimes indicates reworking and reissue.

FALSE BITING: Same as FOUL BITING.

FECIT: (Lat.) "He made." A notation usually indicating the engraver or etcher.

FINE MANNER: A style of engraving, used by Maso Finiguerra and his followers, that creates the effect of a wash drawing by fine lines, hatching, and short strokes; also used by Master E.S.

FLOCK PRINT: A print from a wood block rolled with a paste or gluey ink and dusted with powdered flock or pigment, giving a velvety texture (fifteenth century).

FORMAT: The shape and size of a print, book, or other printed material.

FOUL BITING: Penetration of the etching ground by acid, due to an imperfect ground or to overstrong mordant; sometimes intentionally used to create grainy effects.

FOXING: The appearance of brownish spots on old paper; thought to be due to excessive fermentation of the rags used in its manufacture.

FRENCH CHALK: A form of talc, used in lithography.

FROTTAGE: (Fr.) An ink rubbing made from a relief-cut block. See RUBBING.

GESSO: Gypsum or plaster of Paris mixed with glue; used as a surface coating on a plate with embedded objects to be printed in intaglio or relief, as in a collograph.

GLASS PRINT: See CLICHÉ VERRE.

GOUGE: *Hohleisen* (Ger.) V- or U-shaped tool used in wood or linoleum cut.

GRAFFITO: Casual scratch drawing or writing on walls, also sometimes used as a mural technique.

GRAIN: Surface texture of wood, paper, or specially prepared litho stones and metal plates.

GRAPHICS: Generic term applied to original prints and often to drawings.

GRAVER: See BURIN.

GREASE CRAYON: Black, wax-based stick or pencil used in lithography.

GROUND: See ETCHING GROUND.

GUM ARABIC: Dried, water-soluble substance obtained from the acacia tree; used in lithography to sensitize the stone to water and to "fix" the greasy tusche or crayon.

HASHIRA-E: (Jap., "pillar picture") A long, narrow print designed to be hung on a pillar or column, usually c. 28″ × 4′.

HELIOGRAVURE: Photomechanical intaglio process.

IMPRESSION: Any print.

IMPRESSIT: (Lat., abbreviated Imp.) "He printed."

INCIDIT: (Lat., abbreviated incid., inc.) "He engraved."

INCUNABULA: (Lat. *cuna,* cradle), *Wiegendruck* (Ger.) Literally, "things in the cradle"; the earliest stages of printing, as for example the first books printed from movable type.

INTAGLIO: (It.), *Tiefdruck* (Ger.) Any printmaking technique involving forms incised or otherwise sunk below a plate surface, printed by rubbing ink into the incisions and pulling the plate through the press under pressure, forcing the ink onto the paper.

INVENIT: (Lat., abbreviated inv., in.) "He designed."

KEY BLOCK: The "master" block with the main outlines of a print; blocks inked in other colors are then overprinted.

KUPFERSTICH KABINETT: (Ger., from *Kupferstich,* "engraving on copper") Literally, "copper-engraving room," expression still used for major European print collections.

LAID PAPER: Handmade paper showing the characteristic parallel grid pattern of a wire mold; imitated in machine-made papers by means of a metal cylinder mounted with wires, called a "dandy-roll."

LETTERPRESS: *Buchdruck* (Ger.) Relief printing, as distinguished from lithography, screen printing, etc.

LEVIGATOR: Heavy circular slab with handle, used to resurface and grain litho stone.

LIFT GROUND: An etching ground applied over an image drawn on the plate with a water-soluble solution, often of sugar. During the etching process, the drawn lines dissolve, lifting the ground and allowing the acid to bite into the design.

LINOLEUM CUT: (also LINOCUT) Print from a linoleum block worked with woodcut tools; called "linoleum engraving," if done with engraving tools.

LITHOGRAPHIT: (Lat., abbreviated Lith.) "He drew, or printed, on stone."

LITHOGRAPHY: *Steindruck* (Ger.) The printmaking process, based on the antipathy of grease and water, invented by Senefelder about 1798. An image is drawn on a stone or plate with a greasy crayon or ink and is chemically treated so that the oily image attracts ink and the wet blank areas reject it. The printing surface is planographic (flat), as distinguished from the relief surface of woodcuts and the incised surface of intaglio.

LITHOTINT: A technique of color lithography which imitated a wash drawing; developed and patented by Hullmandel (nineteenth century).

LUCITE: Proprietary name of a transparent plastic, used as a substitute for glass; can be engraved with burins or etching needles.

MACEHEAD: *Mattoir* (Fr.) A stipple engraving tool with irregular points.

MACKLE: (also, MACULE) A flaw caused by creasing of the paper during printing.

MACULATURE: The pulling of a second proof without re-inking the plate, to clear away surplus ink. Also, *makulatur* (Ger.), spoiled or expendable trial proof.

MAKEREADY: Building up weak areas in relief printing by pasting paper on back of block.

MANIÈRE CRIBLÉE: See DOTTED PRINT.

MANIÈRE NOIRE: See MEZZOTINT.

MARGIN: Space around the image area of a print.

MAT: *Passepartout* (Fr. and Ger.) Cardboard frame for prints.

MATRIX: Literally, that which gives form or origin to a thing; a mold for casting type.

METAL COLLAGE: Cutout metal shapes mounted on a metal plate; usually printed in intaglio.

MEZZOTINT: *Manière noire* (Fr.), *Schabblatt* (Ger.) An intaglio technique in which the whole surface of the plate is roughened by metal rockers with sharp teeth, to hold ink and print in a deep black; light areas in the design are produced by burnishing and scraping.

MIXED MEDIA: Combination of various graphic techniques applied to one print.

MONOGRAMMISTS: Early anonymous masters of the print, identified only by their monograms.

MONOTYPE: (also MONOPRINT) A print made by working with printing ink or oil paint directly on a plate or piece of glass and then taking an impression on a sheet of paper by rubbing or printing. Usually only a single print can be produced; the second will leave a weak impression.

MORDANT: A biting agent, generally acid.

MULBERRY PAPER: Japanese paper made from the bark of the mulberry tree.

MULTIPLE TOOL: An engraving tool capable of making several parallel lines at once.

NIELLO: An early Italian technique in which lines are engraved on metal, then filled with a mixture of lead, silver, copper, and sulfur that is melted and fused into them; the lines show up dark against the metal.

NISHIKI-E: (Jap., "brocade picture") Term first applied to Harunobu's brilliantly colored prints, later to all full-color Japanese prints.

OFFSET: Transfer of an image by means of an intermediary, such as the rubber blanket of an offset press; there is no reversal of the image because it passes from plate to blanket to paper.

OILSTONE: Smooth Arkansas abrasive stone, used with oil to sharpen tempered steel tools.

OLEOGRAPH: An early color lithograph printed in oil inks to simulate an oil painting; sometimes printed on a surface embossed to imitate canvas.

ORIGINAL PRINT: A print designed and executed by the artist, usually signed and numbered in a limited edition; as distinguished from a reproduction.

PAPERCUT: A print made from cutout shapes of heavy paper or cardboard mounted on a plate, varnished, and inked in relief and/or intaglio.

PASTE PRINT: A print made from intaglio plates impressed into paper covered with a doughlike substance; the design appears in slight relief (late fifeenth century).

PETROGLYPH: Prehistoric image engraved on rock or stone.

PHOTOLITHOGRAPHY: A lithographic process involving photographic transfer of the image to a sensitized litho stone or plate.

PHOTOMONTAGE: A pictorial composition made of photographic cutouts.

PHOTO-SILKSCREEN: A process involving the transfer of photographic images to silkscreen.

PILLAR PRINT: See HASHIRA-E.

PINXIT: (Lat., abbreviated pinx.) "He painted."

PLANK GRAIN: (also, SIDE GRAIN) Cut along the grain of the wood block, as for woodcuts on pine, poplar, cherry, pear, and others. See WOODCUT.

PLANOGRAPHIC: *Flachdruck* (Ger.) Printed from a level surface, directly or by offset, as in lithography (q.v.) and silkscreen (q.v.).

PLASTER PRINT: A relief print made from an image cut into a cast plaster slab and printed by hand.

PLATE MARK: Indentation on paper left by the outside edges of a plate or stone.

PLEXIGLAS: Proprietary name for a type of plastic that can be used as a printing surface for engraving.

POCHOIR: (Fr.) A process involving the application of color through stencils, used for reproducing works of art in small editions.

POLYAUTOGRAPHY: Early name for lithography.

POUPÉE (Á LA POUPÉE): (Fr.) Pad used for applying ink to parts of a printing surface, sometimes through stencils.

PROGRESSIVE PROOFS: A set of proofs showing color printing in progressive stages from the first color to the finished print, with one superimposed over the other.

PROOF: An impression taken at any stage from a plate or stone, as "artist's proof," "trial proof," "progressive proof."

RAG PAPER: Fine paper usually made of linen rags, free of wood pulp.

REDUCE: To add a substance to ink to make it more transparent or to make it flow more easily.

REGISTER: A mark, cross, or other device used as a guide for the correct placement of the paper in successive printings of one color over another (Jap. *kento*—guide marks on wood blocks for registration).

RELIEF ETCHING: *Hochdruck* (Ger.) A technique in which acid–resist varnish is applied to a metal plate so that the negative areas or background are etched away and the image is left in relief.

RELIEF PRINTING: The method of printing in which the image area is raised on a block or plate, either by cutting away the nonimage area or by building up the level of the image. The image is inked and transferred under pressure to the paper.

REMARQUE PROOF: A proof bearing small test drawings in the margin; the sketches are often removed before the edition is printed.

REPRODUCTION: A copy, usually made by someone other than the original artist. It may be faithfully followed from the original in media and dimensions (a facsimile), or it may be completely transferred from one technique and size to another. Nowadays reproductions are generally produced by photographic means, but see POCHOIR.

RESIN: See ROSIN.

RESIST: An acid-resistant ground applied to the plate before etching. See ETCHING GROUND.

RESTRIKE: A reprinting of a plate, usually unsigned and unnumbered and often made after the artist's death.

RETROUSSAGE: The flicking of a soft rag over an inked intaglio plate to draw the ink out slightly, creating a softer printed line and surface tone.

RICE PAPER: A variety of Chinese paper, made from the Taiwanese tree *Arabia papyrifera*; a term often incorrectly applied to Japanese papers such as mulberry.

ROCKER: A mezzotint tool having a curved blade with numerous tiny teeth used to roughen the plate by rocking back and forth in all directions.

ROSIN: *Kolophonium* (Ger.) Extract from the sap of the pine tree, used in powdered form for aquatint grounds.

ROULETTE: A small toothed wheel set in a handle, used to make dotted lines on metal plates.

RUBBING: (Jap. *ishizuri,* literally "stone-printed picture") A printlike impression made by dabbing or rubbing ink on a sheet of paper placed over a raised or carved surface.

SAND-GROUND AQUATINT: (also, CARBORUNDUM PRINT) A print made by pressing a sheet of sandpaper into an etching plate and running them through the press together.

SCORPER: (also, SCAUPER or SCOOPER) Square or round-faced tool used in wood engraving.

SCRAPER: 1. Triangular, sharp-edged tool used in metal engraving and drypoint to shear off unwanted burr or to make corrections. 2. In a litho press, a narrow piece of boxwood covered with leather which transfers the pressure to the tympan and thus to the paper and stone.

SCULPSIT: (Lat., abbreviated sculp., sc.) "He engraved."

SCUM: An area of unwanted grease forming at the margins of a litho stone or plate.

SERIGRAPHY: *Siebdruck* (Ger.) Printing by the silkscreen process; term generally applied to fine art rather than to commercial work. See SILKSCREEN.

SHUNGA: (Jap., literally "spring pictures") Erotic prints.

SILKSCREEN: (also, SERIGRAPHY) The printmaking process by which soft inks are squeezed through the open areas in silk mesh or similar material stretched on wooden frames.

SIZING: Gelatinous or glutinous substance used to fill the pores of paper or fabric.

SNAKESTONE: (also, SNAKE SLIP) An abrasive stone, available in stick form, for erasing work on the litho stone.

SOFT GROUND: *Vernis mou* (Fr.) An etching ground mixed with tallow or Vaseline. The drawing is usually pressed through a thin sheet of paper into the ground, which adheres to the paper as it is removed. Textured objects can be pressed

directly into the ground and then lifted; etching then produces the texture on the plate.

SPATTER: A technique used by Toulouse-Lautrec and others, by which tusche is spattered on litho stone to produce halftones.

SPITSTICKER: An elliptic engraving tool.

SQUEEGEE: A rubber blade mounted in a handle; used to force ink or paint through the mesh of a silkscreen.

STAGING OUT: See STOPPING OUT.

STATE: *Épreuve d'état* (Fr.), *Probedruck* (Ger.) A stage in the development of a print. Proofs are pulled after significant changes have been made on the plate and show the progress of the print.

STEEL ENGRAVING: An early nineteenth-century print medium used to produce larger editions than were possible from the softer copper plates.

STEEL FACING: The process of coating a copper plate with a thin layer of steel by electrolysis, thus strengthening its surface for further printing; invented in 1859 by F. Joubert.

STENCIL: *Schablone* (Ger.) A cutout used to define and control the application of ink or color to any surface. See POCHOIR and SILKSCREEN.

STIPPLE ENGRAVING: A method of creating a soft halftone effect by engraving tiny dots and flicks.

STOPPING OUT: Blocking out an area of a stone, screen, or plate with gum, glue, or stop-out varnish.

SUGAR AQUATINT: See LIFT GROUND.

SUGAR LIFT: See LIFT GROUND.

TINT TOOL: An engraving tool used for making fine, even lines.

TONE BLOCK: (also, TINT BLOCK). A second, usually solid, color used as background.

TRANSFER LITHOGRAPH: *Umdruck* (Ger.) Design drawn by the artist with grease crayon or tusche on special paper and transferred to litho stone or zinc plate, eliminating reversal of the image.

TUSCHE: *Touche* (Fr.) A grease-based ink used for drawing on litho plates or stones.

UCHIWA-E: (Jap.) "Fan prints."

UKIYO-E: (Jap., literally, "pictures of the transitory world") General term used for a popular school of art centered in Edo in the late seventeenth–nineteenth centuries.

UNDERCUTTING: Biting of the acid in a lateral direction beneath the etching ground.

VELLUM: Originally a name for parchment, now used for Japanese and other fine, sized papers.

VISCOSITY: The rate of flow of a liquid, a characteristic utilized in multicolor printing from one plate with various inks combined.

WASH: *Lavis* (Fr.) Diluted tusche or ink used to produce half tones on litho stones or plates.

WATERMARK: *Filigrane* (Fr.), *Wasserzeichen* (Ger.) A translucent design impressed with wire into paper during manufacture.

WHETSTONE: *Schleifstein* (Ger.) A natural or artificial abrasive stone for sharpening ordinary steel or metal tools with water.

WHITE-LINE ENGRAVING: An engraving that shows a white-line image against a dark background. See also DOTTED PRINT.

WOODCUT: *Gravure sur bois* (Fr.), *Holzschnitt* (Ger.) A relief print made by cutting into the side grain of a wood block with sharp knives, gouges, and other woodcutting tools and printed from the raised areas left.

WOOD ENGRAVING: *Gravure sur bois debout* (Fr.), *Holzstich* (Ger.) A relief print made by cutting into the end grain of a block of wood with the burin and other engraving tools and printed from the surface of the block.

WOOD-PULP PAPER: Paper made of cellulose wood tissue, bleached with sulfurous acids; not durable and unacceptable to print collections.

WOVE PAPER: *Papier vélin* (Fr.) Paper made on a fine wire-mesh screen in a mold or machine.

XYLOGRAPHY: Term for early professional wood engraving.

ZINCOGRAPHY: A nineteenth-century term for lithography on zinc plates; started in 1829.

Selected Bibliography

General Works: History

Adhémar, Jean. *Graphic Art of the 18th Century.* McGraw-Hill, Inc., New York, 1964

Andresen, Andreas. *Der Deutsche Peintre-Graveur,* 5 vols. Leipzig, 1864–78; reprint, Collectors Editions, New York, n.d.

Ars Multiplicata, catalogue, Wallraf-Richartz Museums, Cologne, 1968

Bartsch, Adam von. *Le Peintre-graveur* (15th–17th centuries), 21 vols. Verlagsdruckerei Würzburg G.b.H., Würzburg, 1920

Baskett, Mary Welsh. *American Graphic Workshops: 1968,* catalogue, Cincinnati Art Museum, Cincinnati, Ohio, 1968

Beall, Karen F., et al. *American Prints in the Library of Congress.* Johns Hopkins Press, Baltimore, Md., 1970

Bersier, Jean-Eugène. *La Gravure: Les Procédés, L'Histoire.* Berger Levrault, Paris, 1963

Bloch, Georges. *Pablo Picasso: Catalogue of the Printed Graphic Work 1904–1967.* Editions Kornfeld and Klipstein, Berne, 1968

Bockhoff, Hermann, and Fritz Winger. *Das Grosse Buch Der Graphik.* Georg Westermann Verlag, Braunschweig, 1968

Bolliger, Hans. *Picasso for Vollard,* trans. Norbert Guterman. Harry N. Abrams, Inc., New York, 1956

Breitenbach, Edgar, and Margaret Cogswell. *The American Poster.* The American Federation of Arts and October House, Inc., New York, 1968

Brückner, Wolfgang. *Imagerie Populaire Allemande.* Electa, Milan, 1969

Buchheim, Lothar-Günther. *The Graphic Art of German Expressionism.* Universe Books, New York, 1960

———. *Max Beckmann.* Buchheim Verlag, Feldafing, 1959

Carrington, Fitz Roy, and Campbell Dodgson, eds. *The Print Collector's Quarterly,* 30 vols. New York and London, 1911–1951

Cleaver, James. *A History of Graphic Art.* Philosophical Library, New York, 1963

Delteil, Loys. *Manuel de l'amateur d'estampes des XIXᵉ et XXᵉ siècles (1801–1924),* 4 vols. Dorbon-Aîné, Paris, 1925

———. *Le Peintre-graveur illustré (XIXᵉ et XXᵉ siècles),* 32 vols. Paris, 1906–30; reprint, Collectors Editions and Da Capo Press, New York, 1968

Dumont, Jean-Marie. *Les Maîtres Graveurs Populaires 1800–1850.* L'Imagerie Pellerin, Épinal, 1965

Eichenberg, Fritz, ed. *Artist's Proof Annual.* Pratt Institute, Barre Publishers, and New York Graphic Society, New York, 1961–present; Collector's Edition, reprint of first eight issues, 1972

Fischer, Otto. *Geschichte der Deutschen Zeichnung und Graphik.* F. Bruckmann Verlag, Munich, 1957

Foster, Joseph K. *Posters of Picasso.* Grosset and Dunlap, New York, 1964

Gaehde, Christa M., and Carl Zigrosser. *A Guide to the Collecting and Care of Original Prints.* Crown Publishers, Inc., New York, 1965

Getlein, Frank and Dorothy. *The Bite of the Print.* Bramhall House, New York, 1963

Hargrave, Catherine Perry. *A History of Playing Cards.* Dover Publications, New York, 1966

Harris, Jean. *Édouard Manet, Graphic Works: A Definitive Catalogue Raisonné.* Collectors Editions, New York, 1970

Hayter, Stanley William. *About Prints.* Oxford University Press, London, 1962

Hofman, Werner. *Georges Braque: His Graphic Work.* Harry N. Abrams, Inc., New York, n.d. [1961]

Hogben, Lancelot. *From Cave Painting to Comic Strip.* Chanticleer Press, New York, 1949

Hunter, Sam. *Joan Miró: His Graphic Work.* Harry N. Abrams, Inc., New York, n.d. [1958]

Ivins, William M., Jr. *How Prints Look.* Metropolitan Museum of Art, New York, 1943

———. *Notes on Prints.* Metropolitan Museum of Art, New York, 1930

———. *Prints and Visual Communication.* New York, 1953; reprint, Da Capo Press, New York, 1969

Knappe, Karl Adolf. *Dürer: The Complete Engravings, Etchings, and Woodcuts.* Harry N. Abrams, Inc., New York, 1965

Koschatzky, Walter, and Alice Strobl. *Die Albertina in Wien.* Residenz Verlag, Salzburg, 1970

Kristeller, Paul. *Kupferstich und Holzschnitt in Vier Jahrhunderten.* Bruno Cassirer, Berlin, 1922

Leonard Baskin: The Graphic Work, 1950–1970, catalogue, FAR Gallery, New York, 1970

Leonhard, Kurt. *Picasso: Recent Etchings, Lithographs and Linoleum Cuts.* Harry N. Abrams, Inc., New York, n.d.

Ljubljana Biennale, catalogues, a series illustrating the Yugoslavian exhibitions, under the direction of Zoran Kržišnik, held since 1953

Longstreet, Stephen. *A Treasury of the World's Great Prints: From Dürer to Chagall.* Simon and Schuster, New York, 1961

Mayor, A. Hyatt. *Prints & People.* Metropolitan Museum of Art, New York, 1971

McNulty, Kneeland. *The Collected Prints of Ben Shahn*, catalogue, Philadelphia Museum of Art, 1967

Meyer, Franz. *Marc Chagall: His Graphic Work*. Harry N. Abrams, Inc., New York, 1957

Mongan, Elizabeth, and Carl O. Schniewind. *The First Century of Printmaking: 1400–1500*, catalogue, Art Institute of Chicago, 1941

Orozco, Clemente. *Catalogo Completo de la Obra Grafica de Orozco*, ed. Luigi Marrozzini, Instituto de Cultura Puertorriqueña, San Juan, Puerto Rico, 1970

Panofsky, Erwin. *Albrecht Dürer*, 2 vols. Princeton University Press, Princeton, N.J., 1948

Passeron, Roger. *French Prints of the 20th Century*. Praeger Publishers, Inc., New York, 1970

Picasso: Sixty Years of Graphic Work, catalogue, Los Angeles County Museum of Art. New York Graphic Society, Greenwich, Conn., 1966

Print Council of America. *What Is an Original Print?*, pamphlet, P.C. of A., Inc., 1961

Richards, Maurice, ed. *Posters of Protest and Revolution*. Walker and Co., New York, 1970

Roger-Marx, Claude. *Graphic Art of the 19th Century*. McGraw-Hill, Inc., New York, 1962

———. *La Gravure originale en France de Manet à nos jours*. Hyperion Press, Paris, 1939

Sachs, Paul J. *Modern Prints and Drawings*. Alfred A. Knopf, Inc., New York, 1954

Schiefler, Gustav. *Die Graphik Ernst Ludwig Kirchner, 1917–1927*, 2 vols. Euphorion-Verlag, Berlin, 1929, 1931

Schmidt, Werner. *Russische Graphik des XIX und XX Jahrhunderts*. Seeman, Leipzig, 1967

Shadwell, Wendy. *American Printmaking: The First 150 Years*, catalogue, Museum of Graphic Art, New York, 1969

Shikes, Ralph E. *The Indignant Eye*. Beacon Press, New York, 1969

Sotriffer, Kristian. *Printmaking: History and Technique*. McGraw-Hill, Inc., New York, 1968

Stubbe, Wolf. *Graphic Arts in the 20th Century*. Frederick A. Praeger, New York, 1963

Timm, Werner. *The Graphic Art of Edvard Munch*, trans. Ruth Michaelis-Jena. New York Graphic Society, Greenwich, Conn., 1969

Wechsler, Herman J. *Great Prints and Printmakers*. Harry N. Abrams, Inc., New York, 1967

Werner, Alfred. *The Graphic Works of Odilon Redon*. Dover Publications, Inc., New York, 1969

Wingler, Hans M., ed. *Graphic Work from the Bauhaus*, trans. Gerald Onn. New York Graphic Society, Greenwich, Conn., 1969

Zigrosser, Carl. *The Book of Fine Prints*, rev. ed., Crown Publishers, Inc., 1956

———. *Kaethe Kollwitz*. H. Bittner and Co., New York, 1946

———, ed. *Prints: Thirteen Essays*. Holt, Rinehart and Winston, Inc., New York, 1962

General Works: Technique

Andrews, Michael F. *Creative Printmaking*. Prentice-Hall, Inc., Englewood Cliffs, N.J., 1964

Brunner, Felix. *A Handbook of Graphic Reproductive Processes*. Alec Tiranti, Ltd., London, 1962

Heller, Jules. *Printmaking Today: A Studio Handbook*, 2d ed. Holt, Rinehart and Winston, Inc., New York, 1972

Peterdi, Gabor. *Printmaking*. Macmillan Co., New York, 1959

Ross, John, and Clare Romano. *The Complete Printmaker*. Macmillan Co., New York, 1972

China and Japan

Adachi, Toyohisa, ed. *Sharaku: A Complete Collection*, 4 vols. Adachi Institute, Tokyo, 1940 ff.

Azechi, Umetaro. *Japanese Woodblock Prints: Their Technique and Appreciation*. Toto Shuppan Co., Tokyo, 1963

Binyon, Laurence, and J.J. O'Brien Sexton. *Japanese Colour Prints*. Charles Scribner's Sons, New York, 1923; 2d ed., 1960

Brown, Louise Norton. *Block Printing and Book Illustration in Japan*. E.P. Dutton and Co., New York, 1924

Carter, Thomas Francis. *The Invention of Printing in China and Its Spread Westward*, 2d ed. The Ronald Press, New York, 1955

Hawley, W. M. *Chinese Folk Designs: A Collection of 300 Cut-Paper Designs* reprint, Dover Pictorial Archives Series, New York, 1971

Hillier, Jack R. *Hokusai*, Phaidon Press, London, 1956

———. *Japanese Masters of the Colour Print*. Phaidon Press, London, 1954

———. *The Japanese Print: A New Approach*. G. Bell, London, 1960

———. *Suzuki Harunobu*, catalogue, Philadelphia Museum of Art, Philadelphia, 1970

———. *Utamaro: Color Prints and Paintings*. Phaidon Press, London, 1961

Hirano, Chie. *Kiyonaga: A Study of His Life and Works*. Harvard University Press, Cambridge, Mass., 1939

Hiyama, Yoshio. *Gyotaku: The Art and Technique of the Japanese Fish Print*. University of Washington Press, Seattle, Wash., 1964

Ishida, Mosaku. *Japanese Buddhist Prints,* trans. Charles S. Terry. Kodansha International, Tokyo, 1964

Lane, Richard. *Masters of the Japanese Print.* Doubleday & Co., Inc., Garden City, N.Y., 1962

Michener, James A. *The Hokusai Sketchbooks: Selections from the Manga.* Charles E. Tuttle Co., Rutland, Vt., 1958

———. *Japanese Prints: From the Early Masters to the Modern.* Charles E. Tuttle Co., Rutland, Vt., 1959

Mody, N.H.N. *A Collection of Nagasaki Colour Prints and Paintings: Showing the Influence of Chinese and European Art on That of Japan.* Charles E. Tuttle Co., Rutland, Vt., 1969

Narazaki, Muneshige. *The Japanese Print: Its Evolution and Essence,* trans. C.H. Mitchell. Kodansha International, Tokyo, 1966

Noguchi, Yone. *Hokusai,* 2 vols. Maruzen Co., Ltd., Tokyo, 1940

Schraubstadter, Carl. *Care and Repair of Japanese Prints.* Idlewild Press, Cornwall-on-Hudson, N.Y., 1948

Statler, Oliver. *Modern Japanese Prints: An Art Reborn.* Charles E. Tuttle Co., Rutland, Vt., 1956

Stern, Harold P. *Master Prints of Japan.* Harry N. Abrams, Inc., New York, 1969

Strange, Edward F. *The Colour-prints of Hiroshige.* A. Siegle, London, n.d.

Tschichold, Jan. *Die Bildersammlung der Zehnbambushalle.* Eugen Rentsch Verlag, Erlangen-Zurich, 1970

Turk, Frank A. *The Prints of Japan,* 2d ed. Arco Publishers, London, 1966

Waterhouse, David B. *Harunobu and His Age: The Development of Colour Printing in Japan.* British Museum, London, 1964

Yoshida, Toshi, and Rei Yuki. *Japanese Printmaking: A Handbook of Traditional and Modern Techniques.* Charles E. Tuttle Co., Rutland, Vt., 1966

Relief Prints

Bliss, Douglas Percy. *A History of Wood Engraving.* Spring Books, London, 1964

Bodor, John J. *Rubbings and Textures: A Graphic Technique.* Reinhold Publishing Corp., New York, 1968

Cirker, Blanche, et al., eds. *1800 Woodcuts by Thomas Bewick and His School.* Dover Publications, Inc., New York, 1962

Farleigh, John. *Engraving on Wood.* Dryad Press, Leicester, 1954

Field, Richard S. *Fifteenth Century Woodcuts and Metalcuts from the National Gallery of Art,* catalogue, National Gallery of Art, Washington, D.C., 1965

Gelman, Barbara, ed. *The Wood Engravings of Winslow Homer.* Bounty Books, New York, 1969

Gillon, Edmund Vincent, Jr. *Early New England Gravestone Rubbings.* Dover Publications, Inc., New York, 1966

Hind, Arthur M. *An Introduction to a History of Woodcut,* 2 vols. Dover Publications, Inc., New York, 1963

Janis, Eugenia Parry. *Degas Monotypes: Essay, Catalogue and Checklist,* catalogue, Fogg Art Museum, Harvard University, Cambridge, Mass., 1968

Karshan, Donald. *Picasso Linocuts: 1958–1963.* Tudor Publishing Co., New York, 1968

Kurth, Willi. *The Complete Woodcuts of Dürer.* Dover Publications, Inc., New York, 1963

Musper, H. Th. *Der Holzschnitt in fünf Jahrhunderten.* W. Kohlhammer, Stuttgart, 1964

Rasmusen, Harry. *Printmaking with Monotype.* Chilton and Co., Philadelphia, 1960

Rothenstein, Michael. *Frontiers of Printmaking: New Aspects of Relief Printing.* Reinhold Publishing Corp., New York, 1966

———. *Linocuts and Woodcuts: A Complete Blockprinting Handbook.* Watson-Guptill Publications, Inc., New York, 1962

Intaglio

Bechtel, Edwin de T. *Jacques Callot.* G. Braziller, New York, 1955

Binyon, Laurence. *The Engraved Designs of William Blake.* London, 1926; reprint, Da Capo Press, New York, 1968

Boon, Karel G. *Rembrandt: The Complete Etchings.* Harry N. Abrams, Inc., New York, 1963

———, and Christopher White. *Rembrandt van Rijn's Etchings.* Van Gendt and Co., Amsterdam, 1970

Bosse, Abraham. *Traité des Manières de Graver.* Paris, 1645

Brunsdon, John. *The Technique of Etching and Engraving.* Reinhold Publishing Corp., New York, 1967

Buckland-Wright, John. *Etching and Engraving.* Studio Publications, London, 1953

Burke, Joseph, and Colin Caldwell. *Hogarth: The Complete Engravings.* Harry N. Abrams, Inc., New York, 1968

Butler, J.T. "History of the Mezzotint," *Connoisseur,* March, 1969, p. 199 ff.

Faithorne, William. *The Art of Graveing and Etching.* London, 1662; reprint, Da Capo Press, New York, 1968

Ferrari, Enrique Lafuente. *Goya: His Complete Etchings, Aquatints and Lithographs.* Harry N. Abrams, Inc., New York, 1962

Gabor Peterdi: Graphics 1934–1969. Touchstone Publishers, Ltd., New York, 1970

Getlein, Frank and Dorothy. *Georges Rouault's Miserere.* Bruce Publishing Co., Milwaukee, Wisc., 1964

Goerg, Max, ed. *Max Ernst: Oeuvre Gravé.* Musée d'Art et d'Histoire, Geneva, 1970

Grego, Joseph. *Rowlandson the Caricaturist,* 2 vols. London, 1880; reprint, Collectors Editions, New York, 1969

Hayter, Stanley William. *New Ways of Gravure.* Pantheon Books, Inc., New York, 1949

Hind, Arthur M. *Giovanni Battista Piranesi: A Critical Study. . . .* Philadelphia, 1922; reprint, Da Capo Press, New York, 1968

———. *History of Engraving and Etching from the 15th Century to the Year 1927.* Dover Publications, Inc., New York, 1963

Huxley, Aldous (foreword). *The Complete Etchings of Goya.* Crown Publishers, Inc., New York, 1943

Klein, H. Arthur, ed. *Graphic Works of Peter Bruegel the Elder.* Dover Publications, Inc., New York, 1963

Lavalleye, Jacques. *Pieter Bruegel the Elder and Lucas van Leyden: The Complete Engravings, Etchings and Woodcuts.* Harry N. Abrams, Inc., New York, 1967

Lehrs, Max. *Historical and Critical Catalog of German, Netherlandish, and French Copper Engravings in the 15th Century,* 10 vols. Vienna, 1908–1934; reprint, with five supplementary volumes, Collectors Editions, New York, 1969–70

Leusden, Willem van. *The Etchings of Hercules Seghers and the Problem of His Graphic Technique.* A.W. Bruna and Son, Utrecht, 1961

Lieure, Jules. *Jacques Callot: La vie artistique et catalogue raisonné,* 9 vols. Paris, 1734; rev. ed., Collectors Editions, New York, 1969

Lumsden, Ernest S. *The Art of Etching.* J.B. Lippincott Co., Philadelphia, 1925

Mayor, A. Hyatt. *Giovanni Battista Piranesi.* H. Bittner and Co., New York, 1952

Paulson, Ronald. *Hogarth's Graphic Works,* 2 vols., rev. ed., Yale University Press, New Haven, Conn., 1920

Paultier, M.L. "English Mezzotints." *Toledo Museum News,* Spring 1965, pp. 3–22

Rembrandt, Experimental Etcher, catalogue of an exhibition shown at the Museum of Fine Arts, Boston, and at the Pierpont Morgan Library, New York. New York Graphic Society, Greenwich, Conn., 1969

Shestack, Alan. *Fifteenth Century Engravings of Northern Europe from the National Gallery of Art,* catalogue, National Gallery of Art, Washington, D.C., 1968

———. *The Master E.S.: Five Hundredth Anniversary Exhibition,* catalogue, Philadelphia Museum of Art, Philadelphia, 1967

———, ed. *The Complete Engravings of Martin Schongauer.* Dover Publications, Inc., New York, 1969

Trevelyan, Julian. *Etching: Modern Methods of Intaglio Printmaking.* Watson-Guptill Publications, Inc., New York, 1963

White, Christopher. *Rembrandt as an Etcher: A Study of the Artist at Work,* 2 vols. Pennsylvania State University Press, University Park, Pa., 1969

Wright, Thomas, and Robert H. Evans. *Historical and Descriptive Account of the Caricatures of James Gillray.* Benjamin Blom, Inc., New York, 1968

Zerner, Henri. *The School of Fontainebleau: Etchings and Engravings.* Harry N. Abrams, Inc., New York, 1970

Zigrosser, Carl. *The Complete Etchings of John Marin.* Philadelphia Museum of Art, Philadelphia, 1969

Lithography

Adhémar, Jean. *Toulouse-Lautrec: His Complete Lithographs and Drypoints.* Harry N. Abrams, Inc., New York, 1965

Antreasian, Garo Z., and Clinton Adams. *The Tamarind Book of Lithography: Art & Techniques.* Harry N. Abrams, Inc., New York, 1971

Bild vom Stein, catalogue, State Collection of Graphic Art, Munich. Prestel Verlag, Munich, 1961

Davis, Burke, and Ray King. *The World of Currier and Ives.* Random House, New York, 1968

Dehn, Adolf, and Lawrence Barrett. *How to Draw and Print Lithographs.* Tudor Publishing Co., New York, 1950

Joyant, Maurice. *Henri de Toulouse-Lautrec 1864–1901,* 2 vols. H. Floury, Paris, 1926–27

Julien, Edouard. *Les Affiches de Toulouse-Lautrec.* Editions du Livre, Monte Carlo, 1950

Knigin, Michael, and Murray Zimiles. *The Technique of Fine Art Lithography.* Van Nostrand Reinhold Co., New York, 1970

Lang, Léon. *La Lithographie en France: Des origines au début du romantisme.* Mulhouse, 1946

Larkin, Oliver W. *Daumier: Man of His Time.* Beacon Press, Boston, 1968

Lejeune, Robert. *Honoré Daumier.* Clairfontaine, Lausanne, 1953

Man, Felix. *150 Years of Artists' Lithographs: 1803–1953.*

William Heinemann, Ltd., London, 1953

Mourlot, Fernand. *Braque Lithographe.* Editions du Livre, Monte Carlo, 1963

——. *Chagall Lithographe.* Editions du Livre, Monte Carlo, 1960

Peters, Harry T. *Currier and Ives: Printmakers to the American People.* Doubleday & Co., Garden City, N.Y., 1942

Roger-Marx, Claude. *Bonnard Lithographs.* Editions du Livre, Monte Carlo, 1950

——. *L'Oeuvre gravé de Vuillard.* Editions du Livre, Monte Carlo, 1948

——, and Jean Vallery-Radot. *Daumier, le peintre-graveur,* catalogue, Bibliothèque Nationale, Paris, 1958

Sauret, André. *Picasso Lithographe.* Editions du Livre, Monte Carlo, 1960

Senefelder, Alois. *A Complete Course of Lithography.* London, 1819; reprint, Da Capo Press, New York, 1968

Twyman, Michael. "The Lithographic Hand Press 1796–1850," *Journal of the Printing Historical Society,* No. 3, 1967, pp. 3–50

Weaver, Peter. *The Technique of Lithography.* Reinhold Publishing Corp., New York, 1964

Weber, Wilhelm. *A History of Lithography.* McGraw-Hill, Inc., New York, 1966

Silkscreen

Auvil, Kenneth W. *Serigraphy: Silk Screen Techniques for the Artist.* Prentice-Hall, Inc., Englewood Cliffs, N.J., 1965

Biegeleisen, J.I. *Screen Printing: A Contemporary Guide.* Watson-Guptill Publications, Inc., New York, 1971

Carr, Frances. *A Guide to Screen Process Printing.* Studio Vista Books, London, 1961

Chieffo, Clifford T. *Silk Screen as a Fine Art: A Handbook of Contemporary Silk Screen Printing.* Reinhold Publishing Corp., New York, 1967

Fossett, Robert O. *Techniques in Photography for the Silk Screen Printer.* The Signs of the Times Publishing Co., Cincinnati, 1959

Kinsey, Anthony. *Introducing Screen Printing.* Watson-Guptill Publications, Inc., New York, 1968

Kosloff, Albert, *Photographic Screen Process Printing.* The Signs of the Times Publishing Co., Cincinnati, 1968

Shokler, Harry. *Artist's Manual for Silk Screen Print Making.* Tudor Publishing Co., New York, 1960

Papermaking

Clapperton, Robert H. *Modern Paper-Making,* 3d ed. Oxford University Press, Oxford, 1952

——. *Paper, an Historical Account of Its Making by Hand from the Earliest Times Down to the Present Day.* Oxford University Press, Oxford, 1934

Hunter, Dard. *Papermaking; the History and Technique of an Ancient Craft.* Alfred A. Knopf, Inc., New York, 1943; 2d ed., 1947

——. *Papermaking Through Eighteen Centuries.* William E. Rudge, New York, 1930

Labarre, E. J. *A Dictionary of Paper and Papermaking Terms. . . .* N.V. Swets & Zeitlinger, Amsterdam, 1937

Mason, John. *Paper Making as an Artistic Craft: With a Note on Nylon Paper.* Faber and Faber, Ltd., London, 1959

Papermaking: Art and Craft, catalogue, Library of Congress, Washington, D.C., 1968

Weeks, Lyman H. *A History of Paper Manufacturing in the United States, 1690–1916.* Lockwood Trade Journal Co., New York, 1916

The Illustrated Book

Bland, David. *A History of Book Illustration: The Illuminated Manuscript and the Printed Book.* Faber and Faber, Ltd., London, 1969

Buhler, Albert. *The Fifteenth Century Book.* University of Pennsylvania Press, Philadelphia, 1960

Goldschmidt, E. P. *The Printed Book of the Renaissance: Type, Illustration, Ornament.* Cambridge University Press, Cambridge, 1950

Hofer, Philip. *The Artist and the Book, 1860–1960.* Harvard University Press, Cambridge, Mass., 1961

Horodisch, Abraham. *Picasso as a Book Artist.* World Publishing Co., Cleveland, 1962

Ivins, William M., Jr. *Prints and Books: Informal Papers.* Harvard University Press, Cambridge, Mass., 1926; reprint, Da Capo Press, New York, 1969

Johnson, Alfred F. *French 16th Century Printing.* Ernest Benn, Ltd., London, 1928

——. *Italian 16th Century Printing.* Ernest Benn, Ltd., London, 1926

Lejard, André, ed. *The Art of the French Book: from the early manuscripts to the present time.* Les Editions du Chêne, Paris, 1947

Levarie, Norma. *The Art and History of Books.* James H. Heineman, Inc., New York, 1968

McMurtrie, Douglas C. *The Book: The Story of Printing*

and Bookmaking. Oxford University Press, New York, 1943

Skira, Albert. *Anthologie du Livre Illustré par les peintres et sculpteurs de l'école de Paris.* A. Skira, Geneva, 1946

Steinberg, Saul H. *Five Hundred Years of Printing.* Penguin Books, Baltimore, Md., 1966

Strachan, W.J. *The Artist and the Book in France.* George Wittenborn, Inc., New York, 1970

Wheeler, Monroe, ed. *Modern Painters and Sculptors as Illustrators.* Museum of Modern Art, New York, 1936

Wilson, Adrian. *The Design of Books.* Reinhold Publishing Corp., New York, 1967

———. *The Nuremberg Chronicle Designs.* Privately printed, San Francisco, 1969

Winterich, John T. *Early American Books and Printing.* Houghton Mifflin Co., Boston, 1935

INDEX

All references are to page numbers. Italic numbers indicate the page location of illustrations. Colorplates are distinguished by the word "color" in parentheses.